ANASTASIS

THE MAKING OF AN IMAGE

ANNA D. KARTSONIS

ANASTASIS

THE
MAKING OF AN
IMAGE

PRINCETON UNIVERSITY PRESS

PRINCETON, NEW JERSEY

LIBRARY OF CONGRESS CATALOGING IN PUBLICATION
DATA WILL BE FOUND ON THE LAST PRINTED PAGE OF THIS BOOK

ISBN 0–691–04039–7

THIS BOOK HAS BEEN COMPOSED IN LINOTRON BEMBO

CLOTHBOUND EDITIONS OF PRINCETON UNIVERSITY
PRESS BOOKS ARE PRINTED ON ACID-FREE
PAPER, AND BINDING MATERIALS
ARE CHOSEN FOR STRENGTH
AND DURABILITY

★

PRINTED IN THE UNITED STATES OF AMERICA
BY PRINCETON UNIVERSITY PRESS, PRINCETON, NEW JERSEY

ΤΟΥ ΠΑΤΕΡΑ
ΚΑΙ
ΤΗΣ ΜΗΤΕΡΑΣ
ΜΟΥ

CONTENTS

ILLUSTRATIONS

1. London. British Museum. Ivory plaques with scenes from the Passion.
2. Washington, D.C. Dumbarton Oaks Collection. Pilgrim's ampulla. The Crucifixion (obverse) and the Marys at the Tomb (reverse).
3. Washington, D.C. Dumbarton Oaks Collection. Gold marriage ring. Christ blessing the couple and christological scenes.
4. Museum of Art and Archaeology. University of Missouri-Columbia. Ex Coll. Fouquet. Magical silver bracelet with christological scenes and apotropaic emblems (after Maspero).
5. Florence. Biblioteca Laurenziana. Rabbula Gospels. Cod. Plut. 1, 56, fol. 13r. The Crucifixion, the guards overthrown, the Marys at the tomb, the Chairete.
6. Formerly in the Museum of Cardinal Stefano Borgia, Rome. Eighteenth-century drawing of small bronze plaque (after Garrucci).
7. Monza. Cathedral. Pilgrim's ampulla no. 5. The Marys at the tomb (after Grabar).
8. Washington, D.C. Dumbarton Oaks Collection. Stone relief. Christ's tomb.
9. Mount Athos. Lavra Monastery. Cod. 131 (B 11), fol. 91v-92r. Anastasius Sinaites, *Hodegos*, ch. 12. The Crucifixion.
10. Munich. Bayerische Staatsbibliothek. Cod. gr. 467, fol. 147r. Anastasius Sinaites, *Hodegos*, ch. 12. The Crucifixion.
11. Vienna. Nationalbibliothek. Cod. theol. gr. 40, fol. 176v. Anastasius Sinaites, *Hodegos*, ch. 12. The Crucifixion.
12a. Cambridge. University Library. Add. 3049, fol. 103r. Anastasius Sinaites, *Hodegos*, ch. 12. Cross.
12b. Paris. Bibliothèque Nationale. Cod. gr. 1084, fol. 135v. Anastasius Sinaites, *Hodegos*, ch. 12. Cross.
13. Moscow. Historical Museum. Cod. gr. 265, fol. 72v. Anastasius Sinaites, *Hodegos*, ch. 12. Cross (after Belting).
14a. Rome. S. Maria Antiqua. Doorway to the Palatine ramp. The Anastasis (after Wilpert).
14b. Rome. S. Maria Antiqua. Chapel of the Forty Martyrs. The Anastasis (after Wilpert).
15. Vatican. Biblioteca. Cod. Barb. lat. 2733, fols. 90v-91r. St. Peter's Basilica. Oratory of Pope John VII. Drawing by Grimaldi.
16. Vatican. Biblioteca. Cod. Barb. lat. 2733, fols. 113v-114r. St. Peter's Basilica. Drawing by Grimaldi.
17a. Rome. S. Clemente. Lower Church. Anastasis I (after Wilpert).
17b. Rome. S. Clemente. Lower Church. Anastasis II (after Wilpert).
18. Vatican. Biblioteca. Cosmas Indicopleustes. Cod. gr. 699, fol. 89r. The Last Judgment.

ABBREVIATIONS

See also the list of abbreviations in
Dumbarton Oaks Papers, 27 (1973), 329–339.

Baltimore 1947	*Early Christian and Byzantine Art. An Exhibition Held at the Baltimore Museum of Art. Organized by the Walters Art Gallery* (Baltimore, 1947).
Beck	H. G. Beck, *Kirche und theologische Literatur im byzantinischen Reich* (Munich, 1969).
Belting	H. Belting, *Die Basilica dei SS. Martiri in Cimitile und ihr frühmittelalterlicher Freskenzyklus* (Wiesbaden, 1962).
Bertonière	G. Bertonière, *The Historical Development of the Easter Vigil. OCA* 193 (Rome, 1972).
Brenk	B. Brenk, *Tradition und Neuerung in der christlichen Kunst des ersten Jahrtausends* (Vienna, 1966).
CIEB	*Congrès International d' Etudes Byzantines.*
CSHB	*Corpus Scriptorum Historiae Byzantinae.* Niebuhr ed. (Bonn, 1827ff.).
Dontcheva-Petkova, 1976	L. Dontcheva, "Une croix pectorale-reliquaire en or récemment trouvée à Pliska." *CA*, 25 (1976), 59–66.
Dontcheva-Petkova, 1979	L. Dončeva-Petkova, "Croix d'or-Reliquaire de Pliska." *Culture et art en Bulgarie Médiévale (VIIIe–XIVe s.). Bulletin de l'Institut d'Archéologie*, 35 (1979), 74–91.
Galavaris, *Gregory*	G. Galavaris, *The Illustration of the Liturgical Homilies of Gregory Nazianzenus* (Princeton, 1969).
Grierson, *Catalogue*	Ph. Grierson, *Catalogue of the Byzantine Coins in the Dumbarton Oaks Collection* (Washington, D.C., 1968–1973), II, III.
Jerphanion	G. de Jerphanion, *Une nouvelle province de l'art byzantin. Les églises rupestres de Cappadoce* (Paris, 1925–1942).
Karmires	I. N. Karmires, Ἡ εἰς Ἅδον κάθοδος τοῦ Κυρίου (Athens, 1939).
Lazarev, *Storia*	V. Lazarev, *Storia della pittura bizantina* (Turin, 1967).
Mango, *Sources*	C. Mango, *The Art of the Byzantine Empire 312–1453.* Sources and Documents: The History of Art Series (Englewood Cliffs, 1972).

Mateos	J. Mateos, *Le Typicon de la Grande Eglise. OCA* 165, 166 (Rome, 1962 and 1966).
Restle	M. Restle, *Byzantine Wall Painting in Asia Minor* (Recklinghausen, 1967).
Rosenberg, 1924	M. Rosenberg, *Geschichte der Goldschmiedekunst auf technischer Grundlage. Niello bis zum Jahre 1000 nach Chr.* (Frankfurt a.M., 1924).
Rosenberg, 1922	M. Rosenberg, *Geschichte der Goldschmiedekunst auf technischer Grundlage. Zellenschmelz. III. Die Frühdenkmäler* (Darmstadt, 1922).
Ross I	M. Ross, *Catalogue of the Byzantine and Early Medieval Antiquities in the Dumbarton Oaks Collection.* Volume I: *Metalwork, Ceramics, Glass and Glyptics* (Washington, D.C., 1962).
Ross II	M. Ross, *Catalogue of the Byzantine and Early Medieval Antiquities in the Dumbarton Oaks Collection.* Volume II: *Metalwork, Jewelry, Enamels, Glass and Glyptics* (Washington, D.C., 1965).
Schiller	G. Schiller, *Die Ikonographie der christlichen Kunst* (Gütersloh, 1966–1976), I–IV.
The Treasures of Mount Athos	St. Pelekanides, P. Christou, Chr. Mavropoulou-Tsioumi, S. N. Kadas, *The Treasures of Mount Athos. Illuminated Manuscripts* (Athens, 1973–1979), I–III.
Uthemann	*Anastasii Sinaitae Opera. Viae Dux.* K. H. Uthemann, ed. comment. *CChr. Series Graeca* 8 (Turnhout, 1981).
Uthemann, Synopsis	K. H. Uthemann, "Die dem Anastasios Sinaites zugeschriebene Synopsis de haeresibus et synodis." *Annuarium Historiae Conciliorum,* 14 (1982), 58–95.
Weitzmann, *Elfenbeinskulpturen*	A. Goldschmidt and K. Weitzmann, *Die byzantinischen Elfenbeinskulpturen des X.–XIII. Jahrhunderts* (Berlin, 1930–1934).
Weitzmann, *Sinai Icons* I	K. Weitzmann, *The Monastery of St. Catherine at Mount Sinai: The Icons.* Volume I (Princeton, 1976).
Weitzmann, *Studies*	K. Weitzmann, *Studies in Classical and Byzantine Manuscript Illumination* (Chicago, 1971).
Wilpert	J. Wilpert, *Die römischen Mosaiken und Malereien der kirchlichen Bauten vom IV. bis XIII. Jahrhundert* (Freiburg i. B., 1917).

ACKNOWLEDGMENTS

I am pleased to acknowledge here my debt to those who contributed in so many ways to the making of this book. My gratitude for their help and support is deep and will be lasting.

First and foremost I thank my advisers Hugo Buchthal and Thomas Mathews. Hugo Buchthal recognized in my earlier work a subject worth pursuing; Thomas Mathews helped focus it on the theme of the Anastasis. With patience and generosity they coached me through its subsequent phases. Without their encouragement this work would have remained an unrealized dream. I hope the results will please them.

Work on the Anastasis started at the American School of Classical Studies in Athens. A grant from the British Council and a Junior Fellowship from Dumbarton Oaks made possible its continuation in London and Washington, D.C., where the body of the research was completed. The unique facilities of the Warburg Institute, the British Museum, and the Dumbarton Oaks Center for Byzantine Studies greatly influenced the shape of this book. I wish to express here my gratitude to the directors, librarians, and staff of these institutions for their invaluable assistance and/or financial support. I am especially indebted to James R. McCredie for his decisive help on more than one occasion.

The manuscript was written in my home town, Athens, and was revised in Munich. I wish to thank the Alexander von Humboldt Stiftung, whose grant made this possible. I also wish to thank the directors of the Institute of Art History and the Institute of Byzantine Studies of the University of Munich for their hospitality.

During the various stages of my work I was fortunate to meet several scholars who shared their diverse interests and knowledge with me. The acknowledgments in the text must be limited to specific contributions. However, the scholarly debts of this book are considerable. I therefore wish to express here my additional gratitude to Hans Belting, Margaret English Frazer, Ernst Kitzinger, Robert Nelson, and Gary Vikan for their creative insights into my material and its organization. I wish, moreover, to thank Irina Andreescu, Robin Cormack, Otto Demus, Suzy Dufrenne, Paul C. Finney, Ø. Hjort, Victoria Kepetzis, K. McVey, Eunice Maguire, Henry Maguire, Neil Moran, John Osborne, Yoram Tsafrir, and Kurt Weitzmann. Their conversations enriched and broadened the scope of my work in various ways.

I also owe special thanks to Sue Boyd, David Buckton, Margaret English Frazer, and Michelini Tocci for enabling me to examine works in their keep. Similarly, for facilitating my study of manuscripts in their collections, I express my appreciation to the curators of the departments of manuscripts of the National Library in Athens, the British Library, the Ambrosiana in Milan, the Bayerische Staatsbibliothek in Munich, the Pierpont Morgan Library in New York, the Bibliothèque Nationale in Paris, the Princeton University Library, the Biblioteca Apostolica Vaticana, the Patriarcha Institute for Patristic Studies in Thessalonike, the Biblioteca Marciana in Venice, the Hellenic Institute in Venice, and the

Nationalbibliothek in Vienna. In addition to the photographic credits included at the end of the book, I wish to express here my very special appreciation to Kurt Weitzmann, Natalia Teteriatnikov, and John Osborne for allowing me to publish material from their personal photographic collections.

My acknowledgments would be incomplete if I did not single out my good friend Greg Chamberlain, whose brilliant editorial care helped enhance some of the more positive aspects of my writing, while improving its less attractive features.

The book is also a tribute to Christine Ivusic of Princeton University Press. Her tragic and untimely death was a great loss in many ways. I wish to express here my appreciation for her support, and to thank Robert Brown of Princeton University Press for stepping in and seeing this publication through to its completion.

Finally, I wish to say to Marika Kartsonis, Argyro Dover, and Carl Dover: "Thank you for always being there."

ANASTASIS

THE MAKING OF AN IMAGE

I

THE BACKGROUND

The Middle Byzantine period popularized and crystallized an image that gradually became the visual synonym for Easter. It was called "The Anastasis," which means the Resurrection in Greek.

The image of the Anastasis was interpreted by the Byzantine church as a visual statement of a combined historical, liturgical, and theological importance. Its function and use were therefore diversified accordingly. In this respect it was not an exception. The church took the same attitude toward the visual expression of the other major feasts in the christological cycle. Still, the Anastasis stands apart from these relatives in two important respects: despite the exceptional importance of its content—the Resurrection—the pictorialization of the Anastasis makes its appearance later than the other major scenes in the christological cycle. Also, contrary to the methodology followed in shaping this cycle, the Anastasis does not draw its subject matter from the text of the Gospels. The ramifications of these departures raise important questions about the date and the circumstances which made acceptable the introduction of such an unusual image into the standard christological cycle. In addition, the reasons and manner in which this image was allowed to evolve to the point of making it synonymous with Easter, the most important feast in the liturgical year, promise fruitful insights into the rest of the cycle as well.

The visual prominence that the Anastasis acquired through its association with the feast of Easter is responsible in large measure for the attention the image has attracted to date from art historians. Many of the formal aspects of this iconography have been examined—its date and place of origin, its literary and visual sources, and its compositional variants. But many aspects remain unsettled, while significant related evidence has been ignored or even misinterpreted.

This book will examine the appearance and evolution of this iconography in the context of the times that produced and developed it. The unconventional elements that mark out the Anastasis in the christological cycle particularly invite such an approach. At the same time, an iconography which achieved great popularity must have been an integral part of the cultural and intellectual milieu that produced it, developed it, and chose consciously to use it. Therefore, taking the Anastasis to be symptomatic of its contemporary preoccupations, I propose to reexamine its birth, growth, and dissemination up to the second half of the eleventh century within the framework of the church in whose environment it flourished and whose context helped to shape the visual solutions finally canonized as part of this image.

The Term "Anastasis"

The image of the Anastasis has come to be known in art historical literature by various other names as well. The most common are: Descent into Hell, Harrowing of Hell, *Descensus ad Inferos, Descente aux Limbes, Höllenfahrt, Hadesfahrt*, as well as Resurrection and *Auferstehung*.[1] None of these alternative titles is wrong. However, most superimpose semantic and cultural extensions or limitations on the iconography, which unavoidably affect its understanding and interpretation. Since most Byzantine examples accompanied by an inscription identify their subject matter as "the Anastasis", this will be the primary term used.

A brief review of its usage suggests that the word Ἀνάστασις[2] may be translated in its active sense (from ἀνίστημι) as: "making to stand," "rise up," or "raising up" (someone). The same word also may be used in a middle sense (from ἀνίσταμαι) meaning: "standing up," or "rising up."

As a result of its active and middle usage, the word Ἀνάστασις meaning "resurrection," "raising up," or "rising up" can be applied at the same time both to Christ's own rising, and to his raising of the dead.[3] So the translation of Anastasis as Resurrection is accurate. But any designation of the subject matter of this iconography as the Descent or Harrowing of Hell misrepresents and distorts the message of the chosen label Anastasis. The title and subject matter of this image refer, not to the Descent of Christ into Hell, Hades, Limbo, or Inferno, but to the rising of Christ and his raising of the dead. The concepts of rising and descending are obviously antonymous and therefore not interchangeable. Furthermore, the choice of the one over the other vitally affects the theological emphasis and interpretation of the image labeled Anastasis. Thus, for the sake of adhering to the intentions of the artists this iconography will be identified here either as Anastasis, or as Resurrection.

However, the terminology that we have just rejected, though in disagreement with the apparent intentions of the artists, does have some foundation. For the vital story of the Resurrection was not pictorialized by Christ's bodily rising out of his tomb—as the title Anastasis might suggest. Instead, part of the story of Christ's sojourn to the underworld was selected. According to this story, which is not part of the Gospels, Christ went to Hades after his death on the cross, and before his Resurrection from his tomb. There, Christ defeated Hades' kingdom of the dead, and robbed it of its captives, the dead, starting with Adam. Artists selected to depict as the Anastasis that moment when Christ starts

In the notes, cross-references are made in the form, e.g., n.5.35 (chapter five, note 35).

[1] For an extended list of titles reserved for this iconography in various languages see L. Réau, *L'iconographie de l'art chrétien* (Paris, 1957), II, 531. For a short list of inscriptions accompanying the image see

M. Sotiriou, "Χρυσοκέντητον ἐπιγονάτιον τοῦ Βυζαντινοῦ Μουσείου Ἀθηνῶν μετὰ παραστάσεως τῆς εἰς Ἅδου Καθόδου," *BNJbb*, 11–12 (1934–1936), 291.

[2] H. G. Liddell and R. Scott, *A Greek-English Lexicon* (Oxford, 1968), w. ἀνάστασις.

[3] G. W. Lampe, *A Patristic Greek Lexicon* (Oxford, 1968), w. ἀνάστασις.

pulling Adam from the grave after defeating Hades (fig. 14a). Thus, the theme of the raising of Adam is actually chosen for pictorializing the crucial doctrine of the Resurrection. One of the earliest surviving inscriptions identifying this scene confirms this interpretation by specifying the content of the image as "Τὸν Ἀδὰμ ἀνιστὼν ὁ Χριστὸς ἐκ τοῦ Ἄδου" (fig. 44a).[4] So the characterization of the iconography as "The Descent of Christ into Hades," though alluding to the broader story to which the iconography of the Anastasis belongs, raises different expectations than either the general label "Anastasis," or the specific label "The Anastasis of Adam."

In their frequent use of this misnomer, art historians have followed a practice dating back to the *Painter's Manual*, of the eighteenth century. Its author, Dionysios ek Fourna, entitles this subject "Ἡ εἰς τὸν Ἄδην κάθοδος τοῦ κυρίου."[5] This seems to contradict my earlier assertion about the validity of the term "Anastasis." However, the scene described in this document, as well as the cycle of which it is part, belong to a late type, which consistently expanded the number of scenes in the cycle and the number of motifs in each scene. Thus, the cycle described in the *Painter's Manual*, in accordance with late examples, includes the bodily rising of Christ, while the scene of "The Descent into Hades" includes the binding of Satan and his demons by angels, a feature that does not appear in the Byzantine Anastasis before the late period.[6] This suggests that the new title for the image of the Anastasis forms part of the proliferation of its content at a later stage in Byzantine art.

Until now I have assumed that the inscription "Anastasis"—which normally accompanies this image in the Middle Byzantine period, and which is a twin reference to the bodily rising of Christ and his raising of mankind—acts as a catalyst for the transmission of the message inherent in this iconography. If this assumption is valid, then it is worth noting that the narrative component of this iconography, far from concentrating on Christ's own rising, is instead concerned with the rescue of Adam from the land of the dead. Christ's own Resurrection is not at issue either in the image of the Anastasis or in the broader story of the Descent into the Underworld. This aspect of the miracle of the Resurrection is taken for granted. However, in both instances the opposite is true of the raising of Adam. The recognition of Adam by homilists as "the first created . . . and the first dead amongst men"[7] makes his raising from the dead an act of re-creation on the part of the Logos. This

[4] Chloudof Psalter (Moscow, Historical Museum, cod. 129), fol. 63ʳ, Ps. 67:2. The idea is reiterated in the second representation of the Anastasis, which illustrates Ps. 67:7, fol. 63ᵛ and is labeled Ἄλλη Ἀνάστασις τοῦ Ἀδὰμ. A third representation of the Anastasis (fol. 82ᵛ, Ps. 81:8) is labeled as Ἀνάστασις. M. V. Shchepkina, *Miniatiury Khludovskoi Psaltyri* (Moscow, 1977).

[5] Denys de Fourna, *Manuel d'iconographie chrétienne*, A. Papadopoulos-Kerameus, ed. (St. Petersburg, 1909), 110.

[6] For example, the Anastasis at Sopoćani. G. Millet, *La peinture du Moyen Age en Yougoslavie* (Paris, 1957), II, pls. 14–15. S. Radojčić, *Sopoćani* (Belgrade, 1963), pl. 19. The Kiev Psalter, a 1397 Russian descendant of the psalters with marginal miniatures, similarly adds the motif of the binding of Hades to the traditional first type of Anastasis found in this psalter group (Ps. 23:7, fol. 31ʳ. See Vzdornov in n.6.1).

[7] Pseudo-Epiphanius, *In Sancto et Magno Sabbato*. PG, 43.460f. "ὁ Ἀδὰμ ἐκεῖνος ὁ πάντων ἀνθρώπων πρωτόκτιστος, καὶ πρωτόπλαστος, καὶ πρωτόθνητος."

in turn is interpreted as signifying the opening of the era of Redemption for mankind achieved through the Incarnation, the Passion, and the Death of Christ.[8]

Thus in the image of the Anastasis, Adam stands for Everyman. His Resurrection declares the availability of Resurrection to all mankind, a vital doctrine of the church.[9] Therefore, when Adam's raising is combined with the ambiguous title "Anastasis"—which refers both to the rising of Christ and the raising of mankind—this is not a contradiction but a complementary interaction enriching significantly the narrative content of the image. Because of the twin usage of the word "Anastasis," the label of the iconography acts as a key to the message of the image, which refers simultaneously to the Resurrection of Christ, Adam, and mankind.[10]

The position of the Anastasis in the christological cycle offers a similar key to the message of the iconography, while introducing new ambiguities. Its placement at the end of the Passion in this cycle, which develops chronologically, makes the Anastasis in effect an instant reference to the Resurrection of Christ. However, while artists had no qualms about representing as literal actualities other major events from the life of Christ—such as his Nativity, Baptism, and so on—they apparently felt differently about his Resurrection. They chose to show the Resurrection of Adam instead of the Resurrection of Christ, as we have seen. Moreover, the moment depicted is ambivalent in that the rescue of Adam is far from complete. As a result, neither Adam, nor Christ, nor any of the dead has actually departed from the domain of Hades as yet.[11] This creates the peculiar situation, whereby a scene in the christological cycle that refers to the Resurrection of Christ is taking place in Hades, during the death of Christ. The ambiguity in the element of time in this image is important, for though the rescue of Adam constitutes visual proof of the promised Redemption, it continues to be part of the time period of the three days and three nights during which Christ's body remained dead in the tomb, while his soul went to the Underworld.[12] Thus, the guarantee of Redemption starting here and now with Adam is simultaneously a statement on the works of the Logos Incarnate during the time of the Death of Christ.

We see, then, that the image of the Anastasis does not operate within the standard christological cycle in the same manner as the other scenes representing major events from the

[8] Photius, *Homily* 12.4. B. Laourdas, Φωτίου Ὁμιλίαι (Thessalonike, 1959), 124. C. Mango, *The Homilies of Photius Patriarch of Constantinople* (Cambridge, 1968), 214f. Also n. 3.100.

[9] Ibid. *Homily* 12.3, "καὶ τριήμερος ἔγερσις, τὴν πάντων ἀνάστασιν." I. N. Karmires, Ἡ εἰς Ἅδου κάθοδος τοῦ Χριστοῦ (Athens, 1939), 119–141. Hereafter: Karmires.

[10] The dictionary of Suidas defined the word ἀνάστασις in terms of the raising of Adam as well. *Suidae Lexicon*, ed. A. Adler (Leipzig, 1928), w. ἀνάστασις. Also n.6.105.

[11] J. Wilpert, *Die römischen Mosaiken und Malereien der kirchlichen Bauten vom IV. bis XIII. Jahrhundert* (Freiburg i. B., 1917), II.2, 889. Hereafter: Wilpert.

[12] The sojourn of Christ in Hades, the defeat of Hades, and the rescue of Adam are commemorated on Holy Saturday previous to the commemoration of the rising of Christ on Easter Sunday. The *Painter's Manual*, of Dionysius of Fourna (n.1.5) reflects the same idea when grouping the scene of "The Descent of Christ to Hades" with the scenes of the Passion and not with those of the Resurrection.

life of Christ. This naturally raises questions about the date and reasons for the addition of this scene to the cycle, and about the circumstances of the final canonization of this image as the feast picture for Easter.

THE ART HISTORICAL LITERATURE

One of the earliest studies of the Anastasis was published in the late nineteenth century by Millet in the context of the mosaic at Daphni.[13] His work was followed by Rushforth,[14] Morey[15] and Wilpert[16] from the 1900s to the 1920s, as well as by Weitzmann,[17] Grabar,[18] Demus,[19] M. Sotiriou,[20] and Xyngopoulos[21] in the 1930s. After the Second World War Weitzmann continued and expanded his research,[22] in which he was later followed by Galavaris.[23] Other aspects of the Anastasis were published in the 1960s by Lucchesi Palli,[24] and in the 1970s by Schwartz,[25] Nordhagen,[26] and Davis-Weyer.[27] To these one should add works of a more general nature that have made an effort to review the literature on the

[13] G. Millet, "Mosaiques de Daphni," *MonPiot*, 2 (1895), 204–214. An earlier study by N. Pokrovskii, *Evangelie ü pamiatnikakh ikonografii vizantiiskikh i russkikh* (St. Petersburg, 1892), 399–425, has not left its trace on subsequent bibliography.

[14] G. McN. Rushforth, "S. Maria Antiqua," *BSR*, I (1902), 114–119.

[15] C. R. Morey, *East Christian Paintings in the Freer Collection* (New York, 1914), 45–53. Idem, "Notes on East Christian Miniatures," *AB*, 11 (1929), 57f.

[16] Wilpert, II.2, 887–896.

[17] K. Weitzmann, "Das Evangelion im Skevophylakion zu Lawra," *SemKond*, 8 (1936), 83–98.

[18] A. Grabar, *L'empereur dans l'art byzantin* (Paris, 1936), 245–249. For a review of his opinion, idem, *Christian Iconography* (Princeton, 1968), 123–126. And more recently, "Essai sur les plus anciennes représentations de la 'Résurrection du Christ,' " *Mon Piot*, 63 (1980), 105–41.

[19] E. Diez and O. Demus, *Byzantine Mosaics in Greece* (Cambridge, 1931), 69ff.

[20] M. Sotiriou, "Χρυσοκέντητον ἐπιγονάτιον τοῦ Βυζαντινοῦ Μουσείου," 289–295.

[21] A. Xyngopoulos, "Ὁ ὑμνολογικὸς εἰκονογραφικὸς τύπος τῆς εἰς τὸν Ἅδην καθόδου τοῦ Ἰησοῦ," Ἐπ. Ἑτ.Βυζ.Σπ., 17 (1941), 113–129.

[22] K. Weitzmann, "Aristocratic Psalter and Lectionary," *Record of the Art Museum, Princeton University*, 19 (1960), 98–107. Idem, "Zur byzantinischen Quelle des Wolfenbüttler Musterbuches," *Festschrift Hans H. Hahnloser zum 60. Geburtstag 1959* (Basel, 1961), 233ff. Idem, "A 10th Century Lectionary. A

Lost Masterpiece of the Macedonian Renaissance," *RESEE*, 9 (1971), 617–622. Idem, "The Character and Intellectual Origins of the Macedonian Renaissance," *Studies in Classical and Byzantine Manuscript Illumination* (Chicago, 1971), 210f. Ibid., "The Narrative and Liturgical Gospel Illustrations," 257f. Ibid., "Byzantine Miniature and Icon Painting in the Eleventh Century," 289ff. Weitzmann, "The Constantinopolitan Lectionary, Morgan 639," *Studies in Art and Literature for Belle da Costa Greene* (Princeton, 1954), 358–373. Idem, "An Illustrated Greek New Testament of the Tenth Century in the Walters Art Gallery," *Gatherings in Honor of Dorothy E. Miner* (Baltimore, 1974), 19–38. Idem, "The Selection of Texts for Cyclic Illustration in Byzantine Manuscripts," *Byzantine Books and Bookmen* (Washington, D.C., 1975), 69–105.

[23] G. Galavaris, *The Illustration of the Liturgical Homilies of Gregory Nazianzenus* (Princeton, 1969), 70–99. Hereafter: Galavaris, *Gregory*.

[24] E. Lucchesi Palli, "Der syrisch-palästinensische Darstellungstypus der Höllenfahrt Christi," *RQ*, 57 (1962), 250–267.

[25] E. C. Schwartz, "A New Source for the Byzantine Anastasis," *Marsyas*, 16 (1972–1973), 29–34.

[26] P. J. Nordhagen, "Kristus i Dødsriket," *Kunst og Kultur*, 57 (1974), 165–174. Idem, "The 'Harrowing of Hell' as Imperial Iconography. A Note on Its Earliest Use," *BZ*, 75 (1982), 345–348.

[27] C. Davis-Weyer, "Die ältesten Darstellungen der Hadesfahrt Christi, des Evangelium Nikodemi und ein Mosaik der Zeno-Kapelle," *Roma e l'età Ca-*

subject. Among these the ones most frequently consulted are the works of Villette,[28] Lange,[29] Schiller,[30] and Lucchesi Palli's entry in the *Reallexikon zur Byzantinischen Kunst*.[31] There are also studies contributing to the investigation of various problems of the Anastasis arising from specific monuments, such as the studies of Jerphanion on the Cappadocian frescoes,[32] Kosteckaja's study of the Chloudof Psalter,[33] Belting's study of the Anastasis at Cimitile,[34] and many others.

Until the 1930s attention was focused primarily on the iconographic development of the image in the narrower sense. This sought to establish the pictorial core of the Anastasis, and to disentangle the iconographic motifs added later to this core. During the thirties, the range of interest came to include an effort to establish the compositional variants of the Anastasis, while pinpointing its iconographic antetypes and sources. The examination of the compositional variants continued through the fifties. During the same time the growing interest in the Middle Byzantine feast cycle included an investigation of the role of the Anastasis in the standardized feast cycle, an aspect that still attracts considerable attention. The sixties reopened and expanded on the questions of the date and place of origin of this iconography, and the seventies have shown interest in specific aspects of its sources and use.

The core of the image proved relatively easy to establish. Christ quite literally raises Adam by pulling him up by the hand, while trampling underfoot the conquered Hades, who had been Adam's master until that point. Eve usually follows Adam, raising her hands in supplication to Christ. This central core did not remain unchanged. It gradually came to include four major compositional variants, each essentially determined by Christ's attitude toward Adam:

1. One of the earliest surviving types represented Christ leaning toward Adam in an effort to lift him from his grave (fig. 14a).
2. An important variation brought about a contrapostal relationship between Christ and Adam. Christ continued pulling Adam out of the tomb. This time, however, Christ strode energetically away from Adam and Eve (fig. 84).
3. A third compositional variant focused emphatically on Christ, who was represented fully frontal, hands extended sideways, flanked by Adam and Eve (fig. 44b).
4. The fourth type appeared later than the period we will consider here and was in effect a combination of the second and third types. Here, Christ pulled Adam up while

rolingia (Rome, 1976), 183–194.

[28] J. Villette, *La résurrection du Christ dans l'art chrétien du IIe au VIIe siècle* (Paris, 1957), passim.

[29] R. Lange, *Die Auferstehung* (Recklinghausen, 1966).

[30] G. Schiller, *Die Ikonographie der christlichen Kunst* (Gütersloh, 1973), III.

[31] E. Lucchesi Palli, *RBK*, I, w. "Anastasis," cols. 142–148.

[32] G. de Jerphanion, *Une nouvelle province de l'art byzantin. Les églises rupestres de Cappadoce* (Paris, 1925–1942), I.1, 91f. and II.2, 391f. Hereafter: Jerphanion.

[33] E. O. Kosteckaja, "L'iconographie de la résurrection d'après les miniatures du Psautier Chloudov," *SemKond*, 2 (1928), 60–70.

[34] H. Belting, *Die Basilica dei SS. Martiri in Cimitile und ihr frühmittelalterlicher Freskenzyklus* (Wiesbaden, 1962), 70–77.

marching away from him. Moreover, now Christ also pulled Eve by the hand, thus raising for the first time both Adam and Eve, who flanked him symmetrically (fig. 87).

Once these types had made their appearance, they continued to coexist.

The first three types had already been recognized by Millet in 1895. Their classification was organized more clearly by Morey in 1914. The second compositional type was examined further by Weitzmann in 1936, who dated its appearance in the Macedonian period, and saw in it a revival of the compositional scheme of Heracles dragging Cerberus out of Hades, found on sarcophagi of the second and third centuries A.D. Weitzmann's interpretation has recently been contested by Schwartz, who proposed as a model for this type the triumphant imperial iconography of the emperor dragging a captive, which appears on medallions and coins dating from the fourth to the sixth centuries. In the 1930s Grabar proposed similar sources for the first compositional variant as well. At the time, he formulated the hypothesis that this type of Anastasis synthesized two contradictory motifs which existed separately in imperial iconography. The one involved the emperor's trampling the defeated enemy, and the other his lifting the personification of the liberated province.[35]

The third compositional type was recognized by M. Sotiriou in the mid-thirties as austerely theological because of the organization of its figures.[36] In 1941 Xyngopoulos sought the inspiration for this centralized Anastasis in the Easter Canon of John of Damascus and therefore called it "the hymnological type." On the other hand, Weitzmann proposed in 1960 to call it "the dogmatic type." The first type he called "the narrative type," and the second "the renaissance type," reiterating his conclusion of 1936.[37] Moreover, based on the appearance of "the dogmatic type" in the Chloudof Psalter, Weitzmann dated it to the second half of the ninth century, apparently considering this to be a product of the Macedonian period as well. The Morey-Weitzmann analysis of the first three types was later supported by Galavaris who, however, refuted Xyngopoulos' thesis after an extensive review of its arguments.[38]

The fourth and latest type was discussed by Weitzmann in connection with the Wolfenbüttel Musterbuch and by Der Nersessian in connection with the fresco at Kariye Djami. More recently, Buchthal traced its earliest known examples to Saxon manuscripts of the Goslar region dating from the second quarter of the thirteenth century and reflecting earlier Byzantine sources.[39]

[35] Also, Grabar, *Christian Iconography*, loc. cit., and "Essai sur les plus anciennes représentations de la 'Résurrection du Christ,'" 119.

[36] M. Sotiriou, "Χρυσοκέντητον ἐπιγονάτιον τοῦ Βυζαντινοῦ Μουσείου," 292f.

[37] Weitzmann, "Aristocratic Psalter and Lectionary," 99. [38] Galavaris, *Gregory*, 73–77.

[39] H. Buchthal, *The "Musterbuch" of Wolfenbüttel and Its Position in the Art of the Thirteenth Century* (Vienna, 1979), 19ff. Weitzmann, "Zur byzantinischen Quelle des Wolfenbüttler Musterbuches," 234. S. Der Nersessian, "Program and Iconography of the Frescoes of the Parecclesion," *The Kariye Djami* (Princeton, 1975), IV, 320ff.

To sum up, the core of the image and the basic compositional variants which it governs have been established without major dispute. The same is true of its visual source material and models. Undoubtedly Grabar was right in emphasizing the triumphant character of this image, which had ready-made models in imperial iconography. Nevertheless, it is far from clear when and under what circumstances these imperial models were borrowed. This had occurred sometime before the beginning of the eighth century as witnessed by the earliest examples of the Anastasis dating from the pontificate of John VII (705–707).[40] On the other hand, the gold imperial medallions of the fourth century suggested by Schwartz—and more loosely by Villette[41] and Demus[42]—as models for the second type provide a terminus post quem for the use of these imperial motifs in a Christian context.[43]

The effort to date the genesis of the Anastasis iconography more precisely within these chronological limits has produced two schools of thought. One is led by Grabar, who based his argument on a study of the sources of the first type: "It was probably in the very late antiquity that this . . . iconographic formula was created, later than the image of the Constantinian (christological) cycle but at a time when allegorical images dealing with the triumph of emperors were still in use."[44]

This presumably implies a date in the late sixth to late seventh centuries and is based on Grabar's evaluation of Christ's twin pulling and trampling action as contradictory and compositionally confusing. Nordhagen has recently carried this interpretation further by attributing the synthesis to a broader renaissance movement of the seventh century. However, Schwartz has presented equally early imperial antetypes that combine these two actions. Although she refers only to the second compositional type of Anastasis, her antetypes still manage to raise serious doubts about the basis of Grabar's reasoning, even though they cannot specify any better the date of emergence of the Anastasis.

The other interpretation, which originated in the nineteenth century, links the date of this image with its literary sources. Millet had already asserted in 1895 that the text of the apocryphal Gospel of Nicodemus served as a source of inspiration for the iconography of the Anastasis.[45] The text, which had been published some fifty years earlier by Tischendorf, tells the story of Christ's descent into Hades.[46] This assertion was considered to be so self-evident by art historians that it was not even discussed by them, while alternative texts were not considered seriously. Since the text of Nicodemus had been dated as early

[40] Below, 70ff.

[41] Villette, *La résurrection du Christ*, 98f.

[42] As quoted by H. Hunger, "On the Imitation (Μίμησις) of Antiquity in Byzantine Literature," *DOP*, 23–24 (1969–1970), 23.

[43] These examples correspond accurately to the second type of Anastasis by combining the twin pulling and trampling gestures. Grabar had not found imperial precedents for this twin action in connection with the first type of Anastasis, and this influenced his evaluation of the iconography considerably. However, the combined results of Grabar's and Schwartz's research have produced a plethora of interrelated imperial models for the first and second types, their dates starting from the fourth century on. Even though no surviving example of the second type dates earlier than the ninth century, the imperial models suggested by Schwartz raise at least the possibility of a pre-ninth century date for this type.

[44] Grabar, *Christian Iconography*, 125.

[45] Millet, "Mosaiques de Daphni," 204.

[46] *Evangelia Apocrypha*. C. de Tischendorf, ed. (Leipzig, 1853), 266–311. *The Apocryphal New Testament*, M. R. James, trans. (Oxford, 1971), 117–146.

as the fourth century,[47] it seemed sensible to support a date in the fourth, fifth, or early sixth century for this derivative image. One of the ciborium columns of San Marco in Venice that includes a representation of the Resurrection and was dated until the forties to the sixth century, clinched this theory.[48]

Most inconveniently, however, a number of problems have arisen quite independently of each other in the last thirty years, which call for a reexamination of most facets of this hypothesis. One of the problems is that the Apocryphon of Nicodemus has been redated. A study of the manuscript tradition of its text published by G. C. O'Ceallaigh in 1963 showed that the first version of this text was composed some time around A.D. 600.[49] Similarly, from an art historical viewpoint, the columns of San Marco have proved to be highly problematic Italian works of the thirteenth century.[50] Even if they indeed copy Early Christian works—as has been suggested—the specific date of its models still remains indeterminate. So, even if the basic assumption of this school is accepted at face value, one would still have to note its inability to argue for a date earlier than A.D. 600 for the emergence of the Anastasis.[51]

There are various opinions about the geograhical origin of the iconography. Wilpert placed it in fourth-century Rome.[52] But this opinion has long been refuted.[53] Instead it has been commonly considered a creation of the Byzantine East. Moreover, at the turn of the century Baumstark proposed specifically a Syro-Palestinian provenance for reasons which are no longer self-evident.[54] This thesis was revived in the sixties by Lucchesi Palli, who took it a step further by assuming the simultaneous existence of two different versions of the first type of Anastasis in the East and West by A.D. 700. Accordingly, Christ moved to the left of the viewer in the western variant, and to the right of the viewer in the eastern variant. She illustrated the western version with the examples from S. Maria Antiqua (fig. 14a, 14b), while she recognized the eastern Syro-Palestinian version in the Fieschi Morgan reliquary (fig. 24g). However, Lucchesi Palli's geographical classification is weakened not only by the logistical problems it poses,[55] but also by the results of a reexamination of the

[47] For a list of studies favoring a fourth-century date, see R. Murray, *Symbols of Church and Kingdom* (Cambridge, 1975), 325 n. 6. Also, Davis-Weyer, "Die ältesten Darstellungen der Hadesfahrt Christi," 189f., and M. Alexiou, "The Lament of the Virgin in Byzantine Literature and Modern Greek Folk-Song," *Byzantine and Modern Greek Studies*, 1 (1975), 124ff.

[48] Morey, *East Christian Paintings in the Freer Collection*, 46, 47, 49 listed the column in S. Marco as a sixth-century monument vital to the understanding of the iconography of the Anastasis.

[49] G. C. O'Ceallaigh, "Dating the Commentaries of Nicodemus," *HThR*, 56 (1963), 21–59. This date has been accepted by Murray, *Symbols of Church and Kingdom*, 321, 325 n. 6.

[50] E. Lucchesi Palli, *Die Passions- und Endszenen Christi auf der Ciboriumsäule von San Marco in Venedig*

(Prague, 1942), 104–113; reviewed by A. M. Schneider in *BZ*, 42 (1943–1949), 276–279. For a summary of the controversy, O. Demus, *The Church of San Marco* (Washington, D.C., 1960), 166ff.

[51] Also, 14ff., and 29. [52] Wilpert, II.2, 887ff.

[53] Grabar, *L'empereur dans l'art byzantin*, 245 n. 2. E. Weigand, "Zur Datierung der Ciboriumsäulen von S. Marco in Venedig," *Vth CIEB. Acts* (Rome, 1940), 435ff. Lucchesi Palli, *Die Passions: und Endszenen Christi auf der Ciboriumsäule von San Marco in Venedig*, 184 n.320.

[54] A. Baumstark, "Palaestinensia," *RQ*, 20 (1906), 125.

[55] The direction of Christ's movement in the first type of Anastasis, whether to the right or to the left, contributes to Lucchesi Palli's geographical attribution to the East or West correspondingly. However,

date of the Fieschi Morgan reliquary.[56] More recently, Nordhagen favored a Constantinopolitan attribution. But the poverty of the surviving early examples makes very difficult, if not hopeless, the accumulation of enough proof to support any of these suggestions.

In addition to the problems surrounding the date and place of emergence of this iconography and its visual precedents, disentangling the secondary characteristics of the Anastasis has proved to be a confusing task. A number of motifs appear with insistent regularity in all types of Anastasis, while others vary with equal regularity. The confusion over the date, evolution, and implications of each of these additions to the core of the image has often prevented a more discriminating understanding of the Anastasis, its content, and its variations.

For example, besides the rescue of Adam through the defeat of Hades, any of the Anastasis variants could include the presence of David and Solomon, John the Baptist, Abel, and various other figures mostly anonymous. Art historical literature has collectively identified these figures as the Just, who witnessed and followed in the raising of Adam. However, this identification is only partially correct. By throwing all of them into the same basket this collective label obscures the differences in date and rationale behind the addition of each of these figures to the scheme of the Anastasis. As a result of this categorization the "Just" have received insufficient attention and this has led to significant inaccuracies.

Thus, Millet wrote in 1895 that the earliest example of Anastasis which includes the Baptist came from the frescoes of St. Sophia in Kiev dating from 1037.[57] Millet's assertion was repeated by Morey in 1914,[58] by Weitzmann in 1936,[59] as well as by Xyngopoulos in 1941.[60] Weitzmann furthermore used the presence of the Baptist in the Anastasis miniature of the Phocas Lectionary to support a date in the late tenth century for the contrapostal compositional type of Anastasis. In 1932 Jerphanion published a fresco from the New Tokali church in Cappadocia, which though partially destroyed, leaves no doubt about the presence of the Baptist in it.[61] The exhausting discussions about the date of most Cappadocian churches partly explains why this valuable piece of evidence from New Tokali has been left out of the discussion of the Anastasis until now. This reserve is no longer tenable,

Christ often moves in the "wrong" direction in works whose provenance has never been at issue. For example, Christ moves to the right not only on the Fieschi Morgan reliquary, but also in the two Anastasis frescoes in S. Clemente (below, 82ff.) and the Constantinopolitan Lectionary Morgan 639 (Weitzmann, "The Constantinopolitan Lectionary Morgan 639," 269f., fig. 290). Similarly, Christ moves to the left not only in the Anastasis fresco on the doorway to the Palatine Ramp in S. Maria Antiqua, but also in the Leningrad Lectionary, Public Library, cod. gr. 21, fol. 1ᵛ (Weitzmann, "Narrative and Liturgical Gospel Illustration," 258, fig. 245) and the Stuttgart ivory casket (see nn. 6.119, 120).

[56] See, 94–125.

[57] Millet, "Mosaiques de Daphni," 201.

[58] Morey, *East Christian Paintings in the Freer Collection*, 47.

[59] Weitzmann, "Das Evangelion im Skevophylakion zu Lawra," 87f.

[60] Xyngopoulos, "Ὁ ὑμνολογικὸς εἰκονογραφικὸς τύπος, τῆς εἰς τὸν Ἅδην καθόδου τοῦ Ἰησοῦ," 120.

[61] See, 168–173.

however, since more recent studies date this church in the mid-tenth century and, thus, make the appearance of the Baptist considerably earlier than supposed. Undoubtedly the Baptist's presence among the "Just" took a long time to materialize. Also, his inclusion did not become a staple of the standardized image before the eleventh century or so.

The ambivalent iconographic attitude toward the Baptist contrasts sharply with the certainty with which one comes to expect the figures of King David and King Solomon as part of this image. The first dated appearance of the two biblical kings comes from the Chapel of S. Zeno at S. Prassede in Rome (817–824, fig. 23),[62] which means that it antedates the first appearance of the Baptist by over 125 years. Why, then, did David and Solomon appear and become an essential part of the Anastasis so much earlier than the Baptist? It is hard to believe they are more evidently "Just" than he is. Moreover, why do David and Solomon always appear in the Anastasis together? Their twin presence is normally an iconographic rarity, but the Anastasis canonized them at a relatively early date as part of the standardized iconography. Millet's assertion that Solomon goes with David as Eve goes with Adam does not even begin to introduce the problems surrounding this motif and its ramifications in connection with the figures of the Baptist and the other "Just" in the Anastasis.[63] It becomes apparent that the collective characterization of these regular dramatis personae in the Anastasis as the "Just" either ignores or confuses the problems that arise out of their differences.

But these are not the only motifs that raise questions. Eve's treatment is also at issue. All early examples do not consider her presence mandatory,[64] and even after her inclusion in the Anastasis prevails, Christ studiously maintains a respectable distance from her, up to the Late Byzantine period when the last compositional type appears. The rationale guiding the handling of Eve requires an explanation. Also, the date and reason for the addition of Abel to the Anastasis have not yet been broached (fig. 80).

Other variations in the iconography have been observed but not evaluated, though they are relevant to the study of the image's development. Hades, for instance, may be represented as an old man down on his knees under Christ's heel (fig. 14a); or simply as the *tenebrae*, the sheer darkness of the underworld's abyss (fig. 17a); or as the combination of both (fig. 85). Likewise, the defeat of Hades may be demonstrated by the substitution of his prostrate figure by the broken gates of his kingdom and the scattered keys, bolts, and nails that kept the underworld secure and its prisoners safe inside (fig. 80, 83). Christ's attributes also undergo a slow but definitive change. In the early examples, Christ holds a scroll (fig. 14a), while later he displays prominently a patriarchal cross, which is even used at times for stabbing Hades (fig. 85).[65]

Both Christ's cross-staff and the broken gates of the underworld have been considered tenth-century innovations since 1914, when Morey tabulated the Anastasis on the basis of

[62] See, 88–93ff. [63] Millet, "Mosaiques de Daphni," 208f.

[64] For example, Eve is missing from the representation of the Anastasis in the Chapel of the Forty Martyrs in S. Maria Antiqua. See, 70ff. and 210ff.

[65] M. E. Frazer, "Hades Stabbed by the Cross of Christ," *Metropolitan Museum Journal*, 9 (1974), 153–161.

examples known at the time. But Morey's tables were incomplete and soon out of date. They do not, for example, mention the silver reliquary cross of the Museo Sacro dating from the time of Pascal I (817–824). This reliquary was introduced by Wilpert in 1917,[66] and includes a representation of the Anastasis (fig. 21). Although this example is out of the iconographic mainstream, the cross held by Christ here can hardly be ignored in any discussion of the cross-staff motif in the Anastasis. Similarly, the broken gates of Hades appear on the Fieschi Morgan reliquary (fig. 24g), which was treated extensively by Rosenberg in 1921 and 1924.[67] Although Rosenberg's date of the Fieschi Morgan reliquary at ca. 700 should be revised, it is still amazing that the evidence it contributed to the iconography of the Anastasis did not formally enter discussion of this image until 1962.[68] Instead, Morey repeated the conclusions of his 1914 tabulation in 1929 without revising them.[69] Surprisingly, his work is still cited in recent literature as a basic source of information for the evolution of the Anastasis.

Thus, although the classification of the core and basic compositional types of this iconography have proved relatively easy to establish, refining the chronological evolution and consolidation of fundamental motifs as integral parts of the image has been inconsistent and at times misinformed. As a result, the basic variants of these motifs, their significance, and the circumstances of their addition and dissemination are not clear. The wide distribution of the surviving examples of Anastasis in terms of geography and media is partly responsible for these difficulties along with the fact that important examples appear on objects whose dates are uncertain.

Another problematic aspect of the image concerns the role of the Apocryphon of Nicodemus as the literary source for the Anastasis. As we have already seen, if the text of Nicodemus inspired the Anastasis, then O'Ceallaigh's study also offers a terminus post quem for the creation of this image at ca. 600. Nevertheless, the underlying assumption for this terminus post is in itself problematic, since a number of motifs belonging to the image cannot be traced back to the Nicodemus text, and vice versa.

For example, the text consistently differentiates between the persons of Satan as the devil, and Hades as the ruler and keeper of the underworld. This distinction is not reflected in the image of the Anastasis proper, although according to the text Satan is chained and gagged by the angels, who then deliver him to Hades for safekeeping until doomsday. In its earlier stages, the iconography expresses no interest in clarifying whether the downtrodden enemy is Hades or Satan (fig. 14a). By the ninth century, inscriptions identify the defeated figure as Hades, contrary to the specifications of the text. In the latter part of the

[66] Wilpert, II.2, 895, fig. 420. Schwartz, "A New Source for the Byzantine Anastasis," 30. Davis-Weyer, "Die ältesten Darstellungen der Hadesfahrt Christi," 189.

[67] M. Rosenberg, *Geschichte der Goldschmiedekunst auf technischer Grundlage. Zellenschmelz. III. Die Frühdenkmäler* (Darmstadt, 1922), 31–38. Idem, *Geschichte der Goldschmiedekunst auf technischer Grundlage.*

Niello bis zum Jahre 1000 nach Chr. (Frankfurt a. M., 1924), 61–67. Hereafter: Rosenberg, 1922 and Rosenberg, 1924 correspondingly.

[68] Lucchesi Palli, "Der syrisch-palästinensische Darstellungstypus der Höllenfahrt Christi"; idem, *RBK*, w. "Anastasis."

[69] Morey, "Notes on East Christian Miniatures," 57ff.

ninth century, the chained figure of Hades appears in the Anastasis (fig. 17b). Nevertheless, his fettering by the angels does not become a motif of the official iconography until the Late Byzantine period, as already mentioned. Over a long period the image clearly disagrees with the text of Nicodemus in word as well as in spirit.

There are many more inconsistencies between the text and the image. For one, Solomon is not mentioned in any of the three surviving versions of Nicodemus. Yet Isaiah and Seth, who figure prominently in the text, cannot be identified even in the later and more populous versions of this iconography. If, along with this sample of inconsistencies, we take into account that a number of motifs common to both text and image—such as the Baptist, the broken gates, bolts, and keys—appear in the Anastasis a long time after its inception, then the argument that the text of Nicodemus inspired the image becomes significantly weaker. In fact, the Late Byzantine Anastasis, as described and labeled by the *Painter's Manual*, reflects the text of Nicodemus far better than the earliest examples of this iconography. One wonders therefore whether the text was associated with the image ex post facto, used selectively to enrich the iconography long after the creation of the Anastasis image.

The story of the relationship between this text and the Anastasis has been further complicated by the repeated assertion that this Apocryphon was illustrated at an early date. Accordingly, the image of the Anastasis was conceived as part of an illuminated Nicodemus cycle out of which it migrated to the various other contexts where we now find it.[70] This proposition, though attractive, is very difficult to prove. It is based on a thirteenth-century illuminated Latin manuscript of Nicodemus in Madrid, for which a Byzantine model is postulated on the basis of comparisons with Torcello and the Hamilton Psalter in Berlin.[71] However, the date and provenance of the prototype of this postulated model are open to question. Much more tangible are the conclusions of a study by Davis-Weyer, who reconstructed the earliest known Nicodemus cycle as an Italian creation of the mid-eighth century or earlier. This Italian cycle, however, does not offer leads for the reconstruction of a similar Byzantine cycle. The ciborium columns of San Marco in Venice, which used to bolster the existence of such an early cycle along with a pre-sixth-century date for the Anastasis, have also proven to be late Italian works of problematic ancestry, as already mentioned.[72]

[70] Weitzmann is the primary exponent of this hypothesis. For a review of his opinion, "The Selection of Texts for Cyclic Illustration in Byzantine Manuscripts," 78.

[71] Madrid, Biblioteca Nacional, cod. Vitr. 23–8. The only study of this manuscript was published at the end of the nineteenth century by A. von Erbach-Fürstenau, "L'evangelo di Nicodemo," *Archivio Storico dell'Arte*, 2 (1896), 225–237.

[72] It is of particular interest that this western Nicodemus cycle includes the distinction between the persons of Satan and Hades (Davis-Weyer, "Die ältesten Darstellungen der Hadesfahrt Christi," 185f., 188). Such a distinction is also encountered in Byzantine iconography, though its conception is different. In the context of the Anastasis, the devil is depicted as a dark winged creature dressed in a short tunic in the illustration of Ps. 67:2 on fol. 63ʳ of the Chloudof Psalter (the identification is based on the inscription accompanying the illustration of Ps. 90:11 on fol. 92ᵛ with the Temptation of Christ). The Byzantine iconography of the Anastasis up to the end of the eleventh century does not include the devil beyond the illustration of Ps. 67:2, which calls for its presence. A

Therefore, the assumption that the text of Nicodemus is the breeding ground for the Anastasis has to be rejected. The core of the image alone and the text itself differ in at least two important respects: the text distinguishes Hades from Satan, while the image does not. Instead, the image emphasizes the trampling of the defeated Hades, which is not even mentioned in the Greek text. Also, a number of secondary features of the fully developed Anastasis that echo the text are introduced long after this iconography comes into being. They are quite irrelevant to the question of the text of Nicodemus as the original inspiration for this image.

Finally, art historians have been interested in the role of the Anastasis in the Middle Byzantine feast cycle (fig. 71a). The festival cycle is in effect an abbreviated christological cycle, which concentrates on the main events in the life of Christ. Its basic distinction from an ordinary historical cycle is that the principle followed in the selection of its subject matter is supposed to be governed by liturgical considerations rather than narrative value.[73] As a result, a number of events from the life of Christ, such as most of the miracles, are left out. Although this liturgical cycle is undoubtedly an organic descendant of the historical cycles, little is known about the process of its formation. As a consequence, it is far from clear whether the liturgical transformation of the christological cycle was introduced by means of individual scenes whose function strayed far from their original narrative purpose, or whether the feast cycle as such represented a new concept. In turn, this difficulty often makes hard the evaluation of individual scenes such as the Anastasis, which are common to both christological cycles.

Although it is fairly certain that the feast cycle was stabilized by the tenth century, the date of its emergence is uncertain. It is reasonable to assume the existence of transitional cycles, whose choice of scenes and principle of arrangement were not crystallized. It is no easy matter, though, to try to trace these experiments back in time. Thus, the prehistory of the feast cycle remains unknown to a large extent and along with it the development of the function of the Anastasis within the christological cycle.

Despite all these complications, both types of cycles converge at a point that has serious implications for the position of the Anastasis in the feast cycle. Both cycles present their scenes in chronological sequence. This presentation makes perfect sense for the historical cycle, but for its liturgical counterpart, one might have expected a rearrangement of the

different iconographic distinction is drawn between Hades and the devil in the illustration of Ps. 143:4 in the Barberini Psalter, fol. 231ᵛ, and the Theodore Psalter, fol. 182ᵛ (see also n.6.1). Previous to the Late Byzantine period, the act of fettering is encountered only in the West. Davis-Weyer has identified the fresco of the Anastasis at Müstair as the earliest example of this motif. The adverse results of the fettering on the persons of Hades and Satan are often emphasized in the illustration of the "Regis Victoria" in the Exultet Rolls of S. Italy. Christ is shown here lancing down the bound figure of Hades (see also, 86f.).

[73] Weitzmann defines this as a grouping "of the great feasts which in the Middle Byzantine period were crystallized in a cycle of twelve. There is nothing canonical about these twelve feasts and their selection is, to a certain extent, alterable, since a few of the feasts are interchangeable, but the cycle as such became a convention." "Byzantine Miniature and Icon Painting in the Eleventh Century," 292.

material along hierarchical lines, or according to the liturgical calendar. This expectation would not have been unfounded, for by the tenth century the text of the Lectionary Gospel book has its lections arranged in this way. Thus, it does not open with the reading for the feast of the Annunciation—the traditional opening scene for both illuminated cycles—but with the lection for Easter[74]—the most important feast in the liturgical year, whose date determines the dates of all movable feasts in the church calendar (fig. 80). The hierarchical arrangement of the lectionary text, in which the feast of Easter assumed the leading role, also spread to the eleventh-century liturgical edition of the homilies of Gregory of Nazianzus (fig. 51).[75] It is not surprising then that the illuminated manuscripts of both books illustrate their opening texts—John 1:1 for Lectionaries, and the First Easter Homily of Gregory in the liturgical edition of his homilies—with the image of the Anastasis. This suggests that the iconography of the Anastasis was fully established as the feast picture for Easter by that time, since both these texts were prominent in its celebration. It is interesting that this manner of projecting the importance of the feast of the Anastasis is not reflected in the standardized self-sufficient cycle of the twelve feasts. Here, as in the historical narrative cycles, the first scene is ordinarily the Annunciation, while the Anastasis is placed properly at the end of the Passion of Christ.

Thus, the feast cycle per se is never rearranged on the basis of Middle Byzantine predilections for liturgical and hierachical order. Consequently, even though the Middle Byzantine period stabilized the principle of subject selection for the feast cycle, it continued to prefer the earlier, more traditional historical system of arrangement by chronological sequence. We find the Anastasis so placed both in the earliest dated christological cycle that includes it, the Oratory of John VII in St. Peter's dating from the first decade of the eighth century (fig. 15), as well as in an example of the developed Middle Byzantine feast cycle, an eleventh-century diptych icon from Mt. Sinai.[76] The stable chronological position of the Anastasis in both instances bespeaks long-standing practice, which suggests that the Anastasis became an inalienable part of the christological cycle before the feast cycle acquired a concrete and definite shape.

The assertiveness of the Anastasis as part of both types of cycles has produced some anomalies in art historical literature. For example, this consistent placement has blinded scholars to the fact that the so-called feast cycle was never organized along purely liturgical lines. In turn, this economical attitude toward the feast cycle robbed the Anastasis of its chance to become the image of images, just as Easter is "the feast of feasts" for the church. Similarly, although there is no doubt that Byzantine artists considered this iconography to be an integral part of the cycles of the life of Christ, Millet's monumental study on this subject, L'iconographie de l'Evangile, did not devote a chapter to the Anastasis, because its subject matter is not based on the text of the Gospels.[77] Such realized and unrealized points

[74] Weitzmann, "A 10th Century Lectionary. A Lost Masterpiece," 617ff.

[75] Galavaris, Gregory, passim.

[76] G. and M. Sotiriou, Icônes du Mont Sinai (Athens, 1956), 52ff., pls. 39–41.

[77] G. Millet, Recherches sur l'iconographie de l'évangile aux XIVe, XVe et XVIe siècle d'après les monuments de

of departure vis-à-vis the other christological scenes in both kinds of cycles promise a better understanding of the liturgical transformation of the historical cycle of Christ's life into a feast cycle.

Therefore, despite the voluminous bibliography already devoted to the subject of this image, many of its principal aspects remain open to discussion. These include a number of formal problems relating to its iconographic evolution and sources, its date and place of origin, as well as the development of its use and function. Of particular interest are the circumstances that made acceptable the addition of the Anastasis to the christological cycle, which had not previously incorporated so firmly comparable "uncanonical" scenes. Of broader interest is the variety of ways in which the Anastasis was employed in the context of all types of cycles. Given the unique importance of Easter in the calendar of the church, its use promises to provide useful clues to the mystery of the feast cycle as well.

Mistra, de la Macédoine et du Mont Athos (Paris, 1916), still indispensable for any study of feast cycles along with Weitzmann's studies on the illuminated Lectionaries and Demus's work on Middle Byzantine feast cycles. Also, more recently, Sh. Tsuji, "Byzantine Lectionary Illustration," *Illuminated Manuscripts from American Collections*, G. Vikan, ed. (Princeton, 1973), 34ff.

THE PREHISTORY OF THE IMAGE

Artistic production of Early Christian times shows a marked reluctance to confront the pictorialization of the Resurrection of Christ. As the Gospels chose to assert rather than to describe this event, so early artists chose not to represent it directly.[1] Various alternatives were open to them, and these were preferred and variously applied.[2] The options followed, however, eschewed questions persistently asked from the earliest times about the specific circumstances of Christ's rising, and his whereabouts previous to that—namely, during his death or during his "burial," as texts often prefer to put it. These issues were sufficiently vital to the defense of church doctrine to be included and elaborated upon in such writings as the *Catechetical Lectures* of St. Cyril of Jerusalem.[3] But, the answers formulated and disseminated by the early church about the Resurrection were systematically avoided in the corresponding pictorial answers shaped by the art of the early period.

THE PICTORIAL EVIDENCE

Rather than illustrating explicitly Christ's rising out of the tomb, artists often preferred to allude to it by depicting secondary events that confirmed the reality of the Resurrection. By far the most popular theme in this category up to the second half of the seventh century is that of the Marys at the Tomb, better known as the Myrophores. It appeared possibly as early as the mid-third century at the Baptistery at Dura Europos,[4] and was often used

[1] For a complete list and discussion of the New Testament texts, see Kamires, 9–27. A. Grillmeier, "Der Gottessohn im Totenreich," *Zeitschrift für katholische Theologie*, 71 (1949), 1ff. J. Kroll, *Gott und Hölle* (Leipzig, 1939), 1ff. J. M. McCulloch, *The Harrowing of Hell* (Edinburgh, 1930), 45–66. H. J. Schulz, "Die Höllenfahrt als Anastasis," *Zeitschrift für katholische Theologie*, 81 (1959), 13.

[2] For discussions of the iconography of the Resurrection during the early period, Villette, *La résurrection du Christ*, passim. Grabar, *Christian Iconography*, 123–126. B. Brenk, *Tradition und Neuerung in der christlichen Kunst des ersten Jahrtausends* (Vienna, 1966), 145ff. Hereafter: Brenk.

[3] Cyril of Jerusalem, *Catechesis* IV. Περὶ τῶν δέκα δογμάτων: IV.10 "Περὶ σταυροῦ," IV.11 "Περὶ

ταφῆς," IV.12 "Περὶ τῆς Ἀναστάσεως." PG, 33.468ff. Specific questions relating to the Death and Resurrection of Christ are more extensively dealt with in *Catechesis* XIV, Φωτιζομένων, PG, 33.826ff. Cyril answers here such issues as the nonputrefaction of Christ's dead body in the tomb, PG, 33.846. For the source of this problem, *Catechesis* XVIII, Φωτιζομένων, PG, 33.1025f.

[4] A. Grabar, "La fresque des Saintes Femmes au tombeau à Dura," *L'art de la fin de l'Antiquité et du Moyen Age* (Paris, 1968), I, 517ff. C. H. Kraeling, *Excavations at Dura Europos. Final Report VIII, Part II. The Christian Building* (New Haven, 1967), 76ff., 190ff. For the iconography of the Myrophores, see also Villette, *La résurrection du Christ*, 59ff.

thereafter as evidence of the historical veracity of Christ's rising, either in pictorial cycles of his life, or by itself.

Thus, the presence of the Myrophores is used as the primary reference to the Resurrection in cycles such as the early fifth-century ivories in the British Museum with scenes from the Passion of Christ (fig. 1);[5] S. Apollinare Nuovo in Ravenna;[6] the ampullae from Palestine dating from the mid-seventh century (fig. 2);[7] the gold marriage rings dating from the mid-seventh century (fig. 3), as well as the magical bracelets (fig. 4);[8] and the censers, probably dating as late as the seventh and eighth centuries.[9]

Through frequent use, this theme became an effective pictorial synonym for the Resurrection. Even when the Myrophores were used independently, unsupported by the broader context of a cycle, they were still meant to be interpreted as a direct reference to the historical truth of the Resurrection. Any possible doubt about the function of this scene could be dispelled by the inclusion of external elements. Topographical references to the church of the Holy Sepulchre in Jerusalem served this purpose admirably, especially when accompanied by inscriptions that recalled the words announcing to the Marys the rising of Christ. There are, for example, ampullae whose reverse is taken up entirely by the Myrophores bearing the title inscription ANECTIO + ΚΥΡΙΟC (fig. 2).[10] The reproduction of the *locus sanctus* in combination with the words spoken there enhanced the credibility of the representation and stressed its intended reading as a reference to the rising of Christ.

[5] Four ivory plaques with scenes from the Passion of Christ in the British Museum: a. Pilate Washing His Hands, Christ on the Road to Calvary, The Denial of Peter; b. The Death of Judas, The Crucifixion; c. The Myrophores; d. The Incredulity of Thomas. W. F. Volbach, *Elfenbeinarbeiten der Spätantike und des frühen Mittelalters* (Mainz, 1952), no. 116, pl. 35. E. Kitzinger, *Early Medieval Art in the British Museum* (London, 1960), 21, 100, pl. 7. *Age of Spirituality*, K. Weitzmann, ed. (New York, 1979), no. 452.

[6] E. W. Deichmann, *Ravenna. Kommentar*, 1. Teil (Wiesbaden, 1974), 177f. C. O. Nordström, *Ravena-studien* (Stockholm, 1953), 63ff., 74 n. 11, pl. 21b.

[7] A. Grabar, *Ampoules de Terre Sainte* (Paris, 1968), 58. Monza no. 2, Bobbio nos. 17–19.

[8] M. Ross, *Catalogue of the Byzantine and Early Medieval Antiquities in the Dumbarton Oaks Collection*, Volume II: *Metalwork, Jewelry, Enamels, Glass and Glyptics* (Washington, D.C., 1965), 58f., no.69. Hereafter: Ross II. J. Engemann, "Palästinensische Pilger-ampullen im F. J. Dölger Institut in Bonn," *JbAChr*, 16 (1973), 20f. *Age of Spirituality*, no. 446. For the magical bracelets, see J. Maspero, "Bracelets-amulettes d'époque byzantine," *Annales du Service des Antiquités de l'Egypte*, 9 (1908), 246–258; and E. Kitzinger, "Christian Imagery: Growth and Impact," *Age of Spirituality: A Symposium*, K. Weitzmann, ed., 151, fig. 41.

[9] G. de Jerphanion, "Un nouvel encensoir syrien et la série des objets similaires," *Mélanges syriens offerts à Monsieur René Dussaud* (Paris, 1939), 1, 298–312. K. Weitzmann, "An East Christian Censer," *Record of the Museum of Historic Art. Princeton University*, 3 (1944), 2–4. V. Elbern, "Neuerworbene Bronzebild-werke in der frühchristlich-byzantinischen Samm-lung," *JbBerlMus*, 20 (1970), 2–16. Idem, "Zur Mor-phologie der bronzenen Weihrauchgefässe aus Palästina," *AEspA*, 45–47 (1972–1974), 447–462.

[10] Grabar, *Ampoules de Terre Sainte*, Monza, nos. 5–8; Bobbio nos. 15, 16 (?). Also ampullae in the following Museums: London, British Museum, in O. M. Dalton, *Byzantine Art and Archaeology* (Oxford, 1911), 624, fig. 399; and in Engemann, "Palästinensische Pilgeramupllen im F. J. Dölger In-stitut in Bonn," 6, pl. 6e. Detroit, Institute of Fine Arts in P. Lesley, "An Echo of Early Christianity," *The Art Quarterly. Detroit Institute of Arts*, 2 (1939), 215–232, fig. 1, and in Engemann, op. cit., 6, pl. 9b. Washington, D.C., Dumbarton Oaks Collection in Engemann, op. cit., 6, pl. 9f., and in M. Ross, *Catalogue of the Byzantine and Early Medieval Antiquities in the Dumbarton Oaks Collection*, Volume I: *Metalwork, Ceramics, Glass, Glyptics, Painting* (Washington, D.C., 1962), no. 87. Hereafter: Ross I.

Other scenes also based on the Gospel narrative were sometimes used in lieu of a direct representation of the rising Christ. One was Christ appearing to the Marys after his Resurrection, known as the Chairete, after Christ's greeting to them.[11] We have only a few pre-iconoclastic examples of this scene. Nevertheless, it appears that the Chairete did rival the exclusive role of the Myrophores as a narrative substitute for the Resurrection. Thus, while the Myrophores follow the scene of the Crucifixion in three out of the four marriage rings, the fourth (in the Dumbarton Oaks Collection) uses the Chairete instead. Furthermore, the Chairete was put to such use even earlier than A.D. 536 according to Choricius' description of the mosaic decoration of St. Sergius at Gaza.[12] Few other examples of this placement of the Chairete in christological cycles survive. Still, the history of its interchangeability with the Myrophores must be a long one, since we find it well into the Middle Byzantine period, as for example on an eleventh-century diptych icon at Mount Sinai.[13] The inclusion of the scene in this fully developed feast cycle suggests that the placement of the Chairete on the Dumbarton Oaks ring is not a rarity. It probably stands instead for a secondary iconographic trend with roots in pre-iconoclastic christological cycles, which replaced the Myrophores with the Chairete as a reference to the Resurrection.

The Incredulity of Thomas offered a third alternative for such a historical reference. However this scene never rivaled the popularity of the Myrophores, but rather reinforced its message by appearing next to it without replacing it in cycles.[14]

Despite such pictorial substitutes, the absence of a literal image of the Resurrection must have been conspicuous in the fifth and sixth centuries, when there was interest in christological cycles with a historical bent. Evidence of such interest in the dynamics of the Resurrection comes from the response to this iconographic vacuum. Efforts to fill it produced a series of variations on the theme of the tomb of Christ. One such was the motif of the tomb of Christ exploding with light. This is the closest the early period came to reenacting the Resurrection directly. It reflects a number of homiletical texts which maintained that Christ could not possibly be kept under the bonds of Hades,[15] but rose instead as the sun

[11] Matt. 28:9. K. Weitzmann, "Eine vorikonoklastische Ikone des Sinai mit der Darstellung des Chairete," *Tortulae. RQ.* Suppl. 30 (Rome, 1966), 317–325. Idem, *The Monastery of St. Catherine at Mount Sinai: The Icons,* Volume I (Princeton, 1976), no. B.27. Hereafter: Weitzmann, *Sinai Icons.* I.

[12] Choricius, *Laudatio Marciani,* I.76, R. Foerster, ed. (Leipzig, 1929). C. Mango, *The Art of the Byzantine Empire 312–1453.* Sources and Documents: The History of Art Series (Englewood Cliffs, 1972), 68 n.67. The scene reconstructed here as the Resurrection should be interpreted as the overthrowing of the guards under the impact of the Resurrection. Hereafter: Mango, Sources.

[13] Above, n. I.76.

[14] Grabar, *Christian Iconography,* 124, considers the iconography of the Incredulity of Thomas and the Myrophores as "comparable to the *procès verbal* before a public authority." The Incredulity of Thomas is represented on censers after the scene of the Myrophores with two exceptions in which it appears before the Nativity, Jerphanion, "Un nouvel encensoir syrien et la série des objets similaires," 306 E. On Monza ampulla no. 9 and on the ampulla in the British Museum (above, n.2.10) this scene appears on the reverse of the ampulla subsequent to the scene of the Myrophores.

[15] Athanasius, *De incarnatione. Contra Apollinarium,* I, PG. 26.1117, "μορφὴν ἰδίας ψυχῆς ὡς δεκτικὴν τῶν δεσμῶν τοῦ θανάτου παραστήσας."

of righteousness in the underworld,[16] where his soul flashed forth the light of its divinity and destroyed the kingdom of Hades.[17]

This motif can be seen in the Crucifixion miniature of the Rabbula Gospels written in A.D. 586 (fig. 5).[18] The sepulchre of Christ, which appears in the lower register, indicates that the Resurrection is understood and visualized as a veritable explosion of light bursting open the door of the tomb, overthrowing its three guards in the process.

A comparable interest in illustrating the overcoming of the guards during Christ's rising was expressed as early as the beginning of the fifth century on an ivory diptych in the Castello Sforzesco in Milan.[19] The motif of the open gate of the tomb is relegated to the lower zone of this ivory, which depicts the Myrophores, while the exploding light is omitted. However, the arrested gestures of both guards who appear in the upper zone, and the flying mantle of the one on the left, suggest the shocking impact of Christ's rising. Still, the message of the Rabbula miniature is more explicit and better integrated than that of the Milan ivory, although the intention is the same in both cases.

It is not surprising that the description of the Resurrection's forceful impact on the Holy Sepulchre and its guards was elevated from an iconographic motif to a self-sufficient symbol of Christ's Resurrection. Such an interpretation is possible for a small round bronze plaque once in the Museum of Cardinal Stefano Borgia. This plaque, known to us through an eighteenth-century drawing, depicts the tomb of Christ, its door half-open, flanked by two guards who appear to have tumbled over (fig. 6). The single word ANACTACIC appears above it.[20] The Bronze, which must have been reproduced more than once, illustrates well the extent to which the image of Christ's tomb could become synonymous with his Resurrection. It is important, however, to evaluate this particular piece further.

A closer examination reveals that the representation of the tomb has little in common with the usual representation of the *locus sanctus* as we find it on the ampullae and their relatives. It is instead considerably closer to the round building on the upper part of the Milan ivory.[21] Though schematized, the half-open door of the tomb is rendered in perspective

[16] John of Damascus, *De fide orthodoxa*, IV, PG, 94.1101, "Κάτεισιν εἰς Ἅδην ψυχῇ τεθεωμένη, ἵνα ὥσπερ τοῖς ἐν γῇ ὁ τῆς δικαιοσύνης ἀνέτειλεν ἥλιος, οὕτω καὶ τοῖς ὑπὸ γῆν ἐν σκότει καὶ σκιᾷ θανάτου καθημένοις ἐπιλάμψῃ τὸ φῶς."

[17] Theodore Aboucaras, *Opuscula*, PG, 97.1469, "γυμνὴ (ἡ ψυχὴ τοῦ Κυρίου) ταῖς ἐν σκότει ψυχαῖς ἐνδυμήσασα, καὶ φῶς αὐταῖς τὸ τῆς θεότητος ἀπαστράψασα, καὶ εἰς αὐτὸν τὸν παράδεισον μετατέθηκεν, καὶ τὸ τοῦ Ἅδου βασίλειον καταλέλυκεν."

[18] Florence, Laurenziana, cod. Plut. I, 56, fol. 13ʳ. C. Cecchelli, G. Furlani, M. Salmi, *The Rabula Gospels* (Olten and Lausanne, 1959). Reviewed by A. Grabar in *CA*, 12 (1962), 388f. Also, J. Leroy, *Les manuscrits syriaques peints et enluminés* (Paris, 1964), 189ff.

[19] Volbach, *Elfenbeinarbeiten der Spätantike und des frühen Mittelalters*, no. 111, pl. 33.

[20] P. R. Garrucci, *Storia dell' arte cristiana nei primi otto secoli della chiesa* (Prato, 1880), VI, 126, pl. 480, no. 14. This bronze appears to be lost. Garrucci reproduces it after a drawing of 1749 made by Garampi while this piece belonged to the Vettori Museum. Subsequently it was acquired by Cardinal Stefano Borgia. The obverse represented the cross-nimbed bust of a bearded Christ. The head of Christ markedly resembles the bust of Christ Emmanuel represented on the onyx intaglio in Vienna, which dates from the sixth or seventh century. G. Bovini, "Osservazioni su un cammeo bizantino dei 'Kunsthistorisches Museum' di Vienna," *Atti 1. Congr. Naz. Studi Bizantini. Ravenna 1965* (1966), 39–42. Engemann, op. cit., pl. 16a (above, n.2.8). *Age of Spirituality*, no. 525. However, the spiral rendering of the hair on the Garrucci bronze compares better to that of the head of Christ on the Dumbarton Oaks amethyst intaglio.

and remains attached to its frame despite the small size of the plaque. The Milan and London ivories offer precedents for this feature. In later examples of the theme of the tomb the door becomes unhinged but retains its perspective rendering as a rhomboid, as seen in the Myrophores mosaic at S. Apollinare Nuovo in Ravenna. By the late sixth or early seventh century this door is usually omitted. When included, as on Monza ampulla no. 5, it is transformed to a diminutive rhomboid symbolically placed at the entrance to the tomb (fig. 7); or, it may be moved to the side so as to make room for the cross. This happens in the case of a fragmentary relief in the Dumbarton Oaks Collection (fig. 8).[22]

These factors suggest a date in the later fifth or in the sixth century for the Borgia bronze, and a provenance which, if not Western, is at least unrelated to Palestine. The two guards flanking the tomb bear this out as well. Their bodies, shields and, in particular, their legs compare well to the two soldiers of the London ivory, which is thought to be a Roman work. On the Vatican plaque, however, their treatment is more relaxed. The soldiers' bodies follow the outline of the tondo, thus encouraging the impression that they have tumbled over, while the London ivory soldiers appear to be sleeping.

If this evaluation is correct, the inscription ANACTACIC on it is particularly remarkable. This is the first instance in which the label "Anastasis" is attached to an iconographic scheme referring to the Resurrection of Christ. During the Middle Byzantine period the same word is used to label the standard iconograpy of the raising of Adam and the defeat of Hades. The use of the same label for the early Vatican example and the later standard image can hardly be a coincidence. *Anastasis*

The inscription ANECTIO + ΚΥΡΙΟC on the majority of the ampullae depicting the Myrophores offers a clue. This inscription has already changed the word of the Gospels by using the word ANECTI (*sic*) instead of ἠγέρϑη for greater emphasis, since common usage

Ross I, no. 116. It should be noted that the possibility of a forgery cannot be ruled out entirely in the case of the Borgia bronze.

[21] J. Wilkinson, "The Tomb of Christ; An Outline of Its Structural History," *Levant*, 4 (1972), 91ff., has argued that the image of the tomb of Christ on the ivories "represents the artistic idea of a suitable mausoleum." He also analyzes here the evidence of the ampullae. For a different reconstruction of the tomb, see D. Barag, "Glass Pilgrim Vessels from Jerusalem," *JGS*, 13 (1971), 59ff. Similarly, K. Weitzmann considers the tomb of Christ as it appears in the Rabbula miniature as unrelated to the *locus sanctus* iconography and characterizes it as a Hellenistic tempietto. K. Weitzmann, "*Loca Sancta* and the Representational Arts of Palestine," *DOP*, 28 (1974), 42. The tomb on the Borgia bronze has only one acroterium. Such acroteria often figure on representations of the tomb of Lazarus, as for example on the incised glass disk found in Podgoritza, Albania, dating from the fourth century. *Iskusstvo Vizantii V Sobraniiakh SSSR* (Mos-

cow, 1977), I, no. 92. Such acroteria also decorate the structure on the Dumbarton Oaks glass chalice, which has been identified by Elbern as a reference to the Holy Sepulchre. Ross I, no. 96. V. Elbern, "Ein frühchristliches Kultgefäss aus Glas in der Dumbarton Oaks Collection," *JbBerlMus*, 4 (1962), 17–41, esp. 29ff. *Age of Spirituality*, no. 545.

[22] In the case of Monza ampulla no. 5 and the Dumbarton Oaks fragment we are confronted, it would seem, not so much with the door of the tomb as with the "stone rolled away from the sepulchre" (Luke 24:2). Above the cross on the Dumbarton Oaks fragment there is a rectangular depression whose dimensions roughly correspond to those of the hovering rhomboid because it has been rendered in perspective. P. Underwood, "The Fountain of Life in Manuscripts of the Gospels," *DOP*, 5 (1950), 92, fig. 39. Also, below n.2.32ff. The Dumbarton Oaks fragment allows little doubt about the meaning of the rhomboid in both of these instances which use a related, though distinctly different, motif from the

favors the phrase ἡ ἀνάστασις τοῦ Κυρίου over ἡ ἔγερσις τοῦ Κυρίου.[23] Inscribing the scene of the Myrophores ANECTIO + KYPIOC is only one step from labelling the abbreviated pictorial version of his empty tomb with the inscription ANACTACIC, which is equally abbreviated. Therefore, even though we have no other example for such use of the title inscription ANACTACIC before the ninth century, the roots of the standard Middle Byzantine epigrammatic label can be traced back to this Vatican bronze.

Nevertheless, it is not clear whether the content of the word "Anastasis" on this bronze is identical with that of the common Middle Byzantine inscription. It is also possible that the inscription constitutes here a direct reference to the Anastasis Rotunda, the *locus sanctus* of Christ's Resurrection,[24] even though several considerations discourage this view: First, the iconography of the tomb on the Vatican bronze is unlike the traditional iconography of the *locus sanctus* in Jerusalem. Second, the Vatican plaque compares best with Western works. Third, the single word "Anastasis" is not known to have been associated with depictions of the actual Anastasis Rotunda, though this would offer the best context for the invention of such a title inscription. Even so, it is not possible to ascertain that the Vatican inscription did not allude to the *locus sanctus*. Such a reference would strengthen the content of a portable object decorated with the material symbol of Christ's Resurrection, even if its maker did not care, or know how, to reproduce a better replica of the Anastasis Rotunda.

Nevertheless, the bronze plaque makes clear the extent to which the Early Christian period could use the image of the tomb of Christ and its guards as shorthand for the Resurrection. The strength and continuity of this symbol is attested by a number of post-Iconoclastic examples which continue to use it in a number of variations,[25] even though this symbol had by that time lost a good part of its importance.

During the early period other types of reference to the Resurrection were used as well. These varied in their degree of abstraction and in their sources. For example, the phoenix, the age-old symbol of incessant renewal, was adopted without major alteration, interpreted as a symbol of the resurrected Christ, and applied in a variety of contexts.[26] We find

Borgia bronze. The motif of the open door was also used in the East, as witnessed by the Rabbula Gospels miniature. A different opinion is expressed by Weitzmann, "*Loca Sancta* and the Representational Arts of Palestine," 41. Weitzmann chooses to compare Monza no. 3 with the scene of the Myrophores on the Sancta Sanctorum Panel, on the basis of which he rejects the identification of the object appearing at the entrance of the sepulchre on the ampullae as the stone covering the tomb. Instead he identifies it as an altar connected with the *locus sanctus*. Nevertheless, these motifs are not mutually exclusive. The Dumbarton Oaks fragment proves that it could function as a reference to the stone, and the Sancta Sanctorum Panel that it could also refer to an altar.

[23] Matt. 28:6, Mark 16:6, and Luke 24:6 use the word ἠγέρθη. The word ἀνάστασις offers a more definitive reference to the Resurrection than the word ἔγερσις, which refers more to the idea of awakening. The distinction was apparently intentional, as suggested by Anastasius Sinaites, *Hodegos*, PG, 89. 221/ Uthemann, 13.5.87–89: "(ὁ ἀπόστολος Παῦλος) τὸν μὲν ἡμέτερον θάνατον κοίμησιν ὀνομάζει, τὸν δὲ τοῦ Χριστοῦ θάνατον, οὐ κοίμησιν, ἀλλὰ θάνατον κυρίως προσαγορεύει."

[24] Garrucci, loc. cit., unhesitatingly recognizes the rotunda on this bronze as a reference to the Anastasis Rotunda. Wilkinson, loc. cit., suggests this would have been the standard identification.

[25] For example, Chloudof Psalter, fol. 26ᵛ.

[26] Villette, *La résurrection du Christ*, 36ff. Brenk, 159f. For further bibliography for the phoenix as a

it in the upper part of the cupola of St. George in Thessalonike as the focal point of a zone populated by four imposing angels.[27] We also find it facing Adam in the most interesting floor mosaic at Huarte.[28]

Roman passion sarcophagi, on the other hand, chose a more tangible symbol of the Resurrection, produced by the crossing of Christian and imperial iconographic traditions.[29] In the middle of their long side these sarcophagi present a cross crowned with a Chi-Rho and framed within a victorious crown. This traditional reference to the victorious Crucifixion is planted firmly between two soldiers resting at its foot.[30] The triumphant cross standing between the two guardian soldiers clearly replaces the open sepulchre. In this instance, the function of the cross is similar to the exploding sepulchre in the Rabbula miniature. They both manipulate the image of the tomb and its guardians to refer to the victorious Resurrection of Christ.

An intermediate solution that combines the tomb and the cross of these sarcophagi is found on a fragmentary relief in the Dumbarton Oaks Collection depicting the Holy Sepulchre (fig. 8).[31] As we have seen, the door-leaf has been transformed into a rhomboid which, unhinged and flung out of position, hovers precariously in midair, leaving the entrance to the tomb open for inspection. Outside the now empty tomb one sees a cross atop a trilobed base on the spot where Christ would have stood immediately after the Resurrection.[32] The cross itself here replaces the person of the risen Christ. Therefore, this configuration of the Resurrection is more explicit than the triumphant cross on the passion sarcophagi, since the sarcophagi do not specify the site of the miracle. It is also more forceful owing to the combination of the empty sepulchre, the broken seal of Christ's grave, and the powerful cross.

Vikan believes that the addition of the cross in this representation of Christ's sepulchre

symbol of the resurrected Christ, see M.-T. and P. Canivet, "La mosaique d'Adam dans l'église syrienne de Huarte," *CA*, 25 (1975), 63, n.54.

[27] H. Torp, *Mosaikkene i St. Georgrotunden i Thessaloniki* (Oslo, 1963), 39.

[28] Canivet, op. cit., passim, figs. 4, 5.

[29] Grabar, *L'empereur dans l'art byzantin*, 241ff. Idem, *Christian Iconography*, 124.

[30] Villette, *La résurrection du Christ dans l'art chrétien du IIe au VIIe siècle*, 43f., prefers to interpret the central motif of the passion sarcophagi as an allusion to the victorious person of Christ. For passion sarcophagi see H. von Campenhausen, *Die Pasionssarkophage. Zur Geschichte eines altchristlichen Bilderkreises* (Marburg, 1929). F. Gerke, "Die Zeitbestimmung der Passionssarkophage," *Archaeol. Ertesitö*, 52 (1949), 1–130. M. Lawrence, "Columnar Sarcophagi in the Latin West," *AB*, 14 (1932), 103–185. A. Soper, "The Latin Style on the Christian Sarcophagi of the Fourth Century," *AB*, 19 (1937), 148–202. For a few examples, see also G. Bovini, H. Brandenburg, *Rom und*

Ostia. Repertorium der christlich-antiken Sarkophage, F. W. Deichmann, ed. (Wiesbaden, 1967).

[31] I am grateful to Dr. Gary Vikan for sharing with me his notes on this piece. See also Underwood, "The Fountain of Life in Manuscripts of the Gospels," 91ff., and V. Elbern, *Der eucharistische Kelch im frühen Mittelalter* (Berlin, 1964), 120f., figs. 109–110.

[32] Underwood, op. cit., 90, identifies the base as Golgotha. Vikan gives iconographic parallels for this cross and base and for the placement of crosses in front of the sepulchre. He points out in particular the Perm silver-gilt paten in Leningrad (*Iskusstvo Vizantii V Sobraniiakh SSSR*, II, no. 441), several bronze censers and a series of coins minted by Charlemagne and Louis the Pious [Elbern, *Der eucharistische Kelch im frühen Mittelalter*, 124, fig. 114. Also see, *L'exposition Charlemagne. Oeuvre, rayonnement et survivances* (Aix la Chapelle, 1965), nos. 12–17, 25, 26a.]. The Dumbarton Oaks glass chalice should probably be added to this list (n. 2.21).

reflects the "life-giving" theme pervading this fragment. This is true since the cross can be construed as a twin reference to both the Crucifixion and the person of the risen Christ on the basis of post-Iconoclastic parallels.[33] However, the conjunction of the cross and the open entrance to Christ's tomb allows us to take this interpretation a step further, since the theme of the cross as the Tree of Life[34] is aligned here with the theme of Christ the Door.

The theme of Christ the Door, based on John 10:7ff., lent itself to verbal and pictorial metaphors. A relevant example is offered by the well-known homily of Pseudo-Epiphanius on Holy Saturday: "Christ the heavenly door has arrived. . . . The Lord's are the exits out of the gates of death. You have made the entrances, but he has come to make the exits" for "By the wood of the cross has Christ the Door broken down the woodless gates (of Hades)."[35] Thus, the pictorial alignment of the victorious cross with the open entrance to the tomb of Christ offers a successful analysis of the means and ends of Christ's Resurrection.[36]

Given the fragmentary state of this relief, it is impossible to tell whether it represents a pure allegory of the Anastasis. Like the Perm paten in Leningrad, it could have been instead the central part of the traditional scene of the Myrophores. In either case, this indirect reference to the Resurrection was accepted as part of the sculptural decoration of a late sixth- or early seventh-century church.[37]

In addition to historical paraphrases and symbols, the early period also used a number of antetypes that were believed to pledge the inevitability of the Resurrection. One of the most prominent is Jonah. The parallelism between the adventures of Jonah and Christ's so-

[33] As, for example, in the Chloudof Psalter, fol. 78ᵛ. In this instance Christ stands on the doorstep of the sepulchre while David prophesies about the Resurrection according to the accompanying inscription. For other examples from the Psalters with marginal illustrations, below 131ff. Also, n. 2.32.

[34] Murray, *Symbols of Church and Kingdom*, 320ff. Underwood, op. cit., 91ff. Underwood points out that from the seventh century on, the same life-giving qualities were attributed to the tomb of Christ as well (96ff.). The idea is also supported by Elbern's analysis of the Dumbarton Oaks glass chalice, which he dates to the end of the sixth century (above, n.2.21). For the pictorial use of the motif of the cross as the Tree of Life, E. Kitzinger, "A Pair of Silver Book Covers in the Sion Treasure," *Gatherings in Honor of Dorothy E. Miner* (Baltimore, 1974), 8ff., with previous bibliography.

[35] Pseudo-Epiphanius, *In Sancto et Magno Sabbato*, PG, 43.457 C: "Πάρεστι γὰρ Χριστὸς ἡ οὐράνιος θύρα. Ὁδοποιήσατε τῷ ἐπιβεβηκότι ἐπὶ τῶν τοῦ ᾅδου δυσμῶν. Κύριος ὄνομα αὐτοῦ, καὶ τοῦ Κυρίου Κυρίου αἱ διέξοδοι τῶν τοῦ θανάτου πυλῶν (Ps. 67:5, 21). Ὑμεῖς ἐποιήσατε τὰς εἰσόδους· τὰς διεξόδους αὐτὸς

ποιῆσαι παραγέγονεν"; and PG, 43.456 A: "θύρας ἀθύρους ἄρας ἐκ μέσου, καὶ πύλας ἀξύλους τῷ ξύλῳ τοῦ σταυροῦ Χριστὸς ἡ θύρα κατακλάσας."

[36] For a different pictorial expression of the theme of Christ the heavenly door, see the bronze relief on the royal door of Hagia Sophia in Constantinople, immediately below the mosaic of Leo VI. This dates from the sixth century and portrays an Hetoimasia below an arched opening. The open book of the Hetoimasia quotes a rearranged version of John 10:7ff. H. Kähler, C. Mango, *Die Hagia Sophia* (Berlin, 1967), 32, pl. 62. J. Engemann, "Zu den Apsis-Tituli des Paulinus von Nola," *JbAChr*, 17 (1974), 45. The theme of the heavenly door is also discussed by Barag, "Glass Pilgrim Vessels from Jerusalem," 59ff., where it is associated with the iconography of the tomb of Christ. For a discussion of the use of this theme by Origenes and others, see McCulloch, *The Harrowing of Hell*, 104, 123f. For a different though apparently related use of this theme, Theodore Aboucaras, *Opuscula*, PG, 97.1469. Also, 76ff.

[37] For reconstruction, see Vikan (n. 2.31). He believes that this panel functioned as part of the chancel barrier of a bema, or of a baptismal font.

journ in the underworld had been drawn by Christ himself, which opened the door wide to homilists.[38] For the same reason, the comparison between Christ and Jonah entered liturgical contexts with funerary overtones, as for example, the prayers commemorating the dead. Hence it was translated unto the walls of catacombs, sarcophagi as well as mosaics, such as the one found under the Old St. Peter's in Rome dating from the third century.[39] It also became an integral part of the Holy Saturday vigil as one of its Old Testament readings at least as early as the fifth century.[40] The weekly Sunday service reinforced this association[41] encouraging the depiction of Jonah on liturgical furniture, such as a round stone table in Constantinople.[42]

Likewise, New Testament stories such as that of Lazarus were interpreted as proof of Christ's ability to defeat death. They were, therefore, treated like the story of Jonah in the visual arts, and were also used for the decoration of catacombs, sarcophagi, church furniture,[43] and so on. Nevertheless, the story of Lazarus did not merely presage the rising of Christ. It almost guaranteed it, since it prefaced the Passion. As a consequence, the depiction of Lazarus was at times linked with the Resurrection of Christ. This is the frame of reference on the fifth-century ivories in London and Milan, which depict Lazarus as a scene within a scene by placing it on the open doors of Christ's sepulchre within their representation of the Myrophores. The Raising of Lazarus thus confirms the message of the Myrophores and the empty tomb. The presence of Lazarus on the doors of the tomb on both of these ivories suggests that this use was not uncommon—in the West, at least—since these two works represent different stylistic and iconographic recensions.

A number of alternatives were thus cultivated by the artists of the early period in reference to the Resurrection. These ranged from pure symbols to a broad spectrum of typological parallels and to a small number of narrative historical substitutes. In all of these pictorial expressions artists chose to remain consistently and conspicuously on the periphery of their subject matter, since Christ, its protagonist, is glaringly absent from all of them. His prefigurations, the *loca sancta*, and all other witnesses to the event can hardly replace his presence and personal participation in his own Resurrection. The question thus arises

[38] Matt. 12:40. Also, n. 2.3. PG, 33.848 where the body of Christ in the tomb is compared to the body of Jonah while in the stomach of the whale.

[39] J.M.C. Toynbee, J. B. Ward-Perkins, *The Shrine of St. Peter and the Vatican Excavations* (London, 1956), 74, 99 n.26. For an interpretation of the theme of Jonah in funerary contexts, see M. Lawrence, "Three Pagan Themes in Christian Art," *De Artibus Opuscula XL. Essays in Honor of Erwin Panofsky*, M. Meiss, ed. (New York, 1961), 323–334. C. O. Nordström, "Some Jewish Legends in Byzantine Art," *Byzantion*, 25–27 (1955–1957), 487–508. O. Mitius, *Jonas auf der Denkmälern des christlichen Altertums* (Freiburg/Br., 1897).

[40] Jonah 1:1–4:11. G. Bertonière, *The Historical Development of the Easter Vigil*, OCA 193 (Rome, 1972),

59f., 130ff., Charts A2, C2. Hereafter: Bertonière.

[41] For the reenactment of the Anastasis during the weekly Service of the Eucharist, G. Dix, *The Shape of the Liturgy* (London, 1964), 282ff. R. F. Taft, *The Great Entrance*, OCA 200 (Rome, 1975), 37, 63. See also Canon 90 of the Council in Trullo, which is intended to regulate and enhance the weekly commemoration of the Anastasis, Mansi, 11.981.

[42] J. Ebersolt, "Sculptures chrétiennes inédites du musée de Constantinople," *RA*, 21 (1913), 333–339, fig. 2. Also, *BZ*, 23 (1914–1919), 347. This has been identified as a prothesis table by A. Orlandos, Ἡ ξυλόστεγος παλαιοχριστιανικὴ βασιλικὴ τῆς Μεσογειακῆς Λεκάνης (Athens, 1954), 448.

[43] Ebersolt, loc. cit., fig. 3. Orlandos, loc. cit.

whether the omission of the person of Christ is due to the poverty of the material remains of this iconography, or all these circumlocutions of the Resurrection represent an iconographic principle, and an established attitude.

THE INTERPRETATION OF THE PICTORIAL EVIDENCE

There are many reasons to conclude that accidents of survival are not responsible for the absence of Christ from images of the Resurrection up to the latter part of the seventh century. Both East and West consistently favor historical substitutes for the pictorialization of the Resurrection over a long period of time. In the West, the London and Milan ivories along with the mosaic at S. Apollinare Nuovo parallel the eastern solutions of St. Sergius at Gaza, the Rabbula Gospels, the ampullae, the rings, and the censers. The same is true for the use of symbols and allegories based on the theme of the tomb of Christ, which can allude to the dynamics of the Resurrection without specifying them. All examples indicate a consistent unwillingness to deal with the crucial presence of Christ at his own Resurrection, the ultimate proof of its reality. The acceptance of ancient symbols of Resurrection (such as the phoenix) and prefigurations (such as Jonah and Lazarus) reflect the same reserve.

Moreover, the representation of the person of Christ is continuously rejected independently of the source of patronage, function or usage of the work in which the Resurrection is alluded to. Christ is equally absent in official church art (S. Apollinare Nuovo and St. Sergius at Gaza), in aristocratic art (the ivories, the sarcophagi, and the gold marriage rings), and in folk art (the ampullae, and probably the censers and the Vatican bronze). The context may be strictly liturgical (the stone prothesis tables), funerary (the catacombs and the sarcophagi), commemorative (the ampullae), or just simply personal with phylacteric overtones (the marriage rings, some magical bracelets, and probably the Vatican bronze).

Finally, the same reserve is expressed in christological cycles, which unanimously reject a direct figuration of the Resurrection of Christ up to the time of Pope John VII (705–707). These may be extensive life cycles (S. Apollinare Nuovo) or Passion cycles (the ivories and the sarcophagi). They may be abbreviated cycles with no interest in the chronological sequence of events (as is possible for the ampullae and the Sancta Sanctorum panel[44]) or abbreviated cycles adhering more or less strictly to the chronological sequence of events in the story of Christ (the marriage rings, and the censers).

All these factors combine to confirm that the unequivocal exclusion of a direct or literal figuration of the Resurrection from the visual arts up to the second half of the seventh century is not due to coincidence, but to conscious choice. The fairly wide range of pictorial solutions devised and the variety of contexts within which they appeared suggests, more-

[44] H. Grisar, *Die römische Kapelle Sancta Sanctorum und ihr Schatz* (Freiburg/Br., 1908), 113ff., figs. 59–61. For its date, Weitzmann, *Sinai Icons* I, 32 with previous bibliography.

over, a widely accepted artistic policy whose rationale is not self-evident. An effort to explore this rationale leads to the corresponding literature of the Early Christian period.

The Written Sources

It is conceivable that the absence of a literal image of the Resurrection during the early period reflects the reserve of the New Testament when it comes to describing the specific circumstances surrounding the event. This lacuna has been implicitly considered responsible for the composition of the text of Nicodemus as an unofficial supplement to the Gospel narrative. This assumption has, furthermore, led to the hypothesis which links the creation of the image known as Anastasis with the text of Nicodemus. Accordingly, the late date recently attributed to the Apocryphon has been proposed as the reason for the delayed appearance of the iconography of the Anastasis.[45] Similarly, attempts have been made to explain the image on the basis of the Apocryphon of Nicodemus, even though this text does not lend itself consistently to this purpose, as we have seen.

The Gospels, the Acts, and the Epistles are clearly reserved when describing what happened to Christ after he died or how he actually rose. Although the reticence of the Gospels matches the vagueness of the corresponding pictorial solutions, it can hardly account fully for their meticulousness, or for such features as the mandatory absence of Christ's person at the crucial moment. It is more likely that the attitude of the official texts encouraged rather than inspired the chosen artistic solutions. The attitude of the contemporary patristic literature provides the foundation for this suggestion.[46]

One would expect the Fathers to expound on the subject of Christ's Death and Resurrection in a manner that respected the reserve of the official texts at least as much as artists did. Yet the exact opposite was true, and for very good reasons.

As early as the beginning of the second century, the Fathers of the church introduced and gradually expanded on the subject of Christ's Death and Resurrection by introducing the theme of his journey to the underworld, his deeds and aims there, as well as the manner of his rising out of it.[47] In the process, contrary to the attitude of artists, Fathers and homilists made use of every last reference in the official texts, no matter how indirect or incomplete, as long as it pertained to Christ's sojourn in the grave.[48] The interpretation of the vagueness of the New Testament on this matter was guided, on the one hand, by the age-old Mediterranean tradition that often saw its divinities visiting the underworld,[49] and on the other hand, by such apocryphal literature as the *Odes of Solomon*.[50] However, the in-

[45] Murray, *Symbols of Church and Kingdom*, 328f.

[46] Karmires, 49ff. McCulloch, *The Harrowing of Hell*, 87ff. Grillmeier, "Der Gottessohn im Totenreich," 1–53, 184–203.

[47] The earliest patristic reference to the descent of Christ to the underworld occurs early in the second century in the Epistles of Ignatius. For this and other patristic references: McCulloch, op. cit., 83–130;

Karmires, 27–58; Kroll, *Gott und Hölle*, 6–12.

[48] As, for example, Eph. 4:9, which deduces Christ's descent to Hades or 1 Peter 4:6, which establishes Christ's preaching in the underworld.

[49] Kroll, *Gott und Hölle*, 183ff.

[50] Ibid., 34ff. McCulloch, op. cit., 131ff. Also n. 7.98.

centive to define the narrative and theological content of this story came from a number of successive heresies.[51] The Gnostics, the Marcionites, the Arians, the Apollinarists, and others helped shape its definition. Consequently, the story of Christ's descent to the land of the dead, his preaching and his defeat of death there, followed by his rising along with some of the dead was popularized at a very early date.

By the fourth century this story had become part of church poetry,[52] the Creed,[53] and liturgy.[54] However, the widespread acceptance of this doctrine, which defined the conditions and circumstances of Christ's Resurrection from the dead for the Orthodox church suggests two points. In the first place, the poverty of the New Testament narrative on this matter did not apparently hinder its incorporation into church doctrine. Therefore, the New Testament narrative alone is unlikely to have motivated the consistent self-restraint exhibited by the art of the early period. The attitude of the Gospels was not the deciding factor, though it might have been one among many considerations.

Secondly, the widespread use of the doctrine of the Descent in a variety of official contexts detaches the problem of the sources of the iconography of the Anastasis from the date of the text of Nicodemus. Its existence or consultation was not necessary for the creation of the iconography of the Anastasis, since there were already too many other sources at hand which could have inspired it. The inconsistencies between the Apocryphon and the earliest examples of this image agree with this suggestion. The same is true of the lack of evidence for an illustrated Nicodemus cycle before the mid-eighth century.

The examination of the literary evidence has shown basically two things: The church accepts and develops an elaborate story concerning the whereabouts and deeds of Christ during his Death and his forceful return to life. The church thus demonstrates a great deal of interest in the story of the Resurrection, which it explores in conjunction with the theme of Christ's Death. In contrast, church art refuses direct contact with all aspects of the story of the Resurrection and is even willing to exclude the person of Christ from images designed to refer to his own rising. Neither the Apocryphon of Nicodemus nor the New Testament can account for this consistently abstemious artistic attitude, which cannot be traced to the literary sources of the image of the Anastasis.

So there is, in fact, a dichotomy between the attitude of Early Christian theology and Early Christian art toward this theme. The effort to trace its causes must therefore follow a different course and examine the broader problems attending the pictorialization of the rising of Christ. One of the possible alternatives is to adhere to the logic of the corresponding literary sources. They do not normally consider the story of the Resurrection apart from the broader theme of the Death of Christ and his sojourn to Hades in the course of

[51] Grillmeier, op. cit., 23ff. Karmires, 30f., 37f., 48f.

[52] Kroll, op. cit., 24ff., 68ff., 95ff. Schulz, "Die Höllenfahrt als Anastasis," 36. J. Texidor, "Le thème de la 'Descente aux Enfers' chez saint Ephrem," OrSyr, 6 (1961), 25–41.

[53] Karmires, 33, 41ff. McCulloch, op. cit., 67ff.

F. Cabrol, DACL, "Descente du Christ aux enfers," 683. Idem, Les origines liturgiques (Paris, 1906), 238ff. D. A. Swainson, The Nicene and Apostolic Creeds (London, 1875), 72 n.1.

[54] Kroll, op. cit., 12ff. Karmires, 34f., 43f. Cabrol, "Descente du Christ aux enfers," 684ff. A. de Mees-

the Passion. With this in mind we will return to the pictorial cycles of Christ's life and reexamine them from a different angle.

The Abbreviated Christological Cycles

Extensive narrative cycles, like those of S. Apollinare Nuovo or St. Sergius at Gaza, add nothing new at this point. The same is true of smaller units of these cycles, such as the Passion cycle on the ivories in the British Musuem (fig. 1). In these cases either the Myrophores or the Chairete appear at the appropriate moment without any deviations that might further our understanding.

The opposite is true of several abbreviated life cycles, such as those on Monza ampulla no. 2, the Sancta Sanctorum panel, the marriage rings (fig. 3), the magical bracelets (fig. 4), and the censers. Here the Infancy of Christ is abbreviated into five or fewer scenes, the miracles are excluded, while the Passion is condensed by the combination of the Crucifixion and the Myrophores in most available examples.

The iconography of these cycles is closely interrelated since it follows the same principle of selection in the episodes it includes or excludes. Moreover, it has been associated as a whole with the iconography of the *loca sancta*, bred and nourished in Palestine.[55] However, this type of abbreviated cycle must have spread beyond Palestine by the middle of the seventh century. This is suggested by its appearance on the gold marriage rings, which are believed to come from Constantinople of the mid-seventh century or so.[56] Even though their attribution to Constantinople is not foolproof, there is a marked difference between the earlier cycles of the ampullae and those of the rings. The ampullae, and such immediate relatives as the Sancta Sanctorum panel which probably originated in Palestine, use an abbreviated cycle that does not develop chronologically. The principle of its organization is not immediately apparent. On the other hand, the rings along with the censers rearrange this iconography on a chronological basis. Thus, they reproduce an abbreviated cycle whose sequence is historically accurate, even though all miracles are rigorously excluded. The reason for this rearrangement is not entirely clear. Perhaps such historical accuracy was believed to enhance the beneficial properties of the objects on which this cycle appeared.[57] In any case, it restored the chronological order followed in the earliest christological cycles.

For both the ampullae and the rings, the Crucifixion in combination with the Myro-

ter, *DACL*, "Descente du Christ aux enfers," 693ff.

[55] Weitzmann, "*Loca Sancta* and the Representational Arts of Palestine," 33ff.

[56] Ross II, 59, no. 69.

[57] On the use of objects with such abbreviated cycles as amulets, E. Kitzinger, "Christian Imagery: Growth and Impact," *Age of Spirituality: A Symposium*, K. Weitzmann, ed. (New York, 1980), 151ff.

Also, Engemann, "Palästinensische Pilgerampullen im F. J. Dölger Institut in Bonn," 12f. For a discussion of some uses of magic in the seventh century, see I. Rochow, "Zu 'heidnischen' Bräuchen bei der Bevölkerung des byzantinischen Reiches im 7. Jahrhundert, vor allem auf Grund der Bestimmungen der Trullanum," *Klio*, 60 (1978), 483–499.

phores—or to a lesser extent, the Chairete—serves as a self-sufficient unit that adequately encapsulates the story of the Passion. Furthermore, this pictorial unit was firmly established by the mid-seventh century, and was used beyond Palestine in abbreviated christological cycles. Its apparent standardization as a synopsis of the Passion recommends the examination of individual instances where the two scenes are joined visually, though not necessarily in the context of a complete christological cycle.

We find the Crucifixion and the Myrophores combined on many ampullae. The two scenes can appear either together on the obverse of the flasks—the Crucifixion above, the Myrophores below—[58] or each can occupy one of the faces of the ampulla (fig. 2).[59] The consistent treatment of these two scenes as a unit might have been based in this case on the topographical proximity of the two *loca sancta*.[60] However, it also offered a bird's-eye view of the Passion by concentrating on its beginning and its end.

Beyond its topographical and chronological implications the coupling of the Crucifixion and the Myrophores could also be used to demonstrate the causal relationship of these two scenes. This aim seems to have prompted the rearrangement of the chronological sequence in the lower register of the Rabbula miniature (fig. 5). As a result, the exploding sepulchre of Christ is aligned with the Crucifixion of the top register. The impact of his Resurrection is vividly contrasted with the joint attack on the crucified Christ with the lance and the sponge. The parallel focusing of the two registers on these two antipodal manifestations of Christ proposed the Resurrection as the inevitable result of the Crucifixion. The relegation of the Myrophores and the Chairete to either side of the exploding sepulchre reiterated this message and helped to consolidate the contrasting but complementary significance of the two registers along with their causal relationship.

The standardization of this abbreviated historical reference to the Passion on the basis of the topographical, chronological, and causal association of the Crucifixion with the Resurrection was not limited to the examples mentioned hitherto, but could also include more abstract pictorial variants of these two themes. This understanding lends another dimension to the Dumbarton Oaks fragmentary relief (fig. 8). This work asserts the inevitability of redemption by laying the cross—the evidence of Christ's Passion—over the open gate to Christ's emptied tomb—the evidence of the Resurrection. The passion sarcophagi go one step further by replacing the tomb itself with the triumphant cross, while maintaining the guardian soldiers of the tomb at its foot.

All these variations establish that the Crucifixion and the Resurrection were regularly combined for the purpose of epitomizing the story of the Passion. At the same time, the tradition that aligned these two scenes and projected them as a meaningful unit succeeded in creating a single powerful image of the doctrine of redemption by synthesizing its pic-

[58] Grabar, *Ampoules de Terre Sainte*, Monza nos. 9–14, 26. Bobbio nos. 3–7. Engemann, op. cit., 5, pl. 8f.; and 9, fig. 1: Berlin no. 2 and an amulet in Paris, Cabinet des Medailles.

[59] Grabar, op. cit., Monza nos. 5–8. Also, the am-

pullae at the Institute of Arts in Detroit, and in the Dumbarton Oaks Collection (above, n.2.10).

[60] Weitzmann, "*Loca Sancta* and the Representational Arts of Palestine," 40f.

torial guarantees. The endurance of this composite image throughout Byzantine art and its ability to meet the demands of later periods without compromising its core, recommends searching in the direction of the Crucifixion for clues, which may explain the developments of its standard pictorial complement, the image of the Resurrection.

The Crucifixion

The image of the Crucifixion was a relatively late comer in Christian art. One of the fifth-century London ivories offers the first example of this scene (fig. 1). Christ is depicted on the cross, his eyes wide open, his body fully erect and entirely unaffected by the rigors of his Passion, even though at that moment Longinus is apparently piercing his side with the lance. The wide open eyes and the rigid body of Christ remain characteristic of the iconography throughout the Early Christian period.[61]

The peculiar intensity with which early artists insisted on Christ's unbending body and glaring eyes indicates their desire to depict Christ unaffected by his Crucifixion. Thus, while Early Christian sources assert the Death of Christ on the cross, the artists of the period reject its literal illustration producing a dichotomy, which parallels the one observed between Early Christian sources and images of the Resurrection. It would seem then that the art of the early period circumvented the representation of the Death of Christ on the cross, just as it circumvented the representation of his Resurrection. Given that the images of the Crucifixion and Resurrection formed a composite pictorial unit during this period, the problematic artistic attitude toward each of these two themes would seem to stem from the same, or from similar artistic problems. The Early Christian preference for the image

[61] K. Wessel, *Die Kreuzigung* (Recklinghausen, 1966). Idem, "Frühbyzantinische Darstellung der Kreuzigung Christi," *RAC*, 36 (1960), 45–71. Idem, "Die Entstehung des Crucifixus," *BZ*, 53 (1960), 95–111. J. Reil, *Die frühchristliche Darstellung der Kreuzigung Christi* (Leipzig, 1904), passim. E. Sandberg Vavalà, *La croce dipinta italiana e l'iconografia della passione* (Bologna, 1929). The *History of the Armenians* by Agathangelos, which dates from the fifth century, includes an interesting passage possibly relating to the early history of the Crucifixion iconography: "Because he loved mankind, therefore he became like us, that he might bring us to abundance by the grace of his divinity, which is the will of his begetter. And he fulfilled his will. He glorified the saints by his own endurance, in enduring himself the indignity of affliction, death and torments, with his death and burial. Because men loved to worship images in human shape, skilfully carved from wood, he himself became the image of men, that he might subject to his own image of his divinity the image-makers and image-lovers and image-worshippers. And because men were accustomed to worship lifeless and dead images, he himself became a dead image on the cross. He died and breathed his last, in order that by this (image) familiar to them he might quickly subject them to his own image." Agathangelos, *History of the Armenians*, R. W. Thomson, trans. and comment. (Albany, 1976), 91f., 463, lxxxvi. This peculiar passage, whose context suggests it might be a metaphorical rather than a literal reference to an image of the Crucifixion, was translated before the beginning of the ninth century into Greek. *La version grecque ancienne du livre arménien d'Agathange. Edition critique*, G. Lafontaine (Louvain-la-Neuve, 1973), 202f. Furthermore, it was used as an argument in defense of images by Patriarch Nicephorus in his *Antirrheticus III, Contra Eusebium, Spicilegium Solesmense Sanctorum Patrum*, J. B. Pitra, ed. (Paris, 1852), I, 500f. It also survived as part of an iconophile florilegium attributed to Niketas of Medicium (Vat. gr. 511), as well as part of a monophysitic florilegium in Arabic. S. Gero, *Byzantine Iconoclasm during the Reign of Constantine V*, CSCO 384. Subsidia 52 (Louvain, 1977), 98f. n. 147.

of the live Christ on the cross has attracted considerable attention both from art historians and theologians. Two basic interpretations have been offered for this patently unrealistic treatment of the Crucifixion. Both agree that it can only be understood with reference to church doctrine.

One of them is represented by Grabar, who attributes the visual insistence on Christ's liveliness to the use of the Crucifixion during this period as a symbol of the Resurrection, rather than as a reference to the reality of the Death of Christ.[62] However, this interpretation, which strongly emphasizes the soteriological and symbolical message of the early images of the Crucifixion, is not supported by the surviving pictorial evidence. As we have seen, during the Early Christian period the Crucifixion often forms part of a christological cycle. At least in these instances, the image of the crucified Christ most likely refers primarily to the historical event depicted, and only secondarily to the universality of salvation. The context renders unnecessary the interpretation of the Crucifixion as a symbol of the Resurrection, since the ensuing Myrophores are better suited as a reference to the risen Christ. So it appears that this explanation overinterprets the widespread use of the cross as a symbol of salvation by identifying excessively its message with that of the historical image of the Crucifixion. Moreover, the exclusive interpretation of the image of the Crucifixion in the light of the doctrine of redemption fails to consider the inherent link of this iconography to the christological doctrine as well. For, apart from its unrealistic treatment, this is still a literal illustration of the person of Christ crucified on the cross of Golgotha. It is, therefore, difficult to accept that the theological doctrine which defined the identity of Christ is not even reflected in this image, whose idiosyncrasies relate, after all, only to the person of Christ.

This difficulty is redressed by the alternative interpretation of the iconography of the living Christ on the cross. This takes into account the christological problems that would have to be resolved before a realistic representation of the Crucifixion could materialize. Accordingly, Martin and Grillmeier have suggested that christological considerations prevented early artists from depicting the person of Christ dead on the cross.[63] Historical considerations support this contention.

The period that generated and used the image of this strangely crucified Christ saw bitter argument over the doctrine of his two natures. The importance of these debates was felt not only by learned theologians but also by the man in the street.[64] It is then doubtful

[62] Grabar, *Christian Iconography*, 132. The interpretation of the use of the Crucifixion as symbolic of the victory over death is taken a step further by Schulz, "Die Höllenfahrt als Anastasis," 21ff. Schulz suggests that the Early Christian Crucifixion anticipated the message of the Middle Byzantine Anastasis.

[63] J. R. Martin, "The Dead Christ on the Cross in Byzantine Art," *Late Classical and Mediaeval Studies in Honor of Albert Mathias Friend, Jr.* (Princeton, 1955), 189–197. A Grillmeier, *Der Logos am Kreuz* (Munich 1956), passim.

[64] Though referring to the trinitarian disputes, the following well-known passage of Gregory of Nyssa illustrates the mood of the times: "Everything is full of those who are speaking of unintelligible things—streets, market squares, crossroads. I ask how many oboli I have to pay; in answer they are philosophizing on the born or the unborn; I wish to know the price of bread; one answers: 'The Father is greater than the Son'; I inquire whether my bath is ready; one says:

that contemporary art produced by Christians for Christians would remain oblivious to important christological issues, and choose instead to operate in a vacuum of broad symbols of salvation, while actually representing the very person of Christ on the cross. Independently of the extent to which the church condemned, supported, or dictated the development of Early Christian art—an issue recently reopened by Murray—[65] it was in the personal interest of artists to keep pace with the most recent christological developments, even if only to attract customers by avoiding the pitfalls of heresy. Hence, both surviving visual evidence and historical common sense militate in favor of an interpretation of the peculiarities of the Early Christian Crucifixion primarily on the basis of the current christological disputes. This interpretation is further strengthened by the fact that in the course of the lengthy christological debate a recurrent source of aggravation arose from the following question: How did Christ's suffering on the cross, his Death, his Burial, his Descent to the underworld, and his Resurrection affect the definition of each of his two natures and their interrelationship?

The Theology of the Death of Christ

The depth and significance of the complicated doctrinal problems relating to the definition of the Death of Christ have been closely examined by Grillmeier.[66] His analysis of the fourth- and fifth-century theological exchanges illustrates well the vulnerability of the doctrine of Christ's two natures, the christological doctrine, when confronted with the doctrine of redemption and the necessity of Christ's Death on soteriological grounds. A series of definitions and clarifications gradually took shape and by the late seventh/early eighth century the church had formulated its answers to the challenges of various heresies. These answers followed their own logic and met their own needs, as well as the needs of the times.[67]

The key to understanding the official church outlook is the premise that redemption could not be achieved unless Christ's two natures were complete, perfect as well as hy-

'The Son has been made out of nothing.' " PG. 46.557, translated by A. A. Vasiliev, *History of the Byzantine Empire* (Madison, 1961), 79f.

[65] Sister Charles Murray, "Art and the Early Church," *JThS*, 28 (1977), 303–346. Idem, *Rebirth and Afterlife. A Study of the Transmutation of Some Pagan Imagery in Early Christian Funerary Art.* B.A.R. International Series, 100 (Oxford, 1981).

[66] Grillmeier, "Der Gottessohn im Totenreich," passim. Idem, *Der Logos am Kreuz.* Though the latter of the two works is weak from an art historical viewpoint, Grillmeier's analysis of the theological issues arising out of the theme of the death of Christ is most lucid. On the same subject, see also Reil, *Die frühchristliche Darstellung der Kreuzigung Christi,* 1–35.

[67] The following summary owes a lot to the analysis of the theological development of the theme of the Anastasis by Karmires, 74–144. For a recent review of the gradual development of the christological doctrine, see M. H. Shepherd, Jr., "Christology: A Central Problem of Early Christian Theology and Art," *Age of Spirituality: A Symposium*, K. Weitzmann, ed. (Princeton, 1980), 101–120. The author suggests that the end of paganism in public cult worship and the ban of crucifixion as a form of punishment by Constantine the Great might possibly explain the late emergence of the iconography of the Crucifixion. Moreover, he adopts the christological interpretation of the Early Christian iconography of the live Christ on the cross (pp. 112f.).

postatically united in the one person of Christ without confusion, change, division, or separation. This of course referred to the entire time period of Christ's Death, from the moment of his expiration on the cross, through his sojourn in Hades, to his return among the living. The church had quite a hard time asserting this complicated doctrinal scheme as pertaining to Christ's life and actions on earth, for which numerous eyewitness accounts existed. To extend this assertion to Christ's "life in the tomb" was even harder. In order to do so the church accepted Christ's perfect human death, for his humanity and his sacrifice would have been incomplete without it. Like any human death Christ's death was interpreted as the separation of the body from the soul.[68] Accordingly, the human body of Christ was buried, and his human soul went to the underworld. During their separation from each other in death, both Christ's body and soul retained, on the one hand, all their human attributes, and on the other, their hypostatic union with Christ's divine nature. However, the continuous hypostatic union of the two natures throughout death created a decisive conflict, which stemmed out of the necessary definition of the divine as immortal, immutable, impassible, and undecayable. As a consequence of the union of the two natures in the tomb, the human body did not decay during its three-day burial and the soul was delivered from the underworld. Thus, Christ died and was resurrected according to the official church doctrine without compromising any aspect of the doctrine of the two natures.

The formulation of these answers was not systematic. It remained haphazard until the end of the seventh century. Efforts usually concentrated on rebutting current challenges, rather than on creating a systematic exposition. As a result many important aspects of the main christological problems surrounding Christ's Death were not dealt with until a relatively late date.

One such problem, for example, was the definition of the attributes of Christ's human soul. Although the issue had been broached in the days of Arius early in the fourth century,[69] the need to define it did not arise before the Council of the Three Chapters in the middle of the sixth century. Canon nine of this council defined the attributes of Christ's complete human soul in connection with a reaffirmation of the doctrine of the two natures and in the context of his Death and Resurrection from Hades.[70] Apparently in the middle

[68] For example, Gregory of Nyssa, *Adversus Apollinarem*, PG, 43. 1153, "Οὐδὲν ἕτερόν ἐστιν ὁ θάνατος εἴ μη διάλυσις ψυχῆς τε καὶ σώματος."

[69] Arius had suggested that the Logos took the place of the human soul during death. This was unacceptable, however, since it reduced Christ to Logos and Flesh. Later Apollinarius complicated matters by asserting that there was a human flesh as well as a human soul in Christ. Nevertheless, the soul of Christ did not have a mind of its own, that is, it was not "νοερά." The incompleteness of the human nature of Christ which existed in this respect was made up by the "will and operation" of the Logos, which thus supplied the "νοερὸν" part—the reasonable qualities the soul lacked. But this made the Death and Resurrection of Christ imperfect from the human viewpoint endangering the perfection of the ensuing redemption (Grillmeier, "Der Gottessohn im Totenreich," 36ff.).

[70] Mansi, 9.397–400. Also J. Hefele, *Histoire des conciles* (Paris, 1908), II.2, 1194: "Εἴ τις λέγει, ὅτι οὐχ ὁ Λόγος τοῦ Θεοῦ σαρκωθεὶς σαρκὶ ἐμψυχωμένῃ, ψυχῇ λογικῇ καὶ νοερᾷ κατελήλυθεν εἰς τὸν ᾅδην, καὶ πάλιν εἰς τὸν οὐρανὸν ὁ αὐτὸς ἀναβέβηκεν, ἀλλ᾽ ὁ παρ᾽ αὐτοῖς λεγόμενος νοῦς, ὅν ἀσεβοῦντες λέγουσι κυρίως Χριστὸν, τῇ τῆς μονάδος γνώσει πεποιημένον· ἀνάθεμα ἔστω."

of the sixth century no one questioned the reality of the Passion, the Death, the Descent to Hades, and the Resurrection of Christ. The question revolved around who precisely suffered, who died, who descended, who arose, as well as how.

Similarly, although the question of the wills and energies of Christ's two natures at the time of his Passion and Resurrection had figured prominently in Apollinarius' arguments later in the fourth century,[71] this aspect of the christological doctrine was effectively avoided until the Sixth Ecumenical Council of A.D. 680–681.

The official church of the period under discussion preferred to deliberate at length before defining crucial aspects of the christological doctrine. Likewise it took its time in rebutting various heretical assertions, even though they unmistakably contradicted the Orthodox position on the subject of the Death and Resurrection. For example, Theopaschism was not officially condemned until the Sixth Ecumenical Council, though it had been current for a couple of centuries. During this period Theopaschites had been allowed to argue that the divine had participated in all aspects of the Passion, a view that was patently unacceptable, since it limited the impassibility of the divine.[72] Similarly, Aphthartodocetism spread easily during the sixth century, although, in a sense, it argued for the exact opposite of Theopaschism by attributing immutable qualities to Christ's human nature.[73]

Unfortunately, Grillmeier's study did not follow closely the evolution of the christological arguments concerning the Death and Resurrection of the Logos Incarnate up until the end of the seventh century. This would be a worthwhile project for a theologian or intellectual historian of the period, for the seventh century witnessed a marked willingness and readiness to provide specific answers to all related questions, unlike the previous two centuries. This willingness was crystallized by John of Damascus in the first half of the eighth century in his systematic review of the theology of the Death of Christ, the first of its

[71] Grillmeier, "Der Gottessohn im Totenreich," passim, esp. 42ff.

[72] The condemnation of Theopaschism survives in Canon 81 of the Trullan Council. Mansi, 11.977. G. A. Ralles, M. Potles, Σύνταγμα τῶν θείων καὶ ἱερῶν κανόνων (Athens, 1852), II, 490ff. This condemnation was repeatedly reiterated during the proceedings of the Seventh Ecumenical Council, for ex., Mansi, 12.1143. The issue continued to be alive throughout the first half of the eighth century as attested by John of Damscus, who devoted a long diatribe on this subject, PG, 95.22–63; esp. 33–37. Similarly, the Holy Saturday Canon of Cosmas of Maiouma recapitulates the doctrinal issues as well as the Orthodox answers to Theopaschism:

Βροτοκτόνον, ἀλλ᾽ οὐ θεοκτόνον
ἔφυ τὸ πταῖσμα τοῦ Ἀδάμ·
εἰ γὰρ καὶ πέπονθέ σου
τῆς σαρκὸς ἡ χοϊκὴ οὐσία,
ἀλλ᾽ ἡ θεότης ἀπαθὴς διέμεινε

τὸ φθαρτὸν δέ σου πρὸς ἀφθαρσίαν
μετεστοιχείωσας καὶ ἀφθάρτου ζωῆς
ἔδειξας πηγὴν ἐξ ἀναστάσεως.

Βασιλεύει, ἀλλ᾽ οὐκ αἰωνίζει
ᾅδης τοῦ γένους τῶν βροτῶν
σὺ γὰρ τεθεὶς ἐν τάφῳ
κραταιὲ, ζωαρχικῇ παλάμῃ
τὰ τοῦ θανάτου κλεῖθρα διεσπάραξας
καὶ ἐκήρυξας τοῖς ἀπ᾽ αἰώνων
ἐκεῖ καθεύδουσι λύτρωσιν ἀψευδῆ,
σῶτερ γεγονὼς νεκρῶν πρωτότοκος.

Anthologia graeca carminum christianorum, W. Christ, M. Paranikas, eds. (Leipzig, 1871), 199, 101–116. Triodion Katanyktikon (Rome, 1879), 731.

[73] On aphthartodocetism, see for example, John of Damascus, De haeresibus PG, 94.753f. Leontius of Byzantium, De Sectis 10, PG, 86/1.1261, and H. G. Beck, Kirche und theologische Literatur im byzantinischen Reich (Munich, 1969), 374. Hereafter: Beck.

kind.[74] Even so, the synopsis of the related christological problems presented here illustrates the importance, the complexity, and the growing need of the church well into the seventh century to arrive at the precise definition of the Passion—the Death and Resurrection of Christ—from a christological viewpoint in order to buttress the doctrine of redemption. There could be no redemption unless Christ remained perfect God and perfect man, not only throughout his Incarnation among the living, but also among the dead.

It seems reasonable that the art of this period would reflect the problems surrounding the christological definition of the Death of the Logos Incarnate. Early Christian artistic inhibitions relating to the illustration of the historical events of the Crucifixion and the Resurrection witness by omission the difficulties involved in the representation of Christ dead on the cross, or in Hades. In both instances artists shied away from depicting the person of Christ at some moment during his death, and thus effectively avoided a direct confrontation with the corresponding thorny christological issues. This suggestion is supported by the absence of any contradictory written or visual evidence indicating that the Early Christian period, in contrast to the Middle or Late Byzantine period, produced any images of Christ dead whatsoever. It appears that all facets of the pictorialization of Christ's Death, from the moment of his Death on the cross to his appearance before the Marys after his Resurrection, were consistently eschewed up to the latter part of the seventh century. It would seem, then, that the artistic attitude toward the Crucifixion and the Resurrection iconography should better be considered in the context of the broader artistic rejection of the theme of the Death of Christ during the early period, because of the inherent christological complications.

If this is correct, then the image of Christ alive on the cross may be successfully interpreted as a response to the difficulty of buttressing visually the doctrine of the two natures and their continuous hypostatic union during the Death of Christ. The chosen iconographic solution dealt successfully with this dilemma, for it created no doctrinal conflicts: If taken literally, the moment represented in these early Crucifixions preceded the Death of Christ, thus enabling the artist to avoid direct confrontation with the complexity of this Death, whose theological definition was still incomplete. Moreover, an allegorical interpretation of the same image was not only feasible, but equally satisfying from an Orthodox viewpoint. It succeeded in recalling the Passion of the human nature of Christ on the cross while confirming that throughout its duration Christ's divinity remained "awake."[75]

[74] John of Damascus, *De fide orthodoxa*. PG, 94.1093–1104. Also, Karmires, 75ff.

[75] "Τὸ μὲν γὰρ σῶμα τοῦ Κυρίου μου καθεύδει ἐπὶ τοῦ σταυροῦ, ἡ δὲ Θεότης αὐτοῦ ἐκ δεξιῶν τοῦ πατρὸς ἀγρυπνεῖ. οὐ γὰρ ὑπνεῖ οὐδὲ ὑπνώσσει ὁ φυλάσσων τὸν Ἰσραήλ." D. Kaimakis, *Der Physiologus nach der ersten Redaktion* (Meisenheim am Glan, 1974), 8a, lines 31–34; also 8b, 9a, 9b; D. Offermanns, *Der Physiologus nach den Handschriften G und M* (Meisenheim am Glan, 1966), 18f. This passage is crucial to Grillmeier's interpretation of the image of Christ alive on

the cross as an allusion to the immutability of the Logos (*Der Logos am Kreuz*, 84). The comparison of the death of Christ to the sleep of the lion, which is part of the Physiologus text, survives in one of the megalynaria for Holy Saturday: "Ὡσεὶ λέων, σῶτερ, ὑπνοῖς ἐκ τοῦ θανάτου τὸν Ἀδὰμ ἀφαρπάζων" found in Lavra, cod. Γ 11, published by Sophronios, Leontopoleos Presbyter, "Ἡ ἀκολουθία τοῦ Μεγάλου Σαββάτου καὶ τὰ μεγαλυνάρια τοῦ ἐπιταφίου," Νέα Σιών, 33 (1938), 373.

The open eyes of the crucified figure could assert simultaneously the continuous immutability of the Logos and its continued union to the human nature of Christ on the cross. Artists thus skillfully avoided the snags attending the Christology of the Death of Christ.

Illustrating the Resurrection of Christ was similarly full of doctrinal traps. Up until the Sixth Ecumenical Council the church had concentrated on defining the human body, the human soul, and their hypostatic union to the divine nature in death. To depict the convergence of these elements at the crucial moment of the Resurrection before the Christology of Christ's death had been fully defined apparently held little attraction for Early Christian artists and their patrons. Nevertheless, the Resurrection had to be pictorialized as a complement to the image of the Crucifixion. The solutions in response to this need have been outlined here. They show that artists chose to circumvent these theological issues by preferring pictorial circumlocutions of Christ's Resurrection.

These solutions exude the spirit of compromise that often characterized official theological solutions well into the seventh century. It is not clear whether they were invented and patronized by the church or were just tolerated by it. In any case, artists of the early period decidedly avoided representing Christ dead, on the cross or elsewhere, before the second half of the seventh century. It would seem that until then the doctrinal difficulties outweighed any interest artists might have had in illustrating Christ's "life in the tomb," which started on the cross and ended with his shattering the doors of Hades and his tomb. Since innovation was far from being considered a virtue,[76] image makers and image owners preferred the safety of the trodden path until innovation became a necessity and new circumstances led to the illustration of this facet of Christ's incarnation without the danger of committing major doctrinal errors.

[76] The authority of the fathers of the church as the sole means of settling doctrinal disputes was formally legislated in Canon 9 of the Council in Trullo in A.D. 691. This stated that "If any controversy is raised in regard to Scripture, let (the clergy and the bishops) not interpret it otherwise than as the lights and the doctors of the church in their writings have expounded it, and in these let them glory rather than in making things up out of their own heads, lest through their lack of skill they depart from what is proper." Mansi, 11.952; translated and discussed by J. Pelikan, *The Christian Tradition* (Chicago, 1974), I, 337.

III

THE BEGINNINGS OF THE IMAGE

The surviving visual and literary evidence, though very sparse, suggests that the reluctance of Early Christian artists and patrons to deal with the christological problems of the Death of Christ ended by the first half of the eighth century. Christian art started now to draw its subject matter from the period during which Christ's body and soul remained separated from each other though hypostatically united with the Logos. As a result, from now on the following themes materialize: Christ dead on the cross, the Burial of his dead body, and his actions in the underworld, namely, the Anastasis.

The first surviving Crucifixion icon with Christ dead on the cross probably dates from the first half of the eighth century and comes from Mount Sinai. The first possible mention of the pictorial use of the Burial of Christ also comes from Mount Sinai and dates in the second half of the seventh century. Finally, the first three examples of the Anastasis date in the first decade of the eighth century and come from Rome.

We have no evidence that these new themes were the product of a concerted effort to deal with the portrayal of Christ's Death. However, there are indications that they represent parallel efforts with complementary motives centered on the defense of the Orthodox position vis-à-vis heretical Christology. Nevertheless, each of the themes assumed a different degree of pictorial importance after its appearance, and met with a different degree of acceptance during its subsequent development.

Although this study is only concerned with the Anastasis, the extreme poverty of its earliest material remains suggests its examination within the framework of the pictorialization of the Death of Christ. The Anastasis, which offers the final link in this theme, takes the place of the Myrophores from the time of its earliest appearance. So, the earlier combination of the Crucifixion and the Myrophores as a reference to the Passion and Resurrection leads to the examination of the Anastasis in the context of the updated pictorial version of this reference.

THE *Hodegos* OF ANASTASIUS SINAITES AND SEVENTH-CENTURY CHRISTOLOGY★

The representation of Christ dead on the cross probably materialized some time around the end of the seventh century. The *Hodegos* of Anastasius Sinaites, which also dates from

★ K. H. Uthemann, *Anastasii Sinaitae Opera. Viae Dux. CChr. Series Graeca* 8 (Turnhout, 1981). Here-after: Uthemann. Anastasius Sinaites, *Hodegos*, PG, 89.35–310. Beck, 442ff. B. Altaner, *Patrology* (Lon-

the late seventh century in its present form,[1] has been associated with, and suggested as, offering the mental framework within which this iconographic development could make its debut.[2]

As its name suggests, the *Hodegos* is a handbook for the Orthodox with special emphasis on the theological points considered capable of successfully parrying heretical argumentation. The author makes abundantly clear that he is less interested in style than in effective

[1] The identity of Anastasius Sinaites and the works that should be attributed to him have long been at issue. The dating of the *Hodegos* to the seventh century find Richard and Uthemann in agreement. Richard has convincingly argued that the text was written before 641, but was revised and scholia were added to it by the author after the Sixth Ecumenical Council (681), though before 686–689. These dates are primarily based on internal chronological evidence, as well as on the mention of the Monothelete sect of the Harmasites, which is thought to have been formed as a reaction to the decisions of the Council of 681 (Richard, 30ff.). While Uthemann agrees with these dates he appears to interpret them differently. He believes that sections of the *Hodegos* were written between 631 and 686–689, though probably before the Sixth Ecumenical Council. These were compiled to form the *Hodegos* some time between 686 and 689 and on that occasion the author, Anastasius Sinaites, added only some superficial scholia (Uthemann, ccxviii). More recently Uthemann has expressed in stronger terms the opinion that the scholia formed part of the archetypal *Hodegos* and were not added after the Council of 681, as Richard suggests; however, no specific additional evidence has been offered in support of this opinion (Uthemann, Synopsis, 59 n. 10). Elsewhere Uthemann indicates that the sect of the Harmasites is also mentioned in the *Capita adversus Monothelitas*, which he ascribes to Anastasius Sinaites (ibid., 61 n. 30). It is not possible to evaluate this statement for the purposes of the present study, since this text has not yet been edited and dated (M. Geerard, ed., *Clavis Patrum Graecorum*, 7756).

[2] H. Belting and C. Belting-Ihm, "Das Kreuzbild im Hodegos des Anastasius Sinaites," *Tortulae. RQ*, Suppl. 30 (Rome, 1966), 30–39.

don, 1960), 633f. M. Richard, "Anastase le Sinaite, l'Hodégos et le Monothélisme," *REB*, 16 (1958), 29–42. E. K. Chrysos, "Νεώτεραι ἔρευναι περὶ Ἀναστασίων Σιναϊτῶν," Κληρονομία, 1 (1969), 121–144. K. H. Uthemann, "Antimonophysitische Aporien des Anastasios Sinaites," *BZ*, 74 (1981), 11–26; idem, "Ein Beitrag zur Geschichte der Union des Konzils von Lyon (1274). Bemerkungen zum Codex Parisinus gr. 1115 (Med. Reg. 2951)," *Annuarium Historiae Conciliorum*, 13 (1981), 27–49; idem, "Die dem Anastasios Sinaites zugeschriebene Synopsis de haeresibus et synodis," *Annuarium Historiae Conciliorum*, 14 (1982), 58–95. Hereafter: Uthemann, Synopsis. Idem, "Eine Ergänzung zur Edition von Anastasii Sinaitae *Viae Dux*: Das Verzeichnis benutzter und zitierter Handschriften," *Scriptorium*, 36 (1982), 130–133. A. Kartsonis, "The *Hodegos* of Anastasius Sinaites and Seventh Century Pictorial Polemics," *XVI. Internationaler Byzantinistenkongress. Résumés der Kurzbeiträge* (Vienna, 1981), 10.3. S. H. Griffith and R. Darling, "Anastasius of Sinai, the Monophysites and the Qur'an," *Eighth Annual Byzantine Studies Conference. Abstracts of Papers* (Chicago, 1982), 13. J. A. Munitiz, "Le *Parisinus graecus* 1115: Description et arrière-plan historique," *Scriptorium*, 36 (1982), 51–67.

The present study was concluded before the publication of the much-needed new edition of the *Hodegos* by K. H. Uthemann. Uthemann's work has added considerable fresh information regarding the complex manuscript tradition of this text. Moreover, his book has been amplified by a complementary, though still incomplete, series of articles on important material intrinsically related to his edition of the *Hodegos*. A full evaluation of his important contribution cannot and has not been offered here for a variety of reasons, some of a substantive and some of a technical nature. For instance, the critical apparatus of the new edition does not include one of the earliest *Hodegos* manuscripts, the tenth-century Athos, Lavra, cod. B 11 (Uthemann, xxxi, clxviii f.; Uthemann, Synopsis, 59 n. 10), nor does it provide sufficient information about some other important manuscripts, for ex. Milan, Ambrosiana, gr. 681 (Q 74 sup.), a tenth-century manuscript that includes part of chapter twelve along with its illustration (Uthemann, xlii f., ccxxix f.). It is hoped that the author will soon complete his valuable edition with the publica-

piety. He apologizes for the numerous corrections in his manuscript, as well as for the tautologies that he could not eradicate because of his constant ill health. But this does not prevent him from exhorting future copyists in strong language to reproduce meticulously not only his text but also his scholia, his accents, his punctuation, and even the barbarisms in his language, so that ignorant copying might not cause the inclusion of blasphemies in his book, as had been the case in the past.[3] Apparently the author had no use for dilettantes.

After the table of contents, the first chapter opens with a summary of directives to be followed by any student of his book wishing to become a successful defender of the Orthodox faith. Such a person should live piously, memorize the most important Orthodox definitions, and learn the beliefs of his adversaries by studying their writings. The Scriptures should be studied piously and not mischievously, while chroniclers should be studied for acquiring knowledge of the history of various heresies.

As for strategy and tactics the orthodox defender should avoid debates with uninitiated and unreasonable individuals. Instead he should argue about matters of faith only with whoever was necessary, and as far as necessary. He should also categorically refuse to shift the focus of the argument when his cornered opponent attempted evasion. Moreover, at the beginning of a debate the adversary should be required to take an oath that he would in no way violate his conscience in any of his statements during the debate.[4]

Here Sinaites also clarifies the weapons he considers best suited for such debates. The first is the use of scriptural quotes. The second, which is also stronger and truer, involves the use of "$\pi\rho\alpha\gamma\mu\alpha\tau\iota\kappa\alpha\grave{\iota}$ $\pi\alpha\rho\alpha\sigma\tau\acute{\alpha}\sigma\epsilon\iota\varsigma$" (translated here as: "material productions," or "representations," or "figurations"). This weapon is considered more effective than scriptural quotation because, as Sinaites explains, words can be altered surreptitiously and turned against the defender of the faith. For this reason, he continues, the defender should

[3] PG, 89.36A–B and 88D / Uthemann, 24.122–140 and 3.1.1–8.

[4] PG, 89.40A–41C / Uthemann 1.1.1–70.

tion of an equally thorough study of the Lavra manuscript, as well as more complete information regarding the Milan manuscript, et al. It has also been announced that Uthemann will be publishing new editions of the *Capita contra Monothelitas* [Uthemann, ccxxii n. 53; Uthemann, Synopsis, 61 n. 30; *Clavis Patrum Graecorum*, M. Geerard, ed. (Turnhout, 1979), III, no. 7756] and the three sermons on the creation of man (*Clavis Patrum Graecorum*, III, nos. 7747, 7748, 7749), which contain evidence important for the study of the *Hodegos*. It seems that a thorough evaluation of Uthemann's publication would be premature at this point. In addition it would be inappropriate here, as it would lead this chapter too far afield. However, his work has considerably enriched the available evidence, though it has not altered the substance of

the present study. It has therefore been opted to allow the results of this chapter to stand, while expanding the text for the purpose of including the new manuscript evidence contributed by Uthemann. Footnote references have been extensively revised to include the new edition. The quotes used, unless otherwise specified, draw on the new edition, but the occasional italics, and underscoring in the notes, are mine. The code letters or numbers attributed to individual manuscripts follow Uthemann's *sigla codicum* and manuscript list (Uthemann, ccxlviii, xxxi–lxiv, and below n. 3.10). I wish to express here my thanks to the Alexander von Humboldt Stiftung for making possible the extensive study that has gone into this revision, and to Princeton University Press for accepting it at such a late date.

rather arm himself, if possible, with "πραγματικὰς ἀποδείξεις" (translated here as: "material proofs").[5]

Thus, this populist Orthodox handbook equates "πραγματικαὶ ἀποδείξεις" with "πραγματικαὶ παραστάσεις" and advocates them as the best weapon against heretical arguments. This nonverbal weapon is believed immune to misinterpretation in contradistinction even to the word of the Scriptures. Whatever the precise nature of these superior aids advocated by the *Hodegos*, they are not the kind that are available to every professional defender of Orthodoxy. Sinaites therefore specifies that it is preferable for him "who is capable" to arm himself with this weapon.

One of the interpretations attributed to the term "πραγματικαὶ παραστάσεις" by the author becomes clear in chapter twelve, which concerns the Passion of Christ and the refutation of the Theopaschites, who claimed that Christ's divinity had also suffered during the Passion. The text opens with the following pronouncement: "A most excellent rule of the wisest of men establishes (that): the πραγματικαὶ ἀντιῤῥήσεις καὶ παραστάσεις are stronger, more faithful, and mightier by far than the verbal words, and biblical quotes. For the πραγματικαὶ παραστάσεις may in no way be glossed over or tampered with, while the verbal expositions of books often suffer additions and omissions in the hands of heretics." He offers examples, repeating that scriptural, dogmatic, and patristic quotes have often been altered by the unscrupulous and the careless. He concludes his introductory paragraph: "Therefore the heretics and the unfaithful may be better put to utter shame διὰ πραγμάτων. Thus, while arguing once more against them about the redeeming Passion and the *cross* of Christ, we realized by the aim of their arguments that they were trying to prove God the Logos passible and mortal along with his own flesh. So we no longer made use of words, but answered them by means of πραγματικῶν σχημάτων καὶ ὑποδειγμάτων by inscribing on some tablet the *crucifixion* of the Lord and an inscription, which we will record shortly after giving the (patristic) arguments."[6]

[5] PG, 89.40 C–D / Uthemann, 1.1.27–34.
Σκοποὶ διαλέξεώς εἰσι δύο, ὁ μὲν διὰ γραφικῶν ῥήσεων, ὁ δὲ διὰ πραγματικῶν παραστάσεων, ὅς καὶ ἰσχυρότερος καὶ ἀληθέστερός ἐστι· τὰ μὲν γὰρ ῥήματα τῶν γραφῶν ἴσως καὶ ὑπονοθεύονται. Ὅθεν ἔστιν ἰδέσθαι, ὅτι, ⟨εἰ⟩ χρῆσιν προφέρεις τῷ δι' ἐναντίας, κἀκεῖνος εὐθέως ἑτέραν χρῆσιν προφέρει, καὶ ὁ αἱρετικός, καὶ ὁ Ἰουδαῖος· ὅθεν ὁ δυνάμενος διὰ πραγματικῶν ἀποδείξεων μᾶλλον ὁπλιζέσθω πρὸς τοὺς ἐναντίους.

[6] PG, 89.196A–D / Uthemann, 12.1.1–30.
Ὅρος ἄριστος ἀνδρῶν πανσοφωτάτων τυγχάνει λέγων, ὡς αἱ πραγματικαὶ ἀντιρρήσεις καὶ παραστάσεις ἰσχυρότεραι καὶ πιστότεραι καὶ κραταιότεραι καθ' ὑπερβολὴν τυγχάνουσι τῶν ῥηματικῶν λέξεών τε καὶ βιβλιακῶν ῥήσεων. Αἱ μὲν γὰρ πραγματικαὶ παραστάσεις οὐδαμῶς παραγραφῆναι ἢ ῥᾳδιουργηθῆναι δύνανται· αἱ δὲ ῥηματικαὶ τῶν δέλτων ἐκθέσεις πολλάκις ὑπὸ ἀνδρῶν κακοφρόνων προσθήκας καὶ ὑφαιρέσεις πάσχουσιν, ὡς ἔξεστι μαθεῖν τῷ φιλοπόνῳ—καθὼς καὶ ἤδη προεῖπον—ἐκ πολλῶν ἀντιγράφων οὐ μόνον δογματικῶν, ἀλλὰ καὶ μωσαϊκῶν καὶ προφητικῶν καὶ εὐαγγελικῶν παρηλλαγμένων. Καὶ γοῦν κατὰ τὸν ἐφετινὸν χρόνον διάφορα τεύχη ψηλαφήσας Ἰερεμίου τοῦ προφήτου οὐχ εὗρον ὅλως ἐν αὐτοῖς τὰ τριάκοντα ἀργύρια τῆς τιμῆς τοῦ Χριστοῦ, οὔτε τὴν πρᾶσιν τοῦ ἀγροῦ τοῦ κεραμέως. Εἰ οὖν αὐτῆς τῆς ἱερᾶς γραφῆς οὐκ ἐφείσαντο οἱ κακόπιστοι, πόσῳ γε μᾶλλον τῶν διδασκαλικῶν λόγων καθὼς καὶ ἐν τοῖς ἔμπροσθεν πλατύτερον εἰρήκαμεν.

Οὐκοῦν διὰ πραγμάτων μᾶλλον ἰσχυροτέρως καταισχύνονται οἱ αἱρετικοὶ καὶ ἄπιστοι. Διαλεγομένων γὰρ ἡμῶν πάλιν πρὸς αὐτοὺς περὶ τοῦ σωτηρίου πάθους καὶ τοῦ σταυροῦ τοῦ Χριστοῦ, ὡς εἴδομεν αὐτοὺς ἐκ τοῦ σκοποῦ τῶν χρήσεων, ὧν προέφερον, ἀγωνιζομένους παθητὸν δεῖξαι καὶ τὸν θεὸν λόγον καὶ

So the "*πραγματικαὶ παραστάσεις*" which offer "material proof" for the Orthodox faith were in this case visual aids. The advocacy of visual aids in the war against heresy by this seasoned, venerable, and populist defender of the faith is particularly important, given the aggressiveness with which the visual word is projected as superior to the verbal word in chapter twelve of the *Hodegos*. Furthermore, the programmatic inclusion of "*πραγματικαὶ παραστάσεις*" in the methodological outline of the opening chapter of the book implies that Sinaites resorted more than once to such visual arguments in order to counter the statements of his various opponents. The potential significance of this text for our understanding of the use of the pictorial arts by the seventh-century church is obvious.

Nevertheless, although Sinaites repeatedly refers to the use of "*πραγματικαὶ παραστάσεις*," the present text explicitly requires the presence of an illustration only once. This happens, as promised by the author, in chapter twelve after the listing of the key patristic arguments against Theopaschism:

> Wishing to expose the guile and poison hidden in their souls we confronted them neither verbally nor in writing but *πραγματικῶς διὰ παραδείγματος καὶ σχήματος ἐνυποστάτου*. . . . As already mentioned we sketched on a tablet the [Lord's] holy *cross* [or, the Lord's *crucifixion*] together with an inscription, and placing a finger upon it we cross-questioned them. The inscription ran "The Word of God and the body and the reasonable soul" [or, "The Word of God *on the cross* and the reasonable soul and the body"].[7]

The illustration then followed together with the illustration inscription and an important scholion in which the author adjured the copyist to include "this *τύπον* of the holy *cross* [or, the *crucifixion*]."[8]

The importance of reconstructing the original illustration accompanying chapter twelve and its relation to the problem of the pictorialization of the Death of Christ on the cross in Byzantine art was first noted by H. Belting and Ch. Belting-Ihm. The four Sinaites manuscripts they examined diverge in the text as well as in the manner of illustration.[9] The au-

θνητὸν μετὰ τῆς ἰδίας αὐτοῦ σαρκός, οὐκέτι λοιπὸν διὰ ῥημάτων, ἀλλὰ διὰ πραγματικῶν σχημάτων καὶ ὑποδειγμάτων πρὸς αὐτοὺς ἐχρησάμεθα ἐν πυξίῳ τινὶ διαχαράξαντες τὴν τοῦ δεσπότου <u>σταύρωσιν</u> καί τινα ἐπιγραφήν, ἥντινα μετὰ τὰς χρήσεις διαγράψομεν.

[7] PG, 89.197B–D / Uthemann, 12.3.1–12.
Ὡς γοῦν ταύτας καὶ ἑτέρας πλείους παρήγαγον ἡμῖν χρήσεις παθητήν, ὡς προεῖπον, ἀγωνιζόμενοι δεῖξαι τὴν θεότητα τοῦ Χριστοῦ οἵ τε τὰ Σευήρου καὶ ⟨Γαϊανοῦ⟩ καὶ Θεοδοσίου φρονοῦντες, βουλόμενοι ἡμεῖς τὸν δόλον καὶ τὸν ἰὸν τὸν κεκρυμμένον ἐν τῇ ψυχῇ αὐτῶν στηλιτεῦσαι οὐκέτι ῥηματικῶς καὶ γραφικῶς πρὸς αὐτοὺς παρεταξάμεθα, ἀλλὰ πραγματικῶς διὰ παραδείγματος καὶ σχήματος ἐνυποστάτου, ἐν ᾧ καὶ ἱκανῶς καταισχυνθέντες ἐνετράπησαν. Ὡς γὰρ προεῖπον, ἐν πυξίῳ τινὶ τὸν τίμιον [τοῦ Κυρίου] <u>σταυρὸν</u> [or, τὴν τοῦ δεσπότου <u>σταύρωσιν</u>] μετὰ καὶ ἐπιγραφῆς τινος ἐξετυπώσαμεν[α] καὶ τὸν δάκτυλον

ἐπιτιθέντες διηρωτῶμεν αὐτούς. Ἦν δὲ ἡ ἐπιγραφή· "Θεὸς λόγος καὶ σῶμα καὶ ψυχὴ λογική"[β] [or, "Θεὸς λόγος <u>ἐν σταυρῷ</u> καὶ ψυχὴ λογικὴ καὶ σῶμα"].

α Vat., cod. gr. 1101 (τ) offers the following ammended variant: "Ὡς γὰρ προεῖπον, ἐν πυξίῳ τινὶ τὸν <u>τίμιον σταυρὸν μετὰ τῆς εἰκόνος</u> τοῦ σωτῆρος ἡμῶν Χριστοῦ ἐκτυπώσαντες μετὰ καὶ ἧς μέλλομεν γράψαι ἐπιγραφῆς" (Uthemann, cv, cxxx).
β Uthemann reconstructs this inscription as "Θεὸς λόγος καὶ ψυχὴ λογικὴ καὶ σῶμα" although this inversion does not survive in the text of any of the manuscripts included in his critical apparatus.

[8] PG, 89.197D / Uthemann, 12.3.13–15
Σχόλιον. Καὶ ἐξορκίζομεν εἰς τὸν υἱὸν τοῦ θεοῦ τὸν μεταγράφοντα τὸ βιβλίον, ἵνα τὸν αὐτὸν τύπον ποιήσῃ τοῦ τιμίου <u>σταυροῦ</u> [or, τῆς <u>σταυρώσεως</u>].

[9] Belting, Belting-Ihm, "Das Kreuzbild im Hodegos des Anastasius Sinaites," 31–36, pls. 4–5. 1 / (P) Paris, Bibl. Nat., cod. gr. 1084, fol. 135ᵛ (Uthemann: eleventh c., pl. opp. p. 204); 2 / (A) Moscow, Histor. Mus., cod. gr. 265, fol. 72ᵛ, ninth / tenth c.;

thors therefore reconstructed the text and then suggested that the original illustration was probably a diagram of a cross inscribed in a circle accompanied by the illustration inscription quoted in the text of the *Hodegos*. As a result, the person of Christ was excluded with some hesitation from the reconstructed illustration of the archetype. However, a reconsideration of the textual and pictorial evidence argues for the presence of the figure of Christ in the original illustration of this chapter.

One of the points where the text has been confusing as regards the reconstruction of the accompanying illustration concerns its use of the words σταυρός (cross) and σταύρωσις (crucifixion) in nine passages of this chapter.[10] In one instance all extant manuscripts use the word σταύρωσις,[11] while in five others they all use the word σταυρός.[12] The remaining three passages divide the surviving manuscripts into two major branches, of which one uses or alludes to the word σταύρωσις,[13] while the other similarly employs the word σταυ-

3 / (M) Munich, Staatsbibl., cod. gr. 467, fol. 147, eleventh c. (Uthemann, pl. opp. p. 205); 4 / (W) Vienna, Nationalbibl., cod. theol. gr. 40, fol. 176ᵛ, thirteenth c. [Uthemann, twelfth / thirteenth c.; see also *Kunst der Ostkirche. Stift Herzogenburg* (Vienna, 1977), no. 39, fig. 46].

[10] The passages of chapter twelve that bear upon the illustration in one way or another and use either the word σταυρός or σταύρωσις are the following: Uthemann, 12.1.24, 12.1.29, 12.3.9, 12.3.11–12, 12.3.15, 12.3.18, 12.4.2–3, 12.4.15, 12.4.32. The corresponding passages in PG, 89 are: 196B, 196C, 197C, 197C, 197C, 197D, 201A, 201B, 201C. To these we should add the inscription accompanying the illustration, which is quoted in the text and should be identical with it (PG, 89.197C / Uthemann, 12.3.11–12). Uthemann did not consider all illustration inscriptions as evidence for the reconstruction of chapter twelve, though he heavily relied upon the illustration of the same chapter for the reconstruction of the stemma of the *Hodegos* manuscripts (Uthemann, ccv, clxxxviii ff.). Consequently his critical apparatus and his introduction offer only selective evidence regarding the illustration inscriptions (see notes 3.13, 14). The manuscripts which include some or all of these passages are the following (* denotes the manuscripts included in Uthemann's critical apparatus):

*X Paris, Bibl. Nat., cod. gr. 1115
T Vatican, Bibl., cod. gr. 1101
71 Athos, Dionysiou, cod. 596
*K Athos, Koutloumousiou, cod. 178
*C Cambridge, University Lib., Add. 3049
*Δ Vatican, Bibl., cod. ottob. gr. 268
*A Moscow, Histor. Mus., cod. gr. 265
*Θ Vatican, Bibl., cod. gr. 727

*Σ Madrid, Bibl. Nac., cod. gr. 4669
*V Vatican, Bibl., cod. gr. 1116
*W Vienna, Nationalbibl., cod. theol. gr. 40
*M Munich, Staatsbibl., cod. gr. 467
Λ Athos, Lavra, cod. 131 (B 11)
8 Oxford, Bodl. Lib., cod. Auct. T.1.1
*P Paris, Bibl. Nat., cod. gr. 1084
*I Jerusalem, Patriarch. Lib., cod. Taphou 57
*Ξ Vatican, Bibl., cod. gr. 451
*Ψ Vatican, Bibl., cod. gr. 509
43 Milan, Ambros., cod. gr. 681 (Q 74 sup.)
*D Vatican, Bibl., cod. gr. 1967
*O Oxford, Bodl. Lib., Roe 22
Q Turin, Bibl. Naz., cod. gr. 185
R Vienna, Nationalbibl., cod. theol. gr. 306, 307
88 Rome, Bibl. Angelica, cod. gr. 28

[11] PG, 89.196C / Uthemann, 12.1.29: "ἐν πυξίῳ τινὶ διαχαράξαντες τὴν τοῦ δεσπότου <u>σταύρωσιν</u> καί τινα ἐπιγραφήν, ἥντινα μετὰ τὰς χρήσεις διαγράψομεν."

[12] Uthemann, 12.1.24, 12.3.18, 12.4.2–3, 12.4.15, 12.4.32 corresponding to PG, 89.196B, 197D, 201A, 201B, 201C. In the case of 12.3.15 manuscripts X, K, R and probably Q, which do not produce an illustration, add the word ἡμῖν so that their text reads here "τὸ προκείμενον <u>ἡμῖν</u> τοῦ σταυροῦ ἐκτύπωμα καὶ ὑπόδειγμα καὶ ἐπίγραμμα τῶν τριῶν προσηγοριῶν."

[13] PG, 89.197C / Uthemann, 12.3.9 reads: "Ὡς γὰρ προεῖπον, ἐν πυξίῳ τινὶ τὴν τοῦ δεσπότου <u>σταύρωσιν</u> μετὰ καὶ ἐπιγραφῆς τινὸς ἐξετυπώσαμεν." in M, Λ, P, I, Ξ, Ψ, D. PG, 89.197C / Uthemann, 12.3.11–12 reads: "Θεὸς λόγος <u>ἐν σταυρῷ</u> καὶ ψυχὴ λογικὴ καὶ σῶμα" in the same manuscripts. PG, 89.197C / Uthemann, 12.3.15 reads: "Καὶ ἐξορκίζομεν εἰς τὸν υἱὸν τοῦ θεοῦ τὸν

ρός.[14] However, this subdivision of the manuscript tradition is not as clear as one might have wished, since all manuscripts are not consistent in their use of either alternative. The logistics of the subdivision are further complicated by the fact that the accompanying illustrations and illustration inscriptions do not always agree with each other and/or with the text of the manuscript in which they appear.[15] For example, the text of Paris. gr. 1084 calls for an illustration of the Crucifixion, offers a diagrammatic cross accompanied by an inscription that alludes to the Crucifixion, while in the subsequent scholion it opts for the word *cross* instead of *crucifixion* (fig. 12b). In an effort to resolve this problem the word σταυρός instead of σταύρωσις was opted for by Belting and Belting-Ihm in their reconstruction of the text, thus greatly influencing their decision against the reconstruction of a figurative illustration of the Crucifixion in the archetype of the *Hodegos*.[16] Recently Uthemann followed suit and, for reasons that are not clear, also reconstructed the word σταυρός throughout the text with only one exception, though he appears to favor the reconstruction of an illustration of the Crucifixion in the archetype.[17]

μεταγράφοντα τὸ βιβλίον ἵνα τὸν αὐτὸν τύπον ποιήσῃ τῆς σταυρώσεως" in M, Λ, I, Ξ, Ψ. D omits this passage. For P, see next note. It should be noted that T offers an amendation in 12.3.9 (n. 3.7a). The illustration inscription reads "Θεὸς λόγος ἐν σταυρῷ καὶ ψυχὴ λογικὴ καὶ σῶμα" in C, W (n. 3.20), M, P, I, Ξ, Ψ. C adds "ιṣ χ̄ς νικα." The cases of 43 and D are unclear.

[14] PG, 89.197C / Uthemann, 12.3.9 reads "τὸν τίμιον σταυρόν" in X, K, C, A, Θ, Σ, V, and W, which amends it to: "τὸν τίμιον τοῦ κυρίου σταυρόν." PG, 89.197C / Uthemann, 12.3.11–12 reads: "Θεὸς λόγος καὶ σῶμα καὶ ψυχὴ λογικὴ" in X, K, C, A, Θ, Σ, V. W omits this, though it allows sufficient room for it at the bottom of fol. 176ᵛ. PG, 89.197C / Uthemann, 12.3.15 reads: "τὸν τίμιον σταυρόν" in C; "τοῦ τιμίου σταυροῦ" in A, Θ, Σ, W, P. The scholion is omitted in X, K, V. Their illustration inscription reads "Θεὸς λόγος καὶ σῶμα καὶ ψυχὴ λογικὴ" in Θ, Σ. A produces an alternative I͞C X͞C, Y͞C Θ͞Y. ΝΗ ΚΑ which appears to have been followed by Θ and Σ in addition to the inscription "Θεὸς λόγος καὶ σῶμα καὶ ψυχὴ λογική" (Uthemann, clxxxviii). A similar addition is on the illustration inscription of C (n. 3.13).

[15] The following manuscripts appear to be inconsistent in one or more ways. Illustration and illustration inscription do not agree in C, I, Ξ, Ψ, and possibly in D and 43 as well. Text and illustration do not agree in W, P, I, Ξ, Ψ, D and possibly 43. Text and illustration inscription do not agree in C, A, W. Moreover, illustration and illustration inscription are omitted in contradiction to the requirements of the text in X, T, K, V. Probably related to this is the omission of the scholion (PG, 89.197C / Uthemann, 12.3.15) from X, T (?), K, V, and D. The requisite illustration inscription is notably omitted both in the manuscripts that omit the illustration and in Λ.

[16] The use of the word τύπος in the scholion also contributed to the preference for a diagrammatic instead of a figurative illustration of the Crucifixion. However, the word τύπος should not necessarily be contradistinguished from the word εἰκών. The content of these words had a dynamic development that has not yet been properly studied from a philological viewpoint. For a bibliography on this matter see Murray, "Art and the Early Church," 343 n. 2. Also, C. Mango, *The Homilies of Photius Patriarch of Constantinople* (Cambridge, 1958), 282. Another text attributed to Sinaites by John of Damascus (*De imaginibus* III. PG. 94.1393) proposes an understanding of the word τύπος that differs from its usual translation as "figure" or "type." In reference to a miraculous icon of St. Theodore, Sinaites says how an impious Saracene wounded the saint on the icon with an arrow, and the icon miraculously bled real blood. Sinaites insists on the truth of this story because he saw with his own eyes the icon, its wound, and "τὸν τύπον τοῦ αἵματος." Appropriately the Latin translation of τύπος is given here as "vestigium," and not as "figura." Thus as τύπος αἵματος may refer to the vestiges, the material evidence, of real blood on the icon of St. Theodore, similarly the phrases "τύπος σταυροῦ" and "τύπος σταυρώσεως" may be referred to as material evidence and reminder of the real cross or Crucifixion. In this sense, τύπος designates the function of the illustration as commemorative material evidence of the Crucifixion, and not its form as a diagrammatic symbolical illustration of the Crucifixion. For a translation of the same word as "symbol" see Mango, Sources, 139.

[17] Uthemann allows the word σταύρωσις to stand in 12.1.29; see also n. 3.11. For his opinion regarding

While this aspect of chapter twelve constitutes a real puzzle for the philologist, for the art historian the problem is more apparent than real, since language usage allowed the interchangeability of the two words στανρός and στανρωσις. The word στανρός could be employed freely in contexts that clearly called for the word στανρωσις. As a result, the word "cross" could also mean Crucifixion. Indeed, this happens in the introductory paragraph of this chapter where, as already noted, Anastasius says: "διαλεγομένων γὰρ ἡμῶν πάλιν πρὸς αὐτοὺς περὶ τοῦ σωτηρίου πάθους καὶ τοῦ στανροῦ τοῦ Χριστοῦ . . ."[18] Therefore, even the homogeneous editing of the text with the word στανρός will not necessarily solve the art historical problem regarding the diagrammatic or figurative character of the illustration in question. Let us therefore turn our attention to the surviving illustrations and examine which of the two pictorial alternatives best satisfies the aims of the accompanying text, as well as the conditions of the *Hodegos*.

Three of the surviving *Hodegos* manuscripts depict a Crucifixion with Christ dead on the cross. They represent the mature Middle Byzantine iconographic type, which emphasizes the slumping of Christ's dead body, covering it only with a loincloth. In the case of the tenth-century (Λ) Athos, Lavra, cod. 131 (B 11), fol. 91ᵛ, the drawing of the Crucifixion develops into an elaborate full-page miniature (fig. 9). Christ is here flanked by the mourning figures of Mary and St. John, while two adoring angels float above the arms of the cross pointing to Christ. Text and illustration agree with each other in that the text consistently requires an illustration of the Crucifixion, which is accordingly produced. However, the illustration omits the illustration inscription quoted in the text.

Another manuscript of this group, (M) Munich, State Lib., cod. gr. 467, fol. 147ʳ, offers a drawing of a circle within which is inscribed the sole figure of the crucified Christ dead and loinclothed (fig. 10). In this case, text, illustration, and illustration inscription are in harmony throughout. Moreover, the illustration inscription is intimately interrelated with the Crucifix, flanking it symmetrically within this circle. Similarly, the adjurative scholion symmetrically flanks the Crucifix outside its enveloping circle.

The last manuscript of the group (W) Vienna, Nat. Lib., cod. theol. gr. 40, fol. 176ᵛ, also depicts a drawing of the Crucifix inscribed in a circle, which is in turn enframed by the four corners of a rectangle (fig. 11). Two variants of the illustration inscription are inscribed on the illustration, once within the circle symmetrically flanking the figure of Christ, and once more within each of the corners of the enframing rectangle. The adjurative scholion is placed to the left of the illustration, while below we find as an explicative subtitle the paraphrase of an appropriate passage from the subsequent text of chapter twelve.[19] This would appear to indicate that the twelfth / thirteenth-century manuscript in

the illustration of the *Hodegos* see Uthemann, clxxxviii–cxciii.

[18] PG, 89. 196B / Uthemann 12.1.22–24. Also Lampe, *A Patristic Greek Lexicon*, w. "στανρός," C. Crucifixion.

[19] The inscription within the circle reads: ĪC X̄C, Θ̄C ΛΟΓΟC, CΩΜΑ ΨΥΧΗ (Uthemann, om.). The inscription in the corners of the rectangle encircles the me-

dallion when read counterclockwise starting from the top left corner: ΘΕΟC ΛΟΓΟC ΕΝ CΤΑΥΡΩ (ἐν στανρῷ, Uthemann, om.) / ΚΑΙ ΨΥΧΗ ΛΟΓΙΚΗ / ΝΟΕΡΑ / ΚΑΙ CΩΜΑ. The subtitle of the illustration paraphrases PG, 89.200A / Uthemann 12.3.40ff. (Uthemann, om.). See also n. 3.13. The two illustration inscriptions are written in accented uncials, while the scholion and the subtitle in minuscule.

Vienna is a close relative of the eleventh-century Munich *Hodegos*. However, though this might be true of the illustration and illustration inscription, it is not true of the text, which omits all reference to the Crucifixion except the one common to all surviving manuscripts.

Parallel to the Munich and Vienna illustrations stand the illustrations of a larger group of manuscripts dating from the tenth to the fourteenth centuries and depicting the frugal drawing of a cross inscribed in a circle along with an illustration inscription, which, like the inscription on the Munich and Vienna illustrations, implies the presence of a body affixed on the cross (C, P, I, Ξ, Ψ, 43?). The text of three of the manuscripts requires throughout the presence of the Crucifixion, which the illustration does not reproduce (I, Ξ, Ψ). In the case of the fourth manuscript, the text omits all reference to the Crucifixion in contradiction to the illustration inscription it reproduces (C) (fig. 12a). Finally, there is a manuscript, which offers a mixed textual variant, at times including and at times omitting reference to the Crucifixion (P) (fig. 12b).

A third group of manuscripts illustrates chapter twelve with a bare cross. In two instances the illustration inscription omits reference to the Crucifixion (Θ, Σ), while in the third (A) the inscription is replaced by the unrelated, though traditional $\overline{\text{IC}}$ $\overline{\text{XC}}$ $\overline{\text{YC}}$ $\overline{\text{ΘY}}$ NH (*sic*) KA (fig. 13). In all three examples the neighboring text also omits reference to the Crucifixion. On the contrary, the text of the fourth manuscript similarly decorated only with a cross, calls for a Crucifixion (D).

Finally, there is the negative evidence of a fourth group of manuscripts which omit the illustration as well as the illustration inscription and the adjurative scholion. Most prominent among them stands the problematic (x) Paris, Bib. Nat., cod. gr. 1115, which provides space for an illustration it does not reproduce. The text makes no mention of the Crucifixion except for the one common to all manuscripts. The other two examples in this group simply omit illustration, illustration inscription, and scholion, while their text similarly eschews reference to the Crucifixion (K, V, T?).

The evidence is obviously contradictory and confusing. Any attempt to put some order into this chaos first calls for some observations of a general character. To start with, there can be no doubt that the text of chapter twelve, no matter which its correct editorial variant, demanded the inclusion of an illustration. Secondly, it is important to note that the groups of manuscripts, which have emerged from the classification of the surviving illustrations, do not always coincide with a single textual recension which uniformly refers either to the presence of a cross, or a Crucifixion. This suggests that the recension of the text and the recension of the illustration are not always identical in the individual manuscripts. Instead it appears that some manuscripts which belong to the recension that refers to the use of a cross consulted and reproduced the illustration of manuscripts following the recension that explicitly called for and produced an image of the Crucifixion—as seems to be the case in w (fig. 11). But the reverse was probably true, too, as indicated by I, Ξ, Ψ, D and perhaps P (fig. 12b). Thus cross-breed variants seem to have come into being. We consequently note, for a second time, that neither editorial alternative can function as a guide for the reconstruction of the archetypal illustration. Moreover, the existence of hybrid textual variants (P), and hybrid combinations of text, illustration, and illustration inscription

(C, W, P, figs. 12a, 11, 12b) also indicates that the interchangeability in the usage of the words σταυρός and σταύρωσις already noted encouraged text and illustration to interact.

Turning now to the extant illustrations, we note that most of them reproduce the drawing of a cross with or without the body of Christ on it, inscribed in a circle along with the requisite illustration inscription. In several instances the reading of the inscription is correlated to the cross in a manner suggesting that these two elements should be perceived together as a unit. Thus, in two of the three illustrations depicting the Crucifixion, each line of the inscription crosses the vertical arm of the cross. In the case of the diagrammatic cross in Paris. gr. 1084, the inscription traverses the vertical and then the horizontal arm of the cross in agreement with the preceding text, which calls for the coordinated use of the cross and the inscription (fig. 12b). Similarly, in other instances the inscription is distributed within the round frame (C, I, Ξ, Ψ, 43?).[20] The intention is further clarified through the addition of the enframing circle. Though not mentioned in the text, this circle stresses the unity of the enclosed cross and inscription. This suggestion is confirmed by the repetition of the illustration inscription for a second time in the thickness of the enframing circle in Paris. gr. 1084, as well as by the circular reading of the second inscription, which appears within the corners of the rectangle in the manuscript in Vienna (fig. 11). These features, which are present in most illustrated Sinaites manuscripts—namely, the cross, the inscription, and the circular frame—appear therefore to reflect intentions and methods followed in the illustration of the archetype. This reflection is reinforced by the fact that the text of chapter twelve, which comes after the illustration, makes three additional references to the joint reading of the illustration and the accompanying inscription.[21]

If the surviving examples are reliable to that extent, then the one question requiring an answer is whether Sinaites needed the figure of Christ on the cross to round off his arguments or not. And indeed he did, for the body of Christ offers the crux of Sinaites' answer to Theopaschism. This will become clear, if we follow the text of the *Hodegos* a bit further.

After adjuring the copyist to include the illustration, Sinaites continues by cross-questioning the Theopaschites with the help of his illustration:

"Look at Christ, the Son of the living God, complete and indivisible on the cross; that is God the Logos and the reasonable soul which is hypostatically united to him and the body. Which one of these three was mortified and died and became inert and immobile? Watch carefully: I did not ask you which was crucified, but which of these three (which exist) in Christ was killed and remained dead for three days?" Thus questioned by us, the heretics answered in unison utterly dishonored: "The body of Christ died." We address(ed) them again: "Maybe his soul was killed or died or suffered?" They answer(ed): "Impossible."[22]

[20] Uthemann, cxlv, clxxiv, cxc, cxci n. 28.

[21] PG, 89.201A / Uthemann, 12.3.2–3. PG, 89.201B / Uthemann, 12.4.15, see also n. 5.12. PG, 89.201C / Uthemann, 12.4.32. The last passage reads "Ἐμβλέψατε δὴ εἰς τὸν προκείμενον τοῦ σταυροῦ τύπον καὶ εἰς τὴν τοῦ Χριστοῦ τοῦ ἐν αὐτῷ τρισώνυμον ἐπιγραφήν." The reading presents variations; in P, "τὴν τοῦ Χριστοῦ τὴν ἐν τῷ τρισωνύμῳ ὑπογραφήν,"

and in I. Ξ. Ψ, "τὴν τοῦ Χριστοῦ τοῦ ἐν τῷ τρισωνύμῳ ὑπογραφήν."

[22] PG, 89.197C–D / Uthemann, 12.3.16–28. Τοῦτον τὸν τύπον προθέμενοι ἠρωτήσαμεν αὐτούς· "Ἰδοὺ ὁ Χριστός, ὁ υἱὸς τοῦ θεοῦ τοῦ ζῶντος, ἀνελλιπὴς καὶ ἀδιαίρετος ἐν τῷ σταυρῷ, τουτέστιν ὁ θεὸς λόγος καὶ ἡ καθ᾽ ὑπόστασιν ἡνωμένη αὐτῷ ψυχὴ λογικὴ καὶ τὸ σῶμα. Ποῖον τῶν τριῶν τούτων ἀπέθανε καὶ ἐνε-

At this point Sinaites launches his main verbal attack arguing that God the Logos, the Creator, is impassible, while the body of Christ is passible. The following is part of this argument:

> And watch what I am saying. There were five items on the cross while Christ was nailed on it. There was the sun, which also was the first to receive the nails and the lance, and remained undivided from the cross and impassible to the nails. There was also Christ's all holy body. There was also his holy soul. There was also God the Logos. There was the wood of the cross as well. The four of these (were) created. But the Logos (is) uncreated and the Creator of those. Two of the creations remained impassible, and I mean the sun and his all holy soul. So how could his (uncreated) divinity die? So Christ is immortal in two ways, and mortal in one, that is, in the flesh.[23]

Given the context of the arguments, it is most unlikely that this illustration did not include a body to which Sinaites could point throughout his defense. The populist author is not involved here in an intellectual exercise, but in the serious business of proving an absolute truth in a manner that everyone can understand and no one can misconstrue; this truth concerns the mortality of Christ's body alone. As we have seen, he insists on the material reality and the tangibility of his visual weapons, which he characterizes as: "πραγματικαὶ παραστάσεις," "πραγματικαὶ ἀποδείξεις," "πραγματικαὶ ἀντιρρήσεις," "πράγματα," "πραγματικὰ σχήματα καὶ ὑποδείγματα," "πραγματικῶς . . . παραδείγματα καὶ σχήματα ἐνυπόστατα." The material reality of his representation is precisely what renders this particular πραγματικὴ παράστασις a weapon that is more effective than scriptural and patristic quotes and less liable to misinterpretation than even the best verbal argument. A diagram without the sun, without the wood of the cross, and without "God the Logos, and the reasonable soul which is hypostatically united to Him, and the body"[24] could hardly constitute a self-evident argument against Theopaschism. Moreover, a symbolic diagram could not be easily characterized by Anastasius as "ἐνυπόστατον" for the word "ὑπόστασις," which is a loaded word in any christological context, had been emphatically defined earlier by the author in the following manner: "Impersonal hypostasis does not exist. For all the Fathers say that hypostasis is a person, both as regards the Trinity and the incarnation."[25] Therefore it would be inconsistent and, what is more, ineffectual and contradictory, if Sinaites confronted his equally sincere and serious opponents with the sym-

κρώθη καὶ ἀργὸν καὶ ἀκίνητον γέγονε; Πρόσεχε μετὰ ἀκριβείας. Οὐκ εἶπόν σοι, ποῖον ἐσταυρώθη; ἀλλὰ, ποῖον ἐκ τῶν τριῶν τούτων τῶν ἐν Χριστῷ ἀπέθανε καὶ ἐνεκρώθη τριήμερον;

Ταῦτα ὑφ'ἡμῶν ἐρωτηθέντες ὁμοῦ καὶ ἐσχάτως αἰσχυνθέντες οἱ αἱρετικοὶ λέγουσι· "Τὸ σῶμα ἀπέθανε τὸ τοῦ Χριστοῦ."

Λέγομεν πάλιν πρὸς αὐτούς· "Μὴ ἀπέθανε ἢ ἐνεκρώθη ἢ ἔπαθεν ἡ ψυχὴ αὐτοῦ", Λέγουσιν ἐκεῖνοι· "Μὴ γένοιτο."

[23] PG, 89.200A–B / Uthemann, 12.

Καὶ πρόσεχε, ᾧ λέγω. Πέντε τινὰ ὑπῆρχον ἐν τῷ σταυρῷ προσηλουμένου τοῦ Χριστοῦ ἐν αὐτῷ. Ἦν ὁ ἥλιος, ὅστις καὶ πρῶτος τοὺς ἥλους καὶ τὴν λόγχην ἐδέξατο καὶ ἔμεινεν ἀχώριστος τοῦ σταυροῦ καὶ ἀπαθὴς ἐκ τῶν ἥλων. Ἦν καὶ τὸ πανάγιον Χριστοῦ σῶμα· ἦν καὶ ἡ ἁγία αὐτοῦ ψυχή· ἦν καὶ ὁ θεὸς λόγος· ἦν καὶ τὸ ξύλον τοῦ σταυροῦ. Τὰ τέσσαρα τούτων κτιστά, ὁ δὲ θεὸς λόγος ἄκτιστος καὶ κτίστης αὐτῶν. Διεφυλάχθη τὰ δύο κτίσματα ἀπαθῆ, λέγω δὴ ὁ ἥλιος καὶ ἡ παναγία Χριστοῦ ψυχή. Καὶ πῶς λοιπὸν ἡ θεότης αὐτοῦ ἀποθνήσκειν ἠδύνατο; Ὥστε κατὰ δύο μὲν τρόπους ἀθάνατος ὁ Χριστός, καθ᾽ἕνα δὲ τρόπον θνητὸς ἤγουν τῇ σαρκί.

[24] See n.3.22. [25] PG,89.172B/Uthemann,10.2.5.5–8.

bolic figuration of an impersonal diagram of the Crucifixion. Such a diagram would force Sinaites to present the crux of his argument about the body of Christ on the cross ῥημα-τικῶς and not διὰ πραγμάτων καὶ σχημάτων ἐνυποστάτων. On the contrary, a drawing of the Crucifixion allowed no doubts about the reality of the Passion. Concurrently the inscription and the circle reviewed analytically the hypostatic union of the two natures throughout the Passion.

Indeed, all manuscripts which have been considered here to reflect the archetype in their use of a cross—even if nonfigurative—an illustration inscription and an encircling frame call for the representation of "Θεὸς Λόγος ἐν σταυρῷ καὶ ψυχὴ λογικὴ καὶ σῶμα" in their illustration inscription, and so offer internal confirmation that Sinaites called for the representation of "The Word of God *on the cross* and the reasonable soul and the body." Moreover, the author characterized this sketch as "πραγματικόν" and "ἐνυπόστατον," pointed to it saying "Ἰδοὺ ὁ Χριστός," and referred to it repeatedly within the remaining text of chapter twelve. All this favors the reconstruction of a figurative illustration of the Crucifixion inscribed in a circle along with the illustration inscription at this point in the *Hodegos*.

The frequent omission of the figure of Christ from the illustration in spite of the explicit requirement of the accompanying inscription, and the occasional eradication of the illustration altogether have been attributed to two reasons. The primary explanation addresses the history of the *Hodegos* during the Iconoclastic controversy. If iconoclasts were to use this handbook, they had only one choice: to reject and purge a figurative illustration.[26] The second explanation refers to the scribe's possible inability to draw a figurative representation of the crucifixion.[27] The former explanation seems to be the most plausible, especially if one considers the close collaboration of artists and scribes in Byzantine scriptoria.

Turning once more to the three surviving illustrations of the Crucifixion (figs. 9, 10, 11), it is important to observe that both the Munich and Vienna examples include the essentials: a Crucifix inscribed in a circle along with the requisite illustration inscriptions. However, the use of a second frame as well as a second variant of the illustration inscription suggests that the Vienna illustration represents an enriched version of the original formula. Moreover, this image has been transplanted in the midst of a text that omits all but one explicit reference to the Crucifixion in contrast to the text accompanying the Munich illustration. Similarly, the full-page miniature of the Lavra *Hodegos* is an elaboration of the original illustration through its substitution with the standard Middle Byzantine iconographic variant of the Crucifixion. The full-page prominence of this drawing apparently counterbalanced, for the illustrator, the omission of the encircling frame and the illustration inscription, both of which represent fundamental departures from the prototype. If these observations are well taken, then the Munich *Hodegos* contains the drawing that most nearly reflects the late seventh-century archetype. However, even the Munich illustration should be amended, since all the surviving pre-Iconoclastic examples of the Crucifixion depict Christ dressed in a colobium and not in loincloth, as is the case here.[28]

[26] Chrysos, op. cit., 136f. Uthemann, cxxix, cxlvi, cxci ff.

[27] Uthemann, cxxix n. 170 and n. 173.

[28] The updating of representations of the Crucifix-

But there is more to the story of the *Hodegos* illustration. The author, who advocated at the opening of his book the aggressive use of material representations, remains true to his word. He now recommends using the illustration of the Crucifixion, not only against the Theopaschites, but also against other perversions of truth.[29] Accordingly, before the end of the chapter on Theopaschism, the image of the Crucifixion is used to introduce the topic of the next chapter, which concentrates on refuting the Akephaloi who claimed, as quoted by Sinaites, that "After the indescribable union (of the human and the divine nature) the flesh became deified, and (therefore) may no longer be referred to as nature. For it became such as the God Logos who deified it. And thus, it no longer exists by its own properties, but, through the complete victory of the better (nature), all of Christ became one nature; for the body was blended into the ocean of the divinity. Wherefore this (body) became God through deification."[30]

Sinaites objects passionately to this form of Monophysitism, which regarded Christ's humanity as a drop of vinegar lost in the ocean of his divinity. He points again to the illustration of the Crucifixion and its inscription, inviting his opponents with a distinct note of sarcasm to take a look and tell him: "Maybe God the Logos became consubstantial with the flesh after the union. Maybe his intellectual soul ceased being a soul. Maybe the body became consubstantial with the Logos. Maybe one of the three was deprived of its own properties. Maybe the body of Christ became uncircumscribable. Maybe his intellectual soul became mortal. Maybe God the Logos became passible and mutable. In no way."[31]

The twin employment of the illustration of the Crucifixion to combat first those who attacked the impassibility of the Logos, and second those who denied the perfect humanity of Christ, was thus founded on the theme of the Death of Christ. By using both sides of this coin, Sinaites proved first the immortality and impassibility of the Logos, and second the mortality and passibility of the flesh. However, within the broader theme of the Death of Christ, the Crucifixion was not the sole proof for the Orthodox viewpoint. The Burial of Christ was better suited for this purpose, since it offered uncontestable evidence against those who claimed that the immortal God Logos or his immortal soul died. As Sinaites points out in the chapter against Theopaschism "The grave of Christ will refute them, for

ion during the Middle Byzantine period was not infrequent. The best example to the point comes from the numerous depictions of the crucified Christ in the psalters with marginal miniatures. See, below p. 127.

[29] PG, 89.201A / Uthemann, 12.4.1 ff.

"Οὐ μόνον δὲ εἰς τὸν περὶ τοῦ πάθους Χριστοῦ λόγον συμβάλλεται ἡμῖν τὸ προκείμενον τοῦ σταυροῦ ἐκτύπωμα καὶ ὑπόδειγμα καὶ ἐπίγραμμα τῶν τριῶν προσηγοριῶν (λέγω δὴ τοῦ θεοῦ λόγου καὶ τῆς νοερᾶς ψυχῆς καὶ τοῦ παναγίου σώματος), ἀλλὰ καὶ ἐν πᾶσι τοῖς λοιποῖς τῶν ἐναντίων πρὸς ἡμᾶς προβλήμασι καὶ διαστρέμμασι."

[30] PG, 89.201C / Uthemann, 12.4.23–28.

"Μετὰ τὴν ἄρρητον ἕνωσιν ἐθεώθη ἡ σὰρξ καὶ οὐκέτι λέγεται φύσις· τοιαύτη γὰρ γέγονεν οἷος καὶ ὁ θεώσας

αὐτὴν θεὸς λόγος. Καὶ λοιπὸν οὐκέτι ἐστὶν ἐν τοῖς ἰδίοις ἰδιώμασιν, ἀλλὰ τῇ τοῦ κρείττονος ἐκνικήσει μία φύσις τὸ πᾶν τοῦ Χριστοῦ γέγονε· συνανεκράθη γὰρ τὸ σῶμα τῷ πελάγει τῆς θεότητος, διὸ καὶ τοῦτο τῇ θεώσει θεὸς γέγονεν;

[31] PG, 89.201C–D / Uthemann, 12.4.31–39.

"Ἐμβλέψατε δὴ εἰς τὸν προκείμενον τοῦ σταυροῦ τύπον, καὶ εἰς τὴν τοῦ Χριστοῦ τοῦ ἐν αὐτῷ τρισώνυμον ἐπιγραφήν, καὶ εἴπατε ἡμῖν, μὴ γέγονεν ὁ θεὸς λόγος ὁμοούσιος τῇ σαρκὶ μετὰ τὴν ἕνωσιν; Μὴ ἀπέστη ἡ νοερὰ ψυχὴ τοῦ εἶναι ψυχή; Μὴ γέγονε τὸ σῶμα ὁμοούσιον τῷ λόγῳ; Μὴ ἐστερήθη ἕν τῶν τριῶν τούτων τῆς οἰκείας ἰδιότητος; Μὴ γέγονε τὸ σῶμα Χριστοῦ ἀπερίγραπτον; Μὴ γέγονε θνητὴ ἡ νοερὰ αὐτοῦ ψυχή; Μὴ γέγονε παθητὸς καὶ ρευστὸς ὁ θεὸς λόγος; Οὐδαμῶς."

it contains neither God Logos who was killed, nor the intellectual soul put to death, but the body full of divinity, dead."[32]

The subject of Christ's tomb introduced here in passing is exploited fully by this Orthodox tactician in the following chapter. This is devoted to the refutation of various brands of Monophysitism arguing against the prevalence of the divine nature after the incarnation. To this end Sinaites returns time and again to the following fundamental syllogism in the course of chapter thirteen:

If the flesh was deified by the Logos, and there was only one nature in Christ, then the flesh must have acquired the properties of the Logos. This would mean that throughout the incarnation the flesh was uncircumscribable, uncreated, unshaped,[33] invisible, intangible, etc.[34] Not having the shape of man, Christ would have no hands, no feet, no body, etc.,[35] and therefore he would not be consubstantial with us in his humanity.[36] However, Christ was gestated, born, grew up, and above all died in accordance with the laws of his human nature.[37] Christ's Passion, in particular, proves that his humanity adhered to the laws of human nature. He was humbled even more than the average man, even though the divinity remained unseparated from the flesh and the humanity undivided from the divinity.[38] The Monophysites are, therefore, patently wrong.

During the development of this argument Sinaites lays special emphasis on the following evidence:

In the likeness of dead men God became truly a corpse in the flesh. In the likeness of man he was laid in the grave. And we saw him lying dead full of divinity, divorced from the soul, the body truly dead, soulless, soundless, breathless, speechless, motionless, sightless, unable to move, unable to teach, unable to feel, just the body of God truly dead like all corpses. And upon seeing this vision and mighty sight of the deadness of God's body we were stupefied. And getting back to those words, which the heretics think they (can) utter against us, we questioned them perplexed while observing intently the all holy body of Christ: "If the Logos became flesh, so that his body may become Logos, how (is it possible that) the body of Christ, which spoke from the cross a short while ago, does not utter one word now in the grave even though it has in itself the unsilenceable God Logos. . . . And if the body has become such as the God Logos who deified it, it is self-evident that it did not die but remained immortal in the tomb. . . . And if the flesh were blended into the ocean of the divinity as a drop of vinegar . . . Nicodemus and Joseph rolled up in linens and deposited in the tomb either a ghost and a shadow, or again they rolled up in the winding sheet the ocean of the lone divinity and shut it up (in the tomb) after tying it together. . . . If upon deification the body of Christ became divinity, too, how (is it possible) it does not watch and see as the divinity which watches every-

[32] PG, 89.200C / Uthemann, 12.3.59–65. "Σαρκὶ τῇ θνητῇ καὶ οὐ πνεύματι τῷ ἀθανάτῳ Χριστὸς τέθνηκεν. Οἱ δὲ ψάλλοντες τὸ Ἅγιος, ἀθάνατος ὁ σταυρωθεὶς καὶ παθὼν ὑπὲρ ἡμῶν, ἢ τὸν θεὸν λόγον τὸν ἀθάνατον θανατωθέντα λέγουσιν, ἢ τὴν ψυχὴν αὐτοῦ τὴν ἀθάνατον· ἀλλ'ἐλέγχει αὐτοὺς ὁ τοῦ Χριστοῦ τάφος οὐ θεὸν λόγον νεκρωθέντα ἔχων, οὔτε ψυχὴν νοερὰν θανατωθεῖσαν, ἀλλὰ σῶμα ἔνθεον νεκρόν."

[33] PG, 89.208A / Uthemann, 13.2.19.
[34] PG, 89.208D / Uthemann, 13.2.63.
[35] PG, 89.209D / Uthemann, 13.3.29–30.
[36] PG, 89.216C / Uthemann, 13.4.41–42.
[37] PG, 89.217ff., 232ff. / Uthemann, 13.4.57ff., 13.7.81ff.
[38] PG, 89.221D / Uthemann, 13.5.119–120.

thing, but the body, which has in itself the light that enlightens every man, has the eye(s) closed? How (is it possible) it does not live, that which has inside the life of the world? How (is it possible) it does not breathe, since it is unseparated from God, who is the breath and life of everything? . . . His body did not become uncircumscribable, invisible, uncreated, and without a beginning as the Logos who deified it. Neither was it blended as a drop of vinegar, and altered and changed into an uncircumscribable, consubstantial ocean of divinity. But, after the union, in accordance with their natural properties, the divinity, on the one hand, remains invisible, and, on the other, the body remains visible, circumscribable and created."[39]

And the author concludes with the following scholion:

Faithful, guard these for my sake in time of war against the infidels wielding as a two-edged sword *the cross of Christ and the tomb (of Christ)*. And when they put forth their intricate rigmarole about Theopaschism, lead them to the preceding cross and there, after stabbing them, slaughter them. When, on the other hand, they declare the denial and the imagination of

[39] PG, 89.240Dff. / Uthemann, 13.9.29–90.

Τότε ἀληθῶς ἐν ὁμοιώματι ἀνθρώπων νεκρῶν νεκρὸς σαρκὶ ὁ θεὸς γέγονεν, ἐν ὁμοιώματι ἀνθρώπου ἐν τάφῳ κατετέθη, καὶ εἴδομεν αὐτὸν νεκρὸν κείμενον, ἔνθεον, κεχωρισμένον ψυχῆς, σῶμα νεκρὸν ἀληθῶς, ἄψυχον, ἄλαλον, ἄπνουν, μὴ λαλοῦν, μὴ κινούμενον, μὴ ὁρῶντα, μὴ μεθιστάμενον, μὴ διδάσκοντα, μὴ αἰσθανόμενον, ἀλλὰ νεκρὸν ἀληθῶς σῶμα θεοῦ, ὡς πάντες νεκροί. Καὶ ἰδόντες τὸ ὅραμα καὶ θέαμα τὸ μέγα τοῦτο τῆς θεοσώμου νεκρώσεως ἐξεθαμβήθημεν· καὶ ἀναλαβόντες τὰς ποειρημένας φωνάς, ἃς καθ' ἡμῶν προφέρειν νομίζουσιν οἱ αἱρετικοί, ἀτενίζοντες τῷ παναγίῳ Χριστοῦ σώματι πρὸς αὐτοὺς διαποροῦντες εἴπομεν·

"Εἰ ὁ λόγος σὰρξ ἐγένετο, ἵνα καὶ τὸ σῶμα αὐτοῦ γένηται λόγος, πῶς τὸ πρὸ βραχέος λαλοῦν ἐν τῷ σταυρῷ Χριστοῦ σῶμα νῦν ἐν τῷ τάφῳ οὐ λαλεῖ λόγος καίπερ ἔχον ἐν ἑαυτῷ τὸν ἀσίγητον θεὸν λόγον; Εἰ γὰρ οὐδὲν τῶν ἀνθρωπίνων κατὰ ἄνθρωπον ἔδρασε Χριστός, πῶς καθ' ὁμοιότητα ἀνθρώπων ὑπέμεινε τὴν νέκρωσιν; Καὶ εἰ ἐν πᾶσι τοῖς φυσικοῖς ἡμῶν ὑπὲρ φύσιν ἦν, πῶς κατὰ τὴν φύσιν ἡμῶν χωρισμὸν ψυχῆς κατεδέξατο; Καὶ εἰ τοιοῦτον γέγονε τὸ σῶμα, οἷος ὁ θεώσας αὐτὸ θεὸς λόγος, πρόδηλον ὅτι οὐκ ἀπέθανεν, ἀλλὰ ἀθάνατον ἦν ἐν τῷ μνήματι, ὥσπερ ὁ θεὸς λόγος, καὶ δοκήσει καὶ φαντασίᾳ ὡρᾶτο νεκρόν. Καὶ εἰ ὡς σταγὼν ὄξους συνανεκράθη ἡ σὰρξ τῷ πελάγει τῆς θεότητος καὶ οὐκέτι ἦν μετὰ τὴν ἕνωσιν ἐν οἱῳδήποτε ἰδιώματι ἀνθρώπων, ἢ φάσμα καὶ σκιὰν εἴλησεν ὁ Νικόδημος καὶ Ἰωσὴφ ταῖς ὀθόναις καὶ τέθηκεν ἐν τῷ τάφῳ, ἢ πάλιν πέλαγος μόνης θεότητος εἴλησε σινδόνι καὶ κατέκλεισε δεσμήσας, εἰ δὲ θεότητος φύσις περιεγράφετο ἐν τῷ μνήματι μεταστοιχειώσασα τὸ σῶμα καὶ ἀλλοιώσασα πρὸς τὴν οἰκείαν φύσιν, πῶς ὁ διδοὺς τῷ ἀψύχῳ οὐρανῷ φωνὴν βροντῆς οὐ δέδωκε καὶ τῷ νεκρῷ καὶ ἀψύχῳ αὐτοῦ σώματι φωνὴν ἐν τῷ μνήματι; πῶς ὁ κινῶν τὴν ἄψυχον γῆν ἐκ θεμελίων οὐκ ἐσάλευσε τὴν ἄψυχον αὐτοῦ σάρκα ἐν τῷ μνήματι; πῶς ὁ ἀνοίξας τὰ στόματα τῶν ἀψύχων τάφων οὐκ ἤνοιγε τὸ στόμα αὐτοῦ ἐν τῷ τάφῳ; Εἰ γέγονε τῇ θεώσει καὶ τὸ σῶμα Χριστοῦ θεότης, πῶς οὐ θεωρεῖ καὶ βλέπει ὡς ἡ θεότης ἡ τὰ πάντα θεωροῦσα, ἀλλὰ κεκλεισμένον ἔχει τὸ ὄμμα τὸ σῶμα τὸ ἔχον ἐν ἑαυτῷ τὸ φῶς τὸ φωτίζον πάντα ἄνθρωπον; πῶς οὐ ζῇ τὸ ἔχον ἔνδον τὴν τοῦ κόσμου ζωήν; πῶς οὐκ ἀναπνεῖ ἀχώριστον ὂν τῆς πάντων πνοῆς καὶ ζωῆς θεοῦ; Καὶ γὰρ δυνατωτέρα καθ' ὑπερβολὴν ἐστιν ἡ δύναμις καὶ ἡ ἐνέργεια τοῦ θεοῦ λόγου τοῦ ἐν αὐτῷ ὑπὲρ τὴν δύναμιν καὶ ἐνέργειαν τῆς ψυχῆς τῆς χωρισθείσης ἐξ αὐτοῦ, ἡνίκα εἶπεν ἐν τῷ σταυρῷ· Πάτερ, εἰς χεῖράς σου παρατίθημι τὸ πνεῦμά μου. Εἰ οὖν καινοτομήσας τὴν φύσιν ἐκαινοτόμησε καὶ πάντα τὰ φυσικὰ τῆς φύσεως καὶ οὐ κατὰ ἄνθρωπον ἔδρασέ τι τῶν ἀνθρωπίνων, ἐχρῆν αὐτὸν καὶ τὴν τοῦ σώματος νέκρωσιν μὴ καθ' ἡμᾶς διαπράξασθαι. Εἰ δὲ κατὰ ἀλήθειαν ἀληθῆ θάνατον Χριστοῦ καταγγέλλετε, καὶ ἀληθῆ ψυχῆς ἀπὸ σώματος διάζευξιν, καὶ ἀψευδῆ ἐν τάφῳ τριήμερον νέκρωσιν, καὶ σώματος θνητοῦ ἀφωνίαν καὶ ἀβλεψίαν καὶ ἀκινησίαν ἀφαντασίαστον, γνῶτε σαφῶς, ὦ τῶν αἱρέσεων παῖδες, ὅτιπερ καὶ μετὰ τὴν ἕνωσιν ἑκουσίως οὐ πάντα τὰ καθ' ἡμᾶς ὑπὲρ ἡμᾶς ἔπραξεν ὁ Χριστός, οὐδὲ τοιοῦτον γέγονεν αὐτοῦ τὸ σῶμα, οἷος καὶ ὁ θεώσας αὐτὸ λόγος, ἀπερίγραπτον καὶ ἀόρατον καὶ ἄκτιστον καὶ ἄναρχον· οὐδὲ ὡς σταγὼν ὄξους ἀνεκράθη καὶ ἠλλοιώθη καὶ μετεβλήθη εἰς ἀπερίγραπτον ὁμοούσιον πέλαγος θεότητος, ἀλλ' ἐν ἰδιότητι τῇ κατὰ φύσιν καὶ μετὰ τὴν ἕνωσίν εἰσιν, ἡ μὲν θεότης ἀόρατος, τὸ δὲ σῶμα ὁρατὸν καὶ περιγραπτὸν καὶ κτιστόν."

Christ's nature according to us, bring them to the Lord's tomb, and there, after executing them, refer them to Hades.[40]

Thus, in the conclusion of Sinaites' discussion of the Entombment, the author organically interlinks and equates the polemical value of the cross (the Crucifixion) and the tomb of Christ (the Entombment). As a result, the themes of chapters twelve and thirteen are projected as mutually complementary. Moreover, their arguments develop in a similar pattern. The illustration of the Crucifixion was followed in chapter twelve by an adjurative scholion to the copyist to faithfully reproduce the illustration and the companion inscription. Comparably, he now admonishes the user of the *Hodegos* to preserve and properly wield against heretics the twin weapon of Christ's cross and tomb. Earlier Sinaites pointed to the Crucifixion demanding that his opponent observe closely God the Logos and the body and the reasonable soul depicted upon it. He similarly insists now on the ability to see and witness the corpse of Christ and its tomb. In chapter twelve, after this intensive observation, he confronted the heretic with a rapid succession of interrelated questions bearing upon the impassibility of Christ's divinity. The same method applies in chapter thirteen. After gazing intently at the "vision and terrible sight" of the deadness of God's body at the grave, he showers the Monophysite with a series of questions that can only demonstrate the perfection of Christ's humanity.

Although Sinaites does not mention pointing his finger at the corpse in chapter thirteen, the close relation of its theme to that of the previous chapter and the similar development of the corresponding arguments propose that Sinaites resorted to an illustration in chapter thirteen as well. The explicit alignment of the cross and tomb of Christ as joint components of a single weapon also suggest that the illustration of the Cruccifixion was coupled with an illustration of the Entombment of Christ.[41] The description of this event, which emerges from Sinaites' questions, further encourages this suggestion. The text mentions Nicodemus along with Joseph, their use of fine cloth as a winding sheet for Christ's corpse, which is not only motionless, but also has its eyes closed. The description matches most of the earliest surviving representations of the Entombment, none of which is, however, earlier than the ninth century.

Finally, the text of chapter thirteen includes one more indication suggesting that Anastasius employed here a second illustration as part of his argument. A few manuscripts preserve in chapter thirteen the following scholion: "Ὁ ὀρθόδοξος. Περὶ εἰκόνος." Although this additional reference to an image does not accompany the passage describing Christ's

[40] PG, 89.244B / Uthemann, 13.9.91–100. Σχόλιον. Ταῦτα καὶ πρὸς Ἀρμασίτας ἀπορητέον. Ταῦτά μοι φύλαττε, ὁ πιστός, ἐν καιρῷ τοῦ πρὸς τοὺς ἀλλοφύλους πολέμου, ὥσπερ ῥομφαίαν δίστομον κρατῶν τὸν σταυρὸν τοῦ Χριστοῦ καὶ τὸν τάφον. Καὶ ὁπότε τὰς πολυπλόκους αὐτῶν προβάλλονται τῆς θεοπασχίας φλυαρίας, ἄγαγε αὐτοὺς ἐπὶ τὸν προκείμενον σταυρόν, κἀκεῖ κεντήσας τούτους ἀπόσφαξον. Ὅτε δὲ τὴν φαντασίαν καὶ τὴν ἄρνησιν τῆς καθ᾽ ἡμᾶς φύσεως ἐν Χριστῷ δογματίζουσι, φέρε αὐτοὺς ἐπὶ τὸν δεσποτικὸν τάφον, κἀκεῖ αὐτοὺς θανατώσας τῷ ᾅδῃ παράπεμψον.

[41] The word "τάφος" refers not only to the location of Christ's burial, but also to the act of performing the funeral rites for him, namely, his Entombment. In this respect the usage of τάφος is parallel to that of the word "σταυρός." Liddel and Scott, w. "τάφος."

corpse and Entombment, it is probably significant that it is attached to a comparable and lengthy argument concerning the uncompromising reality of Christ's human death. This scholion may therefore be interpreted as a reference to an illustration of chapter thirteen that demonstrated the unequivocal reality of Christ's human death. Two reasons militate against an alternative suggestion that Sinaites turns once more to the illustration of the Crucifixion. The context offers none of the familiar emphatic references to the cross of Christ. More importantly, the conclusion of chapter thirteen constitutes in fact an adjuration to use "the cross and the tomb" of Christ as a weapon against heretics. It therefore follows that, if this chapter were illustrated, it would be illustrated with an image of the Entombment rather than the Crucifixion.

This scholion has been preserved in the illustrated (Λ) and in the expurgated (x) recension of the *Hodegos*, as well as in a fragment (71) that was written in the eighth/ninth century in uncial and represents one of the earliest survivals of the *Hodegos*. It therefore seems likely that this passage reflects the archetype, though this is still a question for philologists to decide.[42] In any case, the presence of the scholion in these two recensions of the *Hodegos* adds strength to the suggestion that chapter thirteen probably included an illustration of the Entombment. Anastasius returned to this later in the same chapter, arguing that Christ's corpse and its Entombment served as the ultimate certificate of Christ's perfect

[42] This scholion appears before PG, 89.221B2 / Uthemann, 13.5.85 in the eighth-/ninth-century fragment (71) Athos, Dionysiou, cod. 596, fol. 143, which only includes PG, 89.221A3–221B8 / Uthemann, 13.5.69–13.5.89 (Uthemann, lxxxviii, cxxix). It appears in the same place in the tenth century (Λ) Athos, Lavra, cod. 131 (B 11), fol. 112ʳ (Uthemann, om.). The same phrase also figures in (x) Paris, Bibl. Nat., cod. gr. 1115, fol. 98ʳ (Uthemann, loc. cit.). However, here the text sequence differs: the scholion is preceded by PG, 89.204.B2–4 / Uthemann, 13.1.1–3 rather than the normal text sequence. The same is true of (Y) Moscow, Histor. Mus., cod. gr. 443; but this does not reproduce chapter twelve (Uthemann, lxxxix n. 12, xciv; and for the text sequence followed by X and Y, lxxxvi n. 5). Uthemann considers this scholion as evidence for the use of an illustration by the *Hodegos*. He assumes, however, that it refers to the illustration of the Crucifixion depicted in chapter twelve (Uthemann, cxxix, cxcii n. 33). Moreover, he discusses it in connection with the reconstruction of a recension, which he calls η and which includes, among other manuscripts, X, Y, T, K, and 71—namely, a group of manuscripts whose text purges chapter twelve and its illustration (for the stemma of η, Uthemann, cxxx, ccv). Furthermore, he considers Λ and M to be related to each other and places them in a different recension ε, which mentions the Crucifixion and also reproduces its illustration (Uthemann, clxviii, clxxi). However, the absence of the scholion "Ὁ ὀρθόδοξος. Περὶ εἰκόνος" from M (recension ε; Uthemann, clxxi), its inclusion in Λ which was not noted by Uthemann (recension ε), and in the eighth-/ninth-century 71 (recension η; Uthemann, cxxx. Λ, M, and 71 follow the normal text sequence), when interrelated with the presence of the same scholion in X and Y (recension η. X and Y adhere to a different text sequence) and the absence of the same scholion from Z (recension η. Z: Vatican, Bibl., cod. gr. 1702 follows the same text sequence as X and Y; Uthemann, xcv) suggest the following: (a) the eighth-/ninth-century 71, which follows the normal text sequence, belongs to the same recension as Λ and (b) the relation of the purged and the unpurged manuscripts must be more complex than that which is allowed for by the stemma reconstructed by Uthemann. For example, the presence of the scholion "Ὁ ὀρθόδοξος. Περὶ εἰκόνος" in the unexpurgated and illustrated Λ suggests that its recension is more closely associated with the expurgated recension to which X belongs than what Uthemann's stemma indicates (Uthemann, clxxi, ccv). It is interesting that the argument which follows this scholion and which reviews the reality of Christ's death is the subject of Question 168 in the *Amphilochia* of Patriarch Photius, PG, 101.861B–C. Photius largely paraphrases Anastasius' argument).

humanity. This illustration appears to have been purged without a trace during the Iconoclastic period, as neither a cross nor any diagram could even pretend to function as its substitute.

In recapitulation, if the above is correct, then chapter twelve of the *Hodegos* used the illustration of the Crucifixion inscribed in a circle with an analytical inscription to prove that the Logos did not suffer or die on the cross, but only the body. Chapter thirteen, on the other hand, appears to have resorted to a representation of the Entombment of Christ to prove the completeness of Christ's human nature through its perfect human death. Both images were intended as the decisive argument calculated to set the flow of the debate in favor of the Orthodox view.

It is particularly important to note at this juncture the exceptional manner in which the author employs the illustrations. They are used, not to decorate or to clarify the text, but to lead the argument to the desired conclusion. As a result, the Crucifixion and the Entombment are not simply illustrations of the corresponding polemical text, but the core material around which the Orthodox defense is constructed.

The pivotal role reserved for the double-edged sword of the illustration of Christ's cross and tomb witnesses how the author follows his own tactical advice. In the *Hodegos*, as well as in his other writings, Anastasius reiterates his deep-seated belief in the greater efficacy of πραγματικαὶ παραστάσεις over scriptural quotes. This conviction stems from his long experience with the problem of the pernicious falsification of texts by heretics. The resulting unreliability of the written word frustrated him and obsessed him. Confronting heretics with arguments based on quotes from the Scriptures and the Fathers would not necessarily guarantee success under the circumstances.[43] In his effort to overcome this difficulty he proposes the use of "syllogisms and objections and material questions and proofs and assertions and propositions . . . to which the uncorrupted word of the fathers can then be attached as corroboration."[44] Thus, the written word, whether that of the

[43] PG, 89.104, 196A–B, 289, 296 / Uthemann, 6.1.131ff., 12.1.9ff., 13.1.10ff., 22.3.20ff., 23.1.26ff. It is interesting that Anastasius only condemns the falsification of texts which results from malicious intent. He therefore does not mind admitting to the fact that he quotes the Fathers from memory. Actually this is the only point in which he invites correction. PG, 89.161C / Uthemann, 10.1.2.197–204. The preoccupation of Sinaites with the falsification of texts is far from unique for the late seventh century. The question of the authenticity of patristic texts became more important as the official church increased its dependence upon them. This became particularly apparent during the Sixth Ecumenical Council, and later during the reign of Justinian II [G. Head, *Justinian II of Byzantium* (Madison, 1972), 61]. A growing concern about the accuracy of texts was also expressed by the Council of 754, as well as by the Sev-

enth Ecumenical Council of 787 [C. Mango, "The Availability of Books in the Byzantine Empire, A.D. 750–850," *Byzantine Books and Bookmen* (Washington, D.C., 1975), 29ff.]

[44] Uthemann, Synopsis, 81.1–17.
Ἀποχρώμενοι καὶ προφέροντές τινας γραφικάς τε καὶ πατερικὰς χρήσεις καὶ μαρτυρίας περὶ τῆς τοῦ κυριακοῦ σώματος ἀφθαρσίας, καλῶς μὲν τοῖς πατράσιν εἰρημένας, κακῶς δὲ ὑπ᾽ αὐτῶν παρερμηνευομένας (ὅπερ δὴ καὶ ἐπὶ τῶν Σεβηριανῶν καὶ Ἰακωβιτῶν ἔστι κατιδεῖν· πλείστας γὰρ καὶ αὐτοὶ νῦν ἡμῖν προφέρουσι χρήσεις τε καὶ δέλτους τῷ φρονήματι αὐτῶν, ὡς οἴονται, συμφωνούσας), ὅθεν δή, ὡς διὰ πολλῆς πείρας ἐν τούτοις γενόμενοι, φαμὲν πρὸς τοὺς τῆς ἀληθείας ὑπερμάχους ἡμῶν ἀδελφούς, ὡς οὐ πάνυ ἰσχυρὰ οὐδὲ ἀήττητος ἡ διὰ πατερικῶν χρήσεων πρὸς τοὺς ἑτεροδόξους ἀντιπαράταξις. Αἱ γὰρ πλείους τῶν πατερικῶν βίβλων κατενοθεύθησαν ὑπὸ τῶν κατὰ

Scriptures or the Fathers, is relegated to a secondary supportive role while the actual burden of proof is carried by Sinaites' favorite instrument of war, the πραγματικαὶ παραστάσεις καὶ ἀντιρρήσεις, πράγματα, πραγματικὰ σχήματα καὶ ὑποδείγματα. They represent facts that address the material reality of an action or a thing. Anastasius therefore relies on them to force his interlocutors to draw the right (his) conclusions on the basis of their personal experiences.[45] For example, he uses the material reality of the holy communion when discussing the doctrine of the incorruptibility of Christ's body.[46] Elsewhere the audience is invited to seek within themselves evidence of the doctrine of the trinity, since man is made in God's image.[47] Anastasius similarly uses his pictorial weapons as material evidence supporting Orthodox christology by addressing his interlocutor's common sense. As such they assume a quasi-legalistic value. This, in turn, explains the choice of the unusual terms πράγματα, πραγματικαὶ παραστάσεις καὶ ἀντιρρήσεις[48] for these visual aids, and their recommendation as the best tactical weapons[49] for the "slaughtering" of the enemies of Orthodoxy.[50]

The most important question raised here is whether the pictorial polemics of the *Hodegos* constitutes a uniqum in its time. The tactical use of christological imagery for polemical purposes is most unusual for the seventh century, though it becomes standard practice in the post-Iconoclastic period. In fact, during the following century the writings of Sinaites found their place in many Iconophile florilegia. However, even though his work is in a sense precocious, it witnesses a respect for visual material that is well within the frame of mind of the last quarter of the seventh century.

The first time the church expressed an official interest in protecting and regulating its religious imagery was in 691 in Canons 73, 82, and 100 of the Council in Trullo. Canon 100 excommunicated all corrupting images.[51] Thus, on the one hand, it admitted to the

καιροὺς γενομένων αἱρεσιαρχῶν, ὡς μετὰ ταῦτα πλατύτερον ἀποδείξομεν· ἐκ συλλογισμῶν οὖν μᾶλλον καὶ ἀποριῶν καὶ πραγματικῶν ἐρωτήσεων καὶ ἀποδείξεων καὶ καταφά[ν]σεων καὶ προτάσεων κατὰ τῆς παρεμβολῆς τῶν κακοπίστων πάντων ἀντιπαραταξώμεθα καὶ ὁπλισθῶμεν, συνάπτοντες τούτοις καὶ τὰς ἀνοθεύτους τῶν ἁγίων πατέρων φωνὰς εἰς συνηγορίαν. Ὡς γὰρ ἤδη ἔφθην εἰπών, ἡ καταμόνας ἐκ πατερικῶν καὶ γραφικῶν λόγων ἀντιπαράταξις οὐ πάνυ στερρὰ καὶ ἀήττητος τυγχάνει, ὡς αὐτῇ τῇ πείρᾳ πολλάκις ἐμάθομεν ἐν ταῖς πρὸς τοὺς ἑτεροδόξους διαλέξεσι.

[45] PG, 89.296D, 196Aff., 140B / Uthemann, 23.1.27ff., 12.1.4ff., 8.5.125f.

[46] PG, 89.297A / Uthemann, 23.1.36ff.

[47] *Sermo I in creationem secundum imaginem dei*, PG, 44.1340B–C.

[48] See "πρᾶγμα," "πραγματικός," and "παράστασις," in Liddel and Scott; Lampe, *A Patristic Greek Lexicon*; D. Du Cange, C. Du Fresne, *Glossarium ad scriptores mediae et infimae Graecitatis* (Lyons, 1638);

D. Demetrakos, Μέγα Λεξικὸν τῆς Ἑλληνικῆς Γλώσσης (Athens, 1954–1958). It is relevant that a πραγματικὸς could be an attorney, a legal adviser or a civil official and that πραγματικὸς τύπος was synonymous with νόμος and could specifically signify an imperial mandate.

[49] PG, 89.40C, 192B, 201B, 288D / Uthemann, 1.1.33, 10.5.38, 12.4.16, 22.2.109.

[50] PG, 89.192D, 244B, om. / Uthemann, 10.5.65, 13.9.97, 14.1.70.

[51] Mansi, 11.985: "Οἱ ὀφθαλμοί σου ὀρθὰ βλεπέτωσαν, καὶ πάσῃ φυλακῇ τήρει σὴν καρδίαν, ἡ σοφία διακελεύεται. Ῥᾳδίως γὰρ τὰ ἑαυτῶν ἐπὶ τὴν ψυχὴν αἱ τοῦ σώματος αἰσθήσεις εἰσκρίνουσι. Τὰς οὖν ὅρασιν καταγοητευούσας γραφάς, εἴτε ἐν πίναξιν, εἴτε ἄλλως πως ἀνατεθειμένας, καὶ τὸν νοῦν διαφθειρούσας, καὶ κινούσας πρὸς τὰ τῶν αἰσχρῶν ἡδονῶν ὑπεκαύματα, οὐδαμῶς ἀπὸ τοῦ νῦν οἱῳδήποτε τρόπῳ προστάσσομεν ἐγχαράττεσθαι. Εἰ δέ τις τοῦτο πράττειν ἐπιχειροίη, ἀφοριζέσθω."

importance of images, while, on the other, it categorized them as desirable and undesirable images, taking an active step against the latter. Canon 73 indicates that the Council also took steps in favor of the former.[52] It prohibited the representation of the cross on the floor, so that it might not be stepped upon. Thus the church actively protected a desirable image, the cross, which constituted its par excellence visual symbol. Concurrently, Canon 82 further regulated desirable religious images.[53] It promoted figurative christological imagery by expressly repudiating symbolic images of christological truths. It specifically prescribed that Christ should be depicted as a man in memory of "His life in the flesh, His Passion and His salutary Death and the redemption which has thence accrued to the world." So, although Canon 82 addressed the case of the symbolic representation of Christ as a lamb, it established, in fact, a theological principle: that the figurative image of Christ is better suited for the illustration of the "historical truth" of Christ and his incarnation than any of its symbols and prefigurations. In principle this canonical statement parallels the use of figurative illustrations of christological truths by Anastasius in chapters twelve and thirteen of his *Manual*. They both function as reminders of the historical reality of the incarnation and the christological truths invested in it. Both Sinaites and Canon 82 promote the illustration of Christ's person as proof and reflection of his humanity, which made possible mankind's salvation. The difference lies in the polemical objectives of Sinaites' diatribe, which naturally lend vehemence to his use of visual material.

If this is correct, then one may observe that the late seventh-century *Hodegos* prefigures major theological arguments used by the Iconophiles a century later during the Seventh Ecumenical Council in order to justify the use of religious images by the church. It especially demonstrates that the polemical use of christological imagery, so familiar from the post-Iconoclastic period, had roots and advocates in the preceding period. Was then Anastasius Sinaites ahead of his time? Probably not. Canon 82 of the Council in Trullo along with Canons 73 and 100 suggest that the late seventh-century church assumed a comparable stance on this matter. In effect, the church's active interest in legislating its pictorial vocabulary and the interest of the *Hodegos* in exploiting it for the sake of the church doctrine reveal complementary attitudes, and are possibly symptomatic of a broader seventh-century trend to enlist art officially in the service of the church. It is particularly interesting for our understanding of religious art around the year 700 that this late seventh-century trend would resort to concepts, arguments, vocabulary, and attitudes that forecast those of the post-Iconoclastic period.

But let us return to the *Hodegos* which, as we have just seen, offers valuable insight into the milieu whose theology necessitated the alignment of the images of the Crucifixion and the Entombment of Christ. The defense of Orthodoxy against Theopaschism, and espe-

[52] Mansi, 11.976: "Τοῦ ζωοποιοῦ σταυροῦ δείξαντος ἡμῖν τὸ σωτήριον, πᾶσαν σπουδὴν ἡμᾶς τιθέναι χρή, τοῦ τιμὴν τὴν ἀξίαν ἀποδιδόναι τῷ δι' οὗ σεσώσμεθα τοῦ παλαιοῦ πτώματος. Ὅθεν καὶ νῷ καὶ λόγῳ καὶ αἰσθήσει τὴν προσκύνησιν αὐτῷ ἀπονέμοντες, τοὺς ἐν τῷ ἐδάφει τοῦ σταυροῦ τύπους ὑπό τινων κατασκευαζομένους ἐξαφανίζεσθαι παντοίως προστάττομεν. Ὡς ἂν μὴ τῇ τῶν βαδιζόντων καταπατήσει τὸ τῆς νίκης ἡμῖν τρόπαιον ἐξυβρίζοιτο. Τοὺς οὖν ἀπὸ τοῦ νῦν τοῦ σταυροῦ τύπον ἐπὶ τῷ ἐδάφει κατασκευάζοντας ὁρίζομεν ἀφορίζεσθαι."

[53] Mango, Sources, 140. Mansi, 11.978.

cially against Monophysitism, offered in the second half of the seventh century enough theological grounds for overcoming earlier artistic qualms about depicting Christ as dead. The text of Sinaites unhesitatingly links the christology of Christ's Death with its pictorialization. One might expect that the *Hodegos* would handle the third and last phase of Christ's Death, his journey to the underworld, in the same way. However, the present edition of the text does not refer to any illustration of this theme, even though it exploits its christological possibilities. Therefore, the problems attending such an illustration will be put aside for a while, in order to follow the christology of Sinaites on this subject.

 Christ's sojourn in the underworld is also brought forward as part of the Orthodox defense. It appears in a scholion of chapter thirteen, which follows shortly after the scholion Ὁ ὀρθόδοξος.Περὶ εἰκόνος and the related diatribe on the perfection of Christ's human death. Moreover the scholion, which alludes to Christ's visit to Hades, addresses for the first time the sect of the Harmasites. The same sect is addressed only once more, later in the same chapter, in conjunction with the admonition to the faithful to employ the illustrations of the Crucifixion and Entombment of Christ as a double-edged sword.[54] Like all of chapter thirteen, the first anti-Harmasites scholion is used to attack the Monophysitic belief that Christ's nature was one and divine. However, Sinaites extends his refutation to include a denial of the existence of a single and divine energy (operation) in Christ. He thus attaches Monoenergism to Monophysitism, and refutes both of them together in this scholion.[55] His argument runs:

> If Christ's nature and energy were one, and that (were) divine, Christ ought to be present as God altogether everywhere, (being) the same and complete. But heretic, come here with me and follow me on foot to some four locations in Christ's Passion. I mean to Joseph's tomb where he lies dead. Afterward come with me from the tomb to Hades. And from Hades let us go to Paradise. And from Paradise come again outside the tomb in the garden where Mary Magdalen beheld him in the likeness of a gardener. If Christ were only divinity, as you claim, he would be everywhere present as God in the same manner lacking in nothing, for the Divine lacks nothing. So how is (it possible that) Christ is incomplete in the tomb, since his intellectual soul was separated from him when he said: "Father, into thy hands I commend my spirit"? Let us also descend to Hades and see there how Christ despoils the prison. Let us ask Adam, let us ask the bodies and mouths of the resurrected saints to tell us how they saw Christ in Hades. In what body, what nature, and what countenance did he arrive and descend into the underworld? How did he walk on the tracks of the abyss? To which nature did the gates of death open in fear? Upon encountering which form were the gate-keepers of Hades horrified? Could they have seen the divine nature bare? Begone! "No man hath seen God at any time." Then, what? Could it have been the flesh of Christ that they beheld? Not at all. For that was lying full of God, dead and motionless in the tomb. . . . We saw him in the tomb, and he had no soul, nor the spirit of man. And we saw him in Hades, and he had neither body nor blood, nor bones, nor thickness, nor a material form, but the intellectual soul alone, full of God, separated from

[54] See n. 3.40.
[55] Richard, "Anastase le Sinaite, l'Hodégos, et le Monothélisme," 41. Uthemann, Synopsis, 68ff.

the body. . . . In brief, if the heretics were to prove to you that Christ was altogether complete . . . with body and soul on the day of the Passion, it would then be evident that there is only one substance and energy, and not two.[56]

However, such proof is impossible. Therefore Monophysites and Monoenergists are wrong, and Christ has two natures as well as two energies and two wills.

The association of the Monothelete and Monoenergist controversy with the Death and Resurrection of Christ found here went back to Apollinarius and his unacceptable definition of Christ's incomplete human soul. The properties of Christ's perfect human soul were defined in the middle of the sixth century in the Council of the Three Chapters in connection with its journey to the underworld.[57] This, however, left open the question of the number of the wills and energies (operations) in Christ during his life as well as during his Death. The problem reached its height in the seventh century. After a number of unsuccessful attempts to reach a theological compromise, it was resolved by the Sixth Ecumenical Council of 680, which decreed that Christ had two wills and two energies, one for each of his two perfect and complete natures working together for the salvation of mankind.[58]

The crux of the official Orthodox proof revolved around the Death of Christ. Here his human and divine will confirmed their individual and independent existence by conflicting

[56] PG, 89.224f. / Uthemann, 13.6.17–102.

Σχόλιον. Οὕτως ἐρωτήσατε αὐτοὺς καὶ ὑμεῖς καὶ οὕτως ἁρμόσασθε πρὸς αὐτοὺς κατὰ τὸν προκείμενον σκοπόν, τοὺς μὲν Ἰακωβίτας περὶ φύσεως, τοὺς δὲ Ἀρμασίτας περὶ θεανδρικῆς ἐνεργείας. . . .

εἰ οὖν φύσις Χριστοῦ καὶ ἐνέργεια μία καὶ αὕτη θεία, ὀφείλει πάντως ὁ Χριστὸς ἐν παντὶ τόπῳ ὅμοιος καὶ ἀνελλιπὴς εὑρίσκεσθαι ὡς θεός. Δεῦρο μοι λοιπόν, ὦ αἱρετικέ, καὶ ⟨ἀμφοῖν τοῖν ποδοῖν⟩ ἀκολούθει μοι ἐν τέτταρσί τισι τόποις ἐν τῷ πάθει τοῦ Χριστοῦ, λέγω δὴ νεκροῦ αὐτοῦ τυγχάνοντος ἐν τῷ μνήματι τοῦ Ἰωσήφ. εἶτα ἀπὸ τοῦ μνήματος ἐλθέ μοι ἐπὶ τὸν ᾅδην, καὶ ἀπὸ τοῦ ᾅδου ἄγωμεν ἐπὶ τὸν παράδεισον, καὶ ἀπὸ τοῦ παραδείσου πάλιν ἐλθὲ ἐκτὸς τοῦ τάφου ἐν τῷ κήπῳ, ἔνθα αὐτὸν ἐθεάσατο ἐν σχήματι κηπουροῦ ἡ Μαγδαληνὴ Μαρία. Εἰ γὰρ μόνη θεότης ἐστὶν ὁ Χριστός, ὡς λέγετε, ὅμοιος καὶ ἀνελλιπὴς ἐν παντὶ τόπῳ ὡς θεὸς εὑρίσκεται· ἀνελλιπὲς γὰρ τὸ θεῖον. Καὶ πῶς λοιπὸν ἐν τῷ τάφῳ ἐλλιπής ἐστιν ὁ Χριστὸς ψυχῆς νοερᾶς χωρισθείσης ἐξ αὐτοῦ, ἡνίκα εἶπε· Πάτερ, εἰς χεῖράς σου παρατίθημι τὸ πνεῦμά μου; Κατέλθωμεν καὶ ἐν τῷ ᾅδῃ καὶ ἴδωμεν ἐκεῖ Χριστόν, πῶς σκυλεύει τὸ δεσμωτήριον. Ἐρωτήσωμεν τὸν Ἀδάμ, ἐρωτήσωμεν τὰ σώματα καὶ τὰ στόματα τῶν ἀναστάντων ἁγίων, ὅπως εἴπωσιν ἡμῖν, πῶς ἑωράκασιν ἐν τῷ ᾅδῃ Χριστόν, ποίῳ σώματι, ποίᾳ φύσει, ποίᾳ μορφῇ ἦλθε καὶ κατῆλθεν ἐν τοῖς καταχθονίοις, πῶς ἐν ἴχνεσιν

ἀβύσσου περιεπάτησε, ποίᾳ φύσει ἠνοίγησαν φόβῳ πύλαι θανάτου, ποίαν ἰδέαν ἰδόντες οἱ πυλωροὶ τοῦ ᾅδου ἔφριξαν; Ἄρα τὴν θείαν φύσιν ἑωράκασιν γυμνήν; Ἄπαγε. Θεὸν γὰρ οὐδεὶς ἑώρακε πώποτε. Ἀλλὰ τί; Ἄρα τὴν σάρκα τοῦ δεσπότου ἐθεάσαντο; Οὐδαμῶς. Αὕτη γὰρ ἔνθεος ἐν τῷ τάφῳ νεκρὰ καὶ ἀκίνητος ἔκειτο. . . . Ἐν δὲ τῷ τάφῳ εἴδομεν αὐτόν, καὶ οὐκ εἶχε ψυχήν, οὔτε ἀνθρώπου πνεῦμα. Ἐν δὲ τῷ ᾅδῃ εἴδομεν αὐτόν, καὶ οὐκ εἶχε σῶμα, οὔτε αἷμα, οὔτε ὀστᾶ, οὔτε πάχος, οὔτε ὑλικὸν εἶδος, ἀλλὰ μόνην ψυχὴν νοερὰν ἔνθεον σώματος κεχωρισμένην. . . . Καὶ ἵνα συντόμως εἴπω, ἐὰν δείξωσιν ἡμῖν οἱ αἱρετικοὶ παντὶ ἀνελλιπῆ τὸν Χριστὸν ἐν τῷ τάφῳ καὶ ἐν τῷ ᾅδῃ καὶ ἐν τῷ παραδείσῳ μετὰ ψυχῆς καὶ σώματος ὄντα τῇ ἡμέρᾳ τοῦ πάθους, εὔδηλον ὅτι μία οὐσία καὶ ἐνέργεια καὶ οὐ δύο ἐστί.

The argument presented here, which includes the Anastasis as evidence for the Dyothelete doctrine, is repeated in *Sermo III*, also attributed to Sinaites, PG, 89.1172ff.; also, see n. 3* and Beck 445.

[57] See n. 2.70, n. 2.71. Also Athanasius, *De incarnatione. Contra Apollinarium* I, II, PG, 26.1124f., 1160f., and *De sancta Trinitate dialogus* IV, PG, 28. 1260f. (Uthemann, 395f.).

[58] Mansi, 11.637, 639, 704ff. Hefele, op. cit., III / I, 508ff. John of Damascus, *De fide orthodoxa*, PG, 94.1033–1064.

with each other. Thus, Christ's reluctance to meet his death, as expressed in the agony in the garden (Mat. 26:38f.) was cited time and again as proof of a perfect human will in Christ.[59] Similarly, the performance of miracles, above all the miracle of the Resurrection, was proof of the divine energy of the God Logos.[60] Even before the official condemnation of Monotheletism, the Orthodox position had been defined in the writings of Maximus the Confessor, who asserted that "(The Word of God) arose by the power of God."[61] Sinaites offers an example of the way the Resurrection could be used to define the divine energy of Christ. In the first chapter of the *Hodegos*, he suggests that divine energy was manifested through: "the performance of miracles and prodigies, especially those which were not touched or affected by his holy flesh. Such were (the miracles) of the Canaanite woman who did not come to Christ, (the healing) of the child of the centurion, the rending of the veil (of the temple), the darkening of the sun, the splitting of the rocks, the opening of the graves, and the resurrection of the dead. For, while the all holy Body was hanging dead (on the cross) without touching them in any way, the divine energy of the God Logos that resides in it effected and operated these (miracles) alone."[62]

Later on, in the eighth century, when the heat of the Monothelete controversy was supplanted by that of the Iconoclastic controversy, the correlation of the divine energy of the God Logos with the theme of the sojourn in the underworld and the Resurrection was maintained. However, the eighth-century references did not need to argue this point any longer, so they merely asserted it. An example of the ease with which this correlation came to be accepted may be seen in an elaborate paraphrase of the Creed included in the Acts of the Seventh Ecumenical Council of 787: "He rose from the dead on the strength of his own divinity after despoiling Hades, and after freeing those who had been prisoners for ages."[63]

Similarly, the hymnographer Theophanes Graptos (b. ca. 775) says:

[59] Mansi, 11.245ff., 373, 704. John of Damascus, op. cit., PG, 94, 1073–1092.

[60] Mansi, 11.249, 289f., 708. John of Damascus, op. cit. 1049, 1057A–C, 1225. The Orthodox side did not often stress this argument, though it never questioned that Christ's miracles were a manifestation of his divine nature. The necessity of asserting the perfection of Christ's humanity—so much at issue throughout the seventh century—appears to be responsible for this. The Monotheletes, on the other hand overstressed this particular argument, as for example, in Mansi, 11.356, 364, 369. For an analysis of the issues involved, see Hefele, op. cit., III / 1,439f.

[61] Maximus Confessor, *Ad theologiam et oeconomiam*, PG, 90.1137A: "ἠγέρθη ὁ τοῦ Θεοῦ Λόγος ἐκ δυνάμεως Θεοῦ."

[62] PG, 89.45A–B / Uthemann, 1.2.76–87. Also Richard, op. cit., 39f.

Οὕτω πάλιν καὶ ἐπὶ τῶν δύο ἐνεργειῶν νοητέον καὶ ἑρμηνευτέον τοῦ Χριστοῦ. Ἐνέργειαν μὲν αὐτοῦ θείαν ⟨λέγομεν⟩ τὴν τῶν θαυμάτων καὶ τεραστίων ποίησιν, καὶ μάλιστα ἐν οἷς οὐ προσέψαυσεν, οὐδὲ ἥψατο ἡ παναγία αὐτοῦ σάρξ, οἷα ἦν ἡ τῆς θυγατρὸς τῆς Χαναναίας μὴ ἐλθούσης πρὸς Χριστόν, καὶ ἡ τοῦ παιδὸς τοῦ ἑκατοντάρχου ⟨ἴασις⟩, καὶ ἡ τοῦ καταπετάσματος διάρρηξις, καὶ ὁ τοῦ ἡλίου σκοτασμός, καὶ ἡ τῶν πετρῶν διάσχισις, καὶ ἡ τῶν τάφων διάνοιξις, καὶ ἡ τῶν νεκρῶν ἀνάστασις· τοῦ παναγίου γὰρ σώματος νεκροῦ κρεμαμένου καὶ μηδενὶ τούτων προσψαύσαντος ἡ ἐν αὐτῷ τοῦ θεοῦ λόγου θεϊκὴ ἐνέργεια μόνη ταῦτα διεπράξατο καὶ ἐνήργησεν.

[63] Mansi, 12.1138: "τοῦτον ὁμολογοῦμεν θεόν τε καὶ ἄνθρωπον διὰ τὴν ἡμετέραν σωτηρίαν σταυρωθῆναι, καὶ θανάτου γεύσασθαι σαρκί, ταφήν τε τριήμερον καταδέξασθαι, καὶ ἀναστῆναι ἐκ νεκρῶν τῆς οἰκείας δυνάμει θεότητος, τὸν ᾅδην σκυλεύσαντα, καὶ τοὺς ἀπ' αἰῶνος δεσμίους ἐλευθερώσαντα. . . ."

Having slept in the tomb as a man
You rose by your invincible power as God.[64]

While another sticheron goes even further:

In the beginning was the Word
And the Word was with God
And God was the Word
He arose from the dead
Let us give praise unto him.[65]

Beyond offering a key to the rationale which made the representation of the Death of Christ acceptable, Sinaites also provides a vital clue to the theological background, which stimulated more interest in the Resurrection and the circumstances attending it.

It has been shown here that the Orthodox side used extensively the theme of Christ's Death and Resurrection in its struggle against three major heresies throughout the seventh century. The basic argument against Theopaschism revolved around the theme of the lone Death of Christ's human body on the cross. Monophysitism was rejected by building an argument on the dead body of Christ in the tomb. Finally, Monoenergism was disproved by exploiting the theme of the works of Christ in the underworld and his Resurrection from it. Each of these three Orthodox arguments was not isolated from the other two insofar as they shared the same objective. Their aim was to prove that each of Christ's two natures remained complete and perfect as well as hypostatically united to the other nature throughout his incarnation, including his Death.

The official attitude of the church on these matters was defined during the proceedings of the Council of 680 on a theological level. The subsequent Council in Trullo, in 692, reflects to some extent the way in which the new theological emphasis on the Death and Resurrection of Christ was given concrete shape which affected specific aspects of church worship. One immediate result appears to have been the creation of regulations aimed at enhancing the importance of Easter and its weekly commemoration in the church. This is apparently the purpose of Canon 66 which extends the celebration of Easter to the whole week following Easter Day.[66] Similarly Canons 89 and 90 add import to the weekly com-

[64] *Anthologia graeca carminum christianorum*, 125. Beck, 516f.

Ὑπνώσας ἐν τάφῳ ὡς ἄνθρωπος
δυνάμει ἀηττήτῳ σου ὡς Θεὸς ἐξανέστησας
. . . .
τὸ φέγγος τῆς θεότητος ὁμιλῆσαν παχύτητι.

[65] Sticherarion, Athos, Lavra, cod. Γ 72, fol. 50ᵛ,

Ἐν ἀρχῇ ἦν ὁ Λόγος
καὶ ὁ Λόγος ἦν πρὸς τὸν Θεὸν
καὶ Θεὸς ἦν ὁ Λόγος
αὐτὸς ἀνέστη ἐκ νεκρῶν

αὐτὸν δοξολογήσωμεν.

This text has been published in Νέα Σιών, 27 (1932), 471. The manuscript dates from the second half of the tenth century, and not later than 1025. Its stichera are believed to be of an earlier date for the most part. Bertonière, 172f., with further bibliography. Also H. Follieri, *Initia hymnorum ecclesiae graecae*, ST 211–215 (Vatican, 1960–1966).

[66] Mansi, 11.973. Ralles and Potles, op. cit., II, 460–462.

memoration of Easter. Specifically, Canon 89 bans fasting on Saturday evenings[67] and Canon 90 forbids genuflexions on Sundays as weekly reminders of the yearly jubilation on Easter Sunday.[68] The import of some of these regulations is attested by the fact that Pope Sergius refused to sign the Acts of the Council in Trullo because of Canon 89, among others.[69]

In a manner comparable to official theology and liturgy, contemporary church literature found ways of updating its uses of the theme of Christ's Death and Resurrection. The late seventh-century *Hodegos* is a case in point with regard to Orthodox polemics. The new attitude toward these themes also entered the field of homiletical literature, which undoubtedly helped to disseminate them. Thus Sinaites allegedly wrote a sermon on the Descent of Christ to the Underworld.[70] The homily survives only in Syriac and remains unpublished and untranslated, which is particularly unfortunate, since the number of homilies on this subject is small. However, another sermon by Pseudo-Epiphanius offers a powerful insight to the tenor that became acceptable to the Orthodox church at the turn of the eighth century.[71]

The homily of Pseudo-Epiphanius is dedicated to the Holy Saturday and deals with Christ's burial, his spoliation of the underworld, and his raising of the dead from it. The edition and translation of an old Slavic recension along with a study of the Greek text led A. Vaillant to conclude that this sermon was written in the last decade of the seventh century by a Bishop Epiphanius of Cyprus, who participated in the Council in Trullo.[72]

The homily is a particularly baroque piece of church literature which has caused much controversy. The flourish and success with which it dramatizes its subject caused La Piana to associate it in the early 1900s with his theory of the existence of live religious theater in Byzantium.[73] For the same reasons, this homily was suggested as a possible literary source for the image of the Anastasis.[74] However, La Piana's controversial theory conflicted with Millet's proposition that the Apocryphon of Nicodemus was the source for the iconogra-

[67] Mansi, 11.981. Ralles and Potles, op. cit., II, 512–516.

[68] Mansi, 11.981. Ralles and Potles, op. cit., II, 516–518. The continued practice and interpretation of this canon is confirmed by Theodore Studites in his *Quaestiones*, PG, 99.1732. For an early interpretation, see Germanus I, patr., *Historia ecclesiastica et mystica contemplatio*, PG, 98.392C.

[69] As a result, Justinian II ordered the arrest and extradition of the pope to Constantinople. F. Görres, "Justinian II und das römische Papstum," *BZ*, 17 (1908), 440–450.

[70] A. Baumstark, *Geschichte der syrischen Literatur* (Bonn, 1922), 262. I. Ortiz de Urbina, *Patrologia Syriaca* (Rome, 1965), 248. This homily is not listed among

Anastasius' works by Uthemann, ccxii f., 391f.

[71] Pseudo-Epiphanius, *In Sancto et Magno Sabbato*, PG, 43.439–464. Also in *Epiphanii Episcopi Constantiae Opera*, G. Dindorfius, ed. (Leipzig, 1862). J. Quasten, *Patrology* (Utrecht, 1960), III, 395.

[72] A. Vaillant, "L'homélie d'Epiphane sur l'ensevelissement du Christ," *Radovi Starosjavenskog Instituta Knjiga*, 3 (Zagreb, 1958), 1–101. For its date, see page 16.

[73] G. La Piana, "The Byzantine Theater," *Speculum*, 11 (1936), 171–211, with his previous bibliography. Also, V. Cottas, *Le théâtre à Byzance* (Paris, 1931), 257ff.

[74] M. Sotiriou, "Χρυσοκέντητον ἐπιγονάτιον τοῦ Βυζαντινοῦ Μουσείου," 290 n. 2.

phy of the Anastasis. As a consequence, La Piana's interpretation of this homily was rejected outright.[75]

But as we have already seen, the text of Nicodemus cannot be accepted as a direct source for the image of the Anastasis.[76] For similar reasons the homily of Pseudo-Epiphanius does not fit this role either. Both writings include major themes that are not reflected in the early examples of the image of the Anastasis, and vice versa.[77] Furthermore, the essentials of the story behind the image were widely known and used long before either of these literary pieces or the image made their appearance. Consequently, a direct interconnection of these three pieces of evidence is not warranted by the information within each of them. On the other hand, if it is considered that in the past twenty years these two sources have been redated in the seventh century, one may suggest that they are parallel manifestations of the growing interest of the seventh century in Christ's Death and Resurrection. It is important here to underline a common feature which has been regularly ignored: that both the Apocryphon of Nicodemus and the homily of Pseudo-Epiphanius are not only concerned with the exploits of Christ in the underworld, but also express a deep interest in the story of the burial of Christ's body. All these factors match well with the theological and liturgical expressions of the seventh-century interest in the Death of Christ, his Burial, his spoliation of Hades, and the Resurrection from it.

There is little doubt that the liveliness and immediacy of this dramatic homily appealed greatly to the faithful and provided an attractive way of popularizing official theology in the post-680s Orthodox church with the help of such passages as "Yesterday (i.e. on Holy Friday) the incarnation was demonstrated, today the authority; yesterday the feebleness, today the absolute mastery; yesterday the humanity, today the divinity. Yesterday he was stricken, today he strikes the abode of Hades with the lightning of his divinity; yesterday he was bound up, today he ties down the tyrant in indissoluble bonds; yesterday he was condemned, today he presents freedom to the condemned."[78]

Given the populist qualities of this sermon, it is not surprising to find it incorporated in the *Triodion* as a reading at the end of the Holy Saturday Vespers.[79] Although the date of inclusion is not certain, the homily surely enjoyed immense popularity in that position, as

[75] Millet, *Recherches sur l'iconographie de l'évangile,* 612–618, esp. 616ff.

[76] Above, 10f., 14ff., 30.

[77] For example, Christ entered Hades "holding the victorious weapon of the cross" (PG, 43.461) rather than the scroll. He stabbed the tyrant of the underworld, and had him bound in chains, but did not trample this tyrant underfoot (PG, 43.456). These are some of the motifs mentioned in the homily which do not coincide with the early examples of the iconography of the Anastasis. Furthermore, two themes that figure prominently in the homily do not appear in the image until a later date: namely, the theme of the

door, the broken gates, and the broken keys, bolts, and chains, which litter Hades.

[78] PG, 43.440D–441A: "Χθὲς τὰ τῆς οἰκονομίας, σήμερον τὰ τῆς ἐξουσίας· χθὲς τὰ τῆς ἀσθενείας, σήμερον τὰ τῆς αὐθεντίας· χθὲς τὰ τῆς ἀνθρωπότητος, σήμερον τὰ τῆς θεότητος ἐνδείκνυται. Χθὲς ἐρραπίζετο, σήμερον τῇ ἀστραπῇ τῆς θεότητος τὸ τοῦ ᾅδου ῥαπίζει οἰκητήριον· χθὲς ἐδεσμεῖτο, σήμερον ἀλύτοις δεσμοῖς καταδεσμεῖ τὸν τύραννον· χθὲς κατεδικάζετο, σήμερον τοῖς καταδίκοις ἐλευθερίαν χαρίζεται."

[79] *Triodion Katanyktikon,* 760. Bertonière, 158, 192, 238.

attested by its presence in the rubrics for Holy Saturday in a great many liturgical manuscripts.[80]

The subject matter and content of this homily, along with its popular use within the church for the celebration of Holy Saturday, agree well with the liturgical attention paid by the Trullan Council to the enhancement of the honor due to Easter. The early eighth century, moreover, might have produced another homily which energetically expands on the themes, virtues, and style of the homily of Pseudo-Epiphanius. This is another homily for Holy Saturday which, in addition to the themes of the Burial of Christ, his descent, and Resurrection from Hades, introduces the theme of the lamentation of the Virgin over Christ's dead body. It was published as a homily of Patriarch Germanus I, an attribution that has been seriously disputed.[81]

Therefore the canonical decisions taken by the Councils of 680 and 691 seem to have been generally accepted by the first half of the eighth century. An expression of that acceptance is seen in the introduction to church ritual of major hymns such as the Holy Saturday Canon of Cosmas of Maiouma,[82] and the Easter Canon of John of Damascus.[83] These hymns make a special point of including formulaic refutations of Monotheletism, Monoenergism, and Theopaschism, some of which may be seen in the passages already cited here.

By using the *Hodegos* of Sinaites as a guide to the maze of seventh-century theoretical and applied theology, we have been able to trace in the broadest outline this period's need to answer important heretical challenges with lengthy arguments based on various aspects of the Death and Resurrection of Christ. The solutions chosen by the winning party were authorized by the Sixth Ecumenical Council of 680–681. Their application seems to have been initiated by some of the decisions of the Council in Trullo. From then on, the spirit of the Sixth Ecumenical Council was progressively integrated into the worship of the church through homilies and hymns. The works mentioned here hardly encompass the entire range of literature on seventh- and early eighth-century christology, but they adequately illustrate the extent to which theologians were now forced to define even the mi-

[80] The earliest manuscript mentioned by Bertonière dates from the twelfth century. However, see A. von Ehrhard, *Überlieferung und Bestand der hagiographischen und homiletischen Literatur der griechischen Kirche.* TU 50–52 (Leipzig, 1943), passim. Despite the absence of an index, even a cursory examination of the inclusion of this homily in rubrics of manuscripts published by von Ehrhard proves its popularity, whose extent suggests an early and widespread practice. The rubrics give the opening words of the homily: "Τὶ τοῦτο; Σήμερον σιγὴ." A closer study of these entries would probably yield a more precise date for the beginnings of the popularity of this homily. My thanks are due to Prof. Henry Maguire for teaching me the usefulness of this publication.

[81] *In Dominici Corporis Sepulturam.* PG, 98.244–290. Beck, 475, attributes this sermon to Patriarch Germanus II (1222–1240) without explaining his reasons. The same is true of M. Alexiou, "The Lament of the Virgin in Byzantine Literature and Modern Greek Folk-Song," *Byzantine and Modern Greek Studies,* 1 (1975), 121. This opinion apparently depends on the date of the *Epitaphios Threnos* of the Virgin, and its inclusion in the Holy Friday Services. For this, D. I. Pallas, *Passion und Bestattung Christi in Byzanz* (Munich, 1965), 63, and Alexiou, op. cit., 119 and n. 16. And below, n. 3.88.

[82] Above, n. 2.72.

[83] John of Damascus, *Easter Canon.* PG, 96.840–844.

nutiae of the time period spanning Christ's Death on the cross and his rising from the tomb. This massive confrontation of the theological implications of Christ's Death helped clarify the theme of Christ's journey to the underworld and his raising of the dead. Hitherto this doctrine had been employed to demonstrate the hypostatic union of the two natures[84] and to define the intellectual capacities of Christ's perfect human soul. Now it was also used to demonstrate the invincible power of the will and energy of his weaker though perfect human nature. The apparent increase of the liturgical importance of Saturday and Sunday to reflect better the growing liturgical importance of Easter amply confirms the renewed interest of applied theology in the last phase of Christ's Death.

The importance of the text of the *Hodegos* increases within the broader framework since the polemics of Sinaites supply a different example of applied theology. His interest, which is on a less exhalted level than liturgy, lies more with effectiveness than refinement. As a result, Sinaites follows a more populist line in his choice of argument, language, and material evidence. His introductory call for extensive and methodical use of material representations seems unique for the seventh century. But it is doubtful he was the sole defender of the faith to use pictoriated arguments, since his attitude appears to be an exaggerated echo of Canon 82 of the Trullan Council.

Thus the *Hodegos* permits us to reconstruct the doctrinal context which encouraged aligning the scene of the Crucifixion with that of the Entombment as a twin weapon against two major heresies. Although the present edition of the *Hodegos* does not permit the reconstruction of an illustration of the Anastasis, the continuous association of this theme with the previous two in the literature of the seventh and early eighth century suggests that its pictorialization had a similar background and aimed at similar purposes to the image of the Crucifixion and the Entombment, that is, as a "material objection" capable of arguing against a major heresy of the latter part of the seventh century.

EARLY "MATERIAL FIGURATIONS" OF CHRIST'S DEATH AND ANASTASIS

Lifting the pictorial ban on the death of Christ did not mean that the use of the new types was necessarily established overnight, or that the earlier pictorial types were automatically forbidden. Instead, the old types coexisted for a long time alongside the ones which now became acceptable. Furthermore, the newer pictorial solutions met with different degrees of acceptance, but this is difficult to chart owing to the paucity of the surviving material from this period.

The Crucifixion

Although the text of Sinaites provides the best basis for the depiction of Christ dead on the cross, the first example of this iconography dates from the early to middle eighth century

[84] As, for example, Gregory Nazianzenus, *Oratio* XLV. *In Sanctum Pascha*, PG, 36.640f., translated by Ph. Schaff and H. Wace, *A Select Library of Nicene, and Post Nicene Fathers* (Grand Rapids, 1955), VII, 427f.

and comes from a portable icon at Mount Sinai.[85] The direct link between this early version of the new type of Crucifixion and the earlier iconographic type is underlined by its continued use of the colobium to cover Christ's body, and by the fact that an example of the earlier type of Christ alive on the cross in S. Maria Antiqua was used to date the Sinai icon. The basic characteristics of the newer iconographic type of Crucifixion had been fully developed by the turn to the ninth century. By then the colobium had given way to the loincloth, as seen in another icon from Mount Sinai.[86]

Nevertheless, the fully developed image of Christ dead on the cross, as exemplified by the second Sinai icon, did not signal the immediate disappearance of the earlier iconographic type of Christ alive on the cross. The two types continued to coexist up to the end of the Macedonian period.[87]

The Entombment

The theme of the Entombment had no antecedents with which to compete.[88] Sinaites appears to offer the earliest reference for a possible pictorialization of this subject, which also is consistently absent from earlier christological cycles. A second reference appears in the *Vita S. Pancratii*, bishop of Tauromenion, which probably dates from the seventh century.[89] The Entombment forms here part of a christological cycle recommended for the

[85] Weitzmann, *Sinai Icons*, I, no. B.36, 61–64 with previous bibliography. For the earlier dating Belting, "Das Kreuzbild im *Hodegos* des Anastasius Sinaites," 36ff.

[86] Weitzmann, *Sinai Icons*, I, no. B.50, 79–82.

[87] As for example on the altar cross from Ephesos at Vienna (Wessel, *Die Kreuzigung*, 28); the enamel cross at the Museum of Georgian Art in Tiflis [Ch. Amiranachwili, *Les émaux de Géorgie* (Paris, 1962), 28ff.]; the enamel bookcover in Venice, Marciana, cod. lat. I.101, gia Reserv. 56 [J. Beckwith, *The Art of Constantinople* (London, 1961), fig. 110]; on fol. 87ᵛ of the Theodore Psalter of 1066 [S. Der Nersessian, *L'illustration des psautiers grecs du Moyen Age* II. *Londres Add. 19352*. Bibliothèque des Cahiers Archéologiques, 5 (Paris, 1970), fig. 142. Also below, 127f.]; at Purenli Seki Kilise and Kokar Kilise, members of the Irhala group of Cappadocian churches [M. Restle, *Byzantine Wall Painting in Asia Minor* (Recklinghausen, 1967), pls. 485, 476. Hereafter: Restle]. A thirteenth-century reinterpretation of the colobium as a priestly vestment confirms its late survival. This may be seen in Berlin, Staatsbibl., cod. qu. 66, fol. 254ᵛ, where Christ is represented in a mini-colobium decorated with a cross. Millet, *Recherches sur l'iconographie de l'évangile*, 430, fig. 452, which, however, omits the cross on the colobium. Also, R. Hamann-

Mac Lean, "Der berliner Codex graecus quarto 66 und seine nächsten Verwandten als Beispiele des Stilwandels im frühen 13. Jahrhundert," *Studien für Buchmalerei und Goldschmiedekunst des Mittelalters. Festschrift für Karl Hermann Usener zum 60. Geburtstag am 19. August 1965* (Marburg an der Lahn, 1967), 225–250. I am grateful to Prof. Hugo Buchthal for pointing out this corroborating miniature.

[88] For the earliest examples of the Entombment, see K. Weitzmann, "The Origin of the Threnos," *De Artibus Opuscula XL. Essays in Honor of Erwin Panofsky*, M. Meiss, ed. (New York, 1961), 476–490. Also, H. Le Roux, "Les mises au tombeau dans l'enluminure, les ivoires, et la sculpture du IXe au XIIe siècle," *Mélanges offerts à René Crozet* (Poitiers, 1966), I, 479–486. M. Sotiriou, "Ἐνταφιασμός-Θρῆνος" Δελτ.Χριστ.'Αρχ.'Ετ., 7 (1974), 139–148.

[89] *Vita S. Pancratii, ep. Tavromenii*, trans. in Mango, Sources, 138, 265, 137 n. 75. A. N. Veselovskij, ed. *Is istorii romana i pověsti*, I. Sbornik otdělenija russkago jazyka i slovesnosti imperatorskoj Akademii Nauk. 40 / 2 (1886), 77. H. Usener, *Kleine Schriften* (Berlin, 1913), IV, 418–421. Beck, 513. Also A. Frolow, *La relique de la Vraie Croix*, AOC 7 (Paris, 1961), no. 84, p. 214, who dates the text to the eighth or ninth century.

decoration of churches. The First Letter of Pope Gregory II to Emperor Leo III also mentions a representation of the Burial of Christ immediately after that of the Crucifixion, but the date of this letter and its authenticity are far from certain.[90]

If these sources date from the seventh and eighth centuries, they suggest that the image of the Entombment was easily accepted after a good christological raison d'être was provided for it. Nevertheless, its inclusion in christological cycles never became mandatory like the Crucifixion. It is omitted from the mosaic cycle decorating the Oratory of John VII in St. Peter's (705–707). It is also absent from the pictorial cycle mentioned in *Adversus Constantinum Cabalinum*, which has been dubiously attributed to John of Damascus.[91] The position reserved for it in post-Iconoclastic christological cycles did not alter, as we shall see. Thus, although the Macedonian period saw an expansion of the theme of the Burial of Christ, it did not consider either the Entombment, or its various offshoots important enough to integrate them definitively in the standardized feast cycle.

The Anastasis

The situation is different with the theme of the Resurrection. Surviving examples of the new iconography show that the Anastasis was accepted by the first decade of the eighth century. They also indicate that it was allowed to supersede the Myrophores in christological cycles at that early date. The few and uncertain literary sources that survive seem to confirm this. The First Letter of Pope Gregory II to Emperor Leo III mentions the Anastasis as part of a christological cycle between the scenes of the Entombment and the Ascension. Here it is designated only as Anastasis without specifying its content. Another letter, known as the letter of Pope Gregory II to Patriarch Germanus and usually dated to the first half of the eighth century, defends the right to represent in images the voluntary Passion, the spoliation of Hades, and the Ascension of the resurrected Christ.[92] The author evidently refers to a pictorial cycle that includes the image of the Anastasis. Similarly, the *Vita S. Pancratii* specifies the need for a representation of "the Anastasis out of Hades" in christological cycles used for the decoration of churches. The description in *Adversus Constantinum Cabalinum* is even more explicit: "(Let us look at) the Anastasis, the joy of the world, how Christ tramples Hades underfoot, and raises Adam."[93]

[90] Mansi 12.967B, J. Gouillard, "Aux origines de l'iconoclasme: Le témoignage de Grégoire II?" *TM*, 3 (1968), 289 l. 163 and 253ff. Gouillard believes that both the first and second letter of Pope Gregory II to Emperor Leo III were rewritten in the late eighth or early ninth century without precluding that they still echo the Pope's views.

[91] *Adversus Constantinum Cabalinum.* PG, 95.316. Beck, 479. G. Lange, *Bild und Wort* (Würzburg, 1968), 141ff.

[92] The letter to Patriarch Germanus includes the phrase "καὶ τὸν ᾅδην ἐσκύλευσεν." Mansi, 13.96C; PG, 98.152. Gouillard believes that the Patriarch Germanus is the author of this letter, op. cit., 244ff., while D. Stein attributes it to Pope Zacharias at ca. 743. D. Stein, *Der Beginn des byzantinischen Bilderstreites und sein Entwicklung bis in die 40er Jahre des 8. Jahrhunderts* (Munich, 1980), 125ff., 128ff. P. Speck, on the other hand, believes that the letter, which was originally written by Pope Gregory, has survived in an interpolated variation. P. Speck, *Artabasdos, der rechtgläubige Vorkämpfer der göttlichen Lehren.* Ποικίλα Βυζαντινά, 2 (Bonn, 1981), 155ff.

[93] PG, 95.316.

The first surviving examples of the new iconography of the Resurrection come from Rome, and date from the pontificate of Pope John VII (705–707). The Anastasis appears twice in fresco in S. Maria Antiqua (figs. 14a,b),[94] and once as part of the mosaic decoration of the Oratory of John VII in St. Peter's (fig. 15).[95] In the first two, it is used independently of a cycle in a way which has no parallels, while in the third it belongs to a rather extensive christological cycle. The fragmentary condition of the first two has deteriorated since their publication in the early twentieth century, so it is necessary to rely on Wilpert's watercolors more than one might have wished. Even worse, the more important mosaic from the Oratory of John VII is known only through drawings made before its demolition in 1606.

These first three representations of the Anastasis are closely interrelated in their iconographic essentials. They are thought to be an eastern iconographic import of Constantinopolitan origin, and not a local artistic invention. Moreover, the next dated representation of this subject, which also comes from Rome, appears over one hundred years later (fig. 23). It is a mosaic from the Chapel of S. Zeno in S. Maria Prassede from the time of Pascal I (817–824). These three examples in Rome stand, therefore, as the only reflections of the earliest eastern iconography of the new and vital image. This factor coupled with their early and isolated date magnifies their importance and recommends special attention.

The dramatis personae in all three examples of the early eighth century are Christ, Adam, and Hades. Eve appears in the fresco of the entrance to the Palatine ramp in S. Maria Antiqua, and possibly in the Oratory of John VII.[96] She is rising from Adam's side making a gesture of supplication. Both her absence from the fresco of the Chapel of the Forty Martyrs in S. Maria Antiqua, and Christ's marked indifference to her, suggest some hesitation about her presence in this scene. Thus, though accepted, Eve is relegated to a secondary position, decisively excluded from the immediate action. Christ does not pull her up by the hand. She goes wherever Adam goes, but as a follower, not as an equal. The content of the action and the image is determined by the remaining three figures: Christ, Adam, and Hades.

[94] (a) Anastasis fresco, doorway to the Palatine ramp. Wilpert, II, 890; IV, pl. 168.2. P. J. Nordhagen, "The Frescoes of John VII (A.D. 705–707) in S. Maria Antiqua in Rome," *ActaIRNorv*, 3 (1968), 81f., 93, pls. 100B, 101B with previous bibliography. Idem, "Kristus i Dødsriket," 165ff. Idem, " 'The Harrowing of Hell' as Imperial Iconography. A Note on Its Earliest Use," 345ff. (b) Anastasis fresco, Chapel of the Forty Martyrs, Wilpert, II, 890f.; IV, 167.1. Nordhagen, "The Frescoes of John VII (A.D. 705–707) in S. Maria Antigua in Rome," 86, 84, pl. 103. Idem, "Kristus i Dødsriket," 165ff. Idem, " 'The Harrowing of Hell' an Imperial Iconography. A Note on Its Earliest Use," 345ff. Concerning Lucchesi Palli's attribution of this type of Anastasis to the West, see II n. 55, 94ff.

[95] G. Grimaldi, *Descrizione della basilica antica di S. Pietro in Vaticano. Codice Barberini Latino 2733*, R. Niggl, ed. (Vatican, 1972), fols. 90v–91r, fig. 39; fols. 94v–95r, fig. 42. I. Ciampini, *De sacris aedificiis a Constantino Magno constructis* (Rome, 1693), pl. 23. M. van Berchem, E. Clouzot, *Mosaiques chrétiennes du IVe au Xe siècle* (Geneva, 1924), 209–217. S. Waetzoldt, *Die Kopien des 17. Jahrhunderts nach Mosaiken und Wandmalereien in Rom* (Munich, 1964), nos. 894, 895, pp. 68f., figs. 477, 478. P. J. Nordhagen, "The Mosaics of John VII (A.D. 705–707)," *ActaIRNorv*, 2 (1965), 121–166, pl. 18.

[96] Wilpert, II, 891, and Lucchesi Palli, *RBK*, w. "Anastasis," 143, do not see Eve here. Grimaldi's drawings on fol. 104r and 95r of Vat. Barb. lat. 2733 appear to contradict them. Also below, 210ff.

The person of Christ dominates the composition. He strides to the left forcefully taking hold of Adam's wrist with his right hand, while stepping on the head of Hades with his right foot. He is cross-nimbed, holds a scroll with his left hand, and is entirely enveloped in a brilliant mandorla of light. The mandorla isolates Christ from the surrounding material world with two significant exceptions. The tip of the foot which is trampling Hades is outside the mandorla, while Adam's hand, still limp, is already inside it.

Adam, who forms the second side of this triangle, is rising limply out of his rectangular sarcophagus. He is an old man who continues to have one foot literally in the grave. He is not participating actively in the vigorous action that focuses on him, and whose outcome is entirely dependent on the will and energy exhibited by Christ.

On the contrary, Hades is a dark muscular figure still trying hard to hold onto his territory and possessions. Although Christ's trampling foot effortlessly keeps him in check, Hades is still trying to support his falling body with one hand and a bent leg, while with the other hand he is trying to prevent Adam's leg from rising out of the sarcophagus.

Obviously, the primary theme of this image is neither Christ's descent into Hades, nor his Resurrection from it. The interest is focused on the deeds of Christ in the underworld. These are analyzed into two interdependent actions: the raising of Adam following the trampling of Hades, whose hold on Adam is in the process of being broken. The characterization of the personality of each participant describes his individual role astutely and succinctly, adding great cohesion to the content of the image. The forceful will and unimpeded power of Christ the Logos Incarnate is contrasted to the resistance of Hades at the moment of his defeat, and the helplessness and slumber of Adam whose rescue is exclusively the result of Christ's efforts. Thus, the contrasting behavior of the three protagonists heightens the drama of the image.

This iconography offers indeed a forceful illustration of the will and energy of Christ's divinity in action. The mandorla, which explodes with light in the case of the destroyed oratory mosaics, underlines this theme in a particularly judicious manner. For δόξα, as the mandorla is often called, was understood as "an outward manifestation of the invisible divine essence" and was used as such in the visual arts at least as early as the fourth century.[97] In the case of the iconography of the Anastasis it stands for the "flashing light of his divinity" that hit the abode of Hades, defeated its tyrant, set his prisoners free, and brought light into darkness as "the sun of righteousness."[98]

[97] Lampe, *A Patristic Greek Lexicon*, w. "δόξα." Also E. Kriaras, Λεξικὸ τῆς Μεσαιωνικῆς Ἑλληνικῆς καὶ Δημώδους Γραμματείας (Thessalonike, 1968ff.), w. "δόξα." M. Sacopoulo, *La Theotocos à la mandorle de Lythrankomi* (Paris, 1975), 29–40, 102–108; 31ff. for terminology; 34 n. 5 for mandorlas as signs of theophany. A.H.S. Megaw and E.J.W. Hawkins, *The Church of Panagia Kanakaria at Lythrankomi in Cyprus* (Washington, D.C., 1977), 76–79, 94. A. Grabar, "The Virgin in a Mandorla of Light," *Late Classical and Mediaeval Studies in Honor of Albert Mathias Friend, Jr.* (Princeton, 1955), 305–312. Idem, *Martyrium* (Paris, 1943–1946), II, 203, 212f. O. Brendel, "The Origin and Meaning of the Mandorla," *GBA*, 25 (1944), 5ff. F. van der Meer, *Maiestas Domini* (Vatican, 1938), 255–265. For early examples of this iconography, see Sacopoulo, 29 n. 2 for the Callixtus catacomb and Megaw, 76 n. 252 for the Domitilla catacomb dating no later than 366–384.

[98] Above, 21f. For references to Christ as the "sun of

But divinity was perceptible in Hades thanks to its hypostatic union with Christ's created human soul. The possibility of depicting the human soul had already been asserted in the first half of the seventh century by Bishop John of Thessalonike, who also explained why, as well as how: "the Catholic Church recognizes them (i.e. human souls) to be spiritual, but not altogether incorporeal and invisible. . . . rather as having a fine body of an aerial or fiery nature."[99]

In both frescoes in S. Maria Antiqua this fine and aerial soul of Christ is rendered in the shape of his human likeness by means of rapid impressionistic brushstrokes in pale shades suffused with white and red, or white and yellow—the traditional fresco substitute for the light-catching gold of mosaics. At the same time, the mandorla of light enveloping Christ's form suggests only too well that the divinity expressed its will and energy through his visible human soul, thus allowing Adam and the rest of the underworld population to perceive in Hades the presence of the otherwise invisible and uncircumscribable divinity. The mandorla is, therefore, the pictorial formula used to stress succinctly that the theme of the image at hand is the epiphany of the will and energy of the Logos performing the miracle of the Resurrection undivided from Christ's human soul.

Appropriately, Adam's hand is allowed to enter the mandorla. His reentry to paradise is imminent. In fact, his admission to the sphere of the divine has already begun and his deification (along with the deification of mankind) is already under way in this miracle of re-creation, as the Anastasis came to be known.[100]

In reverse, Christ's foot comes ever so slightly out of the mandorla of light in order to trample effortlessly the overthrown figure of Hades on the crown of his head. At an early date Christian art borrowed from imperial art the theme of the triumphant trampling of a defeated enemy producing the theme of Christ trampling on the asp and the basilisc. The gesture was well-known since it formed part of the ritual of imperial triumphs, one of which was celebrated in 705 in the hippodrome of Constantinople in honor of Justinian II.[101] The trampling of Hades, the enemy of mankind, by "the invincible power" of the redeeming Logos is hardly surprising. However, the studious trampling with one foot,

righteousness" in this context see, for example, John of Damascus, *Easter Canon*, PG, 96.841A; Epiphanius, *In die resurrectionis Christi*, PG, 43.465 where Malachi 4:2 is given as the source of this expression. And below, 207f.

[99] Mansi, 13.164f. Translated by Mango, *Sources*, 140. Beck, 458.

[100] The interpretation of the Anastasis as an act of re-creation is best reflected in a special theme in apocryphal and homiletical literature. Accordingly, *The Book of Adam and Eve* asserts that during the Passion "Christ was like unto Adam in everything." As a result, every hour of Adam's creation and fall is compared with every hour of Christ's Passion. In this scheme, the day and hour of Adam's fall from grace

is paralleled to the day and hour of Christ's Death on Holy Friday. A. Wallis Budge, *The Book of the Cave of Treasures* (London, 1927), 221ff., 60ff., 73f. This idea is echoed in Pseudo-Chrysostom, *In S. Paraskeven*, PG, 62.722. Here the sixth day of the Creation, the day of Adam's expulsion from Paradise, is paralleled to the reopening of Paradise on the sixth day of Christ's Passion. John of Damascus also uses this idea in his homily on Holy Friday, PG, 96.589f. Cosmas Indicopleustes also takes the same idea for granted. W. Wolska-Conus, ed., *Cosmas Indicopleustès. Topographie Chrétienne*, SC 159 (Paris, 1970), II, 94f.

[101] Grabar, *L'empereur dans l'art byzantin*, 129, 195. Schwartz, "A New Source for the Byzantine Anastasis," 33f.

which is the only part of Christ's humanity outside the divine umbrella of the mandorla is significant. It suggests that the instrument of the defeat of Hades was Christ's human nature through which the divinity first baited and then despoiled death. This theme, which was associated with Christ's descent to the underworld at least as early as Origen, developed the idea that Christ's humanity served to deceive Hades and/or Satan (that is the forces of Death) forcing him into a destructive confrontation with the Divinity. Its inclusion in the Orthodox Manual by John of Damascus indicates the formal approval of this theme in the early eighth century.[102]

If this analysis is accepted, the iconography of the Anastasis may be interpreted as illustrating the main soteriological and christological arguments canonized by the Sixth Ecumenical Council, applied to some extent by the Trullan Council, and systematized by John of Damascus in his Orthodox Manual. This image can offer a "material objection" to Monotheletism, and Monoenergism, as well as "material proof" in favor of the Orthodox position on the subject. Thus, the earliest examples of the Anastasis actually are excellent πραγματικαὶ παραστάσεις, and as Sinaites suggests, a forceful defense of the Orthodox viewpoint.

An analysis of the method followed in selecting these elements of Christ's sojourn in the underworld which will be included or excluded in the earliest examples of this iconography proves instructive, as the scheme of the action depicted is based on well-known pictorial formulae. The motif of the triumphant trampling of a defeated enemy combined with, or independent of, the motif of lifting up an unfortunate dependent draws on standard imperial triumphant iconography, as Grabar and more recently Schwartz were able to show. Given that all texts treat Christ's victory as a royal victory, the choice of iconographic blueprints that also corresponded to live imperial ritual at the turn of the century was eminently appropriate.

A very small range of pictorial formulae is employed to characterize the actors. The discrete use of the mandorla and the enclosed color scheme help define succinctly Christ's performance as a manifestation of the Logos Incarnate. In addition, the scroll Christ holds offers a secondary, supporting traditional reference to the Word.

The dark naked body of the trampled figure contrasts significantly to the ether lightness of the Logos. We have identified this figure as a personification of Hades on the basis of inscriptions that accompany later examples of the Anastasis. But this figure is not only Hades, master of the underworld, a mythological personality whose actions were well-known. That mythological figure was coconspirator of Satan, who constantly supplied Hades with new prisoners. Hades was helpless without Satan and secondary to him, for his dominion depended on Satan's performance. If the iconographer intended to represent here the defeat of the person of Hades, lord and keeper of the underworld, then Satan should appear next to him, as is the case with the western illustrated cycle of Nicodemus, known to have existed by the mid-eighth century. There would be little point in defeating

[102] McCulloch, *The Harrowing of Hell*, 199ff. John of Damascus, *De fide orthodoxa*, PG, 94.1096f., 981.

Hades while leaving Satan, his supplier, free. Under the circumstances, the trampled figure should be understood as a conflation of these two evil forces as represented by their one and only result: Death.

The interpretation of the figure under Christ's foot as a personification of Death has many literary parallels. From the fourth century, references to the story of Christ's journey to Hades had variously identified the person defeated by Christ as Hades, Satan, or Death. Apparently all these themes stood as metaphors and allegories of man's fall from grace.[103] More elaborate narratives however, such as the Apocryphon of Nicodemus, and certain related sermons of indeterminate date, describe a dialogue between Satan and Hades before Christ's triumphant entry, as well as the subsequent binding of Satan, who is delivered to Hades for safekeeping until the Last Judgment.[104] Thus, the identity of these two figures is differentiated. The opposite is true of the homily of Pseudo-Epiphanius, which also deals extensively with the siege of the underworld. This is more guarded and talks only of a "tyrant." The tyrant, however, is analyzed as "the bitter and insatiable tyrannizing death," "the snake trampled," "the bitter dragon condemned," and so on. And Pseudo-Epiphanius concludes: "(If you follow Christ, you will see) . . . where he put death to death, how he corrupted corruption thoroughly, and where he restored man to his ancient purpose,"[105] which clearly relates to the best-known Easter kontakion:

> Christ arose from the dead
> Trampling on death through death
> And presenting life
> To those who were in the graves.[106]

Thus, the figure trampled here stands for a conflated and suffused mixture of Hades—the lord and keeper of the dead and the underworld regions—and Satan—the devil, the

[103] McCulloch, *The Harrowing of Hell*, 200. John of Damascus, *De fide orthodoxa*, PG, 94.1096, identifies sin as the initial cause of death; he also calls the person defeated by Christ in Hades: "tyrant" and "death." A similar definition is given in the disputed homily of Germanus on Holy Saturday, PG, 98.253D.

[104] *Evangelia Apocrypha* IV (XX). Tischendorf, 304ff. James, 128ff. Eusebius Alexandrinus, *De adventu et annuntiatione Joannis apud inferos*, PG, 86 / 1.509–525. Idem, *De baptismo. De Mt. 11.3*, PG, 86 / 1.371–384. Idem, *In diabolum et orcum*, PG, 86 / 1.383–406. Pseudo-Chrysostom, *In S. Paraskeven*, PG, 62.721–724. Regarding the problem of the author of these homilies, see Beck, 400f., who dates them in the seventh or end of the sixth century. For a discussion of these texts, see McCulloch, op. cit., 174–191, who also discusses the relation of the Apocryphon of Nicodemus and PG, 86 / 1.383–406 in pp. 411–414. Two more close relatives should be added to this group of homilies: Eusebius Alexandrinus, *In venerabilem crucem*, PG, 50.815–820, and idem, *In triduanum resurrectionem Domini*, PG, 50.821–824.

[105] PG, 43.452C: "ὁ πικρὸς καὶ ἀκόρεστος θάνατος τυραννήσας"; 456A–B: "πῶς δὲ τὸν ὄφιν ἐπάτησεν . . . καὶ πῶς τὸν πικρὸν κατεδίκασε δράκοντα;" 456B: "ποῦ δὲ τὸν θάνατον ἐθανάτωσε, καὶ πῶς τὴν φθορὰν κατέφθειρε, καὶ ποῦ τὸν ἄνθρωπον εἰς τὸ ἀρχαῖον κατέστησεν ἀξίωμα."

[106]
> Χριστὸς ἀνέστη ἐκ νεκρῶν
> θανάτῳ θάνατον πατήσας
> καὶ τοῖς ἐν τοῖς μνήμασι
> ζωὴν χαρισάμενος

Πεντηκοστάριον Χαρμόσυνον (Rome, 1883), 6. Follieri, *Initia hymnorum ecclesiae graecae*, V, 104. A. Baumstark, "Bild und Lied des christlichen Ostens," *Festschrift zum sechzigsten Geburtstag von Paul Clemen. 31. Oktober 1926* (Bonn, 1926), 168–180.

snake, the dragon who brought about the fall from grace through Death, the ultimate form of corruption and mutability.[107]

Finally, Adam is characterized by his old, white, and feeble age. His limpness alludes to his long sleep of death manifested by his single external attribute, his sarcophagus.

So, the particulars of this image are communicated through the studied use of an economical range of potent motifs and compositional formulas. The vocabulary, which is borrowed from more than one context, is eclectic. Its previous contexts help it describe more than it actually depicts, extending the message of the image. However, the selectivity that has gone into its pictorial vocabulary cannot be fully appreciated without a brief review of the elements excluded from this iconography, even though they were well known and appreciated.

Beyond the dark color of Hades-Death, nothing suggests that the scene is taking place in the dark interior of the earth. Even Adam's sarcophagus is on the surface of the earth. Similarly, Christ's descending is limited to a light inclination due to his reaching out to Adam. Moreover, the gates, bolts, and keys that were demolished in the presence of Christ are omitted entirely, their place taken by the slab which covered the tomb of Adam and Eve and now lies to the side. Also omitted are the gate-keepers who were terrified;[108] the angelic army that accompanied Christ;[109] the differentiation of Hades from Satan already mentioned; all reference to the battle and to the weapons used to stab[110] and later to bind Death before Christ could reach out to Adam and perform the miracle of Adam's resurrection.

This iconography is economical and judicious in its selection of a pictorial vocabulary. It also proves to be equally systematic in its evasion of major narrative features in the story. Consequently, the topographical and chronological specifics of the story are excluded or diffused in the earliest examples of the Anastasis.

The Anastasis at the entrance to the Palatine ramp elaborates the core of the story further by including above Christ's head two small white-clad figures in a vague landscape. The exact role of these two figures, visible only in Wilpert's watercolor, cannot be defined with accuracy, though they may represent the anonymous dead who rose at the time of the Resurrection,[111] functioning as a reference to the universality of the Anastasis. This example appears to have been peopled by other figures as well, if various diverging descriptions may be accepted.[112] While those figures are no longer visible, their conflicting descriptions

[107] The equation of the terms tyrant, death, and sin is used by John of Damascus, above, n. 3.95. M. Alexiou, *The Ritual Lament in Greek Tradition* (Cambridge, 1974), 26, 49f., suggests that the ideas of death, Charon, and Hades are fused together in the folk tradition. Although she does not trace this idea throughout the Byzantine period in detail, Pseudo-Epiphanius and John of Damascus bear her suggestion out to an extent.

[108] For example, Pseudo-Epiphanius, op. cit., PG, 43.457f. and Anastasius Sinaites, *Hodegos*, PG,

89.225. / Uthemann, 13.6.50f.

[109] *Evangelia Apocrypha*, VI (XXII). Tischendorf, 307. James, 136.

[110] Frazer, "Hades Stabbed by the Cross of Christ," passim. Pseudo-Epiphanius, op. cit., PG, 43.456ff.

[111] Belting, 74f.

[112] Nordhagen, "The Frescoes of John VII (A.D. 705–707) in S. Maria Antiqua in Rome," 82, saw behind an undulating hill-line to the left of Christ's halo one more figure clad in a red chlamys and white tunic, probably holding his hands toward Christ in

call for great caution in their interpretation. In any case, the presence of extra figures in the miracle of the Anastasis asserts that Adam and Eve were not the only ones to rise at the time.

Comparison of the elements included to those excluded from the early examples suggests that the iconography of the Anastasis was not at this stage designed to be a visual reproduction of the chronicle of Christ's spoliation of Hades, and his rescue of Adam along with himself from the underworld. It restricted itself to the only two points in the narrative of the story, which were essential from a doctrinal point of view. Thus, instead of a narrative, the image offered a metaphor of the salvation realized at the moment of the raising of Adam-Everyman following the defeat of Death. Consequently, the artist relies heavily on the beholder's familiarity with the story, which is outlined rather than described here. The success of the image therefore depends on the associational potential of its visual vocabulary, and its ability to stretch the narrative beyond the image itself. The vitality and cogency of the portrayed action is used to integrate this pseudo-narrative image. So although the early representation of the Anastasis is in effect a doctrinal metaphor of the "invincible power" of the Logos, it sufficiently maintains its association with the story that inspired it to offer a less than abstract parable and a paradigm of the will and energy of the Logos in action.

Both representations of the Anastasis at S. Maria Antiqua are single panels. One is in the area of the exit to the Forum Romanum, and the other on the doorway leading to the Palatine ramp and the Palatine palace. In a recent article Nordhagen put forward the hypothesis, that each Anastasis panel was associated with another nearby panel whose theme he reconstructed as the Adoration of the Virgin by Pope John VII. He suggested that the theme of the Anastasis, together with that of the Adoration of the Virgin by the Donor, were joined in a system of portal iconography taken over from Constantinopolitan palace decoration.[113]

Nordhagen's most ingenious hypothesis is apparently based on his long and fruitful familiarity with S. Maria Antiqua. It is most unfortunate that the fragmentary condition and deterioration of the frescoes makes verification of vital points in this hypothesis impossible. There is no way of ascertaining his reconstruction of the Adoration panels: The figure of Pope John VII does not survive in either instance, and, in the case of the panel adjoining the Anastasis at the entrance to the church from the Forum, even the reconstruction of the figure of the Virgin is not entirely certain, judging by Wilpert's watercolors.[114] Moreover,

adoration. Nordhagen suggests that this figure corresponds to the Old Testament figures included in the Anastasis at a later date. He also saw traces of folds belonging to the clothing of other figures to the right of the panel. Rushforth, "S. Maria Antiqua," 116, had seen two more heads below Christ's foot. None of these figures is recorded in Wilpert's watercolor. Today even the two figures recorded by Wilpert are no longer visible. If the above descriptions are accu-

rate, the distribution of these figures alone would render the Anastasis of the entrance to the Palatine Ramp unique.

[113] Nordhagen, "Kristus i Dødsriket," 169ff. My thanks are due to Prof. Ø. Hjort for translating this important article for me. Idem, " 'The Harrowing of Hell' as Imperial Iconography. A Note on Its Earliest Use," 345–348.

[114] Wilpert, IV, pls. 167, 168.

Nordhagen offers no evidence for the attribution of this system of door decoration to Constantinopolitan palace decoration.

Although this hypothesis remains without sufficient proof, the fact, nevertheless, remains that both of these Anastasis panels are located in the immediate vicinity of key passages into and out of the church. This may have been because of the association of the themes of the spoliation of Hades and the Resurrection with the motif of the door or gate. The key to this association, which had long been established, lies with Psalm 23:7ff., which commands: "Lift up your heads, O gates, And be lifted up, O everlasting doors, And the king of glory shall come in! Who is this king of glory? The Lord strong and mighty, The Lord mighty in battle . . ."[115]

This psalm has a long history of liturgical usage in eschatological contexts going far back into the history of Jewish worship. By the time of St. Justin, the psalm was applied to the person of Christ. Subsequently, it was used in the Apocrypha of Bartholomew and Nicodemus in reference to the spoliation of Hades. Much more important was its use in a paschal context as the Great Entrance chant for both masses of Easter in Jerusalem according to the Georgian Lectionary, which dates from the fifth to the eighth centuries.[116] The symbolic interpretation of the Great Entrance as the funeral cortège of Christ was well known throughout the Byzantine and Syrian liturgical realms by the seventh century. This interpretation was furthered by the first half of the eighth century in the *Historia Ecclesiastica* attributed to Patriarch Germanus I, which consolidates the relation of the sojourn of Christ in the underworld and his Anastasis thence with the Great Entrance.[117]

Thus liturgical tradition established a firm connection between Psalm 23 and the themes of Christ's Death, his stay in the underworld, and his victorious Resurrection. Understandably, homilies designed for the celebration of Holy Friday and Holy Saturday exploited this association. Pseudo-Epiphanius and others availed themselves of Psalm 23 in their respective dramatizations of the Burial and the redeeming descent of Christ to Hades.[118] Moreover, the homily of Pseudo-Epiphanius insistently returns to the theme of Christ as the door out of death and sin, as well as into Paradise, as mentioned in the previous chapter.

So we can say, Psalm 23 encouraged the association of door symbolism with the themes of the Death and Resurrection of Christ, in their yearly and weekly remembrance. It is, therefore, conceivable that the position of the two Anastasis panels of S. Maria Antiqua on major door passages of the church was tinged with a measure of door symbolism founded

[115] The following discussion is largely based on R. Taft, "Psalm 24 at the Transfer of Gifts in the Byzantine Liturgy: A Study in the Origins of a Liturgical Practice," *The Word in the World: Essays in Honor of Frederick L. Moriarty, S.J.*, ed. R. Clifford and G. MacRae (Cambridge, 1973), 159–177; for the translation of the psalm 163f. I am thankful to Dr. N. Moran for drawing my attention to this article. See also, R. F. Taft, S.J., *The Great Entrance* (Rome, 1975), OCA 200, 98–112.

[116] Bertonière, 241, 251.

[117] By the time of Symeon of Thessalonike this psalm was also used during the First Entrance. Symeon of Thessalonike, *De sacra liturgia*, PG, 155, 292f.

[118] Pseudo-Epiphanius, op. cit., PG, 43.457ff. Pseudo-Chrysostom, *In S. Paraskeven*, PG, 62.722. Eusebius of Alexandria, *In diabolum et orcum*, PG, 86 / 1.403.

on church ritual. However, as Nordhagen points out, the function which he attributes to these two panels has no parallel among representations of the Anastasis. As a result, though part of his hypothesis is very attractive, it cannot be stretched too far and bear the burden of proof at the same time.

His suggestion that the peculiar function of these panels might be evidence of experimentation with the newly invented iconography of the Anastasis cannot be proved either. The use of the single Anastasis panels in S. Maria Antiqua could easily be idiosyncratic in view of the uneven and extenuated history of the decoration of this church. A study of the ritual of the Great Entrance as well as the celebration of the Holy Saturday in Rome at the time of Pope John VII might provide a more definite answer about the function of these panels. But this is outside the realm of the present study.

Before closing the discussion of the Anastasis in S. Maria Antiqua, it is important to stress that the motif of the broken gates of Hades—which figures so prominently in Psalm 23 as well as in the apocryphal and homiletical literature on the subject—is absent from the iconography of the Anastasis at hand. Its omission confirms that this image is unlikely to have been devised for the purpose of guarding architectural entrances and exits for liturgical, apotropaic or political reasons. These early Anastasis images would have surely included the broken gates of Hades or the open gates of Paradise,[119] if their iconography was originally intended to be associated with a system of portal decoration.

In contrast to the panels of S. Maria Antiqua, the Anastasis mosaic in the Oratory of John VII (fig 15) belongs to a christological cycle, which starts with the Annunciation, and ends with the Myrophores, like most seventh-century cycles examined already. It consists of some fourteen scenes, three of which are miracle scenes. The Passion of Christ is introduced with the Raising of Lazarus and continues with the Entry into Jerusalem and the Last Supper. These appear on the lower register to the left of the central panel, which depicts the donor, Pope John VII, presenting his oratory to Maria Regina to whom it was dedicated. The Crucifixion and the Anastasis take most of the other side of the central panel and are followed by the diminutive representation of the Myrophores.

From the position of the Anastasis here, we can infer that its iconography had been fully integrated in the christological cycle by the early eighth century. Its present pictorial prominence compares with that hitherto reserved for the Myrophores. Apparently, the Anastasis supplants the Myrophores, who are now relegated to a tiny area in the upper right-hand corner at the end of the cycle. This is established by Grimaldi's methodical drawing and labeling of the entire cycle, without which the Myrophores would have gone unnoticed—as indeed is the case in another drawing of the general view of the wall by Grimaldi, and in a drawing by Ciampini, both of which omit the Myrophores.[120]

[119] As, for example, in the twelfth-century Gospel book Paris, Bibl. Nat., cod. gr. 75, fol. 255[r], and in the ca. 1122 Gospel book, Vat., Bibl., cod. Urb. gr. 2, fol. 260[v]. Frazer, "Hades Stabbed by the Cross of Christ," fig. 9.

[120] The Grimaldi and Ciampini drawings do not coincide in every detail. It is not clear whether Eve was included or not. Fols. 95[r] and 104[r] of Vat. Bibl., cod. Barb. lat. 2733 appear, however, to include a supplicating figure, who probably is Eve. The attitude of Hades is not entirely clear either. Adam is rising with one knee bent as in the other two Roman examples. There is no trace of his sarcophagus or the *tenebrae*. The figure of Christ is in an exploding man-

Similarly to the Myrophores, the scenes of the Raising of Lazarus and the Last Supper are underplayed.[121] As a result, the Entry to Jerusalem on the left, and on the right, the Crucifixion and the Anastasis are brought forward as the primary scenes describing the Passion. Thus, the Entry to Jerusalem on the left marks the royal *adventus* and the epiphany of the Messiah, the world saviour.[122] This triumphant procession does not lead to the gates of Jerusalem, but to Maria Regina, another well known "gate." The cycle continues on the other side of the central panel with the Crucifixion and the Anastasis. These two scenes update the traditional pictorial alignment of the Crucifixion and the Myrophores as a soteriological reference to the means and ends of redemption. Concurrently they confirm on a christological level the doctrine of the two natures in accord with interpretations current at the turn of the century.

The central panel acts on this register as a line of demarcation segregating the scenes of the time immediately before from those of the Passion. Through the reference to the incarnation inherent in the figure of Maria Regina, it serves as a mental link which interprets the two sides. The exegetical function of the central panel, which apparently proposes the incarnation as the vehicle of redemption, is not limited to this register. It is also reflected in the organization of the other two registers.

The top register is the only one which invades the area of the central panel with a scene from Christ's life. Significantly, it depicts the Nativity. The presence of the Nativity above the Virgin's crown spells out the intention to organize the cycle around the theme of the incarnation. The scenes of the Annunciation, and the Visitation which precede the Nativity introduce the reality of the incarnation of the Logos, while the Adoration of the Magi, which follows the Nativity, confirms the recognition of the Logos in the child Christ.

The orant figure of the Virgin effects a comparable break in the second register. The Presentation in the Temple on the left illustrates the recognition of Christ's mission by Symeon. It is followed by the Baptism, the traditional reference to the initiation of Christ's mission. The miracles appear to the right of the central panel affirming the manifestation of the Logos through Christ. This is appropriate, since no miracles were performed before the descent of the Holy Spirit during Baptism, as emphasized by Sinaites on the authority of Melito of Sardis.[123] The Virgin serves now as the connecting and dividing link between the time before and after the beginning of Christ's mission.

It appears, therefore, that all three registers are organized along parallel lines around the central panel which stands for the central doctrine of the incarnation. The left side seems concerned with introductory epiphanies, while the right side deals with the results of these

dorla of light. However, the small size of the drawing does not allow us to see how his right hand and trampling foot relate to the mandorla. The Myrophores were undoubtedly relegated to a tertiary position.

[121] These scenes appear to have maintained their importance to a somewhat greater degree than the Myrophores, since they are not omitted from the

Ciampini and the second Grimaldi drawing.

[122] E. Kitzinger, "The Mosaics of the Capella Palatina," *AB*, 31 (1949), 279ff., for this interpretation of the iconography of the Entry to Jerusalem.

[123] Anastasius Sinaites, *Hodegos*, PG, 89.228f. / Uthemann, 13.7.

epiphanies during the three main stages in the life of Christ: the top right side offers the recognition of the Divine in the newborn Christ, the miracles offer the manifestation of the Divine through Christ's mission, while the lower register confirms the achievement of the purpose of the incarnation by means of the operation of the will and energy of the Divine through the human nature of Christ once more. The ultimate aim is to prove redemption achieved through the incarnation. Within this scheme, the rising of the person of Christ himself is not at issue, while the deification of man through the defeat of Hades-Death is. The Anastasis fulfills this function admirably. Appropriately, the Myrophores are superseded and made to yield to the dynamism and tangibility of the message of the Anastasis as defined by the Christology of the Sixth Ecumenical Council.

Throughout the programmatic rearrangement of the story of Christ, the focus is on the orant figure of the Virgin standing on a podium between two unusual free-standing columns. By her attitude and position she provides the mental and material link to the two sides of the surrounding story. As is befitting, the pope stands to her right offering a model of his chapel, and placing himself under her protection as her servant. This is suggested by the Virgin's orant attitude, as well as by the inscription accompanying her: BEATAE DEI GENETRICIS SERVUS, which apparently continues the dedication figuring below the central panel: JOHANNES INDIGNUS EPISCOPUS FECIT.

Pope John VII was interred in this chapel soon after its completion at the end of his short pontificate. This possibility may have been taken into account in the laying out of the oratory decoration. The representation of the pope under the aegis of the interceding Virgin in the midst of the story which proved the reality of redemption achieved through incarnation was appropriate for the pope's funerary chapel. Thus, the earliest example of the Anastasis as part of a christological cycle indicates full awareness of its soteriological and christological implications.

The solid dyothelete position of Rome throughout the seventh century certainly favored the adoption of the Anastasis, but did not breed it. There are numerous reasons for looking to the East for the source of this new image. Rome's total dependence on the East in cultural matters during this period, coupled with the well-known association of John VII with the Byzantine elite in Italy provides the context. The analysis of the surviving sections of the oratory mosaics by Nordhagen has convincingly argued for the presence of Byzantine mosaicists in Rome. Even though no part of the Anastasis survives amongst them, his stylistic and iconographic study of these and other contemporary works has suggested that the Anastasis examples found in Rome in the early eighth century represent ideas and solutions imported from the East.[124] They are, therefore, interpreted here as iconographic reflections of contemporary eastern works, and not as local Roman products. The subsequent iconographic development of the Anastasis confirms this.

If this is correct, the three Roman examples of the Anastasis mirror the ease with which the new "material figuration" of the will and energy of the Logos was accepted. They also

[124] Nordhagen, "The Frescoes of John VII (A.D. 705–707) in S. Maria Antiqua in Rome," 93. Idem, "Kristus i Dødsriket," 172f.

suggest that christological programs capable of asserting visually the new doctrinal refinements acted as the media for disseminating the new iconography, while instructing the public on the most recent christological developments.

The seventh-century cycles examined in the previous chapter, and the series of the gold marriage rings in particular, offer a terminus post quem in the second half of the seventh century for the appearance of the Anastasis. Similarly, the Roman works offer a terminus ante in the first decade of the eighth century. During the same period, we find the *Hodegos* of Sinaites forcefully suggesting the polemical use of figurative illustrations in support of recent Orthodox doctrinal definitions relating to the various phases of Christ's Death. The importance of the issues that these definitions represent is made clear by the Acts of the Sixth Ecumenical Council (680–681), and by the Canons of the Council in Trullo (691). The period following the Council of 680–681 saw the adaptation to the new christological definitions of many aspects of church ritual. Probably, it also witnessed a revision of the text of the *Hodegos* by its author, who was now old and sick. Moreover, it inspired homiletical and hymnological masterpieces. Taking all these factors into account, I suggest a date in the last quarter of the seventh century for the invention of the image of the Anastasis. This was one of many parallel manifestations of the efforts of the church to respond cohesively and consistently to the decisions of its own Ecumenical Council.

IV

THE WEST IN THE NINTH CENTURY

The eighth century has yielded no more representatives of the new iconography. Its subsequent development in the West in the ninth century and the early tenth shows the steady use of the image as part of christological cycles. Its core is condensed, while its primary characteristics are sometimes elaborated in accordance with western iconographic predilections.

The only Anastasis examples that will concern us here are those descending from the same iconographic family as the early eighth-century specimens in Rome. They form an organic group consisting of the following monuments: A fresco from the lower church of S. Clemente (fig. 17a) dating from the pontificate of Leo IV (847–855);[1] a very fragmentary fresco from the house of Giovanni and Paolo in Rome;[2] a second fresco from another part of the lower church of S. Clemente (fig. 17b) dating to the last quarter of the ninth century;[3] a fresco in St. Peter's probably dating from the pontificate of Pope Formosus (891–896), known only through two drawings by Grimaldi (fig. 16);[4] and an early tenth-century fresco from the Basilica dei Santi Martiri in Cimitile.[5]

Despite the apparent affinity of these examples of the Anastasis to the early eighth-century monuments, they form a separate and more developed group. The direction of the action has altered. Christ is now moving to the right without any significant changes except one. His movement has become more schematized and his vitality has been curtailed.

Adam and Eve have given up the sarcophagus rising instead out of a particularly dark hole. The meaning of this motif is elucidated by fol. 8r of the Utrecht Psalter.[6] Here Christ

[1] Wilpert, IV, pl. 209.3. Belting, *Die Basilica dei SS. Martiri in Cimitile und ihr frühmittelalterlicher Freskenzyklus* (Wiesbaden, 1962), 71ff. Hereafter: Belting. R. van Marle, *Le scuole della pittura italiana* (The Hague, 1923), I, fig. 58.

[2] Wilpert, IV, pl. 208.2. Belting, loc. cit.

[3] Wilpert, IV, pl. 229.2. Belting, loc. cit. Idem, *Studien zur beneventanischen Malerei* (Wiesbaden, 1968), 238 n. 19, 239 n. 24.

[4] Grimaldi, *Descrizione della basilica antica di S. Pietro in Vaticano. Codice Barberini Latino 2733.* R. Niggl, ed. (Vatican, 1972), fol. 113v–114r, fig. 55. S. Waetzoldt, *Die Kopien des 17. Jahrhunderts nach Mosaiken*

und Wandmalereien in Rom (Munich, 1964), nos. 933, 934. Figs. 485, 485a. Belting, loc. cit.

[5] Belting, 71ff., figs. 31, 35, 36. Idem, *Studien zur beneventanischen Malerei*, 95ff.

[6] E. T. De Wald, *The Illustrations of the Utrecht Psalter* (Princeton, 1932), 10, pl. 13. See also the illustration of the *Symbolum Apostolorum* on fol. 90r. This includes a similar illustration which, however, adds fire in the dark pit of Adam and Eve in reference to "the fiery gates of Hell." Ibid., 71, pl. 142. Also, H. Schrade, *Ikonographie der christltichen Kunst I. Die Auferstehung Christi* (Berlin, 1932), 36ff.

is stepping with both feet on the prostrate figure of Hades-Death, bending himself in two to pull out of a hole in the ground two figures, probably representing Adam and Eve. This somewhat exaggerated translation of the raising of the dead from the underworld demonstrates a literal interest in the topography of the underworld entirely absent from our earlier examples. The explicit reference to the underworld as a dark pit below the surface of the earth is less direct in our ninth-century Anastasis group, which prefers to depict the underworld as the darkness which envelops Adam. In both examples from S. Clemente, in the Cimitile fresco, as well as in the example from St. Peter's, Christ is apparently advancing into that darkness drawing Adam out of it. The description of the land of the dead as a dark and sunless place, the *tenebrae*,[7] is consistent with descriptions of Hades since Homer's time.

This accurate reference to Adam's resurrection is deemed sufficient in S. Clemente I and in the fresco in St. Peter's. So the figure of Hades is dispensed with. When he is included— as in the second Anastasis from S. Clemente, and in Cimitile—Hades is no longer trampled symbolically and lightly under Christ's foot. Instead, he lies flat on his face while Christ treads on him, irrevocably overwhelming him. The continuing resistance of Hades becomes an empty gesture limited to touching Adam's heel while crushed beneath the heel of the new Adam. The token resistance of Hades-Death becomes a tertiary element from a pictorial point of view—a symbolic reference to the hold of death on man, a fleeting reminder of Hades's struggle in the face of Christ's onslaught. In addition, Hades is fettered in both cases, a fact that lends finality to his defeat.

In the iconography of the early eighth century, the trampling of Hades figured almost as prominently as the raising of Adam. As a result, those two acts balanced each other as means and ends. The difference in their importance increases in this ninth-century group as the interest of the image focuses on the rescue of Adam from the *tenebrae*. Consequently, the personification of the evil forces and even the indirect references to the struggle that preceded the rescue of Adam are not always considered vital. When such references appear, their contribution becomes practically incidental from a pictorial viewpoint.

At the same time, this group shows a tendency to develop specific aspects of the story. The description of the underworld as the *tenebrae*, is improved by the addition of fires, and human *disiecta membra* floating in it, as in the second S. Clemente Anastasis. Thus, the Anastasis comes to include an interpretation of the underworld as Hell. Similarly, a long-staffed cross takes the place of the scroll in Christ's hands. In this way, the second S. Clemente fresco and the Anastasis in St. Peter's specify in the last quarter of the ninth century that salvation became possible through the Passion. A comparable reference to the Passion may be seen in the fresco at Cimitile. Here Christ continues to hold the traditional scroll with his left hand, while his oversized right hand, which firmly grasps Adam's wrist, clearly bears the mark of the nail at the geometric center of the composition.[8]

Lastly, these examples reassert the broader message of the raising of the dead. S. Cle-

[7] Belting, 76. [8] Belting, 76 n. 153, figs. 35-37.

mente II includes to the left of the advancing Christ the frontal portrait of a cleric staring out of the image, possibly suggesting a *commendatio animae* for the soul of the cleric, who has been identified with St. Cyril, the Apostle of the Slavs.[9] In the same spirit, the Anastasis at Cimitile includes a row of four swathed mummies rising out of a strygil sarcophagus, turning toward the dramatic action.[10] By the ninth century the image of the raising of Everyman had been broadened to include a variety of his nameless descendants, who could participate, even if the protagonists ignored them.

The changes in this Anastasis group in the West suggest that the ninth century was interested in elaborating and specifying aspects of the action, location and actors of this theme. An effort to trace the origin of some of the motifs used for this purpose shows a mixture of western and eastern elements.

To start with, although contemporary eastern examples of this iconography allude to the darkness of the underworld in one way or another (as we shall see), Adam and Eve are not enveloped in this darkness. In the East, the *tenebrae* motif does not assume the iconographic importance it acquires in this group of western Anastasis images. Similarly, the eastern Anastasis is not known to include references to Hades as Hell. Such allusions to the underworld as a place of torture and punishment would contradict the image of the Resurrection as the awakening of those asleep for centuries, which is frequent in homiletical literature. Echoing the same attitude, eastern iconography is able to divorce the idea of the underworld from that of Hell and its fires even in images that specifically evoke the Last Judgment. For example, fol. 89[r] of the ninth-century copy of Cosmas Indiopleustes at the Vatican depicts "the subterraneans," that is, "the dead who are arising" at the time of the Last Judgment (fig. 18).[11] These are literally surfacing out of the underworld, distinguished from the earthly and heavenly regions only by its placement at the bottom of this cross-section of the cosmos.[12]

[9] J. Osborne, "Early Medieval Wall-Paintings in the Lower Church of San Clemente, Rome," Dissertation, University of London, 1979. Idem, "The Tomb of St. Cyril in the Lower Church of San Clemente, Rome," *Sixth Annual Byzantine Studies Conference. Abstracts of Papers* (Oberlin, 1980), 28f. Idem, "The Painting of the Anastasis in the Lower Church of San Clemente, Rome: A Re-examination of the Evidence for the Location of the Tomb of St. Cyril," *Byzantion*, 51 (1981), 255–287. I am grateful to Prof. Osborne for making his work available to me ahead of publication. H. Belting, *Studien zur beneventanischen Malerei*, 240, n. 24, had also made a similar suggestion pointing to a comparable portrait of a cleric in the representation of the Last Judgment in Hagios Stefanos in Kastoria (Brenk, *Tradition*, 82, fig. 4).

[10] Belting, 74f., for the identification of these figures as the anonymous dead.

[11] C. Stornajolo, *Le miniature della topografia cristiana di Cosma Indicopleuste* (Milan, 1908), 45f., pl. 49. W. Wolska-Conus, ed., *Cosmas Indicopleustès. Topographie Chrétienne*, SC 141, 159, 197 (Paris, 1968-1973), II, Book V.247. Grabar, *L'empereur dans l'art byzantin*, 251f., pl. 38.1. This miniature should be compared with its relative in the *Sacra Parallela* of John of Damascus which depicts the results of the Last Judgment, rather than its beginnings as the Vatican miniature. Paris, Bibl. Nat., cod. gr. 923, fol. 68[v] (fig. 55). Ibid., pl. 38.2 and K. Weitzmann, *The Miniatures of the Sacra Parallela. Parisinus Graecus 923* (Princeton, 1979), 169f.

[12] Byzantine topography placed Hell in the lowermost regions of Hades. Hell was, therefore, only a part of Hades. See, for example, PG, 86 / 1.404. Hades was often conceived as an intermediate state of souls until the day of Judgment, as for example in Hippolytus, *Liber adversus graecos*, PG, 10.800A, and Gregory of Nyssa, *De anima et resurrectione*, PG, 46.85B; 68A.

The West, however, did not always find it easy to perceive of Hades at the time of the Anastasis as a neutral part of the topography of the cosmos. Fire was a vital feature of the underworld together with horror, as we may see in fol. 29v of the Stuttgart Psalter in the early ninth century (fig. 19).[13] Likewise, many Exultet Rolls dating from the tenth century depict Adam roasting naked on a huge fire together with Eve (fig. 20).[14] Here, the Anastasis consists of Christ dragging Adam out of the fires of Hell, while Eve is begging to be included, as usual. Such references to the underworld as Hell alter dramatically the emphasis of the image: Adam is not saved from death, but rather from punishment for his sins. This makes the message of the Anastasis much more personal, as well as considerably narrower. So the increased importance of the topography of the underworld in this group may be possibly interpreted as the variable adaptation of an eastern theme to a western iconographic tradition, whose tenacity is exemplified by the evolution of a characteristic western type of Anastasis at a later date: the Anastasis from the Mouth of Hell, as seen on fol. 14r of the mid-eleventh-century Cotton Psalter,[15] and the Anastasis in the Madrid manuscript of the Nicodemus Apocryphon.[16]

The cross-staff of Christ, which appears in this iconographic group, may be traced to earlier western examples thematically related to the image of the Anastasis. It may be seen on the silver reliquary cross at the Museo Cristiano, which dates from the time of Pascal I (817–824) and depicts Christ leading Adam toward the gate of Hades or, perhaps, Paradise (fig. 21).[17] The cross held by Christ here may be correlated with fol. 29v of the Stuttgart Psalter, which depicts Christ attacking the gates of Hell with a similar cross.[18]

The dynamic use of the cross against the doors of Hell in the Stuttgart miniature con-

[13] *Der Stuttgarter Bilderpsalter.* B. Bischoff, J. Eschweiler, B. Fischer, H. J. Frede, F. Mütherich (Stuttgart, 1968), 77. E. T. De Wald, *The Stuttgart Psalter* (Princeton, 1930). Davis-Weyer, "Die ältesten Darstellungen der Hadesfahrt Christi, des Evangelium Nikodemi und ein Mosaik der Zeno-Kapelle," 188f., fig. 196. Brenk, *Tradition,* 162f., pl. 58.

[14] M. Avery, *The Exultet Rolls of South Italy* (Princeton, 1936): Capua Cathedral fragment (pl. 27.3). Gaeta Cathedral, Exultet no. 2 (pl. 35.3). Gaeta Cathedral, Exultet no. 5 (pl. 39.5). London, British Museum, cod. Add. 30334 (pl. 48.10). Mirabella Eclano, Collegiate Church Archives (pl. 60.2). Rome, Bibl. Casanatense 724 B 13 (pl. 120.16). Vatican, Bibl. cod. lat. 9820 (pl. 142.14). Also, O. Morisani, "L'iconografia della discesa al limbo nella pittura dell'area di Montecassino," *Siculorum Gymnasium,* N.S., 14 (1961), 84–97 and G. Cavallo, *Rotollo di Exultet dell' Italia Meridionale* (Bari, 1973), 31.

[15] London, British Museum, cod. Cotton, Tib. C.VI, fol. 14r. J.J.G. Alexander, *Insular Manuscripts* (London, 1975–1978), II, no. 98. For antecedents of this theme, see the illustrations of the "mouth of hell" or the "fiery pit containing the head of Death" in the Utrecht Psalter, fols. 9r and 59r in De Wald, *The Illustrations of the Utrecht Psalter,* 11, 46 and pls. 15, 94.

[16] Von Erbach-Fürstenau, "L'evangelo di Nicodemo," 235, fig. 17.

[17] See, 14 and n. 1.66. Also Ph. Lauer, "Le trésor du Sancta Sanctorum," *MonPiot,* 15 (1906), 67–71, pl. 9. L. von Matt, *Die Kunstsammlungen der Biblioteca Apostolica Vaticana Rom* (Rome, 1969), no. 73. Grisar, *Die römische Kapelle Sancta Sanctorum und ihr Schatz,* 97ff.

[18] See, n. 4.13. Davis-Weyer has recognized in these two examples the illustration of two separate incidents in an illuminated cycle of Nicodemus, traceable in the West to the middle of the eighth century. She does not discuss the motif of the cross-staff, which is not mentioned in the Apocryphon of Nicodemus. Its presence is explained by homiletical literature in which it figures prominently as the weapon used during the siege of Hades (n. 3.77 and 205ff). The use of this motif in an extended illuminated cycle of the story of the siege of Hades suggests that this cycle did not draw on the text of the Apocryphon exclusively. The same is true of the motif of the fire of hell in the same miniature.

trasts sharply to the way Christ opens the "gates of death" in an eastern miniature illus-
trating Job 38:17 (fig. 22). This appears on p. 460 of the Patmos Job, cod. 171, whose date
is not yet clear.[19] The Patmos miniature shows Christ lifting his hand in a gesture used
when making the sign of the cross at someone or something.[20] With this exorcism Christ
addresses the kingdom of Hades, whose doorkeepers cringe, and whose gates instantly
break down, as the text demands. Here, the mere expression of Christ's will through a
symbolic gesture suffices to yield the desired result, in contrast to the Stuttgart miniature,
which translates Christ's omnipotence into physical force. In both instances the cross is the
catalyst. But its unfailing powers are demonstrated in diametrically opposite ways.

If the unique Patmos miniature dates from the ninth or tenth century, it illustrates the
existence of a second tradition regarding the theme of the cross as the instrument of the
destruction of Hades-Death. In the first tradition, as in the Stuttgart Psalter, Christ wields
the cross as a material weapon. In the second, as in the Patmos Job, he wields it metaphor-
ically as an invincible symbolic sign. The cross added to the late ninth century examples of
this western Anastasis group is, therefore, at home with both traditions. Christ does not
wield the cross as a weapon against the forces of evil, but holds it as a restrained reminder
of the saving power of the Passion. Nevertheless, since none of the surviving examples
from the East includes the cross in the Anastasis before the early eleventh century, it is not
clear whether the inspiration for it originated in the East or the West.

These two different intrepretations of the cross in the context of the Resurrection seem
to come together in the Exultet Rolls, which often devote two miniatures to the illustra-
tion of the Resurrection (fig. 20). The first, which illustrates Christ's attack on Satan and
Hades in Hell, shows Christ using a lance as a weapon, and not his long-staffed cross.[21]
The second illustration, which depicts Christ dragging Adam from the fires of Hell, in-
cludes the cross.[22] This is held unceremoniously by Christ on his shoulder, in the same
way as in the early ninth century silver reliquary cross, and the Early Christian represen-
tation of Christ treading on the asp and the basilisc.[23]

[19] The history of this manuscript and its illustration
remains open. Weitzmann has dated the group of
miniatures to which the one on p. 460 belongs to the
eleventh century, and has attributed it to an Italian
artist. The manuscript itself, as well as a group of its
illustrations have been dated as early as the seventh
century by some scholars. G. Jacopi, "Le miniature
dei codici di Patmo," *Clara Rhodos*, 6–7 (1932–1933),
574, 586, 589, fig. 110. For a review of the different
scholarly opinions, *L'art byzantin-Art européen* (Ath-
ens, 1964), no. 289. pp. 303, 562f., with previous bib-
liography. Also, K. Weitzmann, *Die byzantinische
Buchmalerei des 9. und 10. Jahrhunderts* (Berlin, 1935),
49. For a revision of part of his opinion, idem, *Illus-
trations in Roll and Codex* (Princeton, 1970), addenda
to p. 120.

[20] For the use of "$\tau\acute{\upsilon}\pi o\varsigma\ \sigma\tau\alpha\upsilon\rho o\tilde{\upsilon}$" as a means of at-
taining victory against evil spirits, see for example,
D. I. Pallas, "Une note sur la décoration de la chapelle
de Haghios Vasileios de Sinassos," *Byzantion*, 48
(1978), 208–226.

[21] Avery, *The Exultet Rolls of South Italy*. Gaeta Ca-
thedral, Exultet Roll no. 5 (pl. 39.4). Gaeta Cathe-
dral, Exultet Roll no.2 (pl. 36.5). Salerno, Bibl. Ca-
pitolare (pl. 155.5). Vatican, Bibl., cod. lat. 9820 (pl.
137.5). Rome, Bibl. Casanatense 724 B 13 (pl. 120.5).

[22] See n. 4.14.

[23] As, for example, in the lunette mosaic in the
Archbishop's Palace in Ravenna. Brenk, *Tradition*,
188ff., pl. 68.

The two different long-staffed objects of the Exultet Rolls—the cross and the lance—occasionally merge. This happens in the illustration of the *Regis victoria* in roll no. 2 at John Ryland's Library in Manchester.[24] Here the staff of the cross ends in a pointed lance. However, Christ does not use it to attack his opponent, but rests its point on the face of the enemy, who is already fettered. It appears that the majority of the rolls differentiate the instrument of attack from that of the Passion.

The tradition that uses the cross as a material weapon against the forces of evil resurfaces in the Velletri Roll of the eleventh century.[25] Significantly, this roll conflates into one the two scenes of most other rolls. Here Christ attacks Satan in the mouth with his cross-staffed lance as forcefully as he attacks the dragon of the underworld with the plain lance in the Exultet Roll no. 2 of the Gaeta Cathedral.[26] At the same time Christ lifts Adam with the other hand in the Velletri Roll. There is little doubt the Velletri Roll represents a later iconographic stage.

The active use of the cross in the pictorial story of the siege of the underworld and the Resurrection appears to belong to a lively and multifaceted pictorial tradition in the West, whose roots may be traced back to the Early Christian period. The East, however, gives no evidence for such a tradition before the eleventh century despite the survival of many examples of the Anastasis. When considering the origin of the cross held by Christ in the Middle Byzantine Anastasis, it is therefore logical to point to the ninth-century West. Moreover, this motif seems to be most at home with the mid-eighth-century western illuminated cycle of Nicodemus, in which it is first encountered and in which it was possibly bred.

The use of this ninth-century group of Anastasis representations is not different in substance from that of the eighth century. There are no examples of the iconography associated with architectural passageways, but we still find it used as a single panel. This is the case with the second Anastasis from S. Clemente. The portrait of the cleric in it has been identified as that of St. Cyril, leading to the plausible suggestion, that this fresco is an example of ninth-century funeral art.[27]

Most examples in this group integrate the Anastasis into the Passion cycle. The first S. Clemente fresco exemplifies this. The Anastasis appears here in conjunction with the Crucifixion and the Myrophores. The Crucifixion is placed on the top northernmost corner of the inner face of the west wall of the nave as it is today. The two other scenes combined

[24] Avery, op. cit., pl. 54.4.
[25] Ibid., pl. 188.3. M. E. Frazer, "Hades Stabbed by the Cross of Christ," *Metropolitan Museum Journal*, 9 (1974), 153–161, fig. 8.
[26] Avery, op. cit., pl. 36.5.
[27] See, n. 4.9. The *nimbus quadratus* used here is also encountered on a number of the Exultet Rolls. Avery (op. cit., 10) points out that it is not only a *viventis insigne* since it is used for Moses. As she suggests, it serves as a mark of distinction. Also, G. Ladner, *Me-dieval Studies*, 3 (1941), 23ff., 36ff. If this is correct, it becomes possible to suggest that the portrait of John VII in the Oratory of John VII in St. Peter's could have been intended as a funerary portrait since the Oratory served as the burial chamber for the pope. Above, 80f. For a more recent interpretation of the *nimbus quadratus*, J. Osborne, "The Portrait of Pope Leo IV in San Clemente, Rome: A Re-examination of the So-called 'Square' Nimbus in Medieval Art," *BSR*, 34 (1979), 58–65.

are at the same height as the Crucifixion, which they touch at a right angle on the inner
face of the wall dividing the nave and the north aisle. The presentation of these three scenes
as a unit continues and expands the older tradition, which presented the Crucifixion and
the Myrophores as a unit. Furthermore, the Myrophores occupy a smaller surface area
than the Anastasis, echoing their lesser importance in the Oratory of John VII. On the
other hand, the significance of the Crucifixion increases, subordinating the Anastasis from
a compositional point of view. This is true of the first S. Clemente fresco, the late ninth-
century work in St. Peter's and the Cimitile fresco. In all three, the Crucifixion occupies a
prominent position preferably centralized and at least twice as large as the Anastasis.
Though we know little else of the christological cycle of Pope Formosus, we know the
Anastasis was in a panel adjacent to a large centralized Crucifixion. The middle of the west
wall at Cimitile is similarly filled by an oversized Crucifixion. The Anastasis is next to it
and the Myrophores immediately below.[28]

So this iconographic group, characterized by a restrained adaptation to western pictorial
idiom, accepts the Anastasis as part of the Passion cycle and subordinates it to the Cruci-
fixion. Though not in competition with the Crucifixion, the Anastasis is nevertheless
competing with the Myrophores. In all three examples Christ is depicted on the cross
wearing a loincloth; his eyes, though, remain wide open. This seems to have been true of
the colobium-clad Christ of the Crucifixion in the Oratory of John VII in the early eighth
century. These examples of the Crucifixion apparently represent another way in which the
iconography of Christ alive on the cross continued to resist change.[29]

The Chapel of S. Zeno in S. Maria Prassede

The chapel of S. Zeno, decorated with mosaics by Pope Pascal I (817–824), includes a rep-
resentation of the Anastasis which, though only partially visible, is of major interest (fig.
23).[30] Its essential characteristics appear to agree with the earlier Anastasis iconography.
Christ holding a scroll and enveloped in a brilliant, exploding mandorla of light, is stretch-
ing out his hand to Adam, who appears together with Eve on the right, and is oddly glanc-
ing in the viewer's direction rather than toward his redeemer. Unfortunately, the lower
part of this panel is covered by a later marble revetment; therefore, we cannot know if the
tenebrae and the figure of Hades were depicted. Even so, this Anastasis includes two im-
portant departures.

The first is an angel who appears behind Christ's mandorla. It has been identified by
Davis-Weyer as a North Italian motif, which makes its first appearance ca. 800 in the Ana-
stasis of the christological cycle decorating the church of St. John the Baptist at Müstair.[31]

[28] Belting, *Studien zur beneventanischen Malerei*,
95ff., fig. 36.

[29] See, n. 3.87.

[30] Davis-Weyer, "Die ältesten Darstellungen der
Hadesfahrt Christi, des Evangelium Nikodemi und
ein Mosaik der Zeno-Kapelle," 183ff. B. Brenk,
"Zum Bildprogram der Zenokapelle in Rom,"
AEspA, 45–47 (1972–1974), 213–221. G. Matthiae,
Mosaici medioevali delle chiese di Roma (Rome, 1967), I,
239ff., 418ff.; II, pl. 37.

[31] Davis-Weyer, op. cit., fig. 189. G. de Franco-
vich, "Il ciclo pittorico della chiesa di San Giovanni a

Its presence has also been linked to the depiction of the fettering of Satan by a second angel, and to the dissemination of the mid-eighth-century western cycle of Nicodemus. As Davis-Weyer has shown, the participation of the angelic host in the siege of Hades is important to the Nicodemus narrative. The popularity of this theme in the West from the mid-eighth century on is attested by the presence of angels in more than one illustrated episode of this story. In addition to the Anastasis, angels accompany Christ during the breaking of the doors of Hades in the Stuttgart Psalter, as well as during the attack on Satan in the Exultet Rolls.

The East, on the other hand, usually excludes angels from the Anastasis. Consequently, the message of the doctrine of redemption carried by this image remains undiluted, unaffected by the addition of secondary narrative features. The absence of the angelic host from the eastern Anastasis was not due to any lack of familiarity with this theme. The role of the angelic host figures in the Greek version of the Apocryphon of Nicodemus as well as in the homilies, which dwell on the dramatic aspects of this story.[32] In some instances the homilies mention that Satan was bound personally by Christ rather than by his angels.[33] Be that as it may, the contribution of the angelic army to this siege was well known in the East. The homily of Pseudo-Epiphanius in particular, whose use was widespread, as we have seen, says Christ was accompanied by innumerable angels,[34] led by the archangels Gabriel and Michael as joint commanders-in-chief. Besides confronting the host of Hades, Gabriel and Michael were the ones who ordered the gates of Hell to open for the King of Glory, antiphonally intoning in "leonine" voices Psalm 23, whose liturgical importance has already been discussed.[35]

The first eastern iconographic concession to this theme is at best symbolic, and at worst entirely unrelated to it. It appears in a miniature of the Anastasis in Mt. Athos, Iviron 1, fol. 1ᵛ, to which we will return later (fig. 50).[36] Here the angels are floating in midair, adoring the frontal figure of the redeemer below. Their presence appears to involve the transplantation of the motif of the angels hovering above Christ in images of the Crucifixion as early as a late seventh-century icon from Mt. Sinai.[37] Similar angels also hover above the

Münster (Müstair) nei Grigioni," *ArtLomb*, 2 (1956), 28ff., fig. 8. L. Birchler, "Zur karolingischen Architektur und Malerei in Münster-Müstair," *Frühmittelalterliche Kunst in den Alpenländern. Akten zum III. Internationalen Kongress für Frühmittelalterforschung* (Lausanne, 1954), 207, fig. 93. For the relation of the Anastasis to the rest of the decoration, see no. 67 on fig. 87, and fig. 89. It is part of a christological cycle, and appears immediately after the Crucifixion. For a color photograph, see n. 6.124.

[32] *Evangelia Apocrypha*, C. de Tischendorf, ed. (Leipzig, 1853), VI (XXII), 307; IX (XXV), 309. *The Apocryphal New Testament*, M. R. James, trans. (Oxford, 1971), 136, 140ff. And, for example, Pseudo-Chrysostom, *In S. Paraskeven*, PG, 62.722.

[33] Ibid., 723. Eusebius Alexandrinus, *In diabolum et*

orcum, PG, 86 / 1.403. Pseudo-Epiphanius, *In Sancto et Magno Sabbato*, PG, 43.441, 456.

[34] Ibid., 456B–C. The phrasing is "μυρίας μυριάδας καὶ χιλίας χιλιάδας ἔχων ἀγγέλων, ἐξουσιῶν, θρόνων ἀθρόνων. . . ."

[35] Ibid., 456f.

[36] A. Xyngopoulos, *Evangiles avec miniatures du monastère d'Iviron au Mont Athos* (Athens, 1932), 6ff., pl. 1. Sotiriou, op. cit., 292, fig. 3 (n. 1.1). Weitzmann, "Aristocratic Psalter and Lectionary," 101f. Xyngopoulos, "'Ο ὑμνολογικὸς εἰκονογραφικὸς τύπος τῆς εἰς τὸν Ἅδην καθόδου τοῦ Ἰησοῦ," 114, fig. 1. Idem, "Τὸ ἱστορημένον Εὐαγγέλιον τοῦ Ἑλληνικοῦ Ἰνστιτούτου τῆς Βενετίας," Θησαυρίσματα, 1 (1962), 63–88.

[37] Weitzmann, *Sinai Icons*, I, no. B. 32.

figure of Christ in representations of the Koemesis of the Virgin during the Middle By-zantine period.[38] Thus, the emergence of angels in the eastern iconography of the Anastasis appears to be associated more with this live pictorial tradition than with any Middle By-zantine interest in illustrating the contribution of the angelic host to the siege of Hades.

The Anastasis miniature of the twelfth-century Melisende Psalter[39] confirms, that the glorification of Christ motivated the inclusion of the two angels in the eastern iconogra-phy, rather than any material assistance that they might have lent to the battle against death. They do not cover their hands in adoration, or in preparation for receiving the res-urrected saints to the Paradise above. Instead, they bear standards on which the Trisagion is inscribed. Thus the liturgical chanting of the Trisagion probably had more to do with these angels than the homily of Pseudo-Epiphanius.[40]

The liturgical potential of these angels is explored further in the twelfth-century Ana-stasis miniature in the liturgical homilies of Gregory in Paris, Bibl. Nat. Cod. gr. 550, fol. 5[r] (fig. 51). Two different kinds of angels are used here. One group, which is of lesser sig-nificance is offering its adoration, while the second group consists of four angels, two of which are archangels—judging by their loros. The latter stand in a separate panel imme-diately above the Anastasis exhibiting the four traditional material reminders of the Pas-sion in a liturgical context: the cross, the lance, the sponge, and the nails.[41]

Earlier, at the turn of the eleventh century, this eastern tradition, which allowed angels and archangels to be depicted in the context of the Anastasis, and the western tradition, which allowed them to participate actively in the defeat of death, apparently met and fa-cilitated the breeding of the ceremonious archangels who ostentatiously guard the majestic Anastasis at Torcello. But we will return to this later.

The second point of departure of the Anastasis of S. Zeno in relation to the contempo-rary western iconography is the presence of two figures to the left of Christ. These are two busts set atop a strygil sarcophagus bearing crowns. The crowns have been the reason for identifying these two figures as David and Solomon. This identification is important both regarding the iconographic evolution of the Anastasis and the appreciation of this partic-ular mosaic. The motif of David and Solomon rising out of a sarcophagus is a canonical feature of the standard Middle Byzantine Anastasis, but was not adopted by the West. The S. Zeno Anastasis, which is exceptional in this respect, offers the first dated example of the

[38] As, for example, in the Phokas Lectionary, fol. 134[v] and Iviron 1, fol. 307[r]. Weitzmann, "Das Evan-gelion im Skevophylakion zu Lawra," pls. 3.1, 4.5.

[39] London, British Museum, Egerton 1139, fol. 9[v]. H. Buchthal, *Miniature Painting in the Latin Kingdom of Jerusalem* (Oxford, 1957), 4, 22f. Buchthal points out that the angels carrying the Trisagion on their stand-ards are based on the mosaic of the Anastasis Rotunda (that is, the new church consecrated in 1149), which, in turn, drew on Constantinopolitan models of the second half of the eleventh century.

[40] It might be worth remembering, that the Trisa-gion is part of the Cheroubikon, which is sung in conjunction with Ps. 23 during the Great Entrance. Taft, loc. cit. (above, n. 3.115). Dix, *The Shape of the Liturgy*, 284. Germanus, *Historia Ecclesiastica*, PG, 98.420.

[41] Xyngopoulos, "'Ο ὑμνολογικὸς εἰκονογραφικὸς τύπος τῆς εἰς τὸν Ἅδην καθόδου τοῦ Ἰησοῦ," 116ff., fig. 3. Galavaris, *Gregory*, 73ff., fig. 401. For other examples of the Anastasis with the symbols of the Passion, see Galavaris, *Gregory*, 75.

motif of David and Solomon in any context. Its inclusion here offers undeniable evidence for the influence of Byzantine models. Furthermore, the combination of this eastern motif, with the western motif of the angel appearing behind Christ's mandorla, makes this mosaic an example of how West met East in early ninth-century Rome. There are therefore many good reasons for examining the two figures of the mosaic of Pascal I minutely.

An examination of the mosaic shows that the area of the faces of the two kings has been disturbed. The face of the second figure in particular has been reset practically at random. The resetting starts at the band which frames the panel on the left, extends over the eye of the first figure, over the entire face of the second figure, and into the outer frame of Christ's mandorla.[42] It does not disturb the hair, which is dark on the first figure and white on the second. This establishes a distinction of age which agrees with the standard Middle Byzantine practice of representing Solomon as a young man and David as old.

The crowns are also undisturbed. These, however, bear no resemblance to the crowns usually worn by the two kings in the eastern examples of the Anastasis. Furthermore, they rest peculiarly almost behind the kings' heads. When compared to the type of crown worn by St. Cecilia in the apse of S. Cecilia in Trastevere—also executed during the pontificate of Pascal I—a clearer idea is gained about the type of crown the artist intended to represent here. A further comparison to any of a number of crowns worn by saints in the Chapel of S. Zeno confirms that the mosaicist was trying to adorn David and Solomon with a type of crown which was currently in fashion in Roman mosaics.[43] The narrowness of the area in which he was obliged to fit these two figures must have been partly responsible for the awkwardness of execution.

Another aspect of these two kings which indicates a conscious effort to adapt this motif to western iconographic realities is their strygil sarcophagus, a type not encountered in the representation of sarcophagi in the East during the Middle Byzantine period. Italy, however, had a long acquaintance with this type, which was also used in the context of the Anastasis. We find the strygil sarcophagi used for the anonymous dead in the Cimitile Anastasis, as well as in the Exultet Roll, Vat. lat. 9820 dated 980–987 (fig. 20). The place of this economical reference to the universality of the Resurrection is taken in the S. Zeno mosaic by a more elaborate reference to two historical and well-known figures. Their inclusion agrees with the general tendency of the ninth century to elaborate and identify with greater precision specific aspects of the Anastasis.

The S. Zeno mosaicist might have found the strygil sarcophagi in the crypt of S. Prassede an additional motive for adapting the sarcophagus of the two kings to local tastes. One of them reputedly contains the relics of S. Prassede, which were translated there by Pascal I, and in whose honor the pope rebuilt and decorated this church so magnificently.

The exploding mandorla of light might be traced to the East on the basis of its appearance in the Chloudof Psalter.[44] But Rome had been familiar with it for some time, since

[42] See fig. 23.
[43] Matthiae, *Mosaici medioevali delle chiese di Roma*, II, pls. 35, 38.
[44] Brenk, "Zum Bildprogram der Zenokapelle in Rom," 217.

we also find it more than a century earlier in the Anastasis in the Oratory of John VII in St. Peter's.

Thus, the S. Zeno mosaicist exemplifies how eastern models operating in ninth-century Rome were consciously dressed in western iconographic idiom after the core of the image had been enriched with local and imported motifs.

Another aspect that adds to the mosaic's importance is its privileged and significant position in the chapel. The mosaic decoration of S. Prassede, whose character is splendidly apocalyptic, honored particularly the two sisters SS. Prassede and Pudenziana in its apse.[45] Appropriately, the two saints were presented to Christ by Peter and Paul accompanied by the square-nimbed donor on the left. Beyond the long established tradition of placing the donor in the apse, the reason for including Pascal I is spelled out in this case by the presence of a nimbed phoenix perched on the branch of a palm tree right above Pascal's square nimbus. Its traditional message is sealed by the inscription at the base of the apse mosaic, according to which the pope expresses the hope that the saints buried here, and S. Prassede in particular, will facilitate his entry into the heavens above.[46] The inscription, the phoenix above the head of Pascal I, the apocalyptic theme of the mosaic decoration, and the rebuilding of the church as the burial site for an important local saint, honored here along with her sister whose famous church is nearby, demonstrate the pious means by which the pope intended to ensure his admission to Paradise when Judgment came.

The pope stretched his aspiration for eternity to include his mother. For this purpose he attached the chapel of S. Zeno to the nave of S. Prassede and decorated it so it could serve as his mother's burial site.[47] Thus Theodora Episcopa, as he labels her, occupies in this chapel a place parallel to that of Pascal I in the main church. The use of the chapel for her burial spells this out even more explicitly than the phoenix does for the pope. Accordingly, the portrait of Theodora Episcopa appears in an arched recession on the wall of this chapel, which corresponds to the main apse of the church.[48] She is represented here together with the Virgin, S. Prassede, and S. Pudenziana below the image of the apocalyptic lamb standing atop the hill whence flow the rivers of Paradise. The arrangement of this panel is considerably more intimate than that of the main apse, since the Virgin, the two saints who flank her and Theodora occupy equal positions. Theodora's worthiness is stressed by the way her figure breaks down entirely the symmetry inherent in the standard portrait of the Virgin flanked by two equal saints. Theodora is differentiated from her companions by her square nimbus, whose function appears to parallel that of the square nimbus of the pope in the main apse. The square nimbus, Theodora's placement in this panel, and the panel's position in the chapel, seem to express the pope's prayer, that his dead mother buried here

[45] Matthiae, op. cit., I, 233f.; II, pl. 38. Van Berchem, Clouzot, *Mosaiques chrétiennes du IVe au Xe siècle*, 227f.

[46] For the inscription, see van Berchem, Clouzot, op. cit., 230. The phoenix above the head of Pascal I is repeated in the apse mosaic in S. Cecilia in Trastevere, idem, fig. 311. The model for this use of the phoenix above the head of the pope went back to the apse mosaic of SS. Cosma and Damian.

[47] U. Nilgen, "Die grosse Reliquieninschrift von Santa Prassede. Eine Quellenkritische Untersuchung zur Zeno-Kapelle," *RQ*, 69 (1972), 7–29. Brenk, op. cit., 213 (n. 4.44).

[48] Van Berchem, Clouzot, op. cit., 240, fig. 303.

would also be considered worthy of eternal life with the help of SS. Prassede and Puden-ziana, and S. Zeno whose relics sanctified her funeral chapel.[49]

The positioning of the Anastasis next to the panel containing the square-nimbed funeral portrait of Theodora Episcopa shows that this iconography could be used alone in a funeral context in early ninth-century Rome. The apocalyptic tenor of the decoration of S. Prassede and S. Zeno helps us interpret this particular Anastasis as an exemplum of Paradise already gained by man.[50]

The function of the Anastasis mosaic in S. Zeno may be compared to that of the second Anastasis from S. Clemente, which included the portrait of a cleric and possibly, with the presence of the same image in the cycle decorating the funeral chapel of Pope John VII in St. Peter's. The use then of the Anastasis in S. Zeno is not unique. It appears to reflect a practice familiar in Rome, at least throughout the ninth century, aiming to express the aspiration of the deceased for an eternal life on the basis of the precedent of Adam's redemption at the time of Christ's own Resurrection.

[49] The parallel orientation of this wall to that of the main apse, and the proximity of the portrait of Theodora Episcopa to that of the representation of the Anastasis parallel significantly the location of the Anastasis of S. Clemente II.

[50] It is unfortunate that the panel corresponding to the Anastasis on the other side of the arch is now invisible. The two panels together could conceivably provide a test to Nordhagen's hypothesis concerning the use of the Anastasis in "portal iconography" since they possibly echo the arrangement of the doorway to the Palatine Ramp in S. Maria Antiqua. However, it is worth noting that the arch formed in the thick-ness of the wall and decorated with a rich garland is invaded rather peculiarly and asymmetrically by the Anastasis panel. This panel extends well above the springing of this arch up to which the present marble revetment reaches. This is why the Anastasis is still visible, even if only in part. The corresponding panel on the other side of the arch does not, however, reach above the springing of the arch, and is, therefore, covered almost entirely by the revetment. Thus, the latter panel, which appears to have included two standing figures, is on the same level as the enframed panel with the portrait of Theodora Episcopa, while the Anastasis panel is on a higher level.

THE HISTORIATED RELIQUARIES

The earliest examples of the Anastasis which have come down to us on objects made in the East appear on a group of three historiated reliquaries of the True Cross, all of which are luxury objects closely related to each other in function, technique, style, and iconography. Although it has been shown that they are closely interdependent for their date, the date of the earliest piece has long been debated. Unfortunately, the representation of the Anastasis on these objects cannot be evaluated before ascertaining the date of the earliest piece, and its two relatives. The date of this group will therefore be reexamined on the basis of evidence other than that offered by their treatment of the Anastasis.

The best known and most luxurious of the three probably belonged in the thirteenth century to Pope Innocent IV (1243–1252). It is now part of the Byzantine collection of the Metropolitan Museum of Art in New York City, and is known as the Fieschi Morgan Reliquary (figs. 24a–i).[1] It is a small silver-gilt box, the obverse of whose lid represents the Crucifixion in cloisonné enamel. This panel and four sides of the box are surrounded by the busts of twenty-seven saints, each identified by an inscription.[2] The reverse of the cover is quite different. Two crossing lines reproduce the shape of the cross and form four panels, each depicting a scene from the life of Christ: the Annunciation, the Nativity, the Crucifixion (for a second time) and the Anastasis. This side is executed in niello, in contrast to the enamel decoration of the exterior. The combination of these two techniques on a reliquary is unusual, and the source of some complications.

* The first version of chapter five was presented as a lecture at the Dumbarton Oaks Center for Byzantine Studies on May 2, 1978. I wish to thank Professors Hugo Buchthal and Thomas Mathews, as well as Professors Otto Demus, Margaret English Frazer, Ernst Kitzinger, Henry Maguire, John Nesbitt, and Gary Vikan for their advice and criticism, from which I benefited in preparing the final version of this chapter. I am also grateful to Professor Frazer for facilitating my examination of the Fieschi Morgan Reliquary, Professor Michelini-Tocci for facilitating my examination of the crosses and reliquaries at the Museo Sacro in the Vatican, and Mme Dončeva-Petkova for providing me with excellent photographs of the Pliska cross.

[1] Rosenberg, 1922, 31–38, figs. 53–57. Rosenberg, 1924, 61–67, figs. 50–57. Lucchesi Palli, "Der syrisch-palästinensische Darstellungstypus der Höllenfahrt Christi," *RQ*, 57 (1962), 250–267. L. Dontcheva, "Une croix pectorale-reliquaire en or récemment trouvée à Pliska," *CA*, 25 (1976), 63, notes 2–4. Hereafter: Dontcheva-Petkova, 1976. L. Dončeva-Petkova, "Croix d' or-Reliquaire de Pliska." *Culture et art en Bulgarie Médiévale (VIIIe–XIVe s.). Bulletin de l'Institut d'Archéologie*, 35 (1979), 83f. Hereafter: Dontcheva-Petkova, 1979. *The Age of Spirituality*, no. 574. *The Metropolitan Museum of Art Bulletin*, 35/2 (1977), no. 85 with a color photograph, O. M. Dalton and R. Fry, *Byzantine Enamels in Mr. Pierpont Morgan's Collection* (London, 1912), 7f., pl. 5.

[2] Rosenberg, 1922, 34.

E. Lucchesi Palli recognized the closeness of the New York reliquary to the one from Pieve of Vicopisano (figs. 25a, b).[3] This is a cross, also silver-gilt, with scenes from the life of Christ in niello. The obverse of the cross represents the Crucifixion in the center surrounded by the Annunciation, Nativity, Baptism, and Presentation in the Temple. The reverse is dominated by the Virgin of the Ascension, who is flanked by a tree and six apostles on either side. The second apostle to her left has been identified as Andrew because of the cross he is carrying. Above the Virgin, Christ is seated in a mandorla held by two angels, while below the Anastasis is represented.

A third reliquary, a close relative of the previous two, was excavated in 1973 in Pliska and was published by L. Dontcheva-Petkova (figs. 26a–e).[4] This consists of three crosses, one inside the other. The outer and middle crosses (to which I will refer as the first and second Pliska cross, respectively) are made of gold and decorated in niello. The innermost cross is wooden and undecorated. The first Pliska cross follows the same scheme of decoration as the Vicopisano reliquary, with one exception: the center of the obverse represents the Transfiguration and not the Crucifixion (figs. 26a–b).[5] The Crucifixion is reserved for the obverse of the second Pliska cross, while the Virgin appears for a second time on the reverse of this second cross as the Nikopoios type (figs. 26c–d). She is surrounded by medallions of four Church Fathers: Chrysostom, Nicholas, Gregory, and Basil (counterclockwise).

In all three reliquaries the quantity and quality of the decoration are apparently related to the value of the material of which they are made and the cost of their production. Accordingly, they can be graded in the following manner: the Fieschi Morgan reliquary first, because of the use of two techniques; the Pliska cross second, as it consists of two extensively decorated gold crosses; and the Vicopisano cross third, since it is made of gilded silver only.

There are also other more distant relatives of this group of historiated reliquaries. One is a larger oval silver reliquary box in the Museo Cristiano at the Vatican.[6] The niello Crucifixion on its cover relates to the Crucifixions on the other reliquaries. Portraits of the evangelists are etched on the longer sides of the Vatican box. Another relative is the bronze cross found in Chersonnesos decorated with representations of the Ascension and the Transfiguration on its reverse.[7] Still another is the half of a bronze cross whose obverse

[3] Lucchesi Palli, op. cit., 256ff., figs. 54–57. For previous bibliography, her note 25. Also, Schiller, III, fig. 99.

[4] Dontcheva-Petkova, 1976, 59–66, figs. 1–5. Dontcheva-Petkova, 1979, 74–91, figs. 1–15.

[5] Minor divergences also appear in the scenes of the Ascension where the mandorla is carried by four rather than two angels. In addition, not one but two apostles carry the cross, presumably Peter and Andrew, Dontcheva-Petkova, 1976, 65 n. 9.

[6] Lauer, "Le trésor du Sancta Sanctorum," 81ff.,

pl. 12.2. A. Prandi, *Roma nell' alto medioevo* (Turin, 1968), 104, fig. 78. Biblioteca Apostolica Vaticana, Museo Sacro, Guida l, *L'arte bizantina nel medioevo* (Rome, 1935), 13f., fig. 6. H. Grisar, *Die römische Kapelle Sancta Sanctorum und ihr Schatz* (Freiburg/Br., 1908), 111f., fig. 55. C. Cecchelli, "Il tesoro del'Laterano. II. Oreficerie, argenti, smalti," *Dedalo*, 7 (1926–1927), 239f.

[7] B. V. Zalesskaja, "Čast' bronzovogo kresta-sklabnja is Hersonesa," *Viz Vrem*, 25 (1964), 167–175. Schiller, III, fig. 456.

only survives representing the Crucifixion, the medallions of two archangels, the Annunciation, and the Anastasis.[8] This has been judged—probably wrongly—to be a late fifteenth-century Balkan work or a forgery. The Chersonnesos cross has been variously dated between the eighth and the eleventh centuries; the Vatican reliquary between the tenth and twelfth centuries; while the Fieschi Morgan, the Vicopisano, and the Pliska reliquaries have been dated between the seventh and the tenth centuries. Nevertheless, a date of about 700 is generally favored for the Fieschi Morgan reliquary, the leading and earliest piece of this group of three reliquaries interrelated in terms of technique, style, iconography, and function.

If the Fieschi Morgan should be dated to about 700, then the representation of the Anastasis on it would present us with a triple first: it would offer the earliest known example of the Anastasis, the earliest known example of the motif of the broken gates of the underworld, and the earliest known example of the motif of David and Solomon. The implications of each of these points are crucial.

If we follow the current consensus and date the New York reliquary to ca. 700, then we would have to consider that the earliest known example of the iconography of the Anastasis appears on the reliquary. Given that such objects are conservative and resist innovation, it is unlikely that any other than well-established christological scenes would be part of its pictorial vocabulary. Consequently, the appearance of the Anastasis on a reliquary at about 700 implies that this pictorial theme had already passed the experimental stage, had ceased being an innovation, and its acceptability had been firmly established by 700. However, the birth and acceptance of the Anastasis were closely interwoven with the christological decisions of the Sixth Ecumenical Council (680–681) and the Trullan Council (692). Thus, the historical context of the iconography raises the question: does a date at ca. 700 allow a sufficient amount of time for the acceptance of the new image of the Anastasis and its migration to conservative phylacteric objects such as the Fieschi Morgan reliquary?

Some of the iconographic particulars of the representation of the Anastasis on the New York reliquary also need to be considered. This is an example of the first type of Anastasis in which Christ is shown moving to the right, holding a scroll, and raising a half-kneeling Adam behind whom Eve stands in supplication. The traditional sarcophagus of Adam has been omitted along with Christ's mandorla. Lack of space is probably responsible for these abbreviations, as well as for the placement of the broken gates of Hades in the upper right corner rather than below Christ. This interpretation is supported by the variant placement of the broken gates of the underworld on the Vicopisano cross, by the X-shaped explosion of light behind the figure of Christ on the Vicopisano and the Pliska crosses, and by the minisarcophagus out of which Adam's figure rises on yet another historiated phylactery, the Martvili triptych (fig. 37).

The motifs of Adam's sarcophagus and Christ's mandorla, which probably figured on

[8] *Frühchristliche Kunst aus Rom. 3. September bis 15. November 1962 in Villa Hügel. Essen* (exh. cat.), no. 333.

the model of the Fieschi Morgan Anastasis, do not contradict a date at ca. 700. The same motifs are present in the early eighth-century examples of the Anastasis in Rome. However, other aspects of the iconography point away from this early date.

As we have seen, no interest is expressed in the topography of the domain of Hades in the early eighth-century examples. Surviving examples from the early ninth century indicate that this aspect of the Anastasis has been modified by the representation of the *tenebrae*, which succeeds in characterizing the underworld (fig. 16a). The broken gates of the underworld, which appear for the first time on the Fieschi Morgan and were probably placed under Christ's feet on its model, express a comparable interest in the accurate description of the overthrown kingdom of Hades. Similarly, the early eighth-century examples stress the struggle between Christ and Hades by representing the latter in a semi-erect stance vigorously resisting Christ's onslaught. Surviving examples of the ninth/tenth century replace the ancient god of S. Maria Antiqua with a sinuous prostrate figure sprawled on the ground irrevocably defeated by Christ, though attempting to maintain a hold on Adam's heel. The Fieschi Morgan, along with its model give us the earliest example of the latter type of Hades.

As suggested in the previous chapter, the more elaborate description of the underworld and the representation of the sprawled Hades indicate a significant development in the iconography of the Anastasis. This development projects the defeat of Hades as a fait accompli and forms part of a broader tendency to focus the image on the rescue of Adam from the dark underworld by toning down the struggle between Christ and Hades which preceded Adam's rescue. This approach, which is witnessed by early ninth-century western examples and which probably has its sources in the late eighth century, is now encountered on this eastern reliquary. Does the eastern origin of the Fieschi Morgan suffice to justify tracing this iconographic approach to Hades and his kingdom back to the beginning of the eighth century? There is no corroborating evidence.

The situation is similar in the case of the motif of David and Solomon, which was probably included on the model of the Fieschi Morgan. The earliest dated example of this motif comes from the Anastasis mosaic in the Chapel of S. Zeno dating 817–824 (fig. 23). The mosaic has been shown adapting an eastern model to local tastes and offering a terminus ante quem for the emergence of the motif of David and Solomon. It is not possible to ascertain the exact date of introduction of this composite motif to Byzantine iconography. While the Fieschi Morgan Anastasis and the S. Zeno mosaic offer the earliest eastern and western examples of this motif, respectively, there is no trace or echo of this motif on works dating before the ninth century. On the other hand, the joint appearance of the two kings constitutes a pictorial motif that is energetically pursued and developed during the Middle Byzantine period. Though the eastern model for the S. Zeno mosaic could date as far back as the late eighth century, the absence of the motif from pre-Iconoclastic works, in contrast to the active interest evidenced by the Post-Iconoclastic period, discourages dating the emergence of this motif as early as ca. 700. This, however, would have to be its date, if the Fieschi Morgan reliquary has been correctly dated at ca. 700.

In review, the analysis of the implications of a date at ca. 700 for the New York phylactery raises many questions which bear directly upon the evolution of the iconography of the Anastasis. None of these questions can be answered with reasonable certainty, though they crucially affect the understanding of the development of the image reached in the previous chapters. The significance of the date of this work for the present study does not permit us to bypass this problem. Laying aside, therefore, the representation of the Anastasis, we will try to ascertain the date of the Fieschi Morgan reliquary by reexamining all related evidence.

Such a reexamination of the New York reliquary is particularly auspicious following the appearance of the Pliska cross. The richness of the christological cycle of the first Pliska cross significantly expands the range of the available evidence. Furthermore, the scheme followed in the decoration of the second Pliska cross—the colobium Crucifixion on the obverse and the Virgin surrounded by four medallions on the reverse—suggests that these three historiated reliquaries may now be linked with a less exalted group of crosses following the same scheme of decoration; for example, the Moscow and London crosses (fig. 27).[9] In addition to expanding the comparative material, this latter group of crosses con-

[9] (1) *Moscow Cross*, obv.: Crucifixion, rev.: Theotokos Nikopoios and four evangelists. Rosenberg, 1924, 59f., figs. 48, 49. Zalesskaja, op. cit., 169, figs. 2a, 2b.

(2) *Rhode Island School of Design Cross*, obv.: Crucifixion, rev.: Theotokos Hodegetria and four evangelists. R. Berliner, "A Palestinian Reliquary Cross of about 590," *Museum Notes. Museum of Art. Rhode Island School of Design, Providence*, 9/3 (March, 1952), figs. 1, 2. Wessel, *Die Kreuzigung* (Recklinghausen, 1966). Dontcheva-Petkova, 1976, 64 n. 13.

(3) *Museo Cristiano Cross*, obv.: Crucifixion, rev.: Theotokos Nikopoios and four evangelists. Prandi, *Roma nell' alto medioevo*, 107, fig. 79. E. S. King, "The Date and Provenance of a Bronze Reliquary Cross in the Museo Cristiano," *MemPontAcc*, 2 (1928), 198ff., pl. 24.1. L. von Matt, *Die Kunstsammlungen der Biblioteca Apostolica Vaticana Rom*, (Rome, 1969), nos. 132, 133.

(4) *Mount Sinai Cross*, obv: Crucifixion (?), rev.: Theotokos Hodegetria and four evangelists. K. Weitzmann, "Mount Sinai's Holy Treasures," *National Geographic Magazine*, 125/1 (January, 1964), ill. on p. 123.

(5) *Detroit Institute of Arts Cross*, obv.: Crucifixion, rev.: Theotokos Nikopoios and four evangelists. *Early Christian and Byzantine Art. An Exhibition held at the Baltimore Museum of Art. Organized by the Walters Art Gallery* (Baltimore, 1947), no. 305, pl. 38. Hereafter: Baltimore 1947.

(6) *Dumbarton Oaks Cross*, obv.: Crucifixion, rev.: Theotokos Hodegetria flanked by Peter and Paul, and a third medallion of unidentified saint. Ross II, no. 98.

(7) *S. Nicolo dei Mendicola Cross, Venice*, obv.: Crucifixion, rev.: Theotokos Nikopoios and four medallions. Counterclockwise: St. John the Baptist, St. Phocas, St. Kyriakus, St. Constantine. S. Bettini, *Venezia e Bisanzio* (Venice, 1974), no. 17. My thanks are due to Sac. Rosolino Scarpa-Parroco of S. Nicolo dei Mendicola for making it possible for me to examine this cross. And below, n. 5.35/11.

(8) *Tbilisi, Martuili Enamel Cross*, obv.: Crucifixion and two archangels, rev.: Virgin Hodegetria and four evangelists. Ch. Amiranachwili, *Les émaux de Géorgie* (Paris, 1962), 28ff.

(9) *Berlin Cross from Smyrna, no. 918*, obv.: Crucifix, rev.: Theotokos orans between two palm leaves. King, op. cit., 200, pl. 28.14.

(10) *Silver Cross in Reggio di Calabria*, obv.: Crucifix and inscription \overline{IC} \overline{XC} NHKA (*sic*), rev.: Theotokos orans, flanked by two Chi Rhos. A. Lipinsky, "Encolpia cruciformi orientali in Italia. I. Calabria e Basilicata," *BGrottaf*, 11 (1957), 32–35.

(11) *Brass Cross in Case Archaeological Collection, University of Chicago*, obv.: Crucifix and four busts, rev.: Theotokos orans and four busts. Baltimore, 1947, no. 299, pl. 46.

(12) *Bronze Cross in the Detroit Institute of Arts*, obv.: lost, rev.: Theotokos Nikopoios and four evangelists. Baltimore, 1947, no. 305 pl. 38.

(13) *Bronze Cross from Vraca, Bulgaria*, obv.: lost, rev.: Theotokos Nikopoios and four evangelists. L. Dončeva-Petkova, "Croix en bronze de Vraca," *Arheologija*, 17/2 (1975), 60–65, figs. 1a–b.

tinues evolving up to the Late Byzantine period. A cross excavated in 1967 in Hagios Po-
lyeuctos in Constantinople, which may be safely dated to the latter part of the twelfth cen-
tury, illustrates this.[10] Therefore, the Pliska cross expands in two significant ways the
material that may be interrelated with this group of historiated reliquaries. As a result, the
Fieschi Morgan and its relatives need not be regarded as oddities, since they can now claim
a place in the evolution of a larger group of objects which had a similar function and dec-
oration.

Earlier Studies

Rosenberg was the first to study the Fieschi Morgan reliquary in depth. His work, from
the early 1920s, is burdened with a heavy dependence on a theory of his time which inter-
preted as early Syro-Palestinian the iconographic type of Crucifixion depicted here—that
is, Christ dressed in a long colobium and staring with wide open eyes.[11] This view how-
ever, has been superseded by later studies, which have allowed a more sophisticated un-
derstanding of this iconography. As a result, this type cannot be used any more as proof of
date and/or origin since its use was widespread and continuous at least until the end of the
Macedonian period.

Rosenberg, who did not know the Vicopisano and Pliska crosses, related the Fieschi
Morgan reliquary to a cross at the Cathedral Treasury in Monza, which he dated to 603.[12]
This impressively precise date has been traditionally attributed to it on the basis of a letter
of Pope Gregory, which mentions a cross he gave to the son of Queen Theodolinda. Ac-
cording to Rosenberg, the iconography of the Crucifixion did not contradict this date, so
he accepted it. However, since there is little proof of a direct link between Pope Gregory
and the Monza cross, its date remains open.

He proceeded with a stylistic comparison between the Monza cross and another reli-
quary, the Goluchov cross, which led him to suggest a date at ca. 700 for the latter.[13] A

(14) *Kanellopoulos Museum Bronze Cross, Athens*,
obv.: Crucifixion, rev.: Theotokos Nikopoios and
four evangelists. *Splendeur de Byzance* (Brussels,
1982), no. 13.

(15) *London nielloed silver cross (private collection)*:
obv.: Crucifixion; rev.: Theotokos Nikopoios and
four evangelists. Unpublished.

[10] The previous group of crosses is related to a later
group in which Christ is represented in loincloth on
the obverse surrounded by four medallions. This
type can be exemplified by a lead cross excavated in
the atrium of Hagios Polyeuctos in 1967 together
with a number of coins of Isaac II Comnenos (1185–
1195). Obv.: Crucifix surrounded by medallions of
the four evangelists, rev.: Meter Theou Orans
flanked by medallions of two archangels, an uniden-
tified saint (top) and St. Basil (bottom). R. M. Har-
rison, N. Firatli, "Excavations at Saraçhane in Istan-
bul: Fourth Preliminary Report," *DOP*, 21 (1967),
275, figs. 21–22. For an intermediate group of crosses
linking those listed in n. 5.9 with the group men-
tioned here, see n. 5.35.

[11] Especially Rosenberg, 1922, 32ff. Rosenberg,
1924, 67, 65.

[12] Rosenberg, 1924, 53, figs. 43–46. Wessel, *Die
Kreuzigung*, 23, 28 n. 47. Lucchesi Palli, "Der syrisch-
palästinensische Darstellungstypus der Höllenfahrt
Christi," 231, n. 6. A. Frolow, *La relique de la Vraie
Croix* (Paris, 1965), no. 159, p. 248f. Idem, "Le culte
de la relique de la Vraie Croix à la fin du VIe– au début
du VIIe siècles," *Byzantinoslavica*, 22 (1961), 320–339,
esp. 324f., fig. 1. "Bayerische Frömmigkeit. 1400
Jahre christliches Bayern," *Das Münster*, 13 (1960),
158f., ill. on pp. 150–151. A. Merati, *Il tesoro del
Duomo di Monza* (Monza, 1963), 22f.

[13] Rosenbereg, 1924, 56–59, fig. 47. Rosenberg,

further stylistic comparison of the Goluchov to the Fieschi Morgan reliquary indicated to him a date around the year 700 for the latter as well. But Rosenberg's stylistic comparisons are not convincing, while the foundation of the Fieschi Morgan's date on that of the Monza cross is unproductive, since the date of the Monza cross is based on local tradition rather than on proof.

Rosenberg also suggested a Syro-Palestinian provenance for the New York stauro-theque. In addition to its use of a colobium Crucifixion, which was at the time interpreted as evidence for such an origin, he considered a Syrian-Melchite All-Saints Litany, which mentions twenty-five saints, eighteen of whom appear on the Fieschi Morgan.[14] Contrary to the cautiousness of Rosenberg's conclusions, this litany has been often cited since then as conclusive proof of the Fieschi Morgan's Syro-Palestinian origin. His caution can be easily understood: nine of the twenty-seven saints on the reliquary are not accounted for in this litany. Furthermore, the litany does not agree with the Fieschi Morgan even in its list of apostles.[15] Consequently, the evidence for the Syro-Palestinian origin of the Fieschi Morgan reliquary is as questionable as the date Rosenberg attributed to it.

Two other studies have also dealt with the question of the date of the New York stauro-theque. Lucchesi Palli accepted Rosenberg's thesis before introducing the evidence of the Vicopisano cross into the discussion. She consequently dated the Fieschi Morgan within the seventh century and the Vicopisano cross later.[16] On the contrary, Dontcheva's publication of the Pliska cross suggested a date in the ninth or tenth century, as well as a Constantinopolitan provenance on the basis of the cross held by St. Andrew in the scene of the Ascension, and the presence of the four Church Fathers medallions surrounding the Virgin.[17]

1922, 34. Frolow, *La relique de la Vraie Croix*, no. 160, pp. 267f. Lipinsky, op. cit., 13–32.

[14] Rosenberg, 122, 34ff.

[15] A. Baumstark, "Eine syrisch-melchitische Aller-heiligenlitanei," *OrChr*, 4 (1904), 98–120. The litany mentions eleven apostles, the Fieschi Morgan reliquary represents twelve. The names of ten apostles are shared by both. The litany mentions thirteen martyrs and the Fieschi Morgan represents ten. The names of seven martyrs are shared by both. The litany mentions one bishop, the Fieschi Morgan represents three, including the one mentioned in the litany.

[16] Lucchesi Palli, op. cit., 250–267. Also, *RBK*, w. "Anastasis."

[17] Dontcheva-Petkova, 1976, 59; idem, 1979, 89ff. the cross was excavated in 1973, 26 meters to the South of the southeastern tower of the west gate of Pliska, and at a depth of 1.70 m together with a mass of pottery sherds. Dontcheva rightly argued that the presence of Chrysostom, Basil, Gregory, and Nicholas on the second Pliska cross argues for a Middle Byzantine date, op. cit. 65f. n. 30. Their representation

on crosses has been associated with Middle Byzantine apse decoration by A. Grabar, "La précieuse croix de Lavra Saint-Athanase au Mont-Athos," *CA*, 19 (1969), 111. Moreover, the Middle Byzantine period witnessed a great intensification of the worship of SS. Basil, Gregory, and Chrysostom, while St. Nicholas closely followed in the honors. The relics of St. Gregory were translated from Cappadocia to the capital by Constantine Porphyrogenitus and deposited in the churches of the Holy Apostles and H. Anastasia. January 19 was set aside to commemorate this event (SCP 401.53). The celebration of his memory on January 25 included a procession from H. Sophia to the Forum, and masses celebrated in the Churches of H. Sophia, H. Apostles, and H. Anastasia [SCP 423; 8.48. J. Mateos, *Le Typicon de la Grande Eglise. OCA* 165, 166 (Rome, 1962 and 1966), I, 210.4. Hereafter: Mateos]. Similarly, January 27 was reserved for the commemoration of the translation of the relics of Chrysostom to the church of the H. Apostles by Theodosius the Younger. The celebration, which took place at the church of the Holy Apostles, included a procession

The Iconography

A comparison of the christological cycles decorating these reliquaries with those of three other groups of objects that served a similar mixture of prophylactic and commemorative functions will prove useful. The comparative material comes first from the late sixth to early seventh century ampullae, designed to contain sanctified oil from the Palestinian *loca sancta* and often worn around the neck as phylacteries. The second group is a series of octagonal marriage rings decorated in niello (fig. 3). Their bezel usually represents the married couple invoking concordance under the aegis of Christ and sometimes the Virgin. The third group is offered by the bowl-shaped censers, which mostly date from the seventh century, though some examples may date from the early eighth century. These objects which have been discussed in varying degree are decorated with abbreviated christological cycles, as are the reliquaries considered here. A comparative list itemizing the scenes of the christological cycles appearing in each group proves the existence of strong links between them as well as undeniable points of disagreement.[18]

To start with, all of these cycles exclude the miracles of the Life of Christ. The ampullae,

that started in H. Sophia, went to the Church of Apostle Thomas at Amantion, and hence to the H. Apostles (scp 425.21. Mateos, I, 212.24). His memory was also celebrated on November 13, when his relics had been deposited under the altar of the Church of the H. Apostles. This celebration also included a procession led by the patriarch from H. Sophia to the Forum and thence to the H. Apostles (scp 217.38. Mateos, I, 100.4). This celebration was in lieu of September 14, the actual date of death of Chrysostom, which was, however, moved because the Raising of the Holy Cross was celebrated on September 14. December 15 commemorated Chrysostom's ordination as patriarch of Constantinople (scp 312.22) and February 26 his ordination to priesthood (scp 492.27). Basil was similarly honored in H. Sophia on January 1 (scp 364.15). The increasing importance of these three Fathers of the Church actively continued into the eleventh century, as attested by the reservation of January 30 for the joint commemoration of Basil, Gregory, and Chrysostom (scp 433.53. For Gregory, see also Galavaris, *Gregory*, 4 n. 5). The feast of the Three Hierarchs, as it was called, was instituted in 1084 (Bertonière, 114. Beck, 555). St. Nicholas's memory was celebrated on December 6 in H. Sophia (scp 284.8) and the translation of his relics on May 8 or 9 (scp 665.49, 672.40). The importance of the worship of these four Church Fathers in Middle Byzantine Constantinople is probably reflected on these crosses as it is on the apse decoration of the same

period. Moreover, the strength of the Constantinopolitan tradition, which associated St. Nicholas with the three hierarchs, is confirmed by the treatment reserved for these four saints, who are represented together as a unit in many churches, as for example, in Cefalu, Capella Palatina, and Martorana. O. Demus, *The Mosaics of Norman Sicily* (London, 1949), 14, 43, 80.

[18] The themes represented on the historiated reliquaries are in italics.

SCENES	Ampullae	Rings	Censers	Reliquaries
1. *Annunciation*	x	x	x	x
2. Visitation	x	x	x	
3. *Nativity*	x	x	x	x
4. Annunciation to the Shepherds	x		x	
5. Magi	x	x	x	
6. *Presentation in the Temple*		x		x
7. *Baptism*	x	x	x	x
8. *Transfiguration*				x
9. Entry to Jerusalem			x	
10. *Crucifixion*	x	x	x	x
11. Myrophores or Chairete	x	x	x	
12. *Anastasis*				x
13. Doubting Thomas	x		x	
14. Walking on the Water	x			
15. *Ascension*	x	x	x	x

the rings, and the censers basically follow the same pattern in their choice of scenes. However, the rings and the censers differ significantly from the ampullae by arranging these scenes in a strict chronological sequence. The scenes common to these three groups, whose dates range from the late sixth to the early eighth century, are: the Annunciation, the Visitation, the Nativity, the Magi, the Baptism, the Crucifixion, the Myrophores, and the Ascension.

The historiated reliquaries, on the other hand, exclude the scenes of the Visitation, the Magi, and the Myrophores, while expanding their christological cycles with the Transfiguration and the Anastasis. They also stabilize as part of their iconographic program the scene of the Presentation in the Temple, which was not normally part of the decoration of the ampullae, the rings, and the censers. Thus they omit certain scenes in favor of others (the Presentation replaces the Visitation) and include new scenes (the Transfiguration and the Anastasis), which occasionally replace older favorites (the Anastasis supplants the Myrophores and the Chairete). They also avoid depicting miracles performed in Christ's lifetime.

It is immediately apparent that the iconographic decoration of the reliquaries reflects better the range of subject matter favored for the illustration of the story of Christ from the ninth century on, than that which was popular during the pre-Iconoclastic period. In fact it compares well with the standard Middle Byzantine church programs as seen, for example, in the mosaic decoration of the eleventh-century churches of Hosios Lukas, Chios, and Daphni. Moreover, all the scenes chosen for the decoration of these reliquaries become a fixed part of the Middle Byzantine feast cycle, which only expands the core provided by the christological cycle of these reliquaries.[19] The composition of the Middle Byzantine synoptic cycle was stabilized by the tenth century, remaining practically unchanged ever since, as witnessed by a pocket-size triptych icon, a minor Slavic work of the seventeenth century at the Benaki Museum in Athens (fig. 28). This reads from left to right across the three leaves: Annunciation, Magi, Presentation in the Temple, Baptism, Raising of Lazarus, Entry into Jerusalem (first row); Crucifixion, Anastasis, Doubting Thomas, Ascension, Transfiguration, Dormition of the Virgin (second row).[20] It is interesting that this late but iconographically traditional work places the Transfiguration out of sequence before the Ascension rather than after the Baptism. As a result, the left leaf of this triptych offers a chronologically distant but programmatically parallel composition to that on the reverse of the Fieschi Morgan cover. The traditional character of this late triptych and the fact that Middle Byzantine feast cycles are known to have rearranged the sequence of their scenes suggest that this late example might very well offer a distant echo of a Middle Byzantine link to the Fieschi Morgan christological cycle. If this is true, then the rectangular shape and the christological cycle of the New York staurotheque reflect triptych

[19] On Middle Byzantine church programs, O. Demus, *Byzantine Mosaic Decoration* (London, 1948), 22ff. The Raising of Lazarus, the Pentecost and the Koimesis are important scenes of the standard feast cycle absent from the cycle of the historiated reliquaries.

[20] The eucharistic scenes crowning each triptych leaf represent later liturgical elaborations and are of no concern in the present context.

icon models. In any case, the iconographic program of these reliquaries points to the presence of post-Iconoclastic predilections and dates these devotional objects accordingly.

This suggestion is strengthened by the presence in the reliquary cycles of particular motifs whose parallels are found in post-Iconoclastic works only. For instance, the Presentation in the Temple includes the motif of the altar, which is characteristic of post-Iconoclastic works and which cannot be traced in the pre-Iconoclastic period. The earliest example of this subject comes from the Dumbarton Oaks marriage ring, but is not used on any of the other rings (fig. 3). Here, as well as in the other pre-Iconoclastic examples, there is no trace of an altar. This motif, which has been interpreted as a reference to the eucharistic aspect of this scene, appears for the first time on the enamel cross of Pascal I (817–824).[21] Thereafter the altar is frequently included. Moreover, the theme of the Visitation, which occurs together with the Presentation in the Temple on the Dumbarton Oaks ring, the Oratory of John VII, and the cross of Pascal I, is omitted in the historiated reliquaries. Its absence similarly echoes the waning interest in the theme of the Visitation characteristic of post-Iconoclastic cycles.

The representation of the Transfiguration on the Pliska cross contains another interesting motif: Elijah and Moses are placed inside Christ's mandorla. Our pre-ninth-century examples, all of which come from monumental works, do not include this motif, which first appears in the Chapel of S. Zeno and is frequent thereafter.[22] The insistence on a per-

[21] For the iconography of the Presentation in the Temple, see D. C. Shorr, "The Iconographic Development of the Presentation in the Temple," *AB*, 28 (1946), 17–33. K. Wessel, "Darstellung Christi im Tempel," *RBK*, I, 1134ff. K. Weitzmann, *The Fresco Cycle of S. Maria di Castelseprio* (Princeton, 1951), 62ff. E. Lucchesi Palli, "Darstellung Christi im Tempel," *LChrI*, I, 473ff. The earliest example of this scene comes from the triumphal arch of S. Maria Maggiore, which is unique in its iconographic particulars. S. Sergius at Gaza included such a scene among its mosaics according to Choricius' description; Mango, Sources, 65. The earliest iconographic approximation of the scheme under consideration appears on the Dumbarton Oaks marriage ring, Ross, II, no. 69, pl. 43. Next comes a mosaic panel at Kalenderhane Camii provisionally dated at ca. 700 by Striker, and in the seventh century by Kitzinger, C. L. Striker, Y. D. Kuban, "Work at Kalenderhane Camii in Istanbul: Third and Fourth Preliminary Reports," *DOP*, 25 (1971), 255f., fig. 11. Also, E. Kitzinger, *Byzantine Art in the Making* (Cambridge, 1977), 155, fig. 206. The scene is also part of the mosaic decoration in the Oratory of John VII in the old St. Peter's. Grimaldi, *Descrizione della basilica antica di S. Pietro in Vaticano. Codice Barberini Latino 2733*, fols. 90v–91r, fig. 39, and Waetzoldt, *Die Kopien des 17.*

Jahrhunderts nach Mosaiken und Malereien, figs. 482, 478, 477. For the cross of Pascal I, see K. Wessel, *Byzantine Enamels* (Recklinghausen, 1967), no. 7.

[22] The earliest known Transfiguration comes from the apse mosaic of S. Apollinare in Classe. There were two sixth-century Transfigurations, one on the facade of the Church at Parenzo, now destroyed, and the famous mosaic apse at the monastery church at Mount Sinai. The Church of SS. Nereo e Achilleo in Rome depicts the Transfiguration on the face of its triumphal arch in mosaic. This dates from the time of Pope Leo III (795–816). Waetzoldt, op. cit., 54, no. 571, fig. 315, and D. Giunta, "I mosaici dell' arco absidale della basilica dei SS. Nereo e Achilleo e l'eresia adozionista del sec. VIII," *Roma e l'età Carolingia* (Rome, 1976), 195ff. The next example, also from Rome, is a mosaic from the Chapel of S. Zeno in S. Prassede (817–824). This is the first example which encloses the two prophets in Christ's mandorla. Brenk, "Zum Bildprogram der Zenokapelle in Rom," 215. The presence of a representation of the Deisis above the Transfiguration mosaic in S. Zeno connects the latter with the Sinai mosaic, as Brenk pointed out. For other ninth-century examples with prophets included in Christ's mandorla, see Chloudof Psalter, fol. 88v; Bristol Psalter, fol. 147v; Theodore Psalter, fol. 118r (below, n. 6.1). Also, Paris, Bibl.

fectly round mandorla, which goes with it, has led Weitzmann to see here the influence of a dome mosaic from the church of the Holy Apostles in Constantinople, dating from the second half of the ninth century and known to us only through descriptions. This motif was popular from the ninth century on as confirmed by its presence in the Paris Gregory, the psalters with marginal illustrations, and in other manuscripts of Constantinopolitan provenance.

A third iconographic motif involves the trees that flank the Virgin in the Ascension scene both on the Pliska and Vicopisano crosses.[23] The representation of the Ascension, as opposed to that of the Transfiguration and the Presentation in the Temple, was extremely popular during the early period. Many examples survive in all kinds of media.[24] Significantly, few early examples include the motif of the two trees, while the Middle Byzantine period developed an iconographic variant that placed the Ascension in a garden with at least two trees, preferably flanking the Virgin. The abbreviated version of this variant may be seen in fol. 77[r] of the Bristol Psalter.[25] The late ninth-century dome mosaic from the church of Hagia Sophia in Thessalonike gives the full version.[26] Here trees are used to isolate all figures, but those which flank the Virgin are a different type that often characterizes post-Iconoclastic Ascensions.[27]

Nat. cod. gr. 510, fol. 75[r] and Athos, Iviron, cod. 1, fol. 303[v] in K. Weitzmann, "A Metamorphosis Icon or Miniature on Mount Sinai," *Starinar*, 20 (1969), 415–421, figs. 3 and 2 (reversed). All surviving examples before Paris gr. 510 represent the two prophets without nimbi. The same is true of the apostles on the Sinai mosaic. All the apostles are nimbed for the first time on the mosaic of SS. Nereo e Achilleo, while on the S. Zeno mosaic only St. Peter is nimbed. The prophets and apostles in the representation of the Transfiguration on the Pliska cross are nimbless. The Transfiguration is also depicted in niello on the lower arm of the Chersonnesos cross. The nimbed prophets are represented outside the mandorla, while the apostles had to be cut off at bust level for lack of space (above, n. 5.7). A comparable use of the Transfiguration is seen on the cover of the reliquary receptacle inside a reliquary of the True Cross from Alba Fucense at the Palazzo Venezia in Rome. This is shaped as a patriarchal cross, which bears at its center the figure of Christ in the mandorla flanked by the busts of Elizah and Moses on either end of the main cross-bar. The overthrown figure of John is represented immediately below, while the figures of Peter and James occupy the suppedaneum of the patriarchal cross. Frolow, *La relique de la Vraie Croix*, 294f., no. 271. Idem, *Les reliquaires de la Vraie Croix* (Paris, 1965), fig. 51.

[23] The Ascension is the primary scene on the Cher-

sonnesos cross taking up three of its arms. The Virgin is depicted as Nikopoios at the center, proving that this poorer cross conflates the two different representations of the Virgin depicted on the reverse sides of the first and second Pliska crosses—the Virgin orans of the Ascension and the Nikopoios surrounded by the medallions of the four Church Fathers. The Chersonnesos cross is also comparable to the Vicopisano and Pliska crosses technically, stylistically, and epigraphically. N. P. Kondakov, *Russkie Klady* (St. Petersburg, 1896), I, 43f., fig. 12. Idem, *Ikonografia Bogomateri* (St. Petersburg, 1915), II, 136, fig. 60. C. O. Nordström, *Ravennastudien* (Stockholm, 1953), 126, figs. 28f. Dontcheva-Petkova, 1976, 64; idem, 1979, 85f., fig. 18. The Chersonnesos cross exemplifies the extent to which the dating of this group has suffered. Kondakov preferred an eighth- to eleventh-century date for it. Schiller dated it in the eighth century on the basis of its similarity to the Vicopisano cross, while Zalesskaya, op. cit., 171, 174, dated it to the tenth / eleventh century. On the other hand, Nordström attributed it to the sixth century.

[24] For the iconography of the Ascension, K. Wessel, *RBK*, w. "Himmelfahrt." Most pre-Iconoclastic examples come from the ampullae. Grabar, *Ampoules de Terre Sainte*, passim. [25] See, n. 6.1.

[26] V. Lazarev, *Storia della pittura bizantina* (Turin, 1967), 128ff., figs. 81–86. Hereafter: Lazarev, *Storia*.

[27] The Virgin of the Ascension does not usually ap-

A triple floral motif that appears on the Crucifixion panel of the Fieschi Morgan lid is also worth considering. This uncommon motif is obviously misplaced. A more sensible placement is reserved for a similar motif on the reverse of the late eighth- to early ninth-century icon of St. Chariton and St. Theodosius from Mt. Sinai (fig. 29).[28] Here the flowers spring out diagonally from the center of the cross forming a pattern that recalls the traditional Chi Rho. The Fieschi Morgan divorces this motif from its context, the cross; but not wishing to omit it, places it in the sky where it makes no more sense. The date of the icon, and the expanded use of this decorative motif in conjunction with the cross in the Uspenski Gospels in Leningrad—a manuscript written in 835 by the successor of Theodore Studites (fig. 30)—points to the first half of the ninth century for the Fieschi Morgan.[29]

Thus the christological program of the historiated reliquaries points to a post- rather than a pre-Iconoclastic date. The same is true of a number of iconographic motifs. The Presentation in the Temple, the Transfiguration and the Ascension (not to mention the Anastasis) include features which appear from the ninth century on. Similarly, the dislocated floral motif on the enamel cover points to the first half of the ninth century for this precious reliquary and its relatives.

The Inscriptions[30]

The spelling and lettering of the Fieschi Morgan's niello inscriptions, like the niello inscriptions of the other two reliquaries and other related works, is by and large acceptable (fig. 24g). The inscriptions on the enamelwork are a different matter (figs. 24b, c, d, e, f). Their lettering is nondescript and their spelling worse. Letters follow each other in the wrong order (ΠΕΤΟΡC instead of ΠΕΤΡΟC, fig. 24b), the letters N (as in HⲰANIC of the Crucifixion) and A (as in O ΑΓΙΟC ΚΟCMAC) are reversed, and M is placed upside down and made

pear flanked by two trees in the early period. There is, however, evidence that the isolated motif of the Virgin flanked by two trees did exist at the time. It is encountered on painted gold glass [G. A. Wellen, *Theotokos* (Utrecht, 1961), pl. 42a] and in the apse mosaic in Panagia Kanakaria, where the Virgin is flanked by two palm trees [Sacopoulo, *La Theotocos à la mandorle de Lythrankomi*, 22f. Megaw and Hawkins, *The Church of Panagia Kanakaria at Lythrankomi in Cyprus*, 53f., 59f.] Their place is taken by two bushy trees in the apse of Eski Baca Kilisesi [J. Lafontaine Dosogne, "L'église dite Eski Baca Kilisesi et la place de la Vièrge dans les absides Cappadociens," *Festschrift Otto Demus. JÖB*, 21 (1972), 163ff., pls. 4–5, esp. pp. 168, 175]. The association of palm trees and epiphanies had a long and continuous history, as for example in the representation of the *Traditio Legis* in S. Costanza, in the dome of the Baptistery of the Arians in Ra-

venna, and in the miniature of the Transfiguration in Paris gr. 510.

[28] Weitzmann, *Sinai Icons*, I, no. B 37b, p. 64f.

[29] Weitzmann, *Die byzantinische Buchmalerei des 9. und 10. Jahrhunderts*, 35, fig. 236. N. Eleopoulos, Ἡ βιβλιοθήκη καὶ τὸ βιβλιογραφικὸν ἐργαστήριον τῆς Μονῆς τῶν Στουδίων (Athens, 1967), 39f., fig. 32. This is the first manuscript entirely written in minuscule. It is dated 835 and was written at the Monastery of Studion by Nicholas, successor to Theodore Studite. Leningrad, Public Library, cod. gr. 219, fol. 263ʳ.

[30] Rosenberg, 1922, 33f. Lucchesi Palli, "Der syrisch-palästinensische Darstellungstypus der Höllenfahrt Christi," 259f. Dontcheva-Petkova, 1976, 61ff. G. Tschubinaschwili, "Ein Goldschmiedetriptychon des VIII.–IX. Jahrhunderts aus Martvili," *ZBildK. NF.*, 41 (1930–1931), 86f.

to look like an ω (Ο ΑΓΙΟC ΠΑΝΤΕΛΕΗωωΝ) (fig. 24c). Names as common as ΙωΑΝΝΗC are spelled differently on different occasions (ΗωΑΝΙC and ΙωΑΝΙC, figs. 24f, b), the title of the Virgin is badly misspelled (ΘΕωΤωΚC), while the inclusion of nonphonetic errors (ΙΔΙ ω ΥωC COΥ instead of ΙΔΕ Ο ΥΙΟC COΥ, fig. 24f) suggest a craftsman whose native tongue was not Greek.

Moreover, the Fieschi Morgan enamelist is unable to fix his letters which float in the rich emerald background. The same is true of the letters on the Beresford Hope cross in the Victoria and Albert Museum (fig. 31)[31] a work dated after the cross of Pascal I. The lettering on the London enamel tries to reproduce the more decorative aspects of the niello script used on the historiated reliquaries. This is not even attempted by the Fieschi Morgan enamelist, who simplifies the same script by avoiding any decorative effects. Everything points to the relative unfamiliarity of this craftsman with the language and the technical problems attending the use of inscriptions on enamels. The contrast between the enamel and the niello inscriptions confirms that two craftsmen are at work here. The identity of the enamelist and the toleration of such barbarisms on a highly luxurious work is something to which we will return. This is not repeated on the other members of this group of reliquaries, whose primary link is their niellowork.

The niello inscriptions also establish a link between our historiated reliquaries and a large group of related crosses, of which the Moscow and London crosses have been offered as examples (fig. 27). The beautiful lettering of the niello inscriptions can be found on liturgical and devotional objects as early as the seventh and as late as the second half of the tenth century.[32] The function of the objects on which this script may be seen and the great chronological span of its use allows the preliminary suggestion that the niello inscriptions follow a traditional liturgical script employed in works of the minor arts whose function is related to common practices of worship. The enamelist of the Beresford cross tries to imitate this script despite the technical difficulties involved. Similarly, the Fieschi Morgan enamelist uses it, though he omits the decorative lines in which the letters of this script characteristically terminate. The technical problems here are largely caused by the transfer of this lettering to the enamel medium. These technical problems are resolved by the end of the

[31] J. Beckwith, *Late Antique and Byzantine Art in the Victoria and Albert Museum* (London, 1963), 18f. K. Wessel, *Byzantine Enamels* (Recklinghausen, 1967), 52–54, no. 8. The Virgin is labeled here ΜΑ, i.e., Maria. The Beresford Hope Cross finds an interesting descendant in the enamel cross in the Brummer Art Gallery (*Early Christian and Byzantine Art*, 1947, no. 524, pl. 69), whose provenance seems to be Constantinopolitan. The shape of the cross and the beading are close to the Beresford-Hope cross. Even closer is the figure of the loinclothed Christ from an iconographical, stylistic and technical point of view. The traditional Crucifixion inscriptions on the arms of the cross allow us to fill in the two medallions flanking Christ, which are empty now, with enamels of the Virgin and John. The two empty medallions above and below Christ probably represented the two archangels following a scheme similar to that of the cross on the Katskhi Icon of the Savior (below, 115). This type of cross continues into the Late Byzantine period, as attested by the Crucifixion on the Dagmar Cross in Copenhagen (Wessel, *Byzantine Enamels*, 185, no. 59) and the enamel cross in the Dumbarton Oaks Collection (Ross, II, no. 159).

[32] As for example, on two silver plates from Constantinople dated at 610 by their stamps (Ross, I, no. 16 and no. 17). Comparable is also the lettering on the cross of Basil II in the Dumbarton Oaks Collection dated between 960 and 963 (Ross, II, no. 97 and no. 98).

ninth century, as witnessed by the enamel medallion portrait of Leo VI (886–912) among others (fig. 32).[33] Therefore, the technical and paleographical considerations involved in the comparison of the Fieschi Morgan enamelwork and the Beresford Hope cross argue for a date in the first half of the ninth century for the New York staurotheque.

One inscription on the Fieschi Morgan enamelwork is of particular interest. The Virgin in the scene of the Crucifixion is entitled ΘΕΟΤΟΚΟС (fig. 24f). Although the Virgin officially qualified as Theotokos after the condemnation of Nestorius by the Council of Ephesus in 431, this title is hardly ever encountered labeling the representation of the Virgin on the background of her image. Its appearance on the Fieschi Morgan comes as a surprise, which is compounded when we find the same title identifying the Nikopoios on the reverse of the second Pliska cross (fig. 26d) and on a great many of its relatives.[34] For example, it is repeated on the Moscow cross, the London cross (fig. 27), a cross in the Rhode Island School of Design, another in the Museo Sacro, and on quite a few others. All of them depict the Crucifixion on the obverse and the Theotokos as Nikopoios or Hodegetria on the reverse. The Theotokos is usually surrounded by medallions of the evangelists. However, the medallions may also depict the Church Fathers Basil, Gregory, Chrysostom, and Nicholas, or the apostles Peter and Paul. Close to this group of crosses comes another group which follows the same iconographic scheme, but labels the Virgin ΜΗΤΗΡ ΘΕΟΥ. This group, of which there are a number of examples in Athens (fig. 33), New York, France, and so on, also has descendants.[35]

Thus, a substantial group of crosses and reliquaries follows the same scheme of deco-

[33] Venice, Tesoro di S.Marco, Crown of Leo VI, Wessel, *Byzantine Enamels*, no. 12. Venice, Marciana, cod. lat. I.101, gia Reserv. 56, enameled bookcover, Wessel, op. cit., no. 13.

[34] Above, n. 5.9.

[35] (1) *Benaki Museum Cross*, obv.: Crucifixion, rev.: Meter Theou Nikopoios and evangelists. A. Frolow, "Le culte de la relique de la Vraie Croix à la fin du VIe– au début du VIIe siècles," 325, fig. 2. Idem, *Les reliquaries de la Vraie Croix*, no. 161, pp. 62, 165 n. 3, 227 n. 1. Dontcheva-Petkova, 1976, 64 n. 15; idem, 1979, 87, fig. 23.

(2) *Stathatos Collection Reliquary Cross, Athens*, obv.: Crucifixion, rev.: Meter Theou orans and evangelists. A Xyngopoulous, Συλλογὴ Ἑλένης Στα-θάτου (Athens, 1951), no. 33, p. 46f., pl. 27. Dontcheva-Petkova 1976, 64 n. 16.

(3) *Berlin Cross no. 1938*, obv.: Crucifixion, rev.: Meter Theou orans and four medallions (evangelists ?). King, op. cit., 199, pl. 25.3 (above n. 5.9/3).

(4) *Berlin Cross no. 1936*, same as previous. King, op. cit., 199, pl. 25.5.

(5) *Metropolitan Museum of Art Cross*, obv.: Crucifix, rev.: Meter Theou Nikopoios, no medallions. King, op. cit. 200, pl. 28.11.

(6) *Siena Cross*: obv.: Crucifix and inscr. I͞C X͞C NIKA, rev.: Meter Theou Nikopoios (back of lyre-throne visible) flanked by two archangels. King, op. cit., 200, pl. 28.13.

(7) *Saint-Michel d'Aiguilhe Cross*, obv.: destroyed (?), rev.: Meter Theou Nikopoios flanked by two medallions containing the inscription labeling her. F. Enaud, "Découverte d'objets et de reliquaires à Saint-Michel d'Aiguilhe (Haute-Loire)," *Monuments Historiques de la France*, 7 (1961), 137, ill. on p. 138.

(8) *Bronze Cross in Reggio di Calabria*, obv.: destroyed, rev.: Meter Theou Nikopoios flanked by two figures (swathed mummies?). Lipinsky, "Encolpia Cruciformi orientali in Italia. I. Calabria e Basilicata," 35f.

(9) *National Archaeological Museum of Athens. Stathatos Collection Cross ET 931*, obv.: Crucifixion with inscription I͞C X͞C NHKA (sic), rev.: Meter Theou orans flanked by two trees.

(10) *Detroit Institute of Fine Arts Bronze Cross*, obv.: lost, rev. Meter Theou and child, orans and two saints. *Early Christian and Byzantine Art*, 1947, no. 302, pl. 46.

(11) *Altar Cross from Ephesos in Vienna*, obv.: Crucifixion surrounded by medallions of John the Bap-

ration and, for the most part, the same technique and style. These objects are further interrelated by their inscriptions, among which the words "Theotokos" and "Meter Theou" are used as titles labeling the representation of the Virgin.

There can be little doubt that the designation of the Virgin as Theotokos is parallel to her designation as Meter Theou. Both titles define her relationship to the divine; the latter as the Mother or Begetter of God and the former as the One Who Gave Birth to God. Either label is therefore acceptable for her representation in the context of the Passion. While the Crucifixion testifies to the perfect human nature in Christ, the label Theotokos or Meter Theou testifies to the perfect participation of the divine nature in the incarnation.

One would expect that either of these titles would be used to identify the Virgin in images of the Crucifixion from the earliest times. But this was not the case. The surviving representations of the Virgin that can be dated to the pre-Iconoclastic period invariably label her as ΜΑΡΙΑ or Η ΑΓΙΑ ΜΑΡΙΑ. For example, the two earliest icons of the Crucifixion which come from Mt. Sinai employ it.[36] The label Hagia Maria is for the most part rejected from the ninth century on. Its disappearance is certainly complete as far as the image of the Crucifixion is concerned, its place taken by the legends Meter Theou or Theotokos, both of which emerge for the first time on Byzantine images after 787.

Meter Theou appears for the first time on another Crucifixion icon at Sinai dated to the late eighth or the first half of the ninth century.[37] Significantly, this representation is the first clear example of a Crucifixion including all attributes of the Middle Byzantine iconographic type: Christ is dead, as denoted by his closed eyes, and wears a loincloth, which emphasizes the vulnerability of his humanity. This type of Crucifixion including the title Meter Theou predominates from the tenth century on, while the colobium type is also used until much later, becoming more and more old fashioned, as we have already noted.

Concurrently, the ninth century witnesses the use of the label Theotokos. For example, fol. 98ʳ of the Pantocrator Psalter 61 is illustrated with an image of the Crucifixion in which the dead and loinclothed Christ is mourned by the Virgin now labeled Η ΑΓΙΑ ΘΕΟΤΟΚΟC (fig. 34).[38] This manuscript dates from the second half of the ninth century, comes from Constantinople, and belongs to the group of Psalters with marginal illustrations, which offers some of the most vivid visual evidence of the awareness and vitality with which artists of the post-Iconoclastic period set out to transcribe in visual terms their theological victory. The experimentation with both types of Crucifixion in these Psalters has long

tist, archangels Michael and Raphael (the medallion of Michael and the fourth medallion on the lower cross arm are destroyed), rev.: Meter Theou orans, flanked by Peter and Paul and surrounded by medallions of four evangelists (the medallions of Mark and John have been destroyed). Above the figure of the Virgin: ΘΕΟΤΟΚΕ ΒΟΗΘΗ. *Vom Altertum zum Mittelalter.* *Kunsthistorisches Museum*, R. Noll, ed. (Vienna, 1958), p. 27, no. B.15, pls. 23–24. Wessel, *Die Kreuzigung*, 28. The altar cross in Vienna and the reliquary cross in S. Nicolo dei Mendicola, Venice (above, n. 5.9/7)

represent the colobium-clad Christ with eyes closed.

A number of additional examples could be added to this list whose members represent a particularly popular type.

[36] Weitzmann, *Sinai Icons*, I, B.32 and B.36.

[37] Ibid., 7f., B.50.

[38] See, n. 6.1. Fol. 98ʳ illustrates Ps. 73.12. For the date and provenance of this psalter, I. Ševčenko, "The Anti-iconoclastic Poem in the Pantocrator Psalter," *CA*, 15 (1965), 39–60.

been ascribed to this activity.[39] Similarly, the change of the titles of the Virgin to Theotokos and Meter Theou should be seen in the same light, namely, as products of post-Iconoclastic visual theology.[40]

Thus, the parallel use of the labels Theotokos and Meter Theou encountered in the sizable group of phylacteries, which includes the Fieschi Morgan reliquary, is clearly reflected in representations of the Crucifixion in other media. However, the latter works cannot be dated before 787. Consequently the presence of the label Theotokos on the Fieschi Morgan reliquary and its relatives proposes for them a date after 787.

Similarly, the unusual inscription ΓΕΝΑ (instead of the common ΓΕΝΝΗCΙC), which identifies the scene of the Nativity on the Fieschi Morgan staurotheque as well as on the Pliska cross, also proposes a date after 700 for our group (figs. 24g, 26a). It is also encountered on the Martvili triptych, a related post-Iconoclastic portable phylactery in Tiflis, which will be discussed later (fig. 37b). Moreover, it figures only once in a monument. This is Acikel Aga Kilise at Belissirema in Cappadocia, which includes an abbreviated christological cycle that compares well with that of the historiated reliquaries.[41] It comprises the Annunciation, Nativity, Presentation in the Temple, Baptism (?), a scene now destroyed, a colobium Crucifixion with Christ alive on the cross and the Virgin labeled Meter Theou, the Anastasis, and the Chairete.

While previous studies have not provided convincing evidence dating the key piece of this group to 700, the iconographic program and certain motifs used in the decoration of this group link its members to post-Iconoclastic trends. The same is true of the legends Theotokos, and possibly ΓΕΝΑ. The dislocated floral motif on the enamel cover of the Fieschi Morgan reliquary points to the earlier part of the ninth century, while paleographical and technical considerations point to the first half of the ninth century.

Stylistic and Other Considerations

THE NIELLOWORK

Dontcheva-Petkova has argued that the intimate stylistic, inscriptional, iconographic, and technical affinities in the niellowork of the Fieschi Morgan and the two historiated crosses from Vicopisano and Pliska suggest that they are products of the same atelier, executed even by the same artist.[42] Though this cannot be proved, the close interrelation of these three pieces is indeed so explicit that they may be considered as of the same provenance and by artists intimately familiar with each other's idiom. They all succeed in abbreviating

[39] Martin, "The Dead Christ on the Cross in Byzantine Art," 189ff. A. Grabar, L'iconoclasme byzantin (Paris, 1957), 228ff.

[40] The evolution of the legends figuring on Byzantine images of the Virgin will be examined more thoroughly elsewhere.

[41] N. Thierry, "Un décor pré-iconoclaste de Cappadoce: Açikel Ağa Kilisesi (Eglise de l' ağa à la main ouverte), CA, 18 (1968), 33–69, fig. 11. Idem, Arts of Cappadocia (London, 1971), 146ff., fig. 82. Thierry dates this chapel to the late seventh/early eighth century while allowing for a possible date in the ninth century. Her argument includes a comparison of its christological program with that of the Fieschi Morgan niellowork ("Un décor . . ." 63 n. 70, 66 n. 81, 64).

[42] Dontcheva-Petkova, 1976, 63.

in the same way a style, which, in contrast to the Fieschi Morgan enamelwork, is at home with volume and space, and does not aim at homogenizing the flow of its design. The relative austerity of the christological program of the Fieschi Morgan, the less congested character of its compositions along with its more controlled organic and economical use of linear design date its niellowork earlier than the other two pieces.

The style of the niellowork of the three historiated reliquaries finds parallels in the group of crosses related to the second Pliska cross.[43] None of them, however, has been dated on the basis of sufficient external evidence. Consequently, the style of the niellowork adds little to our quest for a date.

THE ENAMELWORK

The stylistic analysis of the Fieschi Morgan enamelwork proves complicated but rewarding. Its craftsman uses a schematic, two-dimensional, fragmented concept of the human figure composed of parts whose accurate assembly is only incidental. The eyebrows and the nose are characteristically rendered as a continuous line of uniform thickness spanning the entire width of the face. The eyes have a pronounced almond shape and are filled with color. The mouth is thin and distinct from the other features. A semicircular downward line touching the tip of the broad nose is often used to denote age. The degree of deliberate fragmentation is particularly evident in the rendering of the forearm of the Virgin as a collage of overlapping discs ending in an inadequate number of fingers. This unkind attitude toward volume is further accentuated in the rendering of the drapery as a combination of parallel lines and lines that cross each other at an 80 degree angle once too often. The few attempts of the drapery to respond to the bodies it covers—on the torsos of the Virgin and John—prove to be a lost cause. Still, the predictability of the faces and the drapery succeed in establishing a severely articulated rhythm that spreads from Christ's colobium to the busts that frame the reliquary on all sides.

There are no exact parallels for this abstract, broad rhythm which mostly ignores, or smoothes out in a schematic and angular manner references to the third dimension. Its effective geometrical regularity finds echo in the portrait of St. John Chrysostom in Vienna, Nationalbibliothek, cod. 1007, fol. lr, produced in Salzburg early in the ninth century (fig. 35).[44] The rhythm of this miniature, however, is more curvilinear and dense than that of the Fieschi Morgan enamel. Similarly, the broad rendering of the primary facial features on the New York enamel approximates somewhat the niellowork on the Tassilo Chalice, which dates ca. 780 and might also be a product of Salzburg.[45] These comparisons, however, only illustrate the problem; they do not solve it.

Although the Fieschi Morgan enamelwork has no exact stylistic parallels, a few enamels

[43] The niellowork of this group of crosses is also related to a small silver rectangular piece (3.5 x 2.6 cm) at the Cathedral Treasury at Halberstadt which depicts a colobium Crucifixion. J. Flemming, *Byzantinische Schatzkunst* (Berlin, 1979), 65f., fig. 2.

[44] A. Goldschmidt, *Die deutsche Buchmalerei* (Mu-

nich, 1928), I, 8, 33, pl. 12. *L'exposition Charlemagne*, no. 453.

[45] V. H. Elbern, *Der eucharistische Kelch im frühen Mittelalter* (Berlin, 1964), no. 17, 70f. *L'exposition Charlemagne*, no. 548.

offer a variety of valuable clues, even though they may compare only broadly or partially to the New York reliquary. These will be examined both for the positive and negative evidence they offer.

Foremost are the enamel plaques on the Altheus reliquary at the Sitten Cathedral Treasury in Switzerland, which has been dated between 780 and 799 (fig. 36).[46] These enamels bear the same broad facial features as the Fieschi Morgan and the Tassilo Chalice, though the circle of the eye is formed even more economically by bending the line of the eyebrow backward until it meets the bridge of the nose. The formality of its style also compares well with the fragmented austerity of the Fieschi Morgan enamelwork, though the latter's angularity is replaced by a more curvilinear design.

In addition to their date, the Altheus enamels are also important because they help explain some rather unusual features of the Fieschi Morgan enamelwork. Like St. John Chrysostom of the Viennese miniature, the Altheus saints hold a book in their covered left hand. Only part of it can be seen on the upper left part of the saints' torsos. The rest is obscured by the mantled hands. The part of the book visible is easily open to misinterpretation; and, as Frazer pointed out, this is exactly what happens on many figures on the Fieschi Morgan, whose artist included the upper part of the book, but left out the mantled hands that held it in most cases.[47] As a result, the torso of many Fieschi Morgan saints is decorated with a rectangle, which, being of the same color as their garment, looks like a pocket and not a book.

The Altheus saints also explain another puzzling detail of the Fieschi Morgan enamel. Four touching circles forming a quatrefoil cross are suspended in the air above the shoulders of most saints represented on the thickness of the reliquary. As pointed out by Frazer, the Altheus reliquary provides a clue to the meaning of this incomprehensible symbol. The saints on the Swiss reliquary have three touching circles embroidered on the upper arm of their costumes. A similar function was probably intended originally for the quatrefoil crosses on the Fieschi Morgan. Its enamelist, however, misunderstood their significance and placed them in the air rather than on the saints' costumes.

This craftsman also misunderstood the gesture used for the Altheus saints, or some such similar gesture involving the visibility of fewer than five fingers. This is probably why all hands on the Fieschi Morgan enamelwork have three fingers and a thumb that is stretched out from the palm in the usual 80 degree angle.[48] Consistent to the extreme, the artist gives Christ four toes as well.

The Altheus enamels offer, then, an approximate stylistic echo of the New York reli-

[46] I am grateful to Professor Margaret English Frazer for drawing my attention to this work and for pointing out its ability to explain the "pocket" motif and the motif of the quatrefoil crosses on the enamelwork of the Fieschi Morgan reliquary. For a good color photograph, see J. Hubert, J. Porcher, W. F. Volbah, *L'empire carolingien* (Paris, 1968), fig. 197. *L'exposition Charlemagne*, no. 231. P. Lasko, *Ars Sacra. 800–1200* (London, 1972), 10, fig. 10.

[47] Luke, Mark, Simon, Gregory Thaumatourgos, Nicholas, and Anastasius. The portraits of Nicholas and Anastasius also include a schematized draped hand. Cosmas and Damian, on the other hand, hold their traditional medicinal bottles.

[48] The rhythm of this uniform gesture offers a good excuse for omitting the book probably held by John in the model of this enamel Crucifixion.

quary, while providing the key to secondary motifs that were apparently misunderstood by the Fieschi Morgan enamelist. These correspondences encourage a comparison of the dates of the two enamelworks. The usual dating of the Altheus enamels at the turn of the ninth century agrees with the evidence which has so far placed the Fieschi Morgan in the first half of the ninth century. Moreover, the Swiss enamels tentatively draw the date of the New York reliquary away from the middle and closer to the earlier part of the century.

A stylistic comparison of the New York reliquary with other western works of the first half of the ninth century offers only negative evidence. The enamel cross of Pascal I, a Roman work of 817–824,[49] demonstrates that the Fieschi Morgan enamelist could not have been trained in Rome. Nevertheless, the two works compare in terms of function, since they are both multiple reliquaries. The thickness of the cross of Pascal I is divided by thin metal strips into five compartments leaving little doubt that it was intended to hold more than one relic.[50] Similarly, the New York staurotheque proves to be a multilple reliquary whose interior is shaped by thin metal strips into two crosses, the one inside the other.[51]

Although the cross of Pascal I and the Fieschi Morgan enamelwork prove stylistically dissimilar, they serve similar functions. Furthermore, their techniques are similar, though the color range and design suggest a somewhat more advanced date for the cross of Pascal I

[49] F. Stohlman, *Catalogo del Museo Sacro della Biblioteca Apostolica Vaticana. II. Gli Smalti* (Vatican, 1939), no. s 103, 47f. Wessel, *Byzantine Enamels*, no. 7, pp. 48ff. Frolow, *La relique de la Vraie Croix*, no. 88, 215ff. It is worth noting that the cross is exclusively decorated with an Infancy cycle, i.e., an Incarnation cycle, and the inscription on the thickness of the cross is: "ACCIPE QUAESO A DOMINA MEA REGINA MUNDI HOC VEXILUM CRUCIS QUOD TIBI PASCHALIS EPISCOPUS OPTULIT." The dedication to the Virgin together with the pictorial emphasis on the incarnation recalls the analysis of the mosaic cycle decorating the Oratory of John VII in St. Peter's (above, 78ff.). The cross is thus characterized as a Roman product reflecting the longstanding papal preference for the Virgin, the vehicle of the incarnation and the sole queen of the papal universe. This is supported by the fact that it is most ununusal for a historiated reliquary of the True Cross to exclude all reference to the Passion, concentrating instead only on the story of the Incarnation in its decoration. A similar interest for the earlier part of Christ's life is expressed on the rectangular silver case, which reputedly contained the enamel cross of Pascal I. The cover represents Christ enthroned between Peter and Paul below the medallions of two angels, while the front short side of the thickness of the box represents the apocalyptic lamb flanked by the symbols of the evangelists. The remaining three sides of the box emphatically concentrate on the story of the incarnation excluding all reference to the Passion. They depict the Annunciation,

the Visitation, the Annunciation to the Shepherds and to the Magi, the Magi, and the Presentation in the Temple. It can hardly be accidental that the Virgin is enthroned not only in the scene of the Magi, but, most unusually, in the Presentation in the Temple as well. Good photographs have been published by von Matt, *Die Kunstsammlungen der Biblioteca Apostolica Vaticana Rom*, pls. 78–81.

[50] Professor Frazer first drew my attention to the fact that the cross of Pascal I is also a multiple reliquary. Stohlman, op. cit., 47. Grisar, *Die römische Kapelle Sancta Sanctorum und ihr Schatz*, 79, fig. 34.

[51] Rosenberg, 1924, fig. 52. Rosenberg, 1922, fig. 53. The larger of the two crosses is a patriarchal cross and the cross formed at the center of the patriarchal cross is a Latin cross. The latter has unequal side arms, probably because of the shape of the relic it was intended to house. One more metal strip defines the upper part of the upper bar of the patriarchal cross. Thus, the central receptacle area in the shape of a Latin cross is surrounded by five more receptacle areas inside the remainder of the patriarchal cross. The cover of the staurotheque, which slides in from the top to the bottom, would then secure these precious relics in place. Moreover, the four corners of the box formed four more independent receptacles, which were, however, covered not only by the sliding cover of the staurotheque, but also by individual spring covers fastened along the long sides of the staurotheque. Thus, each of the latter four compartments could open outwardly separately. At some

than for the New York reliquary.[52] Similarly, the Beresford Hope cross, whose date is based on its affinity to the cross of Pascal I, is stylistically unlike the Fieschi Morgan enamelwork (fig. 31). Nevertheless, it also compares to it technically and, as we have seen, paleographically.

The fourth enamel that can yield some information about the New York reliquary is the Martvili triptych in Tbilisi, Georgia (figs. 37a, b) along with its two close stylistic relatives: the medallions of the Virgin and St. Theodore from the Khakhouli triptych (fig. 38),[54] and the enamel Crucifix with four medallions on the Katskhi icon of the Saviour.[55] This group of eastern enamels has been variously dated between the eighth and ninth centuries. Their flowing rhythmic style could not have been more unlike the schematized style of the Fieschi Morgan enamel. Technically, this group is more skilled and refined than any of the enamels mentioned so far. A look at their lettering proves that most technical problems have been solved, while the enamelwork acquires an organic cohesion that transcends the exploitation of the decorative and colorific potential of the medium.

Despite the increasing stylistic and technical differences between the Fieschi Morgan reliquary and the Martvili triptych—the leading piece of this group of enamels—these two works are related in more than one significant way. The Martuili triptych is a portable phylactery about the same size as the Fieschi Morgan staurotheque. Its central plaque is also decorated on both sides much like the lid of the New York reliquary. The obverse represents a formal Deisis group in enamel (fig. 37a). The reverse is niellowork.[56] Inside a rich gold frame, a cross divides the area into four squares (fig. 37b). The two top squares represent two infancy scenes: the Nativity and the Presentation in the Temple, as opposed to the Annunciation and the Nativity on the Fieschi Morgan; the two bottom squares represent two scenes from the Death and Resurrection cycle: the Anastasis and the Myrophores, as opposed to the Crucifixion and the Anastasis on the Fieschi Morgan. The unusual system of decoration of the Martvili triptych relates it to the Fieschi Morgan. The iconography and the inscriptions of its niellowork also relate it intimately to our group of

point, this complex reliquary was probably worn suspended from the neck, as suggested by the two holes marking the frame of the upper side of the box indicating the use of a chain. The direction of the slide-in cover also made possible the use of this portable reliquary as an encolpion (fig. 24h).

[52] Like most other ninth-century enamels both of these reliquaries use emerald green as their background. The richness, vibrancy, and translucency of the Fieschi Morgan green is technically superior to that on the cross of Pascal I. On the other hand, this color is not stable in all areas of the New York staurotheque. At times it becomes a rich forest green, and at times it takes on an olive green hue, but its vividness remains intense at all times. Furthermore, the Fieschi Morgan color scheme is more conservative than its counterpart on the Roman cross avoiding sharp color contrasts.

[53] G. Tschubinaschwili, "Ein Goldschmiedetriptychon des VIII.–IX. Jahrhunderts aus Martvili," 81–87. Ch. Amiranachwili, Les émaux de Géorgie, 25–27, pl. on p. 27. Idem, Georgian Metalwork from Antiquity to the 18th Century (London, 1971), pls. 25–26. Wessel, Byzantine Enamels, 45f., no. 6.

[54] Wessel, op. cit., 54f., no. 9. Amiranachwili, Les émaux de Géorgie, 106f., pl. on p. 106. Idem, Georgian Metalwork from Antiquity to the 18th Century, pls. 69–70. Idem, The Khakhuli Triptych (Tiflis, 1972), pls. 22–23.

[55] Amiranachwili, Les émaux de Géorgie, 54, pl. on p. 54.

[56] Tschubinaschwili, op. cit., fig. on p. 83, Amiranachwili, Georgian Metalwork from Antiquity to the 18th Century, pl. 25. Frolow, "Le culte de la relique de la Vraie Croix à la fin du VIe– au début du VIIe siècles," fig. 6.

historiated reliquaries.[57] Stylistically, however, the Martvili niellowork is later than the Fieschi Morgan niellowork. The pristine clarity of the compositions of the New York staurotheque is deflated, while the economical use of surface lines that described volume so successfully has now given way to an irregular surface pattern creating a smudgy effect.

The size and function of the Martvili triptych as a portable phylactery, the rare combination of the two techniques, the use of its hidden side as a recital of the belief in redemption through the incarnation and Passion of Christ, and the stylistic, iconographic, and inscriptional proximity of its niellowork to that of all three historiated reliquaries establish a close link between the Martvili triptych and the Fieschi Morgan reliquary. Consequently, it is important to compare closely the enamelwork of these two phylacteries despite their apparent differences.

Once more, the correct use of a secondary iconographic motif on the Martvili enamel provides a reasonable explanation for a puzzling feature of the Fieschi Morgan enamelwork. This is the vine depicted behind the back of St. John on the Fieschi Morgan enamel Crucifixion (fig. 24f). The figure of Christ on the enamel Deisis of the Martvili triptych is symmetrically framed by two unfolding tendrils. Similar vines also frame St. John the Baptist and the Virgin, though less emphatically. All these vines end in sharply colored discs and teardrops which contrast strongly with everything surrounding them. These schematized vines act as secondary framing devices within the enamel. The tendrils, which function logically on the Martvili triptych, become a motif that invades even the small medallions of the Khakhouli triptych framing the busts of the Virgin and St. Theodore (fig. 38). The vine behind the Baptist on the Martvili Deisis and the vine behind St. John on the Fieschi Morgan Crucifixion unfold comparably. The latter, however, is poorer and deprived of its logical function as a framing device through the omission of the corresponding vine, which should have been represented behind the Theotokos. By defeating this minor decorative motif of its proper logical function, the Fieschi Morgan enamelist demonstrates once more his intrinsic incomprehension of the pictorial vocabulary he is employing. He was, nevertheless, conversant with this particular enamel motif.

Unfolding curvilinear lines along with sharply colored discs and teardrops seem to have become increasingly popular in the second half of the ninth century as part of a style for cloisonné enamels. This style was characterized by the schematization of organic forms, such as these tendrils, through the use of continuously flowing curvilinear cloisons against a bright emerald or blue background. The result was a light, continuous and vibrant rhythm whose effect was highly decorative.

The best example of the fully developed phase of this style is offered by two magnificent bracelets which made their appearance in Thessalonike in 1956 (fig. 39).[58] Each bracelet is subdivided into numerous rectangular panels, each decorated either with a bird, or a flower. The craftsman's interest focuses on their finely controlled curvilinear design,

[57] Dontcheva-Petkova, 1976, 63f. and 1979, 84f. Lucchesi Palli, op. cit., 262f.
[58] S. Pelekanides, "Τὰ χρυσὰ βυζαντινὰ κοσμή-ματα τῆς Θεσσαλονίκης," ΔΧΑΕ, I (1959), 55–71. M. Ross in L'art byzantin-Art européen (Athens, 1964), no. 463. Wessel, Byzantine Enamels, 64. no. 14.

which indeed maximizes the potential of the cloisonné technique. The design flows over the entire area allotted to it without overcrowding it, and is characterized by the use of many circle and teardrop motifs. These are employed with great discrimination continuously crossing the line between figurative and abstract design. Thus, the teardrop motif may be used alone as an abstract geometric motif, but it may also be metamorphosed into a wing or tail of a bird, the leaves of a clover, or even the negative space between two leaves. Similarly, the circles may be used as a fill-in motif, as the eye of a bird or the heart of a flower.

The great refinement and sophistication of the Thessalonike bracelets indicate that they postdate the Martvili triptych. Another example of the same style, however, undoubtedly antedates the triptych. This is the enamel medallions of the angels set on the back of the Volvinius antependium in Milan, a North Italian work of the mid-ninth century (fig. 40).[59] This work uses the same stylistic principle at an earlier stage of development. The flowing gold lines have been rationalized here as the fully opened wings of the angels. They act as an internal framing device, while offering the excuse for masterful colorific contrasts. These contrasts absorb the attention of the artist so much, that the flowing areas of color are not easy to identify as wings at first glance. However, this identification is confirmed by the medallions of the archangels on the Katskhi icon of the Saviour. The latter illustrate the Byzantine version of the same decorative theme.

The Thessalonike bracelets have been dated by Ross in the ninth century on technical grounds. If this is correct, then they date at the turn of the century, later than the Martvili enamel, whose style they have refined and abstracted with great sensitivity and sophistication. The same stylistic and technical idiom, though at an earlier stage of development, is exhibited by the enamels on the Volvinius antependium of ca. 850. Consequently, the Martvili enamel and its relatives should be dated between these two works in the second half of the ninth century.

Confirmation of this date is offered by the decorative motif used to frame the niello christological scenes on the reverse of the central plaque of the Martvili triptych. This is a continuous scroll forming loops that frame a fleur de lis motif. This type of decorative scroll has been traced by Weitzmann to a group of classicizing Constantinopolitan manuscripts, which depict it in blue against a gold background with an effect comparable to the gilded silver scroll of the Martvili frame (fig. 41).[60] Weitzmann dates this group of manuscripts at the turn of the ninth to the tenth century, and relates it to a number of Touronian manuscripts of the mid-ninth century. Consequently, the type of scroll used to frame the niellowork of the triptych also dates it closer to the end of the ninth century.

Though the Fieschi Morgan enamel reflects a different stylistic school from the broad

[59] L'exposition Charlemagne, no. 559. M. M. Gauthier, Emaux du Moyen Age (Fribourg, 1972), no. 10, 317f. Lasko, op. cit., 50–54. Hubert, Porcher, Volbach, L'empire carolingien, figs. 220, 222.

[60] K. Weitzmann, Die byzantinische buchmalerei des 9. und 10.Jahrhunderts, 8. Weitzmann illustrates two examples of this group which are particularly close to the Martvili scroll: (1) Venice, Marciana, cod. gr. I.18, fol. 170r, fig. 41, and (2) London, British Museum, cod. Add. 11300, fol. 8r, fig. 37.

group of enamels that use the schematized curvilinear style, the staurotheque seems to be aware of motifs peculiar to the enamel medium which are used by this group by the middle of the ninth century, as witnessed by the Volvinius Antependium. However, the greater austerity of the rhythm of the New York enamelwork, its comparability to the Altheus enamels, and the severe clarity and sophistication exhibited by its niellowork when compared to the Martvili niellowork suggest dating the staurotheque earlier than the curvilinear enamel group, in the first half of the ninth century. Thus, the analysis of the Martvili triptych, a relative of the Fieschi Morgan reliquary, also suggests a date in the first half of the ninth century for the New York reliquary.

The study of the enamelwork of the Fieschi Morgan has offered no definite clues about the sources of its style, which remains isolated, though broadly comparable to a style used in the West early in the ninth century. Nevertheless, its comparison with enamels datable from the end of the eighth century to the beginning of the tenth century has led to a number of other than pure stylistic clues. The Altheus reliquary enamels of the end of the eighth century have offered an approximate stylistic parallel while demonstrating that motifs misunderstood by the Fieschi Morgan enamelist were successfully adapted to the enamel medium at that time. The cross of Pascal I (817–824) precluded Rome as the place of origin of the Fieschi Morgan enamelist, though it proved to be technically and functionally parallel to the New York staurotheque. The Beresford Hope cross, dated after the cross of Pascal I, is also technically comparable to the Fieschi Morgan, not only in its handling of the medium, but also in the overall handling of the inscriptions. Finally the comparison with the Martvili triptych, which has been dated to the latter part of the ninth century, has shown it to be a descendant of the Fieschi Morgan. All of this material militates for a date in the first half of the ninth century for the New York reliquary, a date that also agrees with the analysis of its iconography and inscriptions. This conclusion is confirmed by David Buckton's study of the evolution of early medieval enamel technique.[61]

Provenance and Background

A discussion of the provenance of these historiated reliquaries has to take into account that their niellowork is technically, stylistically, and iconographically close enough to suggest the same provenance for all three works. It must also take into account that the enamelist is unfamiliar with the Greek language and misunderstands ordinary components of the pictorial vocabulary he is using.

The enamelist was apparently an outsider among these craftsmen, since none of the characteristics of his work are reflected in the niellowork of this group. Actually the story of his background goes beyond his broad, angular, rhythmic style, which finds no close parallels among eastern and western enamels. It also goes beyond his linguistic *faux pas* and

[61] I wish to thank Dr. Buckton for communicating to me the results of his study. D. Buckton, "The Oppenheim or Fieschi-Morgan Reliquary in New York, and the Antecedents of Middle Byzantine Enamel," *Eighth Annual Byzantine Studies Conference. Abstracts of Papers* (Chicago, 1982), 35–36.

his numerous iconographic misunderstandings of everyday iconographic features with which both East and West were familiar. The organization of the saints around the central panel and on the four sides of the box is more than unconventional. Apostles, evangelists and saints are thrown together with little consideration for status or order of appearance. Peter and Paul are placed on the side of the box with John and Andrew without even being centered (fig. 24b). The lid, which would have been the proper place for the princes of the apostles, is occupied by a pastiche of military and healer saints as well as other apostles and evangelists. To make matters worse, while a number of these peripheral saints are labeled "hagios," most of the apostles and evangelists are deprived of this title. Moreover, the saints on the four sides of the staurotheque appear in individual panels and retain their haloes, as opposed to all the saints on the lid.

All these irregularities suggest that in addition to his iconographic and linguistic difficulties, the enamelist was not at home with conventions governing the hierarchical and orderly representation of apostles, evangelists, and saints in Byzantine art. One is tempted to think that he was not at home with their identities either. So, who was this man, and what were his models?

The enamelwork certainly incorporates features which characterize the niellowork of the broader group of reliquaries and crosses in which the Fieschi Morgan has been classified together with the Pliska and Vicopisano crosses. Most of the surviving objects that use the title Theotokos are members of this group. Equally important is the unorthodox inscription that appears on the *tabula ansata* labeling Christ simply as IC. The same is true of the Vicopisano cross and several other crosses.[62] Moreover, the two rows of busts on either side of the enamel Crucifixion are curved on their lower part, revealing themselves to be incomplete adaptations, possibly from the medallions that often frame the figure of the Theotokos on the niello crosses.

In addition to using niello reliquaries as models, the enamelist appears to have used enamel models as well, as suggested by the curving vine behind St. John. The overall arrangement of the cover of the Fieschi Morgan also differs from the customary Byzantine system of decorating similar rectangular objects. The latter usually articulate a frame around their central composition by means of lines parallel to the edges of the object. Contrary to this system, the central panel of the New York staurotheque is framed by a band of saints articulated into four groups by means of four radiating diagonals. Such diagonals, though not found on flat rectangular objects, are characteristic of pyramidal caskets, which were quite common during the Middle Byzantine period. It seems that a pyramidal casket

[62] Christ is labeled IC on the Vicopisano Cross, the cross of the Rhode Island School of Design, the Dumbarton Oaks Cross, and the Tassilo Chalice (IS). A compromise inscription figures on the Monza cross: ICX. The source for this uncommon label cannot be ascertained. However, we do find Christ addressed only as IHCOY instead of as IHCOY XPICTE on private amulets. This more intimate form of address is found, for example, on the reverse cross on a jasper of Leo VI in the Victoria and Albert Museum (Beckwith, *The Art of Constantinople*, 81f., fig. 102). The arms of this cross are traversed by the inscription IHCOY CωCON. It is, therefore, possible to read the inscription IC on the *tabula ansata* of these crosses either as an abbreviation for IHCOYC, or as IHCOY CωCON.

also played a part in the shaping of this enamelwork. Whether its periphery was occupied by individually framed busts of saints (as those depicted on the thickness of this reliquary box), or by medallion busts, we have no way of knowing. The enamel side of the Fieschi Morgan is apparently a composite in whose making a variety of eastern models were used.

It appears that we have a good enamelist catering to eastern tastes, adapting a variety of models in order to produce the luxurious exterior decoration of a portable reliquary. In the process, he makes all kinds of mistakes, which reveal quite a bit about him. This man had language problems. He was also insufficiently familiar with the mentality governing the distribution of saints according to rank in Byzantine art. He also did not understand some of the standard attributes of these saints, which had long been familiar among craftsmen both in the East and the West. These elements are more than sufficient grounds for suggesting that the enamelist was not working at home. Perhaps he was a recent convert; perhaps he was a recently imported skilled laborer. Whoever he was, he worked next to an excellent niellist, whose work was undoubtedly produced at home in the East, since it relates to a large family of reliquaries whose considerable popularity is attested by the variety of purses at which they aimed. In the case of the Fieschi Morgan, the two craftsmen worked together to produce the luxurious historiated multiple pocket reliquary. The co-operation was not very successful, however, or some of the mistakes of the enamelist would have been avoided under the guidance of the niellist, who was at home with the needs and requirements of such personal phylacteries. Why was this enamelist employed, and why was his uncertain and experimental work given such prominence?

The answer probably lies with the enamel technique itself. It is a fair hypothesis that the owner of the numerous precious relics which were to be encased here asked for an enamel exterior when commissioning his staurotheque. Given that the enamel technique was not widespread in the East before the tenth century, the use of an outsider, such as the Fieschi Morgan enamelist, by a Byzantine workshop is less surprising, especially when his great technical competence is considered. The number of enamels that have survived from the ninth century—the cross of Pascal I in particular—prove the increasing esteem in which this precious technique was held from the early ninth century onward. Formal exchanges of gifts between East and West probably helped spread the popularity and the use of enamel in conjunction with the reestablishment of relic-worship by Iconophiles in the post-Iconoclastic period.

One important exchange of this sort took place in 811 as we learn from the inauguration letter of Patriarch Nicephorus I to Pope Leo III. At the end of this important diplomatic document the patriarch mentions a reliquary as the most important of his gifts to the pope. According to his description this was "a gold pectoral (cross), whose one side is entirely enclosed in crystal, while the other side is εἰκονισμένη in the encaustic technique, and this has inside another pectoral (cross), in which particles of the True Cross are inserted."[63] As

[63] PG, 100.200, and Mansi, 14.56: "εἰς σύμβολον δὲ τῆς μεσιτευούσης ἐν ἡμῖν ἐν κυρίῳ ἀγάπης, ἀπεστείλαμεν τῇ ἀδελφικῇ ὑμῶν μακαριότητι, ἐγκόλπιον χρυσοῦν, οὗ ἡ μία ὄψις κρυστάλλου ἐγκατακεκλεισμένη, ἡ δὲ ἑτέρα εἰκονισμένη δι᾽ ἐγκαύσεως, καὶ αὐτὸς ἔχον ἕτερον ἐγκόλπιον, ἐν ᾧ εἰσι μερίδες τῶν τιμίων ξύλων." Frolow, La relique de la Vraie Croix, no. 86. For an analysis of this document, P. O. Connell, The Ecclesiology of St. Nicephorus I. OCA 194 (Rome, 1972), 68–78.

Frolow pointed out, the reference to the use of a crystal casement for the obverse of the reliquary brings to mind the Monza cross, which is protected like this, and whose niello Crucifixion is related to our group of reliquaries.[64] Moreover, it is important that the reverse of the cross was εἰκονισμένη in the encaustic technique, a term that is applied to niellowork. The word εἰκονισμένη can hardly refer to anything other than figurative decoration in this particular case. The date of this letter and its purpose exclude any other interpretation. Iconoclasm had ended in 787, but it would come back in 815. Acceptance of the Orthodox worship of images and relics could not be taken for granted during this time. Therefore, while the patriarch presented his credentials and verbal proof of his Orthodoxy to the pope through this letter, the accompanying reliquary of the True Cross decorated with figurative representatives offered material proof of the Orthodoxy of Nicephorus.

This letter provides important evidence that pectoral reliquary crosses with figurative decoration were acceptable to Iconophiles of the first post-Iconoclastic period as proof of the sincerity of their Orthodoxy, and their opposition to the tenets of Iconoclasm. The combination of relic worship and image worship on these phylacteries was a natural response to the iconoclastic persecution of relics and images since the days of Constantine V (741–775). Both aspects of Constantine's policy had been considered sacrilegious by the Iconophiles. Consequently the Seventh Ecumenical Council of 787 reinstated the worship of relics together with the worship of images.[65] After that date, the development and use of historiated reliquaries became a suitable and readily available assertion of iconophile Orthodoxy. This is confirmed by another work of Nicephorus, his Third Antirrheticus, written between 818 and 820 after his deposition by Leo V. Here the ex-patriarch asserts that despite the taunts of Iconoclasts who curse "the life-giving woods"—i.e. the relics of the True Cross—countless Christians possess them and wear them in gold and silver cases as phylacteries. These depict "the Passion of Christ and the miracles and the life-giving Anastasis" and "guard and insure our life and the preservation of our souls and bodies."[66]

These two sources establish and explain the widespread use of portable historiated phylacteries in the post-Iconoclastic period. They were the easiest outward means of confessing to Orthodoxy while providing protection against all misfortune.[67] No wonder they were endorsed by the official Iconophile theoreticians, as well as by the man in the street. To judge by the cross of Pascal I, the use of enamel was in demand for a higher class of reliquaries in the first quarter of the ninth century. Such a demand could explain the precedence allotted to the work of the good though unconventional craftsman who decorated the exterior of the New York staurotheque.

The date of the Third Antirrheticus after the return of the Iconoclasts in 815 suggests that the "countless" historiated portable reliquaries possessed by pious Iconophiles were not all destroyed but continued to be venerated after 815. It was undoubtedly difficult to search out and destroy such small personal amulets, which were easy to hide. The owners

[64] Frolow, "Le culte de la relique de la Vraie Croix à la fin du VIe– au début du VIIe siècles," 325.

[65] Act VII. Mansi, 13.405. Ralles and Potles, Σύνταγμα τῶν θείων καὶ ἱερῶν κανόνων, II, 580.

[66] PG, 100.433C. Mango, Sources, 176. For the date of the Third Antirrheticus, Beck, 490.

[67] Frolow, op. cit., 328ff.

of these precious phylacteries, which invoked the healing powers of the story of the Incarnation and Passion for the soul and body of their user, had every reason to preserve them. There is even evidence that the denouncement and destruction of relics of the True Cross was not an imperial policy during the second Iconoclastic period. In fact, the official city relic at Hagia Sophia was officially called by the authorities to prove its powers in 822, when it was invoked to protect the city during the siege of Thomas the Slav.[68] Significantly, the initiative was provided by the Iconoclast emperor Michael II and his young son and co-emperor Theophilus. The illustrated manuscript of Skylitzes in Madrid, which dates from the twelfth or thirteenth century, depicts the actual relic in the hand of Theophilus.[69] This suggests that the relics of the True Cross were not actively denounced between 815 and 843 by Iconoclasts, and that their devotional value was officially admitted and used by the iconoclast emperors themselves. It is unlikely that during the same period the same emperors would have sought out and destroyed "countless" small private reliquaries of the True Cross, even if most of them were historiated, as Nicephorus claims. If they were not sought out systematically, then there would be no reason why their production could not have continued clandestinely by enterprising iconophile goldsmiths. Given the size and private use of these artifacts, jewelers ran much less risk than Lazarus the Painter of having their hands burned.

So the words of Patriarch Nicephorus indicate that the group of historiated reliquaries which concerns us could have been produced in Constantinople. Up to 815 official policy supported and encouraged the widespread demand for such objects in the capital. This policy was withdrawn between 815–843, but the use and demand for such private phylacteries probably continued. It is not likely that the local Constantinopolitan goldsmiths deferred such lucrative business to other metropolitan centers. The figurative crosses and reliquaries demanded by the iconophile market were certainly more expensive than the plain aniconic crosses used by Iconoclasts. Figurative reliquaries required more labor and precious material since they consisted of two or more extensively decorated parts. It is reasonable to assume that the Constantinopolitan demand was met by local jewelers.

Some of the phylacteries sold locally were undoubtedly mass-produced, as suggested by the numerous bronze crosses related to our group of reliquaries which represent the Crucifixion and the standing Virgin surrounded by four medallions. Others, though also produced in considerable numbers, were intended as luxury objects for a wealthier clientele. Such were the silver-gilt Vicopisano cross (12 x 8 cm) and the small but precious gold Pliska cross (4.2 x 3.2 cm). The bronze cross found in Chersonnesos representing in silver inlay

[68] Theophanes Continuatus, *Chronographia*. CSHB, I. Bekker, ed. (Bonn, 1838), 32, 59. Genesius, *Regna*. CSHB, C. Lachmann, ed. (Bonn, 1834), 33, 39. Georgius Kedrenus, *Historiarum Compendium*. CSHB, I. Bekker, ed. (Bonn, 1838), 9.2, 81. Frolow, *La relique de la Vraie Croix*, no. 90.

[69] S. C. Estopañan, *Skyllitzes Matritensis* (Barcelona, 1965), 65, no. 73, pl. p. 248, fol. 33ʳ. A. Grabar

and M. I. Manoussakas, *L'illustration du manuscrit de Skyllitzès de la Bibliiothèque Nationale de Madrid* (Venice, 1979), 35, fig. 22. For the date of the manuscript, see also N. G. Wilson, "The Madrid Scylitzes," *Scrittura e civiltà*, 2 (1978), 209–219. Wilson dates the manuscript to the second half of the twelfth century, and attributes it to an Italo-Greek workshop.

the Ascension and the Transfiguration (7.9 x 5.9 cm) probably belongs in the same category. Still, other portable historiated phylacteries must have been made to order. The Fieschi Morgan belongs to this category.

Despite its pocket size (10.2 x 7.35 cm), its shape is different from that of the mass-produced phylacteries. Its decoration is elaborate and includes the much coveted and expensive enamel technique, knowledge of which was sufficiently rare in the first half of the ninth century in the East to lead to the toleration of the pictorial and verbal barbarisms of an otherwise excellent enamelist. The differences in technical difficulty and expense between the niello and enamel techniques were known and appreciated in the ninth century. This is inferred from a passage in the Life of Basil I, written in the first half of the tenth century. It describes a house of prayer built by Basil I in the eastern part of the palace and dedicated to the Saviour. Its costly magnificence was incredible. "Indeed, the entire pavement is made of solid beaten silver with niello (enkausis) exhibiting the perfection of the jeweler's art," while the beam on top of "the closure that separates the choir from the nave. . . . is of pure gold, and all the wealth of India has been poured upon it. The image of our Lord, the God-man, is represented several times in enamel (chumeusis) upon this beam."[70] The use of niello for the pavement reflects its frequent use for the decoration of gold and silver reliquaries. The function reserved for it in this house of prayer is in sharp contrast to the use of the enamel technique. This is employed on the upper part of the gold choir closure for the portrait of Christ echoing the limited use of enamel on historiated phylacteries up to the end of the century. This passage illustrates the corresponding status of the two techniques during the ninth century. Consequently, the use of enamel on the Fieschi Morgan in the first half of the century is evidence of the luxurious character of this object.

The Fieschi Morgan, furthermore, differs from the other portable historiated reliquaries considered here in its function as a multiple portable reliquary. The patriarchal cross under the lid is subdivided into no fewer than six compartments, and there were four more in the corners of the small box especially designed as separate covered receptacles. In addition to the protection of a considerable number of relics, the owner of the Fieschi Morgan invoked the healing power of the incarnation and the Passion as well as the aid of the Virgin, the evangelists, most apostles, some ecclesiastical saints, and finally, some healer and some military saints. In terms of efficacy, this portable phylactery must have been exceptional. So many guardian saints and so many relics could have probably guaranteed even the bodily and spiritual preservation of an emperor. Actually, iconophile lore attributed the use of a portable historiated phylactery even to Leo the Armenian. The story went that Leo hypocritically took out a historiated phylactery, paid homage to it, and kissed it in order to demonstrate his acceptance of image worship during a public confrontation with Patriarch Nicephorus before reinstating Iconoclasm in 815.[71] Presumably, the private portable his-

[70] Mango, Sources, 196.

[71] Βίος Νικήτα ἡγουμένου Μονῆς Μηδίκου. Μέγας Συναξαριστής, Ἀπρίλιος, K. Doukakis, ed. (Athens, 1892), 46. Beck, 639, dates this text after Symeon Metaphrastes, between the tenth and twelfth centuries. "πρὸς δὲ τὸ συλλεχϑὲν πλῆϑος, τοιαῦτα μεϑ'

toriated phylacteries intended for the protection of so important patrons would be above average in every respect. The Fieschi Morgan, which fulfills this requirement, was probably considered valuable beyond its actual cost, even in its own time.

In the early ninth century few metropolitan centers other than Constantinople had the means, incentive, money, and contact with the outside world to motivate goldsmiths to produce such expensive, fashionable, innovative, and efficacious portable phylacteries. Jerusalem and Palestine were declining in the early ninth century as flourishing Christian centers. Nonetheless, Syro-Palestine has been often proposed as the place of origin of the Fieschi Morgan reliquary, and consequently for the Vicopisano and Pliska crosses. As we have seen, the Syrian-Melchite All-Saints Litany, cautiously referred to by Rosenberg, is far from a solid basis for the attribution of the Fieschi Morgan to Syro-Palestine. Actually, it is doubtful that the selection of saints can help solve the problem of provenance of the New York reliquary and its relatives. All of the saints represented were widely accepted by the Middle Byzantine period, as evidenced by the *Synaxarium Constantinopolitanum* and the *Typicon* of Hagia Sophia.[72]

Iconographic considerations do not encourage attributing this group of reliquaries to Syro-Palestine either. The continuous use of the colobium Crucifixion in the pictorial arts up to the end of the Macedonian period, and occasionally beyond, contradicts a Syro-Palestinian origin for this iconographic type of Crucifixion. Furthermore, the altarlike manger, which is characteristic of Syro-Palestinian works from the sixth to the early tenth centuries,[73] is reduced here. The shallow box that functions as the manger and the attitude of the reclining Virgin are closer to the iconography of the Nativity on the enamel cross of Pascal I and the eleventh-century Constantinopolitan Lavra Skevophylakion Lectionary (fig. 80) than to the *loca sancta* iconography of the Nativity. The Anastasis similarly compares well with the Roman mosaic in the Chapel of S. Zeno (fig. 23). Taking also into account the evidence of the iconography of the Pliska and Vicopisano crosses, we note that the altar in the scene of the Presentation in the Temple has not been correlated with the *loca sancta* iconography but rather with considerations of a liturgical nature. Similarly, the use of the round mandorla characteristic of the Transfiguration on the Pliska cross echoes a motif known from Constantinopolitan works such as the Paris Gregory and Mt. Athos, Iviron, cod. 1, as well as from the Chapel of S. Zeno in Rome. It seems that the group of historiated reliquaries considered here does not reflect the *loca sancta* iconography, which continued in use in Syro-Palestine in the eighth and ninth centuries. It employs instead a pictorial vocabulary known equally well to Constantinople, Italy, and Thessalonike throughout the ninth century. Consequently, the iconography of the Fieschi Morgan, the Vicopisano, and the Pliska reliquaries does not demonstrate a substantial Syro-Palestinian connection. It points to a range of motifs widely used in the ninth century.

Italy has been precluded as the place of origin of this group of historiated reliquaries pri-

ὑποκρίσεως ἀποφθέγγεται. Ἐγὼ μέν, ὦ παρόντες, καὶ τοῦ αὐτοῦ δόγματος ὑμῖν μετέχω, καὶ τῆς αὐτῆς πίστεως, καὶ προσκύνησιν τῶν εἰκόνων ποιοῦμαι· ἐκβαλλὼν ἐγκόλπιον ἐξεικονισμένον, προσκυνῶ καὶ ἀσπάζομαι." [72] SCP, passim. Mateos, passim.
[73] Weitzmann, *Sinai Icons*, I, B.41.

marily for stylistic reasons. The Greek inscriptions also discourage such an attribution. Nothing specific correlates them with Palestine either. On the other hand, historical considerations show that Constantinople was an important center for the production of such historiated reliquaries in the first half of the ninth century. Certain iconographic features of this group were used in ninth-century Constantinople. Constantinopolitan trends are also reflected in the use of the label "Theotokos" for the image of the Virgin, which parallels its use in other Constantinopolitan works, as the Psalter Pantocrator 61 (fig. 34). Finally, the uninterrupted Constantinopolitan production of this type of figurative phylactery well into the Late Byzantine period points to Constantinople. Thus, by the process of elimination, Constantinople and its immediate metropolitan dependencies, such as Thessalonike, emerge as the most likely centers for the production of this group of historiated reliquaries.

All evidence discussed points to a post-787 date for this group. However, several considerations discourage dating the Fieschi Morgan reliquary, the earliest member of the group, before the beginning of the ninth century. The official policy on historiated reliquaries and their popularization is not likely to have been effected overnight, given the moderate iconophile policies of Empress Irene and her chosen Patriarch Tarasius in the early stages of the first post-Iconoclastic period. Similarly, the use of more than one model by the Fieschi Morgan craftsmen suggests that the production of such historiated reliquaries was well under way when the Fieschi Morgan was made. Both these factors argue against dating the New York staurotheque immediately after 787. Moreover, the Fieschi Morgan enamelist uses models that reflect the schematized curvilinear enamel style, whose earliest dated example is the Milan Antependium of the mid-ninth century (fig. 40). The inability of the enamelist to fix his letters witnesses the same technical difficulty as the inscriptions on the Beresford Hope cross (fig. 31), which dates after the cross of Pascal I (817–824). This technical problem was solved before the end of the ninth century, as evidenced by the enamel medallion of Leo VI in Venice (fig. 32). It seems, therefore, that the Milan Antependium and the Beresford Hope cross draw the Fieschi Morgan reliquary into the earlier part of the ninth century. The same is true of Altheus reliquary (fig. 36) and the cross of Pascal I, whose enamel technique compares to that of the New York staurotheque.

For these reasons, I favor a date in the first quarter of the ninth century for the Fieschi Morgan reliquary, and consider as most probable the Constantinopolitan provenance of this group of historiated reliquaries. But the origin and background of the Fieschi Morgan enamelist, who tried to adapt his skill to an alien culture, language, and tastes, remains open to conjecture. We can only say that he knew his craft well, and that he had not learned it either in a Byzantine or in any known western enamel workshop.

The Anastasis

The new date for the Fieschi Morgan reliquary in the first quarter of the ninth century, and particularly its placement in the iconographic context of christological cycles of reliquary crosses of that period, is important in a number of ways. In the narrower iconographic

sense, it suggests that in the early ninth century the East had already produced a type of Anastasis that represented a similar stage of development and required a comparable set of iconographic particulars as its western counterpart, even though what it chose to elaborate differed. The *tenebrae* were replaced by the broken gates of the underworld and the anonymous dead were represented specifically by King David and King Solomon. The inclusion of the Anastasis in abbreviated christological cycles suggests that it had not only become acceptable, but had even become a mandatory part of them.

More important is the use of this proto-post-Iconoclastic cycle, and the Anastasis that is part of it, on portable reliquaries because its function relates to early post-Iconoclastic theory and practice. As we have already seen, the use of relics encased in personal amulets decorated with abbreviated christological cycles functioned primarily as tangible proof of anti-Iconoclastic sentiment in matters of theology and worship, while offering a perpetual incantation on behalf of their owner. The prophylactic and commemorative function of the abbreviated christological cycles of the seventh century ampullae, rings, bracelets and censers was reinterpreted in the first post-Iconoclastic period through the use of comparable cycles on portable reliquaries for polemical purposes. The shift of focus resulting from the use of polemics served to emphasize every major Iconophile position with regard to images, relics, and the cult of the Virgin as the Mother of God, whose incarnation and Passion ensured redemption. Such aggressive material confessions were officially condoned by the church. The image of the Anastasis served as one of the arguments capable of justifying the major Orthodox points. The authority of Patriarch Nicephorus provides once more some clues to the interpretation, which made the Anastasis an integral part of early post-Iconoclastic applied theology.

In his inauguration letter to Pope Leo III the patriarch offers an elaborated and updated version of the traditional profession of faith following a pattern used during the Council of 787.[74] Here he develops at some length the theme of the Resurrection.[75] This is linked to the doctrine of the renewal of Creation through the Passion, in conjunction with the theme of the Resurrection of mankind in the body, and the worship of relics, for the most part the relics of the Just whose "souls are in the hands of the Lord."[76] Thus, the defense of the iconophile theory concerning the worship of relics of the "imitators of Christ's Passion" uses the story of the defeat of Hades and the Resurrection thence, the prime *exemplum* of salvation and redemption. Similarly, the iconophile theory of images employs the theme of the Anastasis as an *exemplum* of the salvation promised for all mankind.

One of the accusations against Iconophiles was that together with the image of Christ they depicted "abominations and forbidden matters," which were unintentionally honored together with Christ. Iconoclasts illustrated this argument with the image of the Anastasis, which depicts "the treading of Hades underfoot, and the overthrowing and abolition of the devil." Nicephorus, who is the source of this, counters the objection of the

[74] Above, n. 3.63. and n. 5.63.

[75] PG, 100.188D–189A. Also, O'Connell, op. cit., 72.

[76] PG, 100.189D. The same expression is used in Mansi, 12.1143B.

Iconoclasts in the Third Antirrheticus by suggesting that homage is due only to holiness, while disgraceful matters are to be regarded and contemplated as depicted, that is, trampled and dead, thus functioning in the image of the Anastasis not as objects of veneration, but as material reminders of the universal salvation of mankind.[77]

As a result, the theme of the Anastasis contributes to the defense of images as well as to the defense of relic worship. The words of Nicephorus, however, go beyond this. They confirm that the motif of the trampling of the figure of Hades was important to the eastern iconographic scheme of the Anastasis in the early ninth century, as is also witnessed by the Fieschi Morgan reliquary. Furthermore, they offer a possible explanation for the omission of the figure of Hades from the representation of the Anastasis in the western ninth-century examples already examined. This omission—also encountered in later eastern examples, as the Lavra Skevophylakion Lectionary (fig. 80)—indicates the existence of a restrained iconographic school of Iconophiles. Their response to iconoclastic criticism appears to have been defensive and/or conciliatory: they chose to delete the person of Hades from the image of the Anastasis rendering it immune to this particular Iconoclastic objection. Nevertheless, the attitude of this pictorial school is not likely to have been very popular in the East, as may be inferred both from the words of the patriarch and the type of Anastasis adopted by post-Iconoclastic historiated reliquaries.

[77] PG, 100.436f.

VI

THE EAST IN THE NINTH CENTURY

That more than one school of thought influenced the post-Iconoclastic development of the image of the Anastasis is not surprising. It is well known that the victorious Iconophile party was not unanimous on theological policy. It was divided into extremists and moderates who fought each other as well as Iconoclasts. The artistic production of the period seems to reflect the disagreements dividing the Iconophiles in the variety of interpretations of the Anastasis during the ninth century. The Psalters with marginal illustrations, Paris gr. 510 and some monumental works now lost, offer samples of diverging attitudes toward this theme. Their interpretations range from extremist to conservative, demonstrating that the post-Iconoclastic development of the iconography in the East was more complex than its use on historiated reliquaries would indicate. A review of this material shows that the ninth century accepted the Anastasis but continued to experiment with it. Different Iconophile schools argued how best to integrate this ideogram of salvation into the fast-developing system of applied theology.

THE PSALTERS WITH MARGINAL ILLUSTRATIONS[1]

The milieu that produced the Psalters with marginal illustrations is still open to question. Nevertheless, the attitude of these manuscripts toward the theme of Christ's Resurrection

[1] Chloudof Psalter: Moscow, Historical Museum, cod. 129 (above, n. 1.4). Mt. Athos, Pantocrator, cod.61 [S. Dufrenne, *L'illustration des psautiers grecs du Moyen Age* I. *Pantocrator 61, Paris Grec 20, British Museum 40731*. Bibliothèque des Cahiers Archéologiques, 1 (Paris, 1966)]. Paris, Bibliothèque Nationale, cod. gr. 20 (ibid.). Bristol Psalter: London, British Museum, cod. Add. 40731 (ibid.). Theodore Psalter. London, British Museum, cod. Add. 19352 [S. Der Nersessian, *L'illustration des psautiers grecs du Moyen Age* II. *Londres Add. 19352*. Bibliothèque des Cahiers Archéologiques, 5 (Paris, 1970). R. Stichel, "Zu Fragen der Publikation byzantinischer illustrierter Psalterhandschriften," *Zeitschrift für Balkanologie*, 12 (1976), 78–85. Chr. Walter, "Pictures of the Clergy in the Theodore Psalter," *REB*, 31 (1973), 229–242]. Barberini Psalter: Vatican, Biblioteca, cod. Barb. gr. 372 [J. G. Anderson, "The Date and Purpose of the Barberini Psalter," *CA*, 31 (1983), 35–67. Spatharakis, *The Portrait in Byzantine Illuminated Manuscripts*, 26–36]. Baltimore, Walters Art Gallery, cod. w 733 [D. Miner, "The 'Monastic' Psalter of the Walters Art Gallery," *Late Classical and Mediaeval Studies in Honor of Albert Mathias Friend, Jr.* (Princeton, 1955), 232–254. A. Cutler, "The Marginal Psalter of the Walters Art Gallery. A reconsideration," *JWAG*, 35 (1977), 37–62]. Mount Sinai, Monastery of St. Catherine, cod. gr. 48 [K. Weitzmann, "The Sinai Psalter cod. 48 with Marginal Illustrations and Three Leaves in Leningrad," *Byzantine Liturgical Psalters and Gospels* (London, 1980), VII]. Hamilton Psalter: Berlin, Kupfestichkabinett, cod. 78.A.9 [D. Wescher, *Miniaturen des Kupfestichkabinetts der Staatlichen Museen Berlin* (Leipzig, 1931), 25–30. Chr. Havice, "The Hamilton Psalter in Berlin, Kupfestichkabinett 78.A.9," Ph.D. Dissertation. The Pennsylvania State

proves their Iconophile extremism. The theme undergoes bold experiments that may be regarded as the Psalter school's contribution to the pictorialization of the Death of Christ.

The illustration of the time period spanning the Death of Christ on the cross and his rising from the tomb is meticulously explored. More than one solution is frequently tried out for the same idea, while the moments chosen for illustration often overlap. These manuscripts continue the tradition of coupling the themes of Christ's Death and Resurrection. As a result, it is best to consider together the pictorial treatment of these two themes in the Psalters with marginal miniatures.

The Crucifixion [2]

The ambivalent eagerness with which the theme of the Death of Christ is approached in this group of manuscripts is best illustrated by the first and most prominent of the scenes that deal with it, the Crucifixion. Ps. 21:2,[3] 45:7,[4] 68:22,[5] 73:12,[6] and 131:7[7] are illustrated with the Crucifixion. However, its portrayal varies to the extent of covering most possible alternatives of depicting Christ alive or dead on the cross dressed in a colobium or a loincloth. The illustration of Ps. 68:22 in the Chloudof Psalter, fol. 67[r], shows Christ alive and dressed in a colobium. The colobium-clad Christ illustrating Ps. 45:7 in the same manuscript, fol. 45[v], is portrayed unquestionably dead on the cross. He is similarly dead on the cross in the illustration of Ps. 73:12, fol. 72[v]. This time, however, he wears only a loincloth. Similarly, the other Psalters reflect willingness to use side by side the oldest type of a colobium-clad Christ alive on the cross, (which harks back to the Rabbula Gospels), the colobium-clad Christ dead on the cross (which appeared in the first half of the eighth century), and finally, the loinclothed Christ dead on the cross, first encountered at the turn to the ninth century.

The whole issue of the pictorialization of a dead or an alive Christ on the cross was apparently wide open in the ninth century, since all types hitherto acceptable to Byzantine art are brought together. The only type of Crucifixion not used here—as far as flaking and overpainting allow us to see—is the loinclothed Christ alive on the cross. This type, which goes back to the Early Christian period, and which became popular in the Carolingian West from the mid-eighth century on, was mostly rejected in the East, though it might have been used occasionally, as we shall see later.[8]

University, 1978]. Kiev Psalter: Leningrad Public Library, Collection of former Society of Amateurs of Ancient Texts, cod. OLDP, F6. [G. Vzdornov, *Isslodovanie o Kievskoi Psaltyri* (Moscow, 1978)]. Also, S. Dufrenne, *Tableaux synoptiques de 15 psautiers médiévaux* (Paris, 1978).

[2] Martin, "The Dead Christ on the Cross in Byzantine Art," 189–196. Grabar, *L'iconoclasme byzantin*, 228–231. R. Hausherr, "Der tote Christus am Kreuz. Zur Ikonographie des Gerokreuzes," Dissertation, Bonn, 1963, 125ff., 205f.

[3] Pantocrator 61, fol. 10[r]. Barberini, fol. 32[r]. Ham-

ilton, fol. 69[v].

[4] Chloudof, fol. 45[v]. Barberini, fol. 75[v]. Hamilton, fol. 106[v].

[5] Chloudof, fol. 67[r]. Bristol, fol. 110[r]. Theodore, fol. 87[v]. Barberini, fol. 109[v]. Hamilton, fol. 135[v].

[6] Chloudof, fol. 72[v]. Pantocrator 61, fol. 98[r], Theodore, fol. 96[r]. Barberini, fol. 119[v]. Hamilton, fol. 144[r].

[7] Theodore, fol. 172[v]. Barberini, fol. 217[r].

[8] The loinclothed figure of Christ makes its appearance as early as the doors of S. Sabina in Rome and the ivory in London [W. F. Volbach, *Early Christian Art*

The Descent from the Cross [9]

At first, fol. 35ᵛ, illustrating Ps. 21.17 in the Bristol Psalter, appears to illustrate the Descent from the Cross. However, a comparison of this miniature with the Chloudof Psalter (fol. 20ʳ), Theodore Psalter (fol. 23ʳ), Barberini Psalter (fol. 37ᵛ), and Hamilton Psalter (fol. 70ᵛ), all of which illustrate the same psalm similarly, allows little doubt that the subject of the Bristol miniature is the Nailing on the Cross and not the Deposition. Even though the theme of the Deposition became popular in the Middle Byzantine period, it is omitted from the cycle of the Death of Christ in Psalters with marginal miniatures, with one exception. This is fol. 163ᵛ of the Hamilton Psalter, where its presence denotes the expansion of the traditional illustration of Ps. 87:7 with the Entombment in this group of manuscripts.

The image of the Descent from the Cross is another theme in this cycle we find no trace of in pictorial and literary pre-Iconoclastic sources. Its earliest example dates probably to the first half of the ninth century and comes from a Northern French manuscript at Angers, Municipal Library, cod. 24. The first Byzantine example is Paris gr. 510, which will be discussed later. The illustration of this scene here after the Crucifixion, in accordance with standard Middle Byzantine practice, shows the familiarity of the ninth century with this iconographic theme. But its absence from earlier sources, in conjunction with its peculiar omission from the Psalters with marginal miniatures which show a lively interest in the Death of Christ, suggest the relative novelty of this theme in the visual arts.

The Entombment [10]

The next theme in this cycle of the Death of Christ illustrates Ps. 87:7 with the Entombment. Much as the *Hodegos* of Sinaites led us to expect, Joseph of Arimathea and Nicodemus are depicted carrying together the inert and stiff body of Christ, which has its eyes

(New York, 1961), 330, fig. 103; 329, fig. 98.]. It appears, however, that this iconography was shocking, as attested by Gregory of Tours, who speaks of a Crucifixion icon at Narbonne begging to be clothed (P.L. 71.724f.). The Carolingian West accepted the loinclothed figure of Christ, so long as it was represented with wide-open eyes. One of the earliest instances of this variant is the animated T of the *Te Igitur* in the Sacramentary of Gellone [B. Teyssèdre, *Le Sacramentaire de Gellone et la figure humaine dans les manuscrits francs du VIIe siècle* (Paris, 1959), 108ff.]. Christ is depicted in the same manner in the Stuttgart Psalter (fols. 25ᵛ, 27ʳ), probably in the Utrecht Psalter (fols. 67ʳ, 51ᵛ, 85ᵛ, 90ʳ), in S. Vincezo al Volturno and in Cimitile (Belting, *Studien zur beneventanischen Malerei*, figs. 41, 105), at S. Angelo in Formis, and in many more instances [J. Reil, *Christus am Kreuz in der Bildkunst der Karolingerzeit* (Leipzig, 1930)]. Therefore, it is not surprising that the papal legate Cardinal Humbert considered blasphemous the standard Middle Byzantine iconography of the dead Christ on the cross at ca. 1054. [L. H. Grondijs, *L'iconographie byzantine du crucifié mort sur la croix. Bibliotheca Byzantina Bruxellensis* 1 (Utrecht, 1947), 129ff.]. Not long thereafter, western art also adopted the image of the dead Christ.

[9] E. C. Parker, "The Descent from the Cross: Its Relation to the Extra-Liturgical *Depositio* Drama," Ph.D. Dissertation, New York University, 1975.

[10] Weitzmann, "The Origin of the Threnos," 476–490. Le Roux, "Les mises au tombeau dans l'enluminure, les ivoires, et la sculpture du IXe au XIIe siècle," I. 479–486. M. Sotiriou, "Ἐνταφιασμὸς-Θρῆνος," 139–148.

closed and is usually swathed in a winding sheet. They are heading for a dark cave on the side of a disproportionately small hill. Sometimes Nicodemus is already inside the cave.[11]

This iconography synthesizes and interprets more than one account of the event. The text of Ps. 87:7 requires the placement "in the lowest pit, in darkness" echoing the Gospels. John 19:39 is the only Gospel text that includes Nicodemus in its narrative of the Entombment, adding that it took place in a garden near Golgotha and in a tomb which was already there but had never been used before. Matthew 27:60 says this tomb belonged to Joseph, it was "hewn out in the rock," and also that Joseph "rolled a great stone against the door of the tomb." Mark 16:46 and Luke 23:53 agree that the tomb was "hewn out of a rock," but they are not as precise as the account in Matthew 27. This iconography, then, appears to owe most of its details to Matthew, which specifies that Christ was buried in a man-made cave, while the location of this cave in a small hill is probably from John, which mentions Golgotha. The text of John also explains the presence of Nicodemus.

The apparent agreement of this image with a synthesis of the Gospel narrative is not surprising. What is puzzling is that its integration into any of the christological cycles encountered so far brings out a telling iconographic incongruity. The tomb of Christ, so accurately represented here as a cave hewn out of the rock of the hill of Golgotha, starkly contrasts with the traditional representation of the tomb as a man-made, self-sufficient structure with recognizable architectural features.[12] For example, earlier christological cycles always depicted the Myrophores approaching one or another version of such a structure. The sequential presentation of the Entombment and the Myrophores in an extended narrative cycle would create a logical conflict over essential features of the burial site of Christ. Moreover, the use of either of these solutions involves a different approach toward this iconographic theme. The cave represents literal adherence to the Gospel narrative, while the architectural structure is instead a reference to the *locus sanctus* of the Holy Sepulchre—even if this results in an anachronism in the scene of the Myrophores. It is thus difficult to support the hypothesis that these two scenes together go back to an Early Christian christological cycle. It is much easier to suggest that they were established independently and only later integrated as a sequence into such cycles.

Awareness of the differences between these two types of burial grounds is manifested in various attempts from the ninth century on to reconcile the pictorial disparity between the unprepossessing cave hewn in the rock of Golgotha and the impressive piece of architecture that served as the Holy Sepulchre. The Paris Gregory uses only the cave. In the Leningrad Gospel Lectionary, cod. gr. 21, Joseph and Nicodemus appear to be inside the burial chamber avoiding a description of the tomb's exterior.[13] Examples from the early tenth

[11] Chloudof, fol. 87ʳ. Pantocrator 61, fol. 122ʳ. Bristol, fol. 145ʳ. Theodore, fol. 116ʳ. Barberini, fol. 143ᵛ. Hamilton, fol. 163ᵛ. In the Chloudof and Barberini Psalter miniatures Joseph and Nicodemus are depicted outside the cave. In the Pantocrator Psalter and in the Bristol Psalter miniatures Nicodemus is already inside the cave.

[12] For the representation of the Holy Sepulchre in the Psalters with marginal illustrations, see A. Grabar, "Quelques notes sur les psautiers illustrés byzantins du IXe siècle," *CA*, 15 (1965), 69f.

[13] C. R. Morey, "Notes on East Christian Miniatures," *AB*, 11 (1929), 84f., fig. 100. The two Marys are depicted here sitting in front of the tomb of

century on often replace the cave of the Entombment with architectural structures of various degrees of sumptuousness, as seen in the New Tokali Kilise and the Cavusin Dovecote in Cappadocia and on an ivory in Munich.[14] By the same token, the iconography of the Myrophores presents us by the eleventh century with a variant closer to the biblical account in its use of a cave as the burial site for Christ's body.[15]

These two traditions are still separate in the early Psalters with marginal illustrations. Here Christ is buried in the simplest cave, in puritan agreement with the Gospel texts, while in all other instances, which are numerous, Christ's tomb is rendered as a free-standing round building. Though the pictorial frugality of these early examples of the Entombment may be attributed to the Gospels, it marks at the same time a fundamentalist attitude that seeks to stress the unceremonious and unadorned humbleness of the burial of the dead body of Christ. There are no parallels in the Early Christian period for this attitude toward the pictorial theme of Christ's tomb. Sinaites, who offers the first known instance in which the image of the burial of Christ was probably used, chooses to exemplify the completeness of Christ's voluntary humiliation by dwelling on the theme of the burial, because it helps argue the total reality of Christ's human nature.[16] His argument requires an unpretentious and realistic image of the Entombment, such as that found in the early Psalters with marginal illustrations.

So the obvious difference of these two pictorial traditions, and the absence of mature solutions to this problem in the surviving examples of the ninth century indicate that the theme of the Entombment was a relatively new addition in christological cycles despite its faithful synthesis of the text of the Gospels. Sinaites exemplifies the kind of context that necessitates the frugality of the early examples of this image, which ran counter to the long-established tradition of using the iconography of the Holy Sepulchre in representations of the tomb of Christ.

Christ, which is hewn in the rock and is blocked by the stone. In the scene of the Entombment, which appears immediately above, Morey believed that "a nearly obliterated tree (to the right) represents the garden, the entrance to which is summarily rendered by the portal to the left." The condition of the miniature discourages any categorical statements. However, there are no iconographic parallels for the representation of the Entombment in the garden without the inclusion of some sort of reference to the tomb of Christ as well. Joseph and Nicodemus might be represented past the entrance of the tomb of Christ, avoiding the depiction of the tomb hewn in the rock twice within the same frame. Elsewhere Morey (op. cit., 69f.) also seems to think that the iconography of the tomb hewn in the rock is a Middle Byzantine development, which frees the iconography of the sepulchre "from the influence of Constantine's *memoria*." For Lectionary Leningrad 21, see also, *Iskusstvo Vizantii V Sobraniiakh SSSR*, II, no. 481, and V. D. Likhacheva, *Iskusstvo Knigi. Konstantinopol* (Moscow,

1976), pls. 5ff.

[14] For the two Cappadocian churches, see chapter seven. For the Munich ivory, Weitzmann, "The Origin of the Threnos," fig. 8, and below, 174, and n. 7.31. The Psalter iconography also marks this transition: Christ is to be buried in a man-made tomb in the Theodore Psalter. Moreover, the burial procession has grown to include an angel above and the two mourning Marys below.

[15] The transition from the man-made structure approached by the Myrophores in the Lectionary Leningrad 21 (Morey, op. cit., 69f., fig. 75) to the uniform representation of the tomb of Christ as the tomb hewn in the rock in the Lectionary Dionysiou 587 is telling. S. M. Pelekanidis, P. C. Christou, Ch. Tsioumis, S. N. Kadas, *The Treasures of Mount Athos. Illuminated Manuscripts* (Athens 1973–1979), I, figs. 192ff.: Dionysiou, cod. 587, fols. 5ʳ, 16ʳ, 113ᵛ twice, 167ᵛ, 170ᵛ, 171v. Hereafter: *The Treasures of Mt. Athos.*

[16] Anastasius Sinaites, *Hodegos*, PG. 89.216ff. Uthe-

The Three Nights and Three Days Before the Rising of Christ [17]

The Psalters with marginal miniatures include a number of illustrations from the period after the burial of Christ in the grave. They illustrate:

a. Ps. 68:28 with the theme of the chief priests bribing the soldiers guarding the tomb of Christ.[18]

b. Ps. 7:7 with David prophesying the Resurrection of Christ in front of Christ's closed tomb while its guards are sleeping.[19]

c. Ps. 9:33[20] and 11:6[21] with David leaning toward the tomb of Christ prophesying about the Resurrection while Christ can be seen sitting inside the tomb, resting comfortably against its wall, and apparently aware of David's presence.

In all these instances the tomb of Christ is depicted either as an isolated small building topped by a pyramidal roof or as a rectangular edifice topped by a ciborium. The use of different types of tomb suggests the presence of more than one model. This is confirmed by the use of two different types of David, as an older or younger man, as for example in the illustration of Ps. 7:7 and 9:33 in the Chloudof Psalter.

The closely interrelated illustrations listed here under *b* and *c* were probably invented specifically for the illustration of Psalters, even though it is not clear why the presence of Christ sitting inside the tomb is required in one instance and not the other. This category of illustrations characterizes the Psalters with marginal illustations as seedbeds for the pictorial exploration of the cycle of the Death and Resurrection of Christ. This is also manifested in the next group of illustrations, all of which confront directly for the first time the theme of Christ's rising from the tomb.

The Bodily Rising of Christ [22]

The theme of the Bodily Rising of Christ, whose exploration was avoided with great consistency throughout the earlier period, now surfaces boldly in a distinct group of miniatures. The variety of the solutions allow little doubt about the pictorial novelty of this subject matter, as well as about the interest of the illustrators of these Psalters in it. The results of these experiments did not spread into the rest of Middle Byzantine art, which faithfully avoided depicting the Bodily Rising of Christ from his tomb. Accidents of survival cannot

mann, 13.4.36ff. deals here with the extremity of Christ's humiliation and poverty beyond human measure which permits no doubt about the reality of Christ's human nature.

[17] The measuring of the time between Holy Friday and Easter Sunday as three nights and three days has been variously interpreted by the Fathers. See, for example Anastasius Sinaites quoting Severus of Antioch, PG, 89.808C, and John of Damascus, *In Sabbatum Sanctum*, PG, 96.625f.

[18] Chloudof, fol. 67ᵛ. Pantocrator 61, fol. 89ʳ. Barberini, fol. 110ʳ. Hamilton, fol. 135ᵛ.

[19] Chloudof, fol. 6ʳ. Theodore, fol. 7ʳ. Barberini, fol 8ᵛ, Hamilton, fol. 50ᵛ.

[20] Chloudof, fol. 9ᵛ. Theodore, fol. 10ʳ. Barberini, fol. 14ᵛ. Hamilton, fol. 56ʳ.

[21] Theodore, fol. 11ᵛ. Barberini, fol. 16ᵛ. Hamilton, fol. 57ᵛ.

[22] Kosteckaja, "L'iconographie de la résurrection d'après les miniatures du Psautier Chloudov," 63ff. Grabar *L'iconoclasme*, 231f., and "Essaie sur les plus anciennes représentations de la 'Résurrection du Christ.' "

explain the contrast between the general attitude and that of the Psalters with marginal illustrations toward this theme. The variety of its interpretations by the latter is the result of intentional experiments that were part of the growing interest in the pictorialization of the different aspects of Christ's Death and Resurrection. These experiments, however, were not generally acceptable.

The cumulative result of the efforts of the illuminators of the Psalters with marginal miniatures provides us with the following variations on the theme of the Bodily Rising of Christ:

 a. Ps. 43:27 (fig. 42)[23] depicts David prophesying in front of Christ's tomb. The door of the tomb is half open, allowing us to glimpse the swathed body of Christ standing upright inside. Christ's eyes are open and turned toward David, to whose call Christ has apparently responded. The Resurrection is beginning.

 b. Ps. 11:6 (fig. 43a)[24] is illustrated once more with David standing next to the tomb prophesying about the Resurrection while Christ is beginning to rise in quite a different manner from the previous illustration. Christ's torso is already outside the tomb, but the lower part of his body is still deep inside. Incongruously, a sarcophagus may be seen in front of the open door blocking the way. This feature is either a misinterpretation of the great stone that Joseph rolled against the door or, more likely, a later addition meant to clarify where the body of Christ lay. But the Resurrection is clearly under way in this instance.

 c. Ps. 9:33 (fig. 43b)[25] offers a more explicit variation of the same moment in the rising of Christ. David is prophesying next to the sepulchre while Christ is energetically putting one foot outside the tomb. We may remember that a more conservative illustration of the same psalm chose instead to show Christ resting in his tomb. Furthermore, it should be observed that Psalter Pantocrator illustrates fol. 24[v] with Christ setting a foot ouside the tomb, and fol. 26[v] with Christ leaning half out of it as described under *b* here. The consecutive appearance of these two miniatures demonstrates the bringing together of two variations of the same theme in the same manuscript. This is again supported by the use of an older and a younger King David in the two Pantocrator miniatures. This is the second collation of two alternative illustrations of the same theme encountered in this group of Psalters. The earlier one was offered by the Chloudof Psalter, fols. 6[r] and 9[v] which illustrated the theme of David prophesying about Christ's Resurrection, as described under *b* and *c* in the previous section.

The interest in the Bodily Rising of Christ manifested in these eastern miniatures of the ninth century is comparable to the illustration of Ps. 142:3 in the Stuttgart Psalter, fol.

[23] Theodore, fol. 55[v]. For a different illustration of the same psalm, below 134.

[24] Pantocrator 61, fol. 26[v]. Bristol, fol. 21[v]. It is not certain that the Bristol Psalter miniature included a sarcophagus since its lower part has been cropped.

For a different illustration of the same psalm, also n. 6.21.

[25] Pantocrator 61, fol. 24[v]. For a different illustration of the same psalm, also n. 6.20.

157[r].[26] Christ is seen lifting himself out of a rectangular sarcophagus, which lies inside a complex domed structure, and gesturing toward another structure surmounted by a cross. The accompanying inscription is "De monumentum Domini dicit." Despite the conflicting identification of the building as the Holy Sepulchre or the Golgotha Memorial, there is little doubt this miniature represents a different iconographic recension from its Byzantine relatives, involving another interpretation of the mechanics of the Bodily Rising of Christ. In the Stuttgart Psalter, Christ raises himself out of his sarcophagus, while in the Byzantine examples he walks out of his sepulchre, which might or might not have contained a sarcophagus. The relationship of these two recensions is far from clear, but they both seem to reflect a fascination with the Resurrection, of which there is no earlier trace.

The interpretation of the Stuttgart Psalter resurfaces during the Ottonian period. Thereafter it develops continuously as part of the western iconographic tradition.[27] The experiments of the Psalters with marginal illustrations on the other hand do not seem to have had any offspring. Much later, probably under the impact of Renaissance iconography, the East adds to its repertory the theme of Christ rising from his sarcophagus as an alternative to the pictorialization of the Resurrection. Both the Anastasis and the rising from the sarcophagus are described in the Painter's Guide.[28] But this is beyond the scope of the present study.

d. The Resurrection of Christ is finally complete in the illustrations accompanying Ps. 30:5,[29] and 77:65.[30] In these, Christ is standing outside his "holy tomb," whose empty darkness is left open for inspection. Two guards are sleeping on the ground. A more frugal variation of this scene depicts Christ addressing David from the threshold of the tomb.

e. The illustration of Ps. 101:14[31] follows a different vein from the previous miniatures in the same group. The risen Christ stands here atop a sarcophagus. Inside it lies Hades trampled underfoot by Christ, who is also addressing a woman whose bust appears above a church, and is labeled "Holy Zion." The sarcophagus in which Hades lies defeated, apparently in lieu of the risen Christ, serves as the foundation of the Church of Zion.

The multiplicity of the scenes illustrating various moments in the actual rising of Christ as well as the way they overlap and differ demonstrates the great attraction of the subject for the illuminators of these Psalters. The affinity of most of these miniatures also suggests

[26] *Der Stuttgarter Bilderpsalter*, 146f. E. T. De Wald, *The Stuttgart Psalter*, 108. Also, F. Rademacher, *ZKunstg*, 28 (1965), 197.

[27] H. Schrade, *Ikonographie der christlichen Kunst. I. Die Auferstehung Christi*.

[28] Denys de Fourna, *Manuel d'iconographie chrétienne*, 110. The Painter's Guide lists before the Resurrection: the Entombment, the Guarding of the Tomb, the Descent to Hades; and after the Resurrection: the Bodily Rising of Christ, the Myrophores, the Chairete, etc.

[29] Chloudof, fol. 26[v]. Pantocrator 61, fol. 30[v]. Hamilton, fol. 80[v].

[30] Chloudof, fol. 78[v]. Theodore, fol. 105[v]. Barberini, fol. 131[v]. Hamilton, fol. 153[r].

[31] Chloudof, fol. 100[v]. Theodore, fol. 134[v]. Barberini, fol. 171[r].

they represent recent, related pictorial solutions. But the liveliness of this experiment has left no traces outside this Psalter group in other monuments of the period.

The Myrophores

Even the traditional theme of the Myrophores is adjusted to the interests of the Psalters.

a. In Ps. 43:27[32] the two Marys are approaching the closed tomb of Christ.

b. Subsequently illustrating the same Ps. 43:27 as well as Ps. 79:4,[33] Martha and Mary may be seen sitting and looking in the direction of the closed sepulchre while David, standing behind it, is prophesying about the Resurrection.

c. Ps. 77:63[34] offers an adapted version of the traditional iconography of the Chairete. Christ is standing outside his empty sepulchre. Two guards are lying asleep in front of it while the two Marys are in deep proskynesis.

The traditional iconography of the Marys is thus adapted to the tenor of the Psalters by the addition of the figure of David and the sepulchre of Christ.

The Anastasis [35]

The scene of the angel announcing to the Marys the Resurrection of Christ, which had been the standard pictorial reference to the Resurrection throughout the early period, is apparently renounced by this Psalter group. Their rich illumination has not a single example of this theme. Its pictorial alternative, the Chairete, appears only once, and then in an iconographic variant that is obviously adapted to the interests of this group of manuscripts. In contrast, the Anastasis is shown in many variations.

a. Ps. 67.2 (fig. 44a)[36] is illustrated with the image of Christ holding a scroll in a mandorla of light. He is turning to Adam and Eve, and pulls Adam by the right hand while Eve is following behind in her usual gesture of supplication. At first glance, the core of this scheme is close to that of the Anastasis of the Palatine Ramp in S. Maria Antiqua, with one vital difference: the scene is taking place on the stomach of Hades, who lies flat on his back irrevocably defeated. This type of Hades—fat, bald, dark, and dressed in a loincloth—is characteristic of the Psalters with marginal miniatures and appears in many contexts. Nearby a number of dark, winged, hairy creatures are fleeing. These are the "enemies" of the Lord who disperse at the time of the Resurrection, in accordance with Ps. 67:2. The inscription, which labels this Anastasis in the Chloudof Psalter, is: "Christ is raising Adam from Hades."[37] This confirms the

[32] Chloudof, fol. 44ʳ. Barberini, fol. 73ʳ. Hamilton, fol. 104ᵛ.

[33] Pantocrator 61, fol. 112ʳ.

[34] Pantocrator 61, fol. 109ʳ.

[35] Kosteckaja, op. cit. Grabar, "Essaie sur les plus anciennes représentations de la 'Résurrection du Christ'."

[36] Chloudof, fol. 63ʳ. Theodore, fol. 82ᵛ. Barberini, fol. 105ʳ. Hamilton, fol. 131ᵛ.

[37] ΤΟΝ ΑΔΑΜ ΑΝΙϹΤΩΝ Χ̄Ϲ ΕΚ ΤΟΥ ΑΔΟΥ.

artist's intention to distinguish this scene of the Anastasis of Adam from the Anastasis of Christ.

b. Ps. 67:7[38] is essentially illustrated with the same scene, but now in profile. The Anastasis is taking place on the midriff of Hades once more, but there are no fleeing devils. The inscription in the Chloudof Psalter is: "Another Anastasis of Adam."

c. At a date later than that of the Chloudof, the illustration of two separate verses of Ps. 67 with two different representations of the Anastasis of Adam was apparently considered redundant. The Bristol Psalter replaces the two illustrations with a different type of Anastasis not previously encountered in the East: the second compositional type.[39] Christ now moves forward, pulling Adam behind him out of his sarcophagus, which also contains Eve and two more figures. Christ, holding an oversized patriarchal cross, is turning his head back, while Hades lies under his feet, crushed at the touch of the cross. This updated illustration of Ps. 67 retains its attachment to verse 2 by including the fleeing "enemies."

It is possible the illustration of the Anastasis accompanying Ps. 67:2 in the Chloudof Psalter was also meant to depict the second type of Anastasis. In this miniature, while Christ's torso is inclined toward Adam, whom he appears to face, his feet face in the opposite direction, giving the impression he is moving away from Adam as in the Bristol Anastasis. The illustration of Ps. 67:2 in the Barberini and Theodore Psalters shows Christ facing Adam, probably reflecting the prototypical illustration of this verse. The Chloudof miniature tried to adapt this prototype to the second type of Anastasis in which Christ drags Adam, but it failed, since only the lower part of Christ's body is shown moving away from Adam and Eve. If this attempt is correctly interepreted, the illustration of Ps. 67:2 in the Chloudof Psalter is the first surviving Byzantine example of the second type of Anastasis.

The second type of Anastasis has been considered by Weitzmann to be a product of the Macedonian period, based on antique models of the theme of Heracles dragging Cerberus out of Hades.[40] On the other hand, Schwartz has shown it had more direct antecedents in the late antique numismatic type of the emperor dragging a captive.[41] Following Lucchesi Palli, Schwartz has also interpreted the Anastasis on the silver cross from the time of Pascal I (817–824) as a seemingly certain example of the same type of Anastasis (fig. 21). This western example, which is a simplified version of the second type, also offers an antecedent for the western variant of this type of Anastasis. This variant is often encountered in the Exultet Rolls from the tenth century on, as for example in Vat. lat. 9820 (fig. 20). Christ drags Adam behind him without looking back, while holding a long-staffed cross

[38] Chloudof, fol. 63v. Pantocrator 61, fol. 83r. Theodore, fol. 83r. Barberini, fol. 105v. Hamilton, fol. 132r.

[39] Bristol, fol. 104r.

[40] Weitzmann, "Das Evangelion im Skevophylakion zu Lawra," 83ff. Idem, "Aristocratic Psalter and

Lectionary," 99. Weitzmann's interpretation is accepted by Galavaris, *Gregory*, 71ff. For the second type of Anastasis, see, 8f. and 204ff.

[41] Schwartz, "A New Source for the Byzantine Anastasis," 29ff.

over his shoulder with the other hand. So the Anastasis of Adam on the early ninth-century Vatican reliquary is a transitional example; it forecasts the forward dragging type used in some of the Exultet Rolls, and at the same time points to the contrapostal dragging type developed in the East, and possibly attempted in the first Anastasis in the Chloudof Psalter.

The points of similarity and difference of these examples in conjunction with their dates in the ninth and tenth centuries suggest that the second type of Anastasis was already germinating in the early ninth century. If this is correct, then the second type of Anastasis—as exemplified by its well-known example in the Phocas Lectionary (fig. 80), is in fact the refinement of an iconographic type that was developing throughout the ninth century, and was based on late antique numismatic models of the fourth and fifth centuries. That such "Constantinian" models might have been sought to inspire this refinement in the latter part of the ninth or in the tenth century would not be out of character, given the general tendency for a "Constantinian" revival, which marks this period, and is particularly well documented by Constantine VII Porphyrogenitus.[42]

 d. Beyond offering examples of the first and possibly the second type of Anastasis, the Chloudof Psalter has the first example of the third type of Anastasis as well (fig. 44b).[43] It illustrates Ps. 81:8, a particularly important psalm from a liturgical point of view. Christ stands frontally in a mandorla of light, gesturing in speech with his right hand. He is flanked on his left by Adam, whom he pulls up by the wrist, and on the right by Eve, who addresses him without his responding. Adam and Eve float in midair while Christ stands precariously atop a hill, which is actually the bald head of the overwhelmed Hades. The unstable way the three figures stand above the head of Hades indicates that this particular scheme has not yet been thoroughly worked out. Another aspect pointing to its relative immaturity is that Christ pulls Adam by the hand, compromising the symmetry sought in this ceremonious composition.

The group of Psalters offers more evidence of experimentation with this type of Anastasis in two variant illustrations of Ps. 106:13–16.[44] The first variant appears in the ninth-century Paris gr. 20. Christ stands frontally, trampling Hades with both feet. His hands are extended outward. The symmetry of his stance is broken both by the lifting of Adam on the one side and by the turn of Christ's head to glance in the opposite direction. The head of Hades and part of his torso are buried under a peculiar construction, which acts as the sarcophagus of Adam and Eve but has an open door on its front long side. On the other side of Christ, three figures rush out of the broken door of a vaulted building, extending their hands toward him.

The variant that illustrates the same psalm in the Barberini and Theodore Psalters

[42] H. Ahrweiler, *L'idéologie politique de l'empire byzantin* (Paris, 1975), 48ff.

[43] Chloudof, fol. 82ᵛ. Barberini, fol. 137ᵛ. Hamilton, fol. 158ʳ, illustrates Ps. 81:8 with the first type of Anastasis. For the liturgical importance of this psalm

and its various reflections in the pictorial arts, below, 156ff., 169f., 183. On the third type of Anastasis, below, 152ff.

[44] Paris gr. 20, fol. 19ᵛ. Theodore, fol. 146ᵛ. Barberini, fol. 181ʳ.

organizes its material more tightly. Christ stands upright (and frontal in the Barberini Psalter, fig. 45) in a mandorla. He holds a scroll in his left hand, and the wrist of the seated Adam with his right hand. In turn, Adam pulls Eve up from below. Eve, in her turn, pulls young Abel (?) out of the open door of Hades. The scene is littered with broken doors, bolts, keys, and chains in line with the text of the psalm. This variant, which looks like a line of dancers led by the immobile figure of Christ, echoes the joyous tenor of the psalm, and confirms the existence of a separate series of experiments on the third type of Anastasis.[45] These experiments, however, like so many others, have left no trace outside the Psalters with marginal miniatures.

The third type of Anastasis, which follows a distinct path of its own in the iconographic evolution of the image, will be further examined at the end of this chapter.

The detailed examination of the Psalters with marginal miniatures has shown that they illustrate the theme of the Crucifixion in all the ways encountered in eastern iconography up to the early ninth century. On the contrary, the Descent from the Cross, which cannot be traced before the ninth century, is not normally illustrated in these manuscripts that, nevertheless, offer the earliest surviving examples of the Entombment of Christ. The pictorialization of the Three Days and Nights before the Resurrection includes the peculiar representation of Christ as dead and buried in his tomb. Moreover, five new pictorial alternatives emerge for the theme of the Bodily Rising of Christ, while the scenes involving the Myrophores do not include their traditional encounter with the angel. Finally, the Anastasis produces four major variants including the first, second, and an immature version of the third iconographic type.

This group of manuscripts apparently invests a great deal of energy in illustrating the Death and Resurrection of Christ. Out of this emerges an elaborate pictorial sequence, which constitutes, in fact, the pictorial cycle of the Death and Resurrection of Christ. It forms part of the broader christological story, but focuses on developing its latter part. This cycle is probably a relatively recent concept, since its component scenes have not yet been blended into a coherent unit. For example, the Entombment shows the body of Christ being carried into a cave-tomb, while the other representations of Christ's tomb depict an architectural structure. So the scene of the Entombment encountered here could hardly form a sequence with most of the following scenes, which include a representation of Christ's tomb. The fancy man-made structure and the unprepossessing cave would starkly contradict each other. Significantly, this iconographic problem is solved later. An architectural structure takes the place of the cave in the representation of the Entombment in the Bristol Psalter. The opposite solution is followed in the Lectionary Dionysiou, cod. 587, in which the tomb of Christ is repeatedly represented as a hill-cave.

The use of more than one miniature to depict overlapping moments in the narrative

[45] The theme of Adam dancing and being joyous after Christ's death in anticipation of his impending resurrection is frequent in paschal literature. A good example is offered by Romanos Melodos, *Canticum* XVI. *De passione*, 1, 2ff. [in J. Pitra, ed., *Analecta Sacra. Spicilegio Solesmensi* (Paris, 1876), 1, 116ff.] where the theme of the dance of Adam forms the refrain.

points to the divergent origin of these illustrations. For example, Psalter Pantocrator 61 illustrates fols. 26v and 24v with the Bodily Rising of Christ (fig. 43). In the first instance Christ's torso is outside the tomb, while in the latter he is also stepping outside his tomb. The minute difference in time between the two miniatures shows that they were not intended to form a sequence in a cycle. Instead, they represent two separate attempts at the illustration of the Bodily Rising of Christ. This view is supported by the use of two different types of King David, one young (fol. 26v) and one old (fol. 24v). So these two scenes seem to have been borrowed from two different, though comparable, sources.

The Psalters with marginal miniatures do not, therefore, present a defined extended cycle of Christ's Death and Resurrection. They testify to an emphatic interest in the pictorial possibilities of such a cycle. They energetically explore and compile all related imagery without trying to shape it into a homogeneous continuum. But in the process they aggressively affirm the right to handle each aspect of the Death and Resurrection of Christ in the visual arts. The Psalters with marginal miniatures thus try to deal the final blow to the age-old taboo, which barred a confrontation with this theme and retarded its pictorial evolution. The spectrum of experimentation in these manuscripts is enough to characterize them as artistically extremist. This is supported by the ultimate rejection of two particularly daring groups of illustrations included here: the Bodily Rising of Christ, and the portrayal of Christ in his tomb after his Entombment and before his Resurrection. The West institutionalized the first of these two themes. But the artistic consensus in the East rejected them, apparently feeling that these two "material proofs" of Christ's humanity went too far.

The aggressive Iconophilia of these Psalters is the most likely source of inspiration for their iconographic extremism.[46] It is not limited to the glorification or vilification of the protagonists of the controversy. It also extends to the forceful affirmation of Iconophile Christology. In this context, the extensive exploration of the cycle of the Death and Resurrection uncompromisingly asserts the Orthodox obligation to portray all phases of the incarnation as confirming its material reality. However, the elaboration of aspects of the incarnation not witnessed by any eye, dead or alive, sets the Psalters apart and defines their extremism.[47]

[46] I. Ševčenko, "The Anti-iconoclastic Poem in the Pantocrator Psalter," 39–60, with previous bibliography.

[47] The traditional distinction between idols and legitimate images was based on the distinction between myth and fact known through the account of witnesses. See, for example, Germanus, *Epistola Germani beatissimi, qui fuit patriarcha Constantinopoleos, ad Joannem episcopum Synadensem.* PG, 98.156–162 and John of Damascus, *In Sabbatum Sanctum*, PG, 96.621C. Also, Pope Gregory II, *Epistola Gregorii sanctissimi papae Romani ad sanctissimum Germanum qui fuerat patriarcha Constantinopoleos.* PG, 98.152C–D (also n. 3.90). The whole issue is discussed at some length by G. B. Ladner, "The Concept of the Image in the Greek Fathers and the Byzantine Iconoclastic Controversy," *DOP*, 7 (1953), 14ff., and by P. J. Alexander, "The Iconoclastic Council of St. Sophia (815) and Its Definition (Horos)," *DOP*, 7 (1959), 35–67, esp. 61, fragment 21 for a quote attributed to Basil of Seleucia. The broader issue of the importance of historical accuracy for Byzantine images is discussed by G. Ostrogorsky, "Les décisions du 'Stoglav' concernant la peinture d'images et les principes de l'iconographie byzantine," *L'art byzantin chez les Slaves. Receuil Uspenskij* (Paris, 1930), I.2, 393–411. Reprinted in G. Ostrogorsky, *Byzanz und die Welt der Slawen* (Darmstadt, 1974), 122–140.

Patriarch Nicephorus offers a sample of Iconoclastic objections to such images, allowing us to infer the Iconoclastic reaction to the iconographic experiments of the Psalter school. Iconoclasts rejected the depiction of the Crucifixion and the Anastasis because of the respective inclusion of the two thieves and of Hades. In both cases the rationale was the same: such images offered contemptible matters for veneration along with Christ. Iconoclasts also objected to the representation of the resurrected Christ, arguing that he had become uncircumscribable after the Resurrection since his body was now incorruptible and immortal.[48] These views were rejected by the pictorial experiments on the cycle of the Death and Resurrection, which aim not only at defense of Iconophile rights and theories. The persistent handling of some of the most sensitive and vulnerable aspects of christological iconography maximizes the offensiveness of these images for Iconoclasts.

The threat Iconoclasm continued to pose well into the 860s probably fostered this sort of pictorial extremism.[49] Artists who were victimized during the second Ionoclastic period eagerly used their craft to stamp out their enemies. The eulogy of Lazarus the painter, the best known artist of the ninth century who was subsequently canonized, confirms this. It is well known that the hands of Lazarus were burned by Iconoclasts to keep him from painting. But Lazarus was still able to produce miraculous images, such as Christ of the Chalke Gate and John the Baptist at the church of the Forerunner tou Phoverou.[50] The entry on St. Lazarus in the *Synaxarium Constantinopolitanum* praises the painter for producing works which served as confessions of his christological Orthodoxy, and whose ingenuity also turned them into "arrows for shooting down the sinners," the Iconoclasts.[51] The use of pictorial polemics by Lazarus was almost unavoidable given the tortures he suffered at the hands of Iconoclasts. The official approval of the polemical use of images reflected in this text could not be limited to Lazarus. In the hands of extremists, it could also produce excessive works that did not meet with general approval even among Iconophiles.

In this Psalter group, the Anastasis receives the same treatment as the rest of the cycle. A wide range of pictorial solutions emerges, some of which are established and old (as in the Chloudof Psalter, fol. 63ᵛ, Ps. 67:7), some of which are new and experimental but reach maturity later (as in the Chloudof Psalter, fol. 82ᵛ, Ps. 81:8, fig. 44b), and some of which have had little or no influence on the subsequent development of the image (as in Paris gr. 20, fol. 19ᵛ, Ps. 106:13–16, and Chloudof Psalter, fol. 100ᵛ, Ps. 101:14).

These representations, like most other ninth-century examples, emphasize the total defeat of Hades. They present, however, an idiosyncratic interpretation of Hades as old and obese, which appears naive in comparison to the ancient lord of the underworld encountered in S. Maria Antiqua, and unnecessary in comparison to the sinuous dark figure in S.

[48] PG, 100.436 and 437ff.

[49] F. Dvornik, "The Patriarch Photius and Iconoclasm," *DOP*, 7 (1953), 69–97.

[50] Mango, Sources, 159, translating Theophanes Continuatus, *Chronographia*. CSHB. I. Bekker, ed. (Bonn, 1838), 102ff.

[51] SCP, November 17, col. 232f.: "Πλεῖστα δέ κο-λαστήρια καθυπέμεινεν . . . ὁμολογῶν τὸν Χριστὸν τέλειον Θεὸν καὶ τέλειον ἄνθρωπον, ἀσυγχύτως, ἀτρέπτως, ἀναλλοιώτως, ἀλλὰ καὶ παρὰ τῶν βδελυκτῶν καὶ ἀνοσίων εἰκονοκαυστῶν . . . διά τε τὸ σέβεσθαι καὶ προσκυνεῖν τὰ τῶν ἁγίων σεβάσμια ἐκτυπώματα διά τε τὸ εὐφυῶς ζωγραφεῖν ταῦτα οἰκειοχείρως τοῖς πίναξιν καὶ οἷα βέλεσι τοὺς ἀλιτηρίους κατατοξεύειν."

Clemente II and the historiated reliquaries. This new type of Hades, which is not found outside this Psalter group, portrays the glutton who grabs and swallows up good and bad alike, as seen in fols. 8ᵛ and 102ᵛ of the Chloudof Psalter. He is not interested in the torture and punishment of sinners. His main concern is that none of his captives escapes. For example, in the representation of the Anastasis in Pantocrator Psalter 61, fol. 83ʳ, the overthrown Hades still clutches onto one soul while another has managed to escape his grasp. The Hades of the Psalters resembles in this respect both the ancient god of the underworld and the sinuous figure who do not release their grip on Adam's heel even after their defeat.

The folkloric character of this obese giant is spelled out on fol. 29ʳ of the Pantocrator Psalter, which illustrates the robbing of the soul of Lazarus from Hades (fig. 46). Hades is shown standing inside a sarcophagus trying to control a number of unruly human souls, which, like the soul of Lazarus, wish to escape the deadly embrace of Hades. The soul of Lazarus, as a young child in a short tunic, has been set free at Christ's command and is about to enter his own tomb from the rear. Inside, the swathed body of Lazarus is awaiting its imminent reunion with its approaching soul. This miniature echoes the Apocryphon of Nicodemus IV (XX), and one of its homiletical descendants usually ascribed to Eusebius of Alexandria.[52] In both texts, the horrified Hades remembers minutes before the Anastasis the ease with which Christ, who is now at the gate, robbed him of the soul of Lazarus. Both texts repeatedly refer to Hades as insatiable and all-devouring, reflecting the iconographic type used by this Psalter group. The Iconoclasts, who had objected to any representation of Hades in the image of the Anastasis, must have considered this grotesque giant particularly offensive. Indeed, this extremist motif, which did not spread outside this group of manuscripts, was also censored by Iconophiles.

One more aspect of the Anastasis in these Psalters is worth noting: the absence of David and Solomon. The tireless efforts of the illustrators to associate the person of David and his prophetic gifts with the Bodily Rising of Christ, are not matched by a similar association of the prophet king (with or without his son Solomon) with the Anastasis. The two kings were not yet established as an essential part of the Anastasis, even though they had been introduced into it by the early ninth century. Therefore, the subsequent consolidation of the motif of David and Solomon as part of the Anastasis cannot be attributed to their prophetic gifts alone. If this were so, the presence of David at least would have been a mandatory motif in the series of Anastasis images that we have just examined.

THE PARIS GREGORY[53]

So far we have identified a number of reactions to the Anastasis which represent different efforts in the ninth century to define the image and its iconographic particulars in terms of

[52] *In diabolum et orcum* in PG, 86/1.389ff. or in *Spicilegium Romanum*, A. Mai, ed. (Rome, 1843), 698. Hades is often characterized as παμφάγος and ἀκόρεστος. For ex., *Evangelia Apocrypha*, C. de Tischendorf, ed., 304.; Pseudo-Epiphanius, PG, 43.452.; Eu-

sebius of Alexandria, loc. cit. For the iconography of Hades, K. Wessel, *RBK*, II, 946ff. and H. Leclercq, *DACL*, VI, 1946ff. and above n. 1.72.

[53] H. Omont, *Miniatures des plus anciens manuscrits grecs de la Bibliothèque Nationale du VIe au XIVe siècle*

the Iconoclastic controversy and its aftermath. Iconoclasts opposed any representation of the resurrected Christ, while arguing that the image of the Anastasis was specifically objectionable because of its inclusion of the person of Hades. Iconophiles asserted in the early ninth century their right to represent the resurrected Christ and formulated various responses concerning the Anastasis. The official position, as represented by Patriarch Nicephorus, refused to give way to Iconoclastic pressure and alter the existing iconographic format of the image. Another more moderate group discreetly responded to the iconoclastic accusation by deleting the personification of Hades. He was replaced by the *tenebrae*, to whose darkness no one could possible object. Then a third group, the Iconophile extremists, aggressively rejected all criticism of the image and its context. They offended Iconoclasts by indulging in almost every aspect of the Death and Resurrection of Christ. They even adopted the illustration of the Bodily Rising of Christ, a new and radical pictorial alternative to the theme of the Resurrection. The extremists did not neglect the Anastasis either. In addition to collecting various compositional experiments, they radicalized the traditional iconography by substituting the usual figure of Hades by the ugly, balding and fat all-devouring giant familiar to everyone from religious folklore. This figure of fairy-tale grotesqueness seems well calculated to add insult to the injury of Iconoclasts who objected to the representation of Hades in the first place.

But the endeavors of ninth-century extremists also offended moderate and conservative Iconophiles, who actually prevailed in the long run. Standard Middle Byzantine iconography chose to pass over the most private moments of Christ's Death for which there were no witnesses. Similarly, the pictorial life of the unsavory, insatiable Hades was cut short. The extent of Iconophile reaction to the immoderate experiments of extremists appears to have survived in the cycle of the Death and Resurrection of Christ illustrating fol. 30ᵛ of Paris gr. 510 (fig. 47), the illuminated manuscript of the homilies of Gregory Nazianzenus, which belonged to Basil I. The representation of the Anastasis is excluded from this cycle. For the first time since the Early Christian period a christological cycle bypasses the Anastasis, a strange omission in a Middle Byzantine cycle.

Any explanation for this must first consider the function of this illustration. It is a full-page miniature divided into three registers depicting the Crucifixion in the first register, the Deposition and the Entombment in the second register and the Chairete in the third register.[54] Der Nersessian suggested that fol. 30ᵛ, a single leaf whose recto remains blank, was misplaced at least as early as the rebinding of the manuscript in 1602. As it is obviously out of context in its present surroundings, she also suggested that it originally illustrated

(Paris, 1929), 13f., pl. 21. S. Der Nersessian, "The Illustrations of the Homilies of Gregory of Nazianzus: Paris Gr. 510. A Study of the Connection between Text and Image," *DOP*, 16 (1962), 195–229. I. Spatharakis, "The Portraits and the Date of Codex Par. gr. 510," *CA*, 23 (1974), 97ff. I. Kalavrezou Maxeiner, "The Portraits of Basil I in Paris gr. 510," *JÖB*, 27 (1978), 19–25. L. Brubaker, "The Illustrated Copy of the *Homilies* of Gregory of Nazianzus in Paris (Bibliothèque Nationale, cod. gr. 510)," Ph.D. Dissertation, Johns Hopkins University, 1982. Idem, "Photios, Paris gr. 510, and the Role of Art in the Second Half of the Ninth Century," *Eighth Annual Byzantine Studies Conference, Abstracts of Papers* (Chicago, 1982), 49–50.

[54] Another scene which figures to the right of the Crucifixion remains unidentified. The representation of the Deposition is identified as Καθέλκυσις rather

the First Easter Homily of Gregory, the opening homily of the manuscript, which is inexplicably without an illustration.

On closer examination, this miniature and the homily of Gregory agree with each other. The fourth paragraph of the homily refers consecutively to Christ's Crucifixion, Death, Entombment, and Resurrection, interpreting their corresponding benefits for mankind as glory, life, resurrection, and fruitbearing.[55] In Early Christian times the fourth paragraph of the First Easter Homily of Gregory inspired a hymn, which paraphrased its text. This hymn, known as "Gregory's hymn" at least as early as the sixth century, subsequently influenced the Easter Canon of John of Damascus.[56] The use of this homily, the derivative hymn, and the Easter Canon during services on Easter Sunday[57] meant that the fourth paragraph and its variations became the best known section of the First Easter Homily, probably because it summarized succinctly a brilliant interpretation of Easter.

The fundamental agreement of the illustration of fol. 30[v] with the fourth paragraph of the First Easter Oration cannot be accidental. By representing the Crucifixion, the Deposition, the Entombment, and the Chairete, this miniature focuses "the reader's attention on the main thesis of the oration" following the same method of illustration as the rest of the manuscript.[58]

The function of fol. 30[v] as the illustration for the First Easter Homily makes the omission of the scene of the Anastasis even more surprising. Indeed both the homily and the derivative hymn were exclusively illustrated with the Anastasis at a later stage, as we shall see. So the reason for its omission from this miniature should be sought elsewhere.

An analysis of the scenes composing the miniature show the top register dominated by the central figure of Christ on the cross. Christ now has his eyes open and is dressed in a long old-fashioned colobium. However, under the flaking colobium an earlier stage in the painting of this Crucifixion can be seen in which Christ wore only a white loincloth. At that stage he probably had his eyes closed as well, but there is no way of ascertaining this now.[59] There is little doubt that the original Crucifixion kept close track of its contemporary trends, as it resembles the one seen on fol. 98[r] of the Psalter Pantocrator 61 (fig. 34) in the relatively stiff posture of the body, the strong outline of the torso muscles, and the

than the usual Ἀποκαθήλωσις, and the Entombment as Ἐνταφιασμὸς rather than Κήδευσις.

[55] Gregory of Nazianzus, *Oratio* 1.4. *In Sanctum Pascha et in tarditatem*, PG, 35.397B. Translated by Ph. Schaff and H. Wace, A *Select Library of Nicene and Post-Nicene Fathers of the Christian Church* (Grand Rapids, 1955), VII, 203.

[56] O. Strunk, "St. Gregory Nazianzus and the Proper Hymns for Easter," *Late Classical and Mediaeval Studies in Honor of Albert Mathias Friend, Jr.* (Princeton, 1955), 87ff., 82ff. As Strunk points out, the influence of this hymn is reflected both in the Easter Canon and in the Homily on Holy Saturday written by John of Damascus. The third paragraph of the latter (PG, 96.604) reflects the fourth paragraph of the First Easter Homily of Gregory. Here again the Crucifixion, Death, Entombment, and Resurrection of Christ are mentioned consecutively. Moreover, the Resurrection now clearly includes the raising of Adam. For the influence of the First Easter Homily on later Church literature, see also I. Sajdak, *De Gregorio Nazianzeno poetarum christianorum fonte* (Cracow, 1917), 17ff., 28ff.

[57] Galavaris, *Gregory*, 14ff., and below 181f.

[58] For the use of the illustrations in the Paris Gregory as "theological exegesis in pictorial form," see Der Nersessian, op. cit., 227.

[59] Omont, loc. cit. Martin, "The Dead Christ on the Cross in Byzantine Art," 191.

great effusion of blood and water springing from Christ's side, "whence flowed the rivers of life; whence sprung the everlasting stream of incorruption," as George of Nikomedia underlines in his sermon on Holy Friday.[60]

Though less of the colobium has flaked off in the scene of the Deposition in the second register, it appears that Christ was originally loinclothed here too. Christ's eyes remain closed in this instance, since he could hardly be depicted alive in this scene.

The original iconography of the crucified Christ on fol. 30ᵛ was up to date. However, it was ultimately rejected and substituted by the traditional type of the colobium-clad Christ.[61] Since the miniature includes representations of the Deposition and Burial of Christ's dead body, the objection must have been to Christ's nakedness rather than the representation of his death per se.

The scene of the Deposition, which appears here for the first time in the East, presents another irregularity. John is cut off from the scene and stands facing us frontally in the middle of the register. As Weitzmann has pointed out, this figure is iconographically problematic. His scale and tradition link him to the Descent from the Cross. His attitude, however, dissociates him from it, as he does not even glance in its direction.[62] John stands apart from his immediate context in the middle of the register.

The scale of the scene of the Entombment which follows on the same register is different from that of the Deposition. The iconography follows the Psalters with marginal illustrations, but includes an unusual deviation: Joseph does not glance at the swathed body of Christ in his hands, but at the beholder, who is thus drawn into the scene. Weitzmann, who noted this departure, named it "The Pause in the Entombment."

The third register depicts the Chairete. Christ dominates the center of the scene flanked by the two Marys. The compositional importance of his figure corresponds to that of the crucified Christ with whom it is aligned. The iconography here includes an unorthodox motif: the empty tomb of Christ. This feature rarely forms part of the Chairete, and when it does—as in Psalter Pantocrator 61, fol. 122ʳ—the tomb is represented as the traditional architectural structure. Here, the illustrator has chosen to duplicate the hill of the Entombment. Thus, the right side of both second and third registers depict the tomb hewn in the rock. Its inclusion in the Chairete becomes stranger in view of the compositional disturbance this motif inflicts upon the centralized composition of the register. Nevertheless, it succeeds in superimposing an artificial narrative link on the sequence Entombment-Chairete, which do not normally follow each other. Moreover, this motif stresses the function of the Chairete as a reference to the Resurrection.

The choice of this scene as the sole reference to the Resurrection is characteristic of Early Christian cycles, but is out of place in a Middle Byzantine cycle. As early as the Fieschi Morgan and as late as Daphni, the iconography of the Anastasis, together with that of the Crucifixion provides the key reference for the theme of the Death and Resurrection of Christ. Even in the most abbreviated cycles the Anastasis is included. Memory of the Early

[60] PG, 100.1489B. For the same idea, 1481B and D.

[61] For a comparable alteration from a loinclothed to a colobium Crucifixion, see Weitzmann, *Sinai Icons*, I, B.32, the first surviving Crucifixion icon dated to the seventh or eighth centuries.

[62] Weitzmann, "The Origin of the Threnos," 479f.

Christian use of the Myrophores and/or the Chairete as a reference to the Resurrection remains alive even after the emergence of the Anastasis—for example, in the Oratory of John VII in Rome (fig. 15), S. Clemente I (fig. 17), Cimitile, Acikel Aga Kilise, an ivory diptych at Milan (fig. 70),[63] a diptych icon of the twelve feasts at Mount Sinai.[64] However, the representation of the Myrophores and/or the Chairete does not eclipse the Anastasis in any of these examples, which date from the beginning of the eighth century to the end of the Middle Byzantine period.

The absence of the Anastasis from fol. 30ᵛ, and its substitution with the Chairete alone stands out as an archaistic characteristic contradicting ninth-century trends. The same is true of the colobium that is forced on the figure of Christ in the scenes of the Crucifixion and Deposition. The way these two traditionalist features figure on this miniature brand it as a conservative work. The manuscript is an important luxury work of the late ninth century; it is, therefore, important to define the conservativism of this miniature, Is it intentional? Or is it the result of faithful copying of an older model dating earlier than ca. 700? If the latter is the case, then the absence of the scene of the Anastasis from this miniature is not particularly significant. But the situation is different if the scene of the Chairete has been deliberately selected to supersede the Anastasis.

There are many arguments against the supposition that this miniature is the result of blind copying. Starting from the top register, the colobium of Christ is only an afterthought, showing that the instinct of the illustrator originally led him to follow the latest iconographic trends. Moreover, the scenes of the Deposition and the Entombment in the second register were lifted from separate sources, as suggested by their difference in scale. It is even more significant that both scenes are invested with comparable sacramental overtones. The Deposition, which is not known to have been illustrated before the eighth century, stands as the reception of Christ's crucified body and hence as the fulfillment of the mystery, as proposed by Parker.[65] Similarly, "The Pause in the Entombment" is "an altogether novel concept of the Entombment: the display of Christ's body," as suggested by Weitzmann.[66]

A different kind of liturgical reference is offered by the peculiar treatment of the figure of John the Evangelist in the same register.[67] While the narrative value of this figure is questionable, he is compositionally important for the clarity of the dominant vertical axis of the miniature. Placed at the geometric center of the entire composition, John is clearly intended to serve as the link between the figures of the crucified and the risen Christ. He joins together the perfect Man-God of the Crucifixion and the perfect God-Man of the Resurrection. In other words, by formal means the illustrator suggests John as the key to understanding the relationship between the persons of the crucified and the resurrected Christ. This is well taken, since the opening of the Gospel according to St. John had long

[63] Weitzmann, *Elfenbeinskulpturen*, II, no. 42.
[64] Sotiriou, *Icônes du Mont Sinai*, 42ff., pls. 39–41.
[65] Parker, op. cit., 20f.
[66] Weitzmann, "The Origin of the Threnos," 479.

[67] Weitzmann interprets John's attitude as an attempt to fuse the scenes of the Deposition and the Entombment.

been considered the most perceptive and appropriate exposition on the essence of the Logos Incarnate and the miracle of the Resurrection. Furthermore, John 1:1ff. had been established as the Gospel reading for Easter Sunday, a practice known to the illuminator of the Paris Gregory. This means that the peculiar compositional role reserved for the figure of John on fol. 30ᵛ is liturgical in inspiration. This interpretation complements the function of the miniature as an illustration of the First Easter Homily of Gregory, which also played a prominent liturgical role on Easter Sunday.

The numerous sacramental and liturgical overtones recognized offer the strongest argument against an interpretation of this miniature as a copy of a pre-eighth-century original. Liturgical references do not characterize pre-Iconoclastic christological cycles, which, in addition, are not known to have included the Deposition.[68] On the other hand, the liturgical transformation of christological cycles is one of the developing characteristics of post-Iconoclastic art. In this respect, fol. 30ᵛ is up to date. It may even be called progressive, since it offers a link with a specific part of the Easter celebration. Although this miniature cannot be designated a feast image, it points in the direction of feast images. It is a serious effort to add a recognizable liturgical dimension to a pictorial work meant to summarize and interpret a text charged with a specific liturgical role. The particular pictorial interpretation offered by this manuscript has left no other traces in Byzantine Art. However, the importance it gives to the figure of John because of his role during Easter Services presages the illustration of John 1:1ff. The opening text of the Gospel of St. John is illustrated from the tenth century on with the portrait of the Evangelist and the feast image for Easter, the Anastasis. This practice, which probably originated in the ninth century, was expanded later. The liturgical edition of the Homilies of Gregory illustrates its opening text, which is the First Easter Homily, with the portrait of the author Gregory Nazianzenus and the Anastasis. Compared with these later developments, the liturgical character of fol. 30ᵛ belongs to an experimental and undeveloped phase, which was, nevertheless, progressive at the time of its appearance.

This miniature exhibits a sophisticated and experimental interpretation of the latest liturgical trends in art combined with a significant measure of archaism in its iconography, as expressed in the use of the old-fashioned colobium for Christ and the Chairete as the sole reference to the Resurrection. It could not possibly copy an earlier original. Its message looks forward to solutions established in the mature Middle Byzantine period, even though its pictorial vocabulary is in part conservative and academic. The academicism of this miniature can probably be explained, if we accept the suggestion that Paris gr. 510 is a work produced for Basil I under the supervision of Patriarch Photius.[69] The aversion of the emperor and the patriarch for the surviving remnants of Iconophile extremism is well known.

However, the pictorial conservativism of fol. 30ᵛ went against the iconographic main-

[68] The emergence of this iconography is not likely to antedate the late seventh-century change of attitude toward the pictorialization of the Death of Christ.

[69] Der Nersessian, op. cit., 227f. Brubaker, "Photius," 50.

stream of the ninth century in its rejection of the Anastasis and the loinclothed Christ. By the same token, the contemporary Psalters with marginal miniatures had become rather irreverent in their obsessive exploration of the pictorialization of the Death and Resurrection of Christ. These two iconographic schools stand out the one as radical and populist, the other as conservative and academic. Their apparent differences over the proper way of expressing Iconophile Orthodoxy in images produced a temporary casualty: the Anastasis. Its eclipse from the Paris Gregory suggests that the authorities could go as far as siding with Iconoclasts in their omission of the image. Though the subsequent evolution of the iconography of the Anastasis proves the attitude reflected in this miniature to be a minor interlude in its history, it is still interesting to note that the image could be bypassed as late as the last quarter of the ninth century.

OTHER NINTH-CENTURY EVIDENCE

The suspicion toward the Anastasis, which marks the Paris Gregory may not have been an isolated case. Other surviving evidence, though scanty and inconclusive, also appears to suggest that artists attached to the court of Basil I did not readily admit the Anastasis in their christological repertoires.

The Holy Apostles

The Church of the Holy Apostles does not seem to have included the Anastasis.[70] Even the mosaic of the Myrophores as described by Mesarites seems to have been made in the twelfth century. This is suggested by the exceptional inclusion of the standing figure of the mosaicist in the scene.[71] Thus, even though the ninth-century mosaics—made in all probability in the reign of Basil I—included the most progressive type of Crucifixion—Christ loinclothed and dead—we have no evidence that they also included an Anastasis. But because of the incomplete and confusing state of the surviving accounts of Rhodios and Mesarites, the question of the exclusion of the Anastasis from the mosaic cycle of the church cannot be settled conclusively.

The Church of the Virgin at Pege

Of the figurative mosaic cycles recorded as made during the reigns of Michael III and Basil I, only one is known to have deviated from a hierarchical scheme of single figures that

[70] The incomplete description by Constantine Rhodius ends with the Crucifixion, in which Christ is depicted "hanging dead upon the wood of the cross" (Mango, Sources, 201. Martin, op. cit., 191f.). The twelfth century account of Mesarites includes a description of the Myrophores and the Chairete, but none of the Anastasis [A. Heisenberg, *Grabeskirche und Apostelkirche* (Leipzig, 1908), II, 59ff., 64f.]. Its absence is remarkable given the extensiveness of this narrative. For a bibliography of the problems surrounding the mosaics of the Holy Apostles, see Lazarev, *Storia*, 66, 95 n. 2. And more recently, A. Wharton Epstein, "The Rebuilding and Redecoration of the Holy Apostles in Constantinople: A Reconsideration," *GRBS*, 23 (1982), 79–92.

[71] Mango, Sources, 233 and n. 255.

started with Christ and his angels and ended up with the most recent saints.[72] This was the Church of the Virgin at Pege, which was restored and decorated by Basil I sometime between the appointment of Leo as co-emperor on January 6, 870, and the death of Constantine, probably on September 3, 879.[73]

Once more our knowledge of the christological cycle is both incomplete and accidental. It is based primarily on a series of epigrams, which have survived in the *Anthologia Graeca* and are attributed to Ignatius, magister of the secretaries. These tell us that the Church of the Virgin at Pege, which was restored by Basil, Constantine and Leo after caving in during the earthquake of 869, contained representations of the Crucifixion, Transfiguration, Presentation in the Temple, the Chairete, and the Ascension in the dome. There must have been a second dome decorated with the Pentecost, but it is not mentioned among the epigrams.[74] Though these epigrams apparently describe an incomplete cycle, the fact remains that the Anastasis is excluded, though the Crucifixion and the Chairete are included once more.

Given the absence of the Anastasis from this incomplete series, the epigram about the Crucifixion is particularly noteworthy:

> The dead Hades disgorges those who have died
> Finding a purgative in the flesh of the Lord.[75]

The descriptive character of such epigrams leads us to venture that this mosaic of the Crucifixion included pictorial references to Hades and the Anastasis. Depending on the choice of emphasis, the Crucifixion of this epigram may be correlated to one of two known types.

The first is represented by the Crucifixion ivory in the Metropolitan Museum of Art in New York. Here the cross is planted on the stomach of Hades, whose identity is certified by the accompanying inscription, so bringing an end to his proverbial gluttony. As Frazer has shown, this idea was based on a long-standing literary image associated both with the celebration of the Anastasis and the Triumph of the Cross. Specifically, the latter association explains this image of the Crucifixion, putting an end to Hades and his disastrous voracity.[76]

The second type of Crucifixion is better known. It is the variant that includes the rising

[72] On early post-Iconoclastic church programs, see S. Der Nersessian, "Le décor des églises du IXe siècle," *VIe CIEB. Acts* (Paris, 1951), 315–320.

[73] *Anthologia Graeca*, H. Stadtmüller, ed. (Leipzig, 1906), I, 109–114. Also, *De sacris aedibus Deiparae ad Fontem, ASS*, November, III, 882, translated in Mango, Sources, 201f. For Constantine and the date of his death, see Spatharakis, op. cit., 104 n. 34 and Kalavrezou Maxeiner, op. cit., 19ff. (n. 6.59).

[74] Mango, Sources, 202.

[75] *Anthologia Graeca*, H. Stadtmüller, ed., I, 111:

Ἐν τῷ αὐτῷ ναῷ, εἰς τὴν σταύρωσιν.

Ὁ νεκρὸς Ἅιδης ἐξεμεῖ τεθνηκότας
κάθαρσιν εὑρὼν σάρκα τὴν τοῦ δεσπότου.

I am thankful to Professor Alan Cameron for confirming that there is no reason to suspect that the lemma and the poem do not belong together.

[76] Frazer, "Hades Stabbed by the Cross of Christ," 153ff. Frazer's identification of the figure stabbed by the cross as Hades has been confirmed by the Crucifixion fresco of the Church of Pološko in Macedonia which dates from the second quarter of the fourteenth century. G. Babić, "Observations sur le cycle des grandes fêtes de l'église de Pološko (Macédoine)," *CA*, 27 (1978), 163–178.

of the dead and is encountered as early as the Utrecht Psalter.[77] This type flourished in the second half of the ninth century in the West, as evidenced by the ivory bookcover of the Pericopes of Henry II, a work of the school of Charles the Bald dating in the 870s and now in Munich (fig. 48)[78] Although this western ivory is not directly related to Byzantine models, it echoes the idea of the dead escaping the clutches of the helpless Hades at the time of the Crucifixion, which is the essence of our epigram. The dead can be seen on the Munich ivory rising out of a variety of tombs, while the classicizing figure of the enthroned Hades (?) lifts up his hand and looks helplessly at the Crucifixion above. Here Hades is not dead, nor does he disgorge the dead literally as on fol. 102[v] of the Chloudof Psalter. Nevertheless, the iconographic type of Crucifixion on this ivory mirrors indirectly the mosaic of the Crucifixion at the Virgin of Pege.

Whether Ignatius was inspired by an image that reflected the first or the second type of Crucifixion, or even some iconographic combination of both, we have no way of knowing. But it probably belonged to a type of ninth-century Crucifixion, which pictorialized literally the idea of the cross as the instrument of the defeat of Hades and the Resurrection of the dead.

The correlation of the Crucifixion with the disgorging of the dead by Hades is based not only on the text of Matthew 27:52f., which makes no mention of Hades. As Frazer has shown, it was rooted in the celebration of the Triumph of the Cross as early as the time of Romanos Melodos, who links the two events in a hymn.[79] The liturgical door unlocked by Frazer leads us to liturgical developments that may be dated with certainty in the first post-Iconoclastic period.

The hymn of the Triumph of the Cross written by Romanos was incorporated by Theodore Studites in his Canon on the Adoration of the Cross.[80] This canon was in turn incorporated in the *Triodion*, where it is still part of the morning service for the feast of the Adoration of the Cross (the Stavroproskynesis).[81] We know quite a bit about this feast. Its celebration on the third Sunday of Lent was begun during the first post-Iconoclastic period as part of the reforms of the *Triodion* introduced by Theodore Studites and his faithful brother Joseph—the so-called "Studite reforms," which were an integral part of the Iconophile framework accepted after 787.[82] It is quite certain that this canon of Theodore—written specifically for this feast, which was part of the liturgical expression of the Iconophile theological system—was intended as a definition of the feast.

[77] De Wald, *The Illustrations of the Utrecht Psalter*, pl. 142.

[78] A. Goldschmidt, *Die Elfenbeinskulpturen aus der Zeit der karolingischen und sachsischen Kaiser* (Berlin, 1914–1926), I, 41, pl. 20. Brenk, 165f. and n. 89 for a list of Carolingian parallels.

[79] Romanos Melodos, *Canticum* VIII. *De crucis triumpho*, in *Analecta Sacra. Spicilegio Solesmensi*. J. Pitra, ed. (Paris, 1876), I, 53ff.

[80] Theodorus Studites, *Canon in Stavroproskynesem*.

PG, 99.1757–1768. The *oikos* at the end of the fifth ode of the canon (col. 1764B) reproduces Romanus, *Canticum* VIII.4. The same text is quoted by the figure of Hades in the representation of the Crucifixion at Pološko (Babić, op. cit., 172 ff.). See also, Beck, 494f.

[81] *Triodion Katanyktikon* (Rome, 1879), 357f.

[82] G. Bekatoros, "Σταυρός," Θρησκευτικὴ καὶ Ἠθικὴ Ἐγκυκλοπαιδεία (Athens, 1967), XI, 435.

The interpretation of the Stavroproskynesis feast offered in this hymn emphatically suggests that Crucifixion = Anastasis. Each of the nine odes of the canon opens with a strophe that expounds on the joy of the Resurrection of Christ and Adam, and its message of salvation. It is only then followed by a second strophe where each ode has a complementary reference to the cross, the instrument of the Passion, Resurrection, and Redemption. Thus, the Stavroproskynesis canon of Theodore Studites celebrates the Anastasis as much as the Crucifixion on that day, since Crucifixion and Anastasis are interpreted as the two interdependent facets of the scheme of Redemption. This interpretation of the Stavroproskynesis is confirmed by Theodore's sermon on the same feast. The feast is once more interpreted as the announcement of the Resurrection of Christ, since death was put to death and life was given to Adam through the cross.[83] Such phrases, which had long belonged to the celebration of Holy Saturday,[84] helped Theodore to forge a direct liturgical link between the Crucifixion and the Anastasis in the feast of the Adoration of the Cross.

We know, therefore, that the traditional interpretation of the Crucifixion and Resurrection as cause and effect, which may be traced back to the Early Christian period, was renewed and consolidated by Theodore Studites after 787. We also know this renewal took place in the context of the new feast of Stavroproskynesis. In the process, Theodore went beyond Romanos Melodos, who had interested himself in the bellyaches suffered by Hades while disgorging the dead as a result of the Crucifixion. Without rejecting the image of Romanos—which is also reflected in the epigram of Ignatios—Theodore offered an interpretation of the Crucifixion based on the Anastasis. To do this he went as far as placing the Anastasis ahead of the Crucifixion in his presentation.

If we put this interpretation of the Crucifixion and its context next to the ninth-century pictorial variants of the Crucifixion that incorporated motifs from the iconography of the Anastasis (such as the defeat of Hades, the rising of Adam and Eve, the rising of David and Solomon, or even the rising of the anonymous dead), we have an image that can function in two ways: in christological cycles as an enriched nonnarrative substitute for the traditional Crucifixion, or by itself as the feast image for the Stavroproskynesis—the Feast of the Adoration of the Cross, a post-Iconoclastic feast.

Another example of the kind of pictorial merger possible for the scenes of the Crucifixion and Anastasis is offered by an ivory bookcover in Leningrad, which probably dates in the eleventh or twelfth centuries (fig. 49).[85] On either side at the foot of Christ's cross, the figures of Adam and Eve, and David and Solomon rise out of their respective sarcophagi. The presence of the two kings means that the motif of the rising dead here alludes to the theme of the Anastasis. Without David and Solomon, the figures of Adam and Eve could

[83] Theodore Studite, *In Stavroproskynesem.* PG, 99.692–700.
693C: Σήμερον προσκυνεῖται σταυρός, καὶ ἡ Χριστοῦ ἀνάστασις εὐαγγελίζεται.
697D: Σταυρῷ νενέκρωται θάνατος, καὶ Ἀδὰμ ἐζωοποίηται.

[84] For example, Pseudo-Epiphanius, PG, 43.456A.
[85] Weitzmann, *Elfenbeinskulpturen*, no. 201 dated in the eleventh century. *Iskusstvo Vizantii V Sobraniiakh SSSR* (Moscow, 1977), II, no. 596 dated in the twelfth century.

be misinterpreted as the anonymous dead who arose at the historical time of the Crucifix-
ion as seen, for example, in Paris gr. 74, fol. 59r.[86]

The Leningrad ivory, the New York ivory, and the epigram of Ignatius all suggest that
the interpretation of the Crucifixion projected through the feast of Stavroproskynesis dur-
ing the ninth century inspired the incorporation of motifs from the Anastasis into the im-
age of the Crucifixion. The resulting amalgam could act effectively as a reference to the
feast of the Stavroproskynesis celebrated on the third Sunday of Lent from the post-Icon-
oclastic period onward, though it could also be incorporated into such christological cycles
as that of the Virgin at Pege.

We have no way of evaluating more precisely the significance of this mosaic of the Vir-
gin at Pege from the 870s. The reference to the defeat of Hades and the rising of the dead
included in this Crucifixion probably made superfluous an independent mosaic of the
Anastasis. So it is possible the Anastasis was excluded from this cycle as well. Beyond
drawing a parallel between this half-documented hypothesis and the exclusion of the
Anastasis from the Paris Gregory, we can do little.

The Church of Zaoutzas

The conservativism that inspired the omission of the Anastasis from the few known works
associated with the name of Basil I receded before the end of the ninth century. We know
this through a panegyric delivered by Leo VI in the church built between 886 and 893 by
Stylianos Zaoutzas, the emperor's powerful father-in-law.[87] The mosaic cycle that deco-
rated it included the hierarchical scheme of the Pantocrator together with his angelic, and
Old and New Testament choirs, as well as "events from the Incarnation." The christolog-
ical cycle so described by Leo consisted of the Annunciation, the Nativity, the Adoration
of the Magi, the Presentation in the Temple, the Baptism, the Transfiguration, the Raising
of Lazarus (described as: throwing off corruption) and the Crucifixion. Leo goes on: "Else-
where the tomb offers Him hospitality, and in another place He is seen trampling on cor-
ruption. And He rises elsewhere and raises Adam along with Himself, and makes His way
to heavens, and His ascent to the Paternal throne together with His human body. His
mother . . . and His disciples are standing there. . . ."[88]

It has been pointed out that if the text is interpreted strictly, there must have been two
separate scenes of the Anastasis.[89] However, the broadness of Leo's description of the

[86] H. Omont, *Evangiles avec peintures byzantines du
XIe siècle* (Paris, 1908).

[87] Leo VI, imp., *Oratio* 34. Λέοντος τοῦ Σοφοῦ πα-
νηγυρικοὶ Λόγοι, Akakios, ed. (Athens, 1868), 274–
280. L. Syndikas, "Παρατηρήσεις σὲ δύο ὁμιλίες τοῦ
Λέοντος Σοφοῦ," Ἐπιστημονικὴ Ἐπετηρὶς τῆς Φι-
λοσοφικῆς Σχολῆς τοῦ Πανεπιστημίου Θεσσαλονίκης,
7 (1957), 207–215. Mango, Sources, 203–205.

[88] The translation offered here is that of Mango,
Sources, 205, with minor emendations. The text of

Akakios, op. cit., 277, as amended by Syndikas,
op. cit., 211, is: "καὶ τάφος ἀλλαχοῦ τοῦτον ξενίζει,
καὶ πατῶν ἑτέρωθι τὴν φθορὰν ὁρᾶται· καὶ τὸν Ἀδὰμ
ἐν ἄλλῳ συνεξεγείρων ἐγείρεται, καὶ ἐπὶ τὴν εἰς οὐ-
ρανοὺς πορείαν ποιούμενος, καὶ τὴν μετὰ τοῦ
προσλήμματος εἰς τὸν πατρικὸν θρόνον ἀνέλευ-
σιν· ἑστήκασιν ἐκεῖ Μήτηρ . . . καὶ μαθηταὶ. . . ."

[89] Mango, Sources, 205 n. 117. Syndikas is con-
vinced that the description refers to two separate
scenes, basing his argument on Grabar's hypothesis

church together with other lapses in its precision discourage such a strict interpretation.[90] Therefore, we will let this problem rest and conclude only that the christological cycle of the Church of Zaoutzas included some version of the Anastasis.

The Church of Zaoutzas is the first post-Iconoclastic church known to have included the Anastasis in its christological cycle. Moreover, it is the first post-Iconoclastic church known to have included a complete cycle. A comparison of "the events of the Incarnation" selected here with those that appear on the historiated reliquaries shows them to be very similar. The church includes all of the reliquary-repertoire, and adds three scenes to it: the Adoration of the Magi, the Raising of Lazarus, and the Entombment. Comparison with the standard feast cycle of the eleventh century proves the Church of Zaoutzas to be short of the Pentecost, and the Dormition of the Virgin. These comparisons suggest that feast cycles were well under way in the latter part of the ninth century. The repertory of the Church of Zaoutzas and its deployment echo very closely the mosaic decoration of churches from the eleventh century. The omission of the scenes of the Pentecost and the Dormition suggest that the cycle was not yet fully developed. Comparison with the program of decoration on historiated reliquaries proves that the christological cycle described by Leo, far from being unique in the ninth century, fits in with other products of that time. Finally, the inclusion of the Adoration of the Magi in this selective christological cycle shows that its roots go back to pre-Iconoclastic abbreviated cycles, a link that has been discussed in connection with the historiated reliquaries. Thus, the Church of Stylianos Zaoutzas and the historiated reliquaries provide us with two abbreviated christological cycles of the ninth century. These cycles are immediate antecedents of the fully developed feast cycles as we know them from the eleventh century, and they echo features of the pre-Iconoclastic abbreviated cycles of the life of Christ. But, what is relevant for us is that the iconography of the Anastasis is an organic part of both of these ninth century cycles, whose appearance and function relate directly to the so-called "feast cycles."

In review, three major trends may be recognized in the evolution of the Anastasis during the ninth century. One is represented by the moderate and traditional iconography of the historiated reliquaries. The second is encountered in the fanatical extremism of the Psalters with marginal miniatures, which energetically explores the iconographic possibilities of the image in the context of the cycle of the Death and Resurrection of Christ. It even develops the Bodily Rising of Christ as a radical iconographic alternative to the scene of the Anastasis. The third trend materializes as an expression of the official conservativism of the time of Basil I, which bypasses the Anastasis in favor of the Chairete, a pre-Iconoclastic image of the Resurrection. The specific reasons, extent, and duration of this reactionary phase is not certain, but we know the Anastasis figured in works patronized by the court soon after Leo VI became emperor.

The revival of the Chairete as a self-contained pictorialization of the Resurrection was

(above, 9). A different reconstruction offered by Frolow has been conclusively disproved by the textual emendations effected by Syndikas. A. Frolow,

"Deux églises byzantines d'après des sermons peu connus de Léon VI le Sage," *EtByz*, 3 (1945), 43–91.

[90] For an example, see Mango, *Sources*, 204 n. 107.

short-lived. The eagerness of the Psalter school to explore the mechanics of the Resurrection along with many aspects of Christ's Death did not spread outside this group of manuscripts either. The moderate and traditional iconography of the Anastasis was the one which prevailed, eventually superseding all other pictorial alternatives for the theme of the Resurrection. Minor iconographic amendments were included portraying the defeat of Hades and his domain as complete and irrevocable, while promoting the presence of Kings David and Solomon as integral to the Anastasis.

The basic visual vocabulary of the image was not altered. However, the interpretation of its function was renewed. As well as remaining part of the christological cycle, the Anastasis now acquired concrete liturgical overtones. The first demonstrable example of this sort is the example of Anastasis illustrating Ps. 81:8 in the Chloudof Psalter. A parallel is drawn here between the Anastasis and a psalm that plays an identifiable liturgical role in the Easter celebration. In other words, this is the first time the image of the Anastasis may be interpreted as a direct pictorial reference to the Easter Services. There is a comparable allusion to Easter in the illustration of fol. 30v of the Paris Gregory despite the omission of the scene of the Anastasis from it. In both cases, an effort is made to link the illustration with a specific aspect of the formal Easter liturgy, allowing the image to function as liturgical commentary in pictorial form. This interest is shared by extremists and conservatives alike. In this way, the ninth-century experiments with the use of the Anastasis and its pictorial alternates as references to specific parts of the Easter liturgy.

Overall, the variety of approaches toward the pictorialization of the theme of the Resurrection suggest there was a debate among Iconophiles during the ninth century. This was probably the result of the need to reexamine and redefine the form as well as the function of christological imagery, so that it might complement in the best possible way the Orthodox Iconophile position. The experiments of the ninth century also produced some pictorial hybrids. Hybrids in form, content, or both. The combination of the image of the Crucifixion with the Anastasis which probably decorated the Church of the Virgin at Pege belongs to the last category. However, of much greater interest is the hybrid offered by the third type of Anastasis.

THE THIRD TYPE OF ANASTASIS

The third type of Anastasis appears first as the illustration of Ps. 81:8 in the Chloudof Psalter (fig. 44b). The strictly frontal figure of Christ in a mandorla of light stands precariously on the head of Hades. He is flanked by Adam and Eve. Christ lifts Adam with one hand and raises the other in a gesture of speech.

The scheme of this miniature may be characterized as unsettled and immature. Adam and Eve are floating in midair. The place of honor on Christ's right side is unexpectedly ceded to Eve. Adam is on Christ's left and raised by Christ's left hand, both of which are irregular features. Moreover, the gesture of lifting Adam compromises the symmetry of this formal composition. The gesture of speech of Christ's right hand is mostly responsible

for this, since it precludes positioning Adam to Christ's right and his being raised by Christ's right hand. The artist apparently did not wish to compromise Christ's frontality or his formal gesture, a combination used for a traditional apocalyptic type of Christ known from many Early Christian works, such as: the panel of the Triumph of Christ on the Door of S. Sabina,[91] Christ of the Ascension miniature on fol. 13ᵛ of the Rabbula Gospels,[92] and Christ in the Transfiguration mosaic at Mount Sinai.[93] The Chloudof miniature appears to integrate into the image of the Anastasis iconographic material from other sources. However, the new synthesis has not yet been normalized, even though it has already produced a new type of Anastasis.

The inconsistencies disappear in the mature version of this type, as witnessed by its first fully developed example, the Gospel Lectionary Iviron, cod. 1, usually dated in the eleventh century (fig. 50).[94] Christ now towers above the trampled figure of Hades, who lies on top of a hill. At the base of the hill, Adam and Eve flank the imposing figure of Christ lifting their hands toward him. Christ reinforces the symmetry of the composition by extending his hands to show the marks of the nails. The symmetry is further enhanced by including above the level of Adam and Eve two more groups led by the kings and prophets lifting their hands to Christ, as well as by two adoring angels hovering above Christ—incidentally, the first angels seen in an eastern Anastasis and in a role radically different from that of their western counterparts.[95]

In the Anastasis of Iviron 1 neither Adam nor Eve comes in contact with Christ, but they are placed below him on the frameline of the illustration, Adam to the right of Christ. The problem of the stability of the three primary figures is solved. At the same time, the effect of the ceremonial frontality and symmetry of the composition is maximized. The result is impressively formal, allowing no doubts about the intention to treat the Anastasis primarily as an epiphany, a revelation of the consequences of the Passion of Christ.

The variations of the mature third type of Anastasis reveal the extent of its flexibility. A feast icon in Leningrad maintains the frontality of Christ, as well as the exhibition of his wounds.[96] The same is true of the Anastasis in Paris gr. 550 (fig. 51), which also adds the

[91] For the third type of Anastasis, see 8f. Also, A. Cutler, *Transfigurations. Studies in the Dynamics of Byzantine Iconography* (University Park, Pa., 1975), 100ff. For the wooden doors of S. Sabina, J. Wiegand, *Das altchristliche Hauptportal an der Kirche der hl. Sabina* (Trier, 1900), and Volbach, *Early Christian Art* 330, pl. 103. *Age of Spirituality*, no. 438.

[92] Florence, Laur., cod. Plut. 1, 56. fol. 13ᵛ. Leroy, *Les manuscrits syriaques peints et enluminés*, 152. Cecchelli, Furlani, Salmi, *The Rabula Gospels*.

[93] G. H. Forsyth, K. Weitzmann, I. Ševčenko, K. Anderegg, *The Monastery of St. Catherine at Mount Sinai. The Church and Fortress of Justinian* (Ann Arbor, n.d.), I, 11ff.

[94] A. Xyngopoulos, *Evangiles avec miniatures du monastère d'Iviron au Mont Athos* (Athens, 1932), 6ff.,

pl. 1. Weitzmann, "The Narrative and Liturgical Gospel Illustrations," 260, dates the manuscript in the eleventh century, while Lazarev, *Storia*, 252 n. 51, prefers a twelfth-century date. The recent publication *The Treasures of Mt. Athos* does not contain an illustration of this important miniature.

[95] Above, 89f.

[96] This is a twelfth-/thirteenth-century icon from the monastery of the Great Lavra on Mt. Athos. M. Chatzidakis, "L'évolution de l'icone aux 11e–13e siècles et la transformation du templon," *XVe CIEB. Rapports et co-rapports* III. *Art et Archéologie* (Athens, 1976), 170, pl. 31, 11. Lazarev, *Storia*, 207, dates it in the second half of the twelfth century. *Iskusstvo Vizantii V Sobraniiakh SSSR*, II, no. 473a.

instruments of the Passion in the hands of four archangels.[97] In both instances Christ dominates the composition by his size, frontality, and emphatic display of the stigmata. However, the symmetry is less strict than in Iviron 1, since Adam and Eve appear together on Christ's right, balanced in a less formal manner on the other side by a group of kings and prophets. This variation of the third type of Anastasis differs little from the first and second types, since it needs only to adjust the figure of Christ in an attitude of strict frontality.

In contrast, the major representations of the third type take the compositional logic of this scheme to its conclusion. In addition to Iviron 1, we can see this in an Anastasis on a Liturgical Psalter leaf at Princeton (fig. 52).[98] The oversize figure of Christ stands on the broken gates of Hades, which lie inside a hill. The defeat of Hades is already accomplished through the Passion, as witnessed by the hand wounds displayed. Flanking the base of the hill that encloses the land of the dead are two sarcophagi out of which rise the suppliant figures of Adam and Eve. This abbreviated example makes clear the message of the third type: Christ defeated Hades and saved Adam, the protoplast, through the Passion. This type of Anastasis is in fact an apocalyptic statement.

The frugal presentation of this fundamental message in the Princeton Anastasis could undoubtedly be enriched by recourse to the other types of Anastasis. Iviron 1 adapts the kings and prophets on either side of the figure of Christ. A fourteenth-century Sticherarion at Mt. Athos, Koutloumousiou, cod. 412, fol. 232v, adds a patriarchal cross—the par excellence instrument of Passion—in Christ's left hand while his right exhibits the nail wound (fig. 53).[99] Christ moreover straddles the broken gates of Hades. He is flanked by Adam and Eve on the right and by the two kings on the left, the same way as in the Leningrad icon. Psalter Vatopedi 760 (fig. 54) dating from the eleventh or twelfth century, is close to the Koutloumousiou Anastasis in the stance and attributes of Christ.[100] Adam and Eve are placed more accurately inside the dungeon of Hades, now littered with broken keys and chains.

Despite its flexibility over the adoption of features from the first and second type of Anastasis, the mature third type is not a paraphrase of them, as it contains stable features that set it apart. One is the immobile frontal figure of Christ offering solemn proof of his Passion. Then there is the symmetrical arrangement of the remaining figures around him, starting with the suppliant protoplasts. And, finally, there is a hill whose interior acts as the abode of Hades, and whose formal function is to allow its summit to set Christ apart.

The formality of the composition as well as some of its persisting iconographic features stress this scene as an apocalyptic epiphany. The frontal figure of Christ on top of a hill in a mandorla of light symmetrically flanked by humans calls to mind the well-known

[97] See n. 4.41.

[98] Weitzmann, "Aristocratic Psalter and Lectionary," 102ff., fig. 1. *Illuminated Manuscripts from American Collections*, no. 30. eleventh or twelfth century. On the reverse of the leaf Ps. 8:7–10 is written.

[99] Strunk, "St. Gregory of Nazianzus and the Proper Hymns for Easter," 82ff., fig. 1. *The Treasures of Mt. Athos*, I, 467. S. Der Nersessian, "L'illustration du stichéraire du monastère de Koutloumous no. 412," *CA*, 26 (1977), 143f., fig. 9.

[100] Weitzmann, "Aristocratic Psalter and Lectionary," 105, fig. 4. Idem, "Das Evangelion in Skevophylakion zu Lawra," 87. This miniature illustrates Ps. 67:2.

scheme of another epiphany on earth, the Transfiguration. Of course, the status of Moses and Elijah is not to be compared with that of Adam and Eve. There is another epiphany, however, which includes Adam and Eve regularly, and which also stresses the display of Christ's wounds. This is the iconography of the Last Judgment.

Christ can be seen displaying his wounds in the Last Judgment as early as the ninth-century illustration of this theme in the *Sacra Parallela* of John of Damascus.[101] In this early example Adam and Eve are not included (fig. 55). They are present, however, in the Last Judgment at Panagia Chalkeon in Thessalonike dating shortly after 1028.[102] Adam and Eve figure here at the feet of an oversized Christ whose hands are extended to show the nail marks. The status of Adam and Eve as suppliants is underlined at Panagia Chalkeon by their size and attitude. This status is further emphasized by the transfer of the protoplasts to a separate zone immediately below the figure of Christ in another version of the Last Judgment. This is where we find them in the Last Judgment at Torcello, and in Mavriotissa in Kastoria[103] at a later date.

The third type of Anastasis in Iviron 1 and on the Princeton leaf offers more than a parallel echo of the iconographic and compositional arrangement of these images of the Last Judgment. All of them focus on the apocalyptic frontal figure of Christ displaying his wounds, flanked by the suppliant figures of the first created and recreated. They all insist on a triangular symmetrical composition hierarchically zoned. Thus, it appears that the mature third type of Anastasis deliberately adapts this apocalyptic blueprint to its own needs.

The thematic affiliation of the Anastasis and the Last Judgment is probably responsible for this exchange. In the standard exegesis of the tenth century, as expressed by Photius, the raising of Adam-Everyman is an act of re-creation.[104] However, it is also an act of Judgment. Specifically, the archetypal Judgment of the archetypal Sinner, whose salvation guarantees the redemption of mankind at the time of the Last Judgment. Accordingly, the *Suda*, a tenth-century dictionary, defines the Anastasis as an act of justice, and as "the second rising to a standing position and the end of the patience of God."[105] That is, it interprets the Anastasis as a reference to the Last Judgment. The fundamental interpretation of

[101] Grabar, *L'empereur dans l'art byzantin*, 251f., pl. 38.1. Weitzmann, *The Miniatures of the Sacra Parallela. Parisinus, Graecus 923*, 169f., fig. 441.

[102] K. Papadopoulos, *Die Wandmalereien des XI. Jahrhunderts in der Kirche* Παναγία τῶν Χαλκέων *in Thessaloniki* (Graz, 1966), 60, pl. 4. Brenk, 83ff., fig. 5, pl. 22.

[103] N. K. Moutsopoulos, Καστοριά. Παναγία Μαυριώτισσα (Athens, 1967), pls. 39, 43. Brenk, 99, pl. 29. St. Pelekanides, Καστοριά (Thessaloniki, 1953), I, pl. 78. The protoplasts are to the right of the Hetoimasia in the two eleventh-century Last Judgment icons on Mount Sinai. Sotiriou, *Icônes du Mont Sinai*, 128ff., pl. 150 and 130, pl. 151. Also, Weitzmann,

"Byzantine Miniature and Icon Painting in the Eleventh Century," 301ff., figs. 303, 304.

[104] Photius, *Homily* XII. Mango, *The Homilies of Photius Patriarch of Constantinople*, 215.

[105] *Suidae Lexicon*. A. Adler, ed. (Leipzig, 1928), I, w. "ἀνάστασις," 2079: Ἀνάστασις: ἐπειδὴ ὁ θάνατος παρὰ φύσιν εἰσῆλθεν, ἡ δὲ ἀνάστασις κατὰ φύσιν. ὁ γὰρ πρωτόπλαστος πρὸ τῆς παραβάσεως ἀθάνατος ἦν. ἀνάστασις δὲ λέγεται, ἐπειδὴ τὸ φθαρὲν πλάσμα διὰ τῆς ἁμαρτίας ὀρθοῦται διὰ δικαιοσύνην. εἰ γὰρ παρέμεινεν ὁ Ἀδὰμ τῇ ἐντολῇ, ἔμεινεν ἂν ζῶν. ἀνάστασις οὖν δευτέρα στάσις καὶ ἡ τῆς μακροθυμίας τοῦ Θεοῦ παῦλα.

redemption as an act of Judgment whose catalyst was the Passion, and whose realization requires the Resurrection of the dead was responsible for the linking of these two themes.

The link also inspired a number of pictorial exchanges between the images of the Anastasis and the Last Judgment. The portrait of the donor(?), which appears below the weighing of the souls in the Last Judgment in Hagios Stephanos, Kastoria before 1040[106] parallels the function of the portrait of Cyril in the second Anastasis from S. Clemente (fig. 17b). The use of the Anastasis in a funeral context in the Chapel of S. Zeno (fig. 23) points to an early date for the use of the Anastasis as an expression of the pious hopes of the deceased for his future. Reference to the Anastasis as a Judgment has already been discerned in the skulls and fires littering the *tenebrae* of the second Anastasis in S. Clemente, not unlike the skulls and fires that figure in the standard Last Judgment. The drawing of Adam and Eve from the fires of Hell in a number of representations of the Anastasis in the Exultet Rolls is in the same spirit as well (fig. 20). In return, the Anastasis often lent to the Last Judgment the figures of Adam and Eve flanking Christ the Judge or his Hetoimasia. It also made possible the presence of the protoplasts in other epiphanies, such as the apocalyptic vision in the apse of St. Barbe at Soganli, Cappadocia.

The semantic interrelation of these two subjects resulted in the exchange of iconographic motifs and compositional schemes. The mature third type of Anastasis, as exemplified by Iviron 1, demonstrates the nature of this interplay. The third type of Anastasis seen in the Chloudof Psalter testifies to its early beginnings. Moreover, the use of this type in the context of Ps. 81:8 is particularly significant.

Psalm 81:8 played a key role in the Holy Saturday Vigil. In the first part of the vigil the baptismal theme was predominant, as we shall see later, while the second part of the vigil concentrated on the theme of the Resurrection. The chanting of Ps. 81:8: "Arise, O God, judge the earth; for thou shalt inherit the nation" marked: "a turning point in the thematic content of the service. Previously the theme of Baptism was predominant in the Old Testament readings, the chants, and the Apostle; with Ps. 81:8, it is the Resurrection which comes into focus," as the two liturgists Bertonière and Mateos agree.[107]

The liturgical significance of this verse during the Middle Byzantine period is illustrated by a ceremony that probably accompanied its chanting as early as the tenth century. While the chanter prepared to intone Ps. 81:8 during the celebration of the Paschal Vigil in the Church of the Lady of Pharos, in which the emperor participated actively,[108] "at this same time, the chartularies of the skevophylakion stand near the altar and remove the plain covering which lies on it, thus revealing the golden one underneath."[109]

Although we do not know the exact meaning of this particular ceremony, which is described in similar terms by Constantine Porphyrogenitus, we know that later offshoots and variations were interpreted either as the rolling away of the stone from Christ's tomb,

[106] Brenk, 81f., fig. 4. [107] Bertonière, 137ff.

[108] Constantin VII Porphyrogénète, *Le livre des cérémonies*, A. Vogt, ed. (Paris, 1935–1940), Text I, 171f.

[109] Bertonière, 138. This text is in the Dresden Praxapostolos, which dates from the mid-tenth to the mid-eleventh century (ibid., 114) and probably describes the same rite as the Book of Ceremonies.

or as the preparation for the adventus, a triumphal adventus, which included the spreading of laurel leaves, the sign of victory.[110]

It seems that apart from introducing the theme of the Resurrection during the Paschal Vigil, Ps. 81:8, which summons Christ to rise and judge the earth, interprets the Resurrection in liturgical and ceremonial terms as the First Adventus—the prototype and guarantee of the Second and Last Adventus, which marks the end of God's patience. The interpretation of Ps. 81:8 as a reference to the Last Judgment is confirmed by the exegetical literature on this psalm.[111] The chanting of this verse on Holy Saturday thus proves the correlation of the themes of the Anastasis and the Last Judgment on a liturgical level. By the same token, the emergence of the third type of Anastasis in the Chloudof Psalter as an illustration of this verse proposes the interpretation of this type of Anastasis apocalyptically as a proto-Judgment.

The exegesis of the Anastasis as an apocalyptic act must have been fairly popular. The interplay between the themes of the Anastasis and the Last Judgment in the visual arts was not limited to the exchange of isolated characteristics. It also produced iconographic hybrids in which these two themes were fused.

This happens in the illustration of Ps. 12 on fol. 44v of the Psalter Vat. gr. 752 dating 1059 (fig. 56).[112] Adam and Eve as suppliants flank the foot of the hill of Hades, inside whose dark cave a naked dark figure labeled "Hades" holds onto a human figure, apparently some unlucky soul. As correctly noted both by De Wald and Brenk, the scheme reflects the third type of Anastasis as seen in Iviron 1. But there is a major difference between the two miniatures: Christ is not standing on top of the hill of Hades giving proof of his Passion. Instead, he is already in an ark of heaven above, physically separated from the figures below. His presence in this relative of the third type of Anastasis is symbolic and unrelated to the actual defeat of Hades and the raising of Adam. This image is even further removed from the actual event than the third type of Anastasis.

In a distinct zone immediately below this scene, a group of men and a group of women rise symmetrically out of two sarcophagi, liftitng their hands in supplication to the scene above. The rising of the anonymous dead is a motif included in the Anastasis at an early date, as we have seen. However, the anonymous dead rose on other occasions as well: at the time of the death of Christ on the cross, according to Matt. 27:52f. and at the time of the Last Judgment, according to the Creed, among other sources. The rising of the dead at the time of the Crucifixion appears at least as early as the Utrecht Psalter, fol. 90r, and becomes a popular theme in the Carolingian West, while the rising of the anonymous dead enters the pictorial scheme of the Last Judgment at least as early as the Vatican manuscript of Cosmas Indicopleustes.

[110] Bertonière, 138, in reference to the Prophetologion Sinai 9 dating from the beginning of the eleventh century (ibid., 116), and Pseudo-Kodinos, *Traité des offices*, J. Verpeaux, ed. (Paris, 1966), 231f.

[111] This psalm is understood as a reference to the Last Judgment by Hesychius, *Fragmenta in Psalmos*, PG, 93.1260C–D and Theodoretus Cyrus, *Interpretatio in Psalmos*, PG, 80.1629C.

[112] E. T. De Wald, *The Illustrations in the Manuscripts of the Septuagint. Volume III. Psalms and Odes. Part 2: Vaticanus graecus 752* (Princeton, 1942), 11f. Brenk, 88f.

Though the anonymous dead on fol. 44ᵛ of Vat. gr. 752 cannot be correlated in any way with the illustration of Matt. 27:52, they can be associated with the rising dead of the Last Judgment, such as those who figure similarly dressed on fol. 51ᵛ of Paris gr. 74, which also dates to the third quarter of the eleventh century.[113] The strict zoning of the Vatican miniature, the appearance of Christ in the ark of heaven separated from the rest, and the inscription that accompanies the rising anonymous dead supports this. This inscription places their Anastasis only in the future: "The dead too shall arise in Christ."[114] The future tense is not accidental. A comparable series of anonymous dead shown rising at the time of the raising of Adam in the traditional first type of Anastasis in the early eleventh-century church of St. Barbe at Soganli in Cappadocia (fig. 67) offers a stark contrast in its inscription: "the dead arose from the graves."[115] The difference in tense suggests a clear line of distinction between the dead who have already risen in the Vatican miniature—Adam and Eve, who are already ouside the dark underworld—and those who will also arise in the name of Christ at the time of the Last Judgment—the man still held by Hades inside his cave and the suppliant figures in the zone below. If this is correct, the Vatican miniature crosses the theme of the Anastasis with that of the Last Judgment. In the resulting hybrid, the characteristics of the third type of Anastasis are predominant, though their clarity is compromised.

The balance between these two themes tilts in the opposite direction in the case of the decoration on the West wall of SS. Peter and Paul at Tat'ev in Armenia.[116] The paintings of this monastic church, which were consecrated with great pomp in the presence of the Katholikos of Armenia in 930, have caused disagreement. Thierry has interpreted the subject of the painting on the West wall as the Last Judgment, while Der Nersessian has read it as the Anastasis.

Christ is enthroned in a mandorla of light flanked by the figures of Peter and Paul standing on footstools. Paul is holding an open book inscribed with Romans 2:16, a clear reference to the Last Judgment. Below Christ, two large angels hold open scrolls. Further down, a great many figures rise out of their open sarcophagi. Two of the figures are identified by inscription as Adam and Eve. The presence of the protoplasts rising out of sarcophagi has led Der Nersessian to identify this scene as the Anastasis. On the contrary, the rest of the iconographic and compositional details have led Thierry to recognize a Last Judgment whose closest parallels come from the Bamberg Apocalypse. The comparison of this monastic church in Soviet Armenia to such a characteristic western product is further supported by the text of Stephen Orbelian, archibishop of Tat'ev, who wrote in 1285 that "Franks" took part in painting the church in the tenth century.[117]

[113] Omont, *Evangiles avec peintures byzantines du XIe siècle.*

[114] Καὶ οἱ νεκροὶ ἐν χριστῷ ἀναστήσονται.

[115] Jerphanion, II/1, 327: I NEKPY EK TON MNHMA-TON ANICTANTΩ.

[116] S. Der Nersessian, *L'art Arménien* (Geneva,

1977), 93ff., pl. 252, figs. 63, 64. N. and M. Thierry, "Peintures murales de charactère occidental en Arménie: Eglise Saint-Pierre et Saint-Paul de Tatev (début du Xe siècle). Rapport Préliminaire," *Byzantion*, 38 (1968), 180–242, esp. 192ff.

[117] Thierry, op. cit., 181ff.

As far as is possible to judge from the published photographs, both scholars are partially right. The scheme of Christ enthroned in a mandorla surrounded by angels and apostles, the angels with the unfolded scrolls, and the sarcophagi out of which numerous figures rise characterize examples of the Last Judgment as early as Müstair.[118] On the other hand, the inclusion of Adam and Eve among the rising dead is at least a concrete reference to the theme of the Anastasis, which sometimes promotes the secondary motif of the anonymous dead to a major theme.

This is the case with the Anastasis relief on the side of a small ivory casket in Stuttgart (fig. 57) classified by Weitzmann in the painterly group of the tenth century.[119] In the center, we see Christ trampling Hades underfoot while raising Adam. The omission of Eve together with the compositional and iconographic particulars makes this Anastasis a direct descendant of the one decorating the Chapel of the Forty Martyrs in S. Maria Antiqua. This traditional image is flanked by four sarcophagi out of which rise eight unidentifiable suppliants larger in size than the central protagonists. These anonymous dead, who resemble the rising dead of the church at Tat'ev, are not a tertiary motif appended to the Anastasis but a vital and prominent part of it. The partly surviving inscription above this relief mentions the opening of the road to Paradise for mortals through the Anastasis.[120] The eight anonymous dead, whose inclusion supersedes even that of Eve, appear to stand as material witnesses for these words, or candidates for the promise.

The pictorial prominence possible for the anonymous dead in images of the Anastasis, coupled with the inclusion of Adam and Eve among them, testifies at least to an intention to incorporate a reference to the Anastasis in the "frankicized" image of the Last Judgment, which decorates the West wall of the early tenth-century Armenian church in Tat'ev.

Both fol. 44v of Vat. gr. 752 and the church in Tat'ev exemplify the kind of iconographic hybrid which could result from the interplay between the Anastasis and the Last Judgment. The west wall of the church of S. Maria Assunta at Torcello, which is the work of Byzantine mosaicists, also integrates the two scenes although in a different way (fig. 58).[121] The upper part of the wall is occupied by the representation of the Crucifixion. Below is the Anastasis, dominated by an oversized Christ. The Anastasis zone is framed by two similarly oversized archangels, dressed in the loros and standing in strict frontality. Immediately below comes the multizoned Last Judgment. The arrangement of the wall is un-

[118] Brenk, 107ff., figs. 7–9, pls. 30–33.

[119] Weitzmann, *Elfenbeinskulpturen*, II, no. 24b.

[120] Ibid., ΒΡΟΤΩΝ ΑΠΑΡΧΗΝ ΟΥΡΑΝΟΔΡΟΜΟΝ ΛΑΒΟΝ. The inscription, which originally ran around all four sides of the ivory casket, begins and ends in the middle of the other long side of the casket. This side reads: Ε ΤΟΝ ΚΕΚΤΗΜΕΝΟΝ + Ο ΜΗ ΜΕΡ. . .ΠΑΤΡ. Its continuation on the two short sides does not survive.

[121] I. Andrescu, "Torcello. I, Le Christ inconnu. II, Anastasis et Jugement Dernier: têtes vraies, têtes fausses," *DOP*, 26 (1972), 183–223. Idem, "Torcello.

III, La chronologie relative des mosaiques pariétales," *DOP*, 30 (1976), 245–345. M. Vecchi, "Santa Maria Assunta: Il completamento del 'Giudizio' sotto i muri della grande navata," *Torcello. Ricerche e contributi* (Rome, 1979), 7–18. The stylistic affinity of the surviving eleventh-century Torcello mosaics with other eastern eleventh-century mosaics was amply demonstrated by Dr. Andreescu in her lectures delivered during the Dumbarton Oaks Symposium, in May 1978. Andreescu, "Torcello. III," 260ff.

usual in several ways. Although the sequence Crucifixion-Anastasis is common, its position on the west wall of a church is not common. Moreover, the sequence Crucifixion–Anastasis–Last Judgment is unique. On the other hand, the Last Judgment is perfectly at home on the west wall of a church.

The uneven treatment of these three scenes and of the figures of Christ in them is another important aspect of the west wall. The Crucifixion is the least visible, placed high up in the gable. It is also the most frugal in its presentation of Christ, the Virgin, and John alone against a plain gold background. Below the crucified Christ is the figure of the risen Christ. This familiar sequence establishes the two scenes as cause and effect. However, the usual balance of this pictorial sequence is upset by the huge figure of the risen Christ which dominates the west wall by his size becoming the focal point of the wall decoration. The shift in focus is emphasized by the two archangels who frame the Anastasis zone. Their importance is stressed along with their relationship to the figure of the risen Christ through formal means: the archangels occupy the full height of the Anastasis register just as Christ does. But, unlike Christ, they stand motionless and ceremoniously in full frontality, exhibiting the orb and a standard as their insignia. Their size and position in the Anastasis zone aligns them with Christ, while their attitude dissociates them from him and the event witnessed in that zone. The archangels therefore stand as a part of the Anastasis zone, but apart from the representation of the Anastasis.

The greater importance of the Anastasis in the sequence Crucifixion–Anastasis is enhanced by the complexity of the latter. The scene is overpopulated and the importance of its actors is graded by their size. The Baptist, who stands apart, pointing Christ out to the beholder, comes second after Christ and the archangels. Adam and Eve are the same size as the Baptist, while David and Solomon are slightly smaller. Even smaller is a group of men standing behind the Baptist. Finally, the diminutive anonymous dead and the tiny figure of Hades appear in the lower part of the scene. The extensive use of an elaborate design simulating the marble of the sarcophagi adds to the complexity of this representation.

The Last Judgment is immediately below the Anastasis. Although it is also elaborate and occupies twice as much wall-space as the Anastasis, its importance is much diffused by its multiple zones, which necessarily make the size of its actors smaller. This is particularly significant for the apocalyptic figure of Christ the Judge, who is immediately below the oversized figure of the Anastasis Christ, but is half its size. The startling contrast of these two representations of Christ has important consequences. Christ the Judge assumes a pictorial role subsidiary to that of the rising Christ. By the same token, Christ of the Anastasis becomes the physical peak, the compositional culmination of the Last Judgment. As a result, the Anastasis formally functions as the first zone of the last Judgment and the introduction to the subsequent zones. The artist therefore treats the Anastasis and the Last Judgment as a compositional unit. The intention is iconographically consolidated through the addition of the oversized archangels, who ostentatiously guard the rising Christ, echoing the loros archangels attending Christ the Judge in the zone below.

This iconographic type of angel is not indigenous to the Anastasis. As we have seen, angels pay homage to the frontal figure of Christ displaying his stigmata in Iviron 1 (fig. 50). By the second half of the eleventh century Constantinople was using a type of Anastasis that included angels floating in the air carrying standards with the Trisagion—as Buchthal has shown in connection with the Melisende Psalter. Similar archangels bearing the symbols of Christ's Passion stand outside the frame of an Anastasis of the third type in Paris gr. 550 (fig. 51) dating from the twelfth century.[122] Moreover, Vat. Urb. gr. 2 and Paris gr. 75 dating from the second quarter of the twelfth century include angels inside the open gates of heavens above the Anastasis.[123] Eastern tradition is therefore known to have associated angels with the image of the Anastasis from the eleventh century on. In the case of Paris gr. 550, the archangels have a passive role as an exegetical reference to the Passion in the Anastasis. In all other instances, the angels are glorifying agents, though in Vat. Urb. gr. 2 the open gates of Paradise discreetly add an apocalyptic dimension to the image. But angels participate actively in the defeat of Hades and Satan in the western iconographic tradition, as seen at Müstair,[124] and the Exultet Rolls (fig. 20).[125] The Torcello archangels follow the Byzantine tradition in their exclusion from the action. However, their monumentality and formality are alien to the eastern image of the Anastasis.

The type of archangel chosen by the Torcello mosaicists stands fully frontal, symmetrically flanked by his wings, dressed in the loros, and holding a staff and an orb. One of the closest parallels comes from the angels populating the zone immediately below the Pantocrator medallion in the dome of St. Sophia in Kiev, dating between 1042 and 1046.[126] The same type of dome archangel is also employed in comparably formal areas and contexts. It frequently figures in apses, as for example, in the left apse in the New Tokali Kilise from the mid-tenth century,[127] in Gelati at 1130,[128] and Cefalu at 1148.[129] Two angels of the same type symmetrically flank Christ in Yilanli Kilise, Cappadocia (fig. 59).[130] Here Christ and the two archangels occupy the western arch of the church. This opens to the narthex, which is entirely decorated with an elaborate representation of the Last Judgment. In view of its position, the composition of Christ and the two archangels has been inter-

[122] See notes 4.39, 4.41.

[123] Frazer, "Hades Stabbed by the Cross of Christ," fig. 9.

[124] Above, n. 4.31. *L'exposition Charlemagne*, nos. 658–661 with further bibliography. A good color photograph of the representation of the Anastasis at Müstair appears in J. Hubert, J. Porcher, W. F. Volbach, *L'Europe des Invasions* (Paris, 1967), pl. 166B.

[125] Avery, *The Exultet Rolls of South Italy*, Gaeta Cathedral, Exultet Roll no. 2 (pl. 36.5). Gaeta Cathedral, Exultet Roll no. 5 (pl. 39.4). Montecassino, Badia, Archives, Exultet Roll no. 2 (pl. 68.12). Rome, Bibl. Casanatense 724 B 13 (pl. 120.5). Vatican, Bibl., cod. lat. 9820 (pl. 137.5).

[126] G. N. Logvni, *Sofia Kievskaia* (Kiev, 1971), pls.

13, 29. O. Powstenko, *The Cathedral of St. Sophia in Kiev* (New York, 1954), pls. 38, 39. The trisagion standards held by the archangels here can be traced back to the Archangels Michael and Gabriel represented on the face of the triumphal arch in S. Apollinare in Classe in Ravenna and dating from the seventh century. Volbach, *Early Christian Art*, 344, pl. 173.

[127] Restle, fig. 123.

[128] Lazarev, *Storia*, 219f., 263 n. 158, figs. 344, 345.

[129] Demus, *The Mosaics of Norman Sicily*, 12, fig. 1. The same type of archangel is also found in the apses of Martorana and Monreale.

[130] N. and M. Thierry, *Nouvelles églises rupestres de Cappadoce* (Paris, 1963), 102, pl. 50b, color pl. opp. p. 48. Restle, figs. 503, 500, 501.

preted as a sort of triumphal arch opening to the narthex and acting as a prologue to the Last Judgment.

The monumentality, formality, stance, costume, and attributes of this iconographic type of archangel seem appropriate in such explicit apocalyptic contexts. This type is at home with formal dogmatic manifestations of Christ as the Pantocrator, as the Logos Incarnate, or as the Judge. The iconography of the Last Judgment is familiar with the type, while that of the Anastasis is not. In the case of Torcello, the proximity of the Last Judgment to the Anastasis and the effort to present these two themes as a continuous unit should be considered responsible for the addition of these angels to the Anastasis. However, their choice as the monumental companions of the rising Christ superimposes on the latter an apocalyptic dimension that transcends the normal interpretation of the Anastasis and succeeds in presenting the Resurrection as a prelude and a complement to the Last Judgment.

The intention to use the archangels as an apocalyptic reference is confirmed by the dragon trampled by the angel on the viewer's right. Although the fanciful dragon seen today seems to owe a lot to an important mid-nineteenth-century restoration, three interrelated engravings, which predate this restoration and were recently published by Andreescu, indicate the head of some sort of a monster in the same place (fig. 60).[131] Beyond standing guard to Christ of the Anastasis, the angel to the right was apparently used to represent the theme of Michael trampling on the dragon, known from western works of the early ninth century.[132] So the Anastasis zone also illustrates the defeat of "the great

[131] As Andreescu has shown, both archangels, as they stand today, are works of the restorer Moro and date from the mid-nineteenth-century restoration of the mosaic. A contemporary document she published says that the angel on the right was in a very bad condition and was entirely reworked by Moro on the basis of a scale drawing first approved by the Academy of Fine Arts [I. Andreescu, "Torcello. III, La chronologie relative des mosaiques pariétales," 285f.; Appendix A4, 268ff. Idem, "Torcello. I, Le Christ inconnu. II, Anastasis et Jugement Dernier: Têtes vraies, têtes fausses," 200, 203]. The extent to which Moro's work was a faithful iconographic copy of the original mosaic may be partly controlled by three engravings that are closely related and date from 1827 and 1853—i.e. prior to Moro's restoration (idem, "Torcello, I," figs. 34 and 35 for the engravings dated 1827 and fig. 31 for the engraving dated May 19, 1853. The latter is an immediate relative of the previous two. The Moro restorations took place between 1852 and 1856. Idem, "Torcello. III," 266). The three engravings tell us that the Moro angels are largely faithful iconographic copies of the mosaics they replaced. However, it seems that the staffs of the original angels did not culminate in trisagion panels as they do today. Therefore, the trisagion vexilla were probably the result of Moro's work. All three engravings show the head of some sort of monster under the feet of the archangel to the right, where Moro later placed his fanciful dragon—apparently an adapted version of the original monster. The change may be due to Moro's efforts to save on the gold tesserae, a factor which affected to an extent the size of the archangel to the right as well (ibid., 270f., and n. 68). In "Torcello. I," 200, Andreescu suggests that there was only a suppedaneum under the feet of the angel to the right originally. Nevertheless, one of the 1827 engravings along with that of 1853 clearly outline the head of some sort of a dragon next to the archangel's right foot.

[132] Goldschmidt, *Die Elfenbeinskulpturen aus der Zeit der karolingischen und sachsischen Kaiser*, I, no. 11. *L'exposition Charlemagne*, no. 522 for the Leipzig ivory of Michael and the dragon dated ca. 800. For the fresco of the Cathedral of Notre Dame, Le Puy, see Demus and Hirmer, *Romanische Wandmalerei*, pl. 38. For other examples, see Brenk, 210, who also discusses this theme and postulates an early Byzantine model.

dragon . . . the old serpent, called the Devil, and Satan which deceiveth the whole world"
by Archangel Michael, according to Apocalypse 12:7ff. Compositional considerations,
however, placed the staff uselessly in Michael's left hand, pointing toward the dragon's tail
instead of its head, as Andreescu observed.[133] Moreover, Michael shows no intention of
using it. He stands immobile over the dragon, holding the orb and the Trisagion vexillum,
which now ends to a pointed lance. According to the prerestoration engravings, the Tri-
sagion vexilla were one of the restorer's dubious contributions to the present mosaic. The
same may be true of the lance at the end of the staff. In any case, the staff is ineffectual as a
weapon. It is therefore possible to prove that this type of archangel and the dragon are not
an established iconographic unit. Rather, the two were clumsily collated for this mosaic.

The presence of the dragon adds an important dimension to the iconographic content of
the Anastasis by illustrating the simultaneous defeat of Hades and the Devil by Christ and
his angels. Western iconography often preferred to distinguish Hades from the Devil in
representations of the Anastasis. Similarly, it encouraged representation of the angelic par-
ticipation in the siege of Hades.[134] The East expressed no interest in either of these ideas in
connection with the image of the Anastasis. However, the Anastasis at Torcello sug-
gests—even if only nominally—the distinction between Hades and the Devil, as well as the
angelic contribution to their downfall. The iconographic vocabulary at Torcello is Byzan-
tine, though its synthesis aims at the satisfaction of a western pictorial tradition. More-
over, the unavoidable parallelism between the respective victories of Christ and his arch-
angel confirms the mosaicist's intention to add an apocalyptic reading to the Anastasis and
so stress the thematic affinity of the Anastasis and the Second Coming.

The monumentality and compositional importance of the rising Christ for both the Ana-
stasis and the Last Judgment is reinforced by his oversized guards. The archangels suc-
cessfully emphasize the apocalyptic nature of the Anastasis through their iconographic
associations and through the addition of the dragon under Michael's feet. The mosaicist
thus suggests a continuous reading for the Anastasis and the Last Judgment, interpreting
the two scenes as complementary and interconnected manifestations of Christ the Re-
deeming Judge.

Consequently, the traditional pictorial alignment of the Crucifixion and the Resurrec-
tion as a cause-and-effect reference to the Passion and Redemption is amended here. It is
expanded to include the final Redemption. But the focus of the west wall is on the rising

[133] Andreescu, "Torcello. I," 200, correctly pointed
out that even if the archangel's staff was originally
meant as a lance, it could not have been functional,
since it is pointing at the dragon's tail rather than
its head. Andreescu understands this to be evidence of
Moro's restoration, while here it is attributed to the
work of the eleventh-century mosaicist. The three
nineteenth-century engravings do not help us decide
this matter conclusively, as the lower part of the arch-
angel's staff is lost in the plumage of his wings. An-
dreescu, loc. cit., has also pointed out that most of the
Anastasis inscriptions have something wrong with
them. One of the mistakes is that the angel to the
right is identified as Gabriel, though he should have
been identified as Michael. She suspects Moro for
these irregularities.

[134] For the distinction of the persons of Hades and
the Devil, above, n. 1.72. For the angelic participa-
tion in the siege of Hades, see above 88ff., and 161.

Christ. While the Anastasis is projected, as usual, as the result of the Passion, it is also interpreted as the historical antecedent and prefiguration of the Last Judgment. These two themes are therefore interlinked on the basis of their mutual message of Resurrection and Redemption, now for the protoplasts and at the end of time for all mankind. The coordination of these two themes effects a micro- and macrocosmic review of the doctrine of Redemption as the result of Christ's Passion.

The range of possible interplay between the themes of the Anastasis and the Last Judgment on the basis of the semantic identity of their message peaks at Torcello, showing that the intentions of the third type of Anastasis, which interpreted this iconography as an apocalyptic proto-Judgment resulting from the Passion, also spread to the other iconographic types of this image as well.

The third type of Anastasis never attained the popularity of the first and second types. It is known to us primarily through manuscript illumination and not at all through church decoration. The prominent apocalyptic memories inherent in its abstract hierarchical scheme generated a variety of confusing or unorthodox pictorial hybrids. Such sources of visual confusion were usually supplanted by more reasonable alternatives in Middle Byzantine art. So it is not surprising that the third type of Anastasis was less in demand than the first and second types whose message was both clear and concrete, and whose pseudo-narrative character made for more flexible use in the context of christological and feast cycles.

VII

DEFINITIONS OF THE TENTH CENTURY

The tenth-century iconography of the Anastasis rejected the extremism of the psalters with marginal miniatures, as well as any radical censoring of the image. The traditional first type became predominant, with the modifications taken on in the course of the ninth century, plus a few more.

Christ advanced toward Adam either to the right (in the Old Tokali Kilise, fig. 61), or to the left (in the Leningrad Lectionary, Public Library, Cod. gr. 21, fol. 1v, fig. 62). He holds the old-fashioned scroll and is enveloped in a mandorla of light sometimes omitted (on an icon at Mount Sinai, fig. 63). He lifts Adam, who is an old man half-kneeling in a schematized shallow sarcophagus, which is also sometimes omitted (in the Old Tokali Kilise). Eve stands ignored behind Adam, raising her hands in supplication. The scene usually takes place in the upper part of the *tenebrae*, whose chasm is at times bordered with hills and rocks (on the Sinai icon and the Leningrad Lectionary). The broken gates of Hades are sometimes included (in the Anastasis miniature in the S. Amberg-Herzog Collection A.S. 502 in Ettiswil, Switzerland, fig. 64). As for the overthrown lord of the underworld, he is either related to the muscular ancient god of S. Maria Antiqua (in the Leningrad Lectionary) or to the sinuous prostrate figure of S. Clemente II (in the Old Tokali Kilise). But the personification of Hades may also be omitted (on the Sinai icon and the miniature in the Amberg-Herzog Collection). Whenever present, Hades, who is now fettered, asserts the power of Death over Man by holding Adam's foot with one, or even both hands (in the Old Tokali Kilise). King David and King Solomon are included with increasing frequency, though their presence is not yet indispensable (on the Sinai icon they are omitted). They are usually represented in bust rising out of a sarcophagus; but the idea of showing them in full figure is also tried out (in the Leningrad Lectionary). John the Baptist is added (in the New Tokali Kilise, fig. 66), increasing the number of identifiable members of the Anastasis cast.

The tenth century thus establishes the first type of Anastasis as the iconographic norm with amendments that clarify rather than alter the content of the image. The prevalence of the oldest type of Anastasis confirms the strength of the past. Traditionalism is similarly expressed in its ongoing use in extended christological cycles, where it affirms the historical reality of the Resurrection. Here the Anastasis is firmly linked to the subcycle of Christ's Death and Resurrection, which continues to develop along with efforts to inte-

grate its growing pictorial vocabulary. This context also adds a doctrinal dimension to the representation of the Resurrection, since it reviews the vital proof of Christ's two natures.

The Old Tokali Kilise in Göreme, Cappadocia, which dates from the second decade of the tenth century,[1] presents the subcycle of the Death and Resurrection as a continuous frieze consisting of the Road to Calvary, a loinclothed Crucifixion, a loinclothed Deposition, the Entombment, the Myrophores and the Angel, and the Anastasis (fig. 61).[2] Compared to the representation of the Deposition in Paris gr. 510, the Old Tokali Kilise shows an interesting iconographic development here by representing Mary's loving embrace of Christ's hands. Moreover, the artist intelligently integrates the last three scenes by manipulating the ancient theme of Christ's tomb. He bypasses the iconographic problem of the tomb hewn in the rock by omitting it in the scene of the Entombment. The funeral cortège instead leads directly to the scene of the encounter of the Myrophores with the Angel, who points to a small bejeweled structure. This is labeled "the tomb" and contains the unfolded shroud and napkin as evidence of Christ's Resurrection.[3] Thus the problem of two different iconographic types of tomb is glossed over. The tomb used here unifies the scenes of the Anastasis and the Myrophores, since it also serves as the sarcophagus for David and Solomon, who emerge from its flattened top, their jewels matching those of the tomb. As a result, the Entombment leads to the Myrophores and the Angel who points past the tomb to the figure of Christ in the act of Resurrection, tying all three scenes together. So while the Road to Calvary leads to the Crucifixion and the Deposition, affirming the vulnerability of Christ's human nature, the Entombment leads to the Anastasis—proof of the inevitable victory of Christ's divinity.

A comparable preoccupation with the iconographic development of the cycle of Christ's Death and Resurrection is shown in the Cavusin Dovecote, also in Cappadocia, dated 963-964 (fig. 65).[4] Its christological cycle contains two representations of the Crucifixion. Christ is loinclothed in both, his face destroyed.[5] In the first, his body is upright, in the second slumping. The unavoidable conclusion is that Christ was represented as alive and dead on the cross in two consecutive scenes, which is unprecedented. The subsequent de-

[1] The Old Tokali Kilise has been convincingly dated by Thierry in the first quarter of the tenth century along with Ayvali Kilise and the Church of the Holy Apostles at Sinassos. N. Thierry, "Un atelier de peinture du début du Xe s. en Cappadoce: l'atelier de l'ancienne église de Tokali," *Bulletin de la société nationale des antiquaires de France* (Paris, 1971), 170–178. Idem, "Ayvali Kilise ou Pigeonnier de Güli Dere," *CA*, 15 (1965), 97–154. Also, R. Cormack, "Byzantine Cappadocia: The Archaic Group of Wall Paintings," *The Journal of the British Archaeological Association*, 30 (1967), 19–36. Jerphanion, I.1, 262ff. Restle, II, no. 10, figs. 61–95. For a color illustration, L. Giovannini, ed., *Arts de Cappadoce* (Geneva, 1971), fig. 67. [2] Restle, II, figs. 77, 92–95.

[3] "TO MNI / MA." The scene of the Myrophores on the reverse of the Martvili triptych, which belongs to the same iconographic recension, appears to be labeled "O ΤΑΦΟC." Tschubinaschwili, "Ein Goldschmiedetriptychon des VIII.–IX. Jahrhunderts aus Martvili," 83, 86.

[4] Jerphanion, I.2, 520ff. For the date 523f., and 529f. For the distribution of the christological cycle 525ff. Fig. 59 is particularly useful for the understanding of the layout of the cycle. For illustrations and plan, also Restle, III, no. 26, figs. 302–329. Color photographs in Giovannini, op. cit., figs. 65, 66. For a view of the narthex, S. Kostoff, *Caves of God* (Cambridge, 1972), pl. 40. [5] Restle, III, fig. 310.

piction of the Deposition stresses once more the theme of the Virgin's grief, already encountered in the Old Tokali Kilise. The Virgin now places her face on Christ's cheek, in a pictorial scheme better known from later monuments, such as the twelfth-century crypt at Aquileia.[6] The mid-tenth-century Cappadocian church therefore shows the Virgin expressing her grief over Christ's dead body in the context of the Deposition, a theme that soon evolves into a new scene in the cycle of the Death and Resurrection, the Lamentation over Christ's dead body.[7] This artist also feels uncomfortable with the motif of the tomb hewn in the rock, which is here replaced by a complex architectural structure in the background. The subsequent Myrophores and the Anastasis are of no special iconographic interest.[8]

The interest of the tenth century in developing the potential of the pictorial theme of Christ's Death and Resurrection reaches an important peak in the New Tokali Kilise in Cappadocia, a close relative of the Cavusin Dovecote, by virtue of its positioning in the area of the apse (fig. 66). In this case the function reserved for the scenes of the Crucifixion, Deposition, Entombment, Myrophores, and Anastasis is more important than their iconography, as we shall soon see. As in the previous instances, the message of the image is realized in the context of the cycle of the Death and Resurrection.

A different sort of peak is reached in the treatment of the Anastasis in the church of St. Barbe at Soganli, Cappadocia, dating to 1006 or 1021 (fig. 67).[9] Here the Anastasis offers the sole reference to the subcycle of the Death and Resurrection at the end of a christological cycle, even to the exclusion of the Crucifixion. Significantly, the Anastasis is contrasted to the representation of the Nativity, which precedes it. The dogmatic function of the Anastasis as a reference to Christ's divinity is thus underlined by contrasting this scene to that of the Nativity, which is invariably a reminder of Christ's humanity.

Christ's movement in the Anastasis toward the bema and the location of the image immediately before the bema arch make it a prelude to the apocalyptic vision of Christ worshiped by the prostrate figures of Adam and Eve, which decorates the apse of the church.[10] The protoplasts of the apse are already admitted to the sphere of the divine, since they appear above the evangelists, in the same zone as the *Maiestas Domini*. The inevitable comparison of the protoplasts' status in the scenes of the Anastasis and the *Maiestas* can hardly be accidental. It emphasizes Christ's divinity in both instances and confirms the Anastasis as a proto-Judgment. The decoration of the bema arch helps define the link between the two neighboring scenes. It shows five medallions of which the central one reinforces the theme of the light, which is important both to the representation of the Anastasis and the

[6] Restle, III, fig. 309. R. Vailland, *Aquilée et les origines byzantines de la Renaissance* (Paris, 1963), 31ff. fig. 9. O. Demus and M. Hirmer, *Romanische Wandmalerei* (Munich, 1968), pl. 27.

[7] The role of this iconographic type of Deposition in the making of the iconography of the Lamentation over Christ's dead body is not usually discussed.

[8] Restle, III, figs. 309, 302.

[9] Jerphanion, II.1, 307ff., pls. 188–193. Restle, III, figs. 433–443. N. Thierry, "L'art monumental byzantin en Asie Mineure du XIe siècle au XIVe," *DOP*, 29 (1975), 84f. For a color photograph of the interior, Giovannini, *Arts de Cappadoce*, fig. 69.

[10] Jerphanion, pls. 186, 1 and 2. Restle, III, fig. 433.

Maiestas Domini, with the incantation ΦΧΦΠ standing for Φῶς Χριστοῦ Φαίνει Πᾶσι, and meaning "The Light of Christ Shines for Everyone."[11] This is flanked by the medallions of David and Solomon, echoing the twin portrait of the two kings standing in three-quarter length behind Christ in the scene of the Anastasis, each holding a cross. Two more medallions complete the decoration of the triumphant bema arch. These are the portraits of Elijah and Isaiah, both associated with visions of light and fire. The bema arch and the bema apse thus include primary iconographic components of the Anastasis, reinforcing its close relationship to the apse decoration.

The Anastasis in St. Barbe at Soganli has a multiple function. It serves as a synopsis of the subcycle of the Death and Resurrection of Christ even to the detriment of the representation of the Crucifixion. Its pairing with the Nativity allows it to recall the divine nature of Christ. Its use as a prelude to the *Maiestas Domini* in the apse underlines the message of salvation in this manifestation of Christ's divine energy. This interpretation of the Anastasis is therefore related to the efforts of the Middle Byzantine period to add an apocalyptic dimension to this iconography, an aspect already examined in connection with the third type of Anastasis.

ASPECTS OF THE LITURGICAL IDENTITY OF THE ANASTASIS

Beyond the traditional interpretation of the Anastasis as an affirmation of the historical reality of the Resurrection and as dogmatic proof of the divine nature and energy of Christ, the tenth-century sanctions this iconography as the liturgical image for Easter. The liturgical overtones attached to some ninth-century examples are distilled and take on a distinct identity commonly referred to as a feast image. Case studies illustrate various aspects of the development of the liturgical identity of the Anastasis in the course of the tenth century, some of its new limits, and its relationship to the earlier interpretations of the image.

The New Tokali Kilise [12]

The New Tokali Kilise is an extention of the Old Tokali Kilise and dates from the middle of the tenth century. Here the cycle of the Death and Resurrection as a whole helps articulate a statement far beyond the message of each of its scenes (fig. 66). The importance of the elaborate Crucifixion is enhanced by its singular choice as the primary decoration of the church apse.[13] It takes place against a brilliantly blue sky below a semicircular section of heavens consisting of three distinct shades. Two angels hover above the loinclothed and apparently dead Christ, who is flanked by the two thieves, John, the Virgin, Longinus,

[11] Jerphanion, II.1, 315, pls. 187.1, 191.2. Restle, III, figs. 433, 436.

[12] Jerphanion, I.2, 297ff. Cormack, "Byzantine Cappadocia: The Archaic Group of Wall Paintings," 19ff. N. Thierry, "Notes critiques à propos des peintures rupestres de Cappadoce," *REB*, 26 (1968), 360f.

Kostoff, *Caves of God*, 211, 216f. For illustrations: Jerphanion, pls. 70–94; Restle, II, figs. 93–123; Giovannini, *Arts de Cappadoce*, fig. 38.

[13] Restle, II, fig. 117. A. Grabar, *Martyrium* (Paris, 1946), II, 273 n. 1.

and Esopos. Moreover, the centurion and his companions, together with the temple, its veil rent asunder, are on the right, and on the left, the three Marys appear behind the figure of the Virgin. The scene is completed with a number of extensive quotations.

The frontal portrait of St. Basil is immediately below the Crucifix. It is flanked by four scenes of the cycle of Christ's Death and Resurrection. However, these are not in the usual chronological sequence, but rearranged around St. Basil: the Deposition and the Entombment to the right of the saint, the Anastasis and the Myrophores to his left. Consequently, the traditional sequence—Deposition, Entombment, Myrophores, Anastasis—is disturbed so as to make a new reading. This is governed by the centralized composition of the apse, which places the Deposition and the Anastasis closer to the central axis of the apse, giving these two scenes precedence over the Entombment and the Myrophores. This is an instance in which the cycle of Christ's Death and Resurrection appears to have been tightly rearranged along hierarchical lines.

From an iconographic and compositional point of view, the representation of the Deposition practically reverses the one at Cavusin.[14] The Virgin placing her cheek against Christ's face is now on the left, reinforcing the centrifugal reading of the apse by leading the eye to the scene of the Entombment to the left. In the scene of the Entombment, Christ is laid in a sarcophagus instead of being carried into the tomb hewn in the rock. His tomb, on the right, is a structure with a conical roof similar to the one in the ninth-century Psalters with marginal miniatures, which combine this type of tomb and a sarcophagus in the context of the Bodily Rising of Christ. The same type is also encountered in the Church of the Holy Apostles at Sinassos, Cappadocia, dating from the first quarter of the tenth century, together with the Old Tokali Kilise. The laying of Christ in a sarcophagus in the scene of the Entombment in the New Tokali Kilise and the expression of Mary's great grief in the scene of the Deposition foreshadow the emergence of the theme of the Lamentation over Christ's Dead Body in christological cycles.

The Anastasis, figuring on the other side of St. Basil, takes precedence over the representation of the Myrophores. It is of the first type and of the greatest interest, even though its lower part is destroyed.[15] Christ advances to the right in a multishaded mandorla, which recalls the section of heavens above the Crucifix. David and Solomon are left behind him, while "John the Forerunner" stands in front of him. Though only the heads of these figures survive, it is apparent that Christ seems oblivious to all three. John the Baptist thus enters the iconography of the Anastasis for the first time.

Significantly, the label "Anastasis," which usually accompanies this image, is substituted here by Ps. 81:8: "Arise, O God, judge the earth." As we have seen, the Chloudof Psalter uses the third type of Anastasis to illustrate this verse, the chanting of which introduced the theme of the Resurrection during the celebration of the Paschal Vigil on Holy Saturday.[16] Unlike the Chloudof Psalter, the New Tokali master uses the last verse of Ps. 81 to label the image of the Anastasis, reversing their roles and putting the main emphasis

[14] Jerphanion, pl. 85.3. [15] Restle, II, figs. 117, 119. [16] See, 156f.

on the image. So the earlier function of the iconography as a comment on the liturgical content of the text changes. The text is now a pointer to the liturgical content of the image.

The transposition of roles of text and image constitute valuable evidence of how feast images were consolidated. In the case of the Chloudof Psalter, the liturgical message of the image is conveyed only in connection with the text. With the New Tokali Kilise, the liturgical message partly relies on the inscription of Ps. 81:8, and partly on its position in the apse in the context of the cycle of Christ's Death and Resurrection. In both cases, the liturgical message of the image is conveyed with the help of one or more external factors.

The association of the New Tokali Anastasis with the liturgical celebration of Easter through the inscription of Ps. 81:8 on it is only part of the liturgical identity of this representation. Its importance to the cycle of Christ's Death and Resurrection stipulates that the Anastasis cannot be considered apart from this cycle, which here transcends its narrative value. Its positioning in the apse of the church establishes the liturgical considerations governing the arrangement of this ensemble.

The Crucifixion above the altar becomes a continuous reminder of the prototypical sacrifice, whose reenactment is the celebration of the Eucharist on the altar below. The figure of Jeremiah, on the left face of the bema arch, proves this was the artist's intention. He gestures toward the Crucifixion and says through the inscription on his scroll: "But I was like a (harmless) lamb that is brought to the slaughter; and I knew not that they had devised devices against me saying. Let us destroy the tree with the fruit it bears" (Jer. 11:19).[17]

The magnitude of Christ's sacrifice is further emphasized by the illustration of the full extent of his humiliation in the scenes of the Deposition and the Entombment below the Crucifixion, on Jeremiah's side of the apse. Both scenes demonstrate Christ's Death according to the flesh, certifying his perfect human nature. At the same time, the corresponding scenes of the Anastasis and the Myrophores, on the other side of St. Basil, testify to the cancellation of Death and its total defeat through the resurrection and redemption of mankind in the person of Adam. These two scenes form a balancing reference to the perfect divinity of the Logos Incarnate. Once more, this is verified with the help of the prophet on the side of the bema arch next to the Mryophores. Ezekiel, who corresponds to Jeremiah, points away from the apse toward the nave and the faithful holding a scroll inscribed with Ezek. 37:1: "The hand of the Lord was upon me and carried me out in the spirit of the Lord, and set me down in the midst of the valley which was full of bones."[18] As early as the third-century Synagogue in Dura Europos, Ezekiel's vision of the valley of the bones was understood as a reference to the rising of the dead. Therefore, the quotation certifies the message of the Myrophores and the Anastasis on this side of the bema apse.

By such pictorial and verbal means, the prototypical sacrifice of the Crucifixion is analyzed down to the humiliating Death and the redeeming Resurrection of Christ corresponding to Christ's two natures as the instruments of the purpose of this sacrifice. The

[17] Jerphanion, I.2, 321, pl. 86.1. Restle, II, fig. 117. [18] Jerphanion, I.2, 322, pl. 86.2. Restle, II, fig. 117.

catalyst of this elaborate apse arrangement is the liturgy, that is, the applied rather than the theoretical branch of theology.

Jeremiah's prophesy inscribed here is read at the end of the service of the ninth hour on Holy Friday, immediately before the reading of Heb. 10:19–31 and the reading of John 19:23–27, both of which deal with the circumstances and meaning of Christ's Death on the cross. Furthermore, the prophesy of Jeremiah follows the important troparion "Σήμερον κρεμᾶται ἐπὶ ξύλου," which reviews the Passion and invokes the Resurrection.[19] Similarly, Ezekiel's vision is used as the Old Testament reading for the Holy Saturday matins. It comes after an invocation to Christ to save man and render him immortal by descending to Hades. The invocation closes with the reading of Matt. 27:62–66, the passage preceding the account of Christ's Resurrection.[20]

Other aspects of the arrangement of this apse support this interpretation. The four scenes dealing with the Death and Resurrection flank the standing figure of St. Basil, who becomes the focus of the lower zone. The saint, who was probably dressed in liturgical vestments, is immediately below the crucified Christ. The central position of the figure of St. Basil, and its use as a physical barrier between the two Burial and the two Resurrection scenes, is appropriate for various reasons. His presence here complements the other pictorial references to the liturgical celebration of Easter, since the liturgy of St. Basil is used on Holy Saturday.[21] Secondly, St. Basil occupies a position of honor in this church, which also includes an interesting life cycle of the saint.[22] Furthermore, his presence is appropriate on a local level. Basil was born in Caesaria, not far from Göreme, home of the New Tokali Kilise, and was one of the principal organizers of monasticism, which was so important to Cappadocia. His position in the center of the apse is also important from a formal point of view. It enhances the upward vertical reading of the apse: from the altar, the celebrant priest and the bishop's throne below the representation of the saint, to St. Basil who wrote the liturgy, to the figure of the sacrificed Christ on the cross, to the section of heavens above Christ's head, to the medallion of an angel, and finally to the scene of the Ascension.[23] The major contrast of the Ascension to the Crucifixion would be first to attract the attention of the faithful who entered the New Tokali Kilise. This contrast reiterated in a different manner the theological truth expounded much more elaborately within the apse.

The church's program of decoration converges in the apse, on the Crucifixion, which is analyzed in several complementary ways: historically as Death and Resurrection, liturgically as Holy Friday and Holy Saturday, and theologically as a summary of the christological doctrine of Christ's two natures. The ultimate aim of this complicated pictorial exercise is, as always, to affirm the doctrine of redemption, which is understood in terms of

[19] *Triodion Katanyktikon* (Rome, 1879), 699f.

[20] Ibid., 734ff.

[21] Ibid., 760. Bertonière, 189.

[22] Jerphanion, 1.2, 358ff. No fewer than three portraits of Basil figure in this church. Ibid., 322.

[23] This sequence is in fact interrupted by a series of portraits of clerical saints who are not visible from the nave (Jerphanion, 1.2, 318ff., pls. 87.1, 85.1, 86.1–2), as well as by a second arch on either of whose sides stand the figures of Constantine and Helen in full regalia (Jerphanion, 1.2,316, pl. 85.1). The two royal figures stand parallel to those of Jeremiah and Ezekiel, offering an additional reference to the saving power of the cross, which is depicted in the apse.

Christ's resurrection of the dead. This is confirmed by the dedicatory inscription in the church itself, though surviving only in part, confirms that one of the major aims was to depict in venerable images how the dead Christ rushed into Hades for us, and apparently, how he effected the Resurrection of the dead.[24]

The cycle of the Death and Resurrection undergoes only minor adjustments to achieve its multiple message. Its strict chronological sequence is compromised for an arrangement along hierarchical lines around the physical and mental axis of the apse. This is determined by the Crucifix, the figure of St. Basil, the bishop's throne, and the altar, and establishes that the liturgical dimension of this decoration was foremost in the mind of the master of the New Tokali Kilise. This is then an example of the incorporation of tangible liturgical references in a program of church decoration. The minor compromise of the chronological integrity of the christological narrative is justified by the emergence of a new principle and system of decoration, which actively enhances the acts of worship performed in the church.

In this context, the Anastasis plays more than one role. On a historical level, it affirms the divine nature and energy of the Logos Incarnate, as well as its importance for the attaining of redemption. On a typological level, it prefigures the Second Coming of Christ as a Judge at the time of the Last Judgment through the inscription of Ps. 81:8. Finally, on a liturgical level, it is inextricably linked with the annual celebration of Easter. Concurrently, on an everyday liturgical level, it is a reminder of the promise of salvation, part of the reenactment of Christ's sacrifice in the mystery of the Eucharist performed regularly on the altar below.

The figure of John the Baptist encountered here for the first time, also plays more than one role. Homiletical and apocryphal literature had associated him from the earliest times with the story of the siege of the underworld.[25] His well-documented presence—for instance, in the Apocryphon of Nicodemus—offers the historical justification for his inclusion in the iconography of the Anastasis. Other Old Testament personalities are also prominent in the various accounts of the defeat of Hades, but they remain unidentified even in the more elaborate version of the Middle Byzantine image. Consequently, the presence of the Baptist in Hades at the time of the Resurrection does not fully account for his exclusive eponymous selection above other prominent prophets, such as Isaiah. Moreover, the idea that the presence of the Baptist was only intended to enhance the narrative of this story is discouraged by the late date of his addition.

Though only the head of the Baptist survives in the New Tokali Anastasis, he was prob-

[24] Jerphanion, I.2, 304ff. The relevant part of the inscription which culminates over the west wall door reads: "ταχυδρόμος ὅπως δι᾽ ἡμᾶς νεκρὸς εἰς Ἅδου τρέχῃ καὶ νεκρ [ῶν πολλοὺς πρὸς ζωὴν ἐξεγείρῃ?]."

[25] Paschal literature had asserted from the earliest times that the Baptist preceded Christ and preached Christ's advent in the underworld as he had done on earth. For example, a homily attributed to Eusebius of Alexandria is entitled De adventu Joannis in infernum, et de ibi inclusis, PG, 86.1, 509ff.; also in Spicilegium Romanum, A. Mai, ed. (Rome, 1843), IX, 688ff. and S. Der Nersessian, "An Armenian Version of the Homilies on the Harrowing of Hell," DOP, 5 (1954), 203ff.

ably raising his right hand in a characteristic gesture, crossing the thumb over the third and fourth fingers while the two remaining fingers point upward. Most representations of the Anastasis which include him show him making this sign in Christ's direction. As early as the sixth century, the gesture is an established part of the iconography of the Forerunner pointing to Christ as the sacrificial lamb. We find it on the Cathedra of Maximianus in Ravenna, where the Baptist holds in his left hand a sphere with the lamb of God.[26] We also find it on the sixth-century icon of the Baptist in Kiev.[27] Here John points to the medallion of Christ above, while the scroll in his left hand quotes John 1:29: "Behold the lamb of God which taketh away the sin of the world." The Baptist holds a scroll with the same quote while pointing to the redeeming figure of Christ in the idiosyncratic illustration of the Anastasis in the twelfth-century illuminated Homilies of John Kokkinobaphos (fig. 68).[28] The traditional gesture of the Baptist usually included in the image of the Anastasis allows us to interpret his presence as a reference to Christ-Amnos in the Anastasis depicted below the Crucifixion in the New Tokali Kilise apse, and above the altar (where the eucharistic bread, also called "amnos," is deposited during the service), is well in tune with the liturgical spirit dominating this pictorial program.

John the Baptist is also identified with the liturgical identity of the image, though in a different way. An allusion to the mystery of baptism is inherent in any image of the Baptist. We have already mentioned the dominant importance of the baptismal theme during the first part of the Easter Vigil. The association of the mystery of baptism with the celebration of Easter may also be partially responsible for the addition of the Baptist to the iconography of the Anastasis. Even so, the position of the Anastasis in the apse of the New Tokali Kilise helps define the Baptist primarily as a eucharistic reference to Christ-Amnos, adding a specific sacramental dimension to the image.

Cavusin Dovecote

The cycle of the Cavusin Dovecote places its iconographically uninteresting Anastasis after the Myrophores on the far left of the lowest register of the west wall of the church (fig. 65). This extensive and elaborate cycle develops in chronological order, with a notable exception that puzzled Jerphanion: the scene of Baptism is taken out of its natural position and placed after the Anastasis.[29] Thus, Anastasis and Baptism appear symmetri-

[26] Volbach, *Early Christian Art*, 356, pl. 227.

[27] Weitzmann, *Sinai Icons*, I, no. B.11.

[28] Vat., Bibl., cod. gr. 1162, fol. 48ᵛ illustrating Ps. 67:7. C. Stornajolo, *Miniature delle Omelie di Giacomo Monaco (Cod. Vat. gr. 1162) e dell' Evangeliario Urbinate (Cod. Vat. Urbin. gr. 2)* (Rome, 1910). Lazarev, *Storia*, 192f., 251 n. 36. Comparably, the Baptist holds an unfolded scroll with the inscription "Ecce Agnus Dei" in the representation of the Anastasis in

the two Exultet Rolls of Montecassino which date from the eleventh cenetury: (a) British Museum, cod. Add. 30337. Avery, *The Exultet Rolls of South Italy*, pl. 48.10. and J. P. Gilson, *An Exultet Roll Illuminated in the XIth Century at the Abbey of Montecassino* (London, 1929). (b) Vat. Bibl., cod. Barb. lat. 592. Avery, op. cit., pl. 149.6.

[29] Jerphanion, I.2, 527.

cally on either end of the lowest register of the west wall, separated by the portraits of some saints.

The antithetical parallelism of these two scenes is not unique. We have already seen it on the historiated reliquaries. The Pliska and the Vicopisano crosses use the obverse and reverse of their lower arm for the two scenes (figs. 25, 26). To achieve this, the Baptism is placed ahead of the Presentation in the Temple, disturbing the chronological sequence of the cycle. Similarly, we find the Baptism above and the Anastasis below on the leaf of a tenth-century triptych(?) icon at Mt. Sinai (fig. 63).[30] Middle Byzantine ivories also draw a pictorial parallel between the theme of Baptism and Resurrection.

The two leaves of a triptych at Munich (fig. 69), dated by Weitzmann in the eleventh century and classified in the painterly group, includes six scenes in three registers reading from left to right: Annunciation, Visitation (first register); Nativity, Presentation in the Temple (second register); Baptism, Anastasis (third register). The central panel is divided into two registers: Crucifixion (upper); Deposition, Entombment (lower).[31] Though the triptych has not survived as a unit, there is no doubt that the scene of the Anastasis is taken out of sequence, and is thus paralleled to the representation of Christ's Baptism.

An ivory diptych at Milan (fig. 70), dated by Weitzmann in the tenth century and classified in the Romanos group, represents on the left leaf from top to bottom: Annunciation and Visitation in a single panel (first register), Nativity (second register), Baptism (third register), Presentation in the Temple (fourth register). The right leaf depicts: Crucifixion (first register), Myrophores (second register), Anastasis (third register), Chairete (fourth register).[32] The scenes of the Baptism and the Anastasis are paralleled once more, though this time the chronological sequence is not disturbed. Moreover, when the diptych is closed, these two scenes are designed to come face to face as they are back to back on the lower arm of the Pliska and Vicopisano crosses.

The alignment of these two scenes is effected even more smoothly in the case of the ivory diptych at the Hermitage (fig. 71a), which has been dated at the end of the tenth century and classified in the Nicephorus group.[33] Each leaf is subdivided into three registers with two scenes each. The scenes read from left to right across both diptych leaves: Annunciation, Visitation, Nativity, Presentation in the Temple (first register); Baptism, Transfiguration, Entry to Jerusalem, Crucifixion (second register); Anastasis, Doubting Thomas, Ascension, Pentecost (third register). The Anastasis is now placed immediately below the scene of Baptism without disturbing the evolution of the cycle.

Another ivory in Leningrad (fig. 71b) belonging to the Romanos group is a variation on the left leaf of the Munich triptych.[34] The scenes here are: Annunciation, Visitation (first register); Nativity, Presentation in the Temple (second register); Baptism, Raising of Lazarus (third register). The substitution of the Raising of Lazarus for the Anastasis, though

[30] Weitzmann, *Sinai Icons*, I, no. B.55.

[31] Munich, Staatsbibl., cod. lat. 6831. Cim. 181. Weitzmann, *Elfenbeinskulpturen*, no. 22a, b.

[32] Milan, Cathedral Treasury. Ibid., no. 42.

[33] Leningrad, Hermitage, no. ω 13. Ibid., no. 122.

[34] Leningrad, Hermitage, no. ω 25. Ibid., no. 59.

unusual, is not surprising, since the Raising of Lazarus had long served as the best preview of the Resurrection.

An oil ampulla once in Berlin, but now lost,[35] suggests that the pictorial parallelism of Baptism and Resurrection might have its roots in the pre-Iconoclastic period. It depicted Christ's Baptism on one face, and on the other, the Crucifixion and the Myrophores, the traditional Early Christian reference to the Resurrection.

In view of this material, it is unlikely that the scene of Baptism in the Cavusin Dovecote was accidentally taken out of sequence and placed on the lowest zone of the west wall as a compositional complement to the Anastasis. Within the framework of the celebration of Easter, and at least as early as the days of Egeria, baptisms took place shortly before the reenactment of the rising of Christ during the Paschal Vigil.[36] The bond was so strong during the early period that in certain areas baptisms were performed only at Easter.[37] This practice continued in the Middle Byzantine period. According to the Constantinopolitan tradition of the ninth and tenth centuries baptisms were a focal point in the first part of the Paschal Vigil.[38] After the commencement of the Old Testament reading the patriarch changed to white in Hagia Sophia and went to the baptistery of the church. After the performance of the rites of Baptism and Chrism, the joyous procession of the newly baptized led by the patriarch came back to the church intoning Ps. 31, using verse 1 as refrain: "Blessed is he whose transgression is forgiven, whose sin is covered." After an imposing entrance into the church with the patriarch holding the Gospel and a candle, Gal. 3:27 was sung: "For as many of you as have been baptized into Christ have put on Christ." This part of the service closed with the reading of Rom. 6:3–11 which explains the reason for the association of baptism with Resurrection: "Know ye not, that so many of us as were baptized into Jesus Christ were baptized into his death? . . . Now if we be dead with Christ, we believe that we shall also live with him: Knowing that Christ being raised from the dead dieth no more; death hath no more dominion over him. . . . Likewise reckon ye also yourselves to be dead indeed unto sin, but alive unto God through Jesus Christ our Lord."

On such a basis, the baptismal theme replaced that of the Resurrection in the first part of the Easter Vigil. After reading Rom. 6:3–11, Ps. 81:8 was chanted: "Arise, O God, judge the earth: for thou shalt inherit the nation," marking the passage to the second part of the Easter Vigil, which was exclusively focused on the theme of the Resurrection.[39]

So there are ample grounds for suggesting that the Easter Vigil could inspire a pictorial parallelism between the images of Baptism—the prototypical baptism—and the Anastasis—the prototypical Resurrection. The alignment of the two images reflected the parallel performance of Baptism and Anastasis in the course of the Easter Vigil. The rite of

[35] Engemann, "Palästinensische Pilgerampullen im F. J. Dölger Institut in Bonn," 6 n. 7, pl. 83f.

[36] Bertonière, 65f. Regarding the appropriateness of Easter for the performance of the mystery of Baptism, see for example, Basil of Caesarea, *Exhortatoria*

ad sanctum baptismo. PG, 31.424.

[37] Socrates, *Historia Ecclesiastica.* PG, 67.640.

[38] Bertonière, 132ff.

[39] Above, 156f.

[40] *Da fide orthodoxa*, PG, 94.117f.

baptism typified the burial of the original sin and opened the road to redemption for those that received it, according to John of Damascus.[40] For this reason, baptism was a prerequisite for redemption. Accordingly, Archangel Michael sent the risen dead to be baptized in the river Jordan before celebrating Passover in the Apocryphon of Nicodemus.[41] Similarly, according to an Easter homily, the thief was baptized in the blood and water from the side of Christ, for he could not have entered Paradise without baptism.[42] Characteristically, though erroneously, Anastasius Sinaites understood the etymology of the word baptism to mean cancellation of the original sin.[43] The Middle Byzantine period also stressed the dependence of redemption on baptism, as indicated by the Synodikon of the Feast of Orthodoxy, a post-Iconoclastic feast commemorating on the first Sunday of Lent the restoration of images in 843.[44]

The antithetic coordination of the two scenes of Baptism and Anastasis is a pictorial formula that seeks to integrate the theological, typological and liturgical realities of the two themes. Since baptism and resurrection opened the door to eternal life as acts of re-creation, the corresponding pictorial formula could play an apotropaic role, as suggested by its use on private phylacteries. The Christian who evoked this composite unit in his prayers for salvation invoked at the same time its guarantee, to which he had a right, since he had already "covered his sin" through baptism. A comparable reference to the "healing" power of this pictorial equation might have also been intended for the Baptism-Anastasis icon from Mt. Sinai (fig. 63). This may be inferred from the presence of one of the healer saints (Cosmas or Damian) on the reverse of the panel.[45] The position of the Anastasis and Baptism on either end of the lowest register on the west wall of the Cavusin Dovecote may be understood as a comparable prayer for the eternal preservation of all those associated with this church. As Jerphanion pointed out, even though the exact circumstances of the foundation of the church are not known, the portrayal of the Emperor Nicephorus Phocas, Empress Theophano, Caesar Bardas Phocas, Kouropalates Leo Phocas, and one more member of the imperial family in the prothesis apse suggests they were benefactors of this establishment together with other officials portrayed on horseback in the nave.[46] The surviving inscriptions accompanying the portraits call for the eternal preservation of the imperial family and the donors of the church. Although the phraseology of these inscriptions is commonplace, their dating to 963–964 adds to their significance. That year the imperial family spent some time in the vicinity of Cavusin accompanying the emperor on a major and successful campaign against the Arabs in Cilicia. This campaign and other victories against the Arabs had gained for the deeply religious emperor the nickname "The White Death of the Arabs."[47]

Under the circumstances, the pictorial prayer for redemption formulated by the align-

[41] *Evangelia Apocrypha*, 310. James, *The Apocryphal New Testament*, 142.

[42] PG, 50.822.

[43] PG, 89.81. Uthemann, 2.8.13–14. "'Βάπταισμα' ἐν ᾧ βάλλεται, ἤγουν πίπτει τὸ πταῖσμα."

[44] J. Gouillard, "Le Synodikon de l'Orthodoxie. Edition et Commentaire," *TM*, 2 (1967), lines 354ff.

[45] Weitzmann, *Sinai Icons*, I, no. B.55, pl. II b.

[46] Jerphanion, I.2, 523ff., 529f.

[47] G. Ostrogorsky, *History of the Byzantine State* (New Brunswick, 1957), 253, 257f.

ment of the Anastasis with Baptism was appropriate. It offered an incantation for the preservation of the emperor monk Nicephorus, his family, and his court in Cappadocia while on an important military campaign. At the same time, the pairing of the two scenes was a reminder of the redemption Orthodoxy guaranteed to the Christian army of Nicephorus, a guarantee denied to the enemy Arabs.

The theological interpretation of baptism as an imitation of Christ's redeeming Death, and its ritual integration into the Paschal Vigil because of its importance as a condition for redemption, gave rise to the pictorial synthesis of the Baptism and the Anastasis. As a unit, the two images were not only a reminder of the ritual celebration of Easter, but also a pictorial incantation for eternal life through redemption.

The Independent Image of the Anastasis

The isolated use of the Anastasis as a single panel in S. Maria Antiqua and in funeral contexts in the Chapel of S. Zeno and in S. Clemente II is quite different from its function when used independently of the christological cycle from the tenth century on. By then, the liturgical identity of the Anastasis as a feast image is well established.

Retracing some of the ninth-century evidence, we note that the representation of the Anastasis is divorced from its christological context in the Psalters with marginal miniatures. As we have seen, the use of the third type of Anastasis as the illustration of Ps. 81:8 in the Chloudof Psalter (fig. 44b) is not only due to the mention of the Resurrection.[48] It also has a liturgical basis, the use of Ps. 81:8 during the Easter Vigil as the introduction to the theme of the Resurrection. The Anastasis is also used as a liturgical comment in pictorial form elsewhere in this Psalter group. In most manuscripts, Ps. 67 is illustrated twice with the Anastasis. It is no accident that Ps. 67 is a considerably important element in the Orthros Service on Easter Sunday. Similarly, Pss. 9:33, 11:6, 43:27, 77:65, and 101:14, which also have some liturgical significance in the celebration of Easter in various liturgical traditions,[49] are illustrated with either the old-fashioned Myrophores, the standard Anastasis, or the radical theme of the Bodily Rising of Christ (figs. 43a,b). The ninth-century artistic school represented by this Psalter group freely employed the image of the Anastasis as a pictorial lemma for the liturgical reality of Easter. In this exegetical capacity, the illustrations drew the reader's attention to the liturgical context of the corresponding passage, functioning as rubrics do in liturgical manuscripts. The liturgical reality of the image was subordinated to the verse it was intended to clarify.

The Anastasis is also used to illustrate the Gospel of St. John in two important examples from the tenth century. But now its pictorial importance increases as it develops to a full-

[48] Above, 156.

[49] The numbers following each psalm are page and chart references to Bertonière's monograph. *Ps. 9:33:* 36, 64, 84, 87, Chart B2. *Ps. 11:6:* 34, Chart B2. *Ps. 43:27:* 82, Chart B2. *Ps. 67:2 and 67:7:* 226, Charts B2, C8. *Ps. 77:65:* 68, Chart C6. *Ps. 79:3:* Charts A3, B2.

Ps. 81:8: Charts A3, A4, A6. *Ps. 101:14:* Charts A3, A4, B1, C9. Grabar has recently offered complementary evidence for the use of the theme of the Resurrection in liturgical prayers and chants in "Essai sur les plus anciennes représentations de la 'Résurrection du Christ,' " 134ff.

page miniature used as a frontispiece to the Gospel and not simply as a marginal comment on the relevant text. The first example is in the Gospel Lectionary in Leningrad, Public Library, cod. gr. 21 (fig. 62) dated around the middle of the tenth century. The author portrait of St. John and the Anastasis, each a full-page miniature, form a composite frontispiece to the text.[50] Similarly, the author portrait of St. John dictating to Prochoros and the Anastasis are combined as antithetic frontispieces to the Gospel in an illustrated New Testament (fig. 64), dated in the first half of the tenth century by Weitzmann and divided between the Walters Art Gallery in Baltimore (w. 524) and the Amberg-Herzog Collection in Ettiswil, Switzerland (A.S. 502).[51]

The use of the Anastasis here is also based on liturgical practice, as Meredith has shown. John 1:1–19 is the lection for Easter Sunday.[52] Consequently, the association of the Anastasis with the beginning of the Gospel of St. John is fundamentally similar to the parallelism of the same image with Pss. 81:8, 67:2, and so on. The image stresses the liturgical nature of the text. Weitzmann has argued that the parallelism between the Anastasis and the beginning of the Gospel of St. John originated in a Lectionary and was inspired by the importance of this book for the performance of the liturgy. He also suggested its migration from Lectionaries to illustrated New Testaments.[53]

The way the church used and interpreted this lection for Easter Sunday helps explain how John 1:1ff. and the image of the Anastasis came to be linked. One of the early sources which relates the liturgical celebration of Easter and this text is a homily attributed to the fifth-century Patriarch Proclus, entitled "To the Holy Easter and to the 'In the Beginning Was the Word.' "[54] Thereafter, all kinds of paschal literature refers to John 1:1ff. For example, both the Holy Saturday homily of John of Damascus[55] and the Easter Sunday Homily of Emperor Leo VI[56] allude to it and pattern part of their homily on it, while an Easter sticheron practically identifies this text with the Resurrection:

> In the beginning was the Word
> And the Word was with God
> And the Word was God
> He is the one who rose from the dead
> Let us give praise unto him.[57]

[50] Above, n. 6.13. Morey, "Notes on East Christian Miniatures," 57f., figs. 61, 63. Weitzmann, "The Narrative and Liturgical Gospel Illustrations," 257f., fig. 245. Lazarev, *Storia*, 139f., 173 n. 53.

[51] K. Weitzmann, "An Illustrated Greek New Testament of the Tenth Century in the Walters Art Gallery," *Gatherings in Honor of Dorothy E. Miner* (Baltimore, 1974), 19–38, fig. 15. M. Chatzidakis, V. Djurić, M. Lazovic, *Les icones dans les collections suisses* (Bern, 1968), no. 4. *Illuminated Greek Manuscripts from American Collections*, G. Vikan, ed. (Princeton, 1973), 41, 62f., no. 5.

[52] C. Meredith, "The Illustrations of Codex Ebnerianus," *JWarb*, 19 (1966), 419–424. For the Constantinopolitan tradition: Bertonière, 149f. For the tradition of Jerusalem, ibid., 13ff., 100.

[53] Weitzmann, "An Illustrated Greek New Testament of the Tenth Century in the Walters Art Gallery," 19. Sh. Tsuji, "Byzantine Lectionary Illustration," *Illuminated Greek Manuscripts from American Collections*, G. Vikan, ed. (Princeton, 1973), 34ff.

[54] Proclus, Εἰς τὸ Ἅγιον Πάσχα, καὶ εἰς τὸ Ἐν ἀρχῇ ἦν ὁ Λόγος, PG, 65.800–805.

[55] *In Sabbatum Sanctum*, PG, 96.604C.

[56] *Oratio X*, PG, 107.104A.

[57] Above, n. 3.65.

These were some of the verbal byproducts of the use of John 1:1ff. as the lection for the Easter Sunday Orthros throughout the East by the tenth century. By the same token, pre-Iconoclastic dramatic homiletical literature identified "the king of glory" (Ps. 23), who despoiled Hades and re-created Adam on the sixth day, with "the Word who was in the beginning" and who came "to redeem the world."[58] Consequently, the use of the Anastasis, which illustrated the trampling of Hades and the raising of Adam by the Logos Incarnate, to illustrate John 1:1ff. by the first half of the tenth century harked back to comparable homiletical parallelisms of considerable antiquity. The varied and traditional use of the beginning of the Gospel of St. John at Easter easily bridged the narrative gaps that separated the image of the Anastasis from this text.

Examination of why John 1:1ff. was chosen as the lection for Easter Sunday led Meredith to prologues and commentaries on the Gospel of St. John.[59] The former, as exemplified by the prologue of Cosmas Indicopleustes, interpret the text as an exposition on Christ's divinity, while the latter, as exemplified by John Chrysostom, are limited to associating the text with Christ's Resurrection. Indeed, the interpretation of Cosmas Indicopleustes, which singles out the preaching of Christ's divinity as the Gospel's main aim, is only a reflection of more learned opinions. For example, in the homily mentioned earlier, Proclus marvels at the sublimity of the concepts expressed in John 1:1ff., considering this text as the most divinely inspired review of the christological doctrine.[60] In the tenth century, Nicetas Paphlagon, a student of Arethas of Caesaria, reiterated the same interpretation in a lengthy and tiring homily dedicated to St. John the Theologian.[61]

The beginning of the Gospel of St. John was consistently interpreted as a unique exposition on the divinity of the Logos Incarnate, the most difficult aspect of the christological doctrine. Comparably, the tenth-century image of the Anastasis continued to demonstrate the will and energy of Christ's divinity as successfully as at the beginning of the eighth century. Though the Dyothelete controversy had long ceased to be anybody's concern, the instrumentality of the divine will and energy of the Logos in the miracle of the Anastasis continued to be remembered. An eleventh-century Easter poem by John Mavropous envisages Christ proceeding to perform the Anastasis girdled in divine strength and protected by the paternal shield of divinity,[62] echoing the same idea as a hymn of Theophanes Graptos (b. 775):

[58] PG, 62.722, note b. PG, 86/1.376 and 403.

[59] Meredith, op. cit., 422f. Also, Anastasius Sinaites, PG, 89.797.

[60] Proclus, PG, 65.801C–D. The divine inspiration of the evangelist John often finds pictorial expression in his portrait. For example in Athos, Dionysiou, cod. 588, fol. 225ᵛ, the opening words of the gospel are transmitted to John from God's hand in the sky, and hence to Prochoros, who is recording them in writing. *The Treasures of Mt. Athos*, I, fig. 287.

[61] Nicetas Paphlagon, *Oratio VI. In laudem S. Joanni*, PG, 105.99–128.

[62] Joannis Euchaita, *Versus Iambici* 105. *In Sanctum Pascha*, PG, 120.1198A–B.

> Τὸ κέντρον ἠμβλύνθη γὰρ ᾅδου παμφάγου.
> Καὶ θάνατος πέπτωκεν ἐλθὼν εἰς νῖκος.
> Χριστὸς γὰρ αὐτὸς καταβὰς τούτων μέχρι,
> Ἰσχὺν θεϊκὴν ἰσχυρῶς ἐζωσμένος,
> Τῷ Πατρικῷ θυρεῷ πεπραγμένος,
> Ἔτριψεν, ἐξέρρηξεν αὐτοὺς ἐξόχως.

Having slept in the tomb as a man
You rose by your invincible power as God.[63]

The image of the Anastasis and the beginning of the Gospel of St. John are, therefore, complementary, each helping to illustrate the doctrinal content of the other. However, the unquestionable importance of John 1:1ff. for Easter Sunday, and the emphatic antiquity of its usage, particularly in Constantinople,[64] lent to the accompanying image of the Anastasis a liturgical dignity and formality that it did not possess earlier with as much clarity.

The parallelism between the Anastasis and John 1:1ff. has the same conceptual basis as the relationship of the pictorial theme of the Resurrection with Pss. 81:8, 67:2, and so on. Nevertheless, the outcome is visually very different. In the earlier cases, the illustration is a marginal comment subordinate to the text. In the tenth-century examples, the importance of the illustration increases. It acquires a status equal to that of the author portrait, taking up a full page, which does not even have to face the text of John 1:1ff. In this guise, image and text stand parallel to each other, defining and expanding each other's content without altering their individual vocabulary. While the image alludes to the liturgical and dogmatic dimensions of the text, the universally recognizable importance of the text for Easter helps focus the liturgical identity of the image, which is now freed both from the christological cycle and the adjacent text as a self-contained pictorial reference to Easter. The image labeled as Anastasis stands as a pictorial synonym to the celebration of the Anastasis and becomes the feast image for Easter.

The use of the new, fully developed feast image together with the author portrait of St. John as a composite frontispiece to the Gospel of St. John in two different types of books dating from the first half of the tenth century supports Weitzmann's proposal that the feast image for Easter emerged in the ninth century.[65] This is also supported by the use of this iconography as a liturgical exegesis in pictorial form in the ninth century Psalters with marginal miniatures. Its role as a feast image develops organically out of the use of the Anastasis as a pictorial rubric.

The use of the Anastasis as a pictorial exegesis for a number of psalms and for John 1:1ff. spread to other texts that hold comparable roles in the performance of Easter. The best known is its illustration of the First Easter Homily of Gregory Nazianzenus, which reflects its use in connection with John 1:1ff. by its combination with the author portrait of St. Gregory into a composite frontispiece to the liturgical edition of the homilies of Gregory. This edition developed by the eleventh century and was patterned after the Lectionaries.[66]

Though the earliest examples of the use of the Anastasis in the context of the First Easter Homily date from the eleventh century, the linking of this text with the image probably

[63] Above, n. 3.64.

[64] In Hagia Sophia in Constantinople the text of John 1:1ff. was first read in Latin by a deacon and then in Greek by the Patriarch. The use of both languages is encountered only during the Easter celebration and only in Constantinople during the Middle Byzantine period. It has been interpreted as a reflection of an ear-

lier local tradition and as part of the mystique of Constantinople as the New Rome. Bertonière, 149f.

[65] Weitzmann, "An Illustrated Greek New Testament of the Tenth Century in the Walters Art Gallery," 35.

[66] Galavaris, *The Illustration of the Liturgical Homilies of Gregory Nazianzenus* (Princeton, 1969), passim.

materialized earlier (fig. 47). The text of this homily has a comparable but lesser liturgical status than John 1:1ff. It also exerted a great influence on paschal literature. As we have seen, at least as early as the sixth century, the fourth paragraph of the homily inspired a hymn that paraphrased it.[67] This paragraph was similarly used in the Easter Canon of John of Damascus, through which it asserted itself as a motif in paschal literature. It is even more important that the homily was read during the Easter Sunday Orthros in the Sabbite-Studite tradition, a practice which passed into the Constantinopolitan tradition between 950 and 1084.[68] Its inclusion in the Easter Sunday Service of Hagia Sophia corresponds to other official efforts of the tenth century to emphasize the importance of the cult of St. Gregory. The transfer of the saint's relics from Cappadocia to the Churches of the Holy Apostles and Hagia Anastasia by Constantine Porphyrogenitus at 950, and the establishment of January 19 as the day commemorating the event in the liturgical calendar of the city[69] indicate the official attitude of this period.

It seems that the First Easter Homily of Gregory was recognized as a part of the Easter Sunday Orthros before the end of the tenth century. Its liturgical importance, though lesser than that of John 1:1ff., was exactly parallel to it. The official sponsoring of the First Easter Homily as a liturgical parallel to John 1:1–19, coupled with the newly acquired importance of the cult of St. Gregory, probably suggested the illustration of both texts with the image of the Anastasis even before the liturgical edition of the Homilies of Gregory emerged. This idea is favored by the fact that the First Easter Homily was already the first text in the ninth-century Constantinopolitan edition of Gregory, as evidenced by the organization of the Paris Gregory.[70] The position of this homily at the head of both editions of Gregory, and the defined function of the tenth-century image of the Anastasis as a self-contained pictorial synonym for Easter, facilitated its link with the First Easter Homily. This link probably emerged between the end of the ninth century and the beginning of the eleventh, given its absence from Paris gr. 510 and the Ambrosiana Gregory.[71]

An offshoot of the use of the Anastasis as the illustration for this homily of Gregory is its use to illustrate two hymns paraphrasing parts of the First and Second Easter Homily of Gregory. A version of the first hymn, which paraphrased paragraph four of the First Easter homily, was used on Easter Sunday.[72] The second hymn, based on the Second

[67] Above, 142.

[68] The reading of the First Easter Homily of Gregory followed the Kiss of Peace after the orthros service on Easter Sunday in the Constantinopolitan tradition as attested by the Dresden Prophetologium (Dresden, Royal Library, cod. A 104), which dates between 950 and 1084. The incorporation of this homily in the services of Hagia Sophia has been interpreted as evidence of monastic influences on the services of the Great Church because this text had formed part of the orthros service on Easter Sunday in the Sabbite-Studite tradition. Bertonière, 114f., 145, 152, 159, 297, 227, 245, Chart C7.

[69] Bertonière, 113, 114, and above n. 5.17. All this witnesses the growing importance of the cult of St. Gregory along with the cult of St. Basil and St. John Chrysostom in the tenth and eleventh centuries.

[70] H. Omont, *Miniatures des plus anciens manuscrits grecs de la Bibliothèque Nationale du VIe au XIVe siècle* (Paris, 1929), 11.

[71] A. Grabar, *Les miniatures du Grégoire de Nazianze de l'Ambrosienne (Ambrosianus 49–50)* (Paris, 1943).

[72] Strunk, "St. Gregory Nazianzus and the Proper Hymns for Easter," 83. Bertonière, 304 nos. 11, 211, 260.

Easter homily, occupied a prominent place in the Easter Sunday orthros.[73] Both these stichera are, therefore, directly connected with the celebration of Easter Sunday, as well as with two of its liturgical components. Though no early illuminated Sticherarion survives, two examples of a later date prove another migration of Anastasis, from the homilies to the corresponding stichera. One is the Sticherarion on Mt. Athos, Koutloumousiou, cod. 412, fol. 232ᵛ (fig. 53), dated in the fourteenth century, already examined in connection with the third type of Anastasis. The other is the thirteenth-century Mt. Sinai, cod. 1216, fol. 220ʳ.[74] Comparably, the Anastasis was used to illustrate other liturgical books, as indicated by its presence in an Octoechos in Messina, University Library, F. S. Salvatore, cod. 51, fol. 60ᵛ, which dates in the eleventh century.[75]

The examples of the Anastasis discussed show that when independent of a christological cycle, the Middle Byzantine image is laden with liturgical overtones. A liturgical dimension is thus given to the representation, associating it with various elements in the liturgical celebration of Easter. This gradually crystallizes into a self-contained identity, which pictorially represents the liturgical reality of the Paschal Services.

An early stage in the liturgical transformation of the Anastasis is seen in the Psalters with marginal illustrations. The liturgical dimension is disguised here by the traditional function of the miniatures as literal illustrations of the text. The pictorial status of the representations as marginal illustrations further confirms the dependence of the image on the text for the realization of its multiple message.

Once broached, the liturgical identity of the Anastasis evolved rapidly. One of the first important steps in its emancipation was the elimination of the literal link between text and image and the use of the image only for its exegetical value. There is no narrative connection between John 1:1ff. and the Anastasis, but their theological interpretations are parallel. Both offer inspired proof of the divinity of the Logos Incarnate, one in word and the other in an image. The image amplifies the text, since both carry the same theological message. The theological message of John 1:1ff. and the image of the Anastasis did not remain limited to their common theological message, but spread to its liturgical expression, Easter. Therefore, the antiquity of the use of John 1:1ff. as the lection for Easter Sunday offered the best context in which to develop and release the liturgical potential of the Anastasis iconography. A substantive link was thus forged between the image and Easter, primarily because of their mutual association with John 1:1ff.

It is not clear whether the Anastasis initially illustrated John 1:1ff marginally. We do know, however, that it was used as a headpiece to the beginning of the Gospel of St. John, physically attached to the text and subordinate to the traditional author portrait preceding

[73] Strunk, loc. cit. Bertonière, 306 no. 79, Chart c7 and p. 140. Also, Charts b2, c8 and pp. 188, 211, 214, 215, 239, 252, 257, 269.

[74] See n. 6.99. For the Sinai manuscript, Strunk, op. cit., passim, figs. 2a–b. For its date, Lazarev, *Storia*, 336 n. 57.

[75] My thanks are due to Professors Belting and Nelson for discussing the Messina Octoechos with me. Ch. Diehl, "Notice sur deux manuscrits à miniatures de la Bibliothèque de Messine," *MélRome*, 8 (1880), 316f.; G. Musolino, *Calabria Bizantina. Iconi e tradizioni religiose* (Venice, 1967), 366, 371; Weitzmann, "The Selection of Texts for Cyclic Illustration in Byzantine Manuscripts," 102 n. 150.

it, as in the Lectionary Dionysiou, cod. 587.[76] The use of the image as a full-page miniature originally facing the text and soon turning its back to it indicates the rapid achievement of the liturgical potential of the image and its complete emancipation from the text. This probably also led to the painting of the Anastasis on independent panels functioning as feast icons for Easter, though no such tenth-century examples are known. The dissemination of the new liturgical image and its adoption in comparable contexts with similar functions—as in the First Easter Homily of Gregory, and the two paschal stichera—were the logical development of the vitality of its new identity.

Though it is easier to trace the growth of the feast image when the iconography is used alone, it is quite clear that it also grew in the context of the christological story. The apse decoration of the New Tokali Kilise is part of an extensive program focusing on the sub-cycle of the Death and Resurrection (fig. 66). This positioning stresses the sacramental aspects of the cycle, spelling out the historical and theological realities typified by the mystery of the Eucharist. Concurrently, it refers to the annual reenactment of the historical and theological reality of Christ's Death and Resurrection through the two prophets who frame the apse holding scrolls quoting Old Testament readings for Holy Friday and Holy Saturday. The same is true of Ps. 81:8, which is used to label the scene of the Anastasis. Through such devices, the New Tokali Kilise succeeds in transforming the pictorial narrative of Christ's Death and Resurrection into a liturgical cycle in the truest sense. The sum of its components typifies visually the historical, theological, and liturgical reality of Christ's redeeming sacrifice in its daily, weekly, and yearly expressions. Thus, this pictorial cycle is wholly integrated into the macrocosmic and microcosmic pattern of the church ritual. The Anastasis, which forms part of it, contributes to all these aspects by adopting specific references that connect it with the celebration of Easter—through the inscription of Ps. 81:8—and with the mystery of the Eucharist—through the inclusion of the Baptist pointing to Christ-Amnos.

The sacramental dimension of the Anastasis offered by this extraordinary Cappadocian church of the mid-tenth century is verified by the use of the Anastasis in the illuminated liturgical rolls. The late eleventh-century roll in Jerusalem (Patriarchal Library, cod. 109) and the mid-twelfth-century roll in Athens (National Library, cod. 2759) contain the liturgy of Chrysostom, and use the Anastasis as a historiated initial A in the prayer preceding that of the Anaphora (fig. 72). In the thirteenth- to fourteenth-century liturgical roll in Lavra, cod. 2, which contains the liturgy of Basil, the illustration of the Anastasis becomes part of the prayer of the Anaphora, whose text it interrupts.[77]

The use of the Anastasis in the two earlier liturgical rolls as a historiated initial mirrors the use of the Anastasis on fol. 2[r] of an eleventh-century manuscript of the liturgical Hom-

[76] The Treasures of Mt. Athos, I, fig. 190.

[77] L. Bréhier, "Les peintures de rouleau liturgique no. 2 du monastère de Lavra," SemKond, 11 (1940), 1–20. A. Grabar, "Un rouleau constantinopolitain et ses peintures," DOP, 8 (1954), 163–199. V. Kepetzis, "Les rouleaux byzantins illustrés (XIe–XIVe siècle). Relation entre texte et image," Diss. 3e cycle. Université de Paris IV, Sorbonne et Ecole Pratique des Hautes Etudes, Ve Section (January 1980), 111f., 120f.

ilies of Gregory, Dionysiou, cod. 61.[78] The iconography of the Anastasis becomes here the historiated initial of the word Anastasis, the first word of the First Easter Homily of Gregory, used on Easter Sunday. The historiated initial, furthermore, overlaps with the headpiece miniature which also represents the Anastasis. In the Dionysiou manuscript, the illustration of the historiated A identifies the form and the content of the word "Anastasis" with the broader liturgical context of the First Easter Homily and the title image Anastasis. Similarly, the use of the Anastasis as a historiated initial in the eleventh and twelfth century liturgical rolls reflects the broader liturgical context of this prayer, the Anaphora which is the core of the eucharistic liturgy. This shorthand pictorial reference to the Resurrection functions as a reminder of the interpretation of the liturgy of the Eucharist as an anamnesis of the Resurrection.[79] Thus, the iconography of the Anastasis functions in the liturgical rolls as a pictorial rubric, a reminder of the interpretation of the liturgy of the Eucharist in a paschal context, confirming the presence of a sacramental layer in the iconography of the Anastasis, whose earliest evidence is the apse decoration of the New Tokali Kilise.

A different liturgical aim is reserved for the scene of the Anastasis in the Cavusin Dovecote and on some of the Middle Byzantine ivories and phylacteries depicting the christological story. These pair the Anastasis with the scene of Baptism recollecting the importance of baptism for redemption as liturgically expressed by the prominence of the baptismal theme in the first part of the Easter Vigil.

There is a number of parallels for the pairing of the scenes of the Baptism and the Anastasis in the visual arts. Its presence in Cavusin is apparently a reflection of a composite pictorial idiom widely known and used in the capital, judging by its appearance on Constantinopolitan ivories and phylacteries. The same is not true of the apse decoration at the New Tokali Kilise, which stands isolated in Middle Byzantine church decoration. It is not easy to determine the sources of this unique arrangement. However, the complexity and sophistication of the realities intelligently synthesized and summarized here without interfering with the lucidity of the narrative, are not at home with local Cappadocian works of this period. Similarly, the style, though related to that of Cavusin Dovecote, is of a far better quality, showing familiarity with Constantinopolitan stylistic trends of the first half of the tenth century.[80] Iconographically, the inclusion of the Baptist in this Anastasis also points to sources outside the local Cappadocian idiom. The Baptist is absent from most Cappadocian representations of the Anastasis. Even when his presence becomes a staple of the iconography in the eleventh entury, his inclusion does not become characteristic of Cappadocian images. On the other hand, the Baptist is found in most Constantinopolitan representations of the Anastasis from the eleventh century on, as exemplified by the Phocas Lectionary and an ivory of the Romanos group in Dresden dated by Weitzmann in the tenth century.[81]

[78] *The Treasures of Mount Athos*, I, fig. 105.

[79] Dix, *The Shape of the Liturgy*, 288ff. and R. F. Taft, S.J., *The Great Entrance. OCA* 200, 37, 63, 281, for a paschal interpretation of the Eucharist as the mystery of redemption.

[80] Cormack, "Byzantine Cappadocia: The Archaic Group of Wall Paintings," 37.

[81] Weitzmann, *Elfenbeinskulpturen*, II, no. 41.

So the apse decoration of the New Tokali Kilise seems to be the work of an artist versed in metropolitan trends in style and iconography. Whether the arrangement of the apse also reflects metropolitan experiments in church programs is hard to tell, given the poverty of the surviving Constantinopolitan material remains. In any case, the New Tokali master (or his sponsors) knew well how to achieve the post-Iconoclastic artistic ideal, which aimed at transforming images into pictorial confessions of the multiple realities of the Orthodox faith.

Although many aspects of the liturgical transformation of the image of the Anastasis are missing, the surviving evidence shows that it was a complex phenomenon with a relatively simple aim. This was to invest the image with the liturgical reality of the event represented, and so organically integrate the image into active church worship. By employing the Anastasis in paschal liturgical contexts, this image gradually developed a paschal liturgical identity of its own. Initially the contexts lending a liturgical dimension to the image were also associated with it in more traditional ways. Thus, the Anastasis also served in the Psalters with marginal miniatures as a literal illustration of the corresponding psalm verses. Similarly, the early parallelism between the image and the beginning of the Gospel of St. John was also based on their parallel contribution to the proof of the divinity of the Logos Incarnate. The gradual emancipation of the image from these texts led to a transposition of emphasis from the text to the image, and to the liturgical identification of the image as a pictorial synonym for Easter.

Concurrently, the image developed other aspects of its liturgical potential in the context of the cycle of Christ's Death and Resurrection. This cycle, whose iconography continued evolving throughout the Middle Byzantine period, chose to stress the vulnerability of Christ's humanity to death by developing the integrated pictorial sequence of the Crucifixion, Deposition, and Entombment. It did so also by experimenting with the theme of Mary's grief in the scene of the Deposition and with the motif of Christ's tomb and sarcophagus in the scene of the Entombment. Later, these experiments gave birth to the scene of the Lamentation, which was also appended to the cycle as easily as the Anastasis had been a few centuries earlier. The active iconographic development of this cycle is in accord with the systematic effort in the ninth and tenth centuries to invest its individual scenes with liturgical and sacramental overtones. The use of this cycle in the New Tokali Kilise apse best illustrates the extent to which the Church sought to integrate its art and its ritual. The pictorial decoration becomes here part of the incessant daily, weekly and annual celebration of Christ's sacrifice and the salvation it guaranteed to mankind. More limited in scope, but still more complex than the self-contained feast image for Easter, is the pairing of the scenes of Baptism and Anastasis in a scheme typifying the first and second part of the Easter Vigil along with all its implications for man.

In all of these related liturgical guises, the Anastasis never rejects any aspect of its traditional past. Its narrative core remains the assertion of the historical reality of the Resurrection. Its theological core remains the demonstration of the will and energy of Christ's divinity. Now the image also stands as a mystical illustration of all aspects of the church

ritual which refer to the miracle of the Resurrection. The harmonizing of all these different layers of the identity of the image, despite the ever-shifting focus, evidences one of the most important aspects of the conceptual character of Middle Byzantine Art.

DAVID AND SOLOMON

King David and King Solomon are exceptionally honored in the Anastasis in St. Barbe by being allowed to share with Christ the symbol of his Passion. In the Old Tokali Kilise, the two kings rise from the top of Christ's tomb which is bejeweled in the same way as David and Solomon. The inference is that Christ's royal tomb is also the tomb of the two kings. These honors raise the question of the role of the two kings in the image of the Anastasis.

The earliest examples of the composite motif of King David and King Solomon date to the first quarter of the ninth century and assert its eastern origin. They figure in the Anastasis representations on the Fieschi Morgan reliquary and in the Chapel of S. Zeno (figs. 24g, 23). The origin of the former is eastern and the latter adapts an eastern model to local tastes, as we have seen. The presence of the joint royal portrait in two different images of the Anastasis in the first quarter of the ninth century suggests the motif of David and Solomon antedates these works.[82]

The Early Christian period favored the iconographic type of David the psalmist, the young man of prodigious talents and courage.[83] This type, which is well represented by the Cyprus plates,[84] was used in a variety of contexts. The iconographic type of David the king and prophet was also known in the early period, but its use was not widespread. Its few known examples date from the sixth century and come from the apse mosaic in St. Catherine's on Mount Sinai, and from the Sinope and Rossano Gospels.[85] In the former, King David appears below the figure of the transfigured Christ as his royal ancestor and prophet. In the latter, he appears as the king and prophet heading several prophetic texts.

Similarly, western artists favor the iconography of David the psalmist up to the 840s. Even when David is represented as the royal choir leader, the young, beardless psalmist is chosen rather than the king, as witnessed by the Vespasian Psalter made in Canterbury in the second quarter of the eighth century, and the Dagulf ivory bookcovers made by the

[82] For the early evidence on the iconography of King David and King Solomon, A. Kartsonis, "David and the Choirs (Vat. gr. 699)," M.A. Thesis, New York University, 1967.

[83] H. Steger, *David. Rex et Propheta* (Nuremberg, 1961).

[84] *Age of Spirituality*, nos. 425–433. *Wealth of the Roman World. A.D. 300–700*, J.P.C. Kent and K. S. Painter, eds. (London, 1977), nos. 179–187.

[85] K. Weitzmann, "The Mosaic in St. Catherine's Monastery on Mount Sinai," *Proceedings of the American Philosophical Society*, 110 (1966), 392–405. Forsyth, Weitzmann, Ševčenko, Anderegg, *The Monastery of St. Catherine at Mount Sinai. The Church and Fortress of Justinian*, I, 11ff. A. Grabar, *Les peintures de l'évangéliaire de Sinope (Bib. Nat., suppl. gr. 1286)* (Paris, 1948), fols. 10[v], 11[r], 15[r], 29[r]. Also below, n. 7.90. Rossano Cathedral, Codex Purpureus, fols. 1[r]–4[v] and 7[r], 7[v]. A. Haseloff, *Codex Purpureus Rossanensis* (Berlin, 1898). David is also represented as a king on a floor mosaic of a sixth-century synagogue in Gaza. A. Ovadiah, "Excavations in the Area of the Ancient Synagogue at Gaza (Preliminary Report)," *Israel Exploration Journal*, 19 (1969), 193–198. M. Barasch, "The David Mosaic at Gaza," *Eretz Israel*, 10 (1971), 94–99 and *Qadmoniot*, 1 (1968), 124ff. I thank Prof. Y. Tsafrir for drawing my attention to and for translating these articles for me.

court school of Charlemagne in the late eighth century.[86] The Northumbrian miniatures illustrating the commentary of Cassiodorus on the Psalms in the second quarter of the eighth century also choose the iconography of the young psalmist twice, even though he is labeled *David Rex* on fol. 81ᵛ.[87] David is bearded for the first time in a western miniature illustrating the Penitence of David in the Carolingian Psalter of St. Gall, made before 841 and based on a Byzantine model of uncertain antiquity.[88]

The representation of David as king is used in the First Bible of Charles the Bald and the Psalterium Aureum of St. Gall in the first half of the ninth century,[89] and thereafter becomes an established theme in western art. Though using a different pictorial vocabulary than the Carolingian West, the Byzantine East also shows an increasing interest in the iconography of David the king from the ninth century on. The choice of the royal type over the psalmist in the standard Middle Byzantine church decoration adequately illustrates the post-Iconoclastic preference.

The pairing of King David and King Solomon into a composite unit has no pre-ninth-century precedent. King Solomon also appears in the Rossano Gospels. Here, however, the artist does not make an effort to differentiate the two kings, or to correlate Solomon and David, though at times he confuses Solomon with Sirach. David and Solomon also appear close to each other in the canon tables of the Rabbula Gospel.[90] The young, beardless, and crownless psalmist stands here with his lyre, while Solomon is bearded, crowned, and sumptuously enthroned across the canon table. This stark contrast between the appearance of David and Solomon confirms the popularity of the young psalmist, and the unfamiliarity of the period with the joint portrait of the royal father and son. This is the only Early Christian example known to draw a parallel between David and Solomon. Significantly, their pictorial synchronization, which characterizes the motif of King David and King Solomon, is absent from the Rabbula Gospel miniature.

The iconography of the Anastasis is the first context in which the age and attributes of

[86] London, British Museum, cod. Cotton Vespasian A.1, fol. 30ᵛ. J.J.G. Alexander, *Insular Manuscripts* (London, 1975-1978), I, no. 29, fig. 146. Steger, op. cit., pl. 3. For the Dagulf ivory bookcover, see Goldschmidt, *Die Elfenbeinskulpturen aus der Zeit der karolingischen und sächsischen Kaiser*, I, no. 3-4. L'exposition Charlemagne, no. 518. Hubert, Porcher, Volbach, *L'empire Carolingien*, 227, pl. 208.

[87] Durham Cathedral Library, cod. B.II.30, fols. 81ᵛ, 172ᵛ. Alexander, *Insular Manuscripts*, I, no. 17, figs. 74, 75. A standing portrait of the young psalmist type labeled DAD PRF is also chosen for the Montpellier Psalter illustrated before 778. *L'exposition Charlemagne*, no. 450.

[88] Wolfcoz Psalter, Zurich, Zentralbibl., cod. C 12, fol. 53ʳ. G. Kauffmann, "Der karolingische Psalter in Zürich und sein Verhältnis zu einigen Problemen byzantinischer Psalterillustration," *Zeitschrift für schweizerische Archäologie und Kunstgeschichte*, 16 (1956), 65-

74. Hubert, Porcher, Volbach, *L'empire Carolingien*, 286 pl. 302.

[89] *First Bible of Charles the Bald*: Paris, Bibl. Nat., cod. lat. 1, fol. 215ᵛ. A. Boinet, *La miniature carolingienne* (Paris, 1920), pl. 49; see also pl. 113a for the Psalter of Charles the Bald. Hubert, Porcher, Volbach, op. cit., pl. 49. *Psalterium Aureum*: Saint-Gall, Stiftsbibl., cod. 22, fol. 2ʳ. Boinet, op. cit., pl. 144a. Hubert, Porcher, Volbach, op. cit., 170, pl: 157.

[90] Florence, Laur., cod. Plut. 1, 56, fol. 4ᵛ, Canon 1. Cecchelli, Furlani, Salmi, *The Rabbula Gospels*. Leroy, *Les manuscrits syriaques peints et enluminés*, 142, pl. 23/1. King Solomon heads the prophesy Sirach 24.21 on fol. 4ʳ of the Rossano Gospels and a portrait of Sirach as a king heads the prophesy Prov. 22:11 on fol. 7ʳ of the same manuscript. Above, n. 7.85 and A. Muñoz, *Il codice purpureo di Rossano e il framento Sinopense* (Rome, 1907), 6, 7.

the two kings are coordinated. The Fieschi Morgan reliquary and the S. Zeno mosaic are its first examples which use the motif of David and Solomon in the early ninth century. However, the presence of this motif in the Anastasis was not standardized in the ninth century. The Psalters with marginal miniatures ignore it despite their pronounced interest in the royal type of David. This ambivalence clears in the tenth century. Thus, the motif of King David and King Solomon, the royal father and royal son, the one older and the other younger, is consolidated as an essential iconographic feature of the Anastasis.

Other Middle Byzantine iconographic contexts also favor this royal pair. Most prominent is the portrayal of the two kings among the prophets surrounding the Pantocrator in churches of this and later periods. From now on, the king is almost invariably accompanied by his royal son in contrast to the lone figure of David in the sixth-century apse mosaic on Mt. Sinai.

The pre-Iconoclastic indifference to the iconographic type of David the king and prophet, and the apparent unfamiliarity of this period with the motif of David and Solomon as father and son starkly contrast the Middle Byzantine interest in the iconography of King David and in the motif of King David and King Solomon. It appears that the joint portrait of the two kings does not date back to the Early Christian period. The absence of the two kings from the three earliest examples of the Anastasis similarly points to the unfamiliarity of the early eighth century with this motif, a suggestion confirmed in the absence of the two kings from the archaistic Middle Byzantine Anastasis on the Stuttgart ivory casket.[91] The Fieschi Morgan reliquary and the late eighth-century model of its Anastasis representation indicate, on the other hand, that the two kings had joined the image of the Anastasis by the end of the eighth century. The available evidence therefore suggests that the motif of David and Solomon was introduced some time between the beginning and the end of the eighth century.

The presence of David and Solomon in the Middle Byzantine image of the Anastasis not only antedates that of John the Baptist—the other peripheral personality one comes to expect as part of the iconography—but also surpasses its importance. Even during the eleventh century when the Baptist becomes a dominant feature of the image, he can still be excluded, but not the two kings. Many examples include David and Solomon, but leave out the Baptist, such as the mosaic at Hosios Lukas (fig. 83), the Morgan Lectionary 639,[92] the Homilies of Gregory Nazianzenus Dionysiou 61,[93] and others.

Why should King David and King Solomon come to be considered sufficiently vital to the iconography of the Anastasis to be included even on such small objects as the historiated reliquaries? Such objects were naturally given to abbreviation, and the self-sufficiency of the motif of the two kings makes it a prime candidate for elimination. But David and Solomon remain a stable feature even in the abbreviated variants of the Anastasis. The historiated reliquaries testify to this for the early post-Iconoclastic period. Similarly, the seal of an emperor Romanus indicates that the two kings persisted as an inalienable part of the Anastasis, even in the shorthand reference of the second type of Anastasis well into the

[91] Weitzmann, *Elfenbeinskulpturen*, II, no. 24b.

[92] K. Weitzmann, "The Constantinopolitan Lec-

tionary Morgan 639," 358ff., fig. 290.

[93] *The Treasures of Mount Athos*, I, fig. 105.

tenth or eleventh centuries.[94] The canonization of David and Solomon as a vital part of the image implies that one or more aspects of their personality were indispensable to the message of the image.

If David were included in the Anastasis alone, his presence would be relatively easy to explain. He is the prophet of redemption par excellence. Moreover, the liturgical importance of the Psalter is indisputable in the post-Iconoclastic period, as confirmed by the Second Act of the Council of 787, which decreed that the Psalter and its exegesis should be known thoroughly by any ecclesiastic considered for promotion to a bishopric.[95] The prophetic and liturgical relevance of David could forge an adequate link between his person and the image of the Anastasis. It is precisely this link which ensures the presence of David in the literary accounts of the siege of Hades. The inclusion of David may have been on a similar basis as the introduction of John the Baptist into the Anastasis. However, an interpretation of David that considers only his prophetic qualities and his broad liturgical value is quite inadequate. It is, in fact, misleading, since it ignores a most important pictorial condition for his inclusion: that he should not appear in the Anastasis without his son Solomon. The pair is considered a single pictorial motif to an even greater extent than the protoplasts. For instance, Adam and Eve are placed symmetrically on either side of the figure of Christ in the third type of Anastasis, as, for example, in Iviron 1 (fig. 50). This is never the case with David and Solomon, who are almost always inseparable.[96]

One would therefore expect Solomon to fulfill in the Anastasis a function similar to David's. But his attributes are difficult to place in the context of the Anastasis. Solomon's presence in the accounts of the siege of Hades is usually bypassed. When mentioned, his role is tertiary compared with that of other Old Testament figures.[97] This factor does not

[94] A lead seal in the Moscow exhibit of 1977 uses the second type of Anastasis seen at Hosios Lukas, except reversed. Its reverse side bears the inscription ΧΕ ΒΘ//ΤΩ CΩ/ ΡΟΜΑ/ Ν/. The Romanus mentioned in the inscription could be either Romanus I Lecapenus (920–944), Romanus II (959–963), Romanus III Argyrus (1028–1034), or Romanus IV Diogenes (1068–1071). It is not possible to identify the correct Romanus. However, given that this iconographic type of Anastasis is popular throughout the eleventh century, a date in the eleventh century seems preferable for this seal. *Iskusstvo Vizantii V Sobraniiakh SSSR*, II, no. 779.

[95] Mansi, 13.420. Ralles and Potles, Σύνταγμα τῶν θείων καὶ ἱερῶν κανόνων, II, 560–564. Hefele, *Histoire des conciles*, III/B, 777f. The memorization of the Psalter was apparently considered an act of piety. In this sense Theodore Studios mentions that his pious mother Theoktista had memorized the entire book. A. Gardner, *Theodore of Studium* (London, 1905), 16.

[96] One of the rare exceptions comes from the representation of the Anastasis in Pürenli Seki Kilise, a member of the Irhala group of Cappadocian churches. Solomon appears here alone behind the figure of Christ, while two upright mummies behind Adam and Eve may be identified as the anonymous dead rising. Further back an inscription identifies the horrified gate-keepers of Hades. The date of this group of churches remains unsettled. N. and M. Thierry, *Nouvelles églises rupestres de Cappadoce*, 150, pl. 68b. Restle, III, fig. 487.

[97] Solomon is absent from all versions of the Apocryphon of Nicodemus, as well as from most paschal homiletical literature. In the homily of Pseudo-Epiphanius he is mentioned in passing (PG, 43.452). In the *Carmina Nisibena* of Ephrem the Syrian, David and Solomon are mentioned together in the context of the siege of Hades. Nevertheless, they are not singled out above all other prophets present there in a manner which could explain their subsequent importance to the image of the Anastasis. E. Beck, *Des heiligen Ephraem des Syrers Carmina Nisibena*, CSCO 241, Scriptores Syri 103 (Louvain, 1963), II. The following hymns mention David, Solomon, or the two of them together: David in 39.13–14, 43.7–8, 71.1; the royal house of David in 58.8; David and Solomon in 53.15–

account for the importance of his person in the Anastasis. Similarly, the liturgical value of his writings was minimal.[98] Consequently, we must look for other aspects of Solomon's personality which may explain his importance for the image of the Anastasis.

Solomon was much better known throughout the Byzantine East as the king whom God had particularly blessed with wisdom and insight. His divine knowledge and his prophetic ability qualified him as a magician whose name could be invoked by a Christian against all sources of evil.[99] His major liturgical contribution, the building of the Temple of Jerusalem, was equally well known. Its decoration with oversized gold cherubs was often cited as a precedent justifying the use of figurative images in church decoration.[100] Furthermore, the proverbial justice of Solomon helped shape a "Solomonic" ideal of sovereignty, which exercised a special appeal during the Macedonian period.[101] Finally, Solomon was remembered as the worthy son of King David.

Though interesting, none of these aspects of his personality forge ipso facto a direct link between the person of the Old Testament King Solomon and the iconography of the Anastasis justifying his pictorial importance for the Middle Byzantine image.

Since neither king can account individually for his exclusive iconographic importance in the Anastasis above all its other prophets, the problem must be reexamined taking special note of the pictorial emphasis on the joint appearance of David and Solomon. What can the motif of the two inseparable kings of the Old Testament uniquely contribute to the Anastasis? Why is the presence of the two kings mandatory even for the most abbreviated versions of the image?

Apart from the Anastasis, the two kings make a joint appearance only once more in the ninth-century Vatican copy of Cosmas Indicopleustes.[102] The miniature of David, Solo-

17, Appendix 13–14; Solomon in 57.18. See also Don J. Texidor, "Le thème de la 'Descente aux Enfers' chez Saint Ephrem," 25–41. Davis-Weyer has been the only one to recognize the presence of Solomon in the canonized image of the Anastasis as evidence of the independence of the image from the Apocryphon of Nicodemus. Davis-Weyer, "Die ältesten Darstellungen der Hadesfahrt Christi, des Evangelium Nikodemi und ein Mosaik der Zeno-Kapelle," 184f.

[98] The odes and psalms of Solomon deal extensively with the siege of the underworld. However, these poetic works, whose attribution to Solomon is more than dubious, were explicitly excluded from any use in the context of the church services by Patriarch Nicephorus I (PG, 100.1057C. Also, PG, 28. 432A). It has been shown that this material was not extensively used by the Greek Fathers in their writings in contrast to Ephrem the Syrian. R. Harris, A. Mingana, *The Odes and Psalms of Solomon* (Manchester, 1920), 3, 16–61, chapters II and III. Nevertheless, the influence of these early works on Middle and Late Byzantine literature has not been yet examined. See also above, n. 2.50 and *The Odes of Solomon*, J. H.

Charlesworth, ed. and trans. (Oxford, 1973), 149–167 for an extensive bibliography.

[99] The use of Solomonic seals and amulets was widespread especially throughout the Early Christian period. Cabrol, Leclercq, *DACL*, w. "Salomon," 589ff. These seals were used by Christians, as may be demonstrated, for example, by a seal whose one side is taken by the Adoration of the Magi and the other by some of the standard Solomonic exorcisms [ibid., I.2 (1907), fig. 508], as well as by the magical bracelets bearing the abbreviated christological cycle [J. Maspero, "Bracelets-amulettes d'époque byzantine," 246–258, figs. 1, 2].

[100] Mansi, 12.1063D.

[101] Constantinus VII Porphyrogenitus, *De administrando imperio*, F. Dvornik, R.J.H. Jenkins, B. Lewis, Gy. Moravcsik, D. Obolensky, S. Runciman, eds. and trans. (London, 1962-1967), II, Commentary, 9.

[102] Vatican, Bibl., cod. gr. 699, fol. 63ᵛ. Stornajolo, *Le miniature della topografia cristiana di Cosma Indicopleuste*, 36f. Cosmas Indicopleustes, *Topographie Chrétienne*, II, v. 122f. Kartsonis, "David and the Choirs (Vat. gr. 699)," passim.

mon, and the Choirs illustrates a text that often prefaces the Psalter. This miniature is, therefore, appropriate as a frontispiece to the Psalter. Needless to say, Solomon's presence in a Psalter frontispiece is unsuitable. His youth and his imperial robes only succeed in characterizing him as his father's royal son. The presence here of this pudgy young boy standing by the enthroned David, is at first glance, as unfounded and irrelevant as the presence of Solomon in the Anastasis. The Vatican miniature, therefore, reinforces the need to define the meaning of the motif of David and Solomon. Both ninth-century versions of this motif stress pictorially the father-son relationship of these two figures. The reason for this visual comment is far from clear. An examination of the illustration and use of Ps. 71 helps trace the foundation and aim of the joint portrait of King David and his younger son King Solomon in the pictorial vocabulary of the ninth and tenth century.

The Illustration of Psalm 71 [103]

Psalm 71 is dedicated by David to Solomon, and is easily the most dynastic of all psalms. The royal father intercedes for his royal son asking

[1] Give the king thy judgements, O God, and thy righteousness unto the king's son. [2] He shall judge thy people with righteousness, and thy poor with judgement. . . . [6] He shall come down like rain upon the fleece. . . . [10] The kings of Tarshish and of the isles shall bring presents: the kings of Sheba, and Seba shall offer gifts [11] Yea, all kings shall fall down before him: all nations shall serve him. . . . [17] His name shall endure for ever: his name shall be continued as long as the sun, men shall be blessed in him: all nations shall call him blessed.

The christological potential of this psalm was appreciated at a very early date. Origenes comments that

The psalm is entitled "to Solomon" but its contents refer both to Solomon himself and to the son born through his seed; this is why it is said "Give the king thy judgements, O God, and thy righteousness unto the king's son." From that point on, prophetic words are uttered about the son of the king—that is, the one to be born by the seed of Solomon—which cannot refer to anyone else except only to Christ the son of God . . . they refer neither to Solomon himself, nor to Roboam who succeeded him . . . but exclusively to our Redeemer.[104]

At a later date, Pseudo-Athanasius says of Ps. 71 in his commentary on the titles of the

[103] Kartsonis, op. cit., 45ff.
[104] Origenes, *Exegetica in Psalmos*, PG, 12.1069. Ἐπιγέγραπται μὲν γὰρ ὁ ψαλμὸς 'Εἰς Σαλομῶν' ἀναφέρεται δὲ τὰ ἐν αὐτῷ εἴς τε αὐτὸν Σολομῶντα καὶ τὸν ἐκ σπέρματος αὐτοῦ γενησόμενον υἱὸν αὐτοῦ· διὸ εἴρηται· 'Ὁ Θεὸς τὸ κρίμα σου τῷ βασιλεῖ δὸς καὶ τὴν δικαιοσύνην σου τῷ υἱῷ τοῦ βασιλέως.' Εἶτα ἑξῆς τούτοις ἐπιφέρονται λόγοι τινὲς προφητικοὶ περὶ τοῦ υἱοῦ τοῦ βασιλέως, δηλαδὴ ἐκ σπέρματος Σολομῶντος γεννηθησομένου, οἵτινες οὐκ ἐφ' ἕτερον ἁρμόζειν δύνανται ἢ ἐπὶ μόνον Χριστὸν τοῦ Θεοῦ. Τὸ γὰρ 'κατακυριεύσει ἀπὸ θαλάσσης ἕως θαλάσσης καὶ ἀπὸ ποταμῶν ἕως περάτων τῆς οἰκουμένης' καὶ παραπλήσια τούτοις οὔτ' ἐπ' αὐτὸν ἀνάγοιτο ἂν τὸν Σολομῶντα, οὐδ' ἐπὶ τὸν ἀναδεξάμενον αὐτοῦ τὴν ἀρχὴν Ροβοάμ, οὐδ' ἐφ' ἕτερον τῶν αὐτοῦ διαδόχων, ἀλλ' ἐπὶ μόνον τὸν ἡμέτερον Σωτῆρα. Theodoretus, *In Psalmum 71*. PG, 80.1428f. confirms the christological interpretation of Origenes.

psalms: "And this speaks of the end of days; to the most peaceful is the psalm dedicated, and by this I mean our Lord Jesus, for 'Solomon' means 'peaceful.' "[105]

The christological interpretation remained alive throughout the Macedonian period. It is repeated by Psellus in his commentary on the titles of the psalms addressed to Michael VII Dukas (1071–1078). Here Psellus understands that the psalm refers to Christ, "the most peaceful."[106]

More specifically, Ps. 71 was interpreted as a reference to the incarnation of the Logos through the Virgin. Particularly responsible for this is verse 6 with its recollection of Judg. 6:26–40. The rain that fell upon Gideon's fleece was interpreted at an early date as a reference to the incarnation of the Logos. The typology of the Virgin came to include all such direct and indirect references to Gideon's fleece. Romanos Melodos, and Theodoret Cyrus identify Mary with Gideon's fleece, and the conception of the Logos Incarnate at the time of the Annunciation with the rain that fell upon the fleece. John of Damascus, moreover, hails Mary as Gideon's Fleece, whence flowed the immortal dew. And Mary continues to be hailed in this way in one of the troparia of the sixth ode of the Service of the Akathistos Hymn.[107]

Following the spirit of the exegesis of verse six as a typological reference to the Virgin and the Annunciation, it is easy to see why verses ten and eleven should call to mind the adoration of the Logos Incarnate by the Magi—the three kings from Persia—as well as the related prophesy of Isa. 49:23, that all kings shall bow down to earth before the Logos Incarnate.

By dedicating Ps. 71 to the royal son Solomon, David in effect prophesies the incarnation and reign of his other son through the Virgin, the Logos Incarnate. Consequently, the psalm succeeds in raising the davidic ancestry of Christ.[108] The first beloved son of David, Solomon, who is mentioned in the title of the psalm, is assimilated to this christological scheme as well. His name is equated with the peacefulness of the Logos Incarnate and its owner is thus projected as a type of the Logos Incarnate.[109] In this way, David, Solomon,

[105] Pseudo-Athanasius, *De Titulis Psalmorum*. PG, 27.937C: "Ἡ προκειμένη ἐπιγραφὴ περιέχει· 'εἰς τὸ τέλος, ψαλμὸς Δαβὶδ εἰς Σαλομών.' Τοῦτο οὖν λέγει· ἐπ' ἐσχάτων τῶν ἡμερῶν εἰς τὸν εἰρηνικώτατόν ἐστω ὁ ψαλμός, λέγω δὴ εἰς τὸν Κύριον Ἰησοῦν· 'Σαλομών' γὰρ 'εἰρηνικὸς' ἑρμηνεύεται." The same interpretation is offered by Theodoretus, loc. cit. and by Athanasius, *Expositio in Psalmos*, PG, 28.324.

[106] Michael Psellus, *Scripta Minora*, E. Kurtz, ed. (Milan, 1946), I, 397, lines 213f.

[107] R. J. Reichmuth, S.J., "Typology in the Genuine Kontakia of Romanos the Melodist," Ph.D. Dissertation, University of Minnesota, 1975, 180–183. The kontakia of Romanos that refer to the fleece of Gideon are 5.4, 37. Pr., 37.12 and 46.26. Also, Theodoretus, op. cit., PG, 80.1433 and Hesychius, *In Psalmum 71*, PG, 93.1236; John of Damascus, *In nativitatem*

b. v. Mariae, II, PG, 96.696; Theodorus Studita, *In Dormitionem Deiparae*, PG, 99.725B; Sophronios Eustratiades, Leontopoleos, Ἡ Θεοτόκος ἐν τῇ ὑμνογραφίᾳ (Paris, 1930), w. "πόκος."

[108] This is one of the major objectives of the psalm according to Origenes, op. cit., PG, 12.1072B. Moreover, Theodoretus elaborates on the idea that Christ is not only king but the son of a king as well: as God, Christ has God—the ruler of all—as his father, while as man, Christ has King David as his forefather (PG, 80.1429C). Similarly, Athanasius interprets Ps. 71:1 as a reference to Christ the King and the son of the King (PG, 28.324).

[109] As Dölger pointed out, the Byzantines took a great interest in questions of etymology believing that "the name of an object expressed its real nature,

the Virgin and Christ are all intertwined in the story of the incarnation. As a result, Ps. 71 reflects on a prophetic, typological, and historical level a multiplicity of realities that are part of the doctrine of the incarnation.

The exegetical literature concerning Ps. 71 leads to this interpretation. More important for us, the illustration of this psalm, as well as illustrations using it, follow this understanding closely. The Stuttgart Psalter, for example, understands that Ps. 71 refers both to Solomon and the incarnation of Christ. It illustrates verse 1 with the Judgment of Solomon, verse 6 with the Annunciation, and verse 10 with the Adoration of the Magi. The psalm as a whole is interpreted as a reference to the incarnation according to the inscription: "Hic psalmus de nativitate Domini dicit: Descendit sicut pluvia in velus, hoc est Deus in utero sanctae Mariae."[110]

The ninth-century psalters with marginal illustrations also offer a consistent interpretation of the psalm as a reference to the incarnation (figs. 73, 74, 76). They often include the Annunciation in connection with verse 6, and the Adoration of the Magi in connection with verses 10f. Wishing to stress the latter, they sometimes include the figure of Isaiah above the Magi. The Theodore Psalter, furthermore, illustrates verse 17 with Christ enthroned, while two groups of people on a lower level look up at him and adore him.[111]

So it is obvious that both East and West uniformly understood this psalm as a reference to the mystery of the incarnation of the Logos. Both also respected the mention of the name of Solomon in the title of the psalm. The Stuttgart Psalter expressed this by attaching to the first verse, which talks about the righteousness of David's son, an illustration of Solomon's Judgment—the best known example of his righteousness. At this point, however, the eastern psalters diverge significantly. They are not interested in offering a literal exegesis for the use of the name of Solomon in verse 1f. They concentrate instead on the presentation of a composite exegetical miniature, which:

or that it was intimately connected with the essence of the object in both its genetic and logical existence." F. Dölger, "Byzantine Literature," *The Cambridge Medieval History* IV. *The Byzantine Empire. Part II: Government and Civilization.* J. M. Hussey, ed. (Cambridge, 1967), 248. Dölger's observation finds confirmation in the definition of the word etymology offered by the *Hodegos* of Anastasius Sinaites, PG, 89.81B Uthemann, 2.8.1–2: "Ἐτυμολογία ἐστὶν ἡ τῆς δυνάμεως τοῦ ὀνόματος ὀρθότης, ἐξ αὐτοῦ ἑρμηνευομένη."

[110] *Der Stuttgarter Bilderpsalter,* B. Bischoff, J. Eschweiler, B. Fischer, H. J. Frede, F. Mütherich, 107f.: *Ps. 71:1,* fol. 83ᵛ, The Judgment of Solomon; *Ps. 71:6,* fol. 83ᵛ, The Annunciation; *Ps. 71:10,* fol. 84ʳ, The Adoration of the Magi. The quote cited here is attached to the Annunciation.

[111] The illustration of Ps. 71 in the psalters with marginal miniatures is as follows:

PANTOCRATOR 61		
fol. 93ᵛ	Ps. 71: Title	Solomon and Christ
	Ps. 71:6	Gideon's Fleece
BRISTOL PSALTER		
fol. 115ʳ,	Ps. 71:6	Gideon's Fleece
fol. 115ᵛ,	Ps. 71:10	The Adoration of the Magi
THEODORE PSALTER		
fol. 91ᵛ	Ps. 71: Title	Christ and Solomon
	Ps.71:6	Gideon's Fleece, and the Annunciation
fol. 92ʳ	Ps. 71:10	Isaiah, The Adoration of the Magi, The Arrival of the Magi
fol. 93ʳ	Ps. 71:17	Christ Worshiped by the Nations
BARBERINI PSALTER		
fol. 114ᵛ	Ps. 71: Title	Same as in Theodore Ps.
	Ps. 71:6	Same as in Theodore Ps.
fol. 115ʳ	Ps. 71:10	Same as in Theodore Ps.
HAMILTON PSALTER		
fol. 139ʳ,	Ps. 71: Title	Solomon and Christ
fol. 139ᵛ	Ps. 71:6:	Gideon's Fleece
	Ps. 71:9	Demons Fleeing
fol. 140ʳ,	Ps. 71:10	The Journey of the Magi, The Adoration of the Magi
fol. 140ᵛ,	Ps. 71:16	The Cross on a Mound

1. Respects the psalm's title reference to Solomon but also points out its inner christo-
 logical meaning;
2. Combines the prophecies of David and Gideon about the Virgin as the vehicle of the
 incarnation;
3. Merges these two concerns into a coherent unit with a visual scheme, which com-
 ments, among other points, on the davidic lineage of the Logos Incarnate.

Psalter Pantocrator, cod. 61, fol. 93ᵛ (fig. 74)[112] illustrates the title of the psalm with the
gold medallion of the cross-nimbed Christ, and an inscription below it reading simply "to
Christ." A boy King Solomon stands frontally next to Christ's medallion and points to it.
The message of this composition is clear. The inscription below the medallion contrasts
with the title of the psalm and points out the christological interpretation that should be
attached to it.

A large gold disc framed in blue below and on the same axis as the medallion of Christ
emits from its lower side a blue band overlaid with three rays and a dove falling vertically
on a gold bust medallion of the Virgin "into the womb of the Virgin," according to an
inscription next to the dove. This composition then shows the conception of the Logos by
the Virgin, who is labeled here as "the holy Theotokos." Consequently, the gold disc
stands for the invisible divinity in the heavens, and the dove for the Holy Ghost, as usual.
The composition is also transformed into Gideon's Fleece by the addition of Gideon next
to the Virgin, while the presence of David on her other side comments on the relevance of
Gideon's Fleece for verse 6 of Ps. 71. The inscriptions which accompany a very abbrevi-
ated version of this illustration in the Bristol Psalter leave no doubt about the intended
meaning of this scene. The emission from heavens is labeled: "the rain-Christ the Word of
God," and the medallion of the Virgin: "the fleece-the Theotokos" (fig. 76).

But the interpretation of the illustration of the title and verse 6 of Ps. 71 is not yet ex-
hausted. A number of elements suggest that the two scenes should be read as one unit. The
medallions of Christ, the divinity and the Virgin are on the same axis. Moreover, the gold
medallions of Christ and the Virgin are almost the same size and equidistant from the
larger gold disc of the divinity. As a result, the bust of the Theotokos which rests on a
rocky hill is formally aligned with the bust of Christ above. Mother and son come to-
gether, and the gold disc acts as their formal link.

The two scenes are further linked by the figures of Gideon and David. Gideon points
down to the earth supporting the Theotokos, while David points above to the disc of the
divinity, Christ, and Solomon. The alignment of mother and son is, moreover, parallel to
the vertical alignment of the royal father and his royal son. So the medallions of the Virgin
and Christ are paralleled by the standing figures of David and his son Solomon.

By such means a chain of filial relationships is established. David dedicates Ps. 71 to his
son Solomon while pointing to Solomon and Christ. Solomon, however, points out that
Christ is the real son of David mentioned in the psalm. While pointing to his two sons

[112] For a color illustration of Pantocrator Psalter, fol. 93ᵛ, see *The Treasures of Mount Athos*, III, fig. 206.

David also stands next to his well-known "daughter," the Virgin, whose son, Christ, is both in her womb and above, next to Solomon, the immediate descendant of David. Thus a pictorial reference to the davidic ancestry of Christ is formulated, while asserting the story of the incarnation.

Consequently, the illustration of Ps. 71 offers a nonnarrative dogmatic exegesis of the doctrine of the incarnation. Accordingly, King David and his royal son Solomon assert their importance in the story of the incarnation and define their roles, not only as prophets and antetypes of Christ, but also as Christ's ancestors. Of all these roles, the one that addresses itself to the historical lineage of Christ is unique. In this role, David and Solomon are irreplaceable. Appropriately, David is labeled "David Theopator"—Father of God—in the Bristol Psalter (fig. 76).

This family portrait is condensed in the illustration of Ps. 71 in the Theodore Psalter, fol. 91ᵛ (fig. 73). Here, the figure of the young and oversized King Solomon appears below the medallion of Christ, on the same axis as the ark of heavens and the medallion of "Meter Theou." So Solomon is physically integrated in the pictorial scheme of the incarnation of the Logos. At the same time, the orant attitude of the young king recalls the intercessory role traditionally reserved for the Virgin, proposing King Solomon once again as an intermediary between Christ above and the Virgin below. Solomon moves out of the marginal role of witness to the dominant role of an organic link in the mystery of the incarnation. The balance therefore tilts and Solomon is specifically proposed as a catalyst in this psalm, which expresses the concern of the house of David for its progeny.

The widespread familiarity of the Macedonian period with the interpretation of Ps. 71 as a reference to the incarnation through the royal house of David is confirmed by other variations in its illustration. Thus, Vat. gr. 1927, fol. 126ᵛ, shows King David and the child Solomon kneeling and praying to heavens above with the opening words of the psalm, while to their right a bust of the Virgin and Child—the Fleece of Gideon—is worshiped by a variety of kings and by all nations.[113] Comparably, Vat. gr. 752, fol. 222ᵛ, illustrates the older and the younger king jointly forecasting the arrival of the Lord in front of a luxurious building.[114] Even when Christ's davidic lineage is not alluded to directly, Ps. 71 is illustrated with a joint portrait of the two kings. Thus, the royal father and the royal son appear invariably together as forecasters and links in the story of the incarnation in the context of Ps. 71. Keeping this in mind, we shall now examine the function reserved for Ps. 71 in the aristocratic psalters.

The Paris Psalter includes a formal portrait of King David standing in severe hierarchical frontality, holding the Psalter open at Ps. 71:1 (fig. 77).[115] The importance of this text is

[113] E. T. De Wald, *The Illustrations in the Manuscripts of the Septuagint. Volume III. Psalms and Odes. Part 1: Vaticanus graecus 1927* (Princeton, 1941), 20f.

[114] E. T. De Wald, *The Illustrations in the Manuscripts of the Septuagint. Volume III. Psalms and Odes. Part 2: Vaticanus graecus 752* (Princeton, 1942), 27.

[115] Paris, Bibl. Nat., cod. gr. 139, fol. 7ᵛ.

H. Buchthal, *The Miniatures of the Paris Psalter* (London, 1938), 25f., pl. VII. Idem, "The Exaltation of David," *JWarb*, 37 (1974), 330–333. K. Weitzmann, "Eine Pariser-Psalter-Kopie des 13. Jahrhunderts auf dem Sinai," *JÖB*, 6 (1957), 125ff. H. Belting, "Zum Palatina-Psalter des 13. Jahrhunderts," *Festschrift Otto Demus. JÖB*, 21 (1972), 17ff.

underlined by the classicizing personification of Prophetia, who stands on David's left and points to the opening words of the psalm. In the greater position of honor, to the right of the king, we see the equally classicizing personification of Sophia. She has given up her scroll for a book, which she holds rather awkwardly under her left arm while raising her right hand in what seems to be an apophatic gesture. A dove hovering on David's nimbus completes the basic description of the miniature.

Given the exegetical interpretation attached to Ps. 71 and the pictorial tradition associated with it, it becomes possible to suggest that this miniature proposes, among other things,[116] the royal house of David as the vehicle of the Incarnation of the Logos. The exegetical and pictorial background of Ps. 71 is offered in support of this suggestion along with the exegetical passages selected to accompany the text of the psalm on fols. 238r to 245r of the manuscript. Furthermore, it is backed up by the figure of Prophetia, who stresses the importance of this psalm in the present context, and by the dove, which practically stands on David's nimbus in the same way as on his "daughter's" nimbus in the illustration of the Annunciation in the Chloudof Psalter, fol. 45r, Ps. 44:11 (fig. 75).[117] These elements converge and propose King David and the son mentioned in Ps. 71 as antecedents of the Incarnation.

The role of Solomon is almost suppressed in the Paris Psalter miniature. Only knowledge of the text of the psalm, and its exegetical and pictorial background imply his inclusion. A further allusion to the younger king is suggested possibly by Sophia. While a personification of Wisdom seems to acompany King Solomon in a miniature designed as a frontispiece to the Wisdom books of the Old Testament,[118] Wisdom is not known to have been associated with the person of King David in any pictorial context other than the miniature of the Paris Psalter and its immediate relatives.

The role of Solomon is understandably underplayed, since the Paris Psalter miniature has a dual function. It acts both as a frontispiece to the text of the Psalter and as a conclusion to the traditional life cycle of David, the story of the young psalmist of many endeavors and gifts. Any explicit pictorial reference to Solomon would deflect this miniature from its purpose.[119]

The decision to include Ps. 71 helped the illustration realize its twin aim. This psalm

[116] This miniature also reflects elements taken from the imperial iconographic tradition becoming a carrier of its messages as well. The appearance of Ps. 71 here has led Buchthal to propose that this miniature reflects the dedication of the Paris Psalter Original by Constantine Porphyrogenitus to his son Romanus. Buchthal, "The Exaltation of David," 332.

[117] In the Chloudof Psalter miniature the Virgin stands frontally before her throne. The angel is approaching from her left, balanced on her right by the standing figure of King David, who addresses the Virgin as his daughter in Ps. 44:11.

[118] As in Copenhagen, G. Konigl. Samml. cod. 6, fol. 83v. J. Beckwith, *The Art of Constantinople*, 85, fig. 109. Also, H. Belting, G. Cavallo, *Die Bibel des Nicetas* (Wiesbaden, 1979), 33f., fig. 1.

[119] For conclusive evidence that fol. 7v of the Paris Psalter still occupies its original position, Weitzmann, "Eine Pariser-Psalter-Kopie des 13. Jahrhunderts auf dem Sinai," 125ff.; Buchthal, "The Exaltation of David," 333.

underlines the unique importance of David as "father of God." By the same token, it asserts the material reality of Christ's human historical ancestry and hence his human nature. Placed at the end of the traditional life cycle of the psalmist, the portrait of David with Ps. 71 in hand proposes the incarnation as the most important historical event in the "life" of David. Concurrently, the use of this portrait as a preface to the text of the Psalter equally proposes the incarnation as the key to the correct understanding of David's psalms.

Thus Ps. 71 is elevated to a confession of faith that addresses the reality of the incarnation of the Logos, on behalf of the author of the Psalter, and its user. As such, it adds a new dimension to the traditional pictorial identity of David. The emphasis goes beyond the usual characterization of David as the prophet, the psalmist, and the antetype of Christ. Above these, it stresses his historical identity as the royal ancestor of Christ. Given the significance, complexity, and density of this message in David's image, it deserves a special name. Following the inscription accompanying the figure of the psalmist in the illustration of Ps. 71 in the Bristol Psalter, I propose the term David-Theopator (fig. 76).

Visual references to David-Theopator did not reach the complexity of the miniature of the Paris Psalter overnight. They were preceded by earlier efforts to mold a frontispiece miniature for the Psalter that would pictorially embrace a reference to Christ's davidic ancestry, and hence to the historical reality of the incarnation. An earlier interest in establishing the psalmist as Theopator may be seen in the Leo Bible, dated about 940.[120]

The miniature that heads the Psalter in the Leo Bible (fig. 78) has the old King David standing in full ceremonial frontality holding an open Psalter. The portrait of David per se is an immediate antecedent of the portrait of the psalmist on fol. 7ᵛ of the Paris Psalter. However, the miniature of the Leo Bible does not attempt to transcribe in visual terms a reference to David-Theopator. The text of the open Psalter is illegible, the dove is omitted, as are the effete personifications of Sophia and Prophetia seen in the Paris Psalter and its relatives. Their place is taken by an elaborate architectural background irrelevant to our discussion. The figure of the old king thus stands devoid of any pictorial context that may help expand his identification as king and prophet to include his characterization as Theopator. Yet this is made clear by the inscription which runs around the frame of the miniature, indicating the interpretation that should be attached to this solemn portrait of the psalmist. As in the rest of the illustrations of the Leo Bible, the catena is the exegetical key to the miniature:[121] "Prophet David, who could express better than you the multitude of the dogmas and the marvellous gifts which the grace of the Holy Spirit supplied for the salvation of mortals. Here, however, we praise you ardently as the begetter of the Incarnation of God."[122]

[120] Vat. Reg. gr. 1, fol. 487ᵛ. *Miniature della Bibbia Cod. Vat. Reg. gr. 1, e del Salterio Cod. Vat. Palat. gr. 381, Collezione Paleografica Vaticana*, facs. 1 (Milan, 1905), 14, pl. 18. Th. Mathews, "The Epigrams of Leo Sacellarios and an Exegetical Approach to the Miniatures of Vat. Reg. Gr. 1," *OCP*, 43 (1977), 94–133. C. Mango, "The Date of Cod. Vat. Reg. gr. 1 and the Macedonian Renaissance," *ActaIRNorv*, 4 (1969), 121ff.

[121] Mathews, op. cit., 122f.

[122] *Miniature della Bibbia Cod. Vat. Reg. gr. 1, e del*

There is, therefore, little doubt that the title page of the Book of Psalms in the Leo Bible represented a portrait of David-Theopator in its purest form, even though it did not include explicit visual remarks to that effect, such as the inscription of Ps. 71:1.

In addition to the emblematic interpretations of the theme of David-Theopator in the Paris Psalter and the Leo Bible, the Vatican copy of Cosmas Indicopleustes formulates a more explicit variant of the same theme. As already noted, it includes a full-page miniature of David and the Choirs (fol. 63v) in which the young Solomon stands next to his enthroned father (fig. 79). The uncalled-for presence of Solomon seemed out of tune earlier in view of the function of this miniature as the illustration of a text used to preface the Psalter. However, after the discussion of Ps. 71 and its role in the shaping of the David-Theopator type, one may interpret the Cosmas miniature as another attempt to broaden the portrait of the psalmist to include a reference to the role of the house of David in the scheme of the incarnation. As was commonly acknowledged from the days of Pseudo-Athanasius to those of Psellus, Solomon means peaceful and Christ is the most peaceful. The joint royal portrait of David and Solomon as father and son also functioned as a reminder of the son born through their seed, Christ. The pictorial pairing of the two kings thus succeeded in connecting the royal house of David with Christ, asserting the davidic ancestry of Christ and, concurrently, his humanity.

Similarly, the joint appearance of the two kings in the Anastasis succeeds in drawing attention to Christ's davidic ancestry, asserting the humanity of the Logos Incarnate in an image that illustrates the effect of his powerful divinity. Actually, this image of redemption and re-creation successfully uses the motif as a reference to the incarnation of the Logos. This interpretation explains why David and Solomon are selected above all other Old Testament personalities present at the time of the Anastasis: David and Solomon are themselves the material proof of the humanity of Christ, and in this respect they are unique. Their pictorial presence consolidates the doctrinal balance of the image of the Anastasis, which now comes to include concrete proof of Christ's humanity while demonstrating the re-creative power of his divinity. It is therefore understandable that the motif of the two kings is canonized as part of the Anastasis and is included even in the most abbreviated versions of the mature Middle Byzantine image.

This interpretation of the motif of the two kings in the iconography of the Anastasis is verified in a poem written by John Mavropous, an influential eleventh-century bishop, about an image of the Anastasis, which must have resembled that of Hosios Lukas. Mavropous admonishes the beholder to

> Receive as the beginning of your own race
> Adam, David and the wise Solomon,

Salterio Cod. Vat. Palat. gr. 381, 14:

+ ΤΙC COY ΦΡΑCΑΙ ΠΡΟΦΗΤΑ ΔΑ(ΥΙ)Δ ΙCΧΥΕΝ:/
ΤΩΝ ΔΟΓΜΑΤΩΝ ΤΕ ΚΑΙ ΞΕΝΩΝ ΧΑΡΙCΜΑΤΩΝ:/
ΤΟΝ ΠΛΟΥΤΟΝ ΟΝΠΕΡ Η ΧΑΡΙC ΤΟΥ ΠΝΕΥΜΑΤΟC:/
ΠΑΡΕCΧΕΝ ΟΝΤΩΝ ΕΙC ΒΡΟΤΩΝ CΩΤΗΡΙΑΝ:/

ΑΛΛ᾽ ΟΥΝ ΝΥΝ ΗΜΕΙC ΩC ΘΕΟΥ CΑΡΚΩCΕΩC:/
ΓΕΝΝΗΤΟΡΑ* ΓΡΑΦΟΝΤΕC ΥΜΝΟΥΜΕΝ ΠΟΘΩ:

* Owing to a misunderstanding this part of the catena has been wrongly transcribed ΓΕΝΝΗΤΟΡ ΑΓΡΑΦΟΝΤΕC in the 1905 edition.

> Who are portrayed alive in this image,
> As the fathers of the one who gives resurrection.[123]

Similarly, the interpretation of the motif of David and Solomon as a short-hand reference to Christ's davidic ancestry and his incarnation explains the preferential treatment reserved for the two kings among the "prophets of the dome" in Middle Byzantine church programs. Moreover, it explains the basis for the inclusion of young King Solomon among these prophets, a practice that does not date back to the pre-Iconoclastic period, as witnessed by the Sinai apse mosaic.

In conclusion, the joint portrait of David and Solomon probably emerged in the eighth century. The representation of the Anastasis on the Fieschi Morgan reliquary and in the Chapel of S. Zeno offer its earliest surviving evidence. The Anastasis motif, however, is part of a broader iconographic trend aiming to formulate a pictorial idiom capable of attesting to Christ's davidic ancestry, and hence to the doctrine of the incarnation. The illustration of Ps. 71, the motif of David and Solomon, and the David-Theopator type are expressions of the same determination to show the historical reality of the incarnation of the Logos through Christ's family pedigree. These iconographic efforts, and their derivatives, are the preparatory steps to a self-sufficient image whose subject is the historical genealogy of the human nature of the Logos Incarnate. Such an image materializes at a later date and is known as The Tree of Jesse.[124] The material presented allows us to trace back to the turn of the eighth/beginning ninth century the emergence of the first inhibited attempts at grappling with the problems of pictorializing such a statement. In these early steps, the reference to Christ's davidic lineage plays only a subsidiary role, which, nevertheless, reinforces the message of the theme to which it is attached. This is the role of David and Solomon on the Fieschi Morgan Reliquary and the other representations of the Anastasis following the same iconographic recension. As we have seen, in this image of redemption the divine energy of the Logos Incarnate manifests itself in the ultimate miracle of the defeat of Death and resurrection of the protoplasts. The addition of David and Solomon here above and behind Christ is a reminder of the historical reality of the incarnation. Thus, even the ultimate miracle of Christ's divinity is coupled with visual proof of his humanity.

[123] Joannis Euchaita, *Versus Iambici* 8, PG, 120.1131f., lines 1240ff.:

Νῦν δ᾽ἐξαναστὰς τοὺς γενάρχας ἑλκύει
Χερσὶ κραταιαῖς ἐκ παλαιῶν μνημάτων.
Πρῶτον δ᾽ ἀνορθοῖ τὸ προπεπτωκὸς πάλαι
Ἔπειτα τὸν βρίθοντα τόνδε πρεσβύτην,
Μεθ᾽ ὧν ἅπασαν ἐξεγείρει τὴν φύσιν,
Δι᾽ ἥν κατελθὼν μέχρι σαρκὸς, καὶ τάφου
Ἅδην πατεῖ τύραννον ἀνθρωποφθόρον.
Πλὴν ὡς ἀπαρχὴν τοῦ γένους τοῦ σοῦ δέχου
Ἀδὰμ, Δαβίδ τε καὶ σοφὸν Σολομῶνα,

Οὕς ἡ γραφή σοι ζῶντας ὧδε δεικνύει,
Ὡς τοῦ διδόντος τὴν ἔγερσιν πατέρας.
Αὐτὸς μὲν οὖν τοὺς ἄνδρας ἐκ νεκρῶν ἔχεις,
Εὔαν γυναῖκες τὴν ἁπάντων μητέρα.

[124] A. Watson, *The Early Iconography of the Tree of Jesse* (Oxford, 1934). Idem, "The Image of the Tree of Jesse on the West Front of Orvietto Cathedral," *Fritz Saxl: A Volume of Memorial Essays from his Friends in England*, D. J. Gordon, ed. (London, 1957), 149ff.

The long tradition of church literature which asserted that Christ saved the Just along with the protoplasts from Hades precluded objections to the presence of David and Solomon in the Anastasis of Adam. John of Damascus had spelled out who could be counted among the Just: they were those who had believed in Christ before the incarnation, "the fathers and prophets, judges, kings and together with them the toparchs and some others from the race of the Jews, who are easy to count and apparent to everyone."[125] David and Solomon could be counted among the Just with no difficulty. The traditional association of David, and to a much lesser extent Solomon, with the chronicle of the siege of Hades also made them acceptable in the Anastasis. This was complemented by the great importance of the Psalter for the liturgy in general and for the celebration of Easter in particular. In none of these contexts, however, had David and Solomon been singled out together above all other patriarchs, prophets, kings, and judges explicitly or implicitly present at the siege of the underworld. So these aspects of the identities of David and Solomon cannot be considered as the motivating forces of their emphatic presence in the image of the Anastasis. More likely, they acted as the necessary background that helped legitimize the motif of the two kings as part of the Anastasis. On the contrary, the exclusive importance reserved for this joint portrait matches their exclusive role as Christ's ancestors. Moreover, the motif of David and Solomon is part of a broader and multifaceted interest in pictorially stressing the importance of the house of David and Solomon for the incarnation. This is the primary role of the two kings in the image of the Anastasis.

The pictorial solutions traced here vary from each other. But they are sufficiently interrelated to suggest that the ninth and tenth centuries had an interest in developing integrated references to Christ's davidic ancestry. There were good reasons why images made after 787 sought to incorporate such references to Christ's humanity. The Second Council of Nicaea established the justification of images as a corollary to the doctrine of the incarnation.[126] Accordingly, the assumption that Christ had a perfect human nature both allowed and necessitated the pictorial representation of "all that concerns his human *oikonomia*," as the council chose to phrase it, or "the events of the incarnation," as Leo VI described the christological cycle of images one hundred years later.[127]

The incarnation argument of the Iconophiles was largely founded on the historicity of Christ's life, for there could be nothing wrong with representing historical events.[128] Early

[125] John of Damascus, *De his qui in fide dormunt*, PG, 95.257ff.

[126] The most comprehensive refutation of Iconoclastic Christology may be found in the proceedings of the sixth session of the Council of 787, where the Iconoclastic position is refuted point by point. A summary is offered here of the Iconophile christological position in the refutation of a number of anathemas pronounced in 754 by the Iconoclasts during the Council of Hieria. A major iconophile point reiterates that God the Logos became a perfect man, therefore, "καϑό ὁ λόγος σάρξ ἐγένετο, καὶ ἐσκήνωσεν ἐν ἡμῖν, τὰ τῆς ἀνϑρωπίνης οἰκονομίας αὐτοῦ ἀναγράφουσι

καὶ εἰκονίζουσι." Mansi, 13.284. For the Iconoclastic position, see the translation of the Iconoclastic Horos by S. Gero, *Byzantine Iconoclasm during the Reign of Constantine V*. CSCO 384. Subsidia 52 (Louvain, 1977), 68–94. Also, E. J. Martin, *A History of the Iconoclastic Controversy* (London, n.d.), 101ff. See also 139f.

[127] Above, n. 6.87.

[128] The so-called letters of Pope Gregory II to Leo the Isaurian and Patriarch Germanus refute that image worship constituted idolatry, arguing that images are pictorial records of first-hand human experiences concerning Christ and his martyrs. As such, they have nothing in common with "Greek myth-mak-

in the controversy John of Damascus had established the representability of all that is visible.[129] Theodore Studios returned to this principle and broadened it to include everything perceptible by the senses.[130] Later Photius extolled "the power of sight" above other senses as a way of arriving at "the intelligible beauty of truth."[131]

The historicity of Christ's life on earth became a factor in the development of religious imagery as early as 692. The famous 82nd Canon of the Council in Trullo ordained the representation of Christ in his human form "to the recollection of His life in the flesh, His Passion and His salutary Death, and the redemption which has thence accrued to the world." Through such images the church gave "preference to the Grace and the Truth which we have received" so that the truth in its fullest manifestation "should be set down before everybody's eyes even in painting."[132]

After 787, Theodore Studios took this concept of the historical truth of the incarnation further. He argued that circumscription is characterized by "seizing, quantity, quality, position, place, time, shape, body."[133] While none of these agents of characterization apply to God, they all apply to Christ because of his incarnation. One more argument was thus formulated to justify the use of images based on the circumscribability of the visible and

ing." Mansi, 12.96off., esp. 963; also PG, 98.152C or Mansi, 13.96. This basis of distinction between idols and images had longstanding roots. It is used, for example, in a quote attributed to Basil of Seleucia at 815. Alexander, "The Iconoclastic Council of St. Sophia (815) and its Definition (Horos)," 61, fragm. 21. Understandably, this argument was widepread in the early Iconoclastic period, as evidenced among others by the writings of Pope Gregory II and Stephen of Bosra. Ladner, "The Concept of the Image in the Greek Fathers and the Byzantine Iconoclastic Controversy," 14f. This line of argument must have proved to be persuasive, for during the second Iconoclastic period, Iconoclasts ceased to characterize images as idols, and called them "spurious" instead. Alexander, op. cit., 41, 44.

[129] John of Damascus, *De imaginibus* III, PG, 94.1344C: "Δυνάμεθα ποιεῖν εἰκόνας πάντων τῶν σχημάτων, ὧν εἴδομεν."

[130] Theodorus Studita, *Refutatio poematum iconomachorum*, PG, 99.449D. "Πᾶν αἰσθητὸν γραπτόν."

[131] For, as Photius has already explained, the knowledge, learning, and comprehension acquired "through sight is shown . . . to be far superior to the learning that penetrates through the ears. . . .—indeed much greater—is the power of the sight." Photius, *Homily* XVII.5–6, in Mango, *The Homilies of Photius Patriarch of Constantinople*, 294f. It should be noted that, according to its title, this homily was "Delivered from the Ambo of the Great Church, on Holy Saturday (i.e., March 29, 867) in the Presence of the Christ-Loving Emperors (i.e., Michael III and Basil I), When the Form of the Theotokos Had Been Depicted and Uncovered." Mango, op. cit., 279ff. It is not accidental that the inauguration of the mosaic of the Virgin on Holy Saturday becomes an occasion for interlinking the doctrine of the incarnation with the defense of images, and their restoration with the Anastasis of the Saviour. Within this context the power of sight is extolled as the best means of arriving at the Truth. The relevant passage runs: "This (i.e., the image of the Virgin) is another shaft being driven today right through the heart of Death, not as the Saviour is engulfed by the tomb of mortality for the common resurrection of our kind, but as the image of the Mother rises up from the depths of oblivion, and raises along with herself the likenesses of the saints. Christ came to us in the flesh, and was borne in the arms of His Mother. This is seen and confirmed and proclaimed in pictures, the teaching made manifest by means of personal eyewitness, and impelling the spectators to unhesitating assent." Mango, op. cit., 293.

[132] Mansi, 11.980. Mango, Sources, 139f. and n. 85.

[133] Theodorus Studita, *Antirrheticus* III. PG, 99.396A: "Εἴδη περιγραφῆς πολλά· ἡ κατάληψις· ἡ ποσότης· ἡ ποιότης· ἡ θέσις· οἱ τόποι· οἱ χρόνοι· τὰ σχήματα· τὰ σώματα ἅτινα ἐπὶ Θεοῦ ἀποφάσκεται· ἐν οὐδενὶ γὰρ τούτων τὸ θεῖον. Χριστὸς δ' ἐνανθρωπήσας εἴσω τούτων δείκνυται."

created humanity of Christ—to paraphrase an argument of Sinaites regarding not only the reality but also the perfection of Christ's human nature.[134]

The historical reality of the incarnation became such a vital part of the defense of images that the depiction of its truth in images was equated with a valid confession of Orthodoxy. Though this attitude had its roots in pictorial arguments such as those used by Sinaites against his contemporary heretics, the post-Iconoclastic period enhanced its importance and canonized it. As Theodore Studios pointed out, rejection of images amounted to a rejection of Christ's Passion,[135] and hence, rejection of the redemption of mankind. So it became necessary to confess "the incarnate advent of the God–Logos through the reason through the mouth, in the heart and the mind, in writing and in images."[136] Those who admitted to the reality of the incarnation but could not tolerate its representation in images were anathematized as "conforming verbally, but materially denying our redemption[137] as well as Christ of the Second Coming."[138]

While post-Iconoclastic Christology recognized images as an applied confession of faith, it also recognized that the images of the visible and created humanity of Christ should be accurate and take into account the various elements that help describe a historical and material reality with precision. These were: quantity, quality, position, place, time, shape, etc. Accuracy had long been the basis of distinction between images and idols. Pictorial elements that could be misunderstood as fabrications of the artist's imagination, or as "greek myth-making" were rigorously prohibited. To ensure the accuracy and Orthodoxy of images, the Council of 787 made clear that the subject matter, disposition, and arrangement of images was the concern of the Church. The painters were to stick to the craft of image making,[139] though this craft was sufficiently sanctified to require of artists to be members of the Church in good standing.[140]

The measures taken to ensure the Orthodoxy of the christological cycle are not spelled out in the proceedings of the Council of 787. However, it is fair to assume that the church sought to buttress the historical accuracy of the images it promoted.[141] The pictorial evo-

[134] See n. 3.39.

[135] Theodorus Studita, *Antirrheticus* III, PG, 99.392D: "Εἰ οὐ περιγραπτὸς ὁ Χριστός, οὐδὲ παθητός. Ἐξ ἴσου γὰρ τῷ ἀπεριγράπτῳ τὸ ἀπαθές. Ἀλλὰ μὴν παθητός, καθά φησι τὰ λόγια· οὐκοῦν καὶ περιγραπτός."

[136] "Le Synodikon de l'Orthodoxie. Edition et commentaire," J. Gouillard, ed. and trans., *TM*, 2 (1967), lines 61f.: "Τῶν τὴν ἔνσαρκον τοῦ Θεοῦ Λόγου παρουσίαν λόγῳ, στόματι, καρδίᾳ καὶ νοΐ, γραφῇ τε καὶ εἰκόσιν ὁμολογούντων, αἰωνία ἡ μνήμη."

[137] Ibid., lines 138–140: "Τοῖς λόγῳ μὲν τὴν ἔνσαρκον οἰκονομίαν τοῦ Θεοῦ Λόγου δεχομένοις, ὁρᾶν δὲ ταύτην δι εἰκόνων οὐκ ἀνεχομένοις, καὶ διὰ τοῦτο ῥήματι μὲν κατασχηματιζομένοις, πράγματι δὲ τὴν σωτηρίαν ἡμῶν ἀρνουμένοις, ἀνάθεμα."

[138] Council of 869, Canon III. Mansi, 16.161.

[139] Mansi, 13.252B: "Οὐ ζωγράφων ἐφεύρεσις ἡ τῶν

εἰκόνων ποίησις, ἀλλὰ τῆς καθολικῆς ἐκκλησίας ἔγκριτος θεσμοθεσία καὶ παράδοσις . . . αὐτῶν (i.e., τῶν πατέρων) ἡ ἐπίνοια καὶ ἡ παράδοσις, καὶ οὐ τοῦ ζωγράφου· τοῦ γὰρ ζωγράφου ἡ τέχνη μόνον· ἡ δὲ διάταξις πρόδηλον τῶν δειμαμένων πατέρων."

[140] The seventh canon of the extremist Ignatian Council of 869 ordained that: "It is most useful to create holy and venerable images. . . . But this should not be done by unworthy men. Therefore, we decree that the men who are condemned and separated from the Church by an anathema should neither paint holy images in the churches nor should they teach in any place as long a they do not abandon their error." Mansi, 16.164, translated by F. Dvornik, "The Patriarch Photius and Iconoclasm," *DOP*, 7 (1953), 84ff.

[141] The importance of the fidelity of the image in relation to its original is discussed further by Ostro-

lution of the theme of Christ's historical ancestry in the ninth and tenth century works examined here was particularly valuable in many ways to the Iconophiles, since it proved the material reality of the incarnation. Moreover, the growing cult of the Virgin, whose genealogy was founded on the royal house of David, probably contributed to the acceptability of the two kings as a reference to the doctrine of the incarnation.[142] The incorporation of the joint portrait of the two kings in the image of the Anastasis offered to this iconography a balancing reference to the humanity of the redeeming Logos Incarnate, while lending a specific historical dimension to the image. Thus, religious art also mirrored the growing interest of the eighth and ninth centuries in the documentation of individual familial ancestry, which is reflected in the increasing employment of family names by the well-to-do in the Middle Byzantine period.[143]

Such were the reasons that induced the addition of the characteristic portrait of the two kings in the iconography of the Resurrection. As a self-contained allusion to the incarnation, which could be interwoven into the fabric of the siege of Hades, their presence gradually came to be recognized as an inalienable part which completed the theological message of the image, and added material proof of its accuracy.

gorsky, "Les décisions du 'Stoglav' concernant la peinture d'images et les principes de l'iconographie byzantine," I.2, 393–411.

[142] The stabilization of the feast of the Dormition of the Virgin no earlier than the ninth to tenth century may be cited as partial evidence of the growth of the cult of the Virgin during the period under consideration. M. Jugie, *La mort et l'assomption de la Sainte Vièrge.* ST 114, VIII (Vatican, 1944), 212, 315ff. Also, A. Wenger, *L'assomption de la T. S. Vierge dans la tradition byzantine du VIe au XIe siècle.* AOC 5 (Paris, 1955), 19ff., 202ff. The Middle Byzantine date of the popularization of the feast of the Koimesis helps date accordingly a representation of the Dormition of the Virgin carved on a rock crystal in the Virginia Museum of Fine Arts, Richmond, Virginia, no. 67–29. J. Beckwith, "Some Early Byzantine Rock Crystals," *Studies in Memory of David Talbot Rice*, G. Robertson and G. Henderson, eds. (Edinburgh, 1975), 3, fig. 2b. The carving technique of this intaglio, along with its gold mount and chain resemble closely another rock crystal carved with the Anastasis, property of Dr. Norman Zaworski on loan to the Cleveland

Museum of Art and the Victoria and Albert Museum. This example represents the cross-nimbed figure of Christ holding a long cross-staff, which is firmly planted on the figure of Hades, or the *tenebrae* (?), while Christ lifts the kneeling figure of Adam. Eve, King David, and (?) King Solomon follow behind Adam. Christ's cross-staff, the two kings, the *tenebrae* or the prostrate and defeated Hades reflect post-Iconoclastic examples of the Anastasis (above, chapter four). This iconographic evidence coupled with the similarity of the Zaworski rock crystal to the Richmond rock crystal regarding their carving and their gold mounts and chains suggest a date in the Middle Byzantine period for the Zaworski rock crystal as well. However, their authenticity remains problematic. J. Beckwith, "Another Late Sixth Century Byzantine Rock Crystal," *Zograf*, 10 (1979), 11f., figs. 1–3. Beckwith dates both of these works in the late sixth century.

[143] Ch. Du Cange, *Familiae Augustae Byzantinae* (Paris, 1680). H. Moritz, *Die Zunamen bei den byzantinischen Historikern und Chronisten* (Landschut, 1897–1898).

VIII

THE ELEVENTH CENTURY

The surviving evidence of the tenth century shows that the period had a strong preference for the first type of Anastasis, which included David and Solomon usually in bust. Though examples of the second and third type have not come down to us, these types very probably continued to evolve during the tenth century.[1] The emergence of a fully developed second type of Anastasis in the eleventh century in the Lectionary in the Lavra Skevophylakion, otherwise known as the Phocas Lectionary (fig. 80),[2] and the refined third type of Anastasis, which illustrated John 1:1 in Iviron 1 (fig. 50),[3] support this idea. The former is the first example of the second type we meet after the questionable miniature illustrating Ps. 67:2 on fol. 63ʳ of the Chloudof Psalter (fig. 44a). The latter is also the first example of the third type of Anastasis to appear after that on fol. 82ᵛ of the Chloudof Psalter illustrating Ps. 81:8 (fig. 44b). As we have already examined at some length the third type of Anastasis, we will concentrate for the moment on the second type, whose popularity in the eleventh century rivaled and at times surpassed that of the first type.

It has already been suggested that the second type of Anastasis was germinating as far back as the first quarter of the ninth century. The silver reliquary cross from the Sancta Sanctorum Treasure shows Christ dragging Adam behind him while holding a cross in his left hand.[4] In the West, this early image of the Anastasis seems to have produced a number of descendants, which we find among the Exultet Rolls, as for example, in Vat. lat. 9820 (fig. 20), which dates between 981 and 987. Here Christ is again dragging Adam behind him while holding a cross in his left hand. Though there are differences between the Anastasis on the silver cross and on the Exultet Rolls, the two follow the same basic line of thought: Christ does not pull Adam up, he drags him out of the underworld. It is not clear what circumstances inspired the fully developed version of the second type of Anastasis in which the dragging redeemer feels the need to turn his head and glance at the progress of the protoplast or, more often, at the beholder of the miracle of the Resurrection. Weitzmann suggested that this scheme followed late antique prototypes of Heracles dragging Cerberus out of Hades. Schwartz traced it instead to Early Christian iconographic prototypes depicting imperial victories.[5] It remains unclear, however, when and by what means these early imperial models were revived. The first eastern example of this type of Anastasis shows a congenital affinity with the tenth-century specimens of the first type, which could indicate the parallel development of these two types in the tenth century at least.

[1] For the different types of Anastasis, see 8f.

[2] Weitzmann, "Das Evangelion in Skevophylakion zu Lawra," 83ff., pl. 2.1. *The Treasures of Mount Athos*, III, fig. 6.

[3] See n. 6.94.

[4] See nn. 1.66, 4.17.

[5] See n. 1.25.

This, however, does not shed any further light on the specific circumstances that helped it materialize. The date of the second type's emergence remains open, since its relation to its first two antecedents, the silver reliquary cross and possibly the Chloudof Psalter, is far from clear.

At the same time, however, the earliest mature example of the second type appears to have developed and crystallized specific components of the iconography of the Anastasis, some of which can be traced as far back as the ninth and tenth centuries in the context of the first type.

THE CHANGING IMAGE

The Cross of Christ

The most prominent motif of the second Anastasis type is the cross held by Christ. In the miniature of the Lavra Skevophylakion Lectionary this is a patriarchal cross held out by Christ for the benefit of the beholder at whom Christ is looking. The cross serves a multiple role. It is the weapon with which Christ broke down the gates of Hades (as seen in the Stuttgart Psalter, fig. 19), and lanced down the forces of evil (as seen in the Exultet Rolls). At the same time it is "the trophy" of the victory of Christ, who

killed the enemy that resides in the flesh (i.e. corruption, death), killing along with it its parent (i.e. the devil and the original sin).[6]

It is, moreover,

the royal sceptre. . . . by means of which having killed you, devious snake, he offered life. . . . the redemption of men, the end of death, the return of men to their country of origin, the retirement of the flaming sword, the defeat and the terror of the devil.[7]

Consequently, the cross,

whose operation the rod (of Moses) presaged,[8]

worked for us

the exodus from harsh Egypt, in the course of which we were liberated from the painful slavery of the earth, we left behind the oppressive Pharaoh, and we were deemed worthy of being and bearing the name of the people of God.[9]

[6] Leo VI, imp. *Oratio* x. *In dominicam resurrectionem*, PG, 107.97A: "Χριστὸς ἐξ ᾅδου τροπαιοφόρος, τὶς οὐ προϋπαντᾶ τοῦ τοιούτου τροπαίου, ποσὶ καὶ φωναῖς ἀξίαις τῷ νικητῇ; Ἔκτεινε γὰρ τὴν ἔχθραν ἐν τῇ σαρκὶ συναποκτείνας αὐτῇ τὸν ταύτης πατέρα."

[7] Leo VI, imp., *Oratio* IX. *In exaltationem sanctae crucis*, PG, 107.93B–C: "Ἰδού μοι τὸ βασιλικὸν σκῆπτρον οἷα παιδὶ ἠγαπημένῳ δίδωσιν ὁ Δεσπότης. Δι' οὗ σὲ τὸν σκόλιον θανατώσας ὄφιν τὴν ζωὴν ἐχαρίσατο. . . . Ὢ φυτὸν ἐν γῇ μὲν βλαστῆσαν . . . καρπὸν τῶν ἀνθρώπων

τὴν σωτηρίαν, τοῦ θανάτου κατάλυσιν, τὴν εἰς τὴν πατρίδα τῶν ἀνθρώπων ἐπάνοδον, τῆς φλογίνης ῥομφαίας τὴν ὑποχώρησιν, τοῦ διαβόλου τὴν ἧτταν καὶ τρόμον, καὶ τὴν ἐπὶ μόνῳ τύπῳ τῆξιν αὐτοῦ καὶ ἀφανισμόν."

[8] Ibid., PG, 107.92B: "οὗ (ξύλου, σταυροῦ) ῥάβδος προμηνύουσα τὴν ἐνέργειαν, τὸν ἀλιτήριον Φαραὼ αὐτοῖς ἄρμασι καὶ ἀναβάταις ἐβύθιζεν."

[9] Idem, *Oratio* X, PG, 107.97B: "Σήμερον ἡμῖν ἡ τῆς χαλεπῆς Αἰγύπτου ἔξοδος ἑορτάζεται, καθ' ἣν τῆς

With such words Leo VI extolls the role of the cross. Characteristically, his Easter Day homily is not entitled "to Easter," but "To the Great Trophy Which Delivers from Death."[10] The cross, thus, occupies a position of honor in the celebration of Easter that corresponds to the position of honor reserved for the Resurrection theme in the celebration of the Feast of the Stavroproskynesis. As a result of the formal interweaving of the themes of the cross and the Anastasis, the patriarchal cross displayed by Christ in the Lavra miniature far transcends its role as the material weapon through which the victory was won, as well as its role as a material reminder of the Passion of Christ. It functions beyond these roles as "the royal sceptre" of Christ, whose authority, like that of the rod of Moses, made possible the passage of mankind into a state of grace once more. The material weapon and instrument of Passion is sanctified as the trophy which functions as the emblem of Christ's sovereignty in his own hands.

The pictorial motif of the cross develops similarly in the context of the iconography of the Resurrection. The Stuttgart Psalter and the Exultet Rolls demonstrate literally the material strength of the cross as a weapon against the sources of evil.[11] Christ, therefore, carries the cross over his shoulder like a soldier carrying his lance home after a battle at the end of the siege of Hades. This is again seen in the Exultet Rolls, as well as on the silver reliquary cross at the Vatican. In the last quarter of the ninth century the cross appears in the hands of Christ not as a weapon, but as a material, though discreet, reminder of the Passion. Evidence of the transformation process is in the second Anastasis in the Lower Church of S. Clemente (fig. 17b). Here the cross takes the place of the traditional scroll. However, the position of the hand that held the scroll remains the same. Consequently the cross is held very awkwardly, encumbering Christ's hand, which is pulling Adam by the wrist out of Hades. This development in the use of the motif of the cross (also witnessed by the Anastasis in St. Peter's, reputedly made at the time of Pope Formosus, fig. 17), coincides with a broader iconographic effort to incorporate in the image of the Anastasis specific allusion to Christ's Passion. Thus, at Cimitile the nail mark on Christ's hand becomes the focus of the composition.

By the early eleventh century, the evidence of Christ's Passion afforded by the stigmata seems to be taken for granted, but its visual importance decreases. The place of honor is now reserved for the cross, which is no longer the elegant symbol of the Passion encountered in S. Clemente II, or in St. Barbe at Soganli (fig. 67). Instead, it is the powerful patriarchal cross held out by Christ for everyone to see and recognize as the "royal sceptre." The choice of the patriarchal cross, rather than the cross with a single cross-bar, seems to have been dictated by the interpretation of the patriarchal cross as a reference to the actual True Cross. As such, the shape chosen for the cross in the second type of Anastasis adds to this symbol of sovereignty a historical as well as a liturgical dimension. Historical, because the patriarchal cross seems to have emulated the True Cross, and liturgical, because this

ἐπωδύνου τοῦ πηλοῦ δουλείας ἠλευθερώθημεν, καὶ τὸν βαρὺν ἐλίπομεν Φαραώ, καὶ Θεοῦ λαὸς εἶναί τε καὶ καλεῖσθαι ἠξιώθημεν."

[10] Ibid., PG, 107.96C: "Εἰς τὸ μέγα καὶ σωτήριον κατὰ τοῦ θανάτου τρόπαιον."
[11] For the following references, see chapter four.

type of cross was firmly established by the tenth century as part of the pictorial vocabulary acceptable for devotional purposes.[12] Consequently, Christ holds the cross in the Lavra Anastasis as his royal sceptre through whose combined historical, theological, and liturgical reality he effects the salvation of mankind. Thus, the symbol of the Passion (which also complements the pictorial motifs of David and Solomon, and the Baptist, which also function as reminders of the doctrine of the incarnation in the image of the Anastasis) is transformed from a weapon and a trophy into a symbol of authority and of sovereignty over all past and present creation.

The Topography of the Anastasis

Christ's sceptre cross, whose use unleashed the divine energy of the Logos at the time of the Resurrection ties in with another motif of the Anastasis, which is fully developed by the eleventh century. This is the motif of the two hills flanking Christ in the Lavra Skevophylakion Anastasis (fig. 80) and other examples from the eleventh century on.

Evidence of interest in aspects of the topography of the region where the Anastasis took place was first noted in the early ninth century. During most of the ninth century this interest focuses mainly on the darkness of the underworld, which is generally placed in the interior of the earth. By the early tenth century, there is a tendency to add to this primary topographical reference some description of the region of earth immediately above Hades. Thus, both the Baptism-Anastasis icon at Mt. Sinai and the Anastasis miniature in the Amberg-Herzog Collection add a prominent mountain behind Christ and place the opening of Hades at its root (figs. 63–64).[13] A comparable though confused interpretation seems to be intended for the rocky formation which borders the right side of the *tenebrae* in the Anastasis miniature of the tenth-century Leningrad Lectionary (fig. 62).[14] This topographical allusion to the regions immediately above the smashed gates of Hades is conventionalized in the Lavra Skevophylakion. The sarcophagi border both the *tenebrae*, as well as each of the two hills flanking the figure of the rising Christ, and the narrow passage out of the dark underworld.

To comprehend the meaning of the motif of the two hills, common in the Anastasis from the eleventh century on, we must go back to the sceptre cross of Christ. From a very early date onward, the power and operation of the cross had been compared to the power and operation of the rod of Moses, which paved the way out of Egypt and drowned the host of the tyrannical Pharaoh.[15] Similarly, the cross brought turmoil to everything, shook the earth . . . tore the stones apart and brought about the readmission of Adam into Paradise[16] after raising him from the lowest depths. The sceptre rod of Moses divided the

[12] For the widespread use of the patriarchal cross for portable reliquaires, see Frolow, *Les reliquaires de la Vraie Croix*, 124ff.

[13] See nn. 7.30, 7.51.

[14] See n. 6.13.

[15] Romanos Melodos, *Canticum* VIII.8, in *Analecta*

Sacra. Spicilegio Solesmensi. J. Pitra, ed., I, 55. Andrew of Crete, *In exaltationem S. Crucis* I. PG, 97.1023A–B.

[16] Romanos Melodos, op. cit., 56: "Αὐτὸ γὰρ τὸ ξύλον, εἰς ὃ ἐγκαυχᾶσαι, τὸ πᾶν ἐκλόνησεν, ἐδόνησε τὴν γῆν, ἐσκότισεν οὐρανόν, ἔρρηξε πέτρας ὁμοῦ καὶ τὸ καταπέτασμα, καὶ τοὺς ἐν μνήμασιν ἐξανέστησε

waters and glorified the name of Moses, just as the sceptre cross of Christ shook the earth, tore apart the stones, "frightened the gate-keeper of Hades, and uncovered the foundation of the world."[17] Then Hades became like the Heavens, and the subterranean regions were filled with light;[18] for after the death and burial of Christ, which made the earth quake in fear,[19] the palaces of Hell were emptied and destroyed, ruined by the sufferer's victory, while the tombs surrendered their dead.[20] The earth was purified,[21] the dust on the ground became betrothed to the Heavens,[22] while Christ, the wisdom and Word and power of God, arose three days later as the sun of righteousness.[23]

These two hills, which are divided by the darkness of Hades in the illustration of the Anastasis in the Lavra Skevophylakion Lectionary, stand, therefore, as evidence of the rending of the earth, and the uncovering of the foundation of the world which took place while Christ lay buried.[24] They also offer evidence of the path followed by the Logos when he rose as the sun of righteousness after despoiling Hades and freeing its prisoners by means of the cross, which had paved the way as had the rod of Moses at the time of the exodus.[25]

By incorporating in the image of the Anastasis reference to the topographical changes effected by the shaking of the earth, the shrinking of the deep, and the rending of mountains in twain,[26] the iconography stresses that "creation did not ignore its Lord and

τοὺς νεκροὺς οἵ βοῶσί μοι· Ἅδη, κατάλαβε: Ὁ Ἀδὰμ γὰρ ἐκτρέχει πάλιν εἰς τὸν παράδεισον." And Andrew of Crete, op. cit., 1016C: "Τὰ δὲ μετὰ τὸν σταυρόν, ὡς φοβερὰ καὶ παράδοξα; Οἷον, . . . γῆ σειομένη, βυθὸς συστελλόμενος, ὄρη σχιζόμενα."

[17] John of Damascus, *In Sabbatum Sanctum*, PG, 96.620C: "καὶ ἔφριξεν ᾅδου πυλωρός, καὶ ἀνεκαλύφθη τὰ τῆς οἰκουμένης θεμέλια."

[18] Ibid., PG, 96.621A: "Νῦν οὐρανὸς ὁ ᾅδης γεγένηται, καὶ φωτὸς πληροῦται τὰ καταχθόνια, καὶ τὸ σκότος τὸ πρὶν διῶκον ἐλαύνεται, καὶ τοῖς τυφλοῖς ἀνάβλεψις δίδοται. Τοῖς γὰρ ἐν σκότει καὶ σκιᾷ θανάτου καθημένοις, ἀνατολὴ ἐξ ὕψους ἐπέφανε." (Luke 1.78f.) Also, John of Damascus, *Easter Canon*, PG, 96.840C–D: "Νῦν πάντα πεπλήρωται φωτός, οὐρανός τε, καὶ γῆ, καὶ τὰ καταχθόνια."

[19] Photius, *Homily* XII. Mango, *The Homilies of Photius Patriarch of Constantinople*, 215f.: "He is crucified and dies and is buried, and the earth quakes in fear, and the curtain of the temple is rent, and stones are torn apart, and the sun is covered with much darkness, . . . grieved and darkened and sorrowful at the Creator's passion, these works of creation all but emitting a cry and bewailing the affront to the common Lord, and vividly expressing by their condition the enormity of the crime."

[20] Photius, *Homily* XI. Ibid., 194: "The earth takes fright and quakes, affected by the sadness of the passion. But also tombs become pregnant and bring

forth the dead and the palaces of Hell are emptied and abolished, despoiled by the Sufferer's victory, while the human race—this was the Lord's goal, for which He endured sufferings and death—is delivered from that bitter and ancient domination."

[21] John of Damascus, *In Sabbatum Sanctum*, PG, 96.620A: "Γῆ ἐσείετο, δεσποτικῷ περιρραινομένη αἵματι, τῶν εἰδωλικῶν λύθρων ἐκτινασσομένη τὸν σπῖλον, καὶ περιχαρῶς σκιρτῶσα τὴν κάθαρσιν."

[22] Georgius Pisida. *In Christi resurrectionem*, PG, 92.1375:

Ὁ φραγμὸς ἤρθη· καὶ τὸ κέντρον ἐφθάρη.
Καὶ πάντα κοινά· καὶ συνῆλθον αἱ φύσεις.
Καὶ χοῦς χαμερπῆς οὐρανοὺς μνηστεύεται,
Καὶ Πνεῦμα πηλὸς ἀρραβῶνα λαμβάνει.

. . . .

Καὶ γίνεται φῶς ἡ γεώδης οὐσία,
Καὶ ζωτικὴ φλὸξ ἡ τεφρώδης αἰθάλη.

[23] See nn. 2.16 and 3.98.

[24] See n. 8.19.

[25] The parallelism drawn between the Exodus from Egypt and the exodus from Hades is also reflected in the inclusion of Exodus 13–15 among the Old Testament readings of the Easter Vigil. Bertonière, Charts A.2, C.2.

[26] Andrew of Crete, *In ramos palmarum*, PG, 97.1016C: "γῆ σειομένη, βυθὸς συστελλόμενος, ὄρη σχιζόμενα."

Maker."[27] The implication is, of course, that the two hills which flank Christ formed only one single mountain previous to this earth-shaking experience. The perception of the earth as a mountain split into two at the time of the Anastasis had its roots in cosmographical cartography. Accordingly, all cross-sections of the earth in the ninth-century illuminated manuscript of Cosmas Indicopleustes show the earth as a single mountain rounded at the top.[28] When rent in two the torn areas would naturally be rough. This is probably why most examples attempt to give a rugged and rocky appearance to the opening of Hades (as in the Leningrad Lectionary) and to the two hills flanking Christ (as in the Homilies of Gregory, Dionysiou, cod. 61).[29] In the case of the Lavra Skevophylakion Anastasis, the two hills are unrealistically shown as smooth. The emphasis is reserved for the sun of righteousness rising between the two hills against a dazzling gold background. It seems, therefore, that the rending of the mountain of earth is a familiar motif of the Anastasis already schematized by the early eleventh century, a suggestion further supported by the preliminary efforts of the first half of the tenth century to include a reference to the mountain of earth behind the figure of the rising Christ.

The understanding of the two hills flanking Christ which is offered here is confirmed by later examples. The Palaeologan interest in the subtleties of naturalistic perspective and coloring often translates the Anastasis in more explicit pictorial terms as the rising of the sun of righteousness out of the dark chasm of Hades which is gaping at the root of the riven mountain. One such example is the representation of the Anastasis of the Church of Christos in Veroia, the work of the painter Kalliergis dated at 1315 (fig. 87).[30] Though such an expansive use of realistic perspective is out of the scope of the eleventh-century Lavra Lectionary, it nevertheless confirms the interpretation of the two hills that flank the figure of the rising Christ and frame the equally symmetrical groups of the immediate beneficiaries of the Resurrection.

Abel

In the case of the Lavra Skevophylakion miniature the beneficiaries of the Anastasis are divided into two groups of three. Adam, Eve, and Abel the Shepherd to the right of the rising Christ are balanced on the other side by David, Solomon, and the Baptist. Of these, only Abel has not been encountered in the Anastasis up till now. His shepherd's dress and staff make his identity clear. Though his inclusion never becomes as vital to the iconography as that of David and Solomon or John the Baptist, Abel's appearance behind the figure of his mother is not infrequent during the eleventh century. Another example is offered by Paris gr. 74, fol. 60[r]. Homiletical literature explains once more the role of this son

[27] Above, n. 8.20, and Theodorus Studita, *In Sanctum Pascha*, PG, 99.717 B–C: "ἡ δὲ κτίσις οὐκ ἠγνόησε τὸν ἑαυτῆς Δεσπότην καὶ Δημιουργόν."

[28] Vat. gr. 699, fols. 41ᵛ, 42ᵛ, et al. See n. 7.102. Also, W. Wolska, *La topographie chrétienne de Cosmas*

Indicopleustès. Théologie et science au VIe siècle (Paris, 1962).

[29] *The Treasures of Mount Athos*, I, fig. 105.

[30] St. Pelekanides, Καλλιέργης. Ὅλης Θετταλίας ἄριστος ζωγράφος (Athens, 1973), 318ff., pl. 35, title-page colorplate.

of Eve in the story of the siege of Hades. The homily of Pseudo-Epiphanius presents Abel early on in the list of those held prisoner by Hades and describes him as "the first dead and first righteous shepherd who typified the unrighteous slaughter of Christ the shepherd."[31]

The martyrdom of Abel is compared to that of Christ, but it is stressed that whereas righteous Abel was only a man, Christ was a man as well as a God at the time of his sacrifice.[32] Although the earth resented being watered with the blood of Abel, it was so weighted down by the blood of Christ it ripped apart.[33] While the blood of Abel, the most righteous of all who lived in the era of the old dispensation, intercedes, the blood of Christ, the most righteous of those of the new dispensation, ransoms mankind and pleads its cause. Abel is, therefore, more than a type of Christ, he is a Christomimetes.[34]

The inclusion of Abel confirms a number of points already asserted by the core of the image. It complements the liturgical idea of Christ-Amnos, which is stressed by the characteristic gesture of the Baptist and the multiple pictorial references to Christ's Passion. It also complements the idea of the Anastasis as the rising of the sun of righteousness from the foundation of the world. His presence underlines the difference between the consequences of his unjust death, as opposed to the unjust slaughter of Christ, the man-God of the new dispensation, whose death ransomed mankind.

Eve

Throughout the period we have considered Eve has assumed a secondary role in the image of the Anastasis. To start with, the Anastasis can take place without her. This is the case with the early eighth-century Anastasis of the Chapel of the Forty Martyrs at S. Maria Antiqua. This attitude apparently continued until a much later date as witnessed by the Stuttgart ivory casket (fig. 57), and the Patmos, cod. 45, an illuminated manuscript of Gregory dated in the eleventh or twelfth century illustrating p. 34 with the second type of Anastasis.[35] Though the omission of Eve is not a common occurrence, her pleading attitude is a must. Equally uncompromising is Christ's studied attitude toward Eve: he never comes in contact with her before the emergence of the fourth type of Anastasis, which flourished during the Palaeologan period. What is more, he does not seem to be aware of her existence. At best, he keeps his distance from her during the time period considered here.

[31] PG, 43.452D: "Ἐκεῖ Ἄβελ ὁ πρωτόθνητος, καὶ πρωτοδίκαιος ποιμὴν Χριστοῦ ποιμένος τύπος τῆς ἀδίκου σφαγῆς." See also, Proclus, In Paraskeven, PG, 65.784.

[32] Romanos Melodos, Canticum XVI.6, op. cit., 118. Also, Proclus, In S. Pascha, PG, 65.793.

[33] Eusebius of Alexandria, In triduanum resurrectionem Domini PG, 50.824: "Οὐ τὸ αἷμα . . . Ἄβελ ἐκχυθὲν ἐβάρησεν αὐτὴν οὕτως ὅσον Ἰουδαῖοι, τὸ μέγα τοῦτο τολμήσαντες ἀσέβημα. Διὰ γὰρ τοῦτο καὶ αἱ σκληραὶ πέτραι ἐσχίζοντο, ἵνα μάθωσιν ὅτι οὗτός ἐστιν ἡ πνευματικὴ καὶ ζῶσα πέτρα."

[34] Pseudo-Chrysostom, De sacrificiis Caini, PG, 62.719–722: "Ἀνῃρέθη ὁ Ἄβελ ὁ πρῶτος τῆς δικαιοσύνης κήρυξ . . . ἐν πολλοῖς μιμητὴς τοῦ Χριστοῦ γενόμενος. Εὑρίσκω γὰρ τὸν ἅγιον Ἄβελ πολλὰς τοῦ Χριστοῦ εἰκόνας δεξάμενον. . . . Ἐβόησε καὶ τὸ αἷμα τοῦ Ἄβελ, βοᾷ καὶ τὸ αἷμα τοῦ Χριστοῦ. Ἀλλ' ἐκεῖνο βοᾷ ἐντυγχάνον, τοῦτο δε βοᾷ ἱλασμὸν φέρον τῷ κόσμῳ. . . . Τὸ γὰρ αἷμα Χριστοῦ ῥαντισμὸς τῆς οἰκουμένης, τὸ αἷμα Χριστοῦ λύτρον τῶν ἀνθρώπων."

[35] G. Jacopi, "Le miniature dei codici di Patmo," 580, pl. 5. For the Stuttgart ivory casket, n. 7.91.

The key to the condescension shown toward Eve in the image of the Anastasis is her role in the original sin, which determines her status at the time of the Anastasis. As Theodore Studites says in his Easter Homily, Eve was taken from Adam's side (rib).[36] Later she was deceived by the snake. Though she did not deceive Adam, she gave him the means to transgress, which he did. So both of them were condemned, "and death reigned from the time of Adam to that of Moses even over those who had not sinned." To correct this state of affairs, Christ willingly submitted to crucifixion. Thus, by means of the wood (of the cross) he cured the original sin, which had been committed through the wood (of the Tree of Paradise). Christ was also pierced on the side (whence flowed the divine blood and water which signify the drink of immortality and the re-creating baptism[37]) so that the side of Christ may cure the pain of Adam's side, i.e., Eve.[38] Through this Christ demonstrated that his Passion achieved salvation not only for men, but for women as well.[39] So, Eve's sorrow came to an end[40] when "life gushed forth from (Christ's) side; for it was not the

[36] Theodorus Studita, *In Sanctum Pascha*, PG, 99.716B–C:

Ἐνύγη καὶ λόγχῃ τὴν πλευρὰν, διὰ τὴν ἐκ τῆς πλευρᾶς τοῦ Ἀδὰμ ληφθεῖσαν γυναῖκα· ἐπειδὴ γὰρ ὁ ὄφις τὴν Εὔαν ἠπάτησεν, ἡ δὲ Εὔα τὸν Ἀδὰμ παραβῆναι παρεσκεύασεν, ἐξῆλθεν δὴ ἀπόφασις κατὰ τῶν ἀμφοτέρων. Καὶ ἐβασίλευσεν ὁ θάνατος ἀπὸ Ἀδὰμ μέχρι Μωϋσέως καὶ ἐπὶ τοὺς μὴ ἁμαρτήσαντας. Διὰ τοῦτο τιτρώσκεται ἡ πλευρὰ, ἵνα μάθωμεν ὅτι οὐ μόνον ἀνδράσιν ἤνεγκεν σωτηρίαν τὸ πάθος τοῦ Χριστοῦ, ἀλλὰ καὶ γυναιξί· Ἀδὰμ γὰρ πρῶτος ἐπλάσθη, εἶτα Εὔα· καὶ Ἀδὰμ οὐκ ἠπατήθη, ἡ δὲ γυνὴ ἀπατηθεῖσα ἐν παραβάσει γέγονε· Σωθήσεται δὲ διὰ τεκνογονίας τῆς ἁγίας Μαρίας· αὕτη γὰρ τὸν Σωτῆρα Χριστὸν ἐτεκνώσατο . . . διὰ ταύτην οὖν τὴν πρόφασιν καὶ ἡ πλευρὰ πλήσσεται τοῦ Χριστοῦ, ἵνα καὶ τὰ προειρημένα οἰκονομηθῇ, καὶ τὸ μυστήριον τοῦ βαπτίσματος κηρυχθῇ, καὶ ἡ χάρις ἡ μέλλουσα λάμψῃ.

This text appears verbatim among the *spuria* of Eusebius of Alexandria, *In triduanam resurrectionem Domini*, PG, 50.822. For the homily of Pseudo-Chrysostom quoted by Theodore Studites (PG, 99.709D–712C), see Pseudo-Chrysostom, *In S. Pascha*, PG, 59.721–724. For the use of this homily in the monastic tradition as part of the Easter Sunday orthros, following the kiss of peace, and often after the First Easter homily of Gregory Nazianzenus, see Bertonière, 278, 227, 243, 273, 160 n. 4. Theodore's homily *In Sanctum Pascha* is also published by A. Mai in *Nova Patrum Bibliotheca*, v.3, 24–33.

[37] John of Damascus, *In Sabbatum Sanctum*, PG, 96.620A: "Καὶ λόγχῃ πλευρὰ νύττεται τοῦ ἐκ πλευρᾶς τοῦ Ἀδὰμ τὴν Εὔαν δημιουργήσαντος, καὶ πηγάζει θεῖον αἷμα καὶ ὕδωρ, πόμα ἀθανασίας, καὶ ἀναπλάσεως βάπτισμα."

[38] Pseudo-Epiphanius, *In Sancto et Magno Sabbato*, PG, 43.464A: "Ὕπνωσα ἐν τῷ σταυρῷ, καὶ ῥομφαίᾳ ἐνύχθην τὴν πλευρὰν, διὰ σὲ τὸν ἐν παραδείσῳ ὑπνώσαντα, καὶ τὴν Εὔαν ἐκ πλευρᾶς ἐξενέγκαντα. Ἡ ἐμὴ πλευρὰ ἰάσατο τὸ ἄλγος τῆς πλευρᾶς."

[39] Above, n. 8.36, and PG, 99.721C. See also, Eusebius of Alexandria, *De baptismo. De Mt. 11.3*, PG, 86/1.373D; Cosmas of Maiouma, *Canon in S. Sabbato*, in *Anthologia graeca carminum christianorum*, W. Christ and M. Paranikas, eds. (Leipzig, 1871), 201, lines 184f. and in *Triodion Katanyktikon*, 733: "τὸν Ἀδὰμ σὺν τῇ Εὔα λυτροῦμαι παγγενῆ."

[40] Romanos Melodos, *Canticum* XVI.1, *De Passione*, in *Analecta Sacra, Spicilegio Solesmensi*, 116:

Τῆς ἔχθρας ἐλύθη τὸν τύραννον,
τῆς Εὔας ἐπαύθη τὸ δάκρυον.

Also, Pseudo-Epiphanius, op. cit., PG, 43.449B, and Leo VI, imp., *Oratio* X. *In dominicam resurrectionem*, PG, 107.113A: "Τὸν Ἀδὰμ ἀνεσώσατο· τῇ Εὔᾳ τὴν λύπην ἤμειψεν εἰς χαράν."

[41] Romanos Melodos, *Canticum* VIII.14. *De Crucis Triumpho. In Analecta Sacra. Spicilegio Solesmensi*, 57f.: "Εἶδον τὸ ξύλον . . . πεφοινιγμένον αἵματι καὶ ὕδατι· καὶ ἔφριξα, οὐκ ἐκ τοῦ αἵματος λέγω, ἀλλ' ἐκ τοῦ ὕδατος. Τὸ μὲν γὰρ προδηλοῖ τὴν σφαγὴν τοῦ Ἰησοῦ, τὸ δὲ τὴν αὐτοῦ ζωήν· ἡ ζωὴ γὰρ ἔβλυσεν ἐκ τῆς πλευρᾶς αὐτοῦ· οὐχὶ γὰρ ὁ πρῶτος, ἀλλ' ὁ δεύτερος Ἀδὰμ Εὔαν ἐβλάστησε τὴν μητέρα τῶν ζώντων πάλιν εἰς τὸν παράδεισον." Also, Cosmas of Maiouma, op. cit., 118, lines 79–81, and *Triodion Katanyktikon*, 730: "λογχευθεὶς τὴν πλευρὰν . . . ἐξ αὐτῆς εἰργάσω τὴν ἀνάπλασιν τῆς Εὔας." The same idea continues in John Geometres, *Carmina*, 82, PG, 106.939:

first but the second Adam who sprouted Eve, the mother of those born again to Paradise.[41]

Death who had entered the world and ruled it through Eve, the first mother, was now defeated by Christ, her son[42] by Mary, the blessed daughter of Eve.[43] So, Eve, the mother of all women,[44] was saved through her child-bearing ability. More specifically, she was saved through her daughter, the Virgin Mary, and her son, Christ, whose sacrifice had been prefigured by her other son, Abel.[45]

Eve came second in the story of the Creation, as well as in the story of the Fall. She triggered Adam's gluttony[46] and this led them both to the insatiable Hades. But, as Theodore stresses, Eve was deceived, while Adam was not. Eve's responsibility for the Fall was therefore secondary to Adam's. It is natural that she should take second place in the Resurrection as well. Many texts gloss over Eve's participation in it, and some examples do not even mention her name. Her position in the iconography of the Anastasis reflects the same attitude during our period: Eve may be omitted, but more often than not, her supplicating figure stands immediately behind the kneeling Adam. So, as Christ is raising the prostrate protoplast by the hand, his mate, the second protoplast, appears to be rising out of the side of the first. As a result, the hierarcy of re-creation retraces the process of Creation, while the mercy of the Logos appropriately concentrates on the most culpable of the two parties, Adam, who sinned consciously, as opposed to Eve, whose deception made her an unwitting accessory to the Fall.

The image of the Anastasis focuses Christ's attention on Adam, the first created and first dead, giving Eve second place in the scheme of redemption throughout our period because of her role in the story of the Creation, the Fall, and the re-creation of man. The addition of Abel behind Eve by the early eleventh century contributes to the consolidation of Eve's role in the image of the Anastasis. As we have seen, the blood of the righteous shepherd

Πλευρᾶς ἔπλασα πλάσμα σῆς Εὔαν πάλαι,
Πλευρὰν δὲ ῥήσσεις τὴν ἐμὴν λόγχῃ σὺ μοι·
Ὅμως τὸ τραῦμα φάρμακον κεραννύει
Τῶν τραυμάτων σου καὶ τὰ ῥεῖθρα βλυστάνει.

[42] Pseudo-Epiphanius, op. cit., PG, 43.452B–C: "τὴν συναιχμάλωτον Εὔαν τῶν ὀδυνῶν λῦσαι πορεύεται ὁ Θεός, καὶ υἱὸς αὐτῆς."

[43] Theodorus Studita, In dormitionem Deiparae, PG, 99.721C: "Πάλαι μὲν διὰ τῆς προμήτορος Εὔας ὁ θάνατος εἰσελθὼν ἐκοσμοκράτησε, νῦν δὲ τῇ μακαρίᾳ θυγατρὶ αὐτῆς ὁμιλήσας ἀποκέκρουσται, ἐκεῖθεν ἐκνικώμενος ὅθεν τὸ κράτος εἰσεδέξατο· ἀγαλλιάσθω τοίνυν τὸ γυναικεῖον γένος ἀντ' ὀνείδους δόξαν κατακληρούμενον· εὐφραινέσθω ἡ Εὔα· οὐκέτι γὰρ ἐπάρατος εὐλογίας γόνον τὴν Μαρίαν περιφέρουσα."

[44] Joannis Euchaita, Versus Iambici 8. In sacram vivificamque Christi Resurrectionem, PG, 120.1132A: "Εὔαν γυναῖκες τὴν ἁπάντων μητέρα."

[45] Theodorus Studita, In Sanctum Pascha, PG, 99.716B. At times Eve's contribution to the Fall is not

looked upon half as charitably. See, for example, Anastasius Sinaites, Quaestiones, PG, 89.625–637, where her mistakes are enumerated. The same mentality governs Canon 70 of the Council in Trullo (Mansi, 11.973), as well as the words of Emperor Theophilus to Kassiani during his bridal contest: "Through a woman evils came to man." Her proverbial answer: "But through a woman better things happened" was considered sufficiently impertinent to disqualify her. The translation is by W. Treadgold, "The Bride-Shows of the Byzantine Emperors," Byzantion, 49 (1979), 403.

[46] Romanos Melodos, Canticum XIV.11. De Virgine juxta crucem. Analecta Sacra. Spicilegio Solesmensi, 104: "Ὑπὸ ἀκρασίας καὶ ἀδηφαγίας ἀρρωστήσας ὁ Ἀδάμ, κατηνέχθη εἰς ᾅδου κατωτάτου, καὶ ἐκεῖ τὸν τῆς ψυχῆς πόνον δακρύει. Ἡ τάλαινα Εὔα, τοῦτον ἐκδιδάξασα τὴν ἀταξίαν, σὺν τούτῳ στενάζει σὺν αὐτῷ ἀρρωστεῖ, ἵνα καὶ συμμάθῃ τοῦ φυλάττειν ἰατροῦ παραγγελίαν."

Abel, the son of Eve, intercedes for Mankind, while the blood of Christ, the son of Mary, the blessed daughter of Eve, ransoms Mankind. So Eve, the mother of Abel, is an antetype as well as an ancestor of the Virgin Mary. Through the inclusion of Abel, the child-bearing ability of Eve is offered indirectly as guarantee of her salvation.

The second type of Anastasis, as known from eleventh-century examples, places its primary emphasis on the rising figure of Christ. The defeat of Hades, already accomplished, is demoted to an academic description. The act itself is of little, if any, interest. Whenever present, the dark Hades lies bound and impotent in the midst of his overrun territory. His original resistance to Christ's onslaught is recalled in his occasional grasping of Adam's foot, a motif sometimes borrowed from the first type where it continues to figure throughout this period, as in the Anastasis in the Morgan Lectionary 639 and the mosaic at Daphni (fig. 85). The raising of Adam also loses some of its glamor in the second type of the image. Adam does not merit now the total attention of the redeemer. He is dragged behind Christ often without even a glance, his raising no longer the object of Christ's efforts, but their result. Consequently, the act of raising Adam loses some of its clarity, and its importance is played down. Its place is taken by the oversized, dominant figure of Christ triumphant, holding his sceptre-cross and striding energetically out of Hades against a sea of light. The abbreviated version of the second type of Anastasis, as the mosaic at Hosios Lukas (fig. 83), when compared to some eleventh-century examples of the first type, as the mosaics at Daphni and Nea Moni at Chios, illustrates the shift of emphasis in the second type of the image. This concentrates now on the rising Christ, and rather takes the remaining narrative components of the image for granted.

Just as the ninth and tenth centuries favored the first type of Anastasis, the eleventh century shows a marked preference for the second type. Its popularity spreads in the first half of the eleventh century throughout the empire, as attested by its use at Hosios Lukas, Hagia Sophia in Kiev, and Karabash Kilise in Cappadocia.[47] The wide dissemination of this type from Constantinople to the provinces in the first part of the century indirectly confirms the suggestion that the second type of the image was developing during the previous century, even though no examples of this phase have survived. The second type of the image continues to flourish alongside the first. Actually, there seems to be no rule about the choice of the one over the other. The two are used interchangeably and share the same basic iconographic vocabulary and its variations. David and Solomon continue to be a vital component, and their prominence increases. The two kings are now represented in three-quarter length, and their sarcophagus moves down to the level of the sarcophagus of Adam and Eve. Thus, the *theopatores* now balance the symmetrical figures of the *propatores*. David and Solomon stop offering a marginal note on Christ's human ancestry and become

[47] For Hagia Sophia in Kiev, see n. 6.126. For Karabash Kilise, which dates at 1060–1061, see Jerphanion, II.1, 333ff. and pls. 195–206. Also, Restle, III, figs. 456–464; N. Thierry, "Etude stylistique des peintures de Karabas Kilise en Cappadoce (1060–1061)," *CA*, 17 (1967), 161–175; idem, "L'art monumental byzantin en Asie Mineure du XIe siècle au XIVe," 91ff.

the second set of Mankind's ancestors, since their son Christ may be seen here re-creating mankind.[48] The figure of John the Baptist is very often included, and the figure of Abel less often than the Baptist. It also becomes usual to place groups of older and younger men on either side of Christ. No woman is ever present among them; Eve, the mother of all women, stands alone as Everywoman. Additional figures of kings may be occasionally seen.[49] None of these additional figures bears attributes that may help us identify them with any degree of certainty. But the fact that they usually seem to rise out of the same sarcophagi as the *propatores* and *theopatores* suggests they are not the anonymous dead, but the Just who participated in the Anastasis. Finally, during the eleventh century the first type of Anastasis adopts the patriarchal cross (as at Daphni) and the motif of the two hills (as in Dionysiou, cod. 587), which were first encountered in the context of the second type. As a result, the iconographic differences between the first and second types of the image are in effect neutralized.

THE ANASTASIS IN ELEVENTH-CENTURY MONUMENTAL MOSAIC DECORATION

By the eleventh century the Anastasis had become the indisputable feast image for Easter and was used in a variety of liturgical contexts.[50] Nevertheless, its use, which shows the same respect for tradition as its iconography, does not violate the proper chronological sequence of the christological cycle, despite the preponderance of Easter over the other "Feasts of the Lord." Both the feast and its image continue to be regarded in the context of the doctrine of the incarnation and its historical reality as reenacted within the liturgical framework of the church. However, the christological cycle may be manipulated so that the Anastasis is further correlated with other scenes in the cycle, thus varying its focus and message, a method already in use in the previous two centuries.

Nea Moni, Chios

In the Katholikon of Nea Moni, founded by Constantine Monomachos, the lower part of the pendentive zone supporting the dome is interpenetrated by eight alternating wide shallow arches and narrower semicircular squinches (figs. 81–82).[51] The four arches mark the east-west, north-south axes of the church, while the alternating squinches diagonally mark the four corners of the square, making it an octagon of unequal sides. On this archi-

[48] For David and Solomon as ancestors of Mankind in the image of the Anastasis, see n. 7.123.

[49] The figure of a third king is at times added next to the two kings, as, for example, in Athos, Dionysiou, cod. 61, fol. 2ʳ and Dionysiou, cod. 587, fol. 2ʳ. *The Treasures of Mount Athos*, I, figs. 105, 190.

[50] Weitzmann, "Byzantine Miniature and Icon Painting in the Eleventh Century," 289ff.

[51] The monastery of Nea Moni was founded by

Constantine Monomachos. The mosaics were executed between 1042 and 1056. Lazarev, *Storia*, 134–136, 150, 178 n. 80 with previous bibliography. Also, Demus, *Byzantine Mosaic Decoration* (London, 1953), figs. 13b and 43b (groundplan). Ch. Bouras, "Die Insel Chios," *Alte Kirchen und Klöster Griechenlands*, E. Melas, ed. (Cologne, 1972), groundplan p. 249, figs. 107–109. Idem, Ἡ Νέα Μονὴ τῆς Χίου (Athens, 1981).

tectural layout, which emphasizes the two axes of the church, we find a rationalized and selective feast cycle. It starts on the northeast squinch with the Annunciation and develops clockwise with the Nativity, the Presentation in the Temple, the Baptism, Transfiguration, Crucifixion, Deposition, and finally the Anastasis. This abbreviated feast cycle, which practically duplicates that of the historiated reliquaries, is expanded by the representation of the Entry to Jerusalem and the Washing of the Feet, and other scenes. These supplements to the main feast cycle are taken out of sequence and placed apart from the pendentive zone, while the scenes composing the abbreviated christological cycle of the pendentive zone are further organized and interwoven.

The axes of the church taken by the shallower, wider, and hence, more visible arches display four fundamental scenes of the christological cycle: the Nativity, Baptism, Crucifixion, and Anastasis. These scenes are grouped in two antipodal but complementary pairs marking the axes of the church, which cross under the center of the dome containing the figure of the Pantocrator. The two pairs are: the Nativity and the Crucifixion on the east-west axis and the Baptism and the Anastasis on the south-north axis.[52] The antithetical pair Nativity-Crucifixion requires little explanation as a synoptic review of the doctrine of the incarnation, and hence, of Christ's human nature. Similarly, the antithetical pair Baptism-Anastasis, already analyzed, may be considered an equally synoptic review of the doctrine of re-creation and redemption, and hence, of Christ's divine nature.

The combination of the selective cycle of the pendentive zone with its architectural layout encourages a twin reading: first, as a historical narrative of the incarnation of the Logos, which traces the periphery of the base of the dome with the Pantocrator; second, as an exegetical synopsis of the doctrines of the incarnation, redemption, and Christ's two natures following a reading that traces the sign of the cross against the dome Pantocrator.

Moreover, there are recognizable liturgical overtones in the latter reading, which traces the sign of the cross following the main axes of the church. The Baptism-Anastasis pair reflects the familiar practice of performing the sacrament of Baptism in the course of the Easter Vigil and its allusion to redemption through Christ's divinity. As noted, this practice resulted in the alignment of the images of Baptism and Anastasis in more than one way in the pictorial arts. Similarly, the Nativity-Crucifixion pair and its allusion to the incarnation may be associated with the performance of the Eucharist on the altar. These two scenes are only part of the longitudinal pictorial axis of the church, which reviews various aspects of the doctrine of the incarnation culminating on the altar where it is commemorated by the Eucharist. The longitudinal axis of the church starts in the esonarthex on an intimate scale. Here the medallion of the Virgin, at the crown of the pumpkin dome, leads to a figure of Christ above the entrance to the nave. Both Christ and the Virgin are flanked by the maternal grandparents of Christ, Joachim and Anna, as well as by St. Stephen the Younger and St. Theodore Studite, two saints of the Iconoclastic period who ardently defended images on the basis of the doctrine of the incarnation.[53] The pictorial argument for

[52] Demus, op. cit., 58.

[53] A. Grabar, M. Chatzidakis, *Greece. Byzantine Mosaics* (Paris, 1959), pl. 15. D. Mouriki, "The Portraits of Theodore Studites in Byzantine Art," *JÖB*, 20 (1971), 259f., fig. 8.

the incarnation continues in the main body of the church with the Crucifixion-Nativity pair, which offers one of the two coordinates analyzing the dome Pantocrator. It culminates in the full figure of the Virgin Orans dominating the apse, below which the mystery of the Eucharist is performed. Thus, the historical and theological content of the Nativity-Crucifixion and Baptism-Anastasis pairs is integrated in the pictorial and architectural layout of the church in a way that evokes the liturgical practices which embodied these doctrines mystically and gave them substance in the framework of the acts of worship performed.

Another aspect of the Anastasis mosaic at Nea Moni which is of particular interest is that Solomon continues to be differentiated from his father in terms of age. However, unlike his traditional Middle Byzantine appearance as a beardless youth, he is middle-aged, has a beard, and much resembles a number of eleventh-century imperial portraits: those of Monomachos[54] and those inscribed as Votaniates.[55] Given that Monomachos was the founder of Nea Moni, it is possible that this iconographic departure from the standardized features of the young Solomon was intentional, and that the portrait of Monomachos took the place of Solomon in the image of the Anastasis.[56] Attention is drawn to this departure by the exaggerated application of the pictorial motif of the colored haloes for the two kings. David's bright red halo and Solomon's bright blue halo were familiar in the context of the Anastasis as witnessed by the Lavra Skevophylakion Lectionary, where the emperors' nimbi are rendered in light pastel hues.[57] Similarly, Solomon has a brilliant blue halo in the Copenhagen miniature of Solomon and Jesus Sirach which dates from the tenth century.[58] The use of colored haloes in the Anastasis, which are not always red and blue as in the examples cited here, has been associated with imperial iconography by Mouriki.[59] Her study of the mosaics of Nea Moni promises to shed more light on this example of Anastasis, which may add an imperial layer to its historical, theological, and liturgical layers.

[54] The best-known portrait of Monomachos is that of the South Gallery of Hagia Sophia. The alterations, however, to which this mosaic head has been submitted have created a great number of questions about its identity. For the most recent attempt to explain the problems involved, see, N. Oikonomides, "The Mosaic Panel of Constantine IX and Zoe in Saint Sophia," *REB*, 36 (1978), 219–232. Other surviving portraits of Constantine IX Monomachos come from Sinait. gr. 364, fol. 3ʳ [I. Spatharakis, *The Portrait in Byzantine Illuminated Manuscripts* (Leiden, 1976), 99ff., fig. 66], and from the crown of Monomachos (Wessel, *Byzantine Enamels*, 98ff., no. 32). John Mavropous repeatedly makes mention of Constantine Monomachos in his poetry, once presenting him as the upkeeper of the pious laws set down by David the Psalmist (PG, 120.1157, lines 456–459). It should be noted, however, that the bearded portrait of Solomon in the company of David finds another parallel on fol. 222ᵛ of Vat. gr. 752 illutrating Ps. 71. This manuscript, which dates to 1059, has been recently recognized as a carrier of contemporary political events. I. Kalavrezou-Maxeiner, "Silvester and Keroularios," *XVI. Internationaler Byzantinistenkongress. Acts* II, JÖB, 32.5 (1982), 453–458.

[55] Spatharakis has renewed the proposition that the four imperial portraits illustrating Coislin 79 may be identified with the predecessor of Nicephorus Votaniates, Michael VII. Spatharakis, op. cit., 107ff., figs. 69–76.

[56] D. Mouriki, *The Frescoes of the Church of the Saviour near Alepohori in Megaris* (Athens, 1978), 38 n. 180.

[57] Above, 204. For a color photograph, *The Treasures of Mount Athos*, III, fig. 6.

[58] Above, n. 7.118.

[59] Mouriki, op. cit., 36ff. where the subject of the colored nimbi is examined.

Hosios Lukas

The prismatic and multifaceted reading of the mosaic of the Anastasis in Nea Moni is not unique. In a different way it is also applied in the Katholikon of Hosios Lukas in Phokis (figs. 83, 84).[60] Here the Anastasis is on the east wall of the south narthex bay. It corresponds to the mosaic of the Crucifixion in the north bay. These two scenes form part of a selective Passion cycle, which includes the representation of the Washing of the Feet and the Doubting Thomas on the north and south walls of the narthex.[61] But the Crucifixion and the Anastasis are distinguished in this cycle because of their position in the lunettes above the north and south doors leading to the nave. The lunette of the central door depicts Christ holding the Gospel book open at John 8:12: "I am the light of the world: he that followeth me shall not walk in darkness, but shall have the light of life." He is also pointing to it with the same gesture the Baptist uses when pointing to Christos-Amnos. The abbreviated Passion cycle in the narthex, and the coordination of the Crucifixion and Anastasis lunettes with that of the image of Christ above the three doorways to the nave on the east narthex wall, suggest a double reading for the Anastasis: as part of the Passion cycle, and as a counterpart to the Crucifixion together with which it frames the image of Christ. Of these two associations, the most important is the alignment of the Anastasis and the Crucifixion as pictorial attendants to the image of Christ, the Light of the World, and as joint guardians of the passage into the church.

The bust of Christ does not stand alone in the central bay. The arches dividing the narthex into three bays show six apostles led by Peter and Paul, to Christ's right and left correspondingly. The eastern and western quarters of the cross-vault over the central bay have medallions of the Virgin and the Baptist, which are aligned with the bust of Christ, while Archangels Michael and Gabriel stand guard on the northern and southern quarters of the cross-vault. The longitudinal axis formed by the portraits of Christ, the orant Virgin, and the Baptist, who gestures in the same way as Christ, culminates on the inner face of the west wall above the main exit from the narthex to the courtyard. The medallions of five saints trace the outline of the lunette above the doorway.[62] The central medallion, which corresponds to Christ's face, shows St. Akindynos (Dangerless). He is flanked on either side by the portraits of Sts. Aphthonius (Abundant or Unenvious) and Elpidophorus (Bearer of Hope) to the north, and by Sts. Pegasius (He Who Gushes Forth) and Anempodistus (He Who Cannot Be Impeded) to the south. The selection of saints that face

[60] Lazarev, *Storia*, 151, 178 n. 81 with previous bibliography. E. Diez and O. Demus, *Byzantine Mosaics in Greece* (Cambridge, 1931). E. Stikas, Τὸ οἰκοδομικὸν χρονικὸν τῆς Μονῆς Ὁσίου Λουκᾶ Φωκίδος (Athens, 1970). Idem, Ὁ κτίτωρ τοῦ καθολικοῦ τῆς Μονῆς Ὁσίου Λουκᾶ (Athens, 1974–1975). Stikas proposes a date during the reign of Constantine Monomachos between 1042 and 1056. M. Chatzidakis, "A propos de la date du fondateur de Saint-Luc," *CA*, 19 (1969), 127–150. Idem, "Précisions sur le fondateur de Saint-

Luc," *CA*, 22 (1972), 87–89. Chatzidakis dates the mosaics at 1011.

[61] For the layout, Demus, *Byzantine Mosaic Decoration*, fig. 42, and M. Chatzidakis, "Athen und Umgebung. Attika und Böotien," *Alte Kirchen und Klöster Griechenlands*, E. Melas, ed., 182f. Stikas, Τὸ οἰκοδομικὸν χρονικὸν τῆς Μονῆς Ὁσίου Λουκᾶ Φωκίδος, pls. 6–12, 14.

[62] Diez and Demus, op. cit., fig. 49.

Christ's image across space and above the central doorways into and out of the church is suggestive. The names of these imitators of Christ, who are commemorated as a group on November 2,[63] stand for some of the major characteristics of Christ as the Light of the World and the guarantor of the light of eternal life of redemption for his followers. This aspect of Christ's identity seems then to be the guiding principle of the decoration of the central narthex bay. The image of the guarantor above the main entrance to the nave marks the physical and spiritual path to redemption his followers should take in and through the Church. The flanking apostles guarantee the teaching of the road to salvation. The medallions of the Virgin and the Baptist guarantee their intercession, while the names of Christ's imitators over the main exit spell out some of the Redeemer's qualities.

The Crucifixion and the Anastasis that flank symmetrically the bust of Christ (the Dangerless, Abundant, Hope-Bearing, Gushing-Forth and Unimpedible Light of the World), expand its message of redemption to the lateral bays. The compositional distribution of the two scenes in the given architectural space shows that their traditional pictorial pairing as cause and effect is maintained. The Crucifixion and the Anastasis are combined here as a pictorial exegesis on many interdependent levels, synthesizing a prismatic interpretation of the essence of the central image of Christ, the Light of the World. On a narrative level, the depiction of the Death and Resurrection confirms the historical reality of the Redeemer. On a theological level it proves his two natures, which guarantee redemption. On a liturgical level, they serve as feast images, drawing attention to the celebration of the Death and Resurrection of Christ on Holy Friday and Holy Saturday which mark the peak of the liturgical calendar and its promise of individual redemption.

Beyond interpreting the essence of the central image of Christ, the synthesis of the three mosaics is linked with the typology of their architectural context. Their position above the main and side passages to the nave makes the three mosaics guardians to the entrance to the church. The Anastasis is a vital component of this complex scheme, not by itself, but as a counterpart of the Crucifixion. Though the two images are not detached from the broader christological context (because of the inclusion of the Washing of the Feet and the Doubting Thomas), their narrative value is secondary. Their context also makes secondary their exegetical value as proof of the doctrine of the two natures. These images are subordinate to the representation of Christ as the Light of the World and its message of redemption, which is of immediate value to the faithful about to enter the church in the hope of achieving redemption. It appears, therefore, that the liturgical value of the Crucifixion-Anastasis pair as a reminder of the redemptive power of the reenactment of the Death and Resurrection of Christ in the mysteries of the church is the main aim of this arrangement.

[63] *SCp*, 187ff. For a comparable group of saints whose names offer mutually complementary concepts and who are commemorated together on the same day as well, see: Sophia, Pistis, Elpis, and Agape, *SCp*, September 17, 51f. For the importance attributed to the etymology of words and names, above, n. 7.109.

Daphni

The promise of redemption, which the combined images of the Crucifixion and the Anastasis offer for the churchgoer, is also present at Daphni (figs. 85, 86).[64] The two mosaics take up most of the eastern wall of the north and south cross arms below cornice level. They are preceded and followed by two scenes belonging to the Passion cycle, the Entry to Jerusalem and the Doubting Thomas, both of which appear on the west wall of the north and south cross arms. Thus, the two mosaics belong both to the extensive christological cycle decorating the higher parts of the church, and to the selective Passion cycle, which forms an independent subdivision on the lower and more intimate wall surface of the north and south cross arms. As a result of their position below cornice level, the visibility of the two mosaics increases, allowing them to address directly the faithful in the church.[65] This is reinforced by their size and position in the eastern part of the church facing the congregation. Moreover, their symmetrical position on either side of the eastern arm of the church formally allows them to function as its frame immediately below the central image of the Pantocrator in the dome.

In all these respects the Crucifixion and Anastasis mosaics at Daphni follow the same principles of distribution as they do at Hosios Lukas. They are part of a christological cycle, which decorates the higher parts of the church and which continues with a selective and semi-independent Passion cycle at a lower and more intimate level not too far above the eyes of the approaching faithful. The two scenes are symmetrically distributed on either side of a central image of Christ, and on the east wall, which is immediately accessible to the entering faithful, formally bridging the north and south sections of the church. At Hosios Lukas they mark the lateral passages into the nave of the church, while at Daphni they span the space across the eastern part of the church, which contains the bema where the mysteries of the church are reenacted. Thus, the Crucifixion and the Anastasis are allowed to stand guard and introduce the eastern and most important architectural part of the church, designating the eastern cross arm as the "door" to redemption for the faithful by bridging the space across it. Though neither of these two images is divorced from the christological cycle, their relation to the section of the church where the sacrament was performed stressed the liturgical dimension of both feast scenes. At Hosios Lukas, Christ, the Light of the World, flanked by the images of his Death and Resurrection, marked the entrance to the church proper, the entrance to the "heaven on earth," which "typifies the Crucifixion, the Burial and the Resurrection of Christ."[66]

At Daphni, the same images guard under the all-seeing eye of the Pantocrator the opening to the bema area, where the sacrament of the Eucharist is performed on the altar. In both cases, the Crucifixion-Anastasis pair formulates an incantation for salvation through

[64] Lazarev, *Storia*, 194ff., 254 n. 53 with previous bibliography. For the layout, Demus, *Byzantine Mosaic Decoration*, fig. 43a, and Chatzidakis, "Athen und Umgebung. Attika und Böotien," 186f. For illustrations, Diez and Demus, op. cit., fig. 100.

[65] I owe this observation to Prof. H. Belting.

[66] Germanus I, patr. *Historia ecclesiastica et mystica contemplatio*, I PG, 98.384f. Translated by Mango, *Sources*, 141f., 123f.

Christ, his church, and her sacraments. In both instances, the emphasis is on the liturgical identity of the two images to which Daphni adds a sacramental dimension in view of the proximity of this pair to the altar. For the altar links the Crucifixion and the Anastasis as the ultimate image of the Entombment, since it typifies "the place where Christ was buried, and on which is set forth the true bread from heaven, the mystic and bloodless sacrifice, i.e. Christ."[67]

The interpretation of these two images at Daphni as guards, frame and introduction to the mystery of the Eucharist may be verified by the treatment of these two scenes in the small church in Veroia painted by Kalliergis in 1315 (figs. 87, 88). The Crucifixion and the Anastasis are set in especially designed blind arches facing each other on the north and south walls of the church.[68] The use of this special framing device stresses the traditional association of the two images with each other across the space of the church. The framed representations of the Crucifixion and the Anastasis are close to the apse, while the framing blind arches offer a scaled-down echo of the bema arch on either side of the apse. Thus the eastern section of the church produces a composition of three arches, the central higher than the lateral. The central arch contains the bema, while the lateral arches contain the images of the Crucifixion and the Anastasis. The three are read together, like all triple arches, along with their content. Iconographic means are also used to suggest forcefully the joint reading of the apse, the Crucifixion, and the Anastasis.

The blind arches of the Crucifixion and the Anastasis are each preceded to the west by a door. The doors define this part of the lowest zone as a self-sufficient unit symmetrically arranged on either side of the apse. The iconographic unit consists of a military saint standing to the east of each door, followed by the framed representation of the Crucifixion and Anastasis on the north and south walls. These are followed by two ecclesiastical saints on each wall, by more ecclesiastical saints on the face of the bema arch, and by two Fathers of the Church on each half of the lower zone of the apse. The high point on this horizontal iconographic composition is the window in the center of the apse, which sheds its allegorical light on the altar, the ultimate focus of the entire arrangement.

In this arrangement, whose liturgical message is clear, the Crucifixion and the Anastasis are taken out of their proper sequence in the christological narrative of the upper zone and made accessible on the lowest zone framed by special monumental arches, which echo the bema arch. The liturgical message of redemption thus returns from the bema to the nave suggesting for this traditional pictorial pair a role as the narrative, theological, and liturgical prelude to the mysteries enacted on the altar. Even more directly than at Daphni, the pairing of the Cruciifixion and the Anastasis contributes to the analysis of the altar as "the place where Christ was buried and on which is set forth . . . the mystic and bloodless sacrifice."

Despite the fourteenth-century date of the church in Veroia, the compositional relationship of its Crucifixion-Anastasis pair to the bema area and the sacraments performed

[67] Ibid., PG, 98.385. Mango, Sources, 142. [68] Pelekanides, Καλλιέργης. 14, pls. 5, 8f.

therein reflects the layout of the corresponding mosaics at Daphni. The two instances are consequently interpreted as parallel expressions of the same intention to use the Crucifixion-Anastasis pair as a sacramental, liturgical, theological, and historical synopsis of Christ and his church as the means and ends to redemption.

One aspect of this interpretation is that it explains some of the details of the two Daphni mosaics. As Belting noted, the Crucifixion and the Anastasis at Daphni do not occupy the middle of the wall space of the north and south cross-arms on which they appear. They are instead pushed closer to the center of the church, thereby attaining greater visiblity. Moreover, they are on the lowest and most intimate zone of decoration. Both of these features are comparable to the positions of the same two scenes in the Veroia church decorated by Kalliergis.

Another aspect of the Daphni mosaics stresses their comparability to the role of the two scenes in the Veroia church. Although they are on a rectangular flat surface, their upper part is arched and bore a wide marble frame following the outline of the present meager mosaic frame of each scene, as witnessed by the remnants of such a frame around the mosaic of the Entry to Jerusalem. As noted by Belting, the use of an affixed arched frame would turn these two mosaics at Daphni into monumental mosaic icons. Belting's interpretation is confirmed by the use of blind arches for these scenes in the early fourteenth-century church in Veroia.

It seems, then, that the Crucifixion-Anastasis pair at Veroia offers a frugal, though developed, interpretation of the christological and sacramental dimension of the two scenes. In this it follows an older tradition in church decoration traceable to the eleventh century. Though the eleventh-century churches examined were not willing to divorce decisively the Crucifixion-Anastasis pair from the rest of the christological cycle as at Veroia, they often allowed it to bridge the church space as a mental doorway leading to redemption through the church and its functions, adding to it a clear sacramental dimension. As monumental icons near the bema, they tended to become active elements in the services and acts of worship performed in the church. So the Crucifixion-Anastasis pair became the visual counterpart of the mystical reenactment of the Death and Resurrection of Christ in the course of the celebration of the Eucharist, acquiring a specific sacramental dimension.[69]

S. Maria Assunta, Torcello

The pictorial alliance of the Crucifixion and the Anastasis as a significant abbreviated reference to redemption through the sacraments is interpreted differently in S. Maria Assunta at Torcello (figs. 89, 58).[70] As already mentioned the two scenes are vertically aligned above the image of the Last Judgment on the west wall of the basilica. The unique arrangement of these three scenes establishes in a contrived way their historical veracity. Concur-

[69] This is confirmed by the frequent use of the representations of the Crucifixion and Anastasis to decorate the two sides of Gospel Bookcovers at a later date.

[70] See n. 6.121. Also Lazarev, Storia, 242, 271 n. 234.

rently, the interpretation of redemption as an act of Judgment, whose catalyst is the Passion and whose vehicle is the resurrection of the dead, offers an understanding of the selection of scenes on an abstract theological level.[71] While neither the historical nor the theological interpretations of the decoration program of the west wall reveal the immediate source of inspiration for this unprecedented iconographic arrangement,[72] the architecture of the church together with its liturgical usage explain the reasons behind the synthesis.

The vertical axis down the middle of the west wall of the basilica comprises (starting at the top) the crucified Christ, the resurrected Christ, Christ the Judge, his Hetoimasia worshiped by the protoplasts, the weighing of the souls, the Virgin orans praying for the remission of our sins, according to the accompanying inscription, and the western door of the basilica (fig. 58).[73] It is hardly accidental that this door, which is the end of this axis, led to the baptistery of the church, where the remission of the original sin and the opening of the door to Paradise and redemption were effected by the performance of the sacrament of baptism, probably during the first part of the Easter Vigil. After that, the newly baptized would be welcomed into the church by the congregation already in it in order to participate in the second part of the Vigil, whose theme was the Resurrection. In all probability, they entered through the west door, which led directly from the baptistery to the basilica. Thus the program chosen for the decoration of the west wall of the basilica is most likely related to the traditional performance of baptisms in the context of the Paschal Vigils.[74] Proof of this, however, will have to await a separate study of eleventh-century liturgical practices in the Veneto area. This line of investigation proposed to Veneto specialists is encouraged by the presence of the traditional antithetical parallelism of the themes of Baptism and Resurrection in the decoration of the Baptistery of San Marco in Venice.[75]

If this is true, then the decoration program for the basilica's west wall greatly enhanced the significance of the baptisms performed in the context of the Paschal Vigil in the baptistery to the west of this door. As noted, redemption was thought impossible without baptism, which was taken to typify the Death and Resurrection of Christ, the cancellation of the original sin, and the renewal of man's immunity to death. Baptism thus unlocked for man the door to his personal redemption. The west wall decoration reviews allegorically the process and aims of baptism by illustrating the events typified by it. Here the Crucifixion illustrates the cause and the Anastasis, together with the Last Judgment, the result. As we have seen in the discussion of the third type of Anastasis, aspects of the liturgical

[71] Above, 156ff.

[72] For a homiletical parallel, see John of Damascus, *In Sabbatum Sanctum*, PG, 96.637. Here the theme of the Last Judgment is used to close the sermon.

[73] VIRGODINATUMPRECEPULSATERGEREATUM. For the Baptistery, see B. Schulz, *Die Kirchenbauten auf der Insel Torcello* (Berlin, 1927), 9ff., pl. 2. F. Forlati, G. Fiocco, *Torcello* (Venice, 1940), 112ff., figs. 47–49, 54. M. Vecchi, "Il Battistero: Pianta originale e recostruzioni poligonali," in *Torcello. Ricerche e contributi* (Rome, 1979) 19–23.

[74] Above, 175f.

[75] R. Tozzi, "I mosaici del Battistero di S. Marco a Venezia e l'arte Bizantina," *Bolletino d'arte*, 26 (1932–33), 418ff. V. Lasareff, "Über eine neue Gruppe byzantinisch-venezianischer Trecento-Bilder," *Art Studies*, 8 (1931), 1–32.

celebration of the Paschal Vigil have led to the pictorial interpretation of the Anastasis at Torcello as a proto-Judgment, which prefigures and guarantees the Second and Last Judgment. As the newly baptized entered the church through the west wall door at the end of the first part of the Paschal Vigil, they had to pass under this image, which reviews the micro- and macrocosmic results of the Passion: redemption already achieved for the protoplasts and promised at the end of time for all those baptized in Christ. The mosaic synthesis on the west wall would then appear to proclaim the newly acquired readiness of those entering the church to face Christ the Judge. The paschal context of this event would naturally render the figure of the Anastasis Christ the focus of the entire wall decoration, especially in view of its formal compositional alignment with the Last Judgment and the two apocalyptic angels.

Thus, the program of decoration of the west wall of S. Maria Assunta at Torcello appears to blend uniquely a number of pictorial trends and liturgical practices with its individual architectural layout. The traditional pairing of the scenes of the Crucifixion and the Anastasis as a cause-and-effect reference to the historical reality of the Death and Resurrection of Christ, to its annual liturgical celebration on Holy Friday and Holy Saturday, and to its weekly commemoration in the sacrament of the Eucharist is employed here in a slightly different way. The message of redemption through the church and its sacraments inherent in the Middle Byzantine pictorial scheme of Crucifixion-Anastasis is expanded by its attachment to the image of the Last Judgment, which often figures on the west wall of churches. The inspiration for this compilation appears to originate in the architectural layout of this particular church (the position of the baptistery to the west of the basilica) together with a standard liturgical practice (the performance of baptism in the context of the liturgical celebration of Easter). If this is true, then the mosaic ensemble partly satisfied the tradition of representing the Last Judgment on the west wall of a church. It also partly conformed to the use of the Crucifixion and the Anastasis as an abridged reference to redemption through the church and its sacraments.

The iconographer seems to have been aware that this unusual pictorial compilation would be puzzling. To clarify the liturgical foundation of the synthesis, he offered a key. This is the monumental figure of Christ in the Anastasis, who is ceremoniously flanked by two colossal archangels and is compositionally interrelated with the representation of the Last Judgment. Size and composition make the figure of Christ the focus of the west wall. But the visual prominence of this figure appears difficult to understand now that the baptistery does not survive and baptisms are no longer associated with Easter. In the late eleventh century, however, the monumental Anastasis Christ was undoubtedly a pictorial clue for the faithful in the church when they turned west to face the arrival of the baptismal procession during the Easter Vigil. Thus the Anastasis appears to have become an active component of the Easter Vigil at Torcello by virtue of its placement and its pictorial context. But this interpretation can be confirmed, rejected, or refined only in conjunction with a specialized study of the liturgical practices surrounding the celebration of Easter in the eleventh- and twelfth-century Veneto.

The eleventh century consolidated and diversified the iconographic tendencies of the image of the Anastasis, which had appeared earlier, without giving up any of its previous definitions. It stabilized the reference to the Passion in the Anastasis by the use of an oversized patriarchal cross held forth by Christ. The patriarchal cross is much more prominent than the cross awkwardly held by Christ in the second representation of the Anastasis in S. Clemente, or the nail mark on Christ's hand in the Anastasis at Cimitile. The choice of this type of cross, which carried a variety of liturgical associations, stands in the iconography of the Anastasis from the eleventh century on as material evidence of Christ's Passion, as the new rod of Moses, the instrument that effected the passage of mankind from slavery to freedom, and as the symbol of the victory over death and the realization of the promise of redemption for mankind. The vitality and importance of this symbol in the context of the image of the Anastasis is confirmed by its use in all three types of Anastasis from the eleventh century on, as exemplified by the mosaic at Daphni, the miniature in the Phocas Lectionary, and the miniature in the Psalter Vatopedi 760. Furthermore, by the eleventh century, the Anastasis usually includes closely related references to the earth's rending in twain at Christ's Passion, and to Christ as the sacrificial lamb through the persons of John the Baptist and Abel.

The widespread use of the second type in the eleventh century suggests a new interpretation of the traditional image. The composition now focuses on Christ's own rising, playing down the importance of the raising, of Adam and the trampling of Hades. Christ, holding the patriarchal cross, leads the way from darkness to the light, rising from the earth split asunder as the sun of righteousness—as John of Damascus had said in his well-known Easter Canon and as John Mavropous stressed in the eleventh century. In this variant, Christ also addresses the beholder by looking at him, encouraging an allegorical interpretation for the image.

These iconographic and compositional modifications reinforce the historical reality of the Anastasis narrative. At the same time, they consolidate its doctrinal balance by recalling that the performance of the miracle of the Resurrection by the will and energy of Christ's divinity became possible through the Passion of his humanity. Thus, the reference to Christ's human nature, originally achieved by the addition of the motif of David and Solomon, the ancestors of Christ and of the reborn mankind,[76] is now amplified by a number of references to the passibility of Christ's human nature.

Similarly, the liturgical identity of the Anastasis as the feast image for Easter is diversified. In addition to the expanded use of the independent image of the Anastasis as the illustration of John 1:1ff. and other comparable liturgical texts, the iconography of the Anastasis often acquires a distinct sacramental dimension. This is first encountered in the apse decoration of the New Tokali Kilise in the mid-tenth century. The Anastasis functions here on two related liturgical levels as a reference to Holy Saturday, and as an allusion to the mystery of the Eucharist. The extended cycle of Christ's Death and Resurrection, the

[76] Above, n. 7.123.

presence of the prophets Jeremiah and Ezekiel on the bema arch, and the inscription of Ps. 81:8 as a label to the Anastasis are responsible for its association with the liturgical celebration of Holy Saturday. The distribution of this cycle on either side of St. Basil and its location in the apse of the church are primarily responsible for the identification of its sacramental aspect. But for the achievement of both aspects of its liturgical identity, the Anastasis is clearly subordinate to the cycle of Christ's Death and Resurrection.

Both liturgical dimensions of the feast image can be realized in a more economical way in eleventh-century churches. The dependence of the Anastasis on the christological cycle decreases. It is only paired with the Crucifixion as a synopsis of the cycle of Christ's Death and Resurrection, echoing the pairing of the iconography of the Crucifixion and the Marys in Early Christian Art. As a result, the Anastasis gains in pictorial prominence. This elliptic pair is judiciously deployed in eleventh-century churches as a pictorial equation that adheres to the same principles as its architectural context and its typology. Accordingly, the Crucifixion and the Anastasis occupy lateral positions of equal value in the lowest zone of church decoration, corresponding to subsidiary architectural units as markers of major architectural subdivisions. They consequently flank a core section of the church, analysing its formal arched shape, framing it as two mutually complementary images of equal importance.[77] Their frequent association with the eastern side of the church increases their visibility while connecting them with the formal function of the church. At Hosios Lukas, this pictorial pair and the image of Christ are also appointed as guardians to the church and its mysteries through its direct association with door symbolism. Similarly, the Crucifixion and the Anastasis demarcate the eastern cross-arm of the church at Daphni, giving shape to a pictorial gate leading to the most sacred part of the church. Thus are the feast images for Holy Firday and Holy Saturday used to analytically introduce the significance of redemption through the church and its mysteries.

In these instances, the effectiveness of the liturgical message of the Anastasis image depends on its formal context. Its iconography is not perceived as a self-sufficient liturgical unit whose narrative and theological content may be superseded. The way it is used indicates and defines the liturgical layer of its identity without ever divorcing it from the christological story, turning it into an active exegetical element that at times seeks to define as well as participate in the church ritual.

Though the Orthodox Church has considered Easter as the feast of feasts from the earliest times,[78] the corresponding image was never divorced from its narrative context and projected as the image of images. Throughout its development, it maintained its basic narrative value as an integral part of the christological story. As such, it acquired various inter-

[77] The representations of the Crucifixion and the Anastasis similarly confront each other on the western arch of the central dome in the Church of San Marco in Venice, on the north and south walls of the Chapel of Hagia Trias at the Chrysostom Monastery near Koutsoventi Cyprus, dating from the beginning of the twelfth century, as well as in other examples of the early twelfth century known to have been influenced by Constantinopolitan models.

[78] See, for example, *Oratio* XLV. *In Sanctum Pascha*. PG, 36.624 and John of Damascus, *Easter Canon*, PG, 96.841D.

pretations contributing to the historical, theological, and liturgical reality of the christolog-
ical story. The emphasis changed from time to time without affecting the foundation of
this iconography as a direct visual demonstration of the Resurrection to the faithful who
saw in it their own regeneration and greatly rejoiced at it, conditioned as they were to syn-
thesize and decipher its various messages.[79]

[79] Joannes Euchaites, PG, 120.1132, lines 1257ff.:

Σὺ δ' ἀξιωθεὶς ὧν ὁρᾷς θεαμάτων
Ἐπικρότησον· σὴν ἀνάπλασιν βλέπεις.
Καὶ χαῖρε, χαῖρε, πάσχα τοῦτο Κυρίου.

CONCLUSIONS

Examination of the image of the Anastasis has shown that its pictorial evolution is inextricably tied with that of the christological theme of the Death of Christ. The subject of the Resurrection of Christ following the defeat of Death and the raising of the protoplasts from the dead had formed part of Byzantine theology and liturgy throughout the Early Christian period. However, its pictorialization was consistently circumvented, largely as a result of the christological difficulties inherent in the representation of the person of Christ—the perfect God and perfect man—at any moment during his Death. And Christ was undoubtedly dead at the moment when he trampled Hades and took hold of Adam's hand in the underworld amid his dead ancestors, the patriarchs, the prophets, and all other anonymous dead, while his body was lying soulless buried in the tomb.

The definitions added to the doctrine of the two natures during the seventh century radically altered the attitude of artists. The defense of the Orthodox position against Monophysites, Theopaschites, and Monothelites produced arguments that focused on the theme of the passibility of Christ's human nature in conjunction with the impassibility of his divine nature as shown by the various facets of his death, which started on the cross, continued in the tomb and the underworld, and ended with the Resurrection. The increasing interest of the seventh century in Christ's Death is reflected in the growing preoccupation of the apocryphal, homiletical and hymnological literature with the theme of the burial of Christ, his defeat of the kingdom of Hades and the ensuing resurrection of the dead. The arguments that the theme of Christ's Death afforded for the Orthodox position were sanctioned by the Sixth Ecumenical Council and contributed to the formulation of canons by the Council in Trullo, which enhanced the liturgical importance of the yearly and weekly commemoration of the Resurrection as the ultimate guarantee of salvation for the Orthodox.

A populist contemporary line of Orthodox polemics, which also used the theme of Christ's Death, advocated, furthermore, the aggressive use of the pictorial arts as a weapon against various heretics. This is attested by the *Hodegos* of Anastasius Sinaites, whose author firmly believed in the invulnerability of the "visual word," and in its ultimate effectiveness, even above and beyond the word of the Scriptures and the Chruch Fathers. This permits a partial reconstruction of the reasons that made acceptable, even mandatory, the illustration of the theme of Christ's Death, of which the subject of the Anastasis forms an essential part. Given the limited objectives of the *Hodegos*, it is unlikely that its author, who used christological imagery as a weapon in chirstological disputes, was the originator of this aggressive use of images. It is more probable that the *Hodegos*, which anticipates methods, themes, and jargon that became widespread during the Iconoclastic

controversy, reflects a broader seventh-century tendency to enlist art in the service of the Church and its current doctrinal struggles.

The suggestion is supported by the well-known Canon 82 of the Council in Trullo, which ordained the figurative rather than the symbolical representation of Christ as a reminder of "His life in the flesh, His Passion, His salutary death and the redemption which has thence accrued to the world."[1] This canon, which employs the pictorial arts to buttress the historicity of Christ's person, Passion, and Death immediately after the condemnation of the Theopsachites in Canon 8I,[2] is not the only evidence of the growing official interest of the Church in the potential of the visual word. Canon 73 of the same council decrees that the representation of the cross should not figure on the ground.[3] The reason is that the image of "the trophy of our victory" should not be stepped on. Instead, "reverence should be paid to it in mind, in speech, and through the senses," a phrase which anticipates the concept of a total confession of faith (through the reason, heart, mind, mouth, in writing, and in images) developed in the post-Iconoclastic period.[4] Canon 73 also reflects the increasing importance of images for the Church, whose attitude is further confirmed by Canon 100.[5] Here all corrupting images are excommunicated, because the sense of vision—along with the other senses of the body—easily reaches the soul. So the official church categorizes images in terms of their desirability. Desirable images are formally adopted and promoted by the Chruch, which regulates their development, while undesirable images are not only censored but excommunicated.

It would seem that the seventh century witnessed a broadening of the interest in and acceptance of the visual arts by the official Church, which actively patronized them so as to align the aims and functions of images with those of the Church. One result was the use of images in seventh-century church polemics. These focused on christological issues whose definitions revolved around the Death of Christ. The use of this theme in seventh-century christological disputes, coupled with the official enlistment of the arts by the Church on a canonical level, was probably responsible for the admission of the subject of Christ's Death in the pictorial arts of the late seventh century in the shape of the representation of the Death of Christ on the cross, the Entombment of his soulless, sightless, and speechless corpse, and the Anastasis from Hades through the will and energy of his divinity.

The three pictorial themes of Christ dead on the cross, the Entombment, and the Anastasis were not the result of a single concerted effort, but rather the result of parallel efforts of a broader trend. These were integrated into the pictorial cycle of the life of Christ with varying regularity, to judge by surviving pictorial and literary evidence, becoming the nucleus of the cycle of Christ's Death and Resurrection. The Iconoclasts toned down the theme of Christ's Death and Resurrection.[6] Then the post-Iconoclastic period brought it

[1] Mango, Sources, 140. [2] Mansi, 11.977. [5] Mansi, 11.985, n. 3.51.

[3] Mansi, 11.976, n. 3.52. [6] B. N. Yiannopoulos, Αἱ χριστολογικαὶ ἀντι-

[4] As for example, in the Synodikon of Orthodoxy. λήψεις τῶν εἰκονομάχων (Athens, 1975), 76ff.
See n. 7.137.

back particularly using the theme of Christ's Death in crucial arguments for the defense of images. Accordingly, Christ's circumscribability was based on his passibility, which, in turn, ensured the salvation of mankind.[7]

The Iconophile emphasis on the soteriological rather than the christological interpretation of Christ's Death and Resurrection caused the corresponding pictorial cycle of Christ's Death and Resurrection to flourish. The scenes of the Deposition and the Lamentation were added to the late seventh-century pictorial nucleus. The early post-Iconoclastic period also experimented with various pictorial alternatives of the Anastasis, which matured after the end of the ninth century as the third and second types of Anastasis. Similarly, at least one Iconophile party showed extreme willingness to confront the theme of Christ's own Resurrection by producing the theme of the Bodily Rising of Christ from the tomb. But this experiment was rejected by the standard Middle Byzantine iconography, which preferred to limit depiction of Christ's Death and Resurrection to events that had been witnessed by human beings whether alive or dead. So the emphasis on the soteriological interpretation of images in the post-Iconoclastic times helped consolidate and expand the theme of Christ's Death and Resurrection in the pictorial arts of the Middle Byzantine period.

The earliest surviving examples of the Anastasis, which apparently materialized in the latter part of the seventh century as a response to heretical attacks on Orthodox Christology, are characterized by a dramatic iconographic nucleus: Christ has just overthrown the Lord of the Underworld and is concentrating on raising Adam the protoplast out of his sarcophagus. The early examples describe the divinity of Christ and the decisive rapidity of his action, the resistance of the muscular earth god to him, as well as the passivity of Adam, the final objective of all the action. But they consistently exclude various narrative details from the image, such as the topography of the event and the reactions of its secondary actors. The image concentrates on illustrating Christ's person at a moment in the last phase of his Death, when his perfect human soul, united with his perfect divine nature, effected the miracle of the Resurrection after defeating Hades by the power of his divinity, while his perfect human body, united with his divinity, was lying dead in the tomb. This image, therefore, provided solid pictorial proof of the perfect will and energy of Christ's divine nature, as distinguished from the perfect will and energy of his human nature.

Surviving evidence does not allow us to associate the birth of this iconography with any known literary text, since more than one text reflects the core of the image, while the image omits vital elements of the corresponding texts. The pseudo-narrative character of the early representations of the Anastasis, coupled with the church's long familiarity with the story of the siege of Hades, dispensed by the latter part of the seventh century with the need for a continuous narrative. Extended narratives such as the Apocryphon of Nicodemus, and the Holy Saturday Homily of Pseudo-Epiphanius, which are now believed to

[7] Above, 201f.

have spanned the seventh century, could have acted as sources for the image, but did not. On the other hand, polemical texts which used the core of the story of Christ's descent to the underworld, offered in the late seventh century a natural milieu for the invention of this image of Christian triumph.

Surviving evidence broadly confirms that the Anastasis first appeared in the East. But it does not permit the beginnings of the image to be geographically pinpointed. The Roman examples dating from the pontificate of Pope John VII (705–707), and seen as reflections of contemporary Constantinopolitan iconographic and stylistic trends by Nordhagen, are the only evidence for the early eastern representations of the Anastasis. The redating of the Fieschi Morgan Reliquary to the first quarter of the ninth century alters the identification of its Anastasis as a Syro-Palestinian type, which was also known in ca. 700. The Fieschi Morgan Anastasis represents in fact a development of the first type of Anastasis, which is reflected in the early eighth-century examples, a type that continues throughout the Middle Byzantine period in the East and in Italy.

Pictorial antecedents of imperial triumphs probably supplied models for the late seventh-century image, which illustrated the Christian triumph over death. These models, which can be traced back to the fourth century, also reflected imperial practices still in existence in the early eighth century, and thus offered to an extent relevant and acceptable pictorial models for adaptation to the current needs of the Church.

Contrary to the image of the dead Christ on the cross, whose acceptability remained under dispute well into the eleventh century, and to the iconography of the Entombment, which was not canonized as an essential part of the christological cycles of the Middle Byzantine period, the image of the Anastasis was established as a vital part of christological cycles soon after its appearance. The historicity of the event represented was thus consolidated pictorially, though its narrative did not draw on the Gospel narrative. The effectiveness and immediacy of the new image were mainly responsible for its wide acceptance as a pictorial reference to the Resurrection. In contrast to all previous iconographic circumlocutions, the Anastasis included the person of Christ, and could, therefore, give proof of important aspects of the christological doctrine, while affirming the soteriological significance of Christ's Death—his "voluntary humiliation," as Sinaites puts it.[8]

Throughout its subsequent development, the Anastasis continued to be recognized as the pictorialization of a part of the life of Christ, whose historicity was never doubted, even when its pictorial representation was disputed. The theological interpretation of the Anastasis also remained stable, from a christological and a soteriological point of view, though both aspects were elaborated and refined in time.

The early eighth-century examples emphasized the instrumentality of Christ's divinity in the defeat of Hades and the raising of Adam. This potent demonstration of the will and energy of Christ's divinity, which took place when Christ's humanity was divided into body and soul was iconographically balanced by the early ninth century through the ad-

[8] PG, 89.237. 220 / Uthemann, 13.8.93f., 13.5.31.

dition of the motif of David and Solomon as a reference to Christ's humanity, since the presence of the two kings asserted the historical reality of Christ's human ancestry. This statement was reinforced by the addition of many references to Christ's Passion, successfully alluding to the sacrifice of Christ's humanity. The early image, which primarily demonstrated the power of the divinity of the Logos Incarnate, thus asserted in its Middle Byzantine version the historical reality and the passibility of Christ's humanity. The Christology of the standard image of the Anastasis was consciously correct and in full agreement with the doctrine of the two natures.

The soteriology of the early eighth-century iconography of the Anastasis was similarly elaborated and refined during its subsequent development. Both iconographic and compositional means were used to focus the image on the raising of Adam and to interpret this as an act of rescue. To this end, the importance of the struggle between Christ and Hades was iconographically reduced by the early ninth century. Hades either lay flat on the ground incapable of any meaningful resistance to Christ's power, or he was entirely left out. There was also an interest in illustrating unpleasant aspects of Hades. Its darkness was stressed, and it was occasionally identified as Hell by the addition of fires and human *disiecta membra* in the *tenebra* in Italian works. The broken doors, keys, bolts and chains in many eastern representations of Hades from the ninth century on contributed to its recognition as a prison from which Adam was rescued. This prison was located in the dark abyss inside the earth which, by the eleventh century, was shown rent asunder, creating a natural passage through which Christ led Adam out of Hades in a new Exodus out of the land of Pharaoh. The contrapposto of the mature second type demonstrated that Christ personally led the way out of Hades. Thus, the focus of the image shifted once more, this time from the raising of Adam to the rising of Christ himself as the sun of righteousness from death to life.

The shifts of emphasis between the early eighth-century examples, the ninth-century examples of the first type of Anastasis, and the mature Middle Byzantine version of the second type of Anastasis show that the earlier examples concentrate on the christological potential of the image, while its later developments are more interested in its soteriological message. The growing pictorial importance of references to the Passion of Christ supports this idea.

The first allusion to the Passion is seen on the silver reliquary cross of Paschal I (817–824), in which Christ holds a cross. By the end of the ninth century and the beginning of the tenth the cross is a motif known to the first type of Anastasis, though it may be exchanged for the stigmata on Christ's hands. The awkwardness with which Christ handles the cross while trying to lift Adam up in the late ninth-century examples suggests that this symbol was a recent addition. By the eleventh century the cross had become a monumental patriarchal cross and a dominant feature of the standardized image. In this guise it shared the focus of the mature Middle Byzantine image with the figure of the rising Christ, who held it forth as the instrument that helped open the road out of the darkness of Hades.

The addition of the figure of the Baptist and Abel bolstered the allusion to Christ's Passion since they had prophesied and prefigured it.

The post-Iconoclastic image, therefore, demonstrates the rescue of Adam and the rising of Christ while insisting that this was made possible by Christ's Passion. The insistence of Iconophile theorists that the passibility of Christ's humanity ensured the salvation of mankind turned the numerous pictorial references of Christ's Passion in the Anastasis into soteriological guarantees. The theological emphasis of the image shifted from an affirmation of the power of Christ's divinity to an assertion of the doctrine of the two natures. From this christological basis, the image-makers of the Middle Byzantine Anastasis chose to emphasize the Passion of Christ as the instrument of salvation from the bonds of death, focusing on the soteriological content of the image.

The soteriological interpretation lent apocalyptic overtones to the post-Iconoclastic Anastasis, as in the interpretation of the *tenebrae* as Hell and especially in the third type of Anastasis, which portrays the Resurrection as a proto-Judgment. The official linking of the theory of the icon with the doctrine of salvation through incarnation in the Second Council of Nicaea was probably responsible for the prevalence of the soteriological interpretation of the post-Iconoclastic image. The first evidence of this interest is the addition of the motif of David and Solomon, Christ's human ancestry, which first signals the importance of the incarnation for this iconography.

The historical identity of the Anastasis was not canceled by any of the developments of the theological identity of the image. Similarly, the fully developed soteriological message of the eleventh century image in no way contradicted its christological content. While the focus of the image shifted, each of its identities complemented the others, expanding the limits of the iconography. This was also true of the liturgical identity of the image, whose traces are plentiful from the ninth century on, and whose variations reflect the structure of the liturgical functions of the church.

The representation of the Anastasis becomes before the end of the ninth century the feast image for Easter, that is, a pictorial reference to the liturgical celebration of the Anastasis. An effort to understand the dimensions of this identity has to take into account that the modern art historical term "feast image" restricts the liturgical interpretation of christological imagery to one liturgical event. In this instance it restricts the liturgical identity of the image of the Anastasis to the liturgical celebration of Easter. But the miracle of the Resurrection was not only commemorated on Easter Sunday. Its fundamental significance caused its association with many liturgical functions, and this naturally broadened the liturgical potential of the image of the Anastasis.

The use of the Anastasis as a pictogram for the most important feast in the church calendar had a number of consequences. Most important was that the image also came to reflect the liturgical ramifications of this feast. Easter celebrated annually the multifaceted reality of Christ's rising. However, the same event was commemorated in the weekly celebration of the Eucharist. This led to the addition of a sacramental dimension to the iconography, linking it with the Eucharist performed on the altar. The performance of bap-

tism during the Easter Vigil expanded the sacramental aspects of the Anastasis. So the image was integrated into the liturgy of the church as one of the many liturgical expressions of the paschal theme.

In its liturgical guise, the Anastasis was used in church decoration as a pictorial echo of the paschal theme reinforcing its importance in the liturgy and typology of the church. It was similarly used in the liturgical books of the church, and probably its liturgical vestments.[9] However, the Anastasis was not the sole pictorial reference to Easter. Another was the portrayal of prophets, whose readings were used on Holy Saturday and whose role was comparable to the image of the Anastasis, given the proper context. For it is invariably the context that is primarily responsible for defining the liturgical identity of the image. The pairing of the Anastasis with the image of the Baptism offers a balanced view of the two parts of the Easter Vigil. Its pairing with the Crucifixion often serves as a reminder of the yearly and weekly reenactment of Christ's Death and Resurrection during Holy Week and in the liturgy of the Eucharist. Its use as an illustration of texts forming part of the Easter celebration (John 1:1ff., The First Easter Homily of Gregory Nazianzenus, the Paschal hymns of Gregory, Ps. 81:8, etc.) renders it a pictorial reference to Easter, while as an illustration of texts used in celebrating the Eucharist (as with the liturgical rolls) it is a reminder of the paschal theme in the service.

In addition to context, specific iconographic amendments to the image contribute to its liturgical identity, even though they also contribute to its christological and soteriological content. Abel and the Baptist, who allude to Christ as the sacrificial lamb, are particularly apt reminders of the sacramental dimension of the liturgical image; the Baptist in particular, since he can recall the association of the image with the mystery of the Eucharist and the mystery of Baptism. Likewise, all references to Christ's Passion stress the sacramental aspect of the iconography. So, the liturgical identity of the Anastasis and its applications are as broad and various as the use of the paschal theme in major services and functions of the Church. The same is true of the theological content of the image, whose christological and soteriological aspects harmonize with the doctrinal significance of the theme of the defeat of Hades, the raising of Adam and the rising of Christ.

We can see that the iconographic evolution of the Anastasis closely follows that of its multifaceted theological and liturgical identities. The mature Middle Byzantine iconography uses the same basic pictorial vocabulary as the earliest known examples: Christ, Adam, and Hades or his kingdom, and usually—though not necessarily—Eve. It later modifies this vocabulary and its composition, discreetly adding motifs that expand its theological and liturgical potential. However, none of these additions annul the original pictorial vocabulary or revolutionize its appearance or its narrative content. For example, the angelic host which accompanied Christ in the siege of Hades and the well-known distinction between Hades and the Devil do not become part of the iconography of this period, which remains extremely economical, shunning unnecessary narrative flourishes.

[9] Symeon of Thessalonike is probably reflecting earlier practices when he describes the use of the iconography of the Anastasis for the *epigonation*. PG, 155.412, 713, 260, 261.

The historical, theological, and liturgical identities of the image do not produce three images, but three related perspective views of one image. As a result, the modifications and additions to the iconography up to the end of the eleventh century are in agreement with all three identities of the image. For example, all actors added to the pictorial core of the image were already dead at the time of the Anastasis of Adam. The Baptist is the best example. According to tradition, he had been the precursor of Christ not only on earth but in Hades as well. So the iconographer respects the historicity of the paschal theme. The Baptist also complements the image's christological and soteriological content, as well as its eucharistic and baptismal dimensions. In this way, care is taken that the different identities of the image do not contradict or cancel out each other, and along with them the truth of the image. Instead, they are orchestrated into an economical pictorial unit whose pseudo-narrative character responds to the needs of the image's historical, doctrinal, and liturgical aspects. These are integrated into the historical, doctrinal, and liturgical aspects of the paschal theme, which they express pictorially.

The analysis of the birth and growth of the image of the Anastasis does not lead to the identification of three independent interpretations of the iconography. It offers a spectrum analysis of a broad range of interdependent concepts which overlap and form a continuous sequence which can be again synthesized into a uniform entity. The prism through which this entity is processed is the historical, doctrinal, and liturgical reality of the Church itself. These three interdependent expressions of the Church are the context and the clues to the standpoint from which the individual examples of the iconography should primarily be considered. The clues and the context vary with the standpoint from which they should be regarded. As a result, the message of the individual image remains flexible and capable of growth within the framework of the Church's evolution, its interests, its theory and practice, buildings, books, and other relevant aspects.

Although the iconographic core of the Anastasis remains largely static, the image continues its growth, which is integrated into the aims and functions of the Church. By the end of the eleventh century the Anastasis is a pictorial confession to the complex truth of the paschal theme. It becomes an active part of church worship, which after the defeat of Iconoclasm demanded of its followers a "total" confession of faith: with one's reason, heart, mind, and mouth, in writing, and in images. The image transcended its own limits to become an important thread in the fabric of the Church. From this position, the image was entitled to command the respect due to it, as ordained by Iconophile theorists. The key to this development was the liturgical transformation of the iconography, which made paying reverence to the image of the Anastasis as acceptable as celebrating the miracle of the Resurrection, since both fully mirrored the actual event.

The earliest-known traces of the liturgical identity of the Anastasis date from the ninth century. However, the variety of the ninth-century evidence suggests that the trend started earlier. Because of the scarcity of pre-ninth-century examples, there is only indirect evidence to support this hypothesis. This comes from two eighth-century representations of the Crucifixion, the icon at Mount Sinai and the fresco in S. Maria Antiqua from the

time of Pope Zacharias I (741–752).[10] Both these representations (the former depicts Christ dead, and the latter alive, on the cross) show streams of blood and water issuing from Christ's wound. This iconographic detail has sacramental overtones. It reflects the mixing of wine with water in the eucharistic chalice, a ritual that was insisted upon in Canon 32 of the Trullan Council.[11] The presence of this liturgical allusion in the first representation of the Crucifixion which depicts Christ dead on the cross encourages the hypothesis that the iconography of the Anastasis also started exploring its liturgical potential during the eighth century, given that both the representation of the Anastasis and Christ dead on the cross were parallel responses to comparable contemporary church problems. Encouraging this interpretation is the fact that the story represented by the Anastasis had been popularized through liturgical, homiletical, and hymnological channels before its acceptance by the art of the church. The inference is that the broad approval of this subject in the liturgical context of the church was apparently responsible for admitting this extra-canonical theme into christological cycles—the first of the kind to be officially accepted.

We can interpret the use of the Anastasis in christological cycles as the first tangible evidence of the opening up of the cycle to liturgical influences. This is not to say that the Anastasis enters christological cycles as a "feast image," but only to suggest that its acceptance as an organic part of the christological cycle implies the opening of the cycle to influences based on and distilled through the services of the church. If this is so, the presence of the Anastasis in christological cycles of the early eighth century, coupled with the sacramental overtones present in the roughly contemporary representation of the Death of Christ on the cross, suggests that the christological cycle began to experiment with the liturgical potential of individual scenes in the eighth century. The fact that the iconography of the dead Christ on the cross met with a different degree of acceptance from that of the Anastasis and continued to be disputed well into the eleventh century cannot alter the evidence of its earliest examples, which date from the eighth century. It does, however, suggest that the liturgical transformation of the christological cycle was not the result of a single programmatic effort, but the cumulative result of experimentation with individual scenes.

The study of the historiated reliquaries of the ninth century and the Church of Zaoutzas has, furthermore, permitted interesting observations about the development of christological cycles. These works establish that the ninth century used an abbreviated christological cycle whose subject selection makes it a link between the synoptic christological cycles of the seventh century and the standard Middle Byzantine feast cycle. In effect, the latter is also a synoptic christological cycle, whose selection of scenes is guided by broad liturgical consideration, which can vary from case to case. While aspects of the ninth-century cycles similarly reflect the liturgical identity of some of its individual scenes, it has not been possible to trace comparable features in the seventh-century abbreviated cycles, though both seventh- and ninth-century versions are invested with phylacteric and exorcistic powers. Moreover, all three cycles exclude the miracles of Christ from their reper-

[10] Weitzmann, *Sinai Icons*, I, no. B.36, p. 63 n. 8 with previous bibliography.
[11] Mansi, 11.956f.

toire, concentrating on themes from the Infancy and the Passion of Christ. A separate study of the ninth-century cycles presented elsewhere, will contribute to the understanding of the process of evolution and liturgical transformation of the synoptic christological cycles from the seventh to the eleventh centuries.

The iconography of the Anastasis has proven to be an organic product of the needs of the Church to defend and define itself. The development of its outward pictorial features is also interwoven with the development of the aims and principles of the Church. By the turn to the twelfth century, the image had been integrated into the complex reality of the paschal theme, demonstrating its historical, theological, and liturgical truth by pictorial means. The result was both simple and complex, thanks to the economical pictorial vocabulary of the Anastasis. For the untutored Christian, it was a potent illustration of Christ's willingness and ability to perform the miracle of the Resurrection, the act which promised redemption for everyone, the spectator included. For the learned theologian, the representation of the Anastasis was also a microcosmic and macrocosmic review of the christological and soteriological doctrines as well as the services of the Church which encapsulated them. Indeed, the commensurability—the symmetria—of all aspects of the mature Middle Byzantine Anastasis prove it to be a rich, sophisticated intellectual product of Byzantine art employing a deceptively frugal pictorial vocabulary, which, nevertheless, rendered the image meaningful and attractive to Christians on all levels.

BIBLIOGRAPHY

PRIMARY SOURCES

Adversus Constantinum Cabalinum. PG, 95.309–344.

Agathangelos. *History of the Armenians.* R. W. Thomson, trans. and comment (Albany, 1976).

—— *La version grecque ancienne du livre arménien d'Agathange.* G. Lafontaine, ed. (Louvain-la-Neuve, 1973).

Anastasius Sinaites. *Hodegos.* PG, 89.35–310.

—— *Anastasii Sinaitae Opera. Viae Dux.* K. H. Uthemann, ed., comment. *CChr. Series Graeca* 8 (Turnhout, 1981).

—— "Die dem Anastasios Sinaites zugeschriebene Synopsis de haeresibus et synodis." K. H. Uthemann, *Annuarium Historiae Conciliorum*, 14 (1982), 58–95.

—— *Quaestiones.* PG, 89.311–824.

—— *Sermo* I. PG, 44.1328–1345.

—— *Sermo* III. PG, 89.1151–1180.

Andreas Cretensis. *In exaltationem S. Crucis* I. PG, 97.1017–1036.

—— *In ramos palmarum.* PG, 97.985–1018.

Anthologia graeca. H. Stadtmüller, ed. (Leipzig, 1906).

Anthologia graeca carminum christianorum. W. Christ, M. Paranikas, eds. (Leipzig, 1871).

Athanasius. *De incarnatione. Contra Apollinarium* I, II. PG, 26.1093–1132, 1131–1166.

—— *Expositio in psalmos.* PG, 28.59–546.

Basilius. *Exhortatoria ad sanctum baptismo.* PG, 31.423–442.

Bibliotheca Hagiographica Graeca. F. Halkin, ed. (Brussels, 1957).

Choricius. *Laudatio Marciani.* R. Foerster, ed. (Leipzig, 1929).

Constantinus VII Porphyrogenitus. *De administrando imperio.* F. Dvornik, R.J.H. Jenkins, B. Lewis, Gy. Moravcsik, D. Obolensky, S. Runciman, eds. and trans. (London, 1962–1967).

—— *De ceremoniis aulae bizantinae.* CSHB. J. J. Reiske, I. Bekker, eds. (Bonn, 1829–1840).

—— *Le livre de cérémonies.* A. Vogt, ed. (Paris, 1935–1940).

Corpus Scriptorum Historiae Byzantinae. Niebuhr, ed. (Bonn, 1827ff.).

Cosmas Indicopleustes. *Topographie Chrétienne.* W. Wolska-Conus, ed. and trans. (Paris, 1968–1973).

Cosmas Maioumensis or Melodos. *Canon in S. Sabbato.* PG, 98.485–488.

Cyrillus Hierosolymitanus. *Catechesis* IV. PG, 33.453–504.

—— *Catechesis* XIV. PG, 33.825–866.

—— *Catechesis* XVIII. PG, 33.1017–1060.

Demetrakos, D. Μέγα Λεξικὸν τῆς Ἑλληνικῆς Γλώσσης (Athens, 1954–58).

Denys de Fourna. *Manuel d'iconographie chrétienne.* A. Papadopoulos-Kerameus, ed. (St. Petersburg, 1909).

De sacris aedibus Deiparae ad Fontem. ASS. November III, 878ff.

Du Cange, D., Du Fresne, C. *Glossarium ad scriptores mediae et infimae Graecitatis* (Lyons, 1638) I–II.

Ephraem Syrus. *Des heiligen Ephraem des Syrers Carmina Nisibena.* E. Beck, ed. and trans. CSCO 241. *Scriptores Syri* 103 (Louvain, 1963).

Epiphanius. *In die resurrectionis Christi.* PG, 43.465ff.

Eusebius Alexandrinus. *De adventu et annuntiatione Joannis apud inferos.* PG, 86/1.509–525.

—— *De baptismo. De Mt. 11.3.* PG, 86/1.371–384.

—— *In diabolum et orcum. Spicilegium Romanum.* A. Mai, ed. (Rome, 1843), 696–703.

—— *In triduanum resurrectionem Domini.* PG, 50.821–824.

—— *In venerabilem crucem.* PG, 50.815–820.

—— Περὶ τῆς παρουσίας Ἰωάννου εἰς τὸν Ἅδην καὶ τῶν ἐκεῖ ὄντων. *Spicilegium Romanum.* A Mai, ed. (Rome, 1843), 688–692.

Evangelia Apocrypha. C. de Tischendorf, ed. (Leipzig, 1853), 266–311.

—— *The Apocryphal New Testament.* M. R. James, trans. (Oxford, 1971), 111–146.

Follieri, H. *Initia hymnorum ecclesiae graecae.* ST 211–215 (Vatican, 1960–1966).

Genesius. *Regna.* CSHB. C. Lachmann, ed. (Bonn, 1834), 117–146.

Georgius Nicomediensis. *In SS. Mariam assistentem cruci.* PG, 100.1457–1490.

Georgius Pisida. *In Christi resurrectionem.* PG, 92.1373–1384.

—— *Hymnus Acathistus.* PG, 92.1348–1372.

Germanus. *In Dominici corporis sepulturam.* PG, 98.244–290.

Germanus I, patr. *Epistola Germani beatissimi, qui fuit patriarcha Constantinopoleos, ad Joannem episcopum Synadensem.* PG, 98.156–162.

—— *Historia ecclesiastica et mystica contemplatio.* PG, 98.383–454.

Gouillard, J. "Aux origines de l'iconoclasme: Le témoignage de Grégoire II?" *TM,* 3 (1968), 243–307.

Gregorius II, papas. *De sacris imaginibus, Epistola prima ad Leonem Isaurum imperatorem.* Mansi, 12.959–974.

—— *De sacris imaginibus. Epistola secunda ad Leonem Isaurum imperatorem.* Mansi. 12.975–982.

—— *Epistola Gregorii sanctissimi papae Romani ad sanctissimum Germanum qui fuerat patriarcha Constantinopoleos.* Mansi, 13.91–100 and PG, 98.148–156.

Gregorius Nazianzenus. *Oratio* I. *In Sanctum Pascha et in tarditatem.* PG, 35.396–401.

—— *Oratio* XLV. *In Sanctum Pascha.* PG, 36.624–664.

Gregorius Nyssenus. *Adversus Apollinarem.* PG, 43.1123–1278.

—— *De anima et resurrectione.* PG, 46.11–160.

Hesychius. *Fragmenta in psalmos.* PG, 93.1179–1340.

Hippolytus, *Liber adversus graecos.* PG, 10.795–802.

Itinera et descriptiones Terrae Sanctae. T. Tobler, ed. (Geneva, 1877).

Joannes Damascenus, *De fide orthodoxa.* PG, 94.789–1228.

—— *De haeresibus.* PG, 94.677–780.

—— *De his qui in fide dormunt.* PG, 95.247–278.

—— *De hymno trisagio.* PG, 95.22–63.

—— *De imaginibus* III. PG, 94.1317–1420.

—— *Easter Canon.* PG, 96.840–844.

—— *In nativitatem b. v. Mariae* II. PG, 96.679–698.

—— *In Sabbatum Sanctum.* PG, 96.601–644.

—— *In Sanctam Paraskeven.* PG, 96.589–600.

Joannes Geometres. *Carmina.* PG, 106.901–1002.

Joannes Mauropous Euchaita. *Versus iambici in magnas festorum tabulas.* PG, 102.1119–1200.

Kedrenus, Georgius. *Historiarum Compendium*. CSHB. I. Bekker, ed. (Bonn. 1838).

Kriaras, E. Λεξικὸ τῆς Μεσαιωνικῆς Ἑλληνικῆς καὶ δημώδους γραμματείας. (Thessalonike, 1968ff.).

Lampe, G. W. *A Patristic Greek Lexicon* (Oxford, 1968).

Leo VI, imp. *Oratio* IX. *In exaltationem sanctae crucis*. PG, 107.88–96.

—— *Oratio* X. *In Dominicam resurrectionem*. PG, 107.96–113.

—— *Oratio* 34. Λέοντος τοῦ Σοφοῦ πανηγυρικοὶ λόγοι. Akakios, ed. (Athens, 1868), 274–280.

Leontius Byzantinus. *De sectis*. PG, 86/1.1193–1268.

Liddell, H. G. and Scott, R. *A Greek-English Lexicon* (Oxford, 1968).

Mango, C. *The Art of the Byzantine Empire 312–1453*. Sources and Documents: The History of Art Series (Englewood Cliffs, 1972).

Mansi, J. D. *Sacrorum conciliorum nova et amplissima collectio*. (Florence and Venice, 1759–1798).

Mateos, J. *Le Typicon de la Grande Eglise*. OCA 165, 166. (Rome, 1962 and 1966).

Maximus Confessor. *Ad theologiam et oeconomiam*. PG, 90.1083–1176.

Μέγας Συναξαριστής. Ἀπρίλιος. K. Doukakis, ed. (Athens, 1892).

Michael Psellus. *Scripta Minora*. E. Kurtz, ed. (Milan, 1946).

Nicephorus I, patr. *Antirrheticus* III. PG, 100.375–534.

—— *Chronographia Brevis*. CSHB. C. de Boor, ed. (Leipzig, 1880).

—— *Epistola ad Leonem III Papam*. PG, 100.169–200.

Nicetas David Paphlagon. *Oratio* VI. *In laudem S. Joannis Evang*. PG, 105.99–128.

The Odes of Solomon. J. H. Charlesworth, ed. and trans. (Oxford, 1973).

Offermans, D. *Der Physiologus nach den Handschriften G und M* (Meisenheim am Glan, 1966).

Opuscula Moralia. De festo Akathisto. PG, 106.1335–1354.

Origenes. *Exegetica in psalmos*. PG, 12.1053–1686.

Patrologia cursus completus. Series graeca. J. P. Migne, ed. (Paris, 1857ff.).

Πεντηκοστάριον χαρμόσυννον. (Rome, 1883).

Photius, patr. *Ad Amphilochium quaestiones*. PG, 101.1–324.

—— *The Homilies of Photius Patriarch of Constantinople*. C. Mango, ed. and trans. (Cambridge, 1958).

—— Φωτίου ὁμιλίαι. B. Laourdas, ed. (Thessalonike, 1959).

Proclus. *In Paraskeven*. PG, 65.781–788.

—— *In S. Pascha*. PG, 65.788–796.

—— *In S. Pascha*. PG, 65.800–805.

Procopius. *De aedificiis*. CSHB.

—— *De bello persico*. CSHB.

Pseudo-Athanasius. *De titulis psalmorum*. PG, 27.649–1344.

Pseudo-Chrysostom. *De sacrificiis Caini*. PG, 62.719–722.

—— *In S. Pascha*. PG, 59.721–724.

—— *In S. Paraskeven*. PG, 62.721–724.

Pseudo-Epiphanius. *In Sancto et Magno Sabbato*. PG, 43.439–464.

—— *Epiphanii Episcopi Constantiae Opera*. G. Dindorfius, ed. (Leipzig, 1862).

—— "L'homélie d'Epiphane sur l'ensevelissement du Christ." A. Vaillant, ed. *Radovi Starosjavenskog Instituta Knjiga*, 3 (Zagreb, 1958), 1–101.

Pseudo-Codinus. *Traité des offices*. A. Verpeaux, ed. (Paris, 1966).

Ralles, G. A. and Potles, M. Σύνταγμα τῶν θείων καὶ ἱερῶν κανόνων. (Athens, 1852–1859).

Romanos Melodos. *Canticum* XVI. *De passione. Canticum* VIII. *De crucis triumpho. Canticum* XVI. *De Virgine juxta crucem.* In *Analecta Sacra. Spicilegio Solesmensi.* J. Pitra, ed. (Paris, 1876), I, 116ff., 53ff.

Schaff, Ph. and Wace, H. *A Select Library of Nicene and Post Nicene Fathers* (Grand Rapids, 1955), VII.

Socrates. *Historia Ecclesiastica.* PG, 67.30–842.

Sophronios Eustratiades, Leontopoleos. Ἡ ἀκολουθία τοῦ Μεγάλου Σαββάτου καὶ τὰ μεγαλυνάρια τοῦ ἐπιταφίου." Νέα Σιών, 33 (1938), 370–377.

—— Ἡ Θεοτόκος ἐν τῇ ὑμνογραφίᾳ. (Paris, 1930).

—— " Ὁ ἅγιος Ἰωάννης ὁ Δαμασκηνὸς καὶ τὰ ποιητικὰ αὐτοῦ ἔργα." Νέα Σιών, 27 (1932), 28–45.

Suidae Lexicon. A. Adler, ed. (Leipzig, 1928).

Symeon Thessalonicensis. *De sacra liturgia.* PG, 155.253–304.

Synaxarium Urbis Constantinopolitanae. H. Delehaye, ed. (Brussels, 1902).

"Le Synodikon de l'Orthodoxie. Edition et commentaire." J. Gouillard, ed. and trans., *TM*, 2 (1967), 1–317.

Theodoretus Cyrensis. *Interpretatio in psalmos.* PG, 80.857–1998.

Theodorus Aboucaras. *Opuscula.* PG, 97.1457–1610.

Theodorus Studita. *Antirrheticus* III. PG, 99.389–436.

—— *Canon in Stavroproskynesem.* PG, 99.1757–1768.

—— *Iambi.* PG, 99.1779–1812.

—— *In dormitionem Deiparae.* PG, 99.720–729.

—— *In Sanctum Pascha.* PG, 99.709–720.

—— *In Stavroproskynesem.* PG, 99.629–700.

—— *Quaestiones.* PG, 99.1729–1734.

—— *Refutatio poematum iconomachorum.* PG, 99.435–478.

Theophanes Continuatus. *Chronographia.* CSHB. I. Bekker, ed. (Bonn, 1838).

Triodion Katanytikon (Rome, 1879).

Usener, H. *Kleine Schriften* (Berlin, 1913), IV.

Vita S. Pancratii, ep. Tavromenii. A. N. Veselovskij, ed. *Iz istorii romana i povesti,* I. *Sbornik otdělenija russkago jazyka i slovesnosti imperatorskoj Akademii Nauk.,* 40/2 (1886).

SECONDARY SOURCES

Age of Spirituality. K. Weitzmann, ed. (New York, 1979)

Age of Spirituality: A Symposium. K. Weitzmann, ed. (New York, 1980).

Ahrweiler, H. *L'idéologie politique de l'empire byzantin* (Paris, 1975).

Alexander, J.J.G. *Insular Manuscripts* (London, 1975–1978).

Alexander, P. J. "The Iconoclastic Council of St. Sophia (815) and Its Definition (Horos)." *DOP*, 7 (1953), 35–67.

Alexiou, M. "The Lament of the Virgin in Byzantine Literature and Modern Greek Folk-Song." *Byzantine and Modern Greek Studies,* 1 (1975), 111–141.

—— *The Ritual Lament in Greek Tradition* (Cambridge, 1974).

Altaner, B. *Patrology* (London, 1960).

Amiranachwili, Ch. *Les émaux de Géorgie* (Paris, 1962).

—— *Georgian Metalwork from Antiquity to the 18th Century* (London, 1971).

—— *The Khakhuli Triptych* (Tiflis, 1972). (In Georgian).

Anderson, J. G. "The Date and Purpose of the Barberini Psalter." *CA*, 31 (1983), 35–67.

Andreescu, I. "Torcello. I, Le Christ inconnu. II, Anastasis et Jugement Dernier: têtes vraies, têtes fausses." *DOP*, 26 (1972), 183–223.

—— "Torcello. III, La chronologie relative des mosaiques pariétales." *DOP*, 30 (1976), 245–345.

L'art byzantin-Art européen (Athens, 1964).

Avery, M. *The Exultet Rolls of South Italy* (Princeton, 1936).

Babić, G. "Observations sur le cycle des grandes fêtes de l'église de Pološko (Macédoine)." *CA*, 27 (1978), 163–178.

Barag, D. "Glass Pilgrim Vessels from Jerusalem." *JGS* 13 (1971), 45–64.

Barasch, M. "The David Mosaic at Gaza." *Eretz Israel*, 10 (1971), 94–99. (In Hebrew).

Bauer, M. "Die Ikonographie der Höllenfahrt Christi von ihren Anfängen bis zum 16. Jahrhundert." Dissertation, Göttingen, 1948.

Baumstark, A. "Bild und Lied des christlichen Ostens." *Festschrift zum sechzigsten Gebürtstag von Paul Clemen. 31. Oktober 1926.* (Bonn. 1926).

—— "Eine syrisch-melchitische Allerheiligenlitanei." *OrChr*, 4 (1904), 98–120.

—— *Geschichte der syrischen Literatur* (Bonn, 1922).

—— "Palaestinensia." *RQ*, 20 (1906), 123ff.

"Bayerische Frömmigkeit. 1400 Jahre christliches Bayern." *Das Münster*, 13 (1960), 158ff.

Beck, H. G. *Kirche und theologische Literatur im byzantinischen Reich* (Munich, 1969).

Beckwith, J. "Another Late Sixth Century Byzantine Rock Crystal." *Zograph*, 10 (1979), 11–12.

—— *The Art of Constantinople* (London, 1961).

—— *Late Antique and Byzantine Art in the Victoria and Albert Museum* (London, 1963).

—— "Some Early Byzantine Rock Crystals." *Studies in Memory of David Talbot Rice.* G. Robertson and G. Henderson, eds. (Edinburgh, 1975), 1ff.

Bekatoros, G. "Σταυρός." Θρησκευτικὴ καὶ Ἠθικὴ Ἐγκυκλοπαιδεία (Athens, 1967), XI, 435ff.

Belting, H. *Die Basilica dei SS. Martiri in Cimitile und ihr frühmittelalterlicher Freskenzyklus* (Wiesbaden, 1962).

—— *Studien zur beneventanischen Malerei* (Wiesbaden, 1968).

—— "Zum Palatina-Psalter des 13. Jahrhunderts." *Festschrift Otto Demus. JÖB*, 21 (1972), 17–39.

—— and Belting-Ihm, C. "Das Kreuzbild im Hodegos des Anastasius Sinaites." *Tortulae. RQ*, Suppl. 30 (Rome, 1966), 30–39.

—— and Cavallo, G. *Die Bibel des Nicetas* (Wiesbaden, 1979).

Berliner, R. "A Palestinian Reliquary Cross of about 590." *Museum Notes. Museum of Art. Rhode Island School of Design, Providence*, 9/3 (March, 1952).

Bertonière, G. *The Historical Development of the Easter Vigil. OCA* 193 (Rome, 1972).

Bettini, S. *Venezia e Bizanzio* (Venice, 1974).

Biblioteca Apostolica Vaticana, Museo Sacro. Guida 1. *L'arte bizantina nel medioevo* (Rome, 1935).

Birchler, L. "Zur karolingischen Architektur und Malerei in Münster-Müstair." *Frühmittelalterliche Kunst in den Alpenländern. Akten zum III. Internationalen Kongress für Frühmittelalterforschung* (Lausanne, 1954).

Boinet, A. *La miniature carolingienne* (Paris, 1920).

Bouras, Ch. "Die Insel Chios." *Alte Kirchen und Klöster-Griechenlands*. E. Melas, ed. (Cologne, 1972), 244–251.

—— Ἡ Νέα Μονὴ τῆς Χίου (Athens, 1981).

Bovini, G., "Osservazioni su un cammeo bizantino dei 'Kunsthistorisches Museum' di Vienna," *Atti 1. Congr. Naz. Studi Bizantini. Ravenna 1965* (Ravenna, 1966), 39–42.

—— and Brandenburg, H. *Rom und Ostia. Repertorium der christlich-antiken Sarkophage*. F. W. Deichmann, ed. (Wiesbaden, 1967).

Bréhier, L. "Les peintures du rouleau liturgique no. 2 du monastère de Lavra." *SemKond*, 11 (1940), 1–20.

Brendel, O. "The Origin and Meaning of the Mandorla." *GBA*, 25 (1944), 5ff.

Brenk, B. *Tradition und Neuerung in der christlichen Kunst des ersten Jahrtausends* (Vienna, 1966).

—— "Zum Bildprogram der Zenokapelle in Rom." *AEspA*, 45–47 (1972–1974), 213–221.

Brubaker, L. "The Illustrated Copy of the *Homilies* of Gregory of Nazianzus in Paris (Bibliothèque Nationale, cod. gr. 510)." Ph.D. Dissertation, Johns Hopkins University, 1982.

—— "Photios, Paris gr. 510 and the Role of Art in the Second Half of the Ninth Century." *Eighth Annual Byzantine Studies Conference. Abstracts of Papers* (Chicago, 1982), 49–50.

Brunetti, M., Bettini, S., Forlati, F., Fiocco, G. *Torcello* (Venice, 1940), 112ff.

Buchthal, H. "The Exaltation of David." *JWarb*, 37 (1974), 330–333.

—— *Miniature Painting in the Latin Kingdom of Jerusalem* (Oxford, 1957).

—— *The Miniatures of the Paris Psalter* (London, 1938).

—— *The "Musterbuch" of Wolfenbüttel and Its Position in the Art of the Thirteenth Century* (Vienna, 1979).

Buchwald, W., Hohlweg, A., Prinz, O. *Tusculum Lexikon* (Hamburg, 1974).

Buckton, D. "The Oppenheim or Fieschi-Morgan Reliquary in New York and Antecedents of Middle Byzantine Enamels," *Eighth Annual Byzantine Studies Conference. Abstracts of Papers* (Chicago, 1982), 35–36.

Cabrol, F. *Les origines liturgiques* (Paris, 1906).

—— and de Meester, A. "Descente du Christ aux enfers." *DACL*, iv.1, 682–696.

Canivet, M.-T., and P. "La mosaique d'Adam dans l'église syrienne de Huarte." *CA*, 25 (1975), 49–71.

Cavallo, G. *Rotollo di Exultet dell' Italia Meridionale* (Bari, 1973).

Cecchelli, C. "Il tesoro del'Laterano. ii. Oreficerie, argenti, smalti." *Dedalo*, 7 (1926–1927), 138–166, 231–254.

—— Furlani, G., and Salmi, M. *The Rabula Gospels* (Olten and Lausanne, 1959).

Chatzidakis, M. "A propos de la date du fondateur de Saint Luc." *CA*, 19 (1969), 127–150.

—— "Athen und Umgebung. Attika und Böotien." *Alte Kirchen und Klöster Griechenlands*. E. Melas, ed. (Cologne, 1972), 182–190.

—— "L'évolution de l'icone aux 11e–13e siècles et la transformation du templon." *XVe CIEB. Rapports et co-rapports* iii. *Art et Archéologie* (Athens, 1976).

—— "Précisions sur le fondateur de Saint-Luc." *CA*, 22 (1972), 87–89.

—— Djurić, V., and Lazovic, M. *Les icones dans les collections suisses* (Bern, 1968).

Chrysos, E. K. "Νεώτεραι ἔρευναι περὶ Ἀναστασίων Σιναϊτῶν." Κληρονομία, 1 (1969), 121–144.

Ciampini, I. *De sacris aedificiis a Constantino Magno constructis* (Rome, 1963).

Cormack, R. "Byzantine Cappadocia: The Archaic Group of Wall Paintings." *The Journal of the British Archaeological Association*, 30 (1967), 19–36.

Cottas, V. *Le théâtre à Byzance* (Paris, 1931).

Cutler, A. "The Marginal Psalter of the Walters Art Gallery: A Reconsideration." *JWAG*, 35 (1977), 37–62.

—— *Transfigurations. Studies in the Dynamics of Byzantine Iconography* (University Park, Pa., 1975).

Dalton, O. M. *Byzantine Art and Archaeology* (Oxford, 1911).

—— and Fry, R. *Byzantine Enamels in Mr. Pierpont Morgan's Collection* (London, 1912).

Davis-Weyer, C. "Die ältesten Darstellungen der Hadesfahrt Christi, des Evangelium Nikodemi und ein Mosaik der Zeno-Kapelle." *Roma e l' età Carolingia* (Rome, 1976), 183–194.

Dawson, Ch. *The Making of Europe* (Cleveland, 1962).

De Frankovich, G. "Il ciclo pittorico della chiesa di San Giovanni a Münster (Müstair) nei Grigioni." *ArtLomb*, 2 (1956).

Deichmann, E. W. *Ravenna* (Wiesbaden, 1974).

Demus, O. *Byzantine Mosaic Decoration* (London, 1948).

—— *The Church of San Marco* (Washington, D.C., 1960).

—— *The Mosaics of Norman Sicily* (London, 1949).

—— and Hirmer, M. *Romanische Wandmalerei* (Munich, 1968).

—— "Studies among the Torcello Mosaics, I; II; III." *The Burlington Magazine*, 82 (1943), 132–141; 84–85 (1944), 41–44 and 195–196.

Der Nersessian, S. "An Armenian Version of the Homilies on the Harrowing of Hell." *DOP*, 5 (1954), 203–224.

—— *L'art Arménien* (Geneva, 1977).

—— "Le décor des églises du IXe siècle." *VIe CIEB. Acts* (Paris, 1951), 315–320.

—— *L'illustration des psautiers grecs du Moyen Age*, II. *Londres Add. 19352*. Bibliothèque des Cahiers Archéologiques, 5 (Paris, 1970).

—— "L'illustration du stichéraire du monastère de Koutloumous no. 412." *CA*, 26 (1977), 137–144.

—— "The Illustrations of the Homilies of Gregory of Nazianzus: Paris Gr. 510. A Study of the Connection between Text and Image." *DOP*, 16 (1962), 195–229.

—— "Program and Iconography of the Frescoes of the Parekklesion." *The Kariye Djami* (Princeton, 1975), IV, 320ff.

De Wald, E. T. *The Illustrations in the Manuscripts of the Septuagint*. Volume III. *Psalms and Odes*. Part I: *Vaticanus graecus 1927* (Princeton, 1941).

—— *The Illustrations in the Manuscripts of the Septuagint*. Volume III. *Psalms and Odes*. Part 2: *Vaticanus graecus 752* (Princeton, 1942).

—— *The Illustrations of the Utrecht Psalter* (Princeton, 1932).

—— *The Stuttgart Psalter* (Princeton, 1930).

Dictionnaire d'archéologie chrétienne et de liturgie. Cabrol, F. Leclercq, H., Marrou, H., et al. (1907–1953).

Diehl, Ch. "Notice sur deux manuscrits à miniatures de la Bibliothèque de Messine." *MélRome*, 8 (1880), 309–322.

Diez, E. and Demus, O. *Byzantine Mosaics in Greece* (Cambridge, 1931).

Dix, G. *The Shape of the Liturgy* (London, 1964).

Dölger, F. "Byzantine Literature." *The Cambridge Medieval History* IV. *The Byzantine Empire*. Part II: *Government and Civlization*. J. M. Hussey, ed. (Cambridge, 1967), 207–263.

Dončeva-Petkova, L. "Croix d'or-reliquaire de Pliska." *Culture et art en Bulgarie Médiévale (VIIIe–XIVe siècle)*. *Bulletin de l'Institut d'Archéologie*, 35 (1979), 74–91.

—— "Croix en bronze de Vraca." *Arheologija*, 17/2 (1975), 60–65.

Dontcheva, L. "Une croix pectorale-reliquaire en or récemment trouvée à Pliska." *CA* 25 (1976), 59–66.

Du Cange, Ch. *Familiae Augustae Byzantinae* (Paris, 1680).

Dufrenne, S. *L'illustration des psautiers grecs du Moyen Age* I. *Pantocrator 61, Paris Grec 20, British Museum 40731*. Bibliothèque des Cahiers Archéologiques, I (Paris, 1966).

—— *Les illustrations du Psautier d' Utrecht* (Paris, n.d.).

—— *Tableaux synoptiques de 15 psautiers médiévaux* (Paris, 1978).

Dvornik, F. "The Patriarch Photius and Iconoclasm." *DOP*, 7 (1953), 67–99.

Early Christian and Byzantine Art. An Exhibition Held at the Baltimore Museum of Art. Organized by the Walters Art Gallery (Baltimore, 1947).

Ebersolt J. "Sculptures chrétiennes inédites du musée de Constantinople." *RA*, 21 (1913), 333–339.

Elbern, V. *Der eucharistische Kelch im frühen Mittelalter* (Berlin, 1964).

—— "Ein frühchristliches Kultgefäss aus Glas in der Dumbarton Oaks Collection." *JbBerlMus*, 4 (1962), 17–41.

—— "Neuerworbene Bronzebildwerke in der frühchristlich-byzantinischen Sammlung," *JbBerlMus*, 20 (1970), 2–16.

—— "Zur Morphologie der bronzenen Weihrauchgefässe aus Palästina," *AEspA*, 45–47 (1972–1974), 447–462.

Eleopoulos, N. Ἡ βιβλιοθήκη καὶ τὸ βιβλιογραφικὸν ἐργαστήριον τῆς Μονῆς τῶν Στουδίων (Athens, 1967).

Enaud, F. "Découverte d'objets et de reliquaires à Saint-Michel d'Aiguilhe (Haute-Loire)." *Monuments Historiques de la France*, 7 (1961), 136ff.

Engemann, J. "Palästinensische Pilgerampullen im F. J. Dölger Institut in Bonn." *JbAChr*, 16 (1973), 5–27.

—— "Zu den Apsis–Tituli des Paulinus von Nola." *JbAChr*, 17 (1974), 21–47.

Epstein, A. Wharton. "The Rebuilding and Redecoration of the Holy Apostles in Constantinople: A Reconsideration." *GRBS*, 23 (1982), 79–92.

Estopañán, S. C. *Skyllitzes Matritensis* (Barcelona, 1965).

L'exposition Charlemagne. Oeuvre, rayonnement et survivances (Aix la Chapelle, 1965).

Flemming, J. *Byzantinische Schatzkunst* (Berlin, 1979).

Forsyth, G. H., Weitzmann, K., Ševčenko, I., Anderegg, K. *The Monastery of St. Catherine at Mount Sinai. The Church and Fortress of Justinian* (Ann Arbor, n.d.), I.

Frazer, M. E. "Hades Stabbed by the Cross of Christ." *Metropolitan Museum Journal*, 9 (1974), 153–161.

Frolow, A. "Le culte de la relique de la Vraie Croix à la fin du VIe– au début du VIIe siècles." *Byzantinoslavica*, 22 (1961), 320–339.

—— "Deux églises byzantines d'après des sermons peu connus de Léon VI le Sage." *EtByz*, 3 (1945), 43–91.

—— "Le médaillon byzantin de Charroux." *CA*, 16 (1966), 39–50.

—— *Les reliquaires de la Vraie Croix* (Paris, 1965).

——— *La relique de la Vraie Croix.* AOC 7 (Paris, 1961).

Frühchristliche Kunst aus Rom. 3. September bis 15. November 1962 in Villa Hügel. Essen (Exhibition Catalogue).

Galavaris, G. *The Illustration of the Liturgical Homilies of Gregory Nazianzenus* (Princeton, 1969).

Gardner, A. *Theodore of Studium* (London, 1905).

Garrucci, P. R. *Storia dell'arte cristiana nei primi otto secoli della chiesa* (Prato, 1872–1880).

Gauthier, M. M. *Emaux du Moyen Age* (Fribourg, 1972).

Gerke, F. "Die Zeitbestimmung der Passionssarkophage." *Archaeol. Ertesitö,* 52 (1949), 1–130.

Gero, S., *Byzantine Iconoclasm during the Reign of Constantine V.* CSCO 384. Subsidia 52 (Louvain, 1977).

Gilson, J. P. *An Exultet Roll Illuminated in the XIth Century at the Abbey of Montecassino* (London, 1929).

Giovannini, L., ed. *Arts de Cappadoce* (Geneva, 1971).

Giunta, D. "I mosaici dell'arco absidale della basilica dei SS. Nereo e Archilleo e l'eresia adozionista del sec. VIII." *Roma e l' età Carolingia* (Rome, 1976), 195ff.

Görres, F. "Justinian II und das römische Papstum." *BZ,* 17 (1908), 440–450.

Goldschmidt, A. *Die deutsche Buchmalerei* (Munich, 1928).

——— Die Elfenbeinskulpturen aus der Zeit der karolingischen und sächsischen Kaiser (Berlin, 1914–1926).

——— and Weitzmann, K. *Die byzantinischen Elfenbeinskulpturen des X.–XIII. Jahrhunderts* (Berlin, 1930–1934).

Grabar, A. *Ampoules de Terre Sainte* (Paris, 1968).

——— *Christian Iconography* (Princeton, 1968).

——— *L'empereur dans l'art byzantin* (Paris, 1936).

——— "Essai sur les plus anciennes représentations de la 'Résurrection du Christ.' " *MonPiot,* 63 (1980), 105–41.

——— "La fresque des Saintes Femmes au tombeau à Dura." *L'art de la fin de l'Antiquité et du Moyen Age* (Paris, 1968), I, 517ff.

——— *L'iconoclasme byzantin* (Paris, 1957).

——— *Martyrium* (Paris, 1943–1946).

——— *Les miniatures du Grégoire de Nazianze de l'Ambrosienne (Ambrosianus 49–50)* (Paris, 1943).

——— *Les peintures de l'évangéliaire de Sinope (Bib. Nat., suppl. gr. 1286)* (Paris, 1948).

——— "La précieuse croix de Lavra Saint-Athanase au Mont-Athos." *CA,* 19 (1969), 99–125.

——— "Quelques notes sur les psautiers illustrés byzantins du IXe siècle." *CA,* 15 (1965), 61–83.

——— "Un rouleau constantinopolitain et ses peintures." *DOP,* 8 (1954), 163–199.

——— *Il tesoro di San Marco. Il tesoro e il museo.* H. R. Hahnloser, ed. (Florence, 1971).

——— "The Virgin in a Mandorla of Light." *Late Classical and Mediaeval Studies in Honor of Albert Mathias Friend, Jr.* (Princeton, 1955), 305–312.

——— and Chatzidakis, M. *Greece. Byzantine Mosaics* (Paris, 1959).

——— and Manoussakas, M. I. *L'illustration du manuscrit de Skyllitzès de la Bibliothèque Nationale de Madrid* (Venice, 1979).

Grierson, Ph. *Catalogue of the Byzantine Coins in the Dumbarton Oaks Collection* (Washington, D.C., 1968–1973), II, III.

Griffith, S. H., Darling, R. "Anastasius of Sinai, the Monophysites and the Qur'an." *Eighth Annual Byzantine Studies Conference. Abstracts of Papers* (Chicago, 1982), 13.

Grillmeier, A. "Der Gottessohn im Totenreich." *Zeitschrift für katholische Theologie*, 71 (1949), 1–53, 184–203.

—— *Der Logos am Kreuz* (Munich, 1956).

Grimaldi, G. *Descrizione della basilica antica di S. Pietro in Vaticano. Codice Barberini Latino 2733.* R. Niggl, ed. (Vatican, 1972).

Grisar, H. *Die römische Kapelle Sancta Sanctorum und ihr Schatz* (Freiburg/Br., 1908).

Grondijs, L. H. *L'iconographie byzantine du crucifié mort sur la croix. Bibliotheca Byzantina Bruxellensis* 1 (Utrecht, 1947).

Grumel, V. *Traité d'études byzantines.* 1 *La chronologie* (Paris, 1958).

Hamann-Mac Lean, R. "Der berliner Codex graecus quarto 66 und seine nächsten Verwandten als Beispiele des Stilwandels im frühen 13. Jahrhundert." *Studien für Buchmalerei und Goldschmiedekunst des Mittelalters. Festschrift für Karl Hermann Usener zum 60. Geburtstag am 19. August 1965* (Marburg an der Lahn, 1967), 225–250.

Harris, R., Mingana, A. *The Odes and Psalms of Solomon* (Manchester, 1920).

Harrison, R. M. and Firatli, N. "Excavations at Sarachane in Istanbul: Fourth Preliminary Report." *DOP*, 21 (1967), 272–279.

Haseloff, A. *Codex Purpureus Rossanensis* (Berlin, 1898).

Hausherr, R. "Der tote Christus am Kreuz. Zur Ikonographie des Gerokreuzes." Dissertation, Bonn, 1963.

Havice, Ch. "The Hamilton Psalter in Berlin, Kupferstichkabinett 78.A.9." Ph.D. Dissertation. The Pennsylvania State University, 1978.

Head, C. *Justinian II of Byzantium* (Madison, 1972).

Hefele, J. *Histoire des conciles.* H. Leclercq, trans. (Paris, 1907ff.)

Heisenberg, A. *Grabeskirche und Apostelkirche* (Leipzig, 1908).

Hubert, J., Porcher, J., Volbach, W. F. *L'empire carolingien* (Paris, 1968).

—— *L'Europe des Invasions* (Paris, 1967).

Hunger, H. "On the Imitation (Μίμησις) of Antiquity in Byzantine Literature," *DOP*, 23–24 (1969–1970), 15–39.

Iskusstvo Vizantii V Sobraniiakh SSSR (Moscow, 1977), I–III.

Jacopi, G. "Le miniature dei codici di Patmo." *Clara Rhodos*, 6–7 (1932–1933).

Jerphanion, G. de "Un nouvel encensoir syrien et la série des objets similaires." *Mélanges syriens offerts à Monsieur René Dussaud* (Paris, 1939), I, 298–312.

—— *Une nouvelle province de l'art byzantin. Les églises rupestres de Cappadoce* (Paris, 1925–1942).

Jugie, M. *La mort et l'assomption de la Sainte Vierge.* ST 114, VIII (Vatican, 1944).

Kähler, H. and Mango, C. *Die Hagia Sophia* (Berlin, 1967).

Kaimakis, D. *Der Physiologus nach der ersten Redaktion* (Meisenheim am Glan, 1974).

Kalavrezou-Maxeiner, I. "The Portraits of Basil I in Paris gr. 510." *JÖB*, 27 (1978), 19–25.

Karmires, I. N. Ἡ εἰς Ἅδου κάθοδος τοῦ Κυρίου (Athens, 1939).

Kartsonis, A. D. "David and the Choirs (Vat. gr. 699)." M.A. Thesis, New York University, 1967.

—— "The *Hodegos* of Anastasius Sinaites and Seventh Century Pictorial Polemics." *XVI. Internationaler Byzantinistenkongress. Résumés der Kurzbeiträge* (Vienna, 1981), 10.3.

Kauffmann, G. "Der karolingische Psalter in Zürich und sein Verhältnis zu einigen Problemen by-

zantinischer Psalterillustration." *Zeitschrift für schweizerische Archäologie und Kunstgeschichte*, 16 (1956), 65–74.

Kepetzis, V. "Les rouleaux byzantins illustrés (XIe–XIVe siècle). Relation entre texte et image." Dissertation 3e cycle. Université de Paris IV, Sorbonne et Ecole Pratique des Hautes Etudes, Ve section. 1980.

King, E. S. "The Date and Provenance of a Bronze Reliquary Cross in the Museo Cristiano." *MemPontAcc*, 2 (1928), 193–205.

Kitzinger, E. *Byzantine Art in the Making* (Cambridge, 1977).

—— "Christian Imagery. Growth and Impact." *Age of Spirituality: A Symposium*. K. Weitzmann, ed. (New York, 1980), 151ff.

—— *Early Medieval Art in the British Museum* (London, 1960).

—— "The Mosaics of the Capella Palatina," *AB*, 31 (1949), 269–292.

—— "A Pair of Silver Book Covers in the Sion Treasure." *Gatherings in Honor of Dorothy E. Miner* (Baltimore, 1974), 3–17.

Kondakov, N. P. *Ikonografia Bogomateri* (St. Petersburg, 1915).

—— *Russkie Klady* (St. Petersburg, 1896).

Kosteckaja, E. O. "L'iconographie de la résurrection d' après les miniatures du Psautier Chloudov." *SemKond*, 2 (1928), 60–70.

Kostoff, S. *Caves of God* (Cambridge, 1972).

Kraeling, C. H. *Excavations at Dura Europos. Final Report VIII, Part II. The Christian Building* (New Haven, 1967).

Kroll, J. *Gott und Hölle* (Leipzig, 1939).

Kuhn, W. "Die Darstellung des Kanawunders im Zeitalter Justinians." *Tortulae. RQ*, Suppl. 30 (1966), 200–216.

Kunst der Ostkirche. Stift Herzogenburg (Vienna, 1977).

Ladner, G. B. "The Concept of the Image in the Greek Fathers and the Byzantine Iconoclastic Controversy." *DOP*, 7 (1953), 1ff.

Lafontaine Dosogne, J. "L'église dite Eski Baca Kilisesi et la place de la Vièrge dans les absides Cappadociens." *Festschrift Otto Demus. JÖB*, 21 (1972), 163ff.

Lange, G. *Die Auferstehung* (Recklinghausen, 1966).

—— *Bild und Wort* (Würzburg, 1968).

La Piana, G. "The Byzantine Theater." *Speculum*, 11 (1936), 171–211.

Lasko, P. *Ars Sacra. 800–1200* (London, 1972).

Lauer, Ph. "Le trésor du Sancta Sanctorum." *MonPiot*, 15 (1906), 67–71.

Lawrence, M. "Columnar Sarcophagi in the Latin West." *AB*, 14 (1932) 103–185.

—— "Three Pagan Themes in Christian Art." *De Artibus Opuscula XL. Essays in Honor of Erwin Panofsky*. M. Meiss, ed. (New York, 1961), 323–334.

Lazarev, V. *Storia della pittura bizantina* (Turin, 1967).

—— "Über eine neue Gruppe byzantinische-venezianischer Trecento-Bilder." *Art Studies*, 8 (1931), 1–32.

Leclercq, H. "Amulettes." *DACL*, I.2, 1784–1860.

—— "Hades." *DACL*, IV.2, 1946–1947.

—— "Salomon." *DACL*, XV.1, 588–602.

Le Roux, H. "Les mises au tombeau dans l'enluminure, les ivoires, et la sculpture du IXe au XIIe siècle." *Mélanges offerts à René Crozet* (Poitiers, 1966), 1, 479–486.

Leroy, J. *Les manuscrits syriaques peints et enluminés* (Paris, 1964).

Lesley, P. "An Echo of Early Christianity," *The Art Quarterly. Detroit Institute of Arts*, 2 (1939), 215–232.

Likhacheva, V. D. *Iskusstvo Knigi. Konstantinopol* (Moscow, 1976).

Lipinsky, A. "Encolpia cruciformi orientali in Italia. 1. Calabria e Basilicata. *BGrottaf*, 11 (1957), 3–37.

Logvni, G. N. *Sofia Kievskaia* (Kiev, 1971).

Lucchesi Palli, E. "Anastasis." *RBK*, 1, cols 142–148.

—— "Darstellung Christi im Tempel." *LChrI*, 1, 473ff.

—— *Die Passions- und Endszenen Christi auf der Ciboriumsäule von San Marco in Venedig* (Prague, 1942).

—— "Der syrisch-palästinensische Darstellungstypus der Höllenfahrt Christi," *RQ*, 57 (1962), 250–267.

McCulloch, J. M. *The Harrowing of Hell* (Edinburgh, 1930).

Mango, C. "The Availability of Books in the Byzantine Empire, A.D. 750–850." *Byzantine Books and Bookmen* (Washington, D.C., 1975), 29ff.

—— "The Date of Cod. Vat. Reg. gr. 1 and the Macedonian Renaissance." *ActaIRNorv.*, 4 (1969), 121ff.

—— *The Homilies of Photius Patriarch of Constantinople* (Cambridge, 1958).

Martin, E. J. *A History of the Iconoclastic Controversy* (London, n.d.).

Martin, J. R. "The Dead Christ on the Cross in Byzantine Art." *Late Classical and Mediaeval Studies in Honor of Albert Mathias Friend, Jr.* (Princeton, 1955), 189–197.

Maspero, J. "Bracelets-amulettes d'époque byzantine." *Annales du Service des Antiquités de l'Egypte*, 9 (1908), 246–258.

Mathews, Th. "The Epigrams of Leo Sacellarios and an Exegetical Approach to the Minatures of Vat. Reg. Gr. 1." *OCP*, 43 (1977), 94–133.

Matthiae, G. *Mosaici medioevali delle chiese di Roma* (Rome, 1967).

Megaw, A.H.S. and Hawkins, E.J.W. *The Church of Panagia Kanakaria at Lythrankomi in Cyprus* (Washington, D.C., 1977).

Melas, E., ed. *Alte Kirchen und Klöster Griechenlands* (Cologne, 1972).

Il Menologio di Basilio II. Codices e Vaticanis Selecti 8 (Turin, 1907).

Merati, A. *Il tesoro del' Duomo di Monza* (Monza, 1963).

Meredith, C. "The Illustrations of Codex Ebnerianus." *JWarb*, 19 (1966), 419–424.

The Metropolitan Museum of Art Bulletin, 35.2 (Autumn 1977).

Millet, G. "Mosaiques de Daphni." *MonPiot*, 2 (1895), 204–214.

—— *La peinture du Moyen Age en Yougoslavie* (Paris, 1957).

—— *Recherches sur l'iconographie de l'évangile aux XIVe, XVe et XVIe siècle d'après les monuments de Mistra, de la Macédoine et du Mont Athos* (Paris, 1916).

Miner, D. "The 'Monastic' Psalter of the Walters Art Gallery." *Late Classical and Mediaeval Studies in Honor of Albert Mathias Friend, Jr.* (Princeton, 1955), 232–254.

Miniature della Bibbia Cod. Vat. Reg. gr. 1, e del Salterio Cod. Vat. Palat. gr. 381. Collezione Paleografica Vaticana. Facs. 1 (Milan, 1905).

Mitius, O. *Jonas auf der Denkmälern des christlichen Altertums* (Freiburg/Br., 1897).

Morey, C. R. *East Christian Paintings in the Freer Collection* (New York, 1914).

—— "Notes on East Christian Miniatures," *AB*, 11 (1929), 5–103.

Morisani, O. *Gli affreschi di S. Angelo in Formis* (Naples, 1962).

—— "L'iconografia della discesa al limbo nella pittura dell'area di Montecassino." *Siculorum Gymnasium*, N.S., 14 (1961), 84–97.

Moritz, H. *Die Zunamen bei den byzantinischen Historikern und Chronisten* (Landschut, 1897–1898).

Mouriki, D. *The Frescoes of the Church of the Savior near Alepohori in Megaris* (Athens, 1978).

—— "The Portraits of Theodore Studites in Byzantine Art." *JÖB*, 20 (1971), 249–280.

Moutsopoulos, N. K. Καστοριά. Παναγία Μαυριώτισσα (Athens, 1967).

Munitiz, J. A. "Le *Parisinus graecus* 1115. Description et arrière-plan historique." *Scriptorium*, 36 (1982), 51–67.

Muñoz, A. *Il codice purpureo di Rossano e il framento Sinopense* (Rome, 1907).

Murray, Ch. "Art and the Early Church." *JThS*, 28 (1977), 303–346.

—— *Rebirth and Afterlife. A Study of the Transmutation of Some Pagan Imagery in Early Christian Funerary Art.* B.A.R. International Series, 100 (Oxford, 1981).

Murray, R. *Symbols of Church and Kingdom* (Cambridge, 1975).

Musolino, G. *Calabria Bizantina. Iconi e tradizioni religiose* (Venice, 1967).

Nilgen, U. "Die grosse Reliquieninschrift von Santa Prassede. Eine Quellenkritische Untersuchung zur Zeno-Kapelle." *RQ*, 69 (1972), 7–29.

Nordhagen, P. J. "The Frescoes of John VII (A.D. 705–707) in S. Maria Antiqua in Rome." *ActaIRNorv*, 3 (1968).

—— " 'The Harrowing of Hell' as Imperial Iconography. A Note on Its Earliest Use." *BZ*, 75 (1982), 345–348.

—— "Kristus i Dødsriket." *Kunst og Kultur*, 57 (1974), 165–174.

—— "The Mosaics of John VII (A.D. 705–707)." *ActaIRNorv*, 2 (1965), 121–166.

Nordström, C. O. *Ravennastudien* (Stockholm, 1953).

—— "Some Jewish Legends in Byzantine Art." *Byzantion*, 25–27 (1955–1957), 487–508.

O'Ceallaigh, G. C. "Dating the Commentaries of Nicodemus." *HThR*, 56 (1963), 21–59.

O'Connell, P. *The Ecclesiology of St. Nicephorus I. OCA* 194 (Rome, 1972).

Oikonomides, N. "The Mosaic Panel of Constantine IX and Zoe in Saint Sophia." *REB* 36 (1978), 219–232.

Omont, H. *Evangiles avec peintures byzantines du XIe siècle* (Paris, 1908).

—— *Miniatures des plus anciens manuscrits grecs de la Bibliothèque Nationale du VIe au XIVe siècle* (Paris, 1929).

Orlandos, A. Ἡ ξυλόστεγος παλαιοχριστιανικὴ βασιλικὴ τῆς Μεσογειακῆς λεκάνης (Athens, 1954).

Ortiz de Urbina, I. *Patrologia Syriaca* (Rome, 1965).

Osborne, J. "Early Medieval Wall-Paintings in the Lower Church of San Clemente, Rome." Ph.D. Dissertation. University of London. 1979.

—— "The Painting of the Anastasis in the Lower Church of San Clemente, Rome: A Re-Examination of the Evidence for the Location of the Tomb of St. Cyril." *Byzantion*, 51 (1981), 255–287.

—— "The Portrait of Pope Leo IV in San Clemente, Rome: A Re-Examination of the So-called 'Square' Nimbus in Medieval Art." *BSR*, 34 (1979), 58–65.

Osborne, J. "The Tomb of St. Cyril in the Lower Church of San Clemente, Rome," *Sixth Annual Byzantine Studies Conference. Abstracts of Papers* (Oberlin, 1980), 28f.

Ostrogorsky, G. "Les décisions du 'Stoglav' concernant la peinture d'images et les principes de l'iconographie byzantine." *L'art byzantin chez les Slaves. Receuil Uspenskij* (Paris, 1930). I.2, 393–411. Reprinted in G. Ostrogorsky, *Byzanz und die Welt der Slawen* (Darmstadt, 1974), 122–140.

—— *History of the Byzantine State* (New Brunswick, 1957).

Ovadiah, A. "Excavations in the Area of the Ancient Synagogue at Gaza (Preliminary Report)." *Israel Exploration Journal*, 19 (1969), 193–198.

—— "The Synagogue at Gaza." *Qadmoniot*, 1 (1968), 124–128.

Pallas, D. I. "Une note sur la décoration de la chapelle de Haghios Basileios de Sinassos." *Byzantion*, 48 (1978), 208–226.

—— *Passion und Bestattung Christi in Byzanz* (Munich, 1965).

Papadopoulos, K. *Die Wandmalereien de XI. Jahrhunderts in der Kirche* Παναγία τῶν Χαλκέων *in Thessaloniki* (Graz, 1966).

Parker, E. C. "The Descent from the Cross: Its Relation to the Extra-Liturgical *Depositio* Drama." Ph.D. Dissertation. New York University, 1975.

Pelekanides, St. Καλλιέργης. Ὅλης Θετταλίας ἄριστος ζωγράφος (Athens, 1973).

—— Καστοριά (Thessaloniki, 1953), I.

—— "Τὰ χρυσὰ βυζαντινὰ κοσμήματα τῆς Θεσσαλονίκης," ΔΧΑΕ, I (1959), 55–71.

—— Christou, P., Mavropoulou-Tsioumi, Chr., Kadas, S. N. *The Treasures of Mount Athos. Illuminated Manuscripts* (Athens, 1973–1979), I–III.

Pelikan, J. *The Christian Tradition* (Chicago, 1971ff.).

Pokrovskii, N. *Evangelie v̈ pamiatnikakh ikonografii vizantiiskikh i russkikh* (St. Petersburg, 1892).

Powstenko, O. *The Cathedral of St. Sophia in Kiev* (New York, 1954).

Prandi, A. *Roma nell' alto medioevo* (Turin, 1968).

Quasten, J. *Patrology* (Utrecht, 1960).

Radojčić, S. *Sopoćani* (Belgrade, 1963).

Reallexikon zur byzantinischen Kunst. K. Wessel, ed. (Stuttgart, 1966ff.).

Réau, L. *L'iconographie de l'art chrétien* (Paris, 1957).

Reichmuth, R. J., S.J. "Typology in the Genuine Kontakia of Romanos the Melodist." Ph.D. Dissertation. University of Minnesota, 1975.

Reil, J. *Christus am Kreuz in der Bildkunst der Karolingerzeit* (Leipzig, 1930).

—— *Die frühchristliche Darstellung der Kreuzigung Christi* (Leipzig, 1904).

Restle, M. *Byzantine Wall Painting in Asia Minor* (Recklinghausen, 1967).

Richard, M. "Anastase le Sinaite, l'Hodégos, et le Monothélisme." *REB*, 16 (1958), 29–42.

Rochow, I. "Zu 'heidnischen' Bräuchen bei der Bevölkerung des byzantinischen Reiches im 7. Jahrhundert, vor allem auf Grund der Bestimmungen der Trullanum." *Klio*, 60 (1978), 483–499.

Romanelli, P. and Nordhagen, P. J. *S. Maria Antiqua* (Rome, 1964).

Rosenberg, M. *Geschichte der Goldschmiedekunst auf technischer Grundlage. Niello bis zum Jahre 1000 nach Chr.* (Frankfurt a. M., 1924).

—— *Geschichte der Goldschmiedekunst auf technischer Grundlage. Zellenschmelz. III. Die Frühdenkmäler* (Darmstadt, 1922).

Ross, M. *Catalogue of the Byzantine and Early Medieval Antiquities in the Dumbarton Oaks Collection.* Volume I: *Metalwork, Ceramics, Glass, Glyptics, Painting* (Washington, D.C., 1962).

—— *Catalogue of the Byzantine and Early Medieval Antiquities in the Dumbarton Oaks Collection.* Volume II: *Metalwork, Jewelry, Enamels, Glass and Glyptics* (Washington, D.C., 1965).

Rushforth, G. McN. "S. Maria Antiqua." *BSR*, 1 (1902), 1–125.

Sacopoulo, M. *La Theotocos à la mandorle de Lythrankomi* (Paris, 1975).

Sajdak, I. *De Gregorio Nazianzeno poetarum christianorum fonte* (Cracow, 1917).

Sakkos, St. N. Περὶ Ἀναστασίων Σιναϊτῶν (Thessalonike, 1964).

Sandberg Vavalà, E. *La croce dipinta italiana e l'iconografia della passione* (Bologna, 1929).

Schiller, G. *Die Ikonographie der christlichen Kunst* (Gütersloh, 1966–1976), I–IV.

Schrade, H. *Ikonographie der christlichen Kunst. I. Die Auferstehung Christi* (Berlin, 1932).

Schulz, B. *Die Kirchenbauten auf der Insel Torcello* (Berlin, 1927).

Schulz, H. J. "Die Höllenfahrt als Anastasis." *Zeitschrift für katholische Theologie*, 81 (1959), 1–66.

Schwartz, E. C. "A New Source for the Byzantine Anastasis." *Marsyas*, 16 (1972–1973), 29–34.

Ševčenko, I. "The Anti-iconoclastic Poem in the Pantocrator Psalter." *CA*, 15 (1965), 39–60.

Shchepkina, M. V. *Miniatiury Khludovskoi Psaltyri* (Moscow, 1977).

Shorr, D. C., "The Iconographic Development of the Presentation in the Temple." *AB*, 28 (1946), 17–33.

Soper, A. "The Latin Style on the Christian Sarcophagi of the Fourth Century." *AB*, 19 (1937), 148–202.

Sotiriou, G. and M. *Icônes du Mont Sinai* (Athens, 1956).

Sotiriou, M. "Ἐνταφιασμὸς-Θρῆνος." Δελτ. Χριστ. Ἀρχ. Ἑτ., 7 (1974), 139–148.

—— "Χρυσοκέντητον ἐπιγονάτιον τοῦ Βυζαντινοῦ Μουσείου Ἀθηνῶν μετὰ παραστάσεως τῆς εἰς Ἅδου καθόδου." *BNJbb*, 11–12 (1934–1936), 284–296.

Spatharakis, I. *The Portrait in Byzantine Illuminated Manuscripts* (Leiden, 1976).

—— "The Portraits and the Date of Codex Par. gr. 510." *CA*, 23 (1974), 97ff.

Speck, P. *Artabasdos, der rechtgläubige Vorkämpfer der göttlichen Lehren.* Ποικίλα Βυζαντινά, 2 (Bonn, 1981).

Splendeur de Byzance (Brussels, 1982).

Steger, H. *David. Rex et Propheta* (Nuremberg, 1961).

Stein, D. *Der Beginn des byzantinischen Bilderstreites und seine Entwicklung bis in die 40er Jahre des 8. Jahrhunderts* (Munich, 1980).

Stichel, R. "Zu Fragen der Publikation byzantinischer illustrierter Psalterhandschriften." *Zeitschrift für Balkanologie*, 12 (1976), 78–85.

Stikas, E. Ὁ κτίτωρ τοῦ καθολικοῦ τῆς Μονῆς Ὁσίου Λουκᾶ (Athens, 1974–1975).

—— Τὸ οἰκοδομικὸν χρονικὸν τῆς Μονῆς Ὁσίου Λουκᾶ (Athens, 1970).

Stohlman, F. *Catalogo del Museo Sacro della Biblioteca Apostolica Vaticana. II. Gli Smalti* (Vatican, 1939).

Stornajolo, C. *Le miniature della topografia cristiana di Cosma Indicopleuste* (Milan, 1908).

—— *Miniature delle Omilie di Giacomo Monaco (Cod. Vat. gr. 1162) e dell' Evangeliario Urbinate (Cod. Vat. Urbin. gr. 2)* (Rome, 1910).

Striker, C. L. and Kuban, Y. D. "Work at Kalenderhane Camii in Istanbul: Third and Fourth Preliminary Reports." *DOP*, 25 (1971), 251–259.

Strunk, O. "St. Gregory Nazianzus and the Proper Hymns for Easter." *Late Classical and Mediaeval Studies in Honor of Albert Mathias Friend, Jr.* (Princeton, 1955), 82–87.

Der Stuttgarter Bilderpsalter. Bischoff, B., Eschweiler, J., Fischer, B., Frede, H. J., Mütherich, F. (Stuttgart, 1968).

Swainson, D. A. *The Nicene and Apostolic Creeds* (London, 1875).

Syndikas, L. "Παρατηρήσεις σὲ δύο ὁμιλίες τοῦ Λέοντος Σοφοῦ." Ἐπιστημονικὴ Ἐπετηρὶς τῆς Φιλοσοφικῆς Σχολῆς τοῦ Πανεπιστημίου Θεσσαλονίκης, 7 (1957), 207–215.

Taft, R. F., S.J. *The Great Entrance. OCA* 200 (Rome, 1975).

—— "Psalm 24 at the Transfer of Gifts in the Byzantine Liturgy: A Study in the Origins of Liturgical Practice." *The Word in the World: Essays in Honor of Frederick L. Moriarty, S.J.* R. Clifford and G. MacRae, eds. (Cambridge, 1973).

Texidor, J. "Le thème de la 'Descente aux Enfers' chez saint Ephrem." *OrSyr,* 6 (1961), 25–41.

Teyssèdre, B. *Le Sacramentaire de Gellone et la figure humaine dans les manuscrits francs du VIIe siècle* (Paris, 1959).

Thierry, N. "L'art monumental byzantin en Asie Mineure du XIe siècle au XIVe." *DOP,* 29 (1975), 75–113.

—— "Un atelier de peinture du début du Xe s. en Cappadoce: l'atelier de l'ancienne église de Tokali." *Bulletin de la société nationale des antiquaires de France* (Paris, 1971), 170–178.

—— "Ayvali Kilise ou Pigeonnier de Güli Dere." *CA,* 15 (1965), 97–154.

—— "Un décor pré-iconoclast de Cappadoce: Açikel Ağa Kilisesi (Eglise de l' ağa à la main ouverte)." *CA,* 18 (1968), 33–69.

—— "Etude stylistique des peintures de Karabas Kilise en Cappadoce (1060–1061)." *CA,* 17 (1967), 161–175.

—— "Notes critiques à propos des peintures rupestres de Cappadoce." *REB,* 26 (1968), 337–366.

Thierry, N. and M. *Nouvelles églises rupestres de Cappadoce* (Paris, 1963).

—— "Peintures murales de charactère occidental en Arménie: Église Saint-Pierre et Saint-Paul de Tatev (début du Xe siècle). Rapport Préliminaire." *Byzantion,* 38 (1968), 180–242.

Θρησκευτικὴ καὶ Ἠθικὴ Ἐγκυκλοπαιδεία (Athens, 1962–1968).

Toynbee, J.M.C., and Ward-Perkins, J. B. *The Shrine of St. Peter and the Vatican Excavations* (London, 1956).

Treadgold, W. "The Bride-Shows of the Byzantine Emperors," *Byzantion,* 49 (1979), 395–413.

Torp, H. *Mosaikkene i St. Georgrotunden i Thessaloniki* (Oslo, 1963).

Tozzi, R. "I mosaici del battistero di S. Marco a Venezia e l'arte Bizantina." *Bolletino d'arte,* 26 (1932–33), 418ff.

Tschubinaschwili, G. "Ein Goldschmiedetriptychon des VIII–IX. Jahrhunderts aus Martvili." *ZBildK. NF.,* 41 (1930–1931), 81–87.

Tsuji, Sh. "Byzantine Lectionary Illustration." *Illuminated Manuscripts from American Collections.* G. Vikan, ed. (Princeton, 1973), 34–39.

Underwood, P. A. "The Fountain of Life in Manuscripts of the Gospels." *DOP,* 5 (1950), 41–139.

—— *The Kariye Djami* (New York, 1966), I–III; and (Princeton, 1975), IV.

Uthemann, K. H. "Antimonophysitische Aporien des Anastasios Sinaites." *BZ,* 74 (1981), 11–26.

—— "Ein Beitrag zur Geschichte der Union des Konzils von Lyon (1274). Bemerkungen zum Codex Parisinus gr. 1115 (Med. Reg. 2951)." *Annuarium Historiae Conciliorum,* 13 (1981), 27–49.

—— "Eine Ergänzung zur Edition von Anastasii Sinaitae *Viae Dux*: Das Verzeichnis benutzter und zitierter Handschriften." *Scriptorium,* 36 (1982), 130–133.

Vailland, R. *Aquilée et les origines byzantines de la Renaissance* (Paris, 1963).

Vaillant, A. "L'homélie d'Epiphane sur l'ensevelissement du Christ." *Radovi Starosjavenskog Instituta Knjiga*, 3 (Zagreb, 1959), 1–101.

Van Berchem, M. and Clouzot, E. *Mosaiques chrétiennes du IVe au Xe siècle* (Geneva, 1924).

Van der Meer, F. *Maiestas Domini* (Vatican, 1938).

Van Marle, R. *Le scuole della pittura italiana* (The Hague, 1923ff.).

Vasiliev, A. A. *History of the Byzantine Empire* (Madison, 1961).

Vecchi, M. *Torcello. Ricerche e contributi* (Rome, 1979).

Vikan, G., ed. *Illuminated Manuscripts from American Collections* (Princeton, 1973).

Villette, J. *La résurrection du Christ dans l'art chrétien du IIe au VIIe siècle* (Paris, 1957).

Volbach, W. F. *Early Christian Art* (New York, 1961).

—— *Elfenbeinarbeiten der Spätantike und des frühen Mittelalters* (Mainz, 1952).

Vom Altertum zum Mittelalter. Kunsthistorisches Museum. R. Noll, ed. (Vienna, 1958).

von Campenhausen, H. *Die Passionssarkophage. Zur Geschichte eines altchristlichen Bilderkreises* (Marburg, 1929).

von Ehrhard, A. *Uberlieferung und Bestand der hagiographischen und homiletischen Literatur der griechischen Kirche*. TU 50–52 (Leipzig, 1937–1943).

von Erbach-Fürstenau, A. "L' evangelo di Nicodemo." *Archivio Storico dell' Arte*, 2 (1896), 225–237.

von Matt, L. *Die Kunstsammlungen der Biblioteca Apostolica Vaticana Rom* (Rome, 1969).

Vzdornov, G. *Isslodovanie o Kievskoi Psaltyri* (Moscow, 1978).

Waetzoldt, S. *Die Kopien des 17. Jahrhunderts nach Mosaiken und Wandmalereien in Rom* (Munich, 1964).

Wallis Budge, A. *The Book of the Cave of Treasures* (London, 1927).

Walter, Chr. "Pictures of the Clergy in the Theordore Psalter." *REB*, 31 (1973), 229–242.

Watson, A. *The Early Iconography of the Tree of Jesse* (Oxford, 1934).

—— "The Image of the Tree of Jesse on the West Front of Orvietto Cathedral." *Fritz Saxl: A Volume of Memorial Essays from his Friends in England*. D. J. Gordon, ed. (London, 1957), 149ff.

Wealth of the Roman World. A.D.300–700, J.P.C. Kent and K. S. Painter, eds. (London, 1977).

Weigand, E. "Zur Datierung der Ciboriumsäulen von S. Marco in Venedig." *Vth CIEB. Acts* (Rome, 1940), 435–451.

Weitzmann, K. "Aristocratic Psalter and Lectionary." *Record of the Art Museum. Princeton University*, 19 (1960), 98–107.

—— "Byzantine Miniature and Icon Painting in the Eleventh Century." *Studies in Classical and Byzantine Manuscript Illumination* (Chicago, 1971), 271–314.

—— *Die byzantinische Buchmalerei des 9. und 10. Jahrhunderts* (Berlin, 1935).

—— "The Character and Intellectual Origins of the Macedonian Renaissance." *Studies in Classical and Byzantine Manuscript Illumination* (Chicago, 1971), 176–224.

—— "The Constantinopolitan Lectionary Morgan 639." *Studies in Art and Literature for Belle da Costa Greene* (Princeton, 1954), 358ff.

—— "An East Christian Censer." *Record of the Museum of Historic Art. Princeton University*, 3 (1944), 2–4.

—— "Das Evangelion im Skevophylakion zu Lawra." *SemKond*, 8 (1936), 83–98.

—— *The Fresco Cycle of S. Maria di Castelseprio* (Princeton, 1951).

—— *Illustrations in Roll and Codex* (rev. ed.: Princeton, 1970).

Weitzmann, K. "An Illustrated Greek New Testament of the Tenth Century in the Walters Art Gallery." *Gatherings in Honor of Dorothy E. Miner* (Baltimore, 1974), 19–38.

—— "An Imperial Lectionary in the Monastery of Dionysiou on Mount Athos: Its Origin and its Wanderings." *RESEE*, 7 (1969), 339–353.

—— "*Loca Sancta* and the Representational Arts of Palestine." *DOP*, 28 (1974), 31–57.

—— "A Metamorphosis Icon or Miniature on Mount Sinai." *Starinar*, 20 (1969), 415–421.

—— *The Miniatures of the Sacra Parallela. Parisinus graecus 923.* (Princeton, 1979).

—— *The Monastery of St. Catherine at Mount Sinai: The Icons.* (Princeton, 1976), I.

—— "The Mosaic in St. Catherine's Monastery on Mount Sinai." *Proceedings of the American Philosophical Society*, 110 (1966), 392–405.

—— "Mount Sinai's Holy Treasures." *National Georgraphic Magazine*, 125/1 (January, 1964), 109–127.

—— "The Narrative and Liturgical Gospel Illustrations." *Studies in Classical and Byzantine Manuscript Illumination* (Chicago, 1971), 247–271.

—— "The Ode Pictures of the Aristocratic Psalter Recension." *DOP*, 30 (1976), 65–85.

—— "The Origin of the Threnos." *De Artibus Opuscula XL. Essays in Honor of Erwin Panofsky*, M. Meiss, ed. (New York, 1961), 476–490.

—— "Eine Pariser-Psalter-Kopie des 13. Jahrhunderts auf dem Sinai." *JÖB*, 6 (1957), 125–143.

—— "The Selection of Texts for Cyclic Illustration in Byzantine Manuscripts." *Byzantine Books and Bookmen* (Washington, D.C., 1975).

—— "The Sinai Psalter cod. 48 with Marginal Illustrations and Three Leaves in Leningrad." *Byzantine Liturgical Psalters and Gospels* (London, 1980), VII. Reprinted from 'Sinaiskaya Psaltir's illyustratsiyami na polyakh,'in Vizantiya, Yuzhnye Slavyane i Drevnyaya Rus', Zapadnaya Europa. *Sbornik statei v chest V. N. Lazarev* (Moscow, 1973), 1–12.

—— *Studies in Classical and Byzantine Manuscript Illumination* (Chicago, 1971).

—— "A 10th Century Lectionary. A Lost Masterpiece of the Macedonian Renaissance," *RESEE*, 9 (1971), 617–640.

—— "Eine vorikonoklastische Ikone des Sinai mit der Darstellung des Chairete," *Tortulae. RQ*, Suppl. 30 (Rome, 1966), 317–325.

—— "Zur byzantinischen Quelle des Wolfenbüttler Musterbuches," *Festschrift Hans R. Hahnloser zum 60. Geburtstag 1959* (Basel, 1961), 223ff.

Wellen, G. A. *Theotokos* (Utrecht, 1961).

Wenger, A. *L'assomption de la T. S. Vierge dans la tradition byzantine du VIe au IXe siècle.* AOC 5 (Paris, 1955).

Wescher, D. *Miniaturen des Kupferstichkabinetts der Staatlichen Museen Berlin* (Leipzig, 1931).

Wessel, K. *Byzantine Enamels* (Recklinghausen, 1967).

—— "Darstellung Christi im Tempel." *RBK*, I, 1134ff.

—— "Die Entstehung des Crucifixus." *BZ*, 53 (1960), 95–111.

—— "Frühbyzantinische Darstellung der Kreuzigung Christi." *RAC*, 36 (1960), 45–71.

—— "Hades." *RBK*, 946–950.

—— "Himmelfahrt." *RBK*, II, 1224–1262.

—— *Koptische Kunst* (Recklinghausen, 1963).

—— *Die Kreuzigung* (Recklinghausen, 1966).

Wiegand, J. *Das altchristliche Hauptportal an der Kirche der hl. Sabina* (Trier, 1900).

Wilkinson, J. "The Tomb of Christ. An Outline of Its Structural History." *Levant*, 4 (1972), 83–98.

Wilpert, J. *Die römischen Mosaiken und Malereien der kirchlichen Bauten vom IV. bis XIII. Jahrhundert* (Freiburg i. B., 1917).

Wilson, N. "The Madrid Skyllitzes." *Scrittura e civiltà*, 2 (1978), 209–219.

Wolska, W. *La Topographie Chrétienne de Cosmas Indicopleustès. Théologie et science au VIe siècle* (Paris, 1962).

Wolska-Conus, W. *Cosmas Indicopleustès. Topographie Chrétienne.* SC 141, 159, 197 (Paris, 1968–1973).

Xyngopoulos, A. *Evangiles avec miniatures du monastère d'Iviron au Mont Athos* (Athens, 1932).

—— "Ὁ ὑμνολογικὸς εἰκονογραφικὸς τύπος τῆς εἰς τὸν Ἅδην καθόδου τοῦ Ἰησοῦ." Ἐπ. Ἑτ. Βυζ. Σπ., 17 (1941), 113–129.

—— "Τὸ ἱστορημένον Εὐαγγέλιον τοῦ Ἑλληνικοῦ Ἰνστιτούτου τῆς Βενετίας." Θησαυρίσματα, 1 (1962), 63–68.

—— Συλλογὴ Ἑλένης Σταθάτου (Athens, 1951).

Yiannopoulos, B. N. Αἱ χριστολογικαὶ ἀντιλήψεις τῶν εἰκονομάχων (Athens, 1975).

Zacos, G. and Veglery, A. *Byzantine Lead Seals* (Basel, 1972).

Zalesskaja, B. V. "Čast' bronzovogo kresta-sklabnja is Hersonesa." *VizVrem*, 25 (1964), 167–175.

INDEX

PHOTOGRAPHIC CREDITS

ILLUSTRATIONS

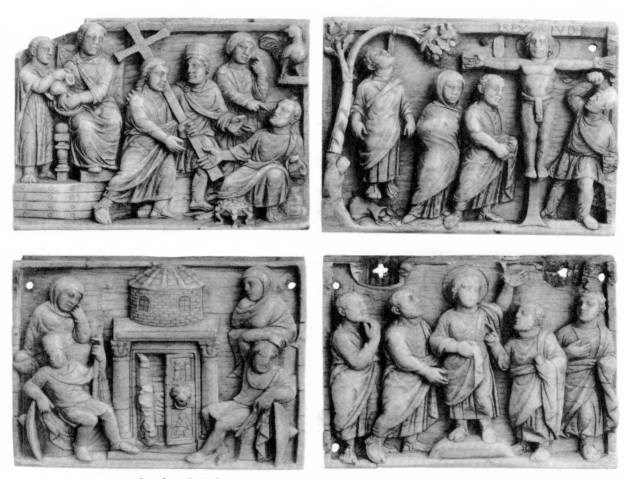

1. London. British Museum. Ivory plaques with scenes from the Passion.

2. Washington, D.C. Dumbarton Oaks Collection. Pilgrim's ampulla. The Crucifixion (obverse) and the Marys at the Tomb (reverse).

3. Washington, D.C. Dumbarton Oaks Collection. Gold marriage ring. Christ blessing the couple and christological scenes.

4. Museum of Art and Archaeology. University of Missouri-Columbia. Ex Coll. Fouquet. Magical silver bracelet with christological scenes and apotropaic emblems (after Maspero).

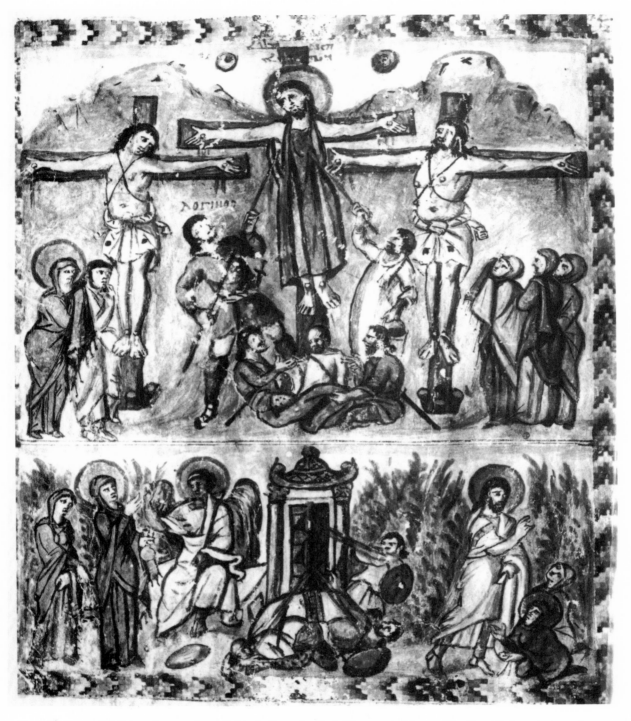

5. Florence. Biblioteca Laurenziana. Rabbula Gospels. Cod. Plut. 1, 56, fol. 13ʳ. The Crucifixion, the guards overthrown, the Marys at the tomb, the Chairete.

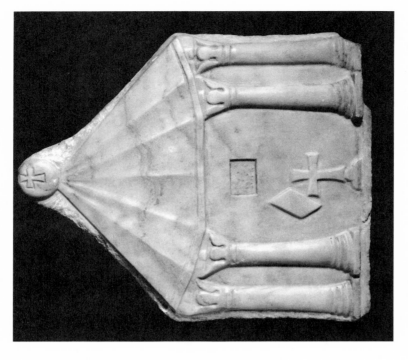

8. Washington, D.C. Dumbarton Oaks Collection. Stone relief. Christ's tomb.

6. Formerly in the Museum of Cardinal Stefano Borgia, Rome. Eighteenth-century drawing of small bronze plaque (after Garrucci).
7. Monza. Cathedral. Pilgrim's ampulla no. 5. The Marys at the tomb.

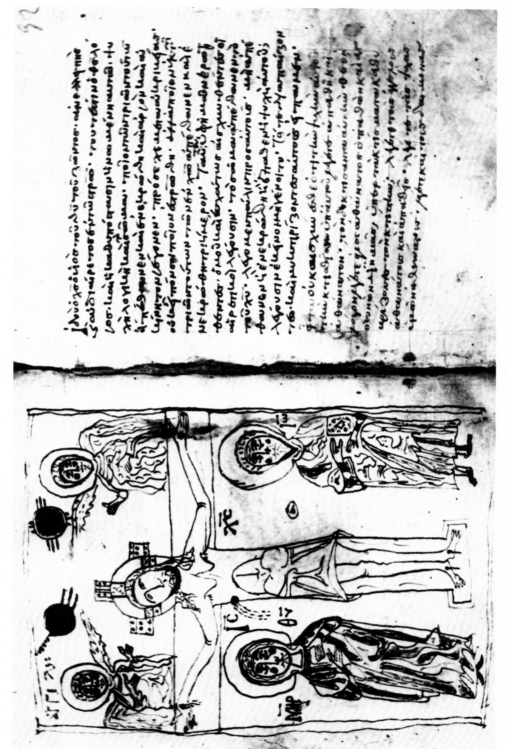

9. Mount Athos. Lavra Monastery. Cod. 131 (B 11), fol. 91ᵛ–92ʳ. Anastasius Sinaites, *Hodegos*, ch. 12. The Crucifixion.

10. Munich. Bayerische Staatsbibliothek. Cod. gr. 467, fol. 147ʳ. Anastasius Sinaites, *Hodegos*, ch. 12. The Crucifixion.

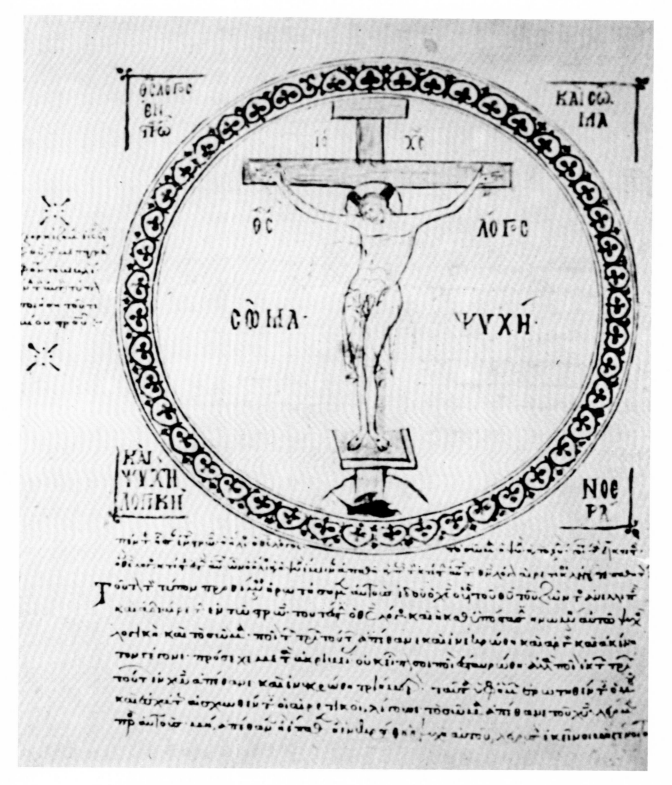

11. Vienna. Nationalbibliothek. Cod. theol. gr. 40, fol. 176ᵛ. Anastasius Sinaites, *Hodegos*, ch. 12. The Crucifixion.

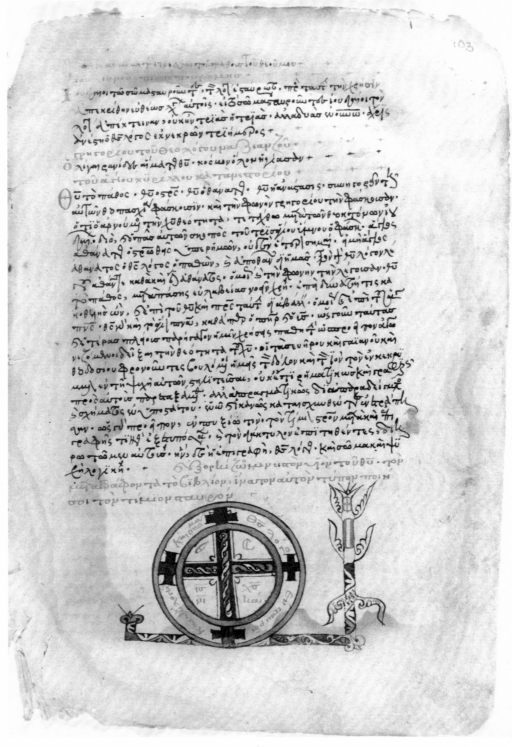

12a. Cambridge. University Library. Add. 3049, fol. 103ʳ. Anastasius Sinaites, *Hodegos*, ch. 12. Cross.

ιωαννης χ̄ω̄ θ̄ε̄ρ̄ο̄ς̄ δ̄η̄ φ̄ρ̄ᾱς̄ ...

καὶ ... ρ̄ο̄φ̄ς̄ ... μ̄ ... τ̄ο̄ν̄ ... δ̄ῑᾱ

χ̄ρ̄ᾱζ̄ᾱ ... τ̄ῑω̄ ...

ο̄ῑ ... μ̄ ... δ̄ ... χ̄ρ̄ᾱφ̄η̄ ... ρ̄ο̄ς̄ ...

τ̄ω̄ ... σ̄η̄ρ̄ ... τ̄ο̄ν̄ δ̄ῑᾱ ...

θ̄ε̄ρ̄ο̄ς̄ ... δ̄ ... μ̄ ...

... ᾱ φ̄ ... θ̄ ... ρ̄ᾱ γ̄ο̄ῡ ... φ̄ρ̄

χ̄ ... κ̄ῑ ... μ̄ ... :~

ΚΑΙ ΕΞΟΡΚΙ͂Ζ ... Μ ... ΕΥΪΟΝ ΤΟ ... Θ̄Ῡ ΤΟΝ
ΜΕΤΑΓΡΑΦΟΝΤΑ ΤΟ ΒΙ ... ΛΙΟΝ ΪΝΑ
ΤΟΝ Θ̄Ῡ ΤΟΝ ΤΥΠΟΝ
ΠΟΙΗCΗ͂ ΤΟ͂Υ CΤΑΥΡ̄Χ̄ :~

οσ ... Β̄Ῡ ... δ̄ῡο̄ς̄ τ̄ο̄ῡ θ̄ῡ ... τ̄ο̄ῡ ... θ̄ω̄ μ̄ το ...

12b. Paris. Bibliothèque Nationale. Cod. gr. 1084, fol. 135ᵛ. Anastasius Sinaites,
Hodegos, ch. 12. Cross.

14b. Rome. S. Maria Antiqua. Chapel of the Forty Martyrs. The Anastasis (after Wilpert).

13. Moscow. Historical Museum. Cod. gr. 265, fol. 72ᵛ. Anastasius Sinaites, *Hodegos*, ch. 12. Cross.

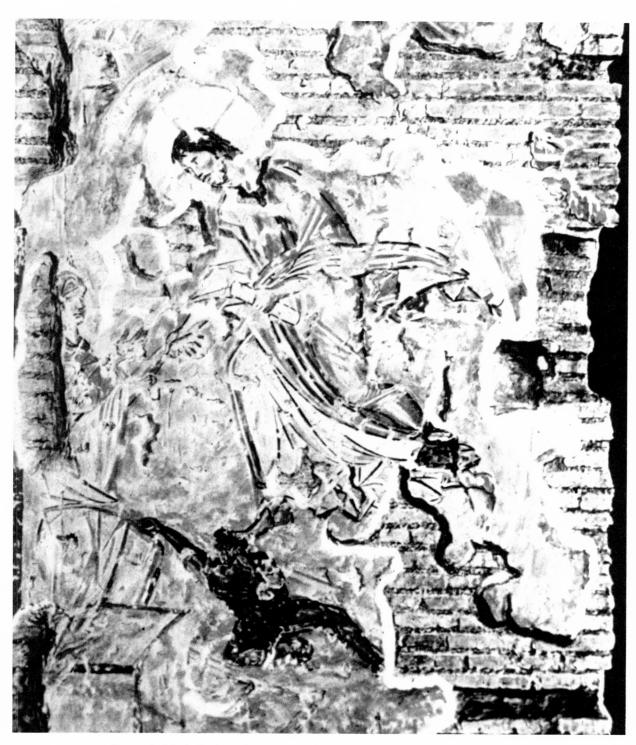

14a. Rome. S. Maria Antiqua. Doorway to the Palatine ramp. The Anastasis (after Wilpert).

15. Vatican. Biblioteca. Cod. Barb. lat. 2733, fols. 90ᵛ–91ʳ. St. Peter's Basilica. Oratory of Pope John VII. Drawing by Grimaldi.

16. Vatican. Biblioteca. Cod. Barb. lat. 2733, fols. 113ᵛ–114ʳ. St. Peter's Basilica. Drawing by Grimaldi.

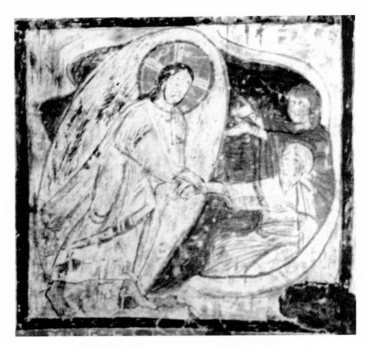

17a. Rome. S. Clemente. Lower Church. Anastasis I
(after Wilpert).

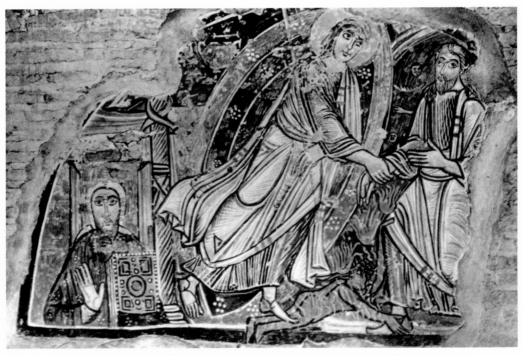

17b. Rome. S. Clemente. Lower Church. Anastasis II (after Wilpert).

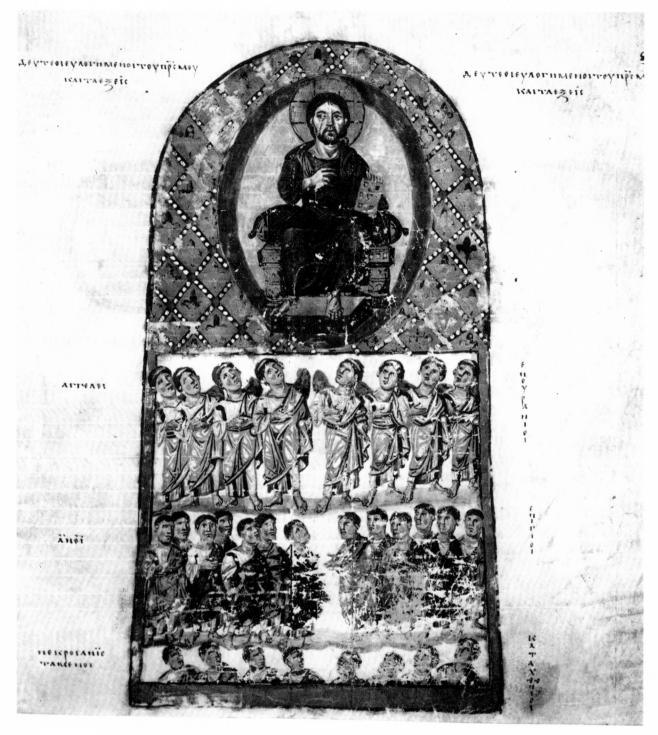

18. Vatican. Biblioteca. Cosmas Indicopleustes. Cod. gr. 699, fol. 89ʳ. The Last Judgment.

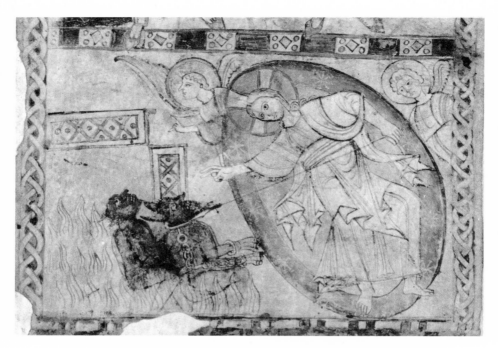

20a. Vatican. Biblioteca. Exultet Roll. Cod. lat. 9820. *Regis Victoria*.

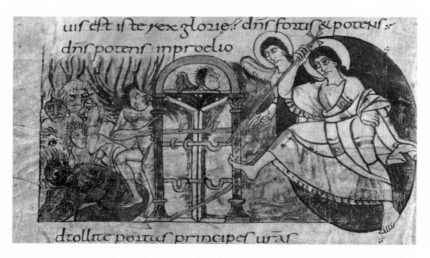

19. Stuttgart. Württembergische Landesbibliothek. Stuttgart Psalter. Cod. lat. 23, fol. 29ᵛ, Ps. 23:24. The breaking of the doors of Hades.

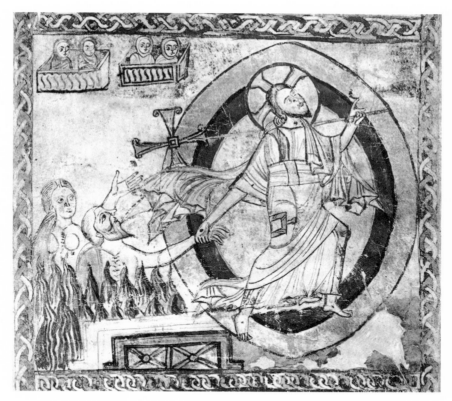

20b. Vatican. Biblioteca. Exultet Roll. Cod. lat. 9820. *Resurrectio Mortuorum*.

21. Vatican. Museo Sacro. Silver reliquary
of Pascal I. The raising of Adam.

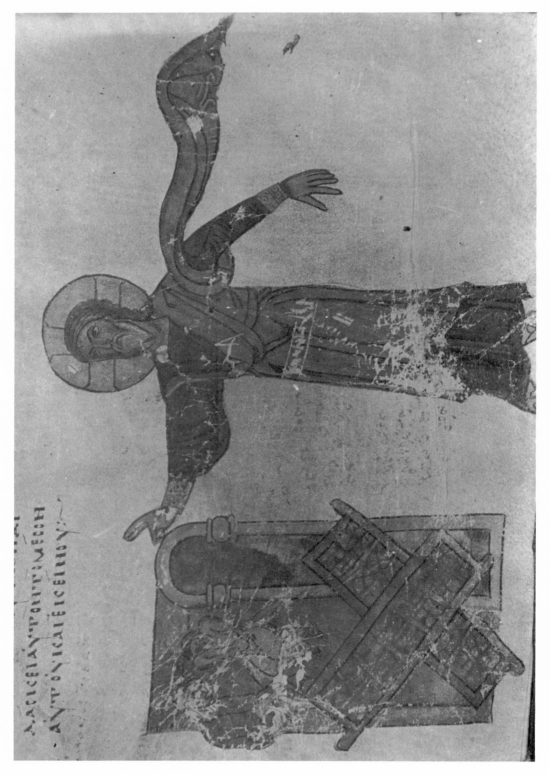

22. Patmos. Monastery of St. John Theologus. Cod. 171, p. 460, Job 38:17. The breaking of the doors of Hades.

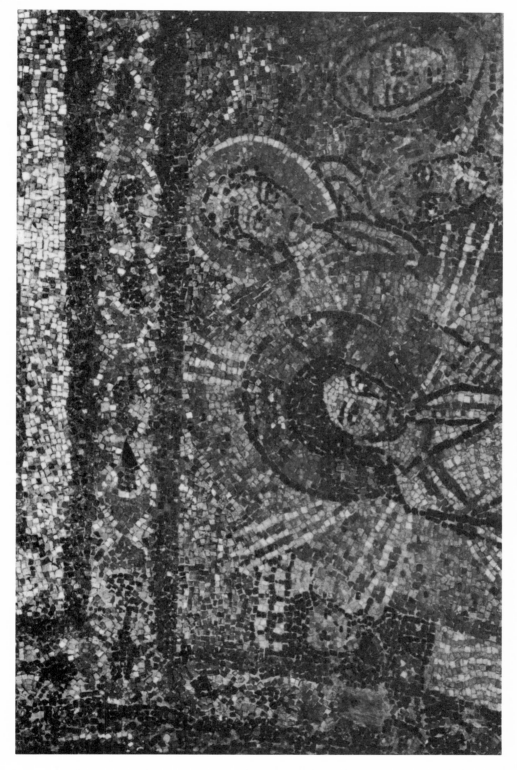

23. Rome. S. Maria Prassede. Chapel of S. Zeno. The Anastasis.

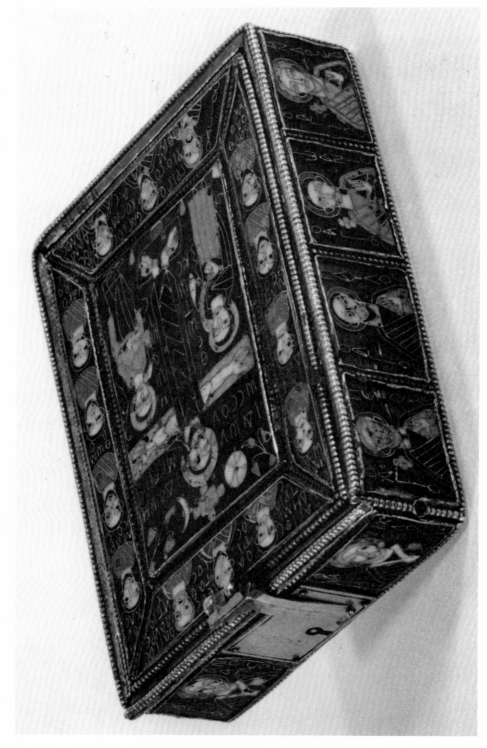

24a. New York. Metropolitan Museum of Art. Fieschi Morgan Reliquary. View of exterior.

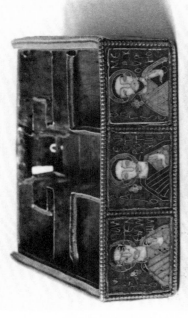

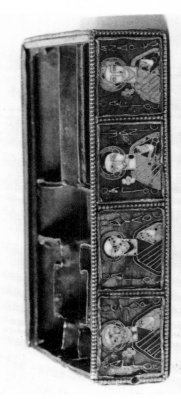

24b. Same. Left side. Sts. Peter, Paul, John, Andrew.

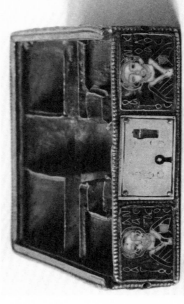

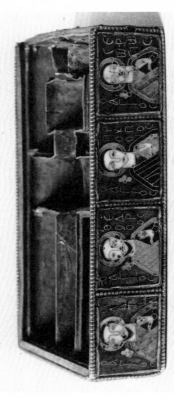

24c. Same. Lower side. Sts. Panteleimon, Eustratios, Merkourios.

24d. Same. Right side. Sts. Platon, Theodore, Procopius, George.

24e. Same. Top side. Sts. Anastasius and Nicholas.

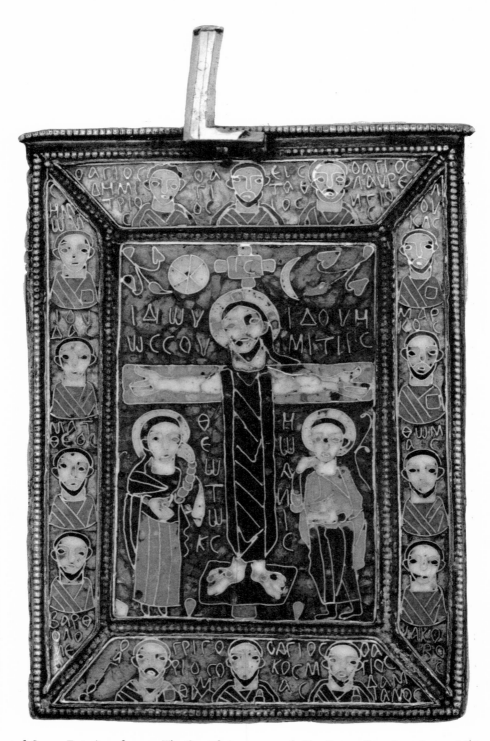

24f. Same. Exterior of cover. The Crucifixion surrounded by Evangelists, Apostles, and Saints.

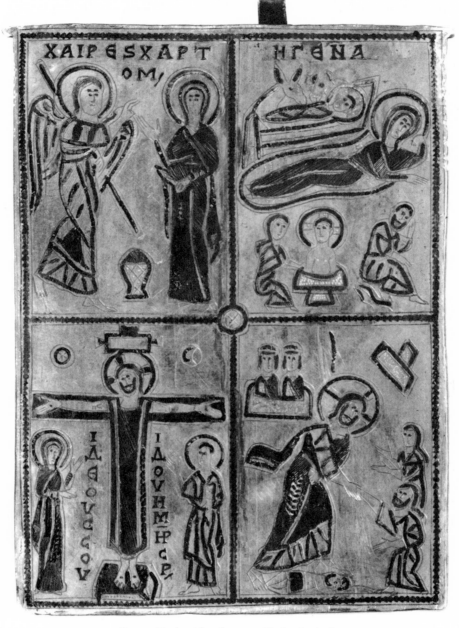

24g. Same. Underside of cover. Christological scenes.

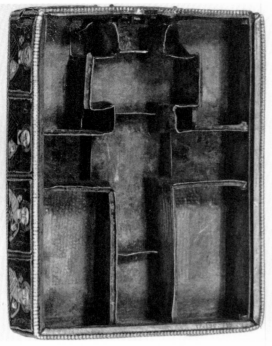

24h. Same. Interior.

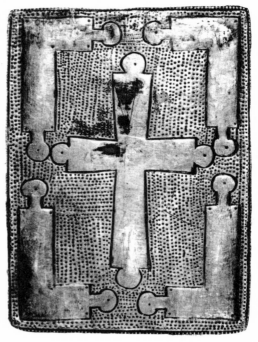

24i. Same. Underside.

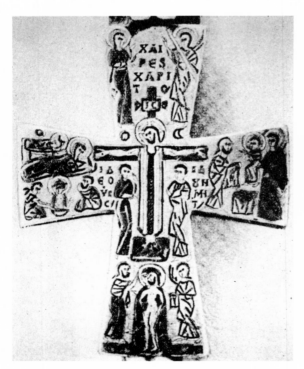

25a. Pisa. Pieve di S. Maria e S. Giovanni.
Vicopisano reliquary cross. Obverse. The
Crucifixion and other christological scenes.

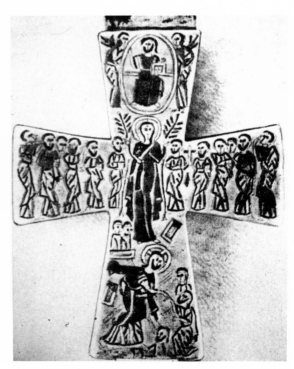

25b. Same. Reverse. The Ascension
and the Anastasis.

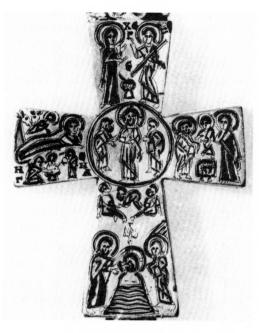

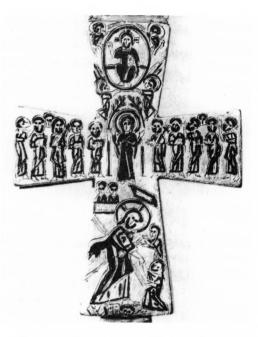

26a. Sofia. Archaeological Museum. Pliska reliquary cross. External cross (Pliska I). Obverse. The Transfiguration and other christological scenes.

26b. Same. External cross (Pliska I). Reverse. The Ascension and the Anastasis.

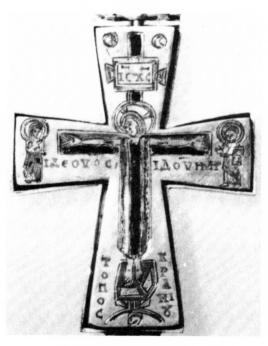

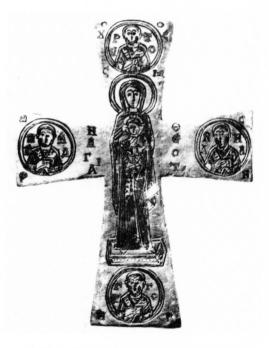

26c. Same. Internal cross (Pliska II). Obverse. The Crucifixion.

26d. Same. Internal cross (Pliska II). Reverse. The Theotokos surrounded by four Church Fathers.

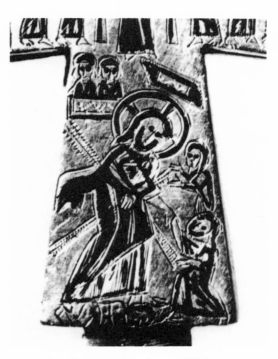

26e. Same. External cross (Pliska 1).
Detail. The Anastasis.

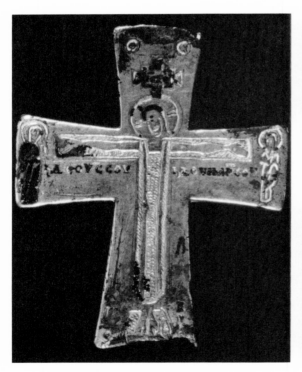

27a. London. Private collection. Reliquary cross.
Obverse. The Crucifixion.

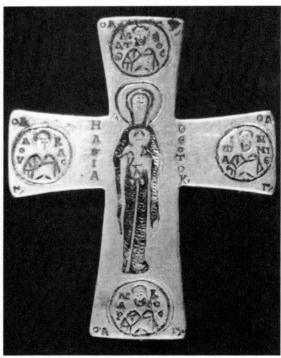

27b. Same. Reverse. The Theotokos surrounded
by four Evangelists.

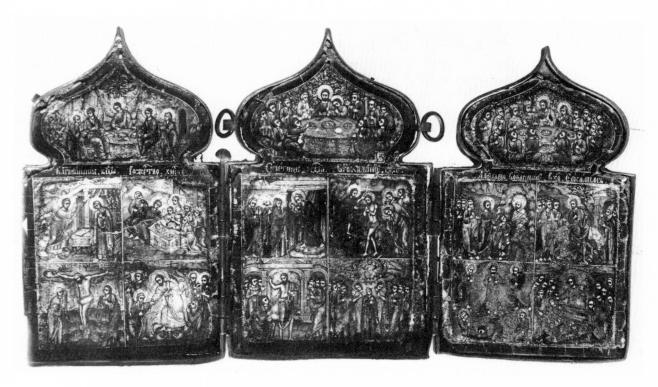

28. Athens. Benaki Museum. Portable triptych icon with christological scenes.

29. Mount Sinai. Monastery of St. Catherine. Icon of Sts. Chariton and Theodosius. Reverse.

30. Leningrad. Public Library, cod. gr. 219, fol. 263ʳ.

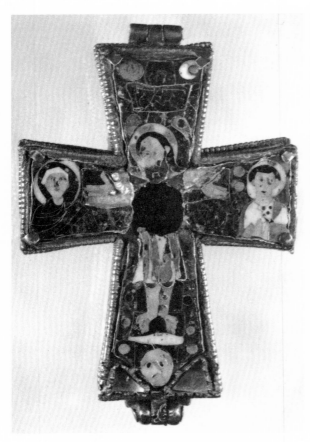

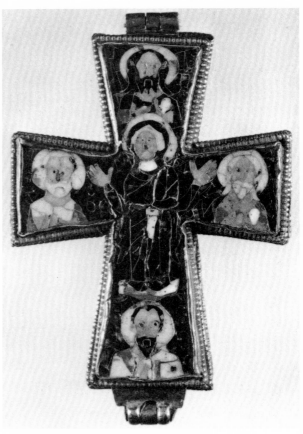

31a. London. Victoria and Albert Museum. Beresford-Hope reliquary cross. Obverse. The Crucifixion.

31b. Same. Reverse. Maria surrounded by Sts. John the Baptist, Paul, Peter, and Andrew.

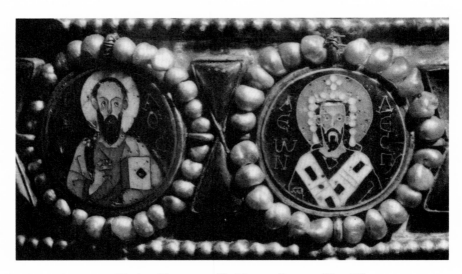

32. Venice. Treasury of S. Marco. Crown of Leo VI.

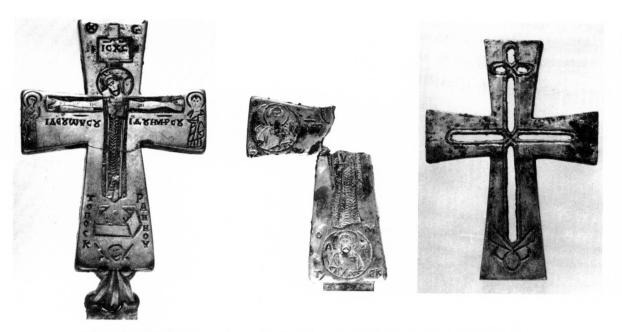

33. Athens. Benaki Museum. Reliquary cross. Obverse. The Crucifixion. Reverse. Meter Theou and the Evangelists.

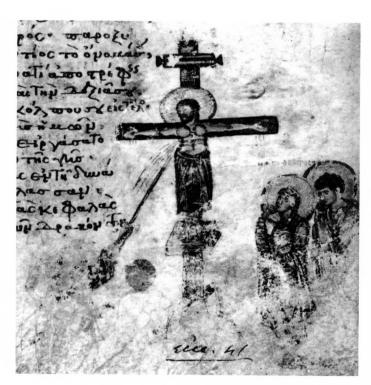

34. Mount Athos. Pantocrator Monastery. Psalter, Cod. 61, fol. 98ʳ, Ps. 73:12. The Crucifixion.

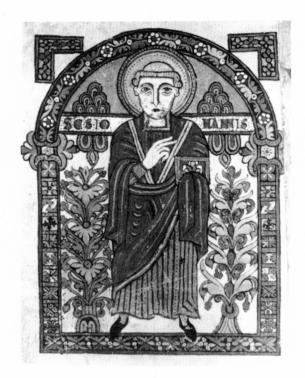

35. Vienna. Nationalbibliothek. Homilies of St. John Chrysostom. Cod. 1007, fol. 1ᵛ. Author portrait.

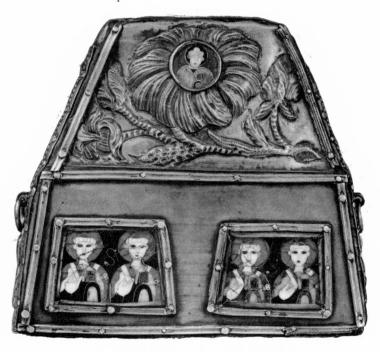

36. Sitten. Cathedral Treasury. Altheus Reliquary.

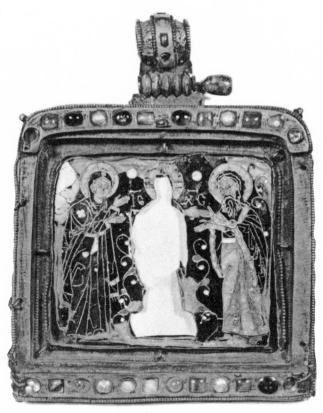

37a. Tbilisi. Georgian State Art Museum. The Martvili Triptych. Obverse. The Deisis.

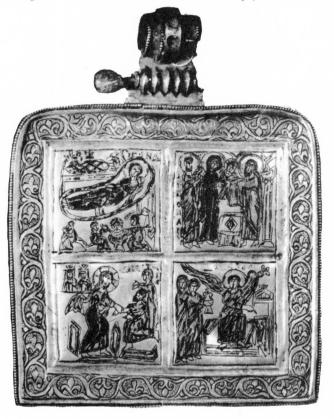

37b. Same. Reverse. Christological scenes.

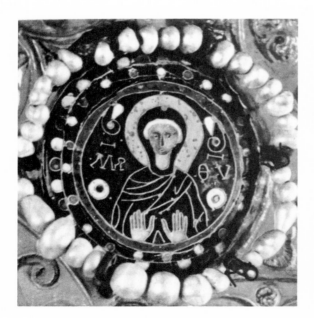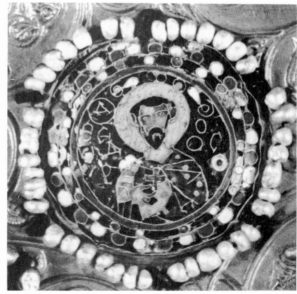

38. Tbilisi. Georgian State Art Museum. The Khakhuli Triptych. Medallions of the Virgin and St. Theodore.

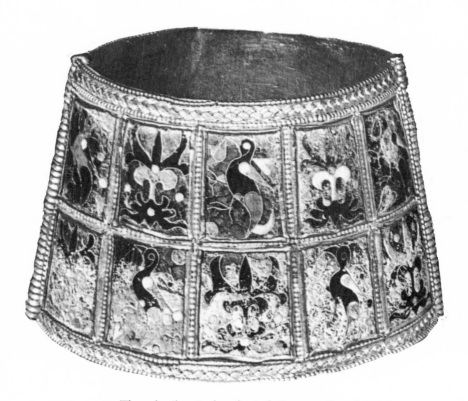

39. Thessalonike. Archaeological Museum. Bracelets.

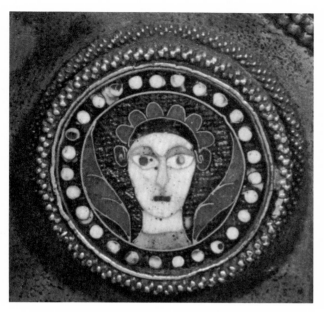

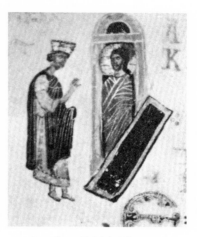

40. Milan. S. Ambrogio. Volvinius Altar. Detail. Medallion of angel.

42. London. British Library. Theodore Psalter. Cod. Add. 19352, fol. 55ᵛ, Ps. 43:27. Christ in his tomb.

41. Venice. Marciana. Cod. gr. I.18, fol. 170ʳ.

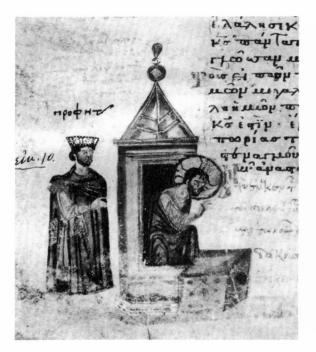

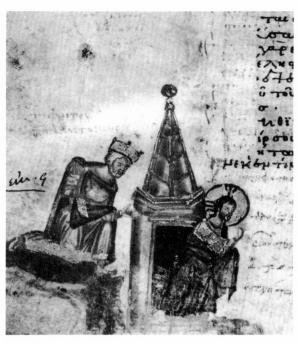

43a. Mount Athos. Pantocrator Monastery. Psalter. Cod. 61, fol. 26ᵛ, Ps. 11:6. Christ rising from his tomb.

43b. Mount Athos. Pantocrator Monastery. Psalter. Cod. 61, fol. 24ᵛ, Ps. 9:33. Christ stepping out of his tomb.

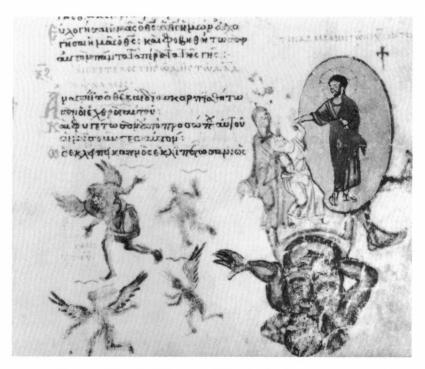

44a. Moscow. Historical Museum. Chloudov Psalter. Cod. gr. 129, fol. 63ʳ, Ps. 67:2. The Anastasis of Adam.

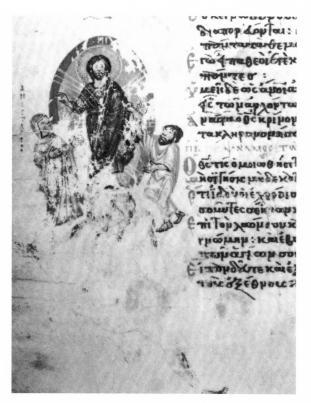

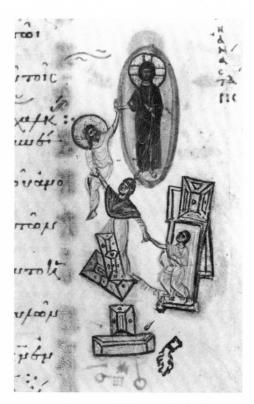

44b. Moscow. Historical Museum. Chloudov
Psalter. Cod. gr. 129, fol. 82ᵛ. Ps. 81:8. The
Anastasis.

45. Vatican. Biblioteca. Barberini
Psalter. Cod. gr. 372, fol. 181ʳ,
Ps. 106:13–16. The Anastasis.

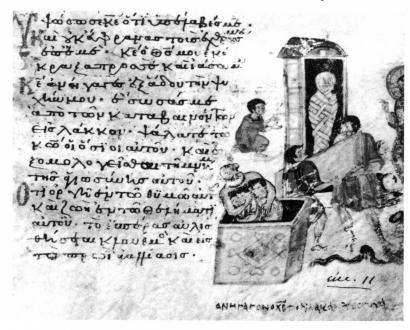

46. Mount Athos. Pantocrator Monastery. Psalter. Cod. 61, fol. 29ʳ,
Ps. 29:4. The raising of Lazarus.

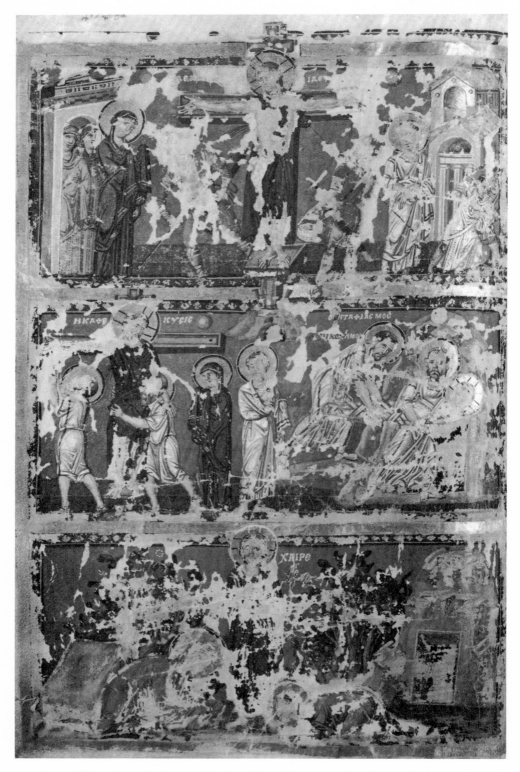

47. Paris, Bibliothèque Nationale. The Homilies of Gregory of Nazianzus. Cod. gr. 510, fol. 30ᵛ. The Crucifixion, Deposition, Entombment, and Chairete.

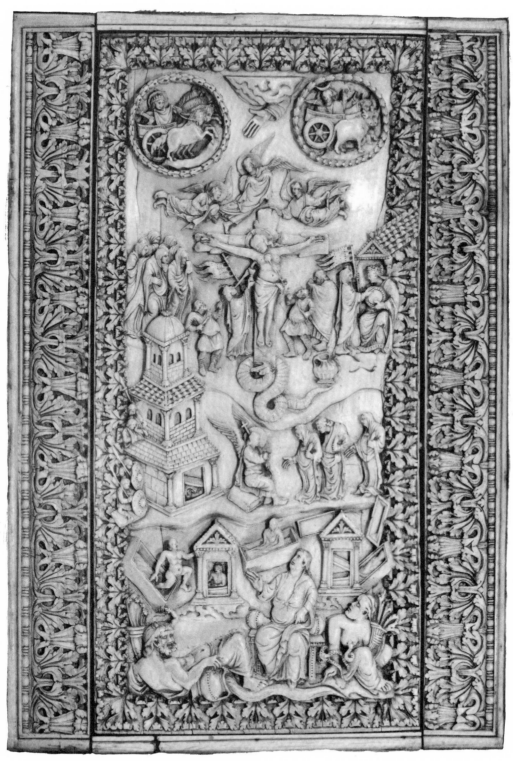

48. Munich. Bayerische Staatsbibliothek. Ivory bookcover. The Crucifixion, the Marys at the tomb, and the rising of the dead.

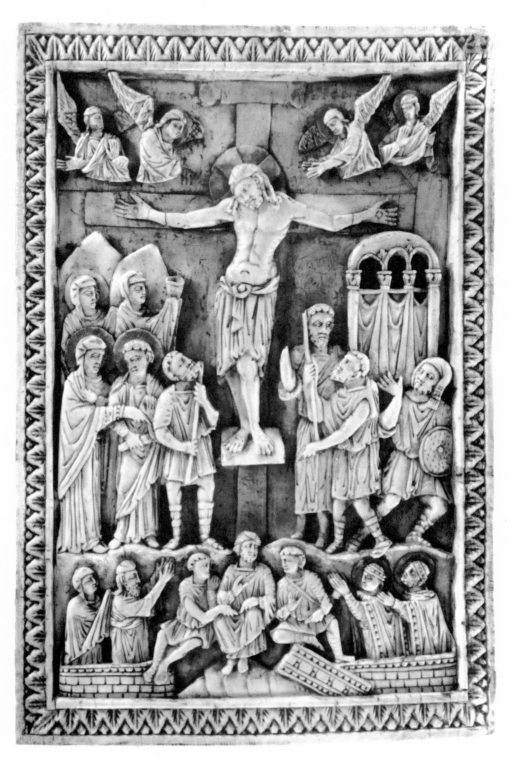

49. Leningrad. Hermitage. Ivory plaque no. ω 26. The Crucifixion and the rising of the dead.

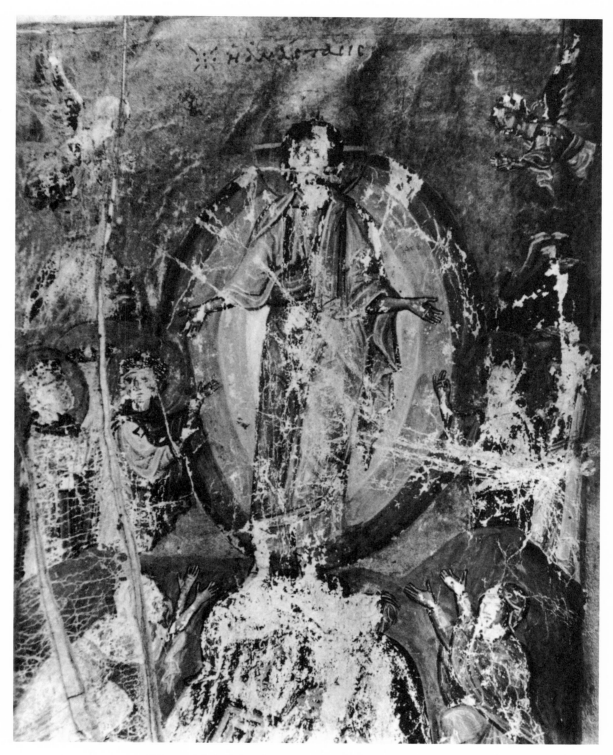

50. Mount Athos. Iviron Monastery. Cod. 1, fol. 1ᵛ. The Anastasis.

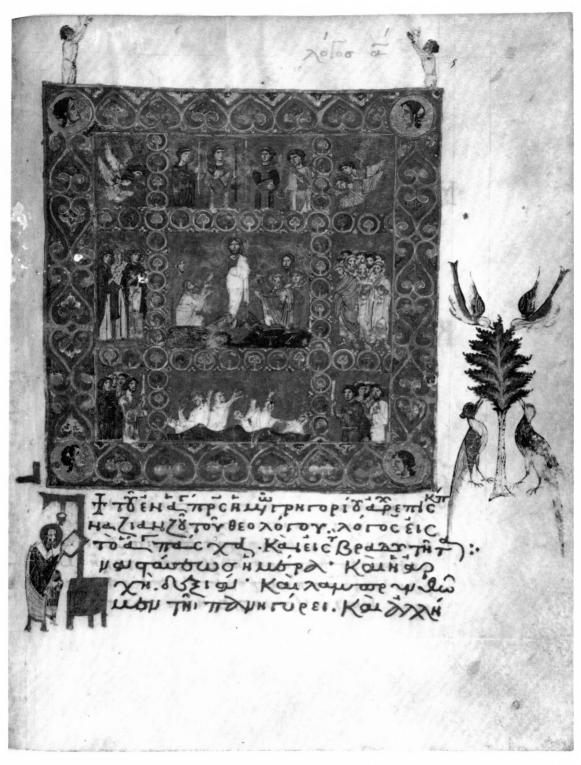

51. Paris. Bibliothèque Nationale. Liturgical Homilies of Gregory of Nazianzus. Cod. gr. 550, fol. 5ʳ. The Anastasis.

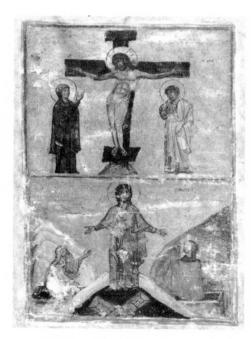

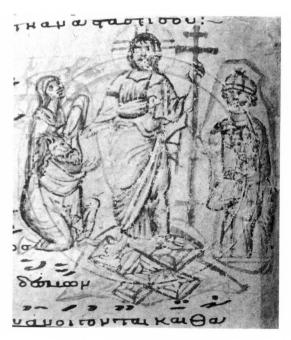

52. Princeton. University Library. Psalter leaf. Cod. 30.20. The Crucifixion and the Anastasis.

53. Mount Athos. Koutloumousiou Monastery. Sticherarion. Cod. 412, fol. 232ᵛ. The Anastasis.

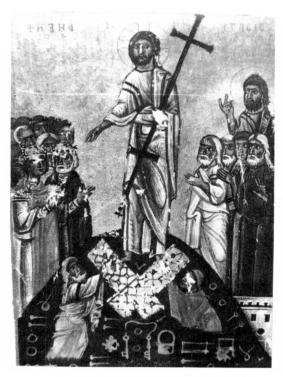

54. Mount Athos. Vatopedi Monastery. Psalter. Cod. 760, fol. 119ᵛ. The Anastasis.

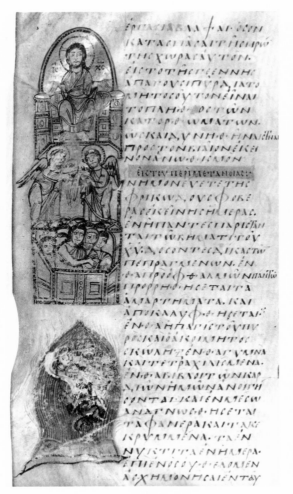

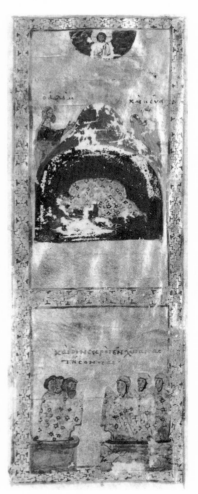

55. Paris. Bibliothèque Nationale. The *Sacra Parallela* of John of Damascus. Cod. gr. 923, fol. 68ᵛ. The Last Judgment.

56. Vatican. Biblioteca. Psalter. Cod. gr. 752, fol. 44ᵛ, Ps. 12. The rising of the dead.

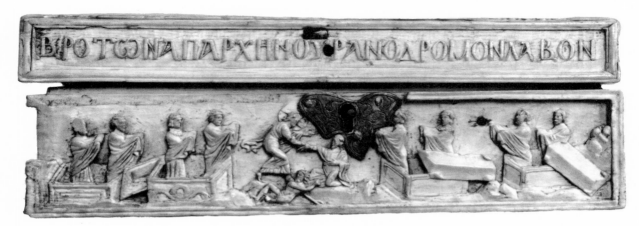

57. Stuttgart. Württembergisches Landesmuseum. Ivory Casket. Side view. The Anastasis.

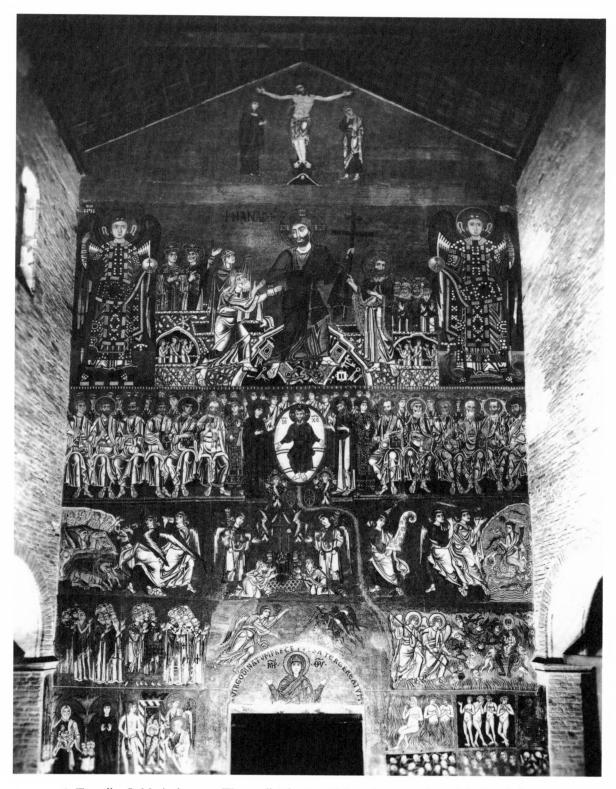

58. Torcello. S. Maria Assunta. West wall. The Crucifixion, the Anastasis, and the Last Judgment.

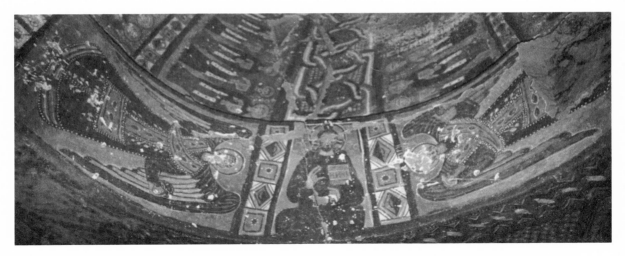

59. Cappadocia. Yilanli Kilise. View looking west. Detail of the Last Judgment.

60. Venice. Museo Correr. Cod. cic. 2233. West wall of S. Maria Assunta, Torcello. Detail of drawing made before the nineteenth-century restoration of the mosaic.

61. Cappadocia. Old Tokali Kilise. Partial view of the vault. Christological cycle.

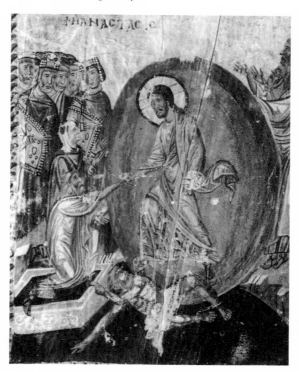

62. Leningrad. Public Library. Lectionary. Cod. gr. 21, fol. 1ᵛ. The Anastasis.

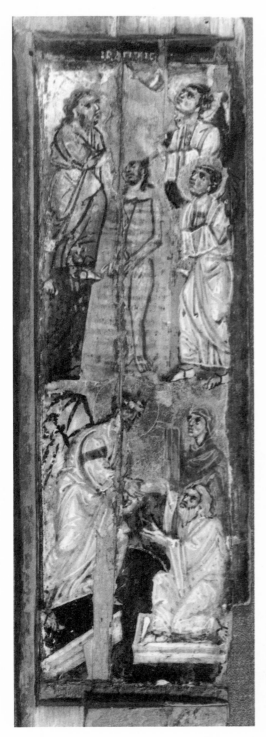

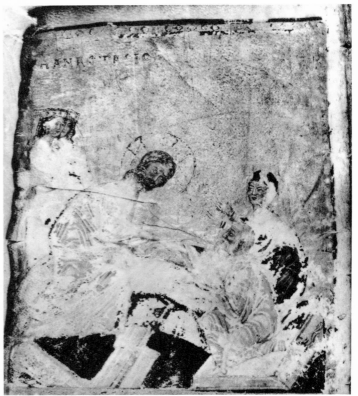

63. Mount Sinai. Monastery of St. Catherine. Icon leaf. The Baptism and the Anastasis.

64. Ettiswil. Amberg-Herzog Collection. Lectionary leaf. A.S. 502. The Anastasis.

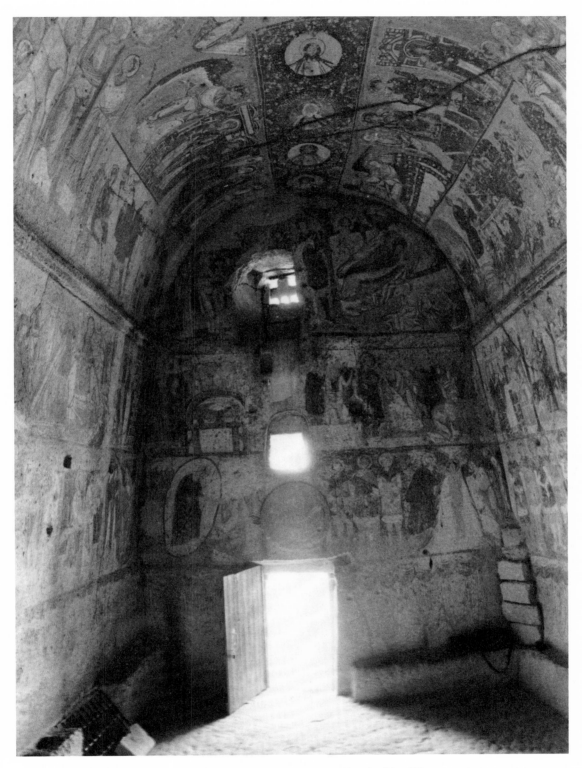

65. Cappadocia. Cavusin Dovecote. View looking West.

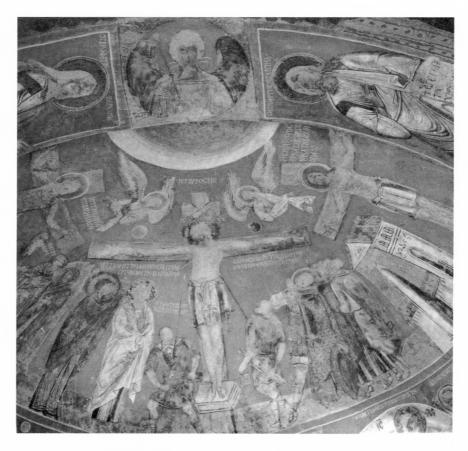

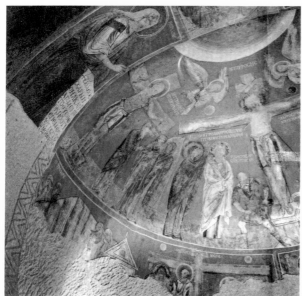 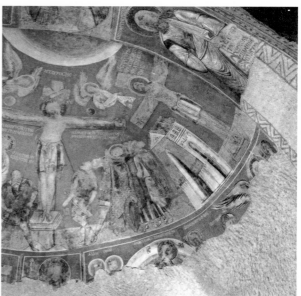

66. Cappadocia. New Tokali Kilise. Views of the main apse.

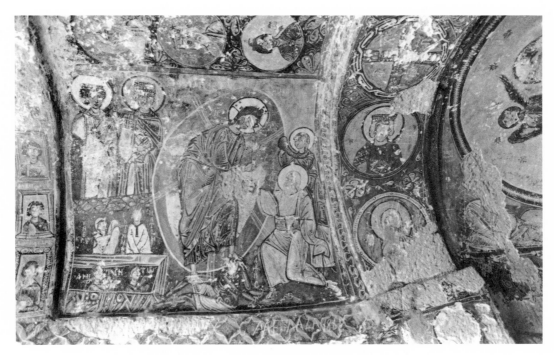

67. Cappadocia. Soganli. St. Barbe. The Anastasis.

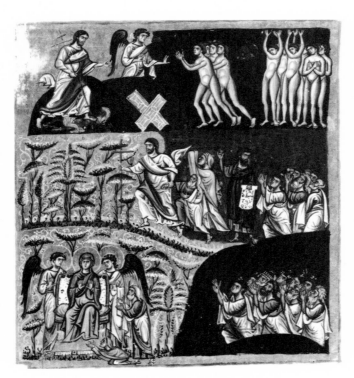

68. Vatican. Biblioteca. James Kokkinobaphos. Cod. gr. 1162, fol. 48ᵛ, Ps. 67:7.

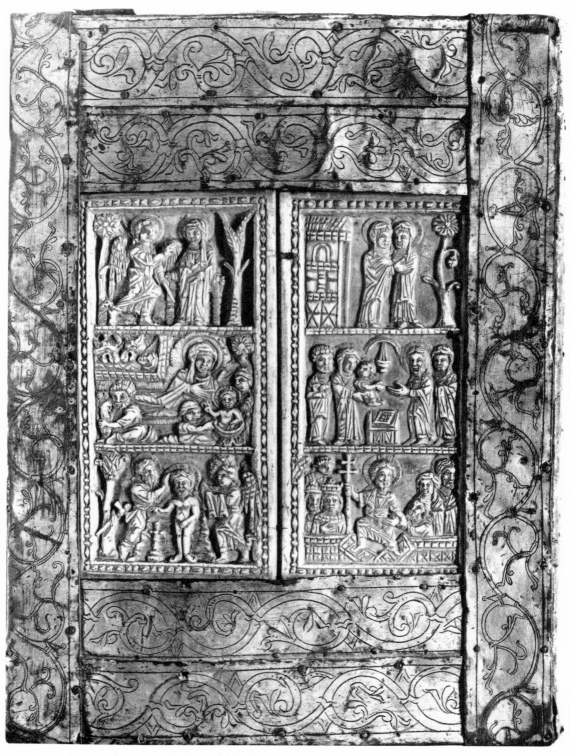

69. Munich. Bayerische Staatsbibliothek. Ivory Bookcover. Christological feast scenes.

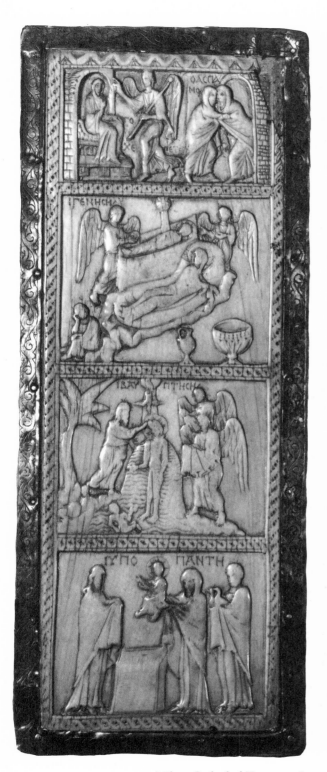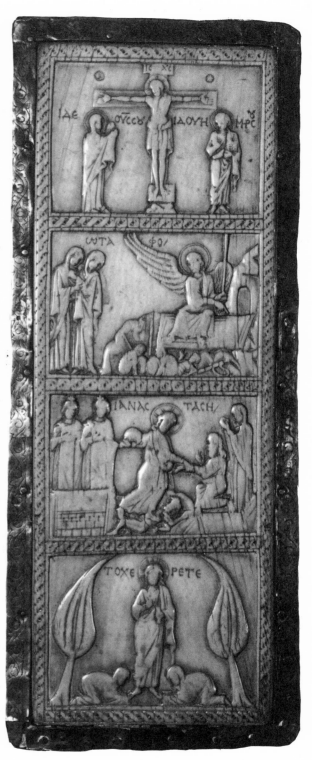

70. Milan. Cathedral Treasury. Ivory Diptych. Christological feast cycle.

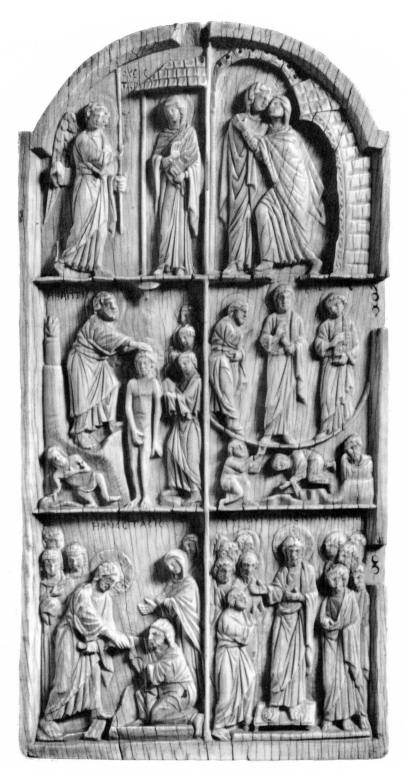

71a. Leningrad. Hermitage. Ivory Diptych no. ω 13.
Christological feast cycle.

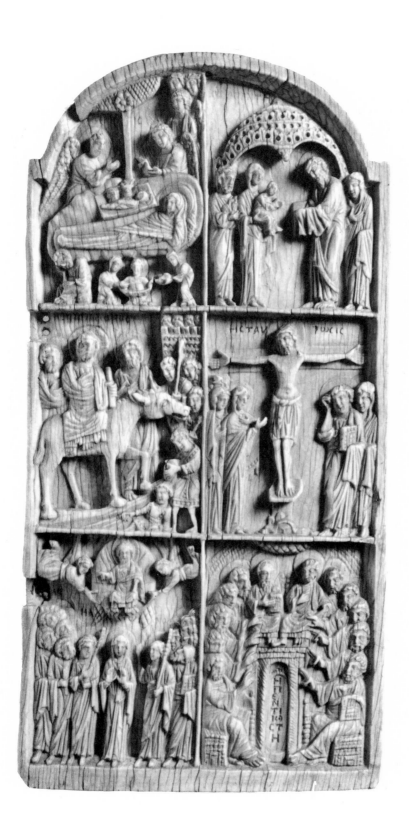

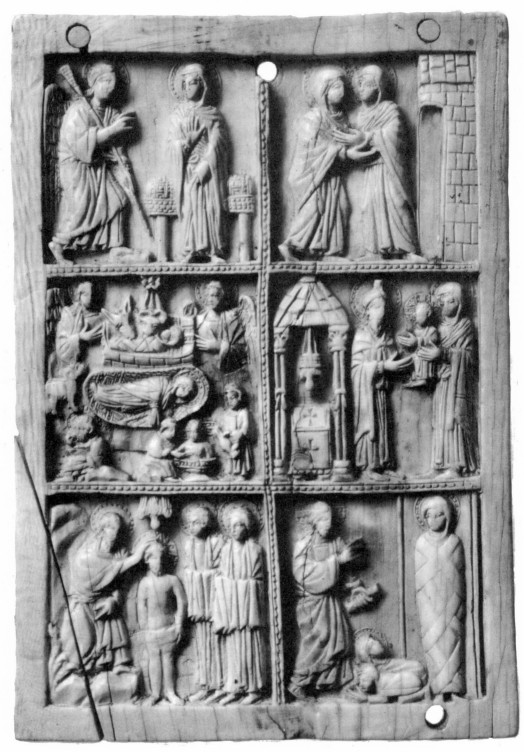

71b. Leningrad. Hermitage. Ivory Diptych panel no. ω 25. Christological feast scenes.

72a. Jerusalem. Patriarchal Library. Liturgical roll. Cod. Taphou 109. Initial A. The Anastasis.

72b. Athens. National Library. Liturgical roll. Cod. 2759.
Initial A. The Anastasis.

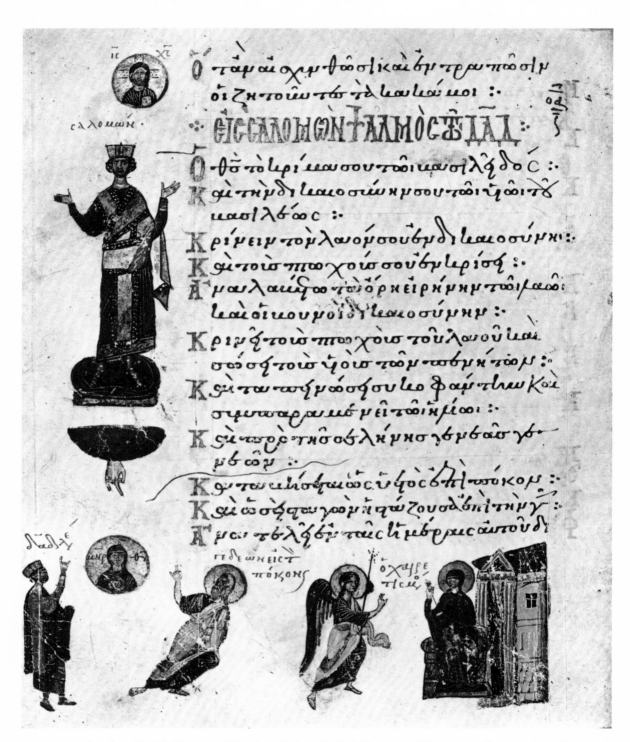

73. London. British Museum. Theodore Psalter. Cod. Add. 19352, fols. 91ᵛ–92ʳ. Ps. 71:1, 6, 10ff.

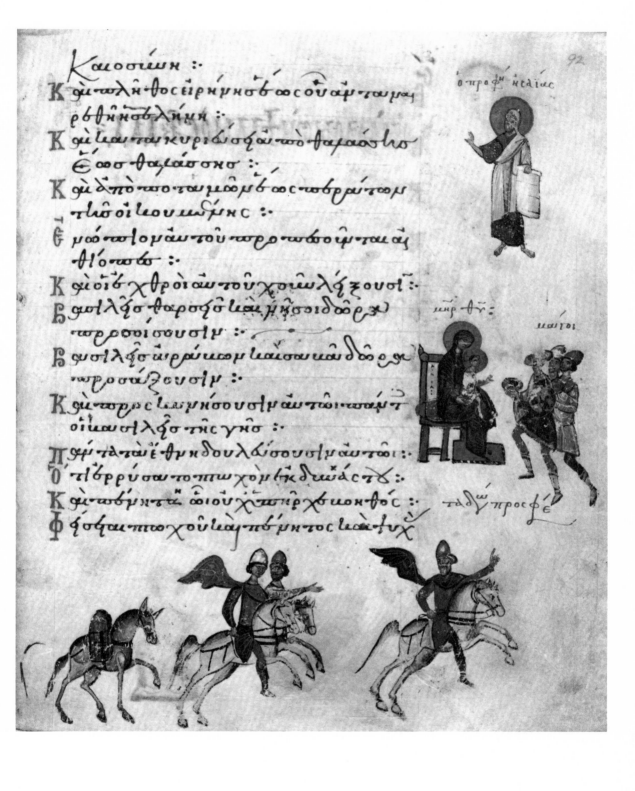

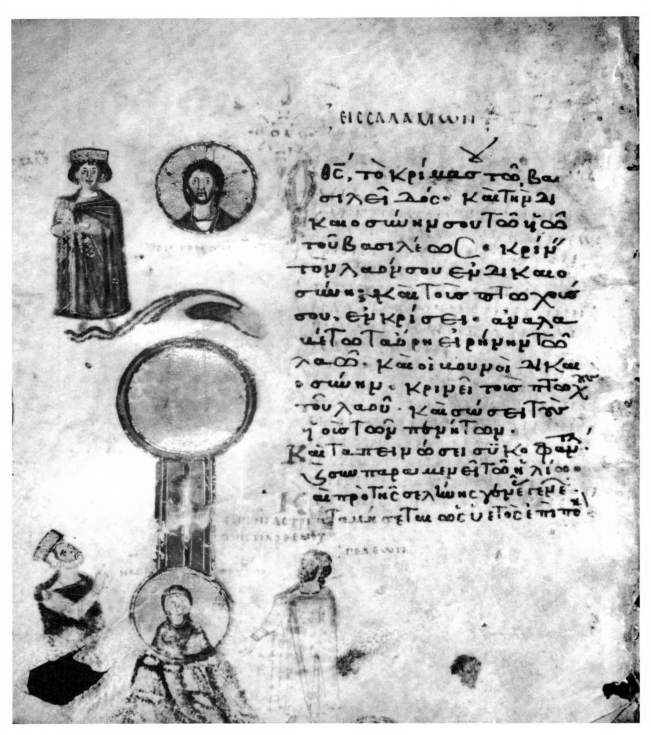

ΕΙϹ ϹΑΛΑΜΩΝ

θ̅ϲ̅, τὸ κρίμα σου τῷ βα
σιλεῖ δός· καὶ τὴν δι
καιοσύνην σου τῷ υἱῷ
τοῦ βασιλέως· κρίν
τον λαόν σου ἐν δικαιο
σύνῃ· καὶ τοὺς πτωχού
σου· ἐν κρίσει· ἀναλα
μβέτω τὰ ὄρη εἰρήνην τῷ
λαῷ· καὶ οἱ βουνοὶ δι και
οσύνην· κρινεῖ τοὺς πτωχ
τοῦ λαοῦ· καὶ σώσει τοὺ
υἱοὺς τῶν πενήτων·

Καὶ ταπεινώσει συκοφά·
ϲουμ παραμενεῖ τῷ ἡ λίου·
καὶ πρὸ τῆς σελήνης γεν εαι·
Καταβήσεται ὡς ὑετὸς ἐπ ι

74. Mount Athos. Pantocrator Monastery. Psalter. Cod. 61, fol. 93ᵛ, Ps. 71:1, 6.

75. Moscow. Historical Museum. Chloudov Psalter. Cod. gr. 129, fol. 45ʳ,
Ps. 44:11. The Annunciation.

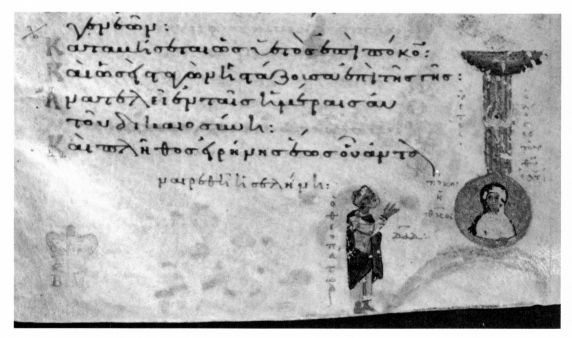

76. London. British Museum. Bristol Psalter. Cod. Add. 40731, fol. 115ʳ, Ps. 71:6.

77. Paris. Bibliothèque Nationale. Paris Psalter. Cod. gr. 139, fol. 7ᵛ. David Theopator.

78. Vatican. Biblioteca. Leo Bible. Cod. Reg. gr. 1, fol. 487ᵛ. David Theopator.

79. Vatican. Biblioteca. Cosmas Indicopleustes. Cod. gr. 699, fol. 63ᵛ. David, Solomon, and the Choirs.

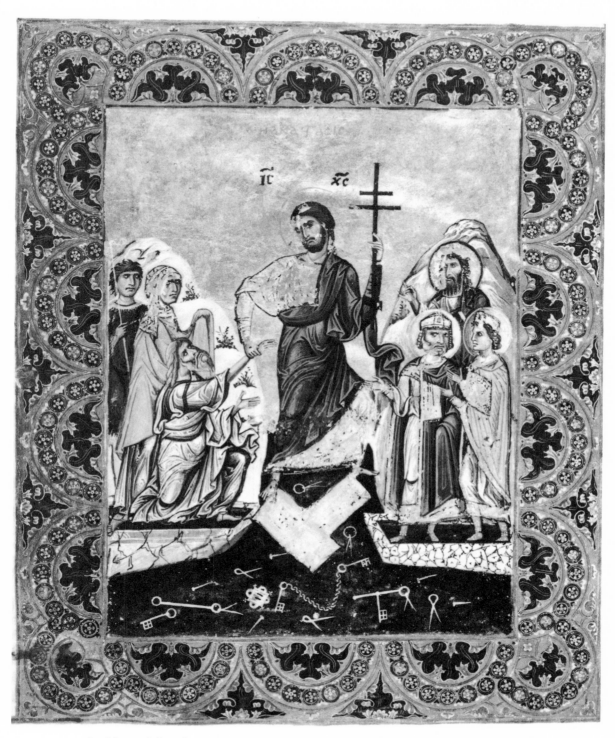

80. Mount Athos. Lavra Monastery. Skevophylakion Lectionary, fol. 1ᵛ. The Anastasis.

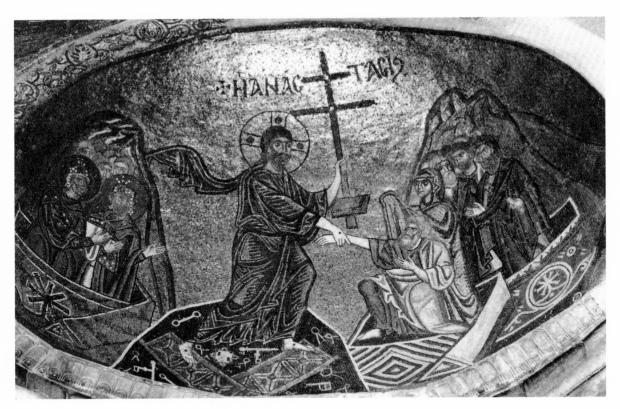

81. Chios. Nea Moni. The Anastasis.

82. Chios. Nea Moni. Groundplan (after Diez–Demus). 1: Nativity, 2: Baptism, 3: Crucifixion, 4: Anastasis.

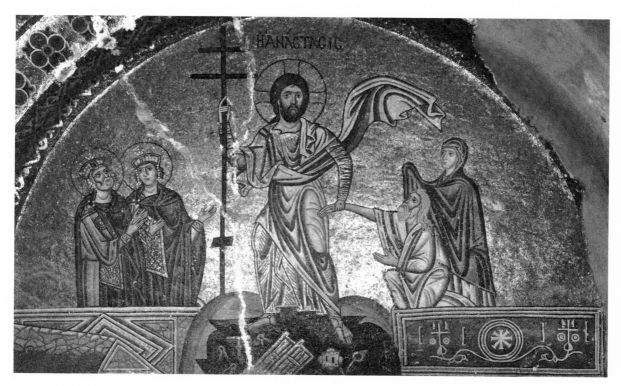

83. Phokis. Hosios Lukas Monastery. The Anastasis.

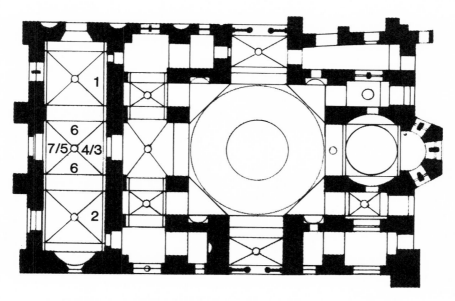

84. Phokis. Hosios Lukas Monastery. Groundplan (after Diez–Demus).
1: Crucifixion, 2: Anastasis, 3: Christ, 4: Virgin, 5: Baptist, 6: Archangels
Michael and Gabriel, 7: Sts. Akindynos, Aphthonios, Elpidophoros,
Pegasios, Anempodistos.

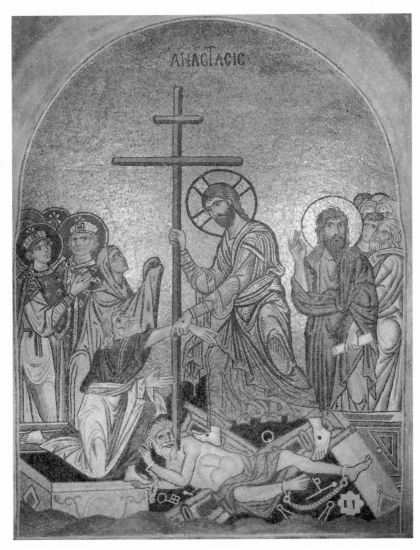

85. Attica. Daphni Monastery. The Anastasis.

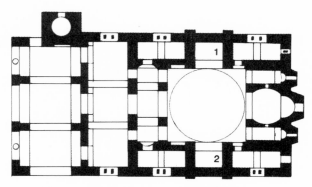

86. Attica. Daphni Monastery. Groundplan (after Diez-
Demus). 1: Crucifixion, 2: Anastasis.

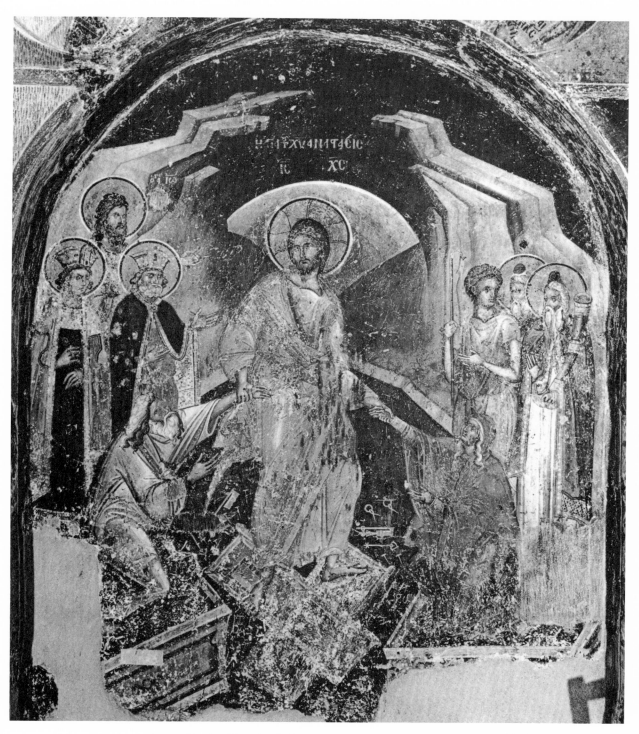

87. Veroia. Church of Christos. The Anastasis by Kalliergis.

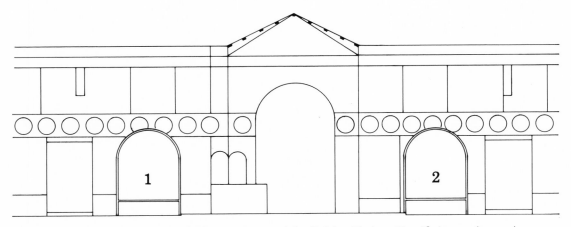

88. Veroia. Church of Christos. Layout (after Pelekanides). 1: Crucifixion, 2: Anastasis.

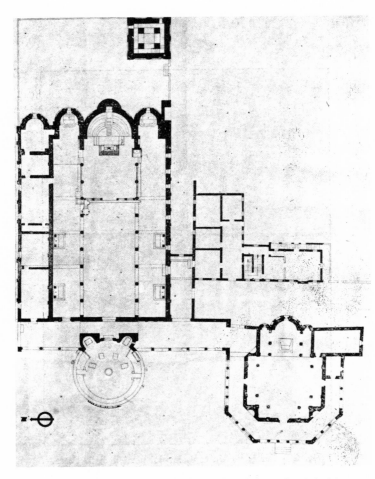

89. Torcello. S. Maria Assunta. Groundplan (after Schulz).